ART BEYOND THE WEST

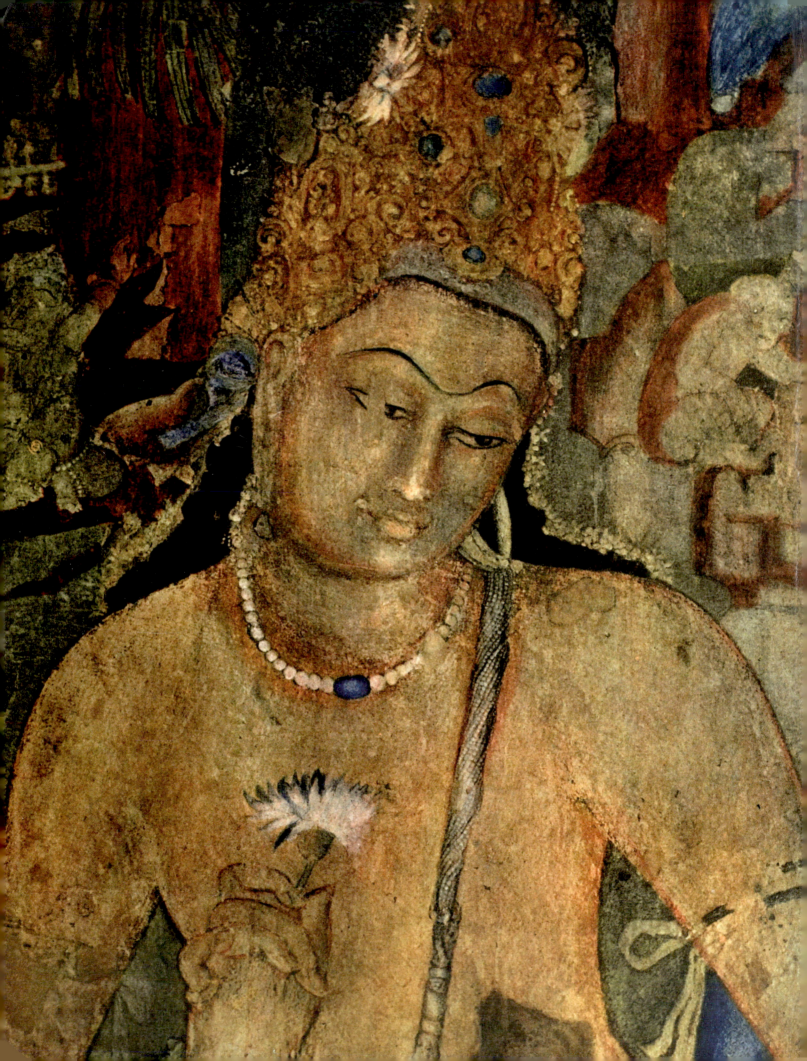

THIRD EDITION

ART BEYOND THE WEST

THE ARTS OF THE ISLAMIC WORLD, INDIA AND SOUTHEAST ASIA, CHINA, JAPAN AND KOREA, THE PACIFIC, AFRICA, AND THE AMERICAS

MICHAEL KAMPEN O'RILEY

PEARSON

Boston Columbus Indianapolis New York San Francisco Upper Saddle River
Amsterdam Cape Town Dubai London Madrid Milan Munich Paris Montreal Toronto
Delhi Mexico City Sao Paulo Sydney Hong Kong Seoul Singapore Taipei Tokyo

Editor in Chief: Sarah Touborg
Editorial Assistant: Victoria Engros
Director of Marketing: Brandy Dawson
Executive Marketing Manager: Kate Mitchell
Production Liaison: Brian K. Mackey
Senior Managing Editor: Melissa Feimer
Production Editor: Laurence King Publishing/Melissa Danny
Senior Operations Supervisor: Mary Fischer
Operations Specialist: Diane Peirano
Text and Cover Designer: Paul Tilby

Photo Researcher: Peter Kent
Senior Digital Media Editor: David Alick
Lead Media Project Manager: Rich Barnes
Full-Service Project Management: Laurence King Publishing/
 Kara Hattersley-Smith
Composition: Laurence King Publishing
Text Font: Weiss LT
Printed in China

Cover image: Ando Hiroshige, *Ohashi Bridge in the Rain*, from *One Hundred Views of Edo*, 1857 (detail). Full-color woodblock print, height 13⅞" (35.5 cm). Fitzwilliam Museum, University of Cambridge. The Bridgeman Art Library, London.

Frontispiece image: *The Beautiful Bodhisattva Padmapani*. Cave 1, Ajanta, India. c. late 5th century CE. Wall painting. Dinodia/Alamy.

Credits and acknowledgments borrowed from other sources and reproduced, with permission, in this textbook appear on page 362.

This book was designed by
Laurence King Publishing Ltd
361–373 City Road
London EC1V 1LR
www.laurenceking.com

Library of Congress Cataloging-in-Publication Data

Kampen-O'Riley, Michael.
 Art beyond the West : the arts of the Islamic world, India and Southeast Asia, China, Japan and Korea, the Pacific, Africa, and the Americas. -- Third Edition.
 pages cm
 Includes bibliographical references and index.
 ISBN-13: 978-0-205-88789-7 (pbk. : alk. paper)
 ISBN-10: 0-205-88789-9 (pbk. : alk. paper)
 1. Art--History--Textbooks. I. Title.
 N5300.K292 2013
 709--dc23
 2012026414

10 9 8 7 6 5 4 3 2 1
ISBN 0–20-588789–9

ACKNOWLEDGMENTS

This revised edition has benefited from the reviews of Kimberly Cleveland, Olawole Famule, Curt Heuer, Lillian B. Joyce, Kristy Phillips, and Marilyn Wyman.

I would like to thank the libraries of Western Carolina University and the University of North Carolina Asheville. Special thanks must also be given to the editorial and picture research staff at Laurence King Publishing, London, including Kara Hattersley-Smith, Melissa Danny, and Peter Kent, who oversaw the thousands of tasks that made this book possible.

MICHAEL KAMPEN O'RILEY
ASHEVILLE, NORTH CAROLINA, 2012

CONTENTS

1: Introduction:
Art Beyond the West 10

2: The Islamic World 22

3: India and Southeast Asia 58

4: China 104

5: Japan and Korea 148

6: The Pacific 200

7: Africa 228

8: The Americas 270

9: Art Without Boundaries 344

**1: INTRODUCTION:
ART BEYOND THE WEST 10**

NON-WESTERN ART AND
AESTHETICS 12
COATLICUE IN CONTEXT 18
QUESTIONS 21

BOXES
 Analyzing Art and Architecture:
 The History of Art: An Academic
 Discipline 13
 In Context: Wo-Haw between
 Two Worlds 16

2: THE ISLAMIC WORLD 22

INTRODUCTION 25
TIME CHART 25
 Muhammad and Early Islamic
 Thought 26
 The Qur'an and Islamic Art 27
BYZANTIUM AND THE UMAYYAD
CALIPHATE (661–750 CE) 29
 Jerusalem: The Dome of the Rock 29
 The Hypostyle Mosque 30
 Damascus: The Great Mosque 31
 Pleasure Palaces and Secular Art 32
THE UMAYYADS AND THEIR
SUCCESSORS IN SPAIN (711–1492) 33
 Córdoba 33
 Granada 34
THE ABBASID CALIPHATE
(750–1258) 36
 Baghdad and Samarra 36
IRAN AND CENTRAL ASIA 38
 The Saljuq Dynasty (1038–1194) 39
 The Ilkhans (1258–1335) 41
 The Timurids (1370–1501) 41
 The Turkomans (1380–1508) 45
 The Safavid Dynasty (1501–1722) 45
 Textiles 48
ANATOLIA AND THE OTTOMAN
TURKS (1453–1574) 50
 Mehmed II and Hagia Sophia 50
 Süleyman the Magnificent
 and Selim II 51
 Recent Islamic Art 54
SUMMARY 55
GLOSSARY 56
QUESTIONS 57

BOXES

Materials and Techniques:
Byzantine and Islamic Mosaics 31

In Context: The "Hakim" and
Renaissance Man 35

In Context: Harun al-Rashid
and Abbasid-Period Books 38

In Context: Persian Poetry,
Painting, and Shi'ite Thought 42

Materials and Techniques:
Islamic Carpets 48

3: INDIA AND SOUTHEAST ASIA 58

INTRODUCTION 60
TIME CHART 61
THE INDUS VALLEY 62
The Aryan Migrations and the Vedic
Period (1500–322 BCE) 64
BUDDHIST ART 64
The Maurya Period (322–185 BCE) 64
The Shunga Period (185–72 BCE)
and Early Andhra Period (70 BCE–
first century CE) 65
The Kushan Period (30–320 CE)
and Later Andhra Period
(first century–320 CE) 70
The Gupta Period (320–500 CE) 72
The Spread of Buddhist Art 73
Afghanistan 74
Nepal and Tibet 74
Sri Lanka 77
Myanmar 77
Indonesia 78
HINDU ART 79
Hindu Art and Architecture in
Southern India 80
Hindu Art and Architecture in
Northern India 85
The Spread of Hindu Art 86
JAIN ART AND ARCHITECTURE 87
ISLAMIC INDIA 89
The Taj Mahal 92
Late Hindu Art in India 94
COLONIAL INDIA 96
MODERN INDIA 99
SUMMARY 101
GLOSSARY 102
QUESTIONS 103
BOXES
Religion: Buddhism 66

Religion: The Dalai Lama 75
Religion: Yoga Then—and Now 79
Religion: Hinduism 81
Analyzing Art and Architecture:
The Hindu Temple: Symbolism
and Terminology 84
Religion: Jainism 88

4: CHINA 104

TIME CHART 107
INTRODUCTION 108
THE NEOLITHIC PERIOD
(C. 7000–2250 BCE) 110
THE XIA DYNASTY (C. 2205–
1700 BCE) AND THE SHANG
DYNASTY (C. 1700–1045 BCE) 111
THE ZHOU DYNASTY (1045–
480 BCE) 114
THE PERIOD OF WARRING STATES
(480–221 BCE) AND THE QIN
DYNASTY (221–206 BCE) 115
The Tomb Complex of Qin
Shihhuangdi 116
THE HAN DYNASTY
(206 BCE–220 CE) 118
The Tomb of the Lady of Dai 118
The Cult of Sacred Mountains
and the *Boshan Lu* 119
THE PERIOD OF DISUNITY:
SIX DYNASTIES (220–589 CE) 121
The Wei Dynasty in Northern
China (388–535 CE) 121
Painting and Calligraphy 122
THE SUI DYNASTY (589–618 CE)
AND THE TANG DYNASTY
(618–907 CE) 124
Painting 124
THE FIVE DYNASTIES (907–60)
AND THE NORTHERN SONG
(960–1127) AND SOUTHERN
SONG DYNASTIES (1127–1279) 128
Painting 128
Ceramics 132
THE YUAN DYNASTY (1279–1368) 132
Painting 133
THE MING DYNASTY (1368–1644) 134
Ceramics 134
Lacquer 136
Painting 137
THE QING DYNASTY (1644–1911) 138

Architecture and Gardening 138
Painting 141
MODERN CHINA (FROM 1911) 143
SUMMARY 145
GLOSSARY 146
QUESTIONS 147
BOXES
In Context: Chinese Writing 113
Materials and Techniques:
Chinese Piece-mold Casting 114
In Context: Xie He and His
Canons of Painting 123
Religion: Chan (Zen) Buddhism,
Enlightenment, and Art 129
Cross-Cultural Contacts: Marco
Polo and the Mongol Court 133
In Context: Guan Yu and
the "Romance of the Three
Kingdoms" 135
Materials and Techniques:
Porcelain 136
Analyzing Art and Architecture:
Feng Shui 139
Cross-Cultural Contacts:
Europe and "Chinoiserie" 142

5: JAPAN AND KOREA 148

INTRODUCTION 150
TIME CHART 151
THE JOMON PERIOD (C. 12,000/
10,500–300 BCE) AND YAYOI
PERIOD (300 BCE–300 CE) 152
THE KOFUN PERIOD
(300–710 CE) 153
Burial Mounds 153
Shinto and Shrines 154
KOREA: THE THREE KINGDOMS
PERIOD (57 BCE–688 CE) 156
THE ASUKA PERIOD (552–645 CE)
AND HAKUHO PERIOD
(645–710 CE) 158
Temples and Shrines 158
THE NARA PERIOD (710–94 CE) 161
Architecture 161
THE HEIAN PERIOD (794–1185) 162
Esoteric Buddhist Art 162
Pure Land Buddhist Art 162
Literature, Calligraphy, and
Painting 164

THE KAMAKURA PERIOD
(1185–1333) AND KORYO KOREA
(918–1392) 167
 Painting 167
 The Shoguns, Daimyo, and
 Samurai 168
 Sculpture 169
 Koryo: Korea 170

THE MUROMACHI (ASHIKAGA)
PERIOD (1392–1573) 170
 Painting 171
 Zen Gardens 172

THE MOMOYAMA PERIOD
(1573–1615) 173
 Architecture and Painted Screens 175
 The Tea Ceremony: Architecture
 and Ceramics 178
 Scroll Painting and Calligraphy 181

THE TOKUGAWA (EDO) PERIOD
(1615–1868) 182
 Architecture 182
 Drawing and Everyday Life
 in Korea 184
 Printmaking and the Ukiyo-e
 Style in Japan 184
 Utamaro 185
 Hokusai 186

THE MEIJI RESTORATION
(1868–1912) 187
 Printmaking and Painting 188

THE MODERN PERIOD
(FROM 1912) 192
 Architecture 192
 Painting, Film, and Video 192

SUMMARY 197

GLOSSARY 198

QUESTIONS 199

BOXES
 Religion: Zen Buddhism 172
 In Context: Japanese Poetry
 and Drama 174
 Cross-Cultural Contacts:
 Westerners and Christianity
 in Japan 175
 Materials and Techniques:
 Japanese Woodblock Printing 185
 Analyzing Art and Architecture:
 Van Gogh and "Japonisme" 190

6: THE PACIFIC 200

INTRODUCTION 203

TIME CHART 203
AUSTRALIA 204
 The Dreaming: The Spiritual
 World 205
 Mimi and the "X-ray" Style 205
 Recent Aboriginal Painting 206
MELANESIA 207
 New Guinea 207
 Papua: The Sepik River Area 208
 Irian Jaya: The Asmat 208
 New Ireland: The Malanggan 210
MICRONESIA 211
 Pohnpei: The Ceremonial
 Complex of Nan Madol 211
 Architecture in the Mariana and
 Caroline Islands 212
 Textiles 213
POLYNESIA 214
 French Polynesia: Tahiti and
 the Marquesas 214
 Western Polynesia: Tonga and
 Samoa 216
 Hawaii 218
 Sculpture and Featherwork 218
 Easter Island 219
 New Zealand: The Maori 220
 The Te Hau-ki-Turanga
 Meeting-house 221
 Colonial and Postcolonial
 New Zealand 224

THE PACIFIC ARTS FESTIVAL 224

SUMMARY 225

GLOSSARY 226

QUESTIONS 227

BOXES
 In Context: The Spread of Art
 and Culture in the Pacific 204
 Cross-Cultural Contacts:
 Paul Gauguin and Polynesia 214
 In Context: Maori Images of
 "Art," "Artist," and "Art
 Criticism" 223

7: AFRICA 228

INTRODUCTION 230
TIME CHART 231
THE HISTORY OF AFRICAN ART
 HISTORY 233
AFRICAN PREHISTORY 233
SOUTHERN AFRICA 235

The Earliest Southern
 African Art 235
Great Zimbabwe 236
EAST AFRICA 238
 Mozambique, Tanzania,
 and Kenya 238
 Rwanda 239
 Ethiopia 239
CENTRAL AFRICA 240
 Chokwe and Kongo 241
WEST AFRICA 242
 Nigeria 242
 Nok 242
 Ile-Ife and the Yoruba Style 243
 Benin 246
 The Modern Yoruba and
 Their Neighbors 250
 Cameroon 254
 Mali and Mauritania 256

POSTCOLONIAL AFRICA AND THE
QUEST FOR CONTEMPORARY
IDENTITIES 258

AFRICAN-AMERICAN ART 263

SUMMARY 267

GLOSSARY 268

QUESTIONS 269

BOXES
 Analyzing Art and Architecture:
 What Is an Authentic African
 Work of Art? 232
 In Context: Artists and
 Attributions 234
 Cross-Cultural Contacts: Pablo
 Picasso and African Art 235
 Analyzing Art and Architecture:
 Primitivism: An Art-Historical
 Definition 236
 Materials and Techniques:
 Lost-Wax Metal Casting 244
 Analyzing Art and Architecture:
 Yoruba Aesthetics 245
 Analyzing Art and Architecture:
 The Harlem Renaissance and Its
 Aftermath 266

8: THE AMERICAS 270

INTRODUCTION 272

SOUTH AMERICA: THE CENTRAL
 ANDES 274

TIME CHART: SOUTH AMERICA 274

Chavín de Huántar 276
Paracas and Nazca 277
Moche and Chanchan 279
Tiahuanaco and Huari 282
The Inca 282
 Cuzco 283
 Machu Picchu 284
 Postconquest Cuzco 285
MESOAMERICA 286
TIME CHART: MESOAMERICA 286
Preclassic Art: The Olmecs 286
Classic Art 289
 The Maya 289
 Xibalba and Maya Painting 290
 Xibalba and Maya Architecture 293
 Tikal 295
 Palenque 296
 Copán and Bonampak 297
 Classic Mexico 299
 Teotihuacán 299
 The Gulf Coast and El Tajín 301
Postclassic Art 305
 The Mixtecs 306
 The Aztecs 307
 Aztec Art and Thought 308
NORTH AMERICA 312
TIME CHART: NORTH AMERICA 312
The Eastern and Southeastern
 United States 314
 The Archaic Period (3000–
 1000 BCE) 314
 The Woodland Traditions:
 The Adena and Hopewell 315
 The Mississippi Period (900–
 1500/1650) 317
The Northwest Pacific Coast 320
 Haida Totem Poles 320
 The Tlingits 322
The Great Plains 324
The Southwestern United States 330
 The Pueblos 330
 The Navajo 335
NATIVE AMERICAN ART IN THE
TWENTIETH AND TWENTY-FIRST
CENTURIES 338
GLOSSARY 342
QUESTIONS 343
BOXES
 In Context: Shamanism and
 the Arts 273
 Materials and Techniques:
 Fiber Art and Weaving 275
 In Context: The Lord of Sipán 281

Analyzing Art and Architecture:
The Mesoamerican Ball Game 294
Analyzing Art and Architecture:
Teotihuacán: City Planning,
Pragmatics, and Theology 302
Analyzing Art and Architecture:
Diego Rivera, Frida Kahlo, and
Aztec Culture 310
Analyzing Art and Architecture:
A Formal Analysis of the
Northwest Pacific Coast Style 322
Materials and Techniques:
Basketmaking 326
Materials and Techniques:
Beadwork 328
In Context: Bury My Heart at
Wounded Knee 329
Cross-Cultural Contacts: Two
Pueblo Clay Artists 334
In Context: "Hozho" as the
Stalk of Life 336
In Context: The "Pow Wow" 340

**9: ART WITHOUT
BOUNDARIES** **344**
PAINTING AND SCULPTURE 347
ARCHITECTURE 351
MULTIMEDIA EXPRESSIONS 354
SUMMARY 356

BIBLIOGRAPHY 357
PICTURE CREDITS 362
INDEX 363

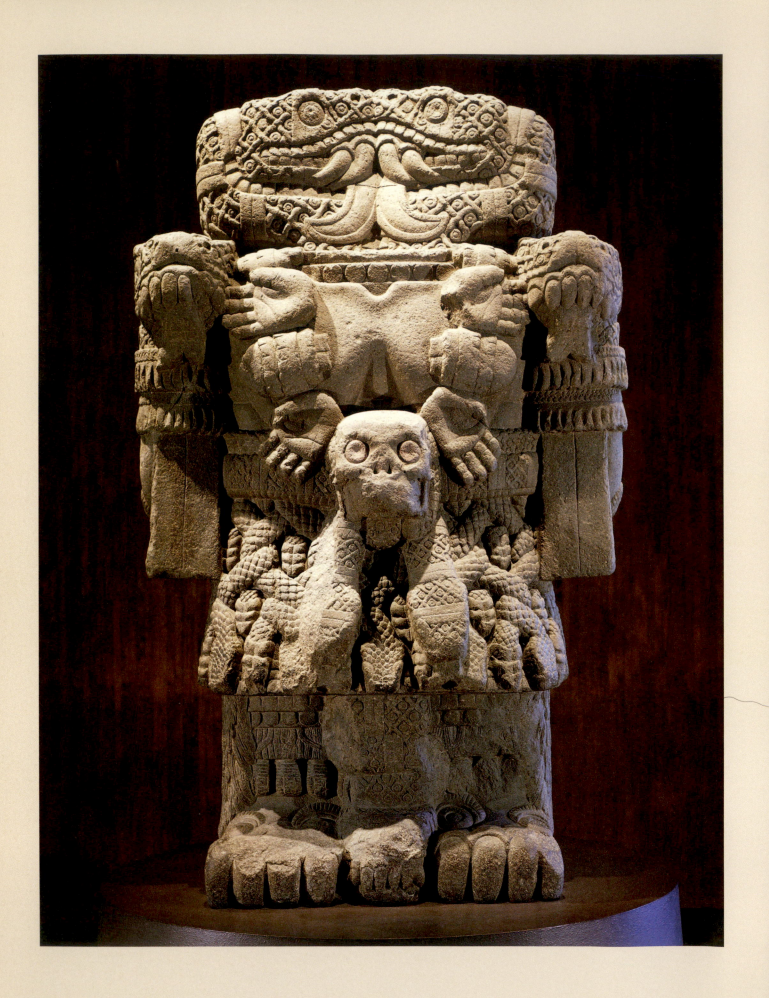

1 Introduction: Art Beyond the West

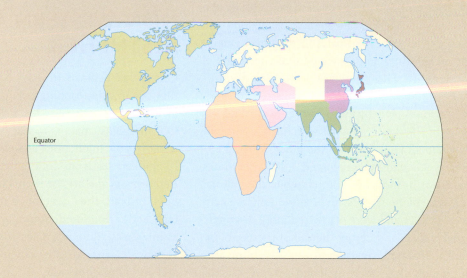

Equator

Non-Western Art and Aesthetics 12

Coatlicue in Context 18

Introduction: Art Beyond the West

This text surveys the art produced beyond the West—in the Islamic world, India and Southeast Asia, China, Korea and Japan, the Pacific region, sub-Saharan Africa, and the Americas—from the earliest times to the present day. This vast geographic area, far larger than the Western world, is home to many cultures with very ancient roots in the distant past. Some of the earliest rock art in Africa and Australia predates the famous Paleolithic cave paintings in France and Spain. The Indus Valley Civilization, Shang-dynasty China, and the earliest Native American ritual centers in South America were contemporaneous with New Kingdom Egypt and early Babylonia in Mesopotamia. (The ancient, pre-Islamic traditions in the arts of Egypt, Mesopotamia, and adjacent lands along the eastern shores of the Mediterranean Sea lie beyond the West, but they played important roles in the development of Western art in antiquity and they are usually included in studies of Western art. Thus, they are not included in this book.) Directly or indirectly, these and other ancient non-Western civilizations gave birth to the cultures and art styles discussed in this text, many of which represent cultural ideas that remain vital forces in the modern world.

Some early Asian cultures coalesced into large states or confederacies, as in India and China, while the cultural units in Africa, the Pacific Islands, and Native America generally remained smaller and were organized more discretely around regional leaders and deities. But all of these groups, large and small, celebrated their identities through the arts, with religious rituals that often included prayers, chants, songs, dances, elaborate forms of costuming, portable art forms, and, at times, monumental art and architecture. Together, these non-Western cultures represent the majority of the land, people, and works of art produced around the world from prehistoric times to the present day, and some of them are poised to become leaders in the international art world of the twenty-first century.

Chapters Two through Eight of this book are devoted to the arts of these indigenous traditions, each of which was built around distinctive sets of religious and philosophical ideals. The latter include what Western thinkers call aesthetics, a branch of philosophy dealing with art, beauty, and how we perceive it. Aesthetics and other key art-related issues are discussed at the outset of each chapter,

in the Introduction, while box features contain important information that lies outside the mainstream text. The first box, *Analyzing Art and Architecture:* The History of Art: An Academic Discipline, appears opposite and discusses further the methodology used in this book. The glossaries at the ends of the chapters list and define important terms that were highlighted in **boldface** when first introduced in the main text. The questions take up the most important ideas introduced in each chapter.

Below, we will take a brief introductory look at these non-Western traditions and their core ideas, chapter by chapter. Many of these ancient ideals remain sacred to billions of people around the world today.

NON-WESTERN ART AND AESTHETICS

Our survey begins with Islamic art, a tradition inspired by the Qur'an, the teachings of Allah as revealed to Muhammad (c. 570–632 CE), his Prophet. Restrictions in the Qur'an against making visual images of Allah, along with other Islamic injunctions against idolatry, discouraged early Islamic artists from following the long-standing figural traditions in the arts of their Persian and Byzantine neighbors. Instead, they developed many highly innovative and intricately structured nonrepresentational art forms such as interlaces and arabesques, which they applied to a wide variety of materials and objects, including their religious and secular architecture. By the sixteenth century, groups of Persian poets known as *zarifs* (dandies, dilettantes, or connoisseurs) had developed a vocabulary of formal or aesthetic terms to discuss the arts. In this, *jamil* (beauty) is related to *ajib* (that which is astonishing), and is dependent on *itidal* (symmetry) and *tanasuh* (harmony or unity). *Musanabah* (balance), *maqadir* (measure), and *bayadat* (spacing) were also important elements in composition. These ideas reflect the emphasis placed upon nonobjective forms in Islamic art and help us understand the aesthetics of that tradition as it developed in tandem with the spread of the religion and culture from the Arabian Peninsula as far east as Indonesia and west to Spain and Portugal.

Some of the oldest and largest religions in the world today emerged from the very ancient literary traditions of

THE HISTORY OF ART: AN ACADEMIC DISCIPLINE

Writers in the West had been commenting on the arts since antiquity, but Art History as an academic discipline and philosophy did not begin to emerge until the late eighteenth century. As part of this complex intellectual movement, scholars began to see the visual arts in terms of a succession of styles that reflected the larger picture of Western history. In the process, they also began to regard "style" as an entity with a life of its own and some writers equated regional period styles with the human cycle of birth, life, and death. In their histories, the key monuments or works of art ("characters") acted their roles in the drama of the period styles ("chapters") that formed part of the epic narrative of Western art.

For some art historians, the formal analysis of period styles has remained an end in itself, and they regard such analysis as synonymous with Art History in its purest sense. For others, that analysis is simply the first step toward a fuller definition and understanding of such styles—why they emerged and what they tell us about the cultural contexts in which they once "lived." The most far-sighted of these scholars realize that the visual arts do not exist in a vacuum, or in passive relationships with the world around them. Art has always had a very active, give-and-take relationship with its cultural context. In this autocatalytic process, the arts absorb ideas from religion, philosophy, politics, society at large, and every other area of thought. With their distinctive material qualities, the visual arts reshape these ideas into new forms of expression, which then influence the sources from which they came and every other conceivable aspect of the cultural context around them.

This form of contextualism differs significantly from the much-maligned Zeitgeist philosophy. Zeitgeist is a loan word from German meaning "time-spirit" or "spirit of the times," and suggests that the general cultural, intellectual, political, and spiritual climate of any given time and place has a certain essence or uniformity. Seeing the visual arts as part of this Zeitgeist can imply that they are merely passive parts and lowly cogs in the greater cultural context of that "spirit of the times." However, this other philosophy of context, as I have described it above, gives the arts full credit for what they have always been—discrete and active ingredients in the recipe for culture, giving it their own distinctive flavor. The visual arts "say" things in ways other art forms cannot. That is the true meaning of period styles—they tell us their version of the culture of which they were active parts, and in so doing add depth to our understanding of that culture.

This book places great emphasis on contextualism, the autocatalytic process by which art interacts with its cultural environment. In order to do this, it sets out to demonstrate how the arts in each region developed around core ideas that fueled that process and uses those core ideas throughout each chapter to discuss the key monuments in that tradition. Most of these ideas are discussed in the opening pages of this introductory chapter under the heading "Non-Western Art and Aesthetics." In each case, they reflect some of the most basic, important, and long-lived philosophical and religious ideals of a particular region, and thus provide a solid platform from which we can understand the art selections in context.

the land that constitutes present-day India. A complex philosophy of art likewise emerged from the group of related religious practices known in the modern world as Hinduism. Key among these is *rasa* (juice or essence), an emotional reaction of satisfaction experienced when looking at art that leads to *brahman*, pure consciousness or bliss, the abstract Absolute. The highest form of *rasa* creates *bhakti*, a bond and intimate relationship between observer, work, and the gods it represents. In some Hindu sects, *bhakti* overlaps with *darsana* (vision of the divine). These highly abstract terms, discussed at greater length in Chapter Three, will take on their full meaning when we apply them to the works of art examined in that chapter and we see how they are displayed in places of worship—microcosms of the universe encompassing the world of humankind and that of the gods.

The second major Indian religion, Buddhism, is well known for its many sculptures of the Buddha, carved in styles that emphasize the inner peace he discovered while

meditating on his path to enlightenment. The Buddhists also developed a complex religious iconography in their pictorial arts and illustrated a large number of divine individuals known as *bodhisattvas*—those who have *bodhi* (wisdom) as their goal and are dedicated to helping humankind. Early on, they also built outdoor places of worship known as stupas, symbolic World Mountains that are diagrams of the Buddhist cosmos. Later, they used their own *chaityas* (assembly halls) as models and carved monumental rock-cut replicas of these structures into stone cliffs, so when you are within that "bubble" of space, you have the illusion of being inside a masonry building.

About the time the arts of these native traditions began to lose some of their original inventive vigor, the Islamic Mughals conquered parts of India and created spectacular fresh Indo-Islamic styles of painting and architecture that flourished for centuries until the British extended their control there. In 1858, Queen Victoria became Empress of India, ushering in nearly a century of direct colonial rule that lasted until 1947. During this period, traditional forms of Indian art coexisted, and in some cases began to fuse, with Western art.

While the great religions were emerging in India, the Chinese were developing their own spiritual and philosophical ideals that would shape indigenous visual art forms there in the centuries to come. Confucius (c. 551–479 BCE) believed that one could achieve *li* (perfect harmony) and *ren* (human-heartedness) in this life by imitating the otherworld of the gods. His near-contemporary Lao Zi ("Old One") (born c. 604 BCE) meanwhile taught and wrote about the *Dao* ("The Way") and the need to live in harmony with nature and the universe. In *ming*, the ultimate inward vision, the vital forces of nature, *yin* and *yang*, become one in the Daoist's experience of the oneness of all creation. A later writer, Xie He (active c. 479–502 CE), said artists must have a "sympathetic responsiveness" to the *qi*, a term that can mean many things, including the "spirit of nature." In the centuries to come, elite groups of Chinese thinkers known as the *wenren* (literati or scholars) debated these issues alongside the philosophy of the Chan (later Zen in Japan) Buddhist sect, which, like Daoism, stressed the importance of meditation, instinctive actions, living in harmony with nature, and creating works of art that express those values. These were often paintings, quickly executed in moments of intense inspiration, or pieces of calligraphy—literally, "beautiful writing"—produced in the same explosive manner.

Western traders arrived in China by 1514, and by the eighteenth century Chinese art had become so sought-after in Europe that the vogue for its aesthetics gave rise to a style of art known as *chinoiserie* (French for "Chinese-style things"). While China was never colonized by the West, foreign involvement there triggered a series of rebellions and

damaging wars, followed by a Communist revolution, all of which stymied home-grown traditions in the arts. However, these have revived along with the Chinese economy in new and vigorous forms in the early twenty-first century.

Japan's ancient native religion, Shintoism, and the art it inspired draw on the unpretentious values of Japan's early agrarian society. Japanese writers use several key terms to describe and explain Shinto aesthetics: *wabi* (purity and humility) and *sabi* (stillness and rusticity). When Buddhism later arrived in Japan via Korea, it brought with it well-developed Chinese styles of architecture and traditions in the pictorial arts, which the Japanese eventually adapted to their own tastes. The so-called "four ideals" of Japanese aesthetics, based on both indigenous and imported traditions, are: the importance attached to suggestion—that which is not fully shown, said, or done but only implied; impermanence—the fleeting or ephemeral nature of existence, which adds a tragic note to art and life; irregularity—which gives art a natural, almost accidental look; and apparent simplicity—which belies the true complexity of art and thought. These principles are examined in greater detail in Chapter Five and are used to examine the key works illustrated there.

Together, these ideals created an art of subtle refinement and restrained beauty with universal appeal. The vogue for Japanese art and aesthetics in the West in the late nineteenth century gave rise to *japonisme* (a French word used to describe the fascination with Japanese-style things). Meanwhile the Japanese art that emerged from the meeting of East and West preserves many traditional Japanese ideals even as it comments on the role of Japan in the contemporary world.

In the Pacific, vast stretches of open water separate thousands of small islands and island groups, many of which developed distinctive, localized religions and art forms. *Mana*, a complex spiritual ideal often simplified in translation as "power," combined with the notion of *tapus* (from which the English term "taboo" is derived), restrictions on the use of that power, helped create distinctive regional philosophies of art. The hundreds of giant stone heads with small torsos carved by the Easter Islanders and erected around the island reflect this philosophy of art and power, and have become internationally recognized symbols of Pacific art and culture. The European maritime powers later colonized many parts of the Pacific, damaging cultural and artistic traditions there. Happily, these are once again being revived and celebrated today.

In Chapter Seven, we move on to sub-Saharan Africa, where many small ethnocultural groups have long performed complex multimedia rituals involving dance, music, prayers, and chants designed to transport performers to a

more spiritual plane of being. Traditionally, most African art has been made of wood and other perishable materials, so very few ancient works used in these ceremonies survive today. In Nigeria, however, artists sculpted clay and cast metals, which means that we have the necessary materials to allow us to study their stylistic development over the centuries. The Yoruba of Nigeria had one of the world's great courtly traditions in the arts, creating a long series of idealized portrait heads of their leaders which embody complex ideas about earthly and spiritual beauty (FIG. 1.1).

Looking at these highly idealized Yoruba portrait heads, we might have made a guess that they were images of semidivine leaders shown at their best so that they might be considered worthy companions of the gods. When we come to interpret the sculptures, however, we have further assistance because Yoruba-speaking scholars, working with modern Yoruba groups, have collected many of the traditional terms that describe their philosophy of beauty as manifested in these regal heads. Yoruba aesthetics center around the phrase *iwa l'ewa* ("character is beauty" or "essential nature is beauty"). The basic Yoruba word for beauty, *ewa*,

incorporates *ifarahon* (clarity of line and form), *jihora* (relative likeness), and *itutu* (a calm, collected, and cool quality), a virtue of the gods. The chapter on African art will explore these ideas in greater depth.

The slave trade, colonization of Africa, and resulting diaspora sent Africans and their cultural traditions around the world. In most places, the colonial period ended in the late twentieth century. In the postcolonial period artists have begun to discover new and creative ways to combine the indigenous and colonial sides of their heritage.

The highly diverse topography of the Americas—deserts, woodlands, prairies, tundras, and mountains—and the ethnocultural diversity of Pre-Columbian (that is, before the arrival of Christopher Columbus and European culture more generally) America combined to produce a wide variety of regional religious systems and styles of art. This text divides this large landmass into South, Meso-, and North America, and examines the regional traditions within each area.

The desert groups along the Peruvian coast in South America had plentiful supplies of clay, built large structures using sun-dried adobe bricks, and were highly skilled in the modeling of clay, producing thousands of highly realistic sculptures depicting themes from their religious and daily lives. Many other groups in and around Peru became technically skilled weavers and so accustomed to composing forms and images within the right-angled warp-and-weft patterns of the threads on their looms that they developed what we may call a "textile aesthetic." The taste for simplified geometric and repeating forms in textiles reappears in other forms of pictorial art incorporating abstracted images of animals and people. They even used these abstracted images to create monumental geoglyphs, drawings or markings on the ground. The short-lived Inca Empire was in the process of building on these and other traditions when the Spanish conquered South America in the sixteenth century, but many of the Pre-Columbian art forms in and around Peru have survived to this day as regional folk traditions.

As Mexico, Canada, and the United States extended their reach into North America, they encountered a wide variety of indigenous artistic traditions flourishing across the continent. Some of the most vital and well-studied art styles come from the southwest of the modern United States, where one sees the large pueblos (Spanish, "villages") and more scattered groups of Navajo living in small hogans, or houses, in the countryside. The Navajo see art and life as a corn plant, with *hozho* ("a world of perfect beauty") as its stalk. *Hozho* can also mean "happiness," "health," "beauty of the land," and "all things in perfect harmony with one another." No one is called an "artist" because, in Navajo thought, everyone has creative powers and can make

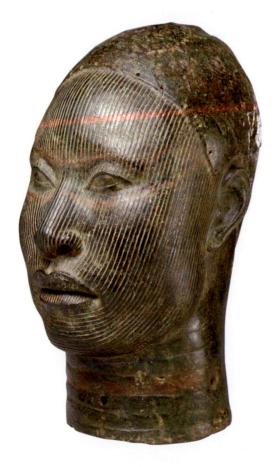

1.1 Head of an *oni* (king). From the Wunmonije Compound in Ife-Ife. 11th–12th century. Zinc and brass, height 12¼" (31 cm). National Commission for Museums and Monuments, Nigeria

WO-HAW BETWEEN TWO WORLDS

In 1875–77, an insightful Native American Kiowa artist illustrated the plight of his people in a remarkably telling image, *Wo-Haw between Two Worlds* (FIG. 1.2). Following their defeat in one of the many one-sided Indian Wars, most of the Kiowa were forcibly relocated to reservations while a small group of warriors, including Wo-Haw, was shipped east to a prison, Fort Marion, in St. Augustine, Florida. Kiowa artists had traditionally drawn and painted on animal hides, but not having such materials to hand in prison, they used the pencils and pieces of discarded ledger paper they received from the prison officers instead. Thus, this type of work is known to us as Ledger Art.

With the sun, moon, and a shooting star as his witnesses, in the image Wo-Haw extends peace pipes to a buffalo (the Native American past) and a domesticated cow (the colonial present). He plants one foot near a miniature buffalo herd and a *tipi* or teepee, a conical tent of hides supported by long thin poles, and the other by cultivated fields and the frame house of a white Euro-American settler. The picture combines remnants of earlier Native American styles of drawing and decoration with Wo-Haw's knowledge of the Western images he had seen in newspapers, magazines, and advertisements while he was in prison. The Ledger image looks to us now like a strikingly prophetic statement, describing the experience of Native American and other non-Western artists around the world as Western influences increasingly came to challenge their ancient traditions and they searched for suitable forms in which to express their experiences caught "between two worlds."

There was no easy and logical solution to larger cultures they represented. Wo-Haw and his people could not return to their past; their society was in ruins. Not only had their buffalo herds been decimated, some of their communities had been destroyed as well, and many of their traditional social customs no longer existed. But fully embracing all things Western would mean simply giving up their cultural identity. They therefore had to ask: What Western influences can we embrace and mix with our heritage and still maintain our traditions? Some artists in colonized or otherwise Western-dominated societies around the world tried to make their problem its own solution—they accepted the duality of their heritage as a reality and looked for creative combinations

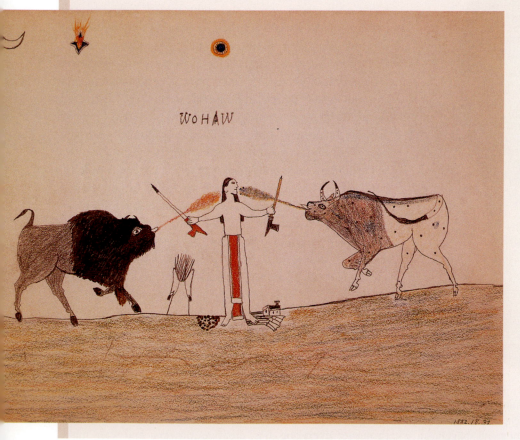

1.2 Wo-Haw, *Wo-Haw between Two Worlds*. 1875–77. Graphite and colored pencil on paper, 8 × 11" (20.3 × 27.9 cm). Courtesy of the Missouri Historical Society, St. Louis

of their indigenous and colonial cultures that would express their current situation in an accurate and meaningful manner.

Until the late twentieth century, however, Western power-figures in the arts tended to reject such "hybridized" forms as aesthetic failures. Traditionally, surveys of non-Western art have stopped shortly before Wo-Haw and other artists around the world found themselves straddling two worlds, creating dual and distinct aesthetic footprints. An early work of Wo-Haw painted on a buffalo skin might have been included in such a survey as an authentic Native American work of art, but not his Ledger Art. Western authorities wanted to see works that spoke exclusively of one culture and a single philosophy of art. The cutoff date for the end of these non-Western traditions varied from place to place. In Latin America, it came with European colonization in the sixteenth century. In many parts of Asia, the terminal date was around 1850, and in the Pacific, Africa, and North America, it came anywhere from about 1850 to 1900. Today, however, writers on art around the world increasingly see great value in non-Western colonial and postcolonial art, and that material is included here with the surveys of fully indigenous art in Chapters Two through Eight. Thus, this image has become a potentially meaningful one for colonized cultures around the world as they reevaluate and attempt to revitalize some of their old traditions.

beautiful, aesthetically pleasing things. *Shil hozho* means "with me there is beauty," and *shaa hozho*, "beauty radiates from me." But *hozho* coexists with *hochzo* ("that which is evil and ugly in the world"). When *hochzo* begins to dominate one's spirit, it is time to conduct a healing ceremony in which all the Navajo art forms are used (FIG. 1.3).

Many of the Navajo and pueblo traditions in the arts of the Southwest have survived, but those of the less sedentary Native American groups on the Great Plains to the north have not. Their portable works of art included buffalo hides painted with pictorial symbols representing each year in their recent past. Storytellers used these symbols to instruct their kinsmen in their ancient cultural traditions and to keep those traditions alive as the newcomers on the prairie began destroying their buffalo herds and fencing off their hunting grounds. The symbols spoke of old values, living in harmony with nature in a rapidly disappearing world. The story of that Plains tradition is discussed in *In Context: Wo-Haw between Two Worlds* (see opposite).

Because there are so many important regional aesthetic and philosophical ideals relating to the arts in the Americas, not all of them can be discussed in the chapter's Introduction. Instead, they are introduced in step with the specific arts to which they relate.

Scholars use the term "Mesoamerica" to refer to an area extending south and east from northern Mexico through the Yucatán Peninsula to Honduras and El Salvador. The Maya in and around the Yucatán Peninsula have been studied with particular interest because they were the only fully literate people in Pre-Columbian America. Their

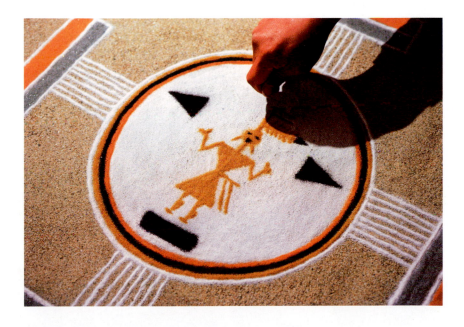

1.3 Navajo sand painter. Shiprock, New Mexico. 2005

inscriptions, pictorial arts, architecture, and literary traditions all worked together to express the power of the gods and their ruler-regents on earth. In their belief system, the Maya rulers traveled from this world to the otherworld of the gods through "portals" in their religious structures; their architecture therefore had a cosmic dimension to rival that of the Hindu and Buddhist temples in India.

Like the Chinese, the Maya placed high value on fine brushwork, which they used to write about their gods and rulers and paint images of them holding court in the otherworld. In fact, the Maya use the same verb for "to paint" and "to write" (*ts'ib*) in all the regional dialects of their language, and an ancient inscription from the eighth century CE refers to the *ah ts'ib* (royal artist-scribes), members of the Maya elite who wrote about and painted the courtly world around them. About half of the Maya glyphs can still be read, and given the stunning beauty of their brushwork, it is to be hoped that some day linguists will discover the Maya word(s) for "beauty" and begin to reconstruct their thinking about aesthetics.

As the Maya declined, the Aztecs built a large empire at the other end of Mesoamerica covering the central part of present-day Mexico. Around 1500 CE, they had begun to absorb the earlier artistic traditions of the peoples they had conquered. Some of this work was directed by an elite class of poet-priests called the *tlamatinime* ("those who know"), who held gatherings to share their poetry and discuss matters of art and philosophy.

Using these two linked tools—general philosophical ideals about art and aesthetics, and the specific words that explain those ideals in their original linguistic and cultural context—we will attempt to see art around the non-Western world as it was seen and understood by the people who created it. For most groups, their art was religious, representing divine themes, beings, and other religious concepts. Those religious philosophies helped shape what we now call their aesthetic values and concepts of beauty, because the latter are tied to qualities attributed to the spiritual beings the works were designed to revere and worship. Often, they include the ideals of "goodness" and "high moral character." That is why the Introduction to each chapter in this book focuses on the most important religious ideals that shaped the art examined in that chapter and, where possible, uses the terms of reference used by those who actually created the art.

In summary, as opposed to being ethnocentric and looking at non-Western art from the outside, we will try to see it from the "inside out." In the following section, we will return to the Aztecs and to the thinking of the *tlamatinime*, their sages, in order to look at an important Aztec sculpture in its cultural context, from the inside out, and try to see that important monument as Mexicans have from the time the *tlamatinime* first looked upon it right down to the present day.

COATLICUE IN CONTEXT

Around 1500 CE, artists working for the Aztec leaders completed a set of very large sculptures honoring an important Aztec goddess, Coatlicue ("She of the Serpent Skirt"), and installed them in a prestigious location, near the main temple in their capital, Tenochtitlán, present-day Mexico City. The vastness of that city—one of the largest in the world at the time—is evident in a mural painted by the twentieth-century artist Diego Rivera in the National Palace, Mexico City (FIG. 1.4). The most completely preserved sculpture is a memorable monument in its own right, but, impressive as it may look in reproduction here, no book illustration can convey the experience Aztecs would have had seeing this towering 11-foot (3.4 m) image of Coatlicue in the heart of Tenochtitlán, or the feeling we have today viewing "She of the Serpent Skirt" in the National Museum of Anthropology in Mexico City mounted on a pedestal under bright spotlights (FIG. 1.5).

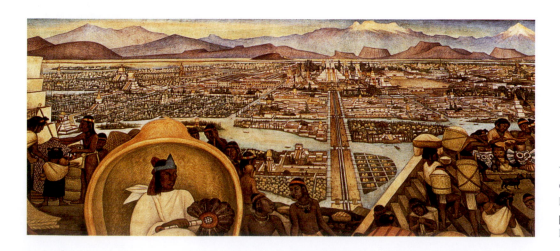

1.4 Diego Rivera, *The Great City of Tenochtitlan*. 1945. Detail of the mural in the patio corridor, National Palace, Mexico City

Coatlicue was an earth goddess associated with the dual themes of life and death. She was called "mother of the earth who gives birth to all celestial things" and "mother of the gods," but it is her death symbolism that is most evident here in the necklace she wears of human hands and hearts with a beady-eyed skull pendant—signs of human sacrifice. The life-and-death aspects of her being are not contradictory, but go together hand in hand and explain the importance of human sacrifice in Aztec thought. Their myths say the gods created this world and everything in it, including humankind, out of their own bodies and blood. Thus, the Aztecs believed that they were born in debt to the gods and had to repay that debt in kind, with their own bodies and blood, for mother earth to be fertile and nourish her children. According to records from this time, people considered it an honor to die for this cause. Many of the bloody sacrificial rituals took place at the main temple in the center of Tenochtitlán (see FIG. 1.4), near where *Coatlicue* and her companion pieces originally stood. Thus, for those attending the rituals—or participating in them—the sculptures were a dramatic reminder: These sacrifices are necessary to keep your world alive! Given this information, do we understand this statue of Coatlicue? Not completely—yet.

The devoutly religious Spanish Catholics, who conquered Tenochtitlán and the rest of Mexico around 1520 in the name of Christendom, were appalled by the Aztecs' pagan religion, with its goddesses like the serpent-covered Coatlicue and its human sacrifices. In the process of demolishing Tenochtitlán and building a new capital over its ruins, the conquerors buried the sculptures of Coatlicue and other unwelcome reminders of the pagan past. The Spanish even made it a crime punishable by death for Aztecs or other Native American people to own non-Christian works of art, so very few reminders of Coatlicue and her world survived the conquest. Most of the Aztec myths and legends were metaphorically buried as well, but the few that were recorded after the European conquest tell various and contradictory stories about the goddess.

Mythologies are created and perpetuated by talented and often competing storytellers who in their quest to outperform one another add new twists to the old tales they have inherited. Perhaps that is why this statue belonged to a set of at least four images of Coatlicue: The Aztec leaders probably wanted to illustrate the various different aspects of the goddess the people knew through the many colorful myths circulating at the time. For instance, another of the statues has a skirt made up of human hearts taken from sacrificial victims, perhaps illustrating another element of the Coatlicue symbolism.

Our statue seems to fit a myth that casts Coatlicue as an elderly guardian priestess of a shrine north of the valley of

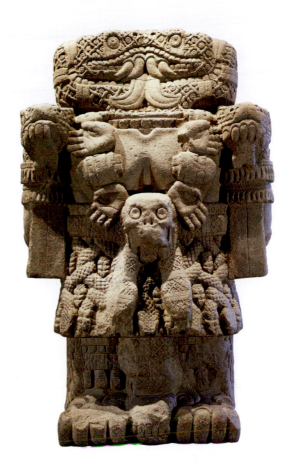

1.5 *Coatlicue*, Tenochtitlán (present-day Mexico City). Aztec. c. 1487–1520). Stone, height 11′4″ (3.45 m). Museo Nacional de Antropología, Mexico City

Mexico, where she became pregnant when a ball of hummingbird feathers touched her breasts. To restore their family honor, Coatlicue's four hundred children decided to kill their pregnant mother, but as they were cutting off her body parts the male child she was carrying leaped forth and killed them all. This was Huitzilopochtli ("Hummingbird on the Left"), who became the Aztec god of war and the sun. The sculptors show us the blood of Coatlicue spurting forth from her wounds, some of which turns into serpents. A pair of very large opposed serpents rise from her severed neck. Thanks to our knowledge of the myth, we are thus able to speculate further about the meaning of this particular image of this goddess. However, this by no means exhausts all the things we need to know about Aztec thought and Coatlicue in connection with this statue.

Aztec society included elite groups of leaders and high-ranking poet-priests—the *tlamatinime* mentioned above, who knew far more about Aztec philosophy and religion than the general public. Post-conquest records tell us that the *tlamatinime* held gatherings to discuss metaphysical issues in the arts. They referred to statues such as this one as a *totecatl*

("finely crafted luxury item") and used the phrase "flower and song," a general term for beauty and the arts, when discussing them. The stonecarvers were probably Toltecs, one of several ethnocultural groups the Aztecs had themselves conquered and then employed as artists, but the *tlamatinime* had a clear hand in the statues' design.

Works of art showing Coatlicue were designed to deliver at least two religious messages. We have already looked at the first—how the fearsomeness of the giant woman of the "serpent skirt" was designed to ensure public support for the ritual of human sacrifice. The second message is more complex: It is aimed at the gods and their high-ranking Aztec regents on earth and deals with creativity and immortality. In their poetry, the *tlamatinime* tell how the ability to create art is a gift from the gods, and how those who use this creative power to honor the gods through "flower and song" will in turn receive yet another gift from the gods—immortality. While the *tlamatinime* did not actually wield the tools and cut the stone, as elite members of Aztec society and patrons of the arts, they nonetheless made artworks honoring the gods possible, instructing the Toltec sculptors before they began their labors. In the manner of architects and artists in charge of large projects, they, not the workers, had their names attached to the project. Thus, the *tlamatinime* could take credit for *Coatlicue*, the sacrificial victim-gifts she inspired, and hopefully receive the gift of immortality from the gods. (The *tlamatinime* were also poets, creators of their own "flower and song" that honored the gods, so they might have had yet another claim to immortality.)

After *Coatlicue* was finished, the *tlamatinime* and other Aztec sages and storytellers looking upon the dramatic, towering images of the serpent goddess probably used the visual experience to revise and build upon the stories they had told about Coatlicue in the past. We must remember that mythology is not history; it comes from revelation, new experiences, and the art of storytelling developed in context with the art and culture around it. In the autocatalytic, or self-propelling, process of cultural dynamics, stories influence the visual arts, which in turn influence stories, songs, rituals, and future works of art in an unending cycle of cultural exchange and development. Had the Spanish not conquered the Aztecs shortly after the Coatlicue sculptures were finished, the excitement they created and the new stories they spawned might have inspired Aztec patrons to commission even more dramatic statues of the goddess, illustrating and embellishing yet other aspects of her complex symbolism, which would have inspired more myths and legends about her, *ad infinitum*.

While the paragraphs above emphasize the thinking of those who created *Coatlicue* and the reactions of the work's original audiences, the full meaning of any work of art for us now also depends upon the way that work has been received by audiences over the ages. Workers digging near the Cathedral of Mexico City unearthed the statue in the eighteenth century, but reburied it shortly thereafter. Its location was recorded, and in the years to come *Coatlicue* was unearthed several times, but the sculpture was not put on permanent display until the Mexican Revolution (1910–20), when the pro-Mexican or native *Mexicanidad* forces in the Revolution recognized the power of *Coatlicue* as an object of Native American cultural pride. Millions of Mestizos—Mexican descendants of the Aztecs and other Native Mexican groups with relatively little Spanish blood—were trying to trying to shake off four hundred years of aristocratic, Hispanic rule and so *Coatlicue* was adopted as a powerful symbol of the power in their Aztec-*Mexicanidad* bloodline.

Since that time, for about a century, the statue of Coatlicue has remained an important symbol of the Native American heritage of modern Mexico. In the 1960s, it helped inspire the Mexican government to build a new National Museum of Anthropology, where *Coatlicue* has long been a popular tourist attraction.

It might seem that we have now exhausted the subject and know precisely what our monumental carving means, but—once again—there is more. At the same time that the symbolism of *Coatlicue* has changed over time, the world's view of Aztec art has changed as well. Until the late twentieth century, writers on art and history treated most of the works illustrated in this book as cultural documents and ethnographic curiosities, but not as works of art worthy of standing alongside the sculptures of Michelangelo or paintings of Rembrandt. When exhibited in museums and galleries, the arts of the Pacific Islands, Africa, and Native America were often titled "tribal" or "ethnic" art. Relatively few colleges and universities offered classes in Aztec or other forms of non-Western art history.

However, after the construction of the National Museum of Anthropology in Mexico in the 1960s as well as other venues where such works were displayed as art, Western attitudes began to change. Though much Asian art had long been accepted in the West as art, its seeming exoticism and sheer "foreignness" meant that it was ghettoized and restricted to the back and upper galleries of art museums, as if it were not quite "fine" enough to be displayed up front with the works of Western masters. That too has changed, and most museum directors, curators, art historians, and art critics around the world now agree that the arts from every corner of the world should stand together on a level aesthetic playing field. Academic classes in art appreciation and history, and the textbooks used to teach them, have started to incorporate non-Western art so that the key monuments ("characters") and period styles ("chapters") from beyond

the West have become part of the larger narrative or story of world art. However, before we conclude this discussion, let us take a look at *Coatlicue* in and out of its original context to see what that tells about its meaning.

The preceding discussion of *Coatlicue* reminds us that, traditionally, works of art were installed in temples, churches, and other buildings and spaces where observers saw them as part of a wide variety of ceremonial and other religious and civic activities. Often, these ceremonies were multimedia experiences that included dance, music, chants, and prayers. Many were designed to transport performers into states of mind where they could transcend everyday concerns and enter purely spiritual realms. However, particularly in the colonial period, it was the fate of many such works of art to be collected and relocated in private homes, libraries, galleries, and museums, where they were put in cases, on pedestals, and hung on walls. In most museums, works of art are given considerable space so that observers can contemplate them, one at a time, in complete isolation from one another and from the daily rituals and activities of the people around them—which is not at all how most early works were conceived to be experienced.

At this point we may ask: What are the pros and cons of such museological practices? Certainly, they have preserved many works and made them available to viewers who would not otherwise have been able to see them, but when we see works in museums or in reproduction we must remember that we are experiencing those objects out of their original cultural context. *Coatlicue*, for example, was part of a large collection of sculptures and other works of art installed in the public spaces, temples, and shrines in the heart of a very large city, where the sights and sounds around it would have included music, speeches, dances, and rituals, not to mention vendors hawking their wares. In Aztec thought, the temple beside *Coatlicue* in the very center of FIG. 1.4 was the *axis mundi*, the central axis of the world that united ritual spaces in Tenochtitlán with the upper and lower worlds of the spirits. There, and only there, did the statue make complete sense, in its original religious context, in the place where the goddess belonged in the minds and hearts of the Aztecs who admired and feared her.

Like *Coatlicue*, many of the works of art illustrated in this book still hold deep personal meaning for the descendants of the original audiences for whom they were created. They were not intended to be art for art's sake; they were created to enhance worship and please the gods. As we have already seen in our brief look at some of the non-Western aesthetic systems, beauty may not originate in the mind of the beholder, but rather in the eyes and virtues of the gods. Artists pleased their gods by creating beauty on their own divine terms—mimicking those ethical or moral values and presenting them to this world and humankind. In their original contexts, the art's finest features were reflections and extensions of those values derived from the spiritual world. Thus, as we see works of art that have been collected and placed in museums and galleries, we must remember that they take on new meaning "out of context" as they interact with people from around the world who are not part of the original audience for whom they were created. However, it's not entirely negative: Putting her on a pedestal, bathing her in electric light, not the brilliance of the sun (her son Huitzilopochtli), for the eyes of people who do not believe in earth mothers or human sacrifice but bring their own aesthetic systems of thought to that experience, *Coatlicue*, along with the other works illustrated in this book, continues to take on ever new and unpredictable meanings.

QUESTIONS

1. What is meant by "contextualism" and why is it important to study works of art in their cultural context?

2. The Introduction talks about core ideas that are essential to an understanding of the arts in each of the areas to be surveyed in this book. What are some of those core ideas and, looking forward, how do you think they might help you understand the arts in which they are manifested?

3. What are some of the distinctive features of art history as an academic discipline? Would an art historian approach the monumental statue of *Coatlicue* in ways that differ from other historians?

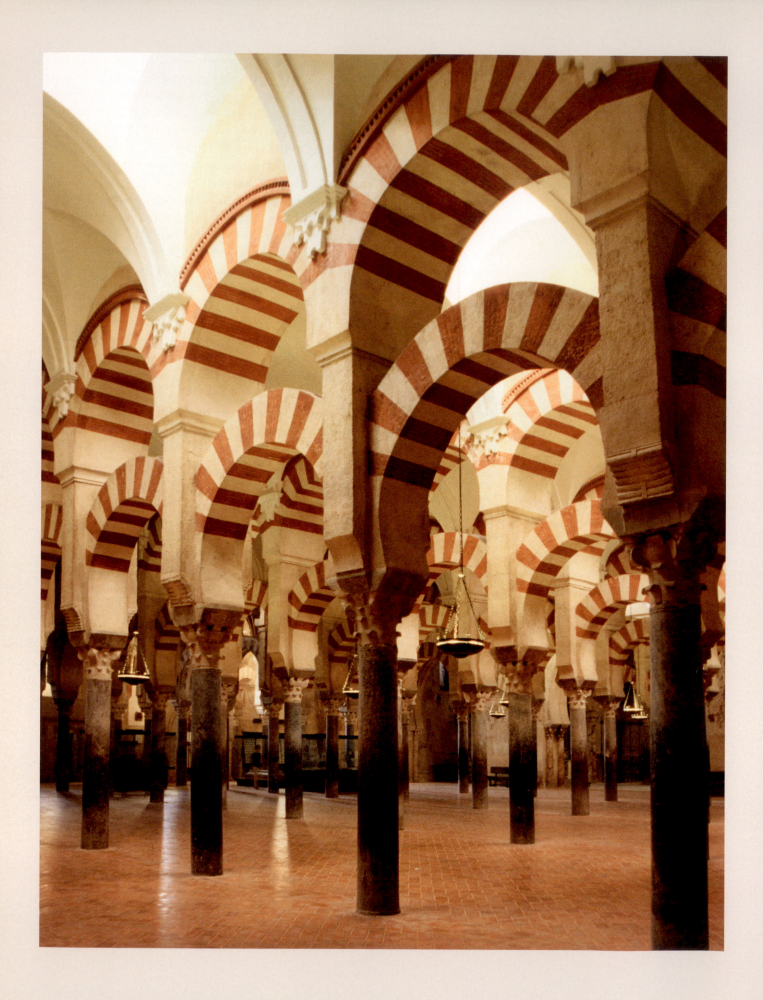

2 | The Islamic World

Equator

Introduction	25
Byzantium and the Umayyad Caliphate (661–750 CE)	29
The Umayyads and their Successors in Spain (711–1492)	33
The Abbasid Caliphate (750–1258)	36
Iran and Central Asia	38
Anatolia and the Ottoman Turks (1453–1574)	50
Summary	55

The Islamic World

Islamic art followed the spread of the Islamic religion from the Arabian Peninsula in Western Asia east through India to Indonesia, and west through Africa to Spain and Portugal. In some places, such as India and parts of Africa, it mixed with local traditions and will be discussed in the chapters relating to those areas. This chapter focuses on the mainstream of Islamic art as it developed in Western and Central Asia and the extension of those traditions to Spain.

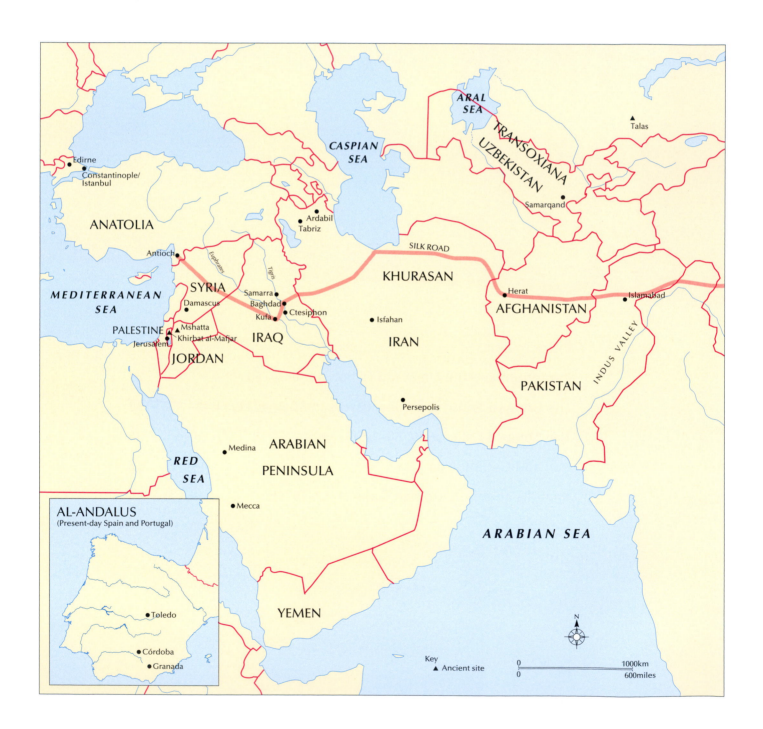

ARAL SEA

Talas

TRANSOXIANA

UZBEKISTAN

CASPIAN SEA

Samarqand

Edirne

Constantinople/ Istanbul

ANATOLIA

Ardabil
Tabriz

SILK ROAD

KHURASAN

Herat

Islamabad

Antioch

Euphrates

Tigris

AFGHANISTAN

MEDITERRANEAN SEA

SYRIA

Samarra
Baghdad
Kufa Ctesiphon

Isfahan

IRAN

INDUS VALLEY

Damascus

Mshatta
Khirbat al-Mafjar

IRAQ

PAKISTAN

PALESTINE

Jerusalem

JORDAN

Persepolis

RED SEA

Medina

ARABIAN

PENINSULA

ARABIAN SEA

Mecca

AL-ANDALUS
(Present-day Spain and Portugal)

YEMEN

N

Toledo

Córdoba

Granada

Key
▲ Ancient site

0 ——— 1000km
0 ——— 600miles

INTRODUCTION

The people of Western and Central Asia traded goods and ideas with Europe, China, and India. This system facilitated exchanges in the arts and the development of a long series of artistic traditions in this large area which lies at the junction between three continents. By the second century BCE, the region lay at the hub of a complex network of overland trade routes known collectively in modern times as the Silk Road. Luxury goods of many kinds, including works of art, as well as technical, philosophical, religious, and other cultural information, traveled along the Silk Road and its many spurs or branches. For nearly two thousand years, these roads were the arteries through which the lifeblood of the Asian economies flowed. For our purposes, it is important to note that rises and falls in patronage of the arts were directly linked to the strength of those economies, and works of art arriving from distant lands often inspired artists and workshops to create new styles.

In the first centuries of the current era, as antiquity was drawing to a close, the artists in two Western Asian empires along the Silk Road were working in styles that mixed elements of those from the past with new ones inspired, perhaps, by works of art arriving along that route. In the third century CE, the Sasanian Persians (c. 224–641 CE) were ruling parts of Western Asia from their capital at Ctesiphon near the intersection of the main branch of the Silk Road and the Tigris River in Iraq. In 330 CE, the Romans moved their capital from Italy to another transportation hub, Byzantium (modern Istanbul), where ships entered the Black Sea and a spur of the Silk Road connected Asia and Europe. By the seventh century, costly wars had weakened the Byzantine and Sasanian Persian empires, so when the Muslims from the Arabian Peninsula began to create their own empire, they met little resistance. As a consequence, within a few decades, they were masters of Western and Central Asia, but the Muslims did not build their traditions in the arts directly upon those of the older cultures in this area. Islam first appeared in a region with relatively few artistic traditions, and as it spread, the Muslims may initially have used Byzantine and Persian architects and artists to assist them. In a very short time, however, they had developed their own specialists in these disciplines. To see how and why the Muslims created such revolutionary art forms, we must first look at their distinctive religious philosophy, which, although it was built on the earlier Judeo-Christian tradition, demanded entirely new forms of expression.

TIME CHART

Western and Central Asia

Muhammad (c. 570–632 CE)

Muhammad flees Mecca: base date of Muslim calendar (622)

The Umayyad Caliphate 661–750

The Abbasid Caliphate 750–1258

Caliph Harun al-Rashid of the *One Thousand and One Nights* (ruled 786–809)

Saljuq rule at Isfahan, Iran (1038–1194)

Genghis Khan (1162–1227) unites Mongols and establishes empire

Mongol invasion of Iraq 1258

Spain (Al-Andalus)

Emirate (c. 750–929) and caliphate (929–1031) of Córdoba

Nasrid Dynasty at Granada (1232–1492)

Iran and Central Asia

Ilkhan rule in and around Iran (1258–1335)

Timur the Lame, reconquest of Mongol Empire (ruled 1370–1405)

Timurid rule in Central Asia (1370–1501)

Turkoman dynasties at Tabriz, Iran (1380–1508)

Safavids rule in Iran (1501–1722)

Shah Tahmasp, Safavid patron of the arts (ruled 1524–76)

Shah Abbas (ruled 1587–1629) moves Safavid capital to Isfahan

Anatolia

Ottomans under Mehmed II capture Constantinople (1453)

Koça Sinan, Ottoman architect (c. 1489–1588)

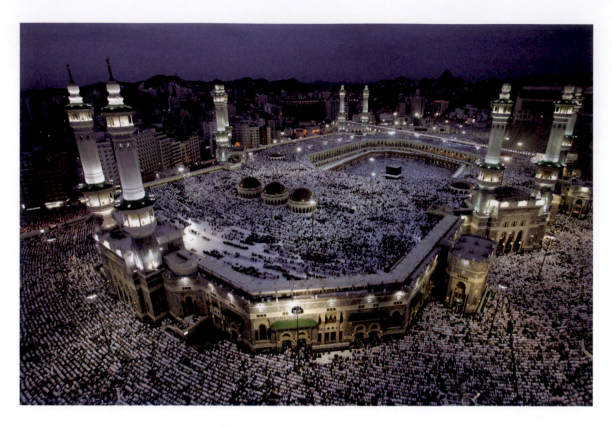

2.1 Ka'ba, Mecca, Saudi Arabia. Photograph 2005

MUHAMMAD AND EARLY ISLAMIC THOUGHT

In his youth, Muhammad (c. 570–632 CE) lived in Mecca, an important trading center at the junction of caravan routes carrying incense and other local goods from that part of the Arabian Peninsula south to Yemen and northwest to the Mediterranean. Mecca was also the home of the Ka'ba, a large cubic shrine draped in a black cloth that remains of paramount religious important today because it marks the heart of the Muslim world (FIG. 2.1). The shrine reflects an earlier tradition in Arabia of placing symbols of divinities in cloth-covered wood frames in designated holy areas of limited access. According to Islamic tradition, the Ka'ba contains a stone that the archangel Jibra'il (Gabriel) gave to Isma'il, son of Abraham, from whom Muhammad's family traced their ancestry.

Before the rise of Islam, a period medieval Islamic historians call the *jahiliyya* (time of ignorance), there were many tribal symbols, fetishes, and statues representing other Arabian gods attached to the shrine. In 610, Muhammad began to have visions in which Gabriel revealed the wisdom of Allah to him, that Allah was the One God, the God of Abraham, and that the other gods at the Ka'ba were false ones. Over a period of twenty years, Allah also revealed his wisdom to Muhammad in the form of the **Qur'an**, or Koran (the revelation or recitation), which has 114 chapters and six thousand verses. According to Muslim belief, the earlier Jewish and Christian scriptures were corrupted by human fabrications, whereas the much later Qur'an represents the unadulterated, eternal, and unchangeable word of God. Until recently, it was not permitted for the Qur'an to be translated from the original Arabic; today, translations usually include the original Arabic text alongside the new foreign-language text. Thus, Arabic has long been and remains the language of Islam around the world, giving the religion a strong and timeless sense of cohesion.

After Muhammad began to spread the word of Allah, he was forced to flee Mecca and take refuge in Yathrib, an oasis city later renamed Medina (City of the Prophet). The Muslim lunar calendar, which is eleven days shorter than the solar year, begins with the date of this flight, the *hijra* or *hegira* (emigration), 622 CE in the Western calendar. Eight years later, Muhammad's army captured Mecca, removed the fetishes and statues from the Ka'ba, and rededicated it to Allah.

During Muhammad's lifetime, his status in the religion grew as he assembled a community of followers, teaching them at his home in the first **mosque** (*masjid* in Arabic, "place of prostration in prayer"). The early mosques were

all-purpose community centers whose functions included worship; by the eleventh century they had become religious centers in the manner of the Christian churches of the day. The great mosque in a town may be known as the *masjid-i-jami*, the Congregational or Friday mosque, because the entire congregation of the faithful will assemble there on Fridays for prayer and a leader will deliver a sermon from the **minbar**, a narrow staircase with a canopy at the top resembling a pulpit in a Christian church. In function, the *minbar* is also much like the *cathedra* or bishop's seat in Christian cathedrals. The prototype of the *minbar* is the somewhat smaller stepped stool the Prophet used when addressing congregations in his house-mosque. As we will see, though the mosque originated on the Arabian Peninsula, as the Muslim faith spread around the world, it took different forms, often reflecting regional architectural traditions.

Unlike Christ, Muhammad is regarded as a prophet, not a deity. In Islam, God is one and has no rivals. No society has ever created a religion and expanded it over such vast territories in such a short period of time. Today, Islam unites over a billion people. This accomplishment and its legacy make Muhammad one of the most influential individuals in human history.

The Qur'an set forth the laws according to which Muslims should live in the "Five Pillars" or acts that form the basis of their faith.

1. The recital of the creed represents a profession of faith: "There is no god but God and Muhammad is His Messenger."
2. Prayer (*namaz*) is to be offered five times a day—at dawn, midday, in the afternoon, at sunset, and before going to bed. Prayers may be offered in private or at a mosque. On Fridays, adult males must purify themselves and pray in the direction of Mecca at a mosque.
3. Muslims must give alms (*zakat*) to benefit the poor and support religious activities in the community.
4. To subjugate the body to the spirit and draw nearer to God, Muslims are required to abstain from food, drink, and sexual relations from sunrise to sunset during Ramadan, the ninth lunar month of the Muslim year.
5. If at all possible, all Muslims are expected at least once during their lifetime to make a pilgrimage (*hajj*) to Mecca, where Muhammad was born.

Second in importance to the Qur'an are the *hadiths* ("narratives"), a set of sayings by Muhammad and stories about him assembled in the eighth and ninth centuries. Third is the *sharia*, the legal system compiled by early Muslims in accordance with the teachings of the Qur'an and *hadiths*. The guiding principle in Muslim thought is a respect for *Sunna* (ancestral precedent or tribal customs), which stems from the teachings of the Prophet and the *hadiths*. Those who accept this principle of authority, and believe the Umayyad dynasty inherited the right to appoint successive **caliphs** (Arabic, *khalifa*, "deputy," "commander," or "successor" of Muhammad), are called **Sunnis.** They represent about 85 percent of all Muslims. The remainder, **Shi'ites**, Shii, or Shias (partisans), believe that Allah wanted the caliphs to come from the family of the Prophet through the line of Muhammad's cousin and son-in-law, Ali ibn Abu Talib. The Sunnis assassinated Ali in 661 and asserted their claims over those of the Shi'ites. This dispute over the right to the title of caliph developed into a schism within Islam that still exists today.

THE QUR'AN AND ISLAMIC ART

The revelations of Allah in the Qur'an gave the tribal societies of the Arabian Peninsula a new sense of identity and purpose through which they could challenge the neighboring Byzantine and Sasanian Persian empires. They also enabled them to reverse the normal pattern of conquest, whereby nomadic warrior societies that subdued well-established, sedentary societies were eventually absorbed into them. Instead, the Arabs impressed their religion upon all the people they conquered, and their language, the sacred one of the Qur'an, put the indelible stamp of the Arab minority on them.

The Qur'an says relatively little about the role of the visual arts in religion. This may reflect the limited role art had played in Arab life up to this time compared to that in many other parts of Western Asia. There is little archeological and literary evidence to suggest the Arabs of Muhammad's time valued the so-called "nomads' gear," the jewelry, embellished weaponry, and armor so cherished in Central Asia, Iran, and Northern Europe in the early Middle Ages. The Prophet himself expressly forbade men to wear gold and silver ornaments. However, Muhammad's family included merchants and traders, and it is known that he owned carpets. Lying on a trade route, Mecca was in contact with the rich and ancient cultural traditions of Western Asia, and its immediate neighbors included the Byzantines and Sasanian Persians to the north. As well as being a trading city, Mecca was also home to Arab, Jewish, and Christian communities, and, like other Arabian oasis towns and cities, it lay at a crossroads of many cultural traditions. The Qur'an reflects Arab interests in these traditions.

Early Islamic thinkers took issue with foregoing pictorial traditions in Western Asia. They had inherited the Second Commandment of the Jews and Christians: "Thou shalt not make to thyself a graven thing [*êidolon* or "idol" in the Septuagint translation], nor the likeness of anything that is in

heaven above, or in the earth beneath, nor of those things that are in the waters under the earth" (Exodus 20:4). The Qur'an also says: "Oh you who believe, indeed wine, games of chance, statues [al-ansab], and arrows for divination are a crime [or 'sin'] originating in Satan" (5:93). In this context, al-ansab may refer specifically to idols—that is, images of gods in human form. Elsewhere, the Qur'an says: "God is the creator of everything," implying, perhaps, that artists who create images of the world may wrongfully usurp the power of Allah. Also, the very fact that Allah is transcendent and has no human form makes it logically impossible to portray him in the arts. Combined, these admonitions led to a prohibition against the representation of Allah in art and, often, a broader prohibition against other images of human or animal figures in religious art. But it did not necessarily extend to secular forms of expression. As the Muslims conquered territories from India to Spain where there were vestiges of the ancient Greco-Roman traditions in the pictorial arts, they began to commission secular art forms that showed them in action, along with the pleasures they enjoyed in everyday life. Most of the major Islamic works of art, however, are decidedly religious, without human imagery, and this mainstream of Islamic art and thought may be called **aniconic** ("without images"). This term differs somewhat from **iconoclasm** (literally, "image-breaking"), which implies a stronger dislike of images and, often, an outright prohibition against them.

Working with these direct and indirect injunctions against figures in religious art, Islamic artists created a wide variety of intertwining stems, tendrils, leaves, and floral motifs arranged in repeating patterns of great mathematical complexity. In the West, these compositions are so closely associated with Islamic art and thought that they are called **arabesques** ("having an Arab quality"). While such repeating decorative motifs and patterns were often used as borders and edges in Greco-Roman works of art, in Muslim art these motifs often become central features. Earlier prototypes for these decorative motifs are plentiful in Roman-ruled areas in the Middle East near the Umayyad Islamic capital at Damascus, but they do not prepare us for the complexity and subtlety of the arabesques to come by Muslim artists. By some miracle of geometry and spatial logic, the elements of **interlaces** meander, often following the radiating lines of rosettes and stars, and ultimately connect and terminate in the right places. In Arab thought, these visible meanders and interlacements are part of an infinite pattern, a vast network that extends far beyond our material world, and so are symbols of the infinite. The way in which the designers subdivide geometric forms, put one inside another, and "lace" them together in perfectly structured forms also reminds one of the Arabic love of mathematics. But there is also an irrational or spiritual quality in the "magic" of these perfect forms. They are "eye-dazzlers," often too complex for viewers to follow and trace out in their mind's eye. Viewers may become lost in the incomprehensible "miracles" of their display. We know they are logical, but they seem to defy their own inbuilt sense of reason. In this way, like so many other aspects of Islamic thinking, arabesques express the duality of earthly and spiritual matters and symbolize the divine unity that underlies all forms of earthly existence, Allah's *al-wahdah fi 'l-kathrh*, "unity in multiplicity," and *al-kathrah fi 'l-wahdah*, "multiplicity in unity." While they are not a portrait of the divine creator, they may be his thumb-print.

To capture the full wisdom and splendor of Allah's words in the Qur'an, Islamic scholars also developed canonical scripts that were written out using many of the same motifs as the arabesques. Very quickly, the art of **calligraphy** (from the Greek *callos*, "beautiful," and *graphos*, "writing") became the single most sacred art form in Islam. All types of arabesques, geometric forms, and calligraphy were combined and applied to objects of every description—wood, stucco, terracotta, stone, metal, glass, ivory, tiles, mosaics, carpets, and tapestries.

Over the centuries, Muslim writers have commented on how Muslim artists and patrons have looked at art. Calligraphy was the first Muslim art form to spawn instruction manuals, a tradition of connoisseurship, and thinkers who discussed it in aesthetic terms. By the fifteenth century, the courtiers in Persia included a group of poets known as **zarifs** (dandies, dilettantes, or connoisseurs), who would express their discriminating tastes in diverse matters ranging from the arts to the court dancers, images of which were popular in bathhouses. They talked about how *jamil* (beauty) is closely related to *ajib* (that which is astonishing) and is dependent on *itidal* (symmetry) and *tanasub* (harmony or unity). The theologian and writer al-Jahiz (c. 776–c. 868) talked about the importance of "balance in the case of buildings, rugs, embroidery, clothes … by balance we mean evenness of design and composition." Ibn al-Haytham, an eleventh-century scholar of optics, said: "Visible objects are felt to be beautiful and appealing only because of the composition and order of their parts among themselves." In addition to the terms mentioned above, commentators talked about the "soundness of shapes," *musanabah* (balance), *maqadir* (measure), *bayadat* (spacing), and composition, the ordering of parts among themselves. Other ideals that would enable us to reconstruct a more complete and integrated philosophy of Islamic art may lie embedded in yet-unstudied Islamic texts. As a result, it is probably true to say that the study of Islamic aesthetics, along with the study of Islamic art in general, remains in its infancy.

BYZANTIUM AND THE UMAYYAD CALIPHATE (661–750 CE)

The Muslims established their first capital at Damascus in 661 CE, which, under the leadership of the Umayyad caliphs, became the first major metropolitan center of Islamic art. Turning to the architecture and pictorial arts of the Byzantines for inspiration, the Umayyads adapted them to their own needs and created works in which we begin to see the emergence of what we may call an early Islamic aesthetic.

JERUSALEM: THE DOME OF THE ROCK

The earliest mosques have been destroyed and rebuilt many times, but one important monument from the Umayyad period has survived intact—the Dome of the Rock on the summit of Mount Moriah in Jerusalem (FIG. 2.2). The builders believed this rocky hilltop was the site of the First and Second Jewish Temples, the place where Adam was created and to which Abraham brought Isaac to be sacrificed. Later legends also said that Muhammad ascended from this rock on his Night Journey to Heaven. Next to the Dome of the Rock is the Al-Aqsa Mosque, part of the Haram ash-Sharif complex, the third holiest site in Islam. Thus, in much the same way that the Qur'an built on the older Judeo-Christian scriptures to fulfill them, the Muslims built the Dome of the Rock in 687–92 CE over this ancient Jewish temple precinct to symbolize the triumph of Islam in Jerusalem.

The actual dome crowning the Dome of the Rock has inner and outer wooden shells and sits on a high drum with sixteen arched windows over a circular arcade of four heavy stone piers and twelve smaller columns, with eight piers and more columns supporting the outer aisle beyond. The central plan of the dome, designed to showcase the crest of the rock, resembles that of the Byzantine *martyria*, circular or

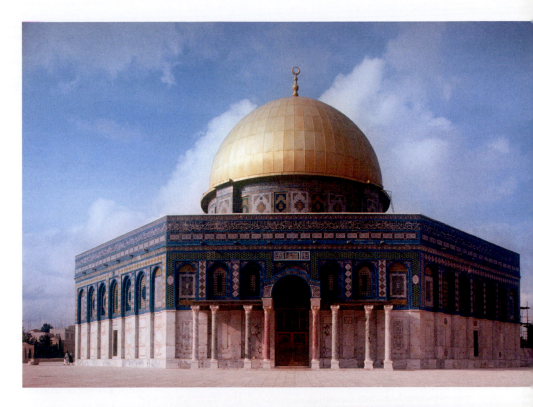

2.2 (TOP) Dome of the Rock, Jerusalem. 687–92 CE, with marbles and mosaics on the exterior from the Ottoman period (1281–1924)

2.3 (ABOVE) Mosaics inside the Dome of the Rock, Jerusalem. 691–92 CE

polygonal tomb shrines in which visitors can walk around the tomb and view the remains of martyrs. This design had already been used in Jerusalem itself in at least two Christian sanctuaries celebrating the Ascension and the Resurrection, so it was a familiar one to builders in the area.

The walls inside the Dome were covered with **mosaics**, some of which are well preserved (FIG. 2.3). Well before this time, the Byzantines had perfected the technique of making wall mosaics with small squares of colored glass called **tesserae**. Unlike the floor mosaics of the Romans, which were usually made with little stones or tiles, the Byzantines used finely cut glass *tesserae* and applied them to the walls, vaults, and domes of buildings, accenting the spaces with dazzling images of rulers and religious figures. Byzantine artists, or Islamic craftsmen working under their supervision, were responsible for making many of the early Islamic mosaics such as those at the Dome of the Rock, but, even at this early date, the Islamic mosaics differ from their Byzantine counterparts in at least two important ways. First, they do not represent figures in elaborate settings. Instead, they show us signs and symbols, some of which are royal insignias of power belonging to the peoples the Muslims conquered. Second, the mosaics do not highlight structural parts of the building but cloak them in a manner that recalls the older tradition of covering religious objects with cloths, most notably the Ka'ba. (See *Materials and Techniques: Byzantine and Islamic Mosaics*, opposite.)

The Dome of the Rock stood on a site sacred to both Jews and Christians. With over 700 feet (213 m) of Islamic inscriptions, which included references to Christ in the Qur'an, and mosaics that reflected the political power and emerging aesthetics of the new religion, it symbolized the rise of Islam in the heartland of the Judeo-Christian world.

THE HYPOSTYLE MOSQUE

To provide the faithful with houses of prayer and further demonstrate the triumph of Islam over the Christians of Western Asia, the Umayyad builders converted some Christian churches into mosques. When building new structures, they also used the Prophet's home in Medina, where he had first preached the Qur'an, as their model (FIG. 2.4). This had a rectangular courtyard with a roofed porch on the south side facing Mecca, an element known as the **qibla** (Arabic, "direction") wall because it faces Mecca, the direction in which prayers are directed. (By this time, Torah niches in Jewish synagogues and altars in Christian churches were oriented to face Jerusalem.) This type of early mosque construction is called a **hypostyle mosque** (Greek *hupostulos*, "resting on pillars"), because the porch roofs rested on colonnades, often of palm trees. But the small and very modest Medinese model would have to be adapted to much larger congregations and

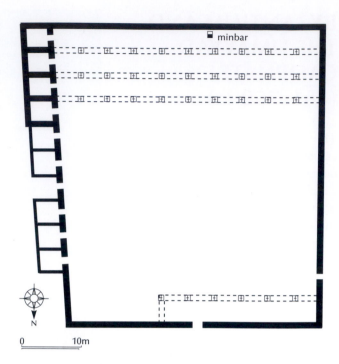

2.4 Reconstructed plan of the House of the Prophet, Medina. 624 CE

the tastes of the wealthy merchants and leaders who wanted their houses of prayer, especially the Friday or Congregational mosques, to be symbols of power. Thus, the roofed colonnade or hypostyle area that provided shade for worshipers facing the *qibla* at Medina was often extended to run round the other sides of the mosque. A niche or recess, known as the **mihrab**, in the center of the *qibla* wall, which may be highly decorative, became the focal point of the mosque. It may have been suggested by the niches in early Christian churches and Jewish synagogues. Speakers address the faithful from a **minbar** or pulpit to the right of the *mihrab*. This feature also comes from the Prophet's courtyard, where a *minbar* was added sometime after his death as the numbers in the community grew.

Muezzins (announcers or criers) announce the call to prayer from the roofs of mosques or nearby towers called **minarets** (Arabic *manara*, "lighthouse"). Many of the earliest structures of this type may have been erected as watchtowers or lighthouses to guide travelers at sea or crossing deserts; only later were they adapted for use alongside mosques and to mark their location for all to see from a great distance. *Muezzins* repeat each of the following phrases three or four times: "*Allahu Akbar* [God is most Great]! I bear witness that there is no god but Allah. I bear witness that Muhammad is the Apostle of Allah! Come to Prayer! Come to success! *Allahu Akbar*! There is no god but Allah!"

BYZANTINE AND ISLAMIC MOSAICS

Lit by hundreds of flickering lamps, the mosaics inside the Dome of the Rock would have glittered and sparkled with such energy that one might almost have believed the building had a life of its own. It is difficult to appreciate the subtleties of these or any other mosaics in reproductions because the thousands of tiny glass *tesserae* reflect light in two distinct ways: from their surfaces, as mirrors, and from within, like jewels. In both cases, the light effects can be fully appreciated only when one is in front of the originals and moving about so that their reflected light is in flux.

Light refracted from within glass has a rich, glowing, and radiant quality that cannot be duplicated using water-based pigments. The Byzantines sometimes sandwiched very thin sheets of beaten gold, known as gold leaf, between pieces of thin glass to represent gold jewelry and glowing backgrounds symbolizing the radiance of Heaven. Those refractions change slightly as one changes one's point of view, but the light from within the *tesserae* does not change as much as that reflected from the surface. Since the *tesserae* in a mosaic will be set at slightly different angles to the wall, the patterns of light reflected from the surface are fragmented, like images in a broken mirror. If one moves even slightly while looking at a mosaic, those sparkling patterns change dramatically, making the figures in the mosaics "behind" the sparkle look as if they are floating in a mysterious otherworld of light. These effects are most dramatic in the low light of lamps and candles, the flickering of which adds to the sparkle and apparent movement of the reflections.

Unlike wall paintings, the colors in mosaics are permanent, but the laborious and time-consuming process of manufacturing and applying the mosaics made this medium so expensive that only the wealthiest patrons could afford to commission them. Thus, in the early Middle Ages, mosaics become closely associated with royal patronage.

DAMASCUS: THE GREAT MOSQUE

Another set of mosaics from this early period survives in the Great Mosque at Damascus, which also has a long history predating Muslim times. The Romans destroyed an Ammonite temple on the site dedicated to Haddad and built another temple in its place dedicated to Jupiter. In the late fourth century, the Christians then replaced that pagan temple with a church dedicated to John the Baptist, which the Muslims incorporated into a new structure in 705 to create the largest mosque in Islam to that date. Traces of the mosque's original mosaics on the exterior remain, and they owe an obvious debt to Byzantine tradition—it is likely that Byzantine mosaicists working under Islamic supervision designed and applied them. In place of the symbols of conquest at the Dome of the Rock, we see beautiful, well-watered landscapes with buildings and tall trees (FIG. 2.5). Two tall trees with thick trunks, orange highlights, and purple shadows rise from the bank of a swiftly flowing river. They frame a large, roofed, concave portico faced with decorative marbles

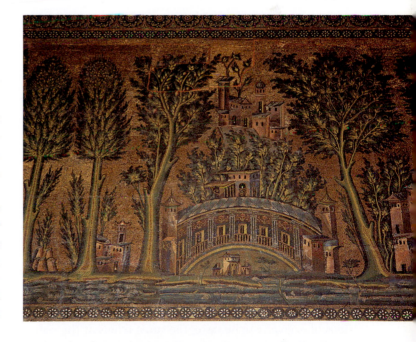

2.5 Portion of a mosaic from the western portico, the Great Mosque. Damascus, Syria. c. 705–14 CE

and flanked by tall towers. The houses in the foreground are shown in miniature to fit in the space under the lower curve of the portico; those in the background and the thick forest of large-leafed trees around them are tall so they rise above it. The many small, eyelike windows in the buildings seem to peer out into space and the towering trees resemble giant statues, but aside from these vague anthropomorphic qualities, there is no hint of a human presence here.

Was there a prohibition in effect against the representation of human figures in a mosque? We may be able to answer the question by determining more precisely what the mosaics represent. Are they topographical views of well-watered gardens in lands the Muslims conquered, or is this another type of kingdom altogether, the cool, shady, and watered Paradise that Allah has reserved for his faithful? The latter might be appropriate for images in a mosque, which was a realm apart from the secular world around it and was often filled with symbols of Paradise. However, a tenth-century writer, looking at all the mosaics when they were far more complete, said, "There is hardly a tree or a notable town that has not been pictured on these walls," suggesting that this and other scenes were meant to represent topographical realities in the Islamic world. Equally, the two interpretations might be combined: Scenes such as that in FIG. 2.5 are clearly based on topographical features the mosaicists may have seen at first hand or in Byzantine buildings, but those in charge of the project probably wanted the faithful to see those landscapes as images of Paradise. Whatever the true meaning, such imagery soon disappears from the mosques as they grow in size and complexity to become expressions of Islamic power.

PLEASURE PALACES AND SECULAR ART

By the early eighth century, as the first great age of conquest drew to a close, Umayyad leaders administering the agricultural lands in Syria and Iraq began building large country palaces for themselves based on earlier Persian, Roman, and Byzantine models. These are lavish complexes with private gardens, pavilions, pools, baths, fountains, molded stuccos, stone reliefs, and mosaics, where the Islamic leaders entertained dignitaries, installed their officials, perhaps housed pilgrims going to and from Mecca, and conducted other dynastic rites of passage.

The Umayyad palaces of this period were decorated with wall paintings, including many closely packed images of animals and dancers, along with large numbers of stucco reliefs that may reflect the tastes of the courtiers cloistered in these remote palaces. In marked contrast to such expressions of nouveau-riche taste, the stone reliefs at the unfinished walled palace, 470 feet (143.3 m) on each side, in the Jordanian desert at Mshatta (c. 743 CE) are memorable

works of the highest quality. The palace included pools, baths, a domed audience hall, and complex patterned decorations inside and out. A tall band of carved limestone reliefs on either side of the central entrance gate extends along the base of the thick façade (FIG. 2.6). Within the band, repeating triangles frame large centralized rosettes, curvilinear vines, and animals that are almost lost within the maze of entwined tendrils around them. Below the rosette, two thirsty lions drink at a scalloped urn from which a tree of life (a Persian device) grows within a tightly woven composition of birds and foliate forms. The tradition of covering the bare structural parts of buildings with a richly decorative "cloth" of tile-mosaics, paneling, and stucco recalls the nomadic practice of draping walls and enclosures with hangings, weapons, and horse gear. Not only is this ideal present in early monuments, such as the palace at Mshatta, it continues. As we look at some of the most lavishly decorated mosques from later centuries, we will see how they have perpetuated this very ancient nomadic system of aesthetics rooted in the early world of the Bedouin tent-dwellers.

At Mshatta, the Persian, Byzantine, and Classical sources have been reworked in a style that is much less dependent on the earlier traditions than were the mosaics of the Great Mosque at Damascus, pointing toward the opulence of later Islamic art. But to appreciate fully the richness and dramatic effects of these shallow, patterned reliefs, we must imagine them illuminated by a bright sun, on a façade standing out in bold relief against the vast expanses of the desert.

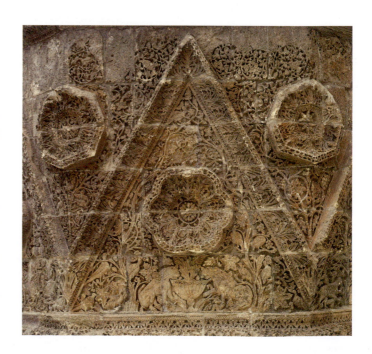

2.6 Detail of the façade of the palace at Mshatta, Jordan. c. 743 CE. Museum für Islamische Kunst, Staatliche Museen, Berlin

THE UMAYYADS AND THEIR SUCCESSORS IN SPAIN (711–1492)

The Umayyads extended their rule to the west, through Egypt and North Africa to the Straits of Gibraltar. Seeing the weakness of the European rulers to the north, Caliph Al Walid established a kingdom that eventually covered much of present-day Spain and Portugal. Known as Al-Andalus (Arabic for *Spania,* "Spain" in Latin), it lasted from 711 to 1492, longer than the Hellenistic Greek and Roman empires combined. The two most famous monuments the Muslims left behind when they retreated, the Great Mosque of Córdoba and the Alhambra in Granada, are spectacular building complexes that reflect the religious and secular traditions of the Muslim world in Europe.

CÓRDOBA

Córdoba was an **emirate** (c. 750–929), caliphate (929–1031), and a great center of learning through the thirteenth century. An emirate is ruled by an emir, an Islamic title of nobility given to a wide range of princes, military offices, and other men of power. Construction of the Great Mosque there began in 784 (FIG. 2.7). It incorporates architectural forms used earlier in Spain by the Romans and Visigoths such as **horseshoe arches,** shapes that were emphasized by the use of alternating light and dark **voussoirs,** wedge-shaped stones. One of the most distinctive features of the mosque is the way the piers supporting these arches on the second level are set over slender stone piers straddling the first level of arches. This arrangement may have been inspired by the superimposed arches with red and cream-colored voussoirs that the Romans used in a nearby aqueduct at Merida. Other scholars believe the builders simply could not find columns tall enough to support a ceiling of this height.

The designers at Córdoba may have also invented the polylobed arches with multiple lobes or cusps and **rib vaulting** techniques one sees on the highly ornate entryway to the *mihrab* (FIG. 2.8). Ribs are arches, often joined by thin layers of stone and used in place of barrel vaults to lighten ceilings and reduce the loads on the supporting walls and piers below. The arches with their ornate, cutout, cloud-like shapes appear to defy gravity as they spring from their bases; instead of landing on the adjacent base, they "fly" to the next. Inside the *mihrab,* crisscrossing ribs rising from columns in every second corner of an octagon form two overlapping squares. The resulting smaller, upper octagon over triangular areas of decoration supports the ribbed dome.

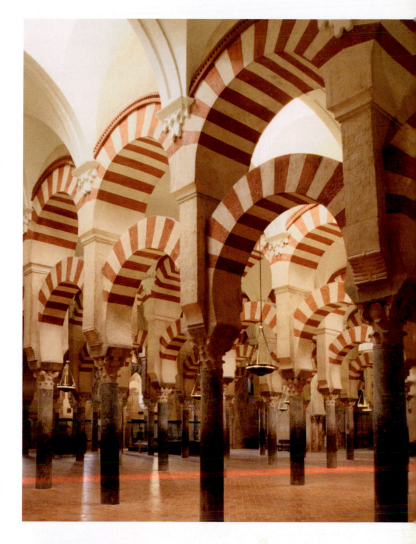

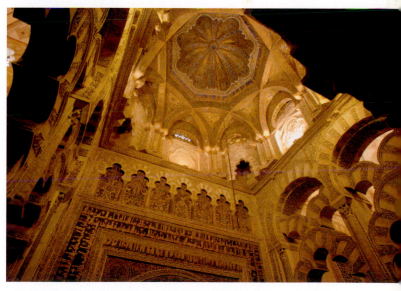

2.7 (TOP) Prayer Hall. Great Mosque, Córdoba. Begun 784–86 CE

2.8 (ABOVE) Dome in front of *mihrab*, Great Mosque, Córdoba. 965 CE

The bottoms and sides of the ribs and the units of space created by their intersections are richly decorated with mosaics and paintings. While Christian architects of this period tended to hide the working parts of their domes and supports, this delight in revealing the underlying geometry and lines of force within the structure captures the essence of a Muslim aesthetic that will become popular in Europe in the Gothic period.

Moving through the vast spaces of this hypostylic hall, the parallax or shutter effects created through the apparent movements of the multicolored, stacked arches as they pass in front and behind one another expand the Muslim genius for the creation of complex abstract forms by putting those forms in motion. Every available space is richly decorated with mosaics, paintings, and gilding. The Great Mosque asks Western viewers to put aside notions of Western architectural aesthetics and delight in the intersecting, cusped arches and those with alternating light and dark voussoirs, which do not seem to be at all pressured by loads from above or concerned with the loads they press on the "insufficient" columns below. They seem to be spreading and expanding overhead. As we pass through them, we do not sense we are in an architecturally defined space, but rather passing through a forest of trunks and tall arching branches enveloped in darkened recesses.

The complex rhythms of the arches and bands of color, along with the decorations in the dome, treat visitors to a splendid visual spectacle of astonishing otherworldly splendor that expresses the majesty of Al-Andalus, the most cultured kingdom of its day in medieval Europe, and the beauty of Allah's Paradise described in the Qur'an where "the god-fearing shall dwell amid gardens and a river in a sure abode, in the presence of a King Omnipotent." The Spanish Christians who eventually took Córdoba back from the Muslims were so impressed with the beauty and size of the Great Mosque that, while they embedded their own cathedral in part of it, they preserved the rest of it as a place of worship for their Muslim countrymen.

GRANADA

In 1492, the Christian monarchs Ferdinand and Isabella of Spain expelled the Muslim Nasrids from Granada and inherited their palace, the Alhambra ("the Red Fortress"). This was built over an earlier fortress and twelfth-century palace with fountains and gardens that had belonged to a high-ranking Jewish official. Successive Muslim rulers expanded the royal residences, administrative buildings, workshops, servants' quarters, and gardens until the complex stretched for nearly half a mile (1 km) along a high crest overlooking Granada. While many ancient places of worship around the

world have survived, it is rare to find a well-preserved palace from this period. Although the aesthetics of the Alhambra were foreign to the victorious Christians, they preserved it in part because it symbolized the *Reconquista*, their long, hard-fought battle to reinstate Christianity on the Iberian Peninsula. (See *In Context*: The "Hakim" and Renaissance Man, opposite.)

For centuries, visitors to the Alhambra have been amazed by the contrast between its rugged, undecorated exterior and sumptuous interior, a seemingly endless maze of interconnected gardens, fountains, and glittering jewel-box pavilions where the delicate filigree on the walls and ceilings creates a worldly version of Paradise as described in the Qur'an. (The word "paradise" is ultimately derived from *faradis*, Persian for "enclosed park.")

Muhammad V (ruled 1362–91) built the Court of the Lions here to add yet another private retreat within the palace (FIG. 2.9). Twelve white marble lions symbolizing strength and courage support a large, round alabaster basin

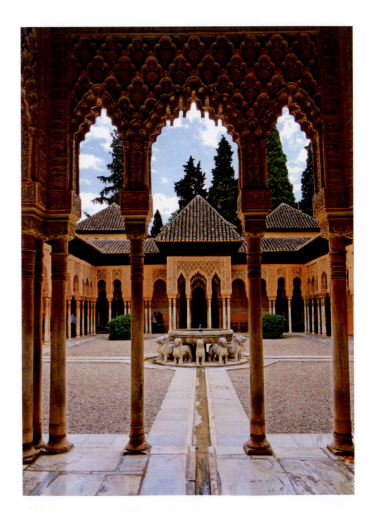

2.9 Court of the Lions, Palace of the Lions, Alhambra, Granada. Completed c. 1380 CE

THE "HAKIM" AND RENAISSANCE MAN

The early Muslims were heirs to the rich cultural traditions of Byzantium, Syria, Egypt, Persia, and other lands they conquered. While literacy was rare in many of these areas and the West during the Middle Ages, Muslims developed a large scholarly class who translated the writings of their predecessors, new subjects, and neighbors, and used their knowledge of medicine, the sciences, Greek philosophy, and Islamic law to help others around them. A highly learned and skilled man who shared his knowledge with others might be called a **hakim** (Arabic, "wise man"). The Persian Avicenna (980–1037) was the most famous *hakim* of his day; schools in the Islamic and European worlds used his *Canon of Medicine* as a textbook until the eighteenth century. The kind of pragmatic wisdom thus translated and circulated helped scholars and students in Al-Andalus become effective engineers, technicians, and industrialists who devised innovative ways to mine silver and gold, produce brass, iron, and lead, and manufacture textiles, glass, and glazed ceramics. They also adapted the Middle Eastern systems of irrigation to their lands, introduced a long list of new foods to Europe, built water mills and domestic water systems, and—centuries before Leonardo da Vinci was born—experimented with hang gliders and aviation.

The rest of Europe knew relatively little about the marvels unfolding in Al-Andalus until the Christian armies dedicated to the reconquest of Iberia captured Toledo in 1085. In the decades to come, teams of Muslim,

Jewish, and Christian scholars translated thousands of Arabic manuscripts from the local libraries into Latin. Eventually, copies of these translations, and others out of similar workshops in Sicily, reached the European universities and other centers of learning, all of which were still obedient to Christendom and its long list of authority figures. Not only did the new manuscripts discuss subjects unknown to the Christians, Arabic translations of Aristotle and other Greek thinkers showed Western scholars *how* to think, on their own, critically, and build upon their new knowledge. Slowly but surely, medieval Europe began to produce thinkers who valued evidence, rationality, and logic over the authority figures of the Christian Church, and the battle between secular and religious thinking that is still being waged to this day began.

That blast of knowledge out of Toledo was just the beginning, and twelfth-century Córdoba produced some thinkers who wrote philosophical works that added more fuel to the intellectual fire about to flare up in the West. Ibn Tufail (1105–85) put the religious thinking of both East and West to one side when he said that we are all born with a *tabula rasa*, with a blank-slate mind, meaning that Christians and Muslims alike are born without any prior divine imprinting and are free to think in any manner they want. Five hundred years later, the English philosopher John Locke (1632–1704) and his contemporaries were still trying to convince the Church-dominated Western world that

people had that freedom. When Ibn Tufail's student Averroes (1126–98) portrayed the world as a complex mechanical device following logical rules, he took God out of the act of creation altogether; the Córdoban Averroes eventually became known as the father of secular thought in Europe.

The most influential Jewish scholar of the Middle Ages, Moses Maimonides (1135–1205), also of Córdoba, was a *hakham* (Hebrew, "wise man"). His *Mishneh Torah*, a fourteen-volume study of the first five books of the Hebrew Bible, incorporates Muslim and Aristotelian thinking; although controversial at the time, his work represents a cornerstone of Jewish scholarship to this day. Maimonides also influenced the thinking of St. Thomas Aquinas (1225–74), who was exposed to Muslim culture in his native Sicily as a child. The Roman Catholic Church regards Aquinas's *Summa Theologica* as the definitive explanation of the Word of God.

With the fall of Córdoba in 1236, Granada became the leading Muslim center in the Iberian Peninsula. By the time it too fell in 1492, Muslim scholarship was already deeply entrenched in Italian Renaissance thought and its ideal of the *Homo Universalis* (Latin, "wise" or "universal man")—the Renaissance Man. In 1492 itself, Leonardo da Vinci, the most famous Renaissance Man, was experimenting with flying machines, including gliders, and accepted no authority other than the complex machinery of nature, as he and Averroes saw it.

in the center of the court that feeds four narrow channels of water, symbolizing the streams in Paradise. The irregularly spaced columns around the courtyard support round arches and richly detailed walls with arabesques and lacy filigree that once echoed the plantings in the now-bare garden. The spaces in the arcade flow into the surrounding pavilions where courtiers gathered to enjoy fine food, poetry readings, music, and dance. While we can still enjoy these well-preserved decorations today, we can only try to imagine the Alhambra as it one was, filled with rugs, stained glass, fine furniture, and courtiers in gold cloth and silks mixing business with pleasure as they tried to sustain their foothold in the last remaining corner of Al-Andalus at the far end of the Islamic world.

THE ABBASID CALIPHATE (750–1258)

Despite the impressiveness of their capital and fortified rural complexes, the Umayyads were unable to maintain their authority over their vast Asian domains. In 750, the Abbasids, who traced their lineage and tradition of leadership to Abbas, uncle of Muhammad, defeated them and moved their capital to Iraq. It was a more central location within the Islamic world in which Iran and Central Asia, with their markets along the Silk Road, were beginning to play increasingly important commercial roles. The legacy of the eighth to tenth centuries in the capital cities of Baghdad and Samarra, when their fortunes were at their height, is tremendous. Many aspects of Islamic law and religious philosophy were formalized here, along with new designs for the mosques and schools where the new learning was taught; some of the scripts used to copy the Qur'an may have been developed here too. The capitals were the greatest centers of learning of their time in Western and Central Asia, if not the world, and much of the scholarship of antiquity that survives today was preserved there. In addition, in the secular sphere, poets were beginning to combine many of the older works in the oral tradition into grand epics, some of which were "published" in books with pictures.

BAGHDAD AND SAMARRA

In 762, the second Abbasid caliph, al-Mansur (ruled 754–75), moved his capital to a site near the Tigris River just north of the old Sasanian capital at Ctesiphon and named the new city Baghdad (City of Peace). This placed him at the major crossroads in Western Asia, where the Silk Road intersected the Tigris River. With the river and caravan routes under his rule radiating out in every direction,

al-Mansur built Baghdad on a circular plan that symbolized its role as the hub within the giant wheel of his authority and the universality of Islam. Earlier imperial cities in this region had been built on circular plans, so the design of the capital was part of the caliph's attempt to preserve earlier royal traditions. In the construction of this great hub, he employed 100,000 workers to ring his new palaces and government buildings with a deep moat and three concentric circular walls pierced by gates opening onto the four quarters of the Islamic Empire.

A contemporary visitor said there were 22,000 carpets on the floors and 38,000 tapestries on the walls of the royal palace complex in Baghdad, which covered about a square mile (2.6 sq km). The spacious royal gardens included such exotic and inventive luxuries as mechanical songbirds perched in gold and silver trees. The Abbasid caliphs also surrounded themselves with some of the most learned poets, artists, rhetoricians, wits, jurists, physicians, grammarians, musicians, and mathematicians of the day. Their courts were far more cultivated than those of their contemporaries in Western Europe. Empress Irene of Constantinople and Charlemagne (Charles the Great) in Aachen, Germany, corresponded with Harun al-Rashid (ruled 786–809), the best known of the Abbasid caliphs in the West. One of the most widely read books in the world, the **One Thousand and One Nights**, has preserved images of his court and medieval Baghdad. When Harun al-Rashid died, his estate included more than 65,000 coats, tunics, cushions, pillows, carpets, and other woven luxury goods.

Despite its name, the City of Peace proved much too noisy for many of the Abbasid caliphs, who built themselves country palace retreats. Conflicts between the Turkic guards and the Arabs of Baghdad arose during the time of Caliph al-Mu'tasim (ruled 833–42 CE), which inspired him to leave the teeming city permanently and establish a new capital 60 miles (96 km) upriver along the Tigris at Samarra. ("Turkish" refers to the culture of present-day Turkey, while "Turkic" refers to the earlier Turks of Central Asian origin.) His eventual successor there, Caliph al-Mutawakkil (ruled 847–61 CE), built numerous buildings at Samarra to house every aspect of his government. These include the largest mosque constructed before modern times, the Great Mosque of Samarra, measuring roughly 800 by 512 feet (243.8 × 156 m) and covering an area of about 10 acres (4.05 hectares) (FIG. 2.10). Originally, the walls of the mosque were about 8 feet (2.4 m) thick and 33 feet (10 m) high, and 464 mud-brick piers supported a teak roof that covered half the mosque. A ramp from the mosque led to a spiral minaret, about 160 feet (48.8 m) tall, known as the *Malwiyya* (Spiral). Recent aerial photographs have begun to reveal the full extent of the enormous, sprawling metropolis

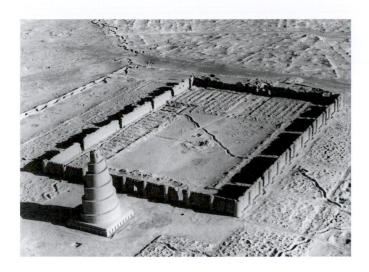

2.10 Aerial view of the Great Mosque, Samarra, with minaret in foreground. 847–61 CE

at Samarra, which extended for about 30 miles (48 km) along the river.

Among their many treasures, the Abbasids had numerous copies of the Qur'an, as well as secular books and collections of early poetry. In previous centuries, writing had played only a minor role in the life of the Arabian societies of the desert. As traders and merchants, they had used it for keeping records, but most business contracts were oral, as was the literary tradition. Poets and those who recited the famous works from the past were eloquent and creative and were expected to embellish the old classics with new flourishes as they delivered them. Theirs was considered to be the highest form of art in the Arab world. But when Jibra'il/Gabriel spoke the first words to the Prophet Muhammad, "Recite in the name of thy lord, / Who taught by the pen, / taught man what he knew not," it heralded a new chapter in Arab thought. Suddenly there was a new source of learning in the words of God, and that message was codified in forms that could not be changed. In addition to the older oral traditions, which persisted as the poets reworked them, Arabs now had a higher form of truth in the words and timeless wisdom of Allah that would not and could not change.

The transition from an oral to a literate society did not happen immediately. Muhammad used secretaries to record some of his revelations; parts of the Qur'an may have been written down in his lifetime, but complete standardized versions of the text did not appear until changes were made to the Arabic script at the end of the eighth century to make it more precise. In Muslim thought, calligraphy is inextricably tied to the Qur'an and the sacred words of Allah. Speaking or copying any part of the Qur'an was a holy act, so scribes had to be well-educated men of the highest moral character.

They learned secret formulas for mixing inks and colored paints, the correct ways to handle writing instruments, and how to sit and breathe while transcribing the sacred words. By about the year 1000, paper, which had been developed in China, had largely replaced the more expensive vellum, made from animal skins. As a result, the number of scribes and manuscripts increased, as did the varieties of Arabic calligraphy, and by the eleventh century, there were several discrete scripts, each of which was uniform and therefore usable by people over a wide area.

The earliest script, **Kufic** (named for the town of Kufa in Iraq), derives from the long angular letters used in the early inscriptions carved on stone monuments. By the time the earliest surviving examples of the Qur'an were written in the eighth century, the stately but spare Kufic had been transformed into a script of great decorative beauty (FIG. 2.11). It features letters with thick, rounded curves and long horizontal stems that accentuate the width of the books of this period. The letters and books themselves are large because two or more readers often used them at the same time. (See *In Context:* Harun al-Rashid and Abbasid-Period Books.)

In addition to the Qur'an, some Muslims also wanted books of their much-loved poetry. By the eleventh century, Islamic poets were collecting some of those works that had been sustained by the oral tradition in the past and weaving the colorful myths, legends, histories, and romances into written epics. To make them even more attractive in book form, patrons hired artists to illustrate or **illuminate** the verses. The word "illuminate" is often used in discussions of medieval European and Islamic art in preference to "illustrate" to emphasize the manner in which the images "enlighten" or "shed light" on the text. Some of the new

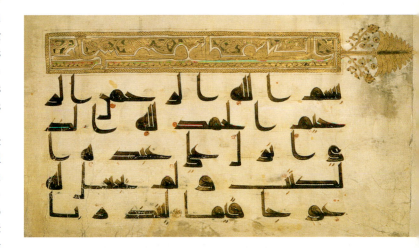

2.11 Folio from a Qur'an on vellum. 9th–early 10th century. 8⅜ × 11⅛″ (21.27 × 28.25 cm). Chester Beatty Library and Oriental Art Gallery, Dublin

HARUN AL-RASHID AND ABBASID-PERIOD BOOKS

The most famous Abbasid caliph, Harun al-Rashid (763–809), is said to have established the *Bayt al-Hikma*, "House of Wisdom," in Baghdad. From the ninth through the thirteenth century, scholars from the far corners of the Muslim world congregated and worked there in teams to translate writings from India, Greece, Byzantium, Sasanian Persia, Syria, and other earlier cultures into Arabic. Before the rise of universities in Asia and the West, these scholars also tutored students in math, science, medicine, law, and other subjects that are still taught in institutions of higher learning.

Legend also has it that Harun al-Rashid helped compile the great Arabic literary classic the *One Thousand and One Nights*, also known as *The Arabian Nights*. Many of the original tales in the collection were drawn from Arabic, Persian, Indian, Egyptian, and Mesopotamian folklore and were probably collected shortly after his time in the later ninth century; others found in the oldest extant copies of the Syrian and Egyptian versions of the classic from the fourteenth and fifteenth centuries, however, may be later additions. Moreover, those early manuscripts do not include some of the most famous tales about Aladdin, Ali Baba, and Sinbad the Sailor, which first appear in the twelve-volume French version of the book translated by Antoine Galland (1646–1715). Galland also included other tales he heard along the way while traveling in the Middle East, and editions of the book since his time have added or eliminated stories, with the result that the book has remained in a lively process of development for over a thousand years. The same is true of most ancient writings, including religious texts, which we only know through much later copies, themselves made after copies, etc.

books commissioned by wealthy patrons might have colophons, inscriptions at the end of the manuscript giving the names of the calligrapher, illuminator, and patron, along with the date. Other, less expensive works were sold in markets, some of which had special areas for these and other affordable works of art.

The *Maqamat* ("Assemblies") of al-Hariri (1054–1122) is a series of fifty picaresque tales set in various parts of the Arab world which relate the misadventures of a wily old rogue called Abu Zayd of Saruj. One page from a *Maqamat* produced in Baghdad in 1237 shows Abu Zayd and a companion seated on camels talking to a man outside a village (FIG. 2.12). In the background we see animals drinking from a pool and the domed arches of a village market with more animals, vendors, people haggling, a guard, and, on the far right, a figure spinning yarn. A mosque to the left behind a sloping palm has a dome covered with blue tiles and Qur'anic inscriptions on its wall and minaret.

The artists of the paintings in the *Maqamat* and other illuminated tales from this period have left us a wealth of information about daily life in medieval Islam that is not found in the literary sources or the scanty archeological record. As in antiquity, Iraq was occupied repeatedly by invaders from Iran and totally devastated by two Mongol invasions in 1258 and 1401. In 1206, Temuchin, or Temujin, of Mongolia, known in the West as Genghis Khan (c. 1162–1227), united the Mongols and created an empire that stretched from Europe to the Pacific. (**Khan** means "ruler" in the Turkic and Mongolian languages of Central Asia.) Under his successors, large portions of Central and Western Asia remained under Mongol rule until the early sixteenth century.

IRAN AND CENTRAL ASIA

The political fortunes of Baghdad had declined well before the production of the *Maqamat* and the Mongol invasion of the mid-thirteenth century. By 1056, the Saljuq (or Seljuq) Turks in Iran, one of the many Turkic, Persian, and Arabic groups ruling there and in Central Asia at this time, were strong enough to ignore the authority of the Arab caliphs and occupy Baghdad and Samarra. Arab interests in Western and Central Asia were further damaged by the Mongol conquests and the empire of satellite states they established along the Silk Road. Although the Mongol campaigns were bloody affairs, the period following them has been called the *Pax Mongolia* because it was a time of great prosperity, when trade flowed freely through the Mongol lands from China to the Mediterranean. With the decentralization of power in the Muslim world after the dissolution of the

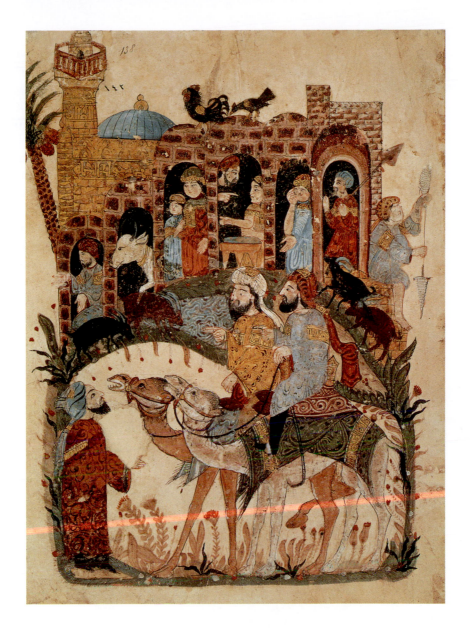

2.12 *Abu Zayd and Al-Harith Questioning Villagers.* Leaf from a manuscript of al-Hariri's *Maqamat.* 1237. Vellum, 13¾ × 10¼" (35 × 26 cm). Bibliothèque Nationale, Paris

Abbasid Empire in 1258, it was also a period that saw the development of many regional styles of Islamic arts, especially in the construction of mosques.

From 1258 to 1335, one of these Mongol groups, the Ilkhans, ruled a large area in and around Iran as "subordinates" to the great Mongol *khan* in China. Later, between 1370 and 1501, the Turco-Mongol Timurids ruled out of Samarqand in Transoxiana (modern Uzbekistan) and Herat in Khurasan near the Iran–Afghanistan border, while the Turkoman dynasties at Tabriz dominated western Iran (1380–1508). In 1501, the Safavids prevailed in Iran and became a world power in commerce until they were overrun by Afghan forces in 1722.

THE SALJUQ DYNASTY (1038–1194)

Like many of these groups, the Saljuqs at Isfahan in central Iran were ambitious builders. In the design of the Great Congregational Mosque (Masjid-i-Jumah) in Isfahan they used **iwans**, an Arabic term for a high vaulted hall that is open at one end and used as a covered entryway and place of assembly (FIG. 2.13). Although *iwans* had been used in pre-Islamic times and in some earlier Islamic palaces, they had no place in the traditional hypostyle mosques. But the Saljuqs saw the expressive potential of the large, open *iwans* as visual focal points for audiences assembled in the rectangular courtyards of their main mosque, and in the twelfth

century they created what is now known as the four-*iwan* mosque plan.

Standing in the center of the rectangular courtyard, the worshiper is surrounded on each side by tall, gracefully arched *iwans*, including the *qibla iwan*, which is slightly larger and domed, accenting the direction in which worshipers direct their prayers. At this time, builders were beginning to use glazed tiles to decorate the architectural surfaces of mosques, palaces, and tombs. **Glazes** are liquids containing silica and various metal oxides, which when heated to very high temperatures in ovens, or kilns, become vitreous or glasslike, giving the clay an attractive, colorful, and durable surface. Earlier Islamic designers had made abundant use of colored glass mosaics on interior walls, but the idea of a building with an exterior of brilliantly colored tiles gleaming in the sun seems to have been a new one. Many of the decorative passages are based on the same basic vocabulary of interlaced tendrils, stems, leaves, and floral forms as the arabesques in other Islamic art forms. At the Great Congregational Mosque, those designs cover the complex curved spaces in and around the *iwans*, giving a new sense of life and vitality to the monumental surfaces.

The surfaces within the *qibla iwan* are also covered with another form of decoration, tiers of niche-shaped forms called **muqarnas** (from a Greek word for "scales"). Vaults with *muqarnas* have also been called stalactite or honeycomb vaults. Each superimposed tier of *muqarnas* projects over the one below to create a three-dimensional lacework, which dematerializes the heavy walls, vaults, and domes and gives the impression that they are virtually weightless, like leaves on a tree or a billowing cloud. However, the *muqarnas* are deceptively strong, loadbearing devices, which actually strengthen the vaults and other architectural surfaces to which they are attached. The *iwan* at Isfahan has survived so well in part because of these logically and mathematically patterned webs of interlocking and supportive cellular units.

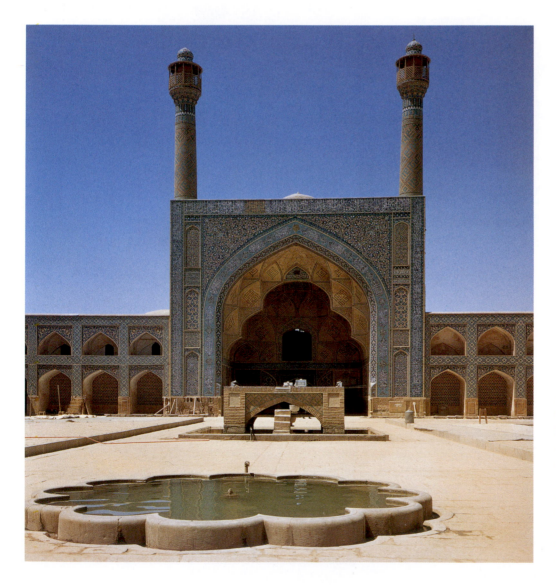

2.13 Great Congregational Mosque (Masjid-i-Jumah), Isfahan, south *iwan*. Main construction 11th–12th centuries
The mosque was built over an earlier hypostyle mosque and reworked until the 17th century so it is difficult to determine which details date from the Saljuq period.

THE ILKHANS (1258–1335)

A sixteenth-century Persian writer, commenting on painting during the rule of the Mongol Ilkhans, said that at this time "the veil was withdrawn from the face of Persian painting and the kind of painting that we know now was created." Appropriately, it seems, the emergence of this classic form of Persian painting can best be seen in the illustrations to the great Mongolian *Shahnama* ("Book of Kings") (1328–36). The *Shahnama* is generally regarded as the Persian national epic and over the years it helped shape Persian ideals of nationalism. It is a mythical epic, created by Firdawsi (c. 935–c. 1020) in Homeric fashion from a vast number of related tales taken from the oral traditions of the day. It gives us a rather gloomy picture of the malevolent world of betrayals and tragedies in which the Iranian kings lived before the Muslim conquests.

The large size of the pages in this version of the *Shahnama*, along with the quality of its calligraphy and brilliance of the illuminations, suggests that it was an expensive luxury item commissioned by a wealthy merchant or member of the Ilkhan court (FIG. 2.14). In this image, *Ardashir Captures Ardavan*, the first Sasanian Persian king, Ardashir (ruled 224–41 CE), who is shown in a royal purple robe, riding a handsome white horse, has vanquished Ardawan, king of the Parthians, the Sasanians' neighbors and arch-enemies. The long, gnarled arms of the Chinese-style tree in the background direct our attention to Ardashir and his men, who ride into the picture from the left. Differences among their hats may identify them with different regions and ethnic groups within the Ilkhanid Empire. The defeated

Ardawan, to the right in a pale robe, hangs his head, which will soon be severed from his body by the executioner behind him. In a daring experiment with composition, the artist has placed one of the bowmen in the lower center of the picture with his back to us and his feet extending outside the frame.

With this victory, after five centuries of foreign rule in Persia by the Hellenistic Greeks, Romans, and Parthians, Ardashir reinstated the legacy of Achaemenid Persian home rule. As we might expect, in addition to offering a basic history lesson, such images in the *Shahnama* are nationalistic allegories of contemporary events—the conquests of the Ilkhans—and they helped inspire the rising tide of nationalism in Persia during the Mongol rule.

THE TIMURIDS (1370–1501)

In the 1370s, after the decline of the Ilkhanid Empire, Timur Lenk, or Timur the Lame (ruled 1370–1405), a Central Asian tribal chief who claimed descent from Genghis Khan, burst forth with great savagery to create a new Turco-Mongol empire that stretched from India to Anatolia. For about a century, the Timurids unified the steppe cultures of the many nomadic and seminomadic groups in the heart of Asia along the Silk Road. Timur, known as Tamerlane or Tamburlane in the West, had unlimited access to the resources of Central and Western Asia and imported the finest materials, craftsmen, and scholars of the day to his capital at Samarqand, Uzbekistan. Many of the stonemasons and painters came from Persia and India. With the influx of this wealth,

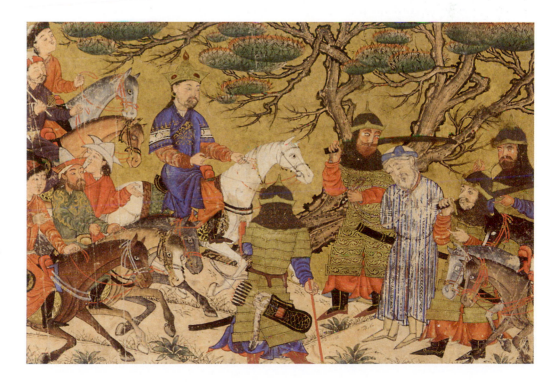

2.14 *Ardashir Captures Ardavan*, from a copy of the *Shahnama* ("Book of Kings") by Firdawsi. Ilkhanid dynasty, c. 1335–40. Detached folio, ink, opaque watercolor, and gold on paper, 23⁵⁄₁₆ × 15⁵⁄₈" (59.2 × 39.7 cm). Origin: probably Tabriz, Iran. Arthur M. Sackler Gallery, Smithsonian Institution

PERSIAN POETRY, PAINTING, AND SHI'ITE THOUGHT

The emergence of the world-famous Persian poets and painters in the fifteenth century represents the climax of a long tradition that had been developing for centuries. It began before the conquest of Baghdad, matured after the rise of the Mongol Ilkhan rulers (1260), and remained vibrant through the sixteenth century. While scholars were collecting and translating books at the House of Wisdom in Baghdad, Persian artists were collecting illustrated books and "translating" their images into distinctly Persian styles of painting. They also worked closely with the Persian poets of the day who wrote verses about story-book worlds where royals and romantics clad in silks and jewels enjoyed intrigues on moonlit nights in lovely, well-watered gardens and on idyllic, flower-covered hillsides. Translating those rarefied visions into pictures, the Persian painters created a world in which miniature, doll-like figures move about in shadow-free make-believe worlds of crystal-clear colors. In addition to illuminating books, some of the Persian painters began to create individual paintings and thus escaped from the anonymity that had surrounded earlier Islamic artists. As such, their names and personalities have survived and we can see them as creative individuals, like their contemporaries in Renaissance Europe.

Everything about those utopian dreams of aristocrats at play in their fantastic, spectral landscapes seems to be supercharged with boundless quantities of otherworldly, spiritualized energy. This rarefied view of life on earth may derive from several sources. The mystical ideals of Sufism were emerging as the Persian style of painting developed, as was the knowledge of the Platonic otherworld of perfect forms and ideals in the Greek texts being translated at the House of Wisdom. These ideas overlapped with the Arabic ideal of *al-a' yan ath-thabitah*, "immutable essences," in which a painted tree might become more than just an image of *a* tree and become a symbol of "treeness" more generally, or of the tree as a plant form.

Finally, and perhaps most importantly, Persian miniature painting is linked to a very specific kind of Shi'ite mysticism. In Shi'ite belief, Allah and Muhammad appointed Ali, his kinsman, to be his successor, and he became the first of twelve kindred **imams**, the true caliphs and rightful successors of Muhammad who share in his divine knowledge and authority. The twelfth and last *imam* was Muhammad ibn al-Hasan, and when he died in 872, Allah hid the *imam*'s spirit in a mystical region between this world and Paradise. It is said that, at Allah's command, he will return with Jesus Christ to establish a kingdom of peace in which the Shi'ites will prevail. In the meantime, the twelfth *imam* is engaged opening paths through his realm so that the wonders of Paradise can reach the Shi'ite world on earth. For the Shi'ite Persian poets and painters, nature was infused with a spiritualism coming from the glory of Allah and Paradise via the work of Muhammad ibn al-Hasan, and their mission was to make that vision accessible to others. To do that, they created images of a highly spiritualized nature, a world of perpetual bloom and eternal springtime that lies somewhere beyond the sunlight and shadows of everyday experience in a dream world illuminated by the glow of Allah and his Paradise.

Samarqand, set in fertile lands along the Silk Road, became one of the grandest cities in the world of its day.

Many of the most impressive buildings commissioned by Timur and his dynastic successors were located in the heart of the city at the Registan, or "Royal Square" (FIG. 2.15). The only Timurid building to survive here is the **madrasa** on the left side of the square (1417–20), which was built for Ulughbeg (1394–1449), Timur's grandson. *Madrasas* were schools for the study of Sunni religious law and first appeared in the eleventh century to counteract the teachings of the Shi'ites. The other buildings from the Timurid period were razed to make way for the Tilakari (Gilded) *madrasa*-mosque (1646–60) in the center, and the *madrasa* of Shirdar (House of the Lion) (1618–35/6) on the right, named after the lions over the *iwan*. The two seventeenth-century structures, built under Uzbek rule, were modeled after Ulughbeg's *madrasa* to create the impression that the entire Registan had been designed by a single gifted architect and built at one time

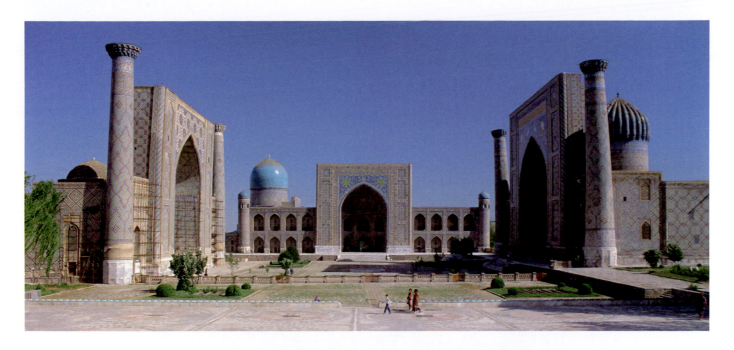

2.15 The Registan, Samarqand, Uzbekistan. The *madrasa* of Ulughbeg (1417–20) on the left, the Tilakari (Gilded) *madrasa*-mosque (1646–60), center, and the *madrasa* of Shirdar (House of the Lion) (1618–35/6)

according to a master plan. The result is one of the largest and most perfectly unified open spaces in the Islamic world.

The tall, gracefully arched *iwan* in the façade of Ulughbeg's *madrasa*, flanked by a pair of minarets, leads to an inner courtyard with four axial *iwans* and arcaded tiers of rooms for study and instruction. The architectural elements of design in this interior court, as well as those of the two later structures, repeat the basic forms on the façades around the Registan, making every section part of a fully integrated visual plan. This sense of unity in the large urban ensemble is enriched by the treatment of the surfaces: the marbles, gilded plaster, brick mosaics, and the tile mosaics with their contrasting geometric, epigraphic, and floral patterns.

The Timurids also held power at Herat in Khurasan, and under the patronage of Sultan Husayn Bayqara (ruled 1470–1506), the great-great-grandson of Timur, the magnificent court there included many of the leading painters and poets of the day, including Abd al-Rahman Jami, known as Jami (1414–92), and one of the most famous painters in Persian history, Bihzad (c. 1455–1536). (See *In Context: Persian Poetry, Painting, and Shi'ite Thought,* opposite.)

Bihzad's best-known work, and one that demonstrates the classic features of his style, an allegory titled *The Seduction of Yusuf* (1488), is based on the tale of Joseph and Potiphar's wife, Zulaykha (FIG. 2.16). The story, which appears in both the Old Testament and the Qur'an, had become popular among Persian poets, including Sa'di of Shiraz. Most of the text accompanying Bihzad's illumination comes from Sa'di's *Bustan* ("The Orchard"), a collection of verses that includes the story of how Zulaykha had decorated seven rooms in her palace with erotic paintings of Yusuf (Joseph) making love to her. Leading the unsuspecting Yusuf from room to room, and locking the doors behind them, she expects the pictures to have aroused him by the time they reach her bedroom. At that point, Zulaykha throws herself at Yusuf. But the locked doors suddenly fly open and the high-minded Yusuf—who knows then that God is still watching him—tears himself from the clutches of the evil temptress Zulaykha and begins his escape. In the spirit of Jami and other poets who had converted the simple narrative into a mystical allegory, Bihzad's illumination tells us that Yusuf (the spiritual beauty of God) transcends the limitations of architecture (the locked doors) and the material world.

As Zulaykha reaches toward the fleeing Yusuf, the diagonal accents of their gestures echo the many diagonals in the cantilevered bedroom and walls of the other rooms in the house, each of which is shown according to its own self-enclosed rules of perspective. The complexity of the architectural maze, in which the individual spaces are not logically interconnected, reflects the mysticism of Sa'di's verses and the plight of Yusuf, who, under the watchful eyes of God, must find his way out of the house. Bihzad has embellished the complex pattern of planes in this maze of overlapping doors, stairways, railings, intersecting walls, wooden screens, and carpets with a wide variety of

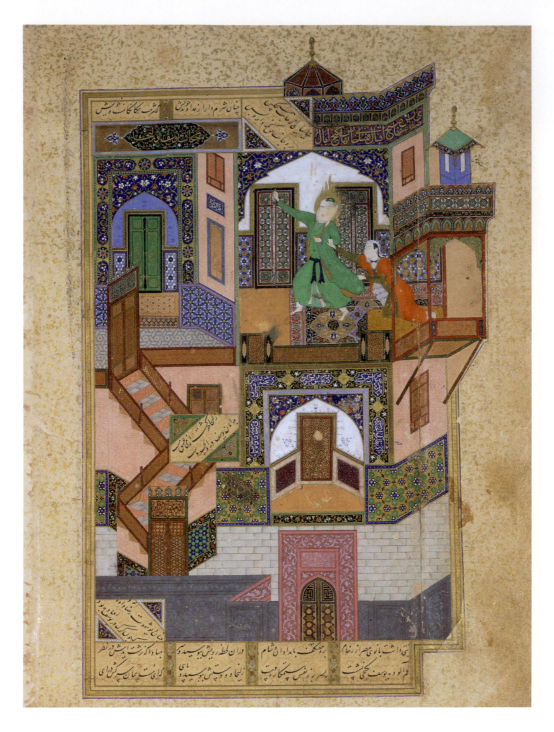

2.16 Bihzad, *The Seduction of Yusuf*, from Sa'di, Bustan. Herat. 1488.
12 × 8½" (30.5 × 21.5 cm). National Library, Cairo, MS. Arab Farsi 908, f. 52v

rich decorative patterns, but nowhere do we see the erotic images mentioned in Sa'di's verses. Although Bihzad uses figures to tell a story, staging it in a series of semidetached images, each seen from its own point of view, the viewer's eyes roam about the picture, looking at the details, as they might when looking at repeating patterns of decorative forms. In this way, Bihzad's narrative technique seems to reflect the strength of the decorative traditions in Islamic art while adding new life to the dramatic events by the way his figures interact with one another.

The belief in dual material-spiritual realities expressed so eloquently in Bihzad's painting is also manifest in an Islamic movement called **Sufism**. For many, the word "Sufi" evokes an image of dancers called Whirling Dervishes (another

word for Sufi), men wearing long white skirts that fly out-
ward in great rippling circles as they spin around and around
for long periods of time. This much-publicized aspect of
Sufi ritualism dates back to the teachings of a thirteenth-
century Persian mystic and Sufi, Jalal ad-Din Muhammad
Rumi. He believed that the bodily experience of music and
repetitive dance movements would create trancelike states
and unite a Whirling Dervish with the divine. By this time,
Sufi dervish orders, such as the Naqshbandi, had their own
hierarchy of masters, disciples, and spokespeople who
explained how Sufism unveiled the "true" mystic levels of
experience encoded in everyday activities. Even the con-
templation and enjoyment of female beauty was explained
as a holy quest for the love of God. At times, the highly
eclectic Sufi thinkers also incorporated ideas from Chris-
tian mysticism, Jewish Kabbalism, and shamanism that were
rejected by the mainstream Muslim authorities of the day.

THE TURKOMANS (1380–1508)

In contrast to Bihzad's highly ordered style, some fifteenth-
century illuminators working in the Turkoman court at
Tabriz in the far northwestern corner of Iran near the
Caspian Sea combined repeated decorative patterns with
images of flora and fauna, all rendered in a much looser,
organic manner. We see this in works such as *Bahram Gur
in the Green Pavilion* (1480s) by Shaykhi (FIG. 2.17). The Sasa-
nian king Bahram Gur (ruled 420–38) was famous for his
bravery in battle, his prowess as a hunter, and his amorous
affairs. Shaykhi had worked in Herat, where he saw the
works of Bihzad and his followers, before moving to Tabriz,
where he then encountered the more ornate style of the
Turkoman court. The framed section of the illumination,
which shows Bahram Gur reclining within the pleasure
pavilion and encircled by women of the court, is composed
with flat, uniformly patterned planes of color, which define
simple, open, and orderly geometric spaces. This section
contrasts sharply with the enchanted garden surrounding
it, a colorful fantasy of lively bush-shaped rocks, toylike
trees, and floating flowers, all of which rise like buoyant
clouds to engulf the pavilion.

This tale, involving the ever-popular Sasanian Persian
ruler, comes from a romantic epic called the *Khamsa* ("Quin-
tet") by the poet Nizami (c. 1141–1203). To complete his
education about love, Bahram Gur was required to visit the
pavilions of six princesses and sleep with them. As in the
Shahnama and other Persian epics of this period, stories such
as this in the *Khamsa* accrued many levels of meaning that
transcend the basic eroticism implicit in the narrative. Thus,
rulers could commission illuminated copies of the *Khamsa*
for their reading pleasure—and their education.

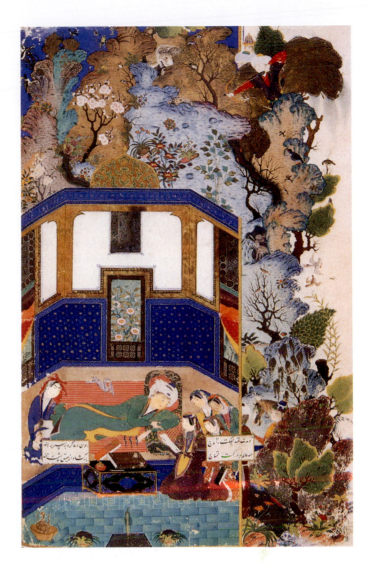

2.17 Shaykhi, *Bahram Gur in the Green Pavilion*, from Nizami,
Khamsa. Tabriz. 1480s. 8⅝ × 5⅝" (21.9 × 14.28 cm). Istanbul,
Topkapi Palace Library, MS. H. 762, f. 170b

THE SAFAVID DYNASTY (1501–1722)

The Safavids, who claimed to be semidivine, created a pow-
erful Iranian theocracy that revived the spirit of the Ach-
aemenid and Sasanian Persian empires. The first Safavid
shah (king), Ismail (ruled 1501–24), established a new court
at Tabriz, but sent his son Tahmasp (1514–76) to be edu-
cated among the literati at Herat, where Bihzad and Jami
had worked. When his father became ill, Tahmasp, who had
trained as a painter, returned to Tabriz where he became
shah at age ten and ruled from 1524 to 1576. By this time,
many of the artists from Timurid Herat were living in Tabriz
where they could study the great Mongol *Shahnama*, which
was held in the court library. Not only did this great epic
of nationalism inspire the artists in Tahmasp's court to work

in the powerfully expressive style of the Turkoman artists, it also encouraged the young shah to commission a new Safavid version. It was an enormous project running to 258 illustrations which kept many of the court calligraphers and painters occupied from about 1525 to 1535. Among the finest illustrations in the epic is *The Court of Gayumars* (c. 1527–28) by Sultan-Muhammad (FIG. 2.18).

Earlier, we saw how Shaykhi combined elements of Bihzad's geometric style with the looser, organic Turkoman style of Tabriz (see FIG. 2.17). Elaborating on the fantasy and wildness of that Turkoman style, Sultan-Muhammad gives this scene from the *Shahnama* a new sense of energy and drama. Persian subjects and animals alike pay homage to Gayumars, their first king, who is enthroned on a mountaintop against a golden sky. To the right sits his son, Siyamak, who will soon die at the hands of a demon; to the left is Prince Hushang, his willowy young grandson, who will avenge his father's wrongful death. They, the courtiers, and animals in Gayumars's realm are arranged in a large circle within a fantastic landscape of shimmering, rainbow-colored rocks that seem to be frosted with running colors, resembling ornate ceramic vessels with thick glazes that have dripped during firing.

This complex imperial image is not only a symbol of timeless Persian power. In the 1520s, it carried another, more specific and timely political message. The year Tahmasp was born, the Ottomans had crushed the Safavids at Chaldiran and, in the tradition of Prince Hushang, the young shah was determined to avenge that "wrongful" defeat and bolster the spirit of Persian nationalism.

Commenting on Sultan-Muhammad's work, another Safavid painter who worked on the project said: "Although it has a thousand eyes, the celestial sphere had not seen his like." But, shortly after this ambitious version of the *Shahnama* was completed, the shah closed down his artistic workshops to concentrate on political and economic matters. As a result, many of the calligraphers and illuminators were forced to move east to the Mughal courts of northern India or west to work for the Safavids' long-standing rivals, the Ottomans in Anatolia.

In a later effort to shore up Safavid rule, Shah Abbas I (ruled 1588–1629) moved his capital to Isfahan, the old Saljuq capital, which was further from the Ottoman border than Tabriz and nearer to the major caravan routes. In his new capital, Abbas revived the earlier Safavid tradition of patronizing the arts, reorganized the textile industry so that it could compete internationally, and converted Isfahan into one of the great art centers of the world.

In Saljuq times, the Great Congregational Mosque had been the heart of the city. Abbas now relocated the center of Isfahan far to the south around a new plaza, where he

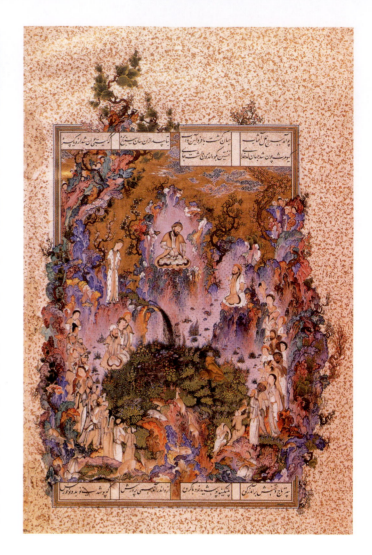

2.18 Sultan-Muhammad, *The Court of Gayumars*, from the copy of the *Shahnama* prepared for Tahmasp I. Tabriz. 1525–35. Ink, color, and gold on paper, 13 × 9" (33 × 22.8 cm). The Aga Khan Trust for Culture, Geneva

built shops for merchants, a special market for fine textiles, a mint, a pavilion for music, two mosques, and a palace. The court itself was used to celebrate festivals and hold military reviews, and it was filled with tents and stalls on market days. Abbas also began the construction of a domed bazaar, over a mile (1.6 km) long, connecting the old and new cities. Over the years, later builders added many new baths, *madrasas*, mosques, shrines, and **caravanserais** to the bazaar. Caravanserais (from the Persian *karvan*, "caravan," and *saray*, "house" or "lodging") were courtyard hotels for caravans in which the sleeping quarters were directly over the stables and storage rooms. In the tradition of the Abbasids at Baghdad, who called their capital the hub and navel of the world, Abbas called this metropolitan renewal his *Nagsh-i Jahan* (Design of the World).

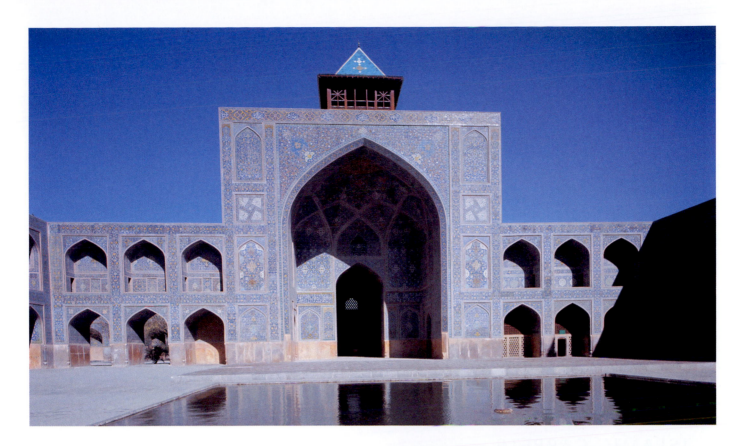

On the south end of the new plaza, Abbas built a mosque, the Masjid-i Shah, known today as the Masjid-i Iman, in the very center of his Design of the World. The arch and halfdome of the mosque's towered portal are covered in some of the finest tilework of the period (FIG. 2.19). The broad bands over the door and around the arch are filled with quotations from the Qur'an that greet the faithful as they enter this place of worship. Within the long inscription, the sunburst pattern under the peak of the arch seems to have thrown parts of the design outward and downward so that they float overhead like the glowing embers of an exploded rocket. The sumptuous beauty of these decorative arabesques is meant to reflect the divine essence of Allah, his infinite wisdom, and the glory of the heavenly Paradise that awaits the faithful.

Passing through the portal into a smaller plaza of the mosque, the visitor is surrounded on all four sides by tall *iwans* leading to vaulted halls (FIG. 2.20). The four-*iwan* arrangement had been popular in Iran since Saljuq times, but the Masjid-i Iman is distinguished by the extent and richness of its marble paneling and glazed tiles. All four *iwans* and the arcades continue the color scheme of the portal, and, with the decorations that encircle the towers and fit the high dome of the *qibla iwan* like a giant laced turban, visitors moving through the court are literally engulfed in a blaze of colored glory.

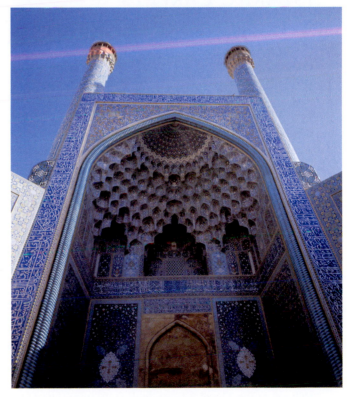

2.19 (TOP) The portal, Masjid-i Iman, formerly the Masjid-i Shah, Isfahan, Iran. 1612–38

2.20 (ABOVE) *Qibla iwan*, Masjid-i Iman, Isfahan, Iran

Despite the decline of the Persian schools of painting in the late sixteenth century, the textile arts remained strong. Much of Abbas's Design of the World was financed through taxes on the manufacture and sale of these luxury items, which were much sought after by wealthy collectors around the world. Even the Prophet, who had lived in austerity, had fine patterned textiles in his home; even when the textile business in Iran had been no more than a cottage industry, it was already an important part of the regional economy.

The early phases of this history are difficult to reconstruct because few of these highly perishable works have survived. Two of the oldest extant fragments of an Islamic woven silk, known as the *Shroud of St. Josse*, come from tenth-century Iran. They escaped destruction because they were used to wrap and preserve the bones of St. Josse in the Abbey of St. Josse-sur-Mer in Normandy in 1134; the silk fragments may have been purchased in the East by one of the patrons of the abbey who took part in the First Crusade (1095–99). One shows two elephants facing each other each with griffins between their feet (FIG. 2.21). This was part of the shroud's central image, which was originally surrounded by elaborately patterned borders, including one, running up the left side, which featured two-humped Bactrian camels. The elephants and camels are rendered as simple geometric forms in a symmetrical design familiar from other early Islamic textiles with repeating patterns that reflect the basic grid of the **warp and weft**. An inverted inscription below reads: "Glory and prosperity to the commander, Abu Mansur Bakhtikin, may God prolong his existence." Bakhtikin was a military officer who had served in Khurasan, northeastern Iran, but who was arrested by his sovereign in 961. The silk may have been commissioned to atone for the deeds that led to his arrest.

The earliest known Islamic carpets date from the thirteenth century, and they too have strong borders and central

MATERIALS AND TECHNIQUES

ISLAMIC CARPETS

Before the establishment of the royal workshops in the great Islamic metropolitan centers, Muslim nomads and villagers had long woven astonishingly beautiful and durable carpets. Of the four fibers traditionally used in the Islamic world—wool, linen, cotton, and silk—silk was by far the most precious and loved for its lustrous sheen, shimmering iridescence, and the subtle designs weavers could create when working with its fine fibers.

The looms used are quite simple. Sturdy rectangular frames hold the foundation threads (the warp and weft) in place. The vertical warp threads are unrolled from the top of the loom downward, and the finished carpet is coiled around a roller at ground level. Lowering the carpet as it is woven allows weavers to sit before the loom and work at hand and eye level. Traditionally, most of the village weavers were women, but the larger workshops have long employed men.

In what are known as hand-knotted carpets, weavers knot pieces of thread about 2 inches (5 cm) long around pairs of warps. By changing the colors of the threads to be knotted according to information on the patterns placed behind the loom, weavers create the desired designs. The warp and weft are usually cotton or wool, and in some fine carpets the knots, normally wool, may be silk. After tying a complete row of knots, one or more wefts are passed through the warp and "beaten" down with a metal comb. The threads extending from the rows of knots form the pile, which the weavers trim from time to time to flatten it. This time-consuming process of knotting can be accelerated by tying knots around three or more warps, but the resulting pile will not be as full and lush. The quality of a carpet is determined in part by the thickness of the pile, which reflects the density of the knotting. Some of the finest Persian carpets, with up to four hundred silk knots per square inch (6.45 sq cm), not only have a very full, soft, and luscious pile but are also very durable.

For centuries, such knotted silk carpets have been prized possessions and status symbols within and outside the Islamic world. In Europe, Islamic carpets were so highly valued that many owners hung them like tapestries or paintings and displayed them on tables. Despite the amazing technology that has become available with the development of computerized looms, modern high-tech attempts to duplicate the subtle effects of hand-knotted carpets have not been entirely successful.

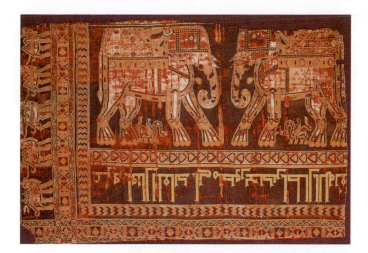

2.21 Detail of the *Shroud of St. Josse*. Before 961. Silk, 37 × 20½" (94 × 52 cm). Louvre Museum, Paris

This was probably woven on a draw loom, a 1st-century CE invention in which the somewhat cumbersome system of levers and shafts to raise and lower the warps were replaced with fine strings. This allowed weavers to create more complex, detailed designs more quickly and easily.

areas with stylized animals framed by thinner square and octagonal borders. These relatively small works, about 3 by 5 feet (1 × 1.5 m), are called Ushak animal carpets after their subject matter and place of origin in western Anatolia. Sometime around the end of the fifteenth century, the larger and more complex medallion carpets appeared. Typically, these have complex florid medallions on decorative fields in the central areas with quarter-medallions in each corner.

The more ornate medallion carpets reflect decorative trends in other forms of Islamic art. It appears that the illuminators of the day created motifs that were then taken up by artists working in different materials, including fibers. The size and cost of the highly ambitious medallion carpets indicate that they were made for the very wealthiest patrons. As patterns became ever more complex, the early geometric designs disappeared.

The masterpieces of this period are two similar carpets with wool knots and silk warps, which are known as the Ardabil carpets because some scholars believe they came from Ardabil in northern Iran. The slight variations in the knot count and length of pile between the two carpets (one now in London, the other in Los Angeles) suggest that they were probably made in different workshops from a single set of pattern drawings. The London Ardabil carpet (1539–40), with about 25 million knots, is over 35 feet (10.7 m) long and has a radiant sunburst medallion pattern in the center surrounded by sixteen pendants and two mosque lamps (FIG. 2.22). The very rich pattern of arabesques and

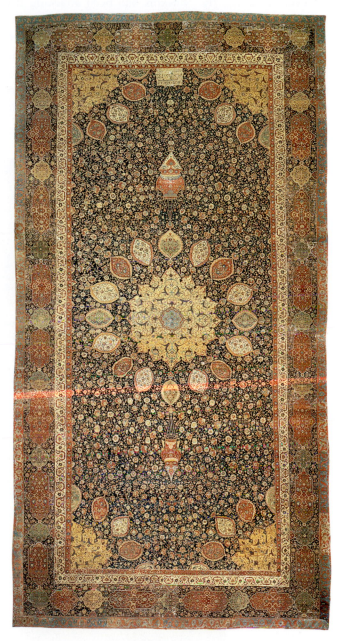

2.22 Ardabil carpet, Tabriz? 1539–40. Wool pile on silk warps and wefts, 35'5" × 21'2" (10.79 × 6.45 m). Victoria and Albert Museum, London

densely packed foliate forms (black, green, white, yellow, and a variety of blues and reds) floats upon an intensely rich and deep blue background. The techniques used to create this and other Islamic carpets are discussed in *Materials and Techniques: Islamic Carpets* opposite.

ANATOLIA AND THE OTTOMAN TURKS (1453–1574)

For seven centuries, the Muslims had been attacking the Byzantine capital, Constantinople, and failing to breach its thick, well-defended walls. Finally, in 1453, Mehmed II (ruled 1451–81) fulfilled an ancient Muslim dream and captured the city. Ruling out of Constantinople, which eventually became known as Istanbul, Mehmed and his Ottoman successors now commanded the remains of the Roman–Byzantine Empire. As a way of further affirming their new position as the heirs to Greco-Roman civilization, the Ottomans also wanted to add Renaissance Europe to their dominions.

MEHMED II AND HAGIA SOPHIA

The enormous domed church of Hagia Sophia, which had been built in Constantinople by Emperor Justinian I in 532–37, was to become an important symbol of Ottoman destiny (FIG. 2.23). Some historians regard it as the last major Roman building; others see it as one of the first major

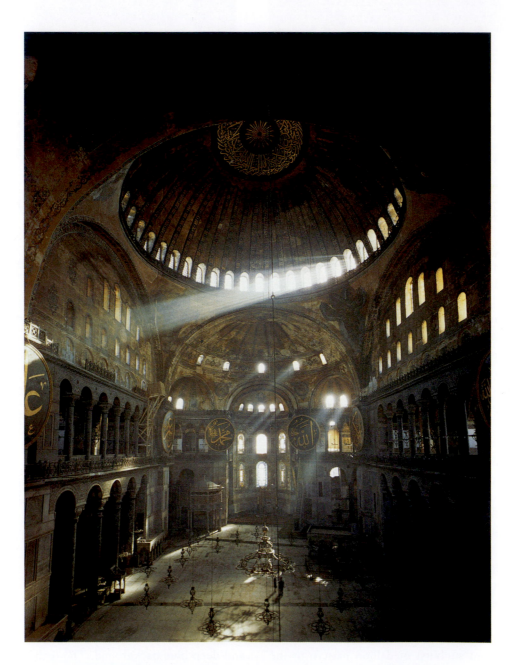

2.23 Anthemius of Tralles and Isidorus of Miletus, Hagia Sophia, Istanbul. 532–37. Rededicated as the Mosque of Ayasofya in 1453 and as a secular museum in 1934

medieval monuments. The Byzantine rulers, who called themselves Roman emperors, made no such distinction; in their imperial vision, they were heirs to a seamless history of regal authority that reached back to the conquests of Alexander the Great in the fourth century BCE.

From a modern standpoint, Hagia Sophia, standing as it does at the junction of antiquity and the Middle Ages, brings together the cosmic symbolism and imperialism of both epochs in the Mediterranean. The four large pendentives under the dome represent the four corners of the universe, the circular base of the dome symbolizes eternity, and the rounded hemispheric shape of its dome echoes the larger dome of the heavens above. By capturing this time-honored Roman and Byzantine symbol of authority and turning it in to a mosque, Mehmed II served notice that his dynasty now sat on the throne of the Roman–Byzantine Empire. Although the Ottomans had been building domed and vaulted mosques in Anatolia and Edirne for over a century, Hagia Sophia became an important model for the Ottoman mosques of the fifteenth century.

SÜLEYMAN THE MAGNIFICENT AND SELIM II

The full genius of the style of mosque that combined Byzantine and Ottoman ideals emerged a century later under the rule of Süleyman II Kanuni ("Lawgiver") (ruled 1520–66) and his successor, Selim II (ruled 1566–74). Under their patronage, Koça (Joseph) Sinan (c. 1489–1588), known as Sinan the Great, became the most famous architect in Islamic history.

After designing at least three hundred buildings, in 1568–74 Sinan created his acknowledged masterpiece, the Selimiye Cami (Mosque of Selim II), outside Istanbul at Edirne, the Ottoman summer capital (FIG. 2.24). In it, Sinan cleverly adapted the technology and style of Hagia Sophia to Islamic needs. As one walks under the dome, the difference between the longitudinal axis of Hagia Sophia and the mosque's fully integrated and centralized octofoil plan is immediately evident. The square platform over a fountain supported by an arcade of twelve short marble columns, known as the *dikka*, provided an elevated place for the *muezzin* to sit and chant,

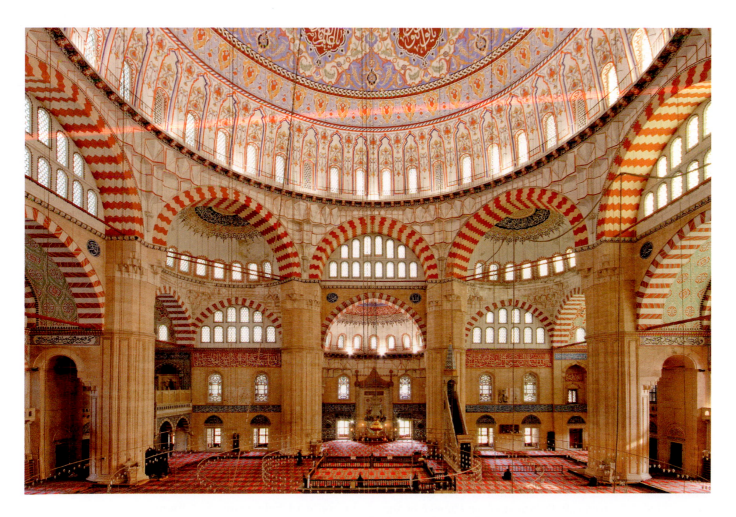

2.24 Koça Sinan, Selimiye Cami (Mosque of Selim II), Edirne, Turkey. 1568–74. Interior

but it was not a visual focal point for worshipers. Looking upward, one sees the honeycomb patterns of *muqarnas* that further identify this structure as a Muslim adaptation of an older Christian design.

Süleyman, known as Süleyman the Magnificent in the West, was a trained goldsmith and enthusiastic patron of the decorative arts. At a time when many art forms in Persia were in decline, Süleyman's rule represented a truly spectacular period for calligraphy, manuscript illustration, metalworking, textile design, and ceramics. The styles in which artists of every medium within the Ottoman Empire worked were heavily influenced by the Naqashkhane, the society of painters in Süleyman's imperial painting studio, who created designs that were used in the production of palace works of art in all media. Using brilliant colors with an impeccable instinct for detail, the Naqashkhane painted delightful images of floral forms that suggest a bountiful, joyful Paradise.

In one of their most decorative works, the Naqashkhane painters illuminated the imperial *tughra*, Süleyman's official monogram or ornate signature, which he affixed to important imperial documents (FIG. 2.25). The Ottoman *tughra* includes the ruler's name, title (*khan*, "lord"), motto, and the name of his father. Subsections of the *tughra* contain distinct, contrasting designs featuring natural and stylized motifs set on a plain or colored background. Some of the crescent-shaped areas formed by the intersection of the vertical lines and horse tail-shapes that give the *tughra* its name (*tug* means "horse tail") have black, pale-blue, and red floral motifs set upon gold backgrounds. The area between the concentric

teardrop shapes on the left is filled with blue and gold floral patterns. Inside the smaller oval, the lower half has a compact floral pattern, while the upper section is filled with four sprays of blue, red, and gold carnations. Other variations on these forms are placed against a white background.

One of the finest and most famous examples of Ottoman art, a set of glazed tiles now installed in the Topkapi Palace, was originally designed for a kiosk commissioned by Süleyman around 1527–28 but that burned down in 1633 (FIG. 2.26). In the center, trees set against a dark-blue background sprout a pattern of white flowers and fill an arch with a lighter border, over which meandering Chinese cloud motifs dance in the triangular spandrels. The panels to the left and the right, packed with lively patterns of floral motifs, are prime examples of the **Saz** style.

To explain the complex origins of that style, we must go back to 1514, when the Ottomans defeated the Safavids at Chaldiran and returned home with caravan-loads of booty, including Chinese art and Safavid artists. Working at the court and the nearby workshops in Nicea (present-day Iznik), the transplanted Safavids created a new style of decoration. This was based in part on Chinese art of the Ming and Yuan periods, including their blue-on-white ware, and featured repeating patterns of highly stylized, gracefully curved flowers, scrolls, and lancet leaves with sharply defined, jagged, or serrated edges. The name may come from the reed (*saz*) pens the designers in the royal drafting studio used to draw the designs on paper, after which they were delivered to other workshops. There they served as the models for *Saz* designs on a variety of materials. In the case of the tiles for Süleyman's kiosk, after the ceramists transferred the drawings to one set of tiles, they reversed them to make another opposing set of tiles for the other side of the kiosk. The tiles are painted in shades of blue and turquoise with a white overglaze, in the manner of the Chinese porcelains in the palace collection. Thus the debt to China in the subject matter and technique is twofold; and, further to illustrate the importance of long-range trade relationships in both directions along the Silk Road, we should note that the Chinese originally developed their blue-and-white ware by imitating certain cobalt-decorated ceramics they had imported from Iran and Iraq.

In the years to come, while Ottoman artists were making the *Saz* style more "Ottoman," Turkish began to displace Persian as the official court language. In this move away from the older traditions of the East, the Ottomans also commissioned a series of projects to celebrate *their* feelings of nationalism, including a monumental Ottoman version of the old Persian national epic, Firdawsi's *Shahnama*. In honor of Süleyman, the Ottoman version of the epic included ancestors of the Ottoman sultans instead of the

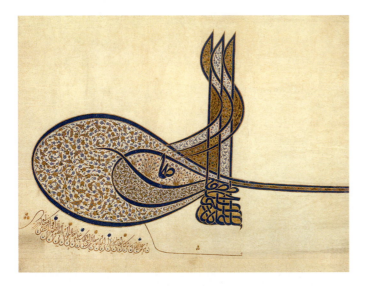

2.25 Illuminated *tughra* of Sultan Süleyman. c. 1555–60. 20½ × 25⅜" (52 × 64.5 cm). The Metropolitan Museum of Art, New York, 38.149.1

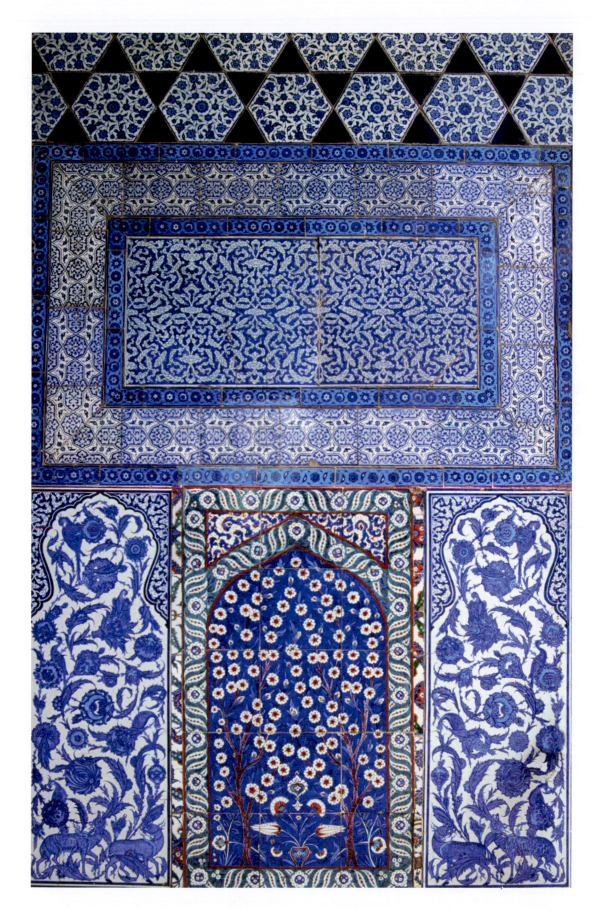

2.26 Underglaze-painted tiles from the kiosk of Süleyman. Topkapi Palace, Istanbul. c. 1527–28. Reset in the Sunnet Odasi

Persian kings and was called the *Sulaymannama* ("History of Süleyman"). A younger contemporary of Sinan, Arif Chelebi, known as Arifi (died 1561–62), illuminated one of the largest and most important images in the new version of the epic, which appeared in 1558 with 617 pages and sixty-nine illustrations, four of which were double-paged.

One of these double-page illustrations, Arifi's *The Siege of Belgrade*, portrays the event in contrasting modes. The left side, not shown here, is rather conventional, in the mode of the Herat and Tabriz painters, with small figures placed within gardens and architectural spaces defined by flat, colored, and brightly decorated planes. The bottom of the right half of FIG. 2.27 also includes the familiar Iranian-styled

garden, but from the portion of the image above we can tell that Arifi has been looking at European Renaissance art, very possibly Venetian oil paintings. He has studied the way Renaissance artists depicted figures as mobile objects, created landscapes as deep spaces, and rendered architecture according to the laws of perspective. Arifi went to great trouble to arrange a large number of dissimilar buildings in overlapping groups and to use elements of linear perspective, along with modeling and shadows, to give the fictive architecture of Belgrade a sense of mass and depth. In the background, a group of soldiers gather around a tower that is heavily modeled in shades of blue to accentuate its roundness. From there they watch four men trapped at the top of another burning tower on the left. Unlike the restrained figures in traditional Islamic paintings, the desperate men gesture wildly, as do their compatriots to the right who are watching the debacle from an arcade.

RECENT ISLAMIC ART

In many parts of the world, Islamic communities continue to build new mosques using traditional designs, while others are increasingly combining those traditions with regional and local building practices. Perhaps the most astonishing of these regional adaptations is the National Mosque of Pakistan in Islamabad, also known as the Faisal Mosque for its patron, King Faisal bin Abdul Aziz of Saudi Arabia (FIG. 2.28), designed by the Turkish architect Vedat Dalokay (1927–91). When it opened in 1986, standing triumphantly before the Margalla foothills of the Himalayas, it could accommodate up to 300,000 worshipers, making it the largest mosque in the world. However, many Muslims were slow to accept it. Aside from its tall, thin Turkish-style minarets, the building did not resemble any regional style of mosque construction from the past in Southern Asia, or indeed in the architect's home land of Turkey.

Dalokay wanted the building's triangular geometries to echo the lines of traditional Arab Bedouin tents, as well as the giant tents with lavish furnishings Muslim leaders often erected along the way as they traveled and visited their subjects in the provinces. These palace-sized structures with grand entryways, carpets, lamps, curtains, and balconies with staircases spoke to the power of the leaders as representatives of Allah on earth; thus, the tent symbolism of the Faisal Mosque is resplendent with meaning. But the symbolism was lost on many worshipers for whom the mosque simply did not look like a mosque. Also, inside, the rhythms of the ribs lining the walls and ceilings echoing those on the outside did not blend well with the cursive lines of the calligraphy surrounding the worship area; hence, some felt that the building failed to provide a traditional setting for

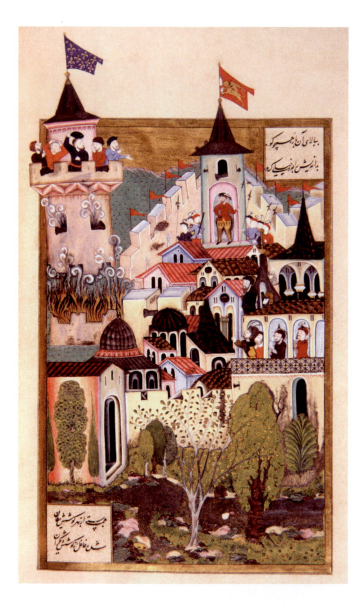

2.27 Arifi, *The Siege of Belgrade* (right side), from the *Sulaymannama*, Istanbul. 1558. Topkapi Palace Library, Istanbul, MS H. 1517, ff. 108v–109r

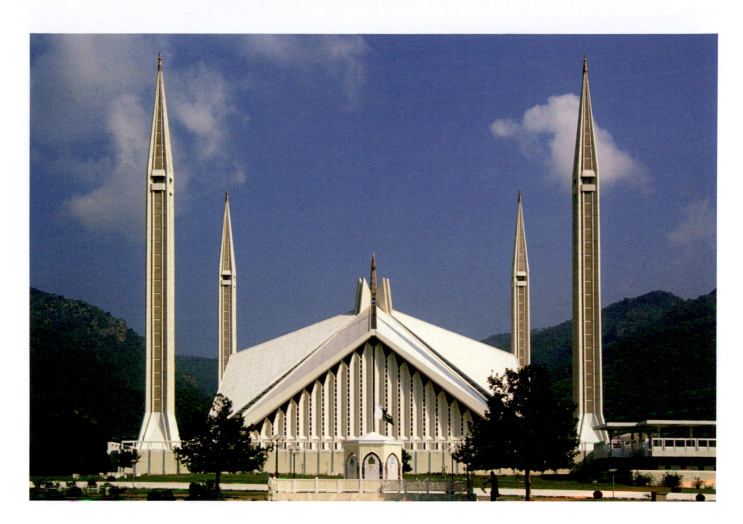

2.28 Vedat Dalokay, National Mosque of Pakistan (Faisal Mosque), Islamabad. 1986

the Word of God. Thus, while the mosque references Arabic history, it took some time before its remarkable beauty was fully recognized in the Muslim world.

SUMMARY

The Ottoman Empire remained powerful for centuries but by the seventeenth century many parts of the Islamic world in Western and Central Asia were in decline. The region's wealth had rested on the trade in handmade goods over long distances along the Silk Road and its many tributaries. But when the Europeans established sea routes connecting the East and West in the sixteenth century, they flooded many of the Eastern markets reached by the Silk Road with inexpensive, machine-made products. This ultimately damaged the craft traditions and economy of the entire Islamic world.

After World War II, as the colonial age drew to a close and many Islamic countries assumed home rule, those with large oil reserves became very wealthy and some Islamic regions once again became international economic powerhouses. With a corresponding revival of Islamic nationalism and a new visibility, the West began to recognize the importance of Islamic art and culture, both past and present. Even during the sustained economic downturn in the region that had lasted for centuries, many Islamic groups had maintained their traditions in the arts. Today, Islam is the fastest-growing monotheistic religion in the world, with over a billion followers, and Muslims are building more new places of worship than the members of any other faith. The ways in which new mosques mix ideas from the past with modern ones reflect the emerging roles of mosques in contemporary society as they serve their communities and act as symbols of Muslim identity within and outside Muslim countries. Increasingly, Islamic art and culture are becoming part of the international global community of the twenty-first century, and in the last chapter of this book, we will see how two skyscrapers in Muslim Dubai have attracted the attention of that community.

GLOSSARY

ANICONIC "Without images." A tradition in the arts that limits the use of imagery, especially of the human figure in religious contexts.

ARABESQUE Literally, "having an Arab quality." Highly complex decorative forms often based on foliate forms. The term is also used for straight-lined, geometric forms, also known as INTERLACES. These eye-dazzlers obey rules of logic, but in their complexity take on astonishing, near-magical qualities. This dual character reflects the Islamic belief that earthly forms have spiritual, otherworldly counterparts. Also used in reference to highly decorative musical forms in the West.

CALIPH (Arabic, *khalifa*, "deputy," "commander," or "successor" of Mohammed). Supreme ruler of the Islamic world.

CALLIGRAPHY From the Greek *kallos*, "beauty," and *graphos*, "writing"—hence literally, "beautiful handwriting." The most sacred art form in Islam because many early written documents record portions of the QUR'AN.

CARAVANSERAI From the Persian *karvan*, "caravan," and *saray*, "house" or "lodging." Courtyard hotels for caravans in which the sleeping quarters were often directly over the stables and storage rooms.

EMIRATE (Arabic, *amir*). An emirate is a Muslim political territory ruled by an emir, a title given to a wide range of princes and military officers.

GLAZE As an artists' material, liquid containing silica and metal oxides applied to a clay surface. When heated or fired to very high temperatures in an oven called a kiln, the glazes become vitreous or glasslike and give the clay an attractive, colorful, and durable surface.

HAKIM Arabic, "wise man." A highly learned and skilled man in the Islamic world. A possible prototype for the concept of the Renaissance Man in Europe.

HORSESHOE ARCH A type of arch that is curved more than 180 degrees and resembles a horseshoe.

HYPOSTYLE MOSQUE Greek *hupostulos*, "resting on pillars." An early type of MOSQUE in which the porch roofs rested on colonnades, often of palm trees.

ICONOCLASM Literally, "image-breaking." A fear of and/or prohibition against the use of images in art. Often the representation of spiritual beings in human form.

ILLUMINATE To "enlighten" or "shed light." Often used in place of the word "illustrate" in discussions of medieval European and Islamic art to emphasize the way in which pictures are used to augment and increase the information in a corresponding text.

IMAM An Islamic man of authority, often the leader of worship in a mosque and Muslim community. In SHI'ITE belief, twelve men (seventh to ninth centuries CE) who were free from sin and chosen by Allah to be perfect examples for the faithful.

INTERLACES See ARABESQUES.

IWAN High-vaulted halls that are open at one end and used as covered entryways to MOSQUES and other Muslim buildings.

KHAN "Ruler" in the Turkic and Mongolian languages of Central Asia.

KUFIC An early form of Arabic script named after the town of Kufa in Iraq. It is characterized by large letters with thick, rounded curves and long horizontal stems that could be easily seen by two or more readers at the same time.

MADRASA Schools of SUNNI religious law attached to MOSQUES that appeared in the eleventh century to counteract the teachings of the SHI'ITES.

MIHRAB Arabic, *mahgrib*. A niche or recess in the center of the *qibla* wall in a MOSQUE.

MINARET From the Arabic *manara*, "lighthouse." Towers near or attached to MOSQUES from which announcers, known as *muezzins*, call the faithful to prayer.

MINBAR In a MOSQUE, a narrow staircase with a canopy at the top resembling a pulpit in a Christian church. The prototype of the *minbar* is the stepped stool the Prophet used when addressing congregations in his house-mosque.

MOSAICS A two-dimensional art form in which artists work with small colored stones or pieces of colored cut glass known as *TESSERAE*. Mosaics may be applied to floors, walls, or portable items and are valued for their durability and the reflective qualities of the glass.

MOSQUE In Arabic, *masjid*, "place of prostration in prayer." Early mosques were all-purpose community centers whose functions included worship. Around the eleventh century, they became religious centers like the Christian churches of the day. A *masjid-i-jami* (Congregational or Friday mosque) is a large mosque where an entire congregation will assemble for worship and to hear a sermon on Fridays. Worshipers face and direct their prayers toward the *qibla* wall facing Mecca and the Ka'ba. The *mihrab*, a niche or recess in the center of the *qibla*, further emphasizes that directional symbolism. Muslim leaders deliver messages from the *minbar*, a narrow staircase with a canopy at the top resembling a pulpit in a Christian church. Many of the earliest mosques were HYPOSTYLE buildings (from the Greek *hupostulos*, "resting on pillars") and had large open spaces for worshipers.

MUQARNAS From a Greek word for "scales." Tiers of niche-shaped forms applied to vaults and other parts of ceilings. *Muqarnas* may appear to lighten and dematerialize the overhead structures, but they actually strengthen them.

ONE THOUSAND AND ONE NIGHTS Also known as *The Arabian Nights*. The best-known Arabic literary work in the West, begun about the ninth century. A constantly evolving collection of tales drawn from Arabic, Persian, Indian, Egyptian, and Mesopotamian folklore. The most famous tales about Aladdin, Ali Baba, and Sinbad the Sailor are late additions.

QIBLA Arabic, "direction." The *qibla* wall in a MOSQUE faces Mecca, the direction in which prayers are oriented.

QUR'AN Arabic, "the revelation" or "recitation"; also written Koran. In Muslim thought, the unadulterated, eternal, and unchangeable word of God; the final revelation

of God to humankind, which includes the "Five Pillars" that form the basis of Muslim belief. The fact that copying the Qur'an is a holy act helped make CALLIGRAPHY a major Islamic art form.

RIB VAULTING Vaults that are constructed around rib supports, which make those vaults lighter in weight than barrel vaults. Visually, ribs provide lines that create rhythmic accents and decorative patterns.

SAZ A decorative style heavily influenced by Chinese art of the Ming and Yuan periods. Probably named for the reed (*saz*) pens used by sixteenth-century designers in the Ottoman workshops at Nicea (present-day Iznik).

SHI'ITE Shi'ite Muslims—also known as Shii or Shias ("partisans")—believe that Allah wanted the CALIPHS to come from the Prophet's family through the line of Muhammad's cousin and son-in-law, Ali ibn Abu Talib. See also SUNNI.

SUFISM Islamic movement dating back to the thirteenth century and the writings of a Persian mystic, Jalal ad-Din Muhammad Rumi, that emphasizes the dual material-spiritual nature of all things.

SUNNI The majority of Muslims are Sunni. They support a line of CALIPHS originating in the Umayyad dynasty. Their dispute with the SHI'ITES over this succession developed into a schism within Islam that exists to this day.

TESSERAE Small squares of colored glass used to make MOSAICS.

VOUSSOIRS Wedge-shaped stones used in arches. When used in alternating light and dark colors, they add a decorative quality to arches.

WARP AND WEFT The two sets of threads running perpendicular to one another in a loom. From the weaver's perspective, the weft threads run from the left to right and are woven into the warp, the threads that run to and from the weaver.

ZARIF Arabic, "dandy," "dilettante," or "connoisseur." Well-educated Persian courtiers whose interests included the arts and aesthetics.

QUESTIONS

1. How have Islamic laws and customs shaped artistic traditions over the ages?

2. Outline the development of mosque design since the beginnings of Islam. How are contemporary architects responding to the challenge of creating new religious buildings?

3. What impact did Islamic scholarship in the Middle Ages have on the later development of Western thought?

4. The Muslims applied their many "decorative" forms or motifs to a wide variety of objects: mosaics, tiles, stonework, woodcarvings, glass, metalwork, paintings, textiles, and other materials. How do these so-called "decorative" arts differ in form and expression from the contemporary decorative arts in the modern Western world?

5. In Sufi thought, almost everything has a worldly *and* a spiritual level of meaning. How is that duality manifested elsewhere in the visual arts of Islam?

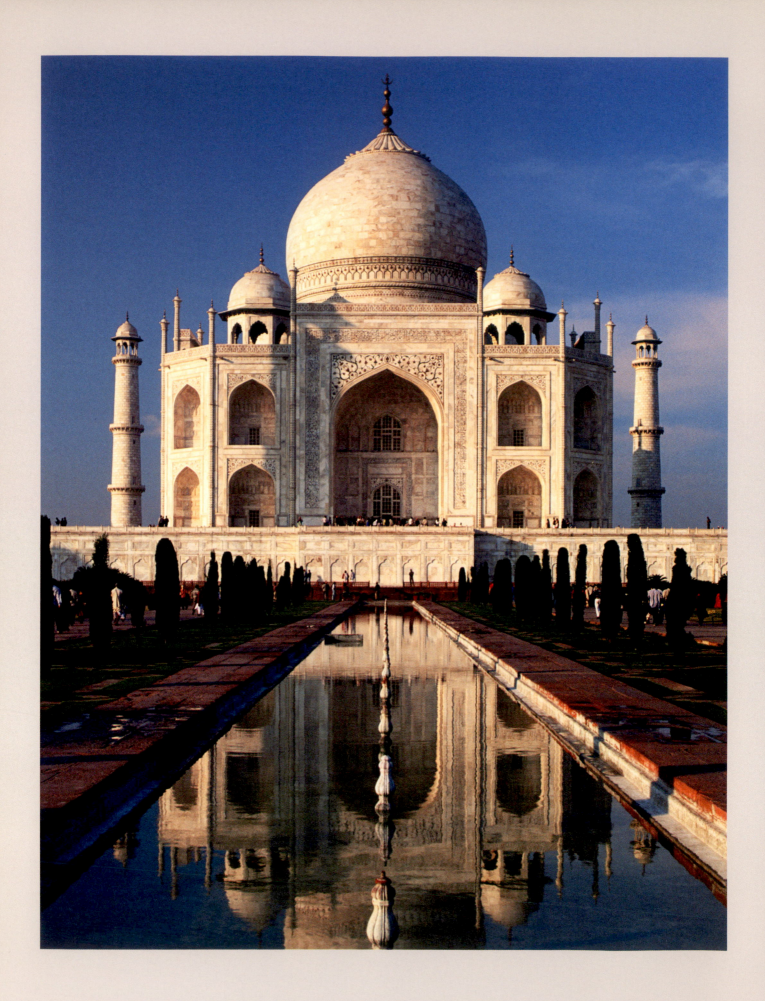

3 | India and Southeast Asia

Equator

Introduction	**60**
The Indus Valley	**62**
Buddhist Art	**64**
Hindu Art	**79**
Jain Art and Architecture	**87**
Islamic India	**89**
Colonial India	**96**
Modern India	**99**
Summary	**101**

India and Southeast Asia

The Indian subcontinent is a large, diamond-shaped land bordered by the Indus River to the northwest, the Ganges River and snow-capped Himalayas to the northeast, the Arabian Sea to the west, and the Bay of Bengal to the east. Although until modern times it was a collection of regional kingdoms rather than a single unified country, it produced many common forms of art, religion, and culture. Types of Indian art spread through Pakistan, Nepal, and Sri Lanka (Ceylon), and beyond the subcontinent to northwest Afghanistan, Tibet, Myanmar (Burma), Thailand, Cambodia, Vietnam, Malaysia, and portions of Indonesia.

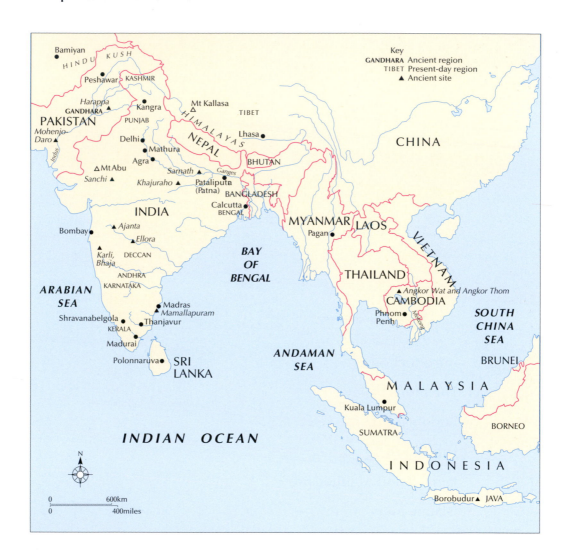

INTRODUCTION

The great religions of India—**Brahmanism**, **Hinduism**, **Buddhism**, and **Jainism**—have common roots in the literary and philosophical writings of India in the first millennium BCE. These works are in **Sanskrit**, an ancient Indo-Aryan language that occupies a position in India similar to that of Greek and Latin in the West. Some of the ideas contained in these writings remain important to the religions and their arts to this day. For example, Hindus believe that the material world around them, **maya**, is an illusion. Only the **brahman**, the all-inclusive, universal, and eternal spiritual reality that extends to all temporal and divine

beings, is real and everlasting, and the faithful should strive to ascend to it. The Jains call the ancients who founded their religion "pathfinders" and try to live in great purity as they follow the pathfinders to the *brahman*. While Buddhists do not aspire to this quality, the **Buddha** achieved *nirvana*, a supreme form of enlightenment that freed him from all earthly concerns and desires. In Sanskrit, the term means "to extinguish" or "blow out." It marks the end of all earthly and afflicted states of mind such as greed, hatred, or obsessive fixations. There are several ways to achieve this. One is through meditation. Members of all the Indian religions use a form of meditation and discipline for the mind and body known as **yoga** (meaning "to yoke"). Through yoga, they attempt to "yoke" themselves to higher spiritual forces. By complete devotion to the gods and through the renunciation of personal and earthly desires and pleasures, Hindus strive toward this eternal state of pure consciousness and bliss, which they call **moksa**.

As part of their meditation, the members of these Indian religions practice **darsana**, the act of visualizing the gods. To help them in this visualization process, religious leaders commissioned artists to produce sculptured and painted images of the gods in easily recognizable visual forms, such as humans or animals. Images were not only aids to meditation but also products of it, as artists discovered their imagery through intense meditation as they attempted to give form to the formless. Buddhists showed the Buddha as a powerful man and the supreme meditator, the perfect image of total inner peace. To convey this ideal of human perfection and spiritual purity, his features are often idealized and very smooth. This image of the human body as a symbol of repose and complete detachment is also manifest in Hindu and Jain art. It is part of a distinctive Indian sense of beauty in which sensuous figures, rich ornamentation, pronounced textures, and intense colors express a delight in the world as a gift of the gods—a world filled with the spiritual energy of the gods themselves.

The great Indian religions provided permanent homes for their religious images in shrines and temples, architectural replicas or microcosms of the universe the gods had created. This enabled worshipers to make symbolic journeys through the universe as they worshiped and meditated in the presence of the gods who had created it. These symbolic passages replicated the ones the worshipers wanted to make as they rose above the material world and ascended to the transcendental realm.

This conception of the place of worship as a microcosm of the universe shaped the design of Indian temples and shrines and the placement of art in those spaces. Hindus envision their temples as cosmic mountains, with a small inner chamber or sacred cave called the "womb chamber" at the heart of those

TIME CHART

Indus Valley Civilization (c. 2700–1200 BCE)

The Vedic Period (1500–322 BCE)
> Aryan invasions (c. 1500–1000 BCE)
> *Upanisads* developed (800–600 BCE)
> Mahavira, founder of Jainism (599–527 BCE)
> The historical Buddha (c. 563–483 BCE)
> Alexander the Great campaigns in Gandhara (327–326 BCE)

Maurya Period (322–185 BCE)
> Emperor Ashoka (269–232 BCE)
> Shunga Period (185–72 BCE)

Andhra Period (70 BCE–320 CE)

Kushan Period (30–320 CE)

Gupta Period: North India (320–500 CE)

Pallava Period: South India (500–750 CE)

Chola Kingdom (846–1173)

Mughal Empire: North India (1526–1858)

British Rule (1858–1947)

mountains. This part of the temple, accented by the tall peak-like tower above it, might contain symbolic images of the male and female principles that represent the unity of the cosmos.

Buddhist temple complexes are often designed with some tall temples in the center, surrounded by walls and smaller temples to replicate the Buddhist image of the universe, with the sacred Mount Meru at the center, ringed by lesser mountains, oceans with island continents, and a huge wall. Another distinctive type of Buddhist place of worship, the **stupa**, is a large, hill-like shrine that symbolizes the World Mountain and dome of heaven. The first stupas included relics of the Buddha. Some of the larger stupas are circled by walkways, relief sculptures, fences, and gates. Walking around the stupa and relics of the Buddha while looking at images of the Buddha's path to spiritual enlightenment, the faithful can join him in his passage to *nirvana*. Ascending

from one level to the next while walking around some of the largest stupas, pilgrims also make a symbolic ascent from the mundane world to the elevated realm of the spirits.

In India, high-ranking priests known as brahmins speculated on the nature of Indian art and developed the concept of **rasa**, which lies at the heart of traditional Indian aesthetics. *Rasa* is the emotional reaction of pleasure and satisfaction that the visual arts, music, poetry, and drama can give to the senses and spirit of the viewer. Reacting to art, the viewer becomes one with the *rasa*-inspiring object and all creation. For art to do this, however, it must go beyond mere description: It must be capable of conveying universal ideas that appeal to the viewer's heart and instincts. In Indian thought, the cumulative experience of the emotions of many past lives within everyone can be activated into spiritual responses by art, leading to the pure bliss and ultimate fulfillment of the inner being. However, the artists did not necessarily belong to the brahmin caste, and it is not entirely clear to what degree they understood and followed the theories of the brahmin aesthetes as they made the art.

Although the names of the architects and artists who created these magnificent monuments have not been preserved, as the individuals entrusted to design and oversee the construction of the holy works of art, they were highly revered in Indian society. Modern spectators continue to marvel at the way they managed to create such moving and revealing expressions of the great Indian religious philosophies that bridge the gap between the seen (unreal) and unseen (but real) worlds. Their works have helped centuries of worshipers to cross the bridge that leads from the illusory nature of this existence to the invisible reality of the spirit.

THE INDUS VALLEY

The earliest Indian civilization, based around the Indus River in present-day Pakistan and reaching into Afghanistan and northwest India, predates the development of Buddhism, Hinduism, and Jainism. It is known as the Indus Valley or Harappan Civilization (after Harappa, one of its major cities). The economy was based on the cultivation of wheat, barley, and peas, and on trade with the Mesopotamians and others to the west. The presence of Indus Valley seals in Mesopotamian cities of known dates helps to place the Indus Valley Civilization at around 2700–1200 BCE, which makes it roughly contemporary with the Old, Middle, and Late Kingdoms in Egypt, the Sumerian, Akkadian, and Old Babylonian periods in Mesopotamia, and the Minoan civilization in the Aegean Sea.

No royal tomb, palace, image of a god, or public artwork that can be precisely identified as to its function has yet been found, but the Indus Valley builders constructed well-planned cities with walled neighborhoods, broad avenues, granaries, and baths. Wooden and kiln-fired brick buildings in the most extensively excavated city, Mohenjo-Daro (City of the Dead), were organized in rectangular blocks around two major roads intersecting at right angles (FIG. 3.1). Houses in the city (which had about 35,000 inhabitants) were up to three stories tall and constructed around central courtyards. A large reservoir or bath with a brick floor sealed with bitumen may have provided water for local residences, some of which had sewer systems. Alternatively, it may have been used for general bathing and ritual purification ceremonies.

In contrast to the cylindrical seals found in Mesopotamia, most of the roughly two thousand known Indus Valley seals are rectangular stamps carved from fine-grained steatite, a soft, greenish-gray stone. Modern plaster impressions from the ancient seals reveal that the ancient miniaturists were highly skilled at capturing the textures of animal hides and could render anatomical details with such accuracy that they could suggest the underlying skeletal structures of the animals (FIG. 3.2, left). A bull with muscular flanks, bulging shoulders, and thin bony legs stands on a ground line

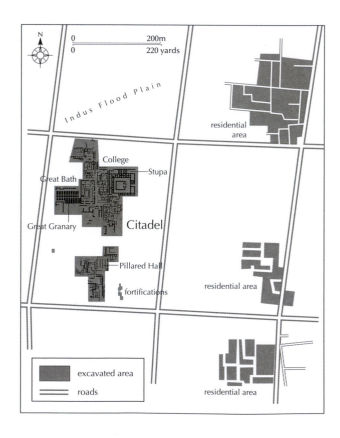

3.1 Plan of Mohenjo-Daro, Pakistan, showing residential areas and citadel. c. 2300 BCE and later

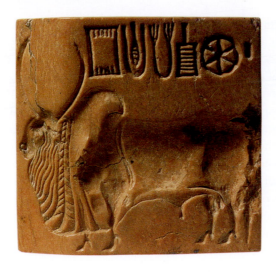
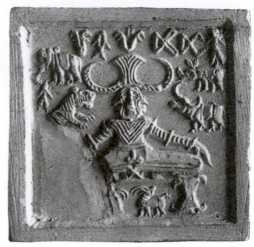

3.2 Seal and seal impression from the Indus Valley Civilization: (left) seal, horned bull with hieroglyphics; (right) seal impression, *yogi*, "holy man," or *yogini*, "holy woman," with hieroglyphs. Pakistan, Mohenjo-Daro. 3rd millennium BCE. Width 1³⁄₈″ (3.2 cm). National Museum, Karachi; National Museum, New Delhi, respectively

below characters in the Indus Valley script. In later Indian art, the bull is associated with the Hindu god Shiva and male potency, themes that may have been important in the Indus Valley culture as well. By emphasizing the striations around the bull's neck and his tall crescent-shaped horns, which blend with the shapes of the script, the artist has created a unified composition of linear and modeled forms. The calmness and fluidity with which the anatomy of the bull are treated, characteristic of the Indus Valley imagery in general, stand in marked contrast to the hardness of the figures from this period in Mesopotamian carvings.

Figures seated in yoga positions—that of a *yogi* (holy man) or *yogini* (holy woman)—and many other subjects on the Indus Valley seals (FIG. 3.2, right) reappear later in Buddhist and Hindu art. The practice of yoga, which includes *prana* (breath control), is pursued by members of many religions in India. Its purpose is to "yoke" oneself to universal, divine forces. This continuity of thought, through time and among the Indian religions, unites elements of the Indus Valley Civilization with later epochs of Indian history. However, the script—with about four hundred known signs—remains undeciphered, making it difficult for scholars to interpret the symbolism of the bulls and other recurring themes on the seals and to reconstruct the details of early Indian religious beliefs. The most that can be said is that this was a highly structured, organized urban culture with an agricultural economy, which probably worshiped gods and goddesses of fertility and may have practiced elements of asceticism and yogic meditation.

The same qualities of smoothness, repose, and fluidity in the arts are even more evident when they appear on a somewhat larger scale in the carving of a figure from Harappa that appears to be dancing (FIG. 3.3). The figure's legs are broken, and its head may have been fastened by dowels inserted in the saucer-shaped depression in the neck. Even

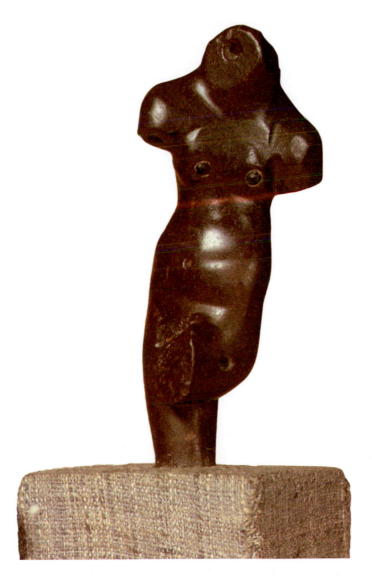

3.3 *Dancing Figure*. Pakistan, Harappa. c. 2300–1750 BCE. Limestone, height 3⅞″ (9.8 cm). National Museum of India, New Delhi

in fragmentary condition, the astonishing organic qualities of the form are fully evident and surpass those of any known Mesopotamian figurines of this period. In marked contrast to the tense, rock-hard muscularity of the Egyptian rulers and gods from this time, the dancer from Harappa is soft and relaxed. Unlike the Grecian ideal of the athletic male who was capable of moving with strength and grace, the muscles of this figure are in repose, as they would be during meditation. In a manner that will remain part of the Indian tradition, the body expresses a kind of control and inner strength that is fundamental to all forms of Indian religion. The realism that gives this figure such a strong sense of immediacy and individuality may be derived from techniques used in modeling clay.

The artist who carved this torso seems to be interested not only in how the body looks, but also in how the relaxed muscle groups interact with the skeleton supporting them. The turning, twisting figure, whose left knee was raised, demonstrates an understanding of how the human spine flexes with weight shifts—an idea that will not appear in Western sculpture until the early fifth century BCE. Nor will this remarkable sense of the body in motion be seen again in the known stone carvings of India until the emergence of Buddhist art in the late centuries BCE. (It should by noted that the close association of the figure's very complex *tribhanga* ("three bends") pose with later periods of Indian art has made some authorities question the dating of this work.)

THE ARYAN MIGRATIONS AND THE VEDIC PERIOD (1500–322 BCE)

During the period from approximately 1500 to 1000 BCE, groups of Aryan people from the northwest emigrated to India. The Aryans spoke Sanskrit, which became the classic literary language of India. It is used today in sacred contexts, and many languages still spoken in this region derive from it. In addition to their language, the Aryans appear to have brought a strong set of beliefs and traditions to India, including the **Vedas** (Sanskrit for "knowledge"), ancient poetic hymns and philosophical writings directed to the gods that give this period its name.

The Aryans practiced a hierarchical social order, which placed warriors at the apex and provided the basis for the religiously sanctioned social class (or caste) system that has persisted throughout Indian history. Many of the deities described in the Vedas and worshiped by the Aryans are representations of natural forces such as Indra (thunder), Varuna (the sky), and Surya (the sun). As no images survive, it is believed that the Aryans were aniconic—that is, they did not employ or permit representations of objects in their art. It is possible, however, that they made images out

of perishable materials such as woods, and that these have therefore not survived.

New philosophical texts, the Brahmanas and **Upanisads** (c. 800–600 BCE), reflecting Aryan and non-Aryan ideas, expanded upon the cryptic Vedic hymns and explained the relationship of the individual to the universe. They outlined the principles of the brahman (universal soul) and the system of reincarnation known as **samsara** (Sanskrit for "continuous flow"), the cycle in which the **atman** (interior self or soul) within all sentient beings returns again and again to earth in human or animal form. It is only by understanding the true nature of the *brahman* that the *atman* can be released from this cycle of rebirths. The Upanisads also explain the principle of **dharma** (natural law, what one "ought" to do according to one's station in life), and **karma** (a person's actions and the effect they have on the progress of his or her *atman* in future bodies). The Buddhist, Hindu, and Jain adaptations of these ideas are explained in the boxes below. (See *Religion:* Buddhism, page 66; *Religion:* The Dalai Lama, page 75; *Religion:* Yoga Then—and Now, page 79; *Religion:* Hinduism, page 81; and *Religion:* Jainism, page 88.)

BUDDHIST ART

THE MAURYA PERIOD (322–185 BCE)

In 327–326 BCE, the Greek armies of Alexander the Great marched through the Persian-held region of Gandhara in Pakistan and parts of Afghanistan and Kashmir, and established Hellenistic kingdoms there that introduced Greek art and culture to this part of Asia. After the death of Alexander in 323 BCE, the Greeks were driven back to Gandhara by Chandragupta Maurya, who founded the Maurya dynasty (322–185 BCE). Chandragupta's grandson Ashoka (ruled c. 273–232 BCE) consolidated Maurya rule over northern and central India though a series of bloody campaigns. He converted to Buddhism, and both Greek and Persian influences can be seen in the works he commissioned. A lost text by Megasthenes, a Greek scribe and ambassador to India, said that Ashoka's palace at Pataliputra (modern Patna) on the Ganges River was based on the ancient Achaemenid palace at Persepolis in Iran, and that the city was protected by a high wall with 570 towers, sixty-four gates, and a deep moat over 600 feet (183 m) wide. Unfortunately, like most other ancient Asian capitals, nothing remains of Pataliputra today.

Ashoka and his predecessors also erected a series of imperial pillars throughout their empire bearing edicts and Buddhist teachings. Such tapered sandstone pillars had long been used in India to display laws, standards, and other symbols of rulers. In Ashoka's time, a famous, highly

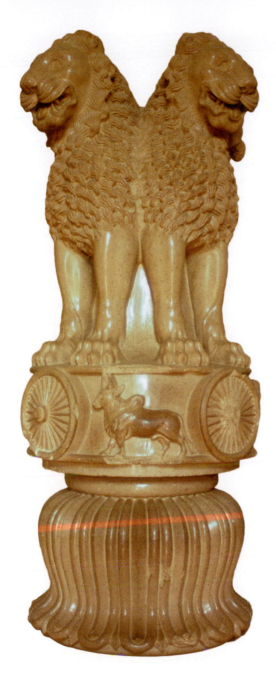

3.4 Lion capital of a column erected by Emperor Ashoka (ruled 273–232 BCE). India, Pataliputra. Polished sandstone, height 7′ (2.13 m). Archaeological Museum, Sarnath

back), as they are on the capitals of Persian columns. The crispness and ornamental treatment of the lions' neatly patterned curls, their sinewy legs, and the lustrous finish reflect the styles of Achaemenid Persian sculpture in Persepolis and Susa.

The lions symbolize the Buddha as Shakyamuni ("Sage of the Shakya Clan") and the world quarters or directions radiating out from the column over which the Mauryan and Buddhist laws extended. That law and Buddhist wisdom were represented by a large wheel known as the *dharmachakra* mounted on the backs of the lions. It also represented the Wheel of Life and was a solar symbol because, like the sun, it brought light to the world. Turning it, one controlled the sun, an important symbol of the universal power of the Buddha and the Maurya rulers. As the Buddha taught the law, he set the wheel in motion and became the *chakravartin* (Turner of the Wheel or World Ruler). At this early date in the history of Buddhist art, the Buddha is not yet shown in human form; he appears here only in symbolic form, as the Wheel of Life. Other symbols or icons of the Buddha appearing elsewhere in the art of this period include the bodhi tree (representing his enlightenment), a riderless horse, and footprints.

Wheels also appear on the base below the lions' feet, along with animals (bull, elephant, horse, and lion) that may symbolize the four great rivers of the world. The base is an inverted, bell-shaped lotus, an important symbol in later Buddhist art and architectural iconography. The lotus flower, which is clean and pure even though it grows out of muddy waters, symbolizes the purity of the divine when it is manifest in the material world.

THE SHUNGA PERIOD (185–72 BCE) AND EARLY ANDHRA PERIOD (70 BCE– FIRST CENTURY CE)

After the fall of the Maurya dynasty, the Shunga dynasty (185–72 BCE) ruled in the north central region of India and the Satavahana family governed the Andhra region (central and southern India). Although many of the leaders were not themselves Buddhist, these periods were important ones for Buddhist art and architecture, which developed new monumental forms.

The relatively small burial or reliquary mounds erected in sacred places for wealthy individuals and rulers in the Maurya period became lavish and imposing centers of Buddhist worship known as stupas. After the Buddha was cremated, his remains were allegedly distributed to eight localities in India and enshrined in stupas, where they became focal points of Buddhist devotional practice. Ashoka is said to

polished memorial stone stood in the Deer Park at Sarnath, where the Buddha had preached his first sermon. The well-preserved capital of one of Ashoka's imperial columns erected at Sarnath has been adopted as the symbol of the modern Republic of India (FIG. 3.4).

Ashoka may have imported sculptors from Persia and the nearby Hellenistic kingdom of Bactria in northern Afghanistan and Uzbekistan to work on this and other projects. The front quarters of four lions are addorsed (or back to

BUDDHISM

The Buddhist religion developed out of the teachings of an early Hindu called Siddhartha Gautama (563–483 BCE), who lived in the foothills of Nepal, near the present border with India. He was the son of Queen Maya and King Shudodhana and would later be called the Buddha ("the Enlightened or Awakened One" or "one who has gained wisdom"). He is also called Shakyamuni (sage of the Shakya clan). In response to his deep concern for the sufferings of all living beings, Siddhartha left his palace and family to become a wandering ascetic. Through meditation, he achieved *nirvana*, a release from all earthly desires, and began teaching a new code known as the Eightfold Path (right views, right aspirations, right speech, right conduct, right livelihood, right effort, right mindfulness, and right contemplation). This path would lead his followers away from the suffering in life caused by ignorance. His teachings were a reaction against much of the older Veda-based Brahmanic law,

ritualism, hierarchical social order, caste system, and hereditary class of priests. They placed a new emphasis on mental discipline, spiritual self-control, moral living, and salvation for the masses, making religion accessible to everyone.

The Buddha's teachings were collected in a series of texts known as *sutras*. The early Theravada (School of the Elders) or Hinayana (Lesser Vehicle) type of Buddhism has long been associated with monastic communities. The Mahayana (Greater Vehicle) type of Buddhism, which appeared around 1 CE, appealed to the masses. It sees the Buddha as divine, wants everyone to achieve buddhahood (a higher state than *nirvana*), and recognizes many Buddhas, from the past, present, and future. Mahayana Buddhism also stresses the importance of the *bodhisattvas*, those who have *bodhi* (wisdom or enlightenment), also known as buddhas-in-the-making. *Bodhisattvas* are compassionate and accessible saintlike beings who have reached the threshold

of *nirvana* but have delayed their own enlightenment so they can reach back to help others. The very important and popular *bodhisattva* Avalokitesvara ("the being capable of enlightened insight"), known as Guanyin in China and Kannon in Japan, was often illustrated in the arts. While the Buddha usually wears a monkish robe, the *sanghati*, the *bodhisattvas* wear princely garb, as the Buddha had done in his youthful days.

In addition to the historical Shakyamuni Buddha, Mahayana Buddhism also recognizes numerous buddhas in the past, present, and future. These include Maitreya (a *bodhisattva* who will become the Buddha of the future) and the Amitabha Buddha of infinite light, space, and time who dwells in a paradise known as the Western Pure Land. Buddhists do not believe that the spirits of the Buddha and the *bodhisattvas* dwell within works of art, but visual images are important aids for meditators and worshipers.

have opened these stupas and further divided and distributed the remains.

By the Shunga period, stupas had become large, hemispheric mounds with masts symbolizing the axis of the World Mountain. A stupa built by Ashoka in the village of Sanchi in central India was enlarged in the first century BCE to become a massive, hemispheric monument (FIG. 3.5). Known as the Mahastupa (Great Stupa), the dome-shaped monument symbolizing the arc of the sky may contain some of the remains of the Buddha that Ashoka redistributed during his reign. The stone *vedika* (railing or fence) around the shoulder of the mound, which separates the sacred and profane worlds and stands 11 feet (3.35 m) high, is carved in

imitation of slotted wooden rail fences; added in the first century BCE, it may be a stone imitation of the wooden fence enclosing Ashoka's original stupa. *Toranas* (gates) in the outer *vedika* around the stupa point to the cardinal points of the compass. A double stairway leads to an elevated terrace, a pathway around the shoulder of the drum enclosed by the upper *vedika*. The brick and rubble mass of the dome, with a stone facing from the Shunga period, may originally have been covered with stucco and whitewashed.

A *yasti* (mast or axis of the World Mountain), with a three-tiered *chattra* (umbrella) symbolizing the Buddha, law, and the community of monks, rises within the *harmika* (square fence) crowning the mound. This is the realm of the

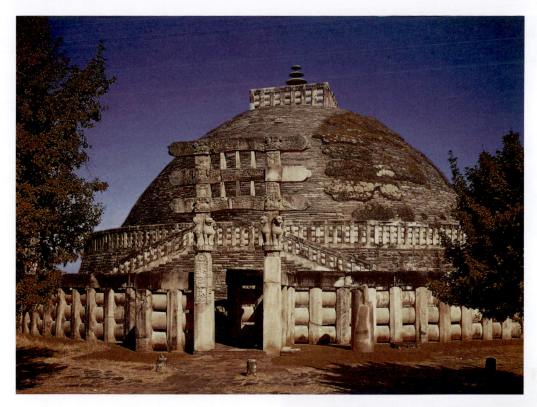

3.5 (ABOVE) The Great Stupa, Sanchi, India. Maurya and early Andhra periods, 3rd century BCE–3rd century CE. Height 65' (19.8 m)

3.6 (RIGHT) Northern *torana* ("gateway"), Great Stupa, Sanchi. Completed 1st century BCE

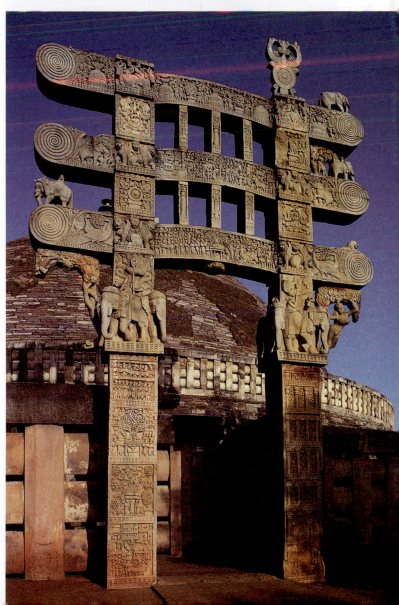

gods at the summit of the symbolic cosmic mountain. As the axis of the universe, the stupa unites the heavenly and earthly realms of existence. Moving in a clockwise direction around the stupa, retracing the path of the sun across the sky, pilgrims encircle the axis of the symbolic World Mountain and **mandala** (literally, a circle or an arc), a diagram of the Buddhist cosmos. This idea that a place of worship where the faithful commune with otherworldly spiritual forces should be a mandala, a symbolic cosmos linking this world with the otherworld, will remain an important part of Buddhist, Hindu, and Jain thought in India for centuries to come.

The ornate *toranas*, 35 feet (10.7 m) tall, which may have been preceded by simpler stone or wooden prototypes, were added in the Andhra period (FIG. 3.6). The tall, square gate posts are crowned by addorsed elephant capitals and other animals and three superimposed, curved architraves terminating in tightly bound volutes, which may reflect the shapes of their wooden prototypes. These architraves illustrate detailed *jatakas*, stories about the lives of the Buddha, who is still not shown in human form in this period;

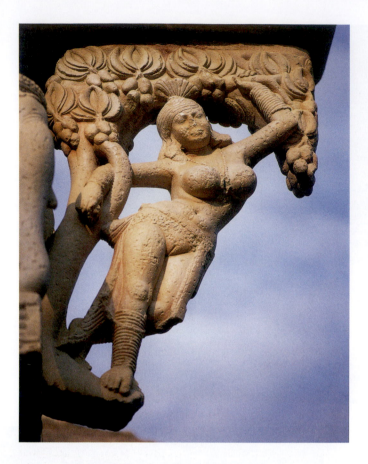

3.7 *Yakshi* bracket figure from the east gate of the Great Stupa, Sanchi. Stone, height c. 60" (1.52 m). Early Andhra period, 1st century BCE

his presence is indicated by symbols such as the lotus, the wheel, footsteps, or an empty throne.

Bracket figures outside the capitals below the architraves on this *torana* represent tree goddesses known as **yakshis** (male gods are called *yakshas*) (FIG. 3.7). They are ancient, pre-Buddhist spirits associated with the generative or productive forces of nature, water, and the strength of the inner breath (*prana*). They are also mythical beings in Hindu and Jain thought. Here, the *yakshi*, wearing a diaphanous garment evident only in its hems, appears to be nude. Her prominent breasts and sexual parts personify the sap that gives life to the flowers and fruit of the tree. She assumes a *tribhanga* ("three bends") pose similar to that of the miniature stone figure from Harappa (see FIG. 3.3). The voluptuous figures grasp trees and hang there like fruit, literally dancing in the air before the visitors as they approach the grand solemnity of the massive stupa in the background.

Smaller stupas were incorporated in the **chaitya** halls, Buddhist assembly halls and places of worship. The ancient assembly halls that were made of wood and other perishable materials have long since vanished, but many of the rock-cut *chaityas* carved from the second century BCE onward in the western Indian region known as the Deccan remain well preserved to this day. Technically, such *chaityas* are sculptural images of architectural façades and interiors. As rock-cut images of the wooden *chaityas*, the elaborate façades with horseshoe-shaped entryways, interior columns, and raftered ceilings are purely decorative and do not perform the architectural functions of the forms they imitate. The rock-cut sanctuaries also underline the importance of caves as places of worship and meditation in earlier Indian religions. Along with the *chaityas*, the builders excavated large numbers of **viharas** (monks' cells) to house the growing numbers of monks in the Buddhist communities. With the Hindu and Jain rock-cut places of worship, these monuments (roughly twelve hundred in number) preserve a wealth of information about the art and architecture of this early period of Indian art.

The manner in which the traditional wood *chaitya* hall was translated into stone can best be seen by looking at the façade of the very early rock-cut temple at Bhaja from the first century BCE (FIG. 3.8). The stonecarvers began by constructing a long tunnel at the apex of the vault and carved downward to floor level so that a minimum of scaffolding was needed. The monumental arch over the entryway is carved in imitation of contemporary wooden *chaitya* hall façades. Around the entryway are sculpted images of smaller halls with arched roofs and multistory, balconied pavilions with railings and windows (some showing people within), which provide a panoramic view of an ancient Buddhist community. The wooden doors and wall that once protected the entryway are missing, so the polygonal, inward-tilted columns (reflecting construction techniques in wood) and portions of the stupa inside the hall are now visible through the open vault.

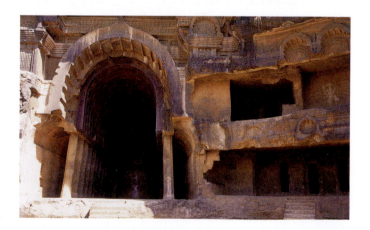

3.8 Exterior of *chaitya* hall at Bhaja, India. Late Shunga period, c. 1st century BCE

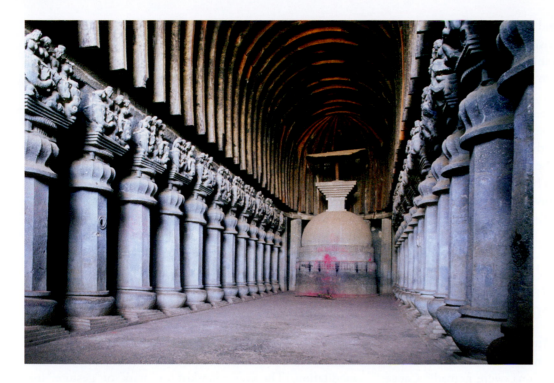

3.9 (LEFT) Interior of the *chaitya* hall at Karli, India. Early 2nd century CE

3.10 (BELOW LEFT) Plan of the *chaitya* hall at Karli, with numbers keyed to major features in the drawing: (a) vestibule; (b) nave; (c) side aisles; (d) stupa

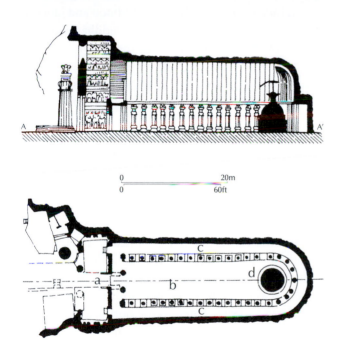

The interior decorations of this architectural type are more fully developed in the nave of the *chaitya* hall at nearby Karli, dating from the second century CE (FIGS. 3.9, 3.10). It is a large rock-cut space, 124 feet (37.8 m) long, 46 feet (13.26 m) wide, and 45 feet (13.7 m) high. Thirty-seven closely set octagonal columns run the length of the hall and behind the stupa at the back so that worshipers can walk around it. While the seven columns in the curve around the stupa have no decorative capitals, the thirty along the

sides of the hall rising out of globular, pot-shaped bases terminate in ornate ones. These capitals are composed of inverted and fluted bell-shaped lotus blossoms (a motif that can be traced back to the imperial columns of Ashoka) supporting stepped platforms and couples symbolizing fertility and harmony, riding on kneeling elephants and horses. The sculptures on these closely spaced capitals, which give the impression of forming a continuous high relief running along the nave, may represent the nobility coming to pay homage to the Buddha and his stupa at the far end of the hall. The importance of the rites of worship at the stupa is emphasized by the relief-carved fences around it that mark the circular paths followed by worshipers, and by the tall, prominent *chattra* on the *yasti* that symbolizes the axis of the World Mountain around which everything in the Buddhist world is centered.

A shaft of light streaming in the doorway through the original façade of this *chaitya* would have highlighted the rows of columns, sculptured capitals, and the bold shape of the stupa at the far end. Even without that façade, the spotlighting effect inside is dramatic, and the high barrel vaults amplify the faintest sounds of footsteps and voices as they echo down the nave. In the dim light of the hall, which may have been augmented by lamps and torches in ancient times, the massive columns and ribs crossing the vault over the stupa are so dramatic and convincingly functional that it is easy to forget that, in truth, the hall is a bubble inside a massive cliff. The hollowed-out architectural spaces here, and in other Indian rock-cut temples, confound any sense

of material reality, of mass and space, and of what is "real" and "unreal." They give the visitor the impression of being inside a masonry or wooden building rather than one carved out of a cliff. What appear to be functional architectural forms are, in fact, sculptures. As highly realistic illusions of architecture, the rock-cut temples are a reminder of an important axiom in Indian thought—the world, that which is visible, is an illusion, while that which is invisible is real. As expressions of this idea, the mysterious cavelike spaces of a rock-cut *chaitya* can help bridge this gap between the seen and unseen worlds and give a sense of presence to the formless spiritual reality of *brahman*.

THE KUSHAN PERIOD (30–320 CE) AND LATER ANDHRA PERIOD (FIRST CENTURY–320 CE)

The Kushans, known as the Yueh-chin when they lived in the region of Central Asia that now corresponds to southern Mongolia and northwestern China, were nomadic Caucasians who migrated south to what are now Pakistan, Afghanistan, and northern India. They established an empire that extended from Gandhara into northern India, with capitals at Peshawar in the north and Mathura, near Delhi, in India. Two very important developments in the early Kushan period changed the course of Buddhism and Buddhist art in India and Asia. First, the severe, monkish form of Buddhism that had been prevalent (known as Hinayana or Theravada Buddhism) was augmented by Mahayana Buddhism, in which the Buddha was a god and savior surrounded by a cosmology of compassionate **bodhisattvas** (those who have wisdom, *bodhi*, as their goal). These changes made the religion more accessible and attractive to ordinary people.

Second, by 30 CE, trade along a set of interconnected caravan routes later to be known as the Silk Road, linking China with the Mediterranean world in the West, was at its height. The economic importance of the commerce and wealth generated by this road, which spanned a quarter of the globe, can hardly be overestimated. As the Parthians around the northern portions of present-day Iran began to block the Silk Road, caravans took a detour through the Kushan territories in northern India. This trade brought the Kushans into contact with the culture and art of the Romans, whose expanding empire in the East along the Silk Road nearly touched the Buddhist world.

Under Kanishka (early second century CE), who established an empire that extended from Central Asia to northern India, Indians trained in Roman styles worked in Gandhara, a region previously exposed to the arts of the Persians, Greeks, and Maurya emperors. The result was a hybrid Eastern–Western style that represents the easternmost extension of Roman influence in the arts. The combination of Mahayana Buddhism, in which the Buddha was worshiped, and the latest developments in Roman art, in which the gods, rulers, and other heroic figures were portrayed as regal men and women, helped inspire Kushan artists in Gandhara to create monumental images of a Romano-Indian Buddha. Under these influences, the Buddha was envisioned as a human-turned-divine who had transcended all earthly boundaries of time, space, and gender. He was the supreme meditator who overcame his own ego and earthly desires to become the ideal monk and teacher, the embodiment of wisdom and compassion who could show humankind the way to self-realization.

Some of the earliest examples may have been made by itinerant Roman-trained sculptors who adapted their skills to fit the new subject matter, adding Buddhist symbols and the characteristic Buddha hand gestures or **mudras**, a repertoire of symbolic gestures that convey ideas such as teaching, setting the Wheel of the Law in motion, blessings, and meditation. (The *mudra*, Sanskrit for "mark" or "gesture," like yoga and Indian dance, is also part of Hindu and Jain thinking.) The most celebrated Gandhara Buddhas may be the work of skilled sculptors from this region who fully integrated the Roman styles into their art. They show the Buddha with a Roman nose, cupid-bow lips, and wavy locks of hair—features resembling many Roman portraits of noblemen, emperors, and the gods, especially idealized images of the full-faced Apollo (FIG. 3.11). The Classical Roman patterns of folds in the Buddha's toga have been somewhat simplified into alternating patterns of sharp folds and smaller creases that seem to convey the sense of repose and peace in the Buddha's enlightenment. Conversely, the *ushnisha* (a knot of hair over the head symbolizing superior spiritual knowledge) and the ears elongated from heavy jewelry worn in his youthful princely days are typically Indian.

Ultimately, the Classical style, as filtered through its provincial, Eastern Romanized practitioners, does not seem to have been perfectly suited to the portrayal of the Indian ideals of internal, transcendental bliss, and Gandhara art did little to influence the development of Buddhist art in the rest of the Indian world. Also, the Classical tradition was in decline by the third century CE, and the subsequent history of Buddhist art in India derives almost entirely from local sources.

About the time the Gandhara artists were creating their Romanized versions of the Buddha, Kushan artists in north central India at Mathura were developing a more typically Indian image of the Buddha and his *bodhisattvas*. The sculptors in this area had already carved royal portraits of Kushan leaders in thick robes and heavy Kushan boots, and robust images of *yakshis*. A rigidly frontal image of Kanishka, with

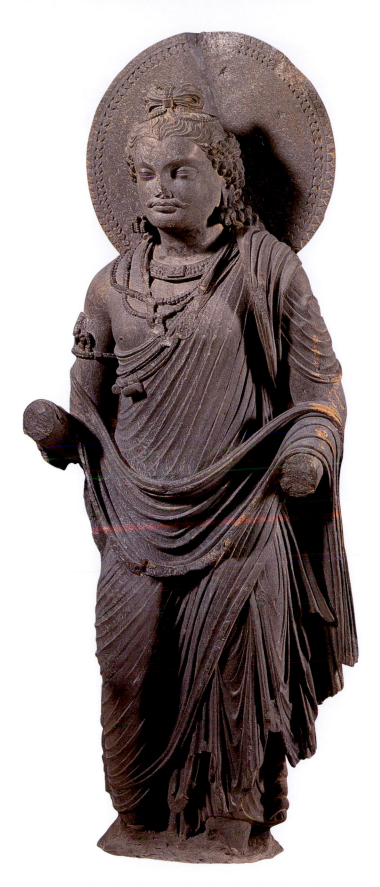

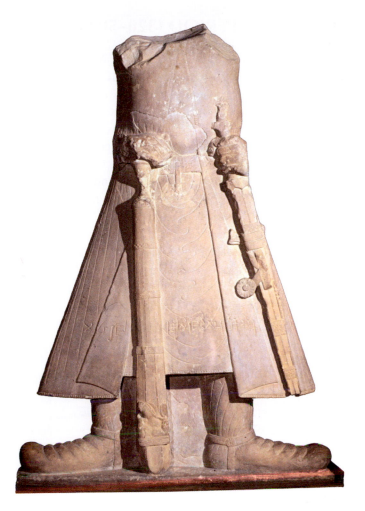

3.12 *Kanishka I*. India, Uttar Pradesh, Mathura. Kushan period, c. 120 CE. Red sandstone, height 5'4" (1.62 m). Museum of Archaeology, Mathura

large feet and hands holding a sword and mace, portrays him in the spirit of the inscription across his mantle, which calls him "The Great King, the King of Kings, His Majesty Kanishka" (FIG. 3.12). From other images of Kanishka, it seems likely that the head on this statue (now missing) would have been massive and bearded. With its strong silhouette, this rather flat, hard-edged figure with simplified forms conveys a great sense of imperial authority. Kanishka's uniform—puffy padded boots and a thick mantle that falls in stiff folds—reflects the ruler's ancient Kushan heritage, that of his warrior-horsemen forefathers who lived and fought for centuries in the cool northern mountain highlands. In this ceremonial outfit, completely unsuited to everyday use in the heat of Mathura, the idol-like image of the mountaineer-warrior-king seems to capture the essence of the conquering hero who had built an empire that incorporated Hellenistic lands and exceeded the dimensions of the earlier holdings of Ashoka.

3.11 *Standing Buddha*. Jamalgarhi region, Gandhara, Pakistan. 2nd–3rd century CE. Gray schist, height 36½" (92.7 cm), width 13" (33.6 cm). The British Museum, London

THE GUPTA PERIOD (320–500 CE)

By the late Kushan period, around 300 CE, Mathura sculpture had lost its early robust character and begun to take on a new delicacy and sensuality. While the Kushan dynasties that supported the Mathura artists declined, their traditions were continued and reached a magnificent climax under the patronage of the Gupta rulers (320–640 CE). The period was named after Chandragupta I (ruled 320–35 CE), who was crowned in Pataliputra, the ancient Mauryan capital. At their peak, under Chandragupta II (ruled 375–415 CE), the Guptas controlled an empire that included northern India and parts of the south during what has been called the "classical" period of Indian art.

The single most famous Gupta image of the Buddha from Sarnath represents him as a spiritualized *yogi* ascetic, seated cross-legged on a lion throne (FIG. 3.13). Although the Buddha may appear to be nude, the hemlines of his sheer muslin garment, known as a *sanghati*, are visible at his neck, wrist, and ankles. In some sculptures from this period, the *sanghati* literally disappears as if it had been soaked in water. The large round **nimbus** or sun orb surrounding the Buddha's head represents the universal spirit of the Buddha. The deer and six disciples turning the Wheel of the Law in the register below refer to the Deer Park at Sarnath, where the Buddha preached his first sermon. Like the orb of the sun behind him, the Wheel of the Buddha's Law brings light to all parts of the earth.

The figure bears the distinguishing marks of the Buddha—the *ushnisha*, *urna* (tuft of hair or mole between the brows) and *mudra* (see FIG. 3.11). The Buddha holds his hands in the *dharmachakra mudra*. This is the hand gesture for teaching in which the Buddha sets the Wheel (*chakra*) of the Law (*dharma*) in motion and counts the principles of his Eightfold Path of Righteousness on his fingers. The texture of the carefully patterned snailshell curls in the Buddha's hair contrasts with the smoothness of his idealized body as it appears through his *sanghati*. The winged lions on the back of the throne symbolize royalty, the Buddha as the lion of the Shakya clan, and the regal roar and authority of his preaching.

The Buddha's idealized features, which fuse human beauty with a sense of spiritual purity, can be explained in

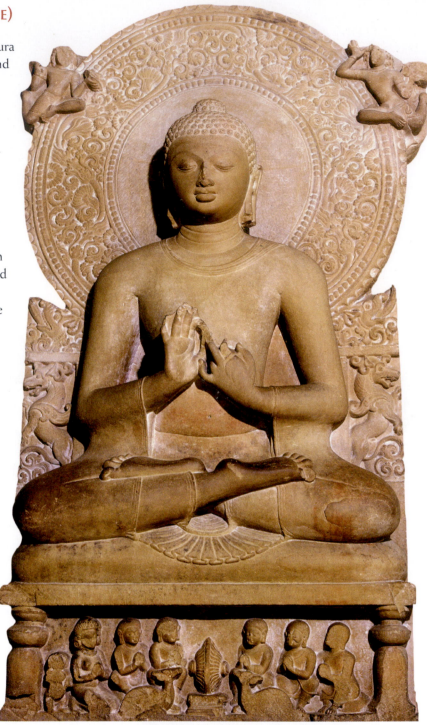

3.13 *Seated Buddha Preaching the First Sermon*. Sarnath, India. 5th century CE. Chunar sandstone, height 5'3" (1.60 m). Archaeological Museum, Sarnath

part by certain metaphors that abound in Buddhist poetry and prose of this period. They equate the hero's brow to the arc of a bow and his eyes to lotus buds or a fish. His idealized features and his serene, downcast eyes reflect his inward focus, away from the transitory world around him, and are emphasized by the concentric circles on the nimbus behind his head. The textures of the repeating patterns of detailed foliate forms in the nimbus and on the back of the throne contrast with the smoothness of the Buddha's body, which, in its serene pose, reflects his state of enlightenment, tranquility, inner spiritual strength, and otherworldliness. In such works as this, the Guptas achieved a delicate balance between detailed and idealized forms that is one of the characteristics of classical Indian art.

The idealism of the Sarnath Buddha is also expressed in the finest surviving paintings from this period, in the rock-cut *chaityas* and *viharas* of Ajanta in the Deccan region of western India. Much of the rock carving (four *chaitya* halls and twenty-five *viharas*) and painting was done during the time of the Vakataka rulers in this area in the late fifth century CE. The temples, sculptures, and paintings in this large horseshoe-shaped ravine are some of the most astonishing monuments in India. The paintings were applied to a moist coat of lime over layers of clay, cow dung, and other elements that had been spread onto the rock faces of the walls. Most of the paintings relate episodes from the *jatakas* (stories about the lives of the Buddha); many would have been very large and illustrate more than one tale. The compositions devised by the painters as they experimented with the representation of figures in space are somewhat more daring and inventive than those attempted by contemporary stone-carvers. Unfortunately, today the paintings exist only in fragments, so the full spectacle of their grandeur, with surrounding sculptures and rock-cut architectural details, has been lost.

The *bodhisattva* Padmapani, in the *tribhanga* pose, holds a blue lotus and wears a jeweled tiara, pearls, and a sacred thread woven from seed pearls (FIG. 3.14). This style of painting depends heavily on lines to define features and uses very little shading or modeling. The resulting smoothness of the *bodhisattva's* body, devoid of anatomical detailing, the downturned eyes, arched brows, and the full but narrow mouth resemble the features of the Buddha from Sarnath (see FIG. 3.13). As in many of the Ajanta paintings, Padmapani's blissful, dreamy eyes, languorous pose, and transcendent appearance express depths of emotion that are seldom found in Gupta sculpture. He seems to be impervious to the menagerie of smaller figures, peacocks, monkeys, and fantastic creatures around him. The idealized features of the *bodhisattva*, who remains calm like an island of spiritual disengagement in the sea of activity around him, are bathed in

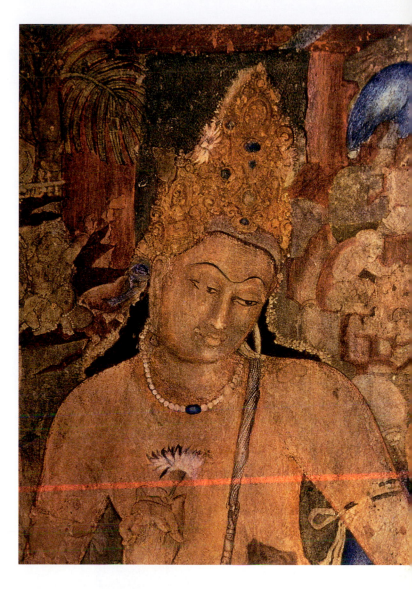

3.14 *The Beautiful Bodhisattva Padmapani.* Cave 1, Ajanta, India. c. late 5th century CE. Wall painting

a soft, glowing light with no shadows. As one on the edge of *nirvana*, who has glimpsed the reality of the *brahman*, he is aloof and spiritually disengaged, knowing that the sights and sounds around him are a grand illusion.

THE SPREAD OF BUDDHIST ART

Buddhism spread outward from India in every direction—west to Afghanistan, north to Kashmir, northeast to Nepal, Tibet, China, Korea, and Japan, south to Sri Lanka, and southeast through Myanmar to Indonesia. With it spread the Indian-Buddhist traditions in the arts. This chapter will deal with Buddhist art in the areas immediately around India and Southeast Asia. Buddhist art in China, Korea, and Japan is discussed in Chapters Four and Five.

AFGHANISTAN

The sculptors at Bamiyan, Afghanistan, expressed the magnitude of the new Mahayana Buddhist ideal, the Vairochana Buddha (the Body of Bliss or the Buddha Essence), by creating a series of colossal sculptures, the largest of which were between 120 and 175 feet (36.5–53.3 m) tall (FIG. 3.15). This is the eternal form of the Buddha, of which his earthly body is no more than a transient manifestation. Unfortunately, many of these colossi have been badly damaged over the ages by vandals. Encased in his deep, close-fitting niche, like a relic buried in a stupa, the largest of these Buddhas of Bamiyan once towered over the surrounding landscape. Chinese, Indian, and Western Asian styles of art mingle freely in Bamiyan, an international trading center on the southern

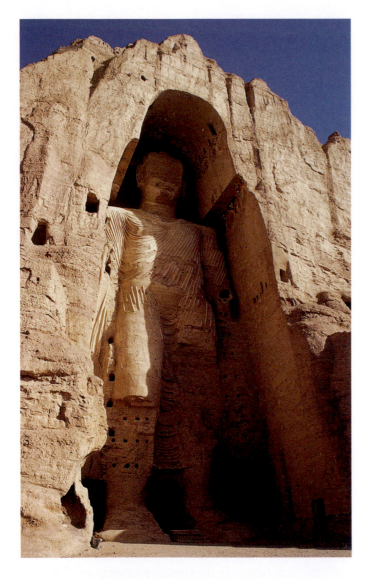

3.15 *Colossal Buddha*. Bamiyan, Afghanistan. Stone, height 175′ (53.3 m). 2nd–5th century CE; destroyed in 2001 by the Taliban

part of the Silk Road. The body of the Buddha, which may have been gilded, was once clothed in string-type drapery (applied lime plaster and paint). This technique of rendering the *sanghati* as a semitransparent cover visible only in its folds was derived in large part from Gupta sculptures in styles such as that of the Buddha from Sarnath. The double halo, formed by the carvings on the cliff behind the Buddha's head and the body-shaped niche, would be copied as far east as Japan. In fact, the colossus was so popular that it spawned a lively trade in miniature replicas, which were carried to the far ends of the caravan route that connected northern China with the eastern Mediterranean.

NEPAL AND TIBET

As the Muslim invaders in northern India destroyed the Buddhist and Hindu centers of worship there in the eleventh and twelfth centuries, many of the monks fled to Nepal and moved north through the towering ranges of the Himalayas into Tibet. Combining elements of the native Tibetan mystical religion known as Bon with Mahayana Buddhism and its complex pantheon of deities, the communities of Buddhist monks created a highly mystical form of Tantric or Vajrayana (the diamond vehicle) Buddhism. Many related varieties of the religious sect took root in the isolated valleys and monastic establishments of this remote and decentralized land, as Buddhist ideas were interpreted by highly revered local religious leaders known as lamas (see *Religion: The Dalai Lama*, opposite). Lamaists believe that through a supreme effort an individual can awaken the Buddha spirit within and achieve enlightenment in a single lifetime. Art became important as an aid in this time-shortened quest. Originally, along with Buddhism, Tibet received its art styles from northern India and Nepal. But in much the same way as the Tibetans made changes to the Indian religion, they looked beyond India to the decorative arts of Central Asia and to China to create their own distinctive styles of painting, sculpture, and architecture.

Some elements of the Gupta or Ajanta style of painting are preserved in the best-known type of painting to come from Nepal and Tibet, the **thangkas** (literally, "rolled-up cloths"). These portable hanging scrolls, representing important religious and historical figures, could be rolled up as they were moved from one location to another in the sparsely populated Tibetan highlands. The *thangka* represents Buddhist authority figures: political leaders, revered teachers, lamas, *bodhisattvas*, and the Buddha himself. Inscriptions indicate that the Tibetans believed that the revered subjects the *thangkas* represented were joined with their images. Therefore, the *thangka* image had to represent the essence and importance of that figure, showing it frontally, in a position of authority surrounded by a symmetrical composition

THE DALAI LAMA

The honorific title of Dalai Lama (literally, "Ocean High Priest") is of disputed origin and meaning. Buddhist writers tell us that, in 1578, a Mongol leader, Altan Khan, first granted the title to Sonam Gyatso, a Tibetan Buddhist leader. He and subsequent holders of the title have been spiritual guides to the Tibetans; many have ruled Tibet or played an important role in its government while residing in Lhasa, the capital. The Dalai Lamas have long been a focal point for Tibetan cultural identity and, recently, symbols of their struggle for independence from China. They are also *tulkus*, members of a small class who, according to Buddhist belief, can control the forms in which they are reincarnated. Each Dalai Lama is able to choose the successor in whom he will be reincarnated. Thus, in theory all Dalai Lamas have been of the same spirit and essence, and manifestations of the Bodhisattva of Compassion, Avalokitesvara, who is the patron deity of Tibet.

The fourteenth (and current) Dalai Lama, Tenzin Gyatso, was formally enthroned in 1950 but, after Tibet was incorporated into the Chinese Republic, went into exile in India in 1959, whence he continued to run the Central Tibetan Administration. He has written extensively on his role in Tibet and Buddhism; in 1989, he won the Nobel Peace Prize. The Dalai Lama has said that his successor, if there is one, might be a woman, but that he or she may not come from Tibet as long as it is under Chinese rule. Meanwhile, the Chinese government insists that it has the right to appoint the current Dalai Lama's successor so the fate of this ancient office remains in question.

of attendants and religious symbols. In this sense it is hieratic—presented in a way so that the figure appears to have greater authority than the other figures around it.

A thirteenth-century *thangka* from central Tibet represents Manjushri, a high-ranking *bodhisattva* and symbol of wisdom (FIG. 3.16). He dwelt in the heavenly Pure Land and is shown here with lotus blossoms (symbols of purity), enthroned in the cross-legged position of a *yogi* before a tall, multiplatform temple flanked by two smaller temples. Additional images of Manjushri above the temples and at the base of the *thangka* show him with two or four arms, wielding a sword to cut through ignorance. At times he is also shown with a book, the *Sutra of Transcendent Wisdom*. The careful balance of this composition would seem to reflect the Tibetan Buddhist emphasis on order, balance, and harmony in their cosmology, and the careful manner in which they constructed their hierarchy of Buddhist figureheads, some of which were drawn from Hinduism and Central Asia. The brilliance of the reds and golds of this and other *thankgas* would have made such images easily visible to all who saw them, even in the dim light of the candles and lamps of the monasteries.

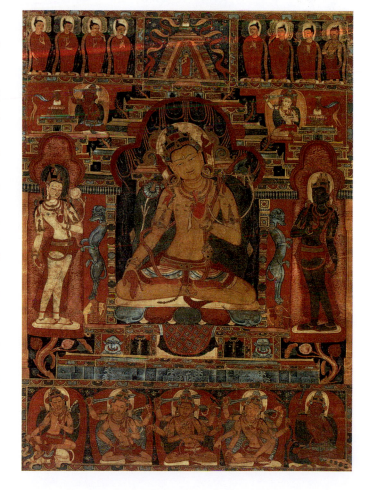

3.16 *Manjushri*. Central Tibet. Gouache on cotton, height 22" (55.9 cm). Private collection

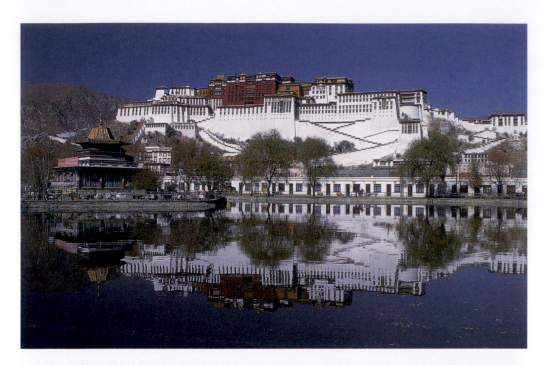

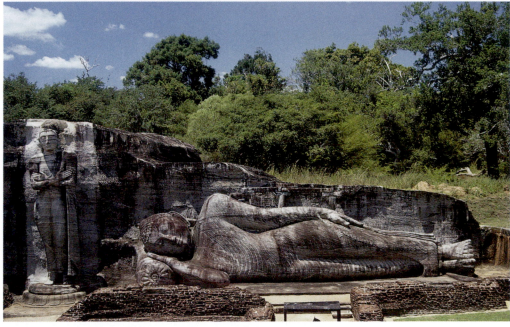

3.17 (**LEFT, TOP**) The Potala monastery-palace, Lhasa, Tibet. 17th century CE

3.18 (**LEFT**) *Ananda Attending the Parinirvana of the Buddha.* Gal *vihara*, near Polonnaruva, Sri Lanka. 12th century CE. Granulite, length c. 45' (13.7 m), height c. 23' (7 m)

As early as the eleventh century, the Tibetans began making portraits of nobles, monks, lamas, and other venerated religious leaders that seem to be based on firsthand observations of individuals. While these images on *thangkas* are realistic, they are also icons that elevated their historical subjects to semidivine status. The authority vested in the Dalai Lamas and their power to lead their followers to enlightenment made them some of the most important icons in Tibetan art. The fifth Dalai Lama (died 1682) allied with the Mongols, unified Tibet, consolidated all political and religious powers in his person, and expressed his triumphs in the construction of a series of hilltop monasteries, including the Potala monastery-palace at Lhasa (FIG. 3.17).

This complex incorporated earlier buildings with wall paintings dating back to the eighth century and followed a time-honored Tibetan system of construction. The basic building form used in the Potala, derived from the traditional Tibetan farmhouse, consists of a rectangle with tapered and whitewashed walls of sunbaked brick, narrow windows, interior column supports, and an enclosed courtyard. The red palace—ranged around an atrium at the center of the complex where the tomb of the fifth Dalai Lama

is located—became the religious center of all Tibet. The topographical demands of this site did not allow the builders to follow the traditional Buddhist mandala plan in which a tall central temple (symbolizing Mount Meru) would have been surrounded by lower temples and walls representing the Buddhist cosmos. The roof treatment, with Buddhist emblems such as the Wheel of the Law, deer (from the Buddha's first sermon), and finials in the form of mythic creatures, is only faintly visible in the photograph here. When viewed from the plains below, the powerful simplicity of the earth-hugging trapezoidal forms rising out of the hill with their many eyelike windows expresses the political and spiritual power of the Dalai Lama as well as the austerity of life in this harsh Himalayan climate, while preserving the look of Tibetan folk architecture.

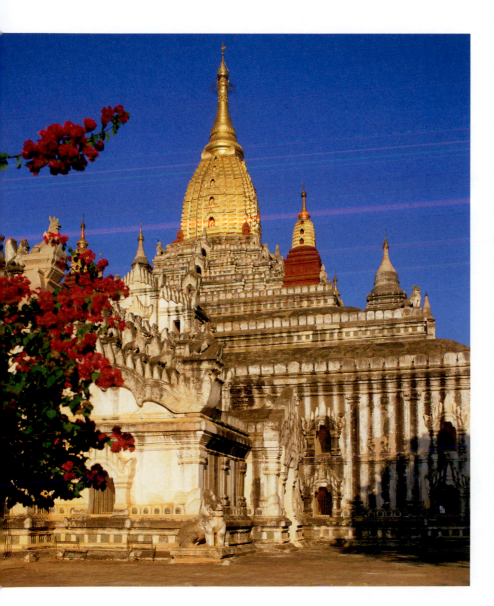

3.19 The Ananda temple. c. 1100. Pagan, Myanmar

SRI LANKA

Legend has it that a son and daughter of Ashoka carried Buddhism to Sri Lanka, a large island off the southern tip of the Indian mainland, in the late third century BCE. Thereafter, it remained a stronghold of Hinayana Buddhism. Many Sri Lankan painters and sculptors made extensive use of free-flowing lines, which gave their works an energetic, sensual quality. The latest important works on the island are the temples, stupas, and late twelfth-century monumental rock-cut sculptures at Polonnaruva, a royal city from the eighth to the thirteenth century. The period of the greatest artistic activity came during the reign of the last great monarch, Parakrama Bahu I (ruled 1153–86). The sculptors of a scene showing the Buddha's favorite disciple, Ananda, attending the Buddha's *nirvana*, present elements of the Sri Lankan style on a monumental scale (FIG. 3.18). Even though the Buddha is reclining, the narrow stringlike folds in his *sanghati* and the lines around his shoulder and down his arm, hip, and legs retain a sense of energy and movement. This gracefulness became an important element in Southeast Asian Buddhist art. Yet, in keeping with the ancient Hinayana form of Buddhism its creators followed, the arts of Sri Lanka seem to be deliberately archaic.

MYANMAR

From the ninth to the thirteenth century, before Myanmar was invaded by the Siamese and the Chinese under Kubilai Khan, Buddhist art flourished in the administrative center of Pagan. The most famous and venerated shrine among the roughly two thousand Buddhist monuments in this area, the Ananda Temple, was dedicated in 1090 (FIG. 3.19). A solid block of masonry in the heart of the cruciform terrace platforms, framed by four colossal statues of the Buddha, roughly 34 feet (10.4 m) tall, supports the central spire, which rises to a height of 165 feet (50.3 m). The elegant shape of this spire is reflected in the smaller towers on the corners of the terraces and myriad spikes and pinnacles ornamenting the skyline. The source for the cruciform plan of this mountain of brick, white stucco, and gilding appears to have been the Brahmanic architecture of nearby Bengal, India.

INDONESIA

The cruciform plan underwent considerable modifications when it was used for the construction of an enormous and profusely decorated mountain-shaped stupa at Borobudur (or Barabudur) on the island of Java in Indonesia (FIG. 3.20). The origins of the monument are obscure; it may have been built around 800 CE but was not known by the outside world until the nineteenth century. The stupa, built over a crest of a small hill, is about 408 feet (124.5 m) wide on each side, 105 feet (32 m) tall, and is decorated with over 10 miles (16 km) of relief sculptures in open-air galleries. The stairways that bisect all four sides of the structure are oriented to the cardinal directions. Borobudur represents Mount Meru, the centerpiece of the Buddhist and Hindu universes; its name may mean "mountain of the Buddhas."

The base and first five levels, which are rectangular, represent the terrestrial world. Reliefs on the ground level of the stupa illustrate the plight of mankind moving through endless cycles of birth, death, and reincarnation. The walls of the next four tiers show scenes from the life of the Buddha taken from the *jatakas* and the **sutras** (a *sutra* may be an aphorism, a concise, often cleverly worded statement, or a collection of

aphorisms in the form of a manual). The three round, uppermost levels of the structure represent the celestial realm and support seventy-two stupas. Each of the latter originally contained a statue of the preaching Buddha seated in a yoga position, and together they surround a larger, central stupa.

Borobudur is the ultimate diagram or mandala of the Buddhist cosmos and ideal of existence. Moving around it and ascending to the summit, pilgrims can relive their own previous lives and those of the Buddha, and see things to come in the future. They ascend from the human Sphere of Desire to the Sphere of Form, and finally arrive at the uppermost stupas, the Sphere of Formlessness, which symbolizes the Buddha's ultimate attainment of *nirvana*. Combined, the symbolism of the architecture and the reliefs to be viewed while encircling it outline a microcosm of all earthly and heavenly existence in a consummate statement of the Mahayana Buddhist philosophy. In the physical act of following the galleries clockwise around the monument, ascending upward from reliefs representing the world of desire, past the stories of the Buddha who escaped from *karma* to images of *bodhisattvas* such as Maitreya, the Buddha of the Future, devotees follow in the Buddha's footsteps. Unlike Hinayana Buddhism and the stupa at Sanchi, both of which provide a

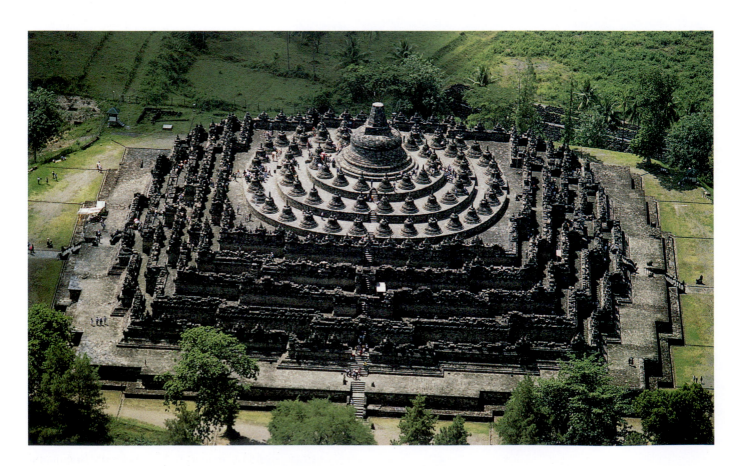

3.20 Borobudur, Java. Aerial view. Late 8th century

YOGA THEN—AND NOW

The term "yoga" has several possible sources in Sanskrit. *Yuj* means to control, yoke, or unite. *Yujir samadhau* means to contemplate or absorb. Practitioners of yoga are called *yogi* or *yogini*. They believe that certain forms of disciplined contemplation or meditation suspend the mind's normal mental activities—its traditional patterns of associations—and free it to experience other, higher states of existence. Yoga has long been part of the ancient religious traditions in India, including Hinduism, Buddhism, and Jainism. In Hindu thought, the higher states of mind achieved through yoga can liberate practitioners from all worldly suffering and the ongoing cycle of birth and death in *samsara*, and help them bond with the supreme being. Art may play a role in this process, but it is anchored in the material world and cannot replace religious meditation as the vehicle used to reach the highest levels of spiritual existence.

Images of figures in the traditional seated, cross-legged pose used by *yogis* appear on seals from the Indus Valley Civilization (third millennium BCE), but we cannot be certain they are practicing yoga techniques of meditation as we know them from later times. Scholars have found many possible references to the practice of yoga in early Indian writings, but the first solid evidence for this tradition comes from the time of the historic Buddha (sixth century BCE). Hatha yoga (fifteenth century CE) introduced many of the full-body positions now in popular use around the world in modern yoga, a nonreligious discipline many users believe may improve one's physical and mental health.

In recent years, a wide variety of teachers have helped to bring the ancient practices of yoga into the mainstream in the West. Maharishi Mahesh Yogi (1914–2008) was the Beatles' guru and the leader of the Transcendental Movement; he also formed the Natural Law Party to promote world peace. Some of his teachings, such as "yogic flying," a form of hopping or levitation while meditating, remain controversial among many *yogis* around the world.

single step toward release from *karma*, Mahayana Buddhism and Borobudur present the ascent as many-leveled, but as capable of being achieved in one lifetime.

HINDU ART

"Hindu" emerged as a cultural term in the twelfth century to designate the people of the Indian subcontinent. Later, around 1800, the name began to be used more specifically to refer to the many related Veda-based philosophical, religious, and cultural ideas of that area. Hinduism has often been called the oldest and most complex religion in the world; it is a collection of many sects with many names and belief systems that have changed over the course of the past two thousand years. However, at its core Hinduism has sets of ancient and distinctive religious ideals shared by about a billion people today in and around India who identify themselves, with pride, as Hindus.

As Buddhism spread throughout most of Asia and declined in importance at home, Hinduism remained the most powerful religious force in India. Hindu artists incorporated and transformed elements of Buddhist art to illustrate their many gods and teach their dogmas. In parts of India, the Buddha was identified as an incarnation of Vishnu, an important Hindu deity. The first Hindu sculptures appeared at about the time the **Bhagavad Gita** discussed this important association between Buddha and Vishnu (second century BCE), and by the sixth century CE the image-types of Hindu deities were well established.

Collectively, Hindu thinkers have used many terms and ideas to explain the roles of the arts in their various sects, three of which are described below and are essential to this survey of Hindu art. The long Indian tradition of speculation on art and aesthetics centers on the concept of *rasa* ("juice" or "essence"), the emotional reaction and satisfaction one may experience when looking at art. The term can also mean "taste" or "flavor." Just as a spice has a tangible form and leaves an aftertaste, so art has form and leaves the viewer with an aftertaste, an experience, *rasa*, that gives delight and bliss, and leads one to *brahman*. *Brahman* has been described many ways, as pure consciousness or pure bliss, the abstract Absolute, and that which is permanent and immutable and may be personified as a god. One reaches

that state of spiritual development by ritual, meditation, and self-control in a quest that begins in one's earlier lives and that continues through successive reincarnations.

This experience of *rasa* in the face of art happens intuitively, through the subject matter and the manner of its presentation or style. Indian theorists say there are many types of *rasa*. The highest of these, *santa*, a form of spiritual tranquility, comes directly from the experience of art and creates **bhakti**, a bond with the art. The word *"bhakti"* comes from a Sanskrit root, *bhaj*, "to share in or belong to," and refers to a fully engaged level of devotion and intimate relationship with God—in this case, one created and augmented through the contemplation of the visual arts. With its emphasis on personalized experience, *bhakti* overlaps in some sects with *darsana*, a Sanskrit word meaning "sight" or "vision," and more specifically a "vision of the divine." It can also mean "to see with reverence and devotion." For our purposes here, we are especially concerned with the way works of art enable viewers to have this vision.

HINDU ART AND ARCHITECTURE IN SOUTHERN INDIA

Hindu art flourished in southern India under the Pallava dynasty (c. 500–750 CE), which ruled from Kanchi, just west of Madras. Many of the rock-cut monuments at Mamallapuram (City of Mamalla) were carved during the reign of Mamalla I (630–68 CE). The granite outcrops and cliffs covering several square miles along the coast of the Bay of Bengal were converted into a series of monuments that have long attracted throngs of pilgrims and tourists. The most famous of these monuments, an unfinished cliff carving, may represent *The Descent of the Ganges* or *The Penance of Arjuna* (FIG. 3.21), episodes from the *Mahabharata*. In this great war epic, Arjuna was one of the legendary Pandava brothers who underwent penance beside a river to enlist the aid of the god Shiva in battle. In the carving, he is shown seated beside a small shrine to Shiva to the left of the cleft in the cliff. During the rainy season, water from a cistern above cascades down the center of the relief, over cobra-headed spirits of water and earth called *nagas*, illustrating the descent of the sacred river goddess Ganga to the earth as it was filtered through Shiva's hair. All of creation, the river deities, lions, bears, cats, mice, deer, *devas* (gods), and a pair of slightly larger-than-lifesize elephants with their calves, converge upon the sacred waters. Room for each animal and person was created by carving out individual pockets of space along the face of the cliff. While the elephants, which occupy a prominent position in the relief, are highly naturalistic, the lions, with their schematic, curly manes, recall the heraldic style of the much earlier Indian sculptures from the Maurya period. The enormous relief is not a narrative as such and gives little sense of any space or time in which the individual figures exist because, in fact, it represents all space and all time—the eternal present.

A number of **ratha** (literally, "chariot of the gods") shrines were carved from a series of boulder outcrops (FIG. 3.22). Most likely commissioned by Mamalla I, these provide a kind of historical museum of the mid-seventh-century southern Indian Hindu architectural types used during

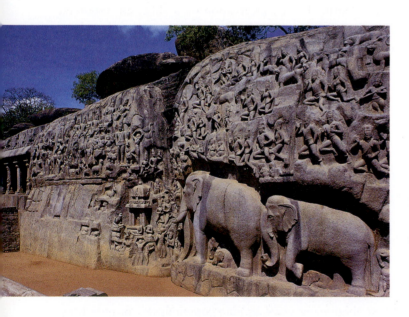

3.21 *The Descent of the Ganges* (or *The Penance of Arjuna*). Mamallapuram, India. Pallava period, 7th century

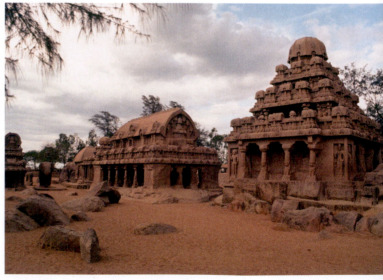

3.22 The Dharmaraja Ratha. Mamallapuram, India. Pallava period, mid-7th century

Mamalla's reign. The wooden, brick, and masonry building types built at this time around Mamallapuram have been translated into monumental stone sculptures. By reproducing the architecture in sculptural form, the two art forms are inextricably fused in monuments that may confound the viewer's sense of what is architecture and what is sculpture. The technology required to carve these large architectural sculptures is similar to that developed earlier by the sculptors of the Buddhist cave-temples (see FIG. 3.9). But here the process is reversed—the *rathas* are envisioned as masses in space, not spaces within a mass.

The Dharmaraja Ratha is a good illustrative example of an early southern-style Hindu temple. Had it been completed, it would have had pillared porches bordered by sculptures set in niches on all four sides and a **garbhagriha** (womb chamber, the sanctuary or inner chamber housing the image). One of these exterior statues is a portrait of the patron, Mamalla I, posed stiffly, like a god. Above, each level of the tall, three-stepped, pyramidal **vimana** (tower) below the octagonal capstone is lined with small sculptured images of shrines with barrel vaults. Faces peer out from the small horseshoe-shaped windows in the shrines and the windows on the cornice. These vaults resemble those of an adjacent shrine and the tall gateways of Hindu temples that were built in this area a millennium later. Work on the unfinished *rathas* may have stopped with the death of Mamalla I in 668 CE.

RELIGION

HINDUISM

Hinduism is comprised of many interrelated sects focusing on the ancient wisdom of the Vedas. Depending on the sect, the most important gods are Brahma (the Creator), Vishnu, Shiva, and the goddess Devi. Vishnu, whose consort is Lakshmi (good fortune), is illustrated in many forms or aspects as a boar, man-lion, fish, and Krishna the herdsman-warrior. Shiva also has many roles and forms. He is the protector of animals and the great *yogi* who meditates in the Himalayas. As a cosmic dancer, Shiva destroys and recreates the world. In his triple aspect as Mahadeva, Lord of Lords, Shiva is Aghora (destruction), Tatpurusa (preservation), and Vamadeva (creation). For many Hindus, Shiva, who incorporated the character of many of the Hindu gods into his identity, is the supreme god. However, the goddess Devi can take forms symbolizing beauty, benevolence, and wealth, as well as power and wrath. As Durga (she who is difficult to go against), Devi is a very powerful warrior goddess of

virtue and protector of civilization. At times, she may be stronger and more revered than Shiva or Vishnu.

However, all the Hindu gods, with their multiple forms or aspects, are essentially one because they are manifestations of the one all-inclusive and eternal spiritual reality, *brahman*, encompassing all temporal and divine beings. Hindu deities come from the *brahman*, or Formless One, exist in the Subtle Body, and enter the Gross Body when they manifest themselves in our world.

The **brahmins** are an ancient, highly trained class of priests dating back to Vedic times who perform many of the Hindu sacrifices and rituals. The practice of reciting prayers and placing offerings in fires so that the flames carry messages to the gods may date back to the Indus Valley period. The priests watch over the correctness and purity of these and other rituals aimed at the propitiation of the gods and achievement of *moksa*. This is a state of pure consciousness and bliss, achieved by those who have escaped

samsara, the ongoing cycle of birth, death, and reincarnation. To achieve *moksa*, Hindus must renounce all desires and consider every action a sacrifice to the gods.

These rules and principles for the attainment of *moksa* are explained in Hindu writings, the *Puranas* (book-length mythic poems about the gods) and *Tantras* (ritual forms for propitiating them). The literature also provided artists with a rich collection of visual images to illustrate. One of the most important Hindu texts embodying the Krishna myth, the *Bhagavad Gita* ("Song of the Lord [Krishna]"), explains how the faithful can bond with the godhead through *bhakti* (an individual's love of God), meditation, and reason. The concept of *bhakti* emphasizes the importance of a personal, intimate, and loving relationship with a god—as opposed to the performance of traditional rituals. The wisdom and truths of the gods are revealed directly to the faithful through this bonding. *Bhakti* yoga became one of the ways in which Hindus could achieve *moksa*.

Another very dramatic step in the development of the sculptured Hindu temple took place a century later at Ellora in the Deccan, an important ancient pilgrimage site for Hindus, Buddhists, and Jains alike. About thirty-two cave-temples at Ellora were begun in the days of King Krishna I (ruled 756–73 CE) of the Rashtrakuta dynasty (FIGS. 3.23, 3.24). The monolithic, rock-cut Kailasanatha temple complex (757–90 CE) was dedicated to Shiva as the Lord of Kailasa, the great snow-capped mountain in western Tibet where his throne was said to be located. The temple was originally whitewashed to simulate the color of Shiva's snow-covered mountain.

The enormous amount of hard volcanic rock that had to be quarried in the cutting of the temple can be gauged by looking at the dimensions of the cliffs in the background, which are 120 feet (36.6 m) tall. The box-shaped courtyard excavated around the temple measures 276 by 154 feet (84.1 × 46.9 m, roughly the size of a football field) and the temple, which is 96 feet (29.3 m) high, is three times the height of the tallest *ratha* at Mamallapuram.

Visitors approach the Kailasanatha temple through an entrance gate or **gopura** (a) in a high sculptured wall, to the

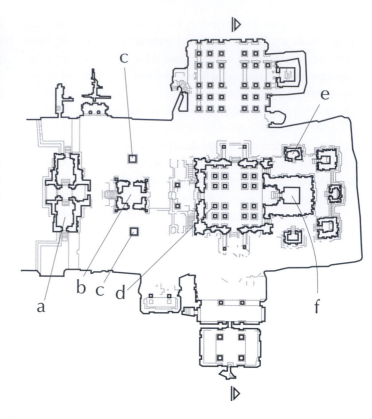

3.23 (ABOVE) Ground plan of the upper story of the Kailasanatha temple and neighboring rock-cut temples at Ellora. Main features: (a) *gopura*; (b) Nandi shrine; (c) elephants; (d) *mandapa*; (e) subsidiary shrines; (f) *garbhagriha*

3.24 (LEFT) Kailasanatha temple. Ellora, India. Rashtrakuta dynasty, 757–90

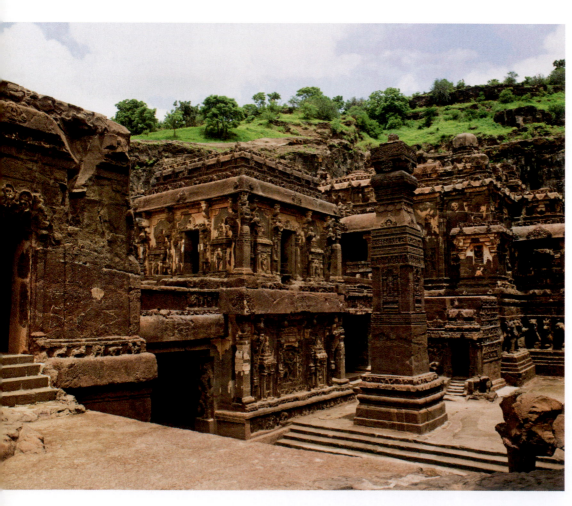

Nandi shrine, named for the bull that Shiva rides (b), flanked by a pair of elephants (c) and freestanding piers, to the columned assembly hall, or **mandapa** (d), and to the subsidiary shrines (e) or the thick-walled *lingam* shrine in the *garbhagriha* (womb chamber) or sacred cavern in the cosmic mountain/temple (f). Additional rock-cut shrines are located in the walls behind the colonnade around the courtyard. The plan of this and other early Hindu temples reflects the designs of the Buddhist *chaitya* hall temples. The rich detailing of the freestanding towers, decorative niches, statuary, and the four-tiered *vimana* (central tower) are elaborations on the styles of temple design at Mamallapuram. The deeply shadowed columns, cornices, and niches holding statues of deities add drama to the texture of highlights and dark shadows. A set of five shrines encircling the main sanctum and the side porches of the *mandapa* give the temple many right-angled wall faces that add to the profusion of complex architectural and sculptural forms filling the walled courtyard.

To compound the spectacle of the exposed, sculptured Kailasanatha temple, the Rashtrakutan builders cut shrines with columnar halls and monumental relief sculptures into the side walls of the enclosure. The *mandapa* of the Lankesvara temple to the left is similar in design to the Kailasanatha temple, but larger, with more massive piers. The works at Ellora extend far beyond the area seen here and include Buddhist, Hindu, and Jain cave-temples. Combining the technology and splendor of the earlier Hindu rock-cut temples at Mamallapuram with the cave-temples at Bhaja and Karli, the builders at Ellora have created what may be the most impressive set of rock-cut monuments in India. Looking at the Kailasanatha temple, Krishna I, who commissioned it, said: "How is it possible that I built this other than by magic?"

Because of its geographic position and the strength of its kingdoms, southern India was able to continue its indigenous artistic traditions after 1000, while the Muslims took over much of northern India by 1200. The political conditions in the early years of the Chola dynasty (c. 850–1310) under the rule of Rajaraja I (ruled c. 985–1014), known as the "king of kings," are reflected in the fortifications and moat surrounding the temple in his capital at Thanjavur. The temple, known as the Rajarajeshvara or Brihadesvara temple to Shiva, represents one of the high points of the southern Indian style of temple construction (FIG. 3.25).

Visitors approaching the wall precinct, which measures 877 by 455 feet (267 × 139 m), enter through a gate tower

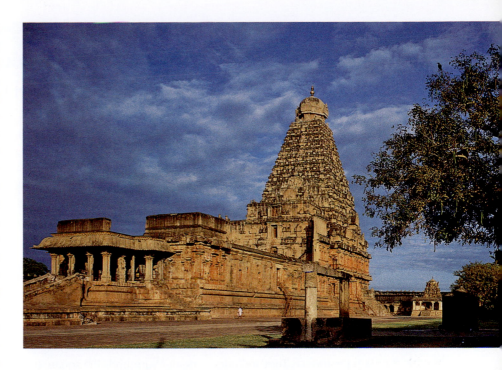

3.25 The Rajarajeshvara or Brihadesvara temple to Shiva at Thanjavur (Tanjore), India. c. 1000

on an axis leading to the *vimana*, which rises to a height of 216 feet (66 m). Steps passing the open, columnar shrine to Nandi (Shiva's bull mount) lead to a colonnaded porch, flat-roofed *mandapa* halls, an enclosure with thirty-six columns, and the square shrine. The inner ambulatory of the shrine is lit by windows that are flanked by niches containing monumental statues representing aspects of Shiva and other Hindu deities. Worshipers move through a succession of progressively smaller and darker spaces until they arrive at the cult image, a **lingam** (plural *linga*), in the *garbhagriha*. The *lingam* is a symbol of male sexuality, specifically that of Shiva. Some of the earliest examples are highly explicit; later *linga* tend to be more abstract and geometric and appear with the *yoni*, a circular symbol of female sexuality. In yet other temples, the symbols are invisible and said to be made of ether. The walls of *garbhagrihas* tend to be plain and dark so that nothing within distracts the worshiper from the rather simplified images of the *lingam* and *yoni* in the heart of the temple. The rite of circumambulation around the *lingam* shrine is as important to the Hindus as the rite is for the Buddhist worshiping at stupas. (See *Analyzing Art and Architecture: The Hindu Temple: Symbolism and Terminology*, page 84.)

A monolithic, eight-ribbed *stupika* (capstone) topped by a gold-plated finial rises above the steep thirteen-level pyramidal *vimana*. This giant tower is decorated with ribbed domes, *chaityas*, window motifs, and statues of dwarfs. Local legends say that a ramp 4½ miles (7 km) long was constructed to

THE HINDU TEMPLE: SYMBOLISM AND TERMINOLOGY

To ensure the purity of a temple and make certain that the god or gods to whom a temple is dedicated will take up residence there, every step of its planning and construction has to follow precise ritual procedures. Sites with fertile ground are preferred. Any spirits living there are "removed," and cows (sacred animals) are pastured on the temple grounds before construction begins. Descriptions of these rituals were recorded in texts by the sixth century CE. They include the recitation of mystic syllables, or mantras, designed to attract the deities.

The axis of a Hindu temple runs east to west, in the same direction that the sun travels. Many other features of its design are also determined by astronomical and astrological factors. Most important, to attract the gods who dwell throughout the cosmos, Hindu temples are designed as mandalas, specifically, the mandala of the Cosmic Man, the father of humanity. A checkerboard pattern of (usually sixty-four) squares belonging to lesser deities surrounds the square (the *garbhagriha*) housing the *brahman* at the heart of the temple. Although non-Hindus may see this chamber as dark, in Hindu thought, it is filled with the pure light of the *brahman*. In most Hindu temples dedicated to Shiva, this inner chamber houses an image of Shiva in his first or Formless emanation of the *brahman*. The *mandapas* represent the second, Subtle Body state of the threefold emanation of the gods. Mystic forms of numerology accentuate the universal, cosmic symbolism of the temple. Once consecrated, the temple becomes a place for individual devotion, prayers, and offerings to the deity, as well as more public rituals such as dancing and sacrifices in the *mandapas*.

roll the 80-ton (81 tonnes) helmet-shaped *stupika* to the top of the *vimana*. With its many superimposed rows of miniature buildings, the steeply terraced tower looks like a Hindu hilltown, a densely populated World Mountain.

During the Chola period, the Brihadesvara temple housed many bronze and copper sculptures, which were carried through the temple in ritual processions. Some of them may have resembled the statue *Shiva as Nataraja, Lord of the Dance* (FIG. 3.26). The idealized, impassive god, with long hair (a sign of asceticism) and smooth features, who resembles sculptures in the niches of the Rajarajeshvara temple, dances within a flaming circle. His raised leg symbolizes the need to escape from the ignorance of the world below, represented as a demon, on which he dances. Shiva's *tribhanga* pose resembles that of figures from earlier periods of Indian art at Harappa and Sanchi. He dances to the rhythm of the heartbeat of the cosmos, symbolized by the fire on the ring encircling him. His lower right hand makes the *mudra* of blessing. According to one interpretation, Shiva's dance, performed periodically, destroys the universe, which will be

3.26 *Shiva as Nataraja, Lord of the Dance*. India. Chola period, 11th–12th century. Bronze, height 32" (82 cm). Museum Rietberg, Zürich

born again in a perpetual cycle of death and rebirth. The fire symbolizes the destruction of *samsara* and *maya*, the illusions of this world created by ego-centered thinking. Thus, dance embodies liberation, the freedom the believer gains through *bhakti*, the love of Shiva.

Shiva's dance also celebrates life as an eternal "becoming" in which nothing begins or ends, in which creative and destructive forces are unified and balanced. Shiva holds a flame, which symbolizes the fire that will consume the universe, and a drum, symbol of *akasa*, the prime substance from which the universe will be rebuilt. The drum is also a common instrument of the ascetics, of whom Shiva is the patron god.

HINDU ART AND ARCHITECTURE IN NORTHERN INDIA

In contrast to southern Hindu temples such as that at Thanjavur, Hindu temples in the north tend to be very compact, with high bases and tall central towers. Many regions in the north have excellent stone for carving, and there is a wide variety of architectural sculptures there, ranging from delicately carved decorative reliefs to nearly freestanding, lifesize sculptures.

The Kandarya Mahadeva (Lord of Lords) temple in Khajuraho, capital of the Chandella dynasty, is widely regarded as the classic example of the northern Indian Hindu temple type (FIGS. 3.27, 3.28). As such, it illustrates some important differences between the northern and southern Hindu temple types. Unlike the sprawling temple complexes of southern India, the temple at Khajuraho is compacted into a unified, organic whole on a single high platform. It has a double cruciform plan with short arms extending from the long, east–west axis at the *mandapa* and *garbhagriha*. Although the original white gesso "snow" coating on its exterior has disappeared, the tall buff sandstone structure still resembles the crests of the Himalayas, the inaccessible snow-capped home of the gods.

The axial approach leads visitors up a set of stairs through a porch to the *mandapa* and the sanctuary, holding a Shiva *lingam*. The rhythm of the closely spaced horizontals on the base seems to create pulsating waves of energy that rise through the columns on the porches and give birth to the towers and the *amalaka* (sunburst) crowns at their summits, pointing to the otherworld of the heavens. The hypnotic power of these repetitive, echoing horizontal lines has been compared to the rhythms of Hindu chants, with their carefully constructed patterns of repeated words and phrases. The manner in which these horizontal accents blend into the vertical lines of the towers allows the eyes to move upward and inward along the roofline turrets to a central tower with a gently curved profile known as a **sikara**.

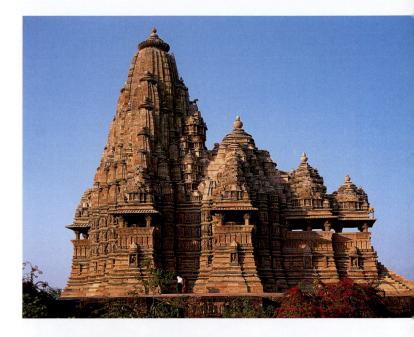

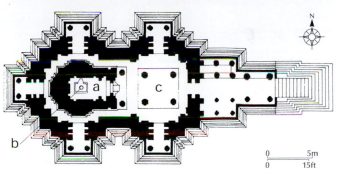

3.27 (ABOVE, TOP) Kandarya Mahadeva temple. Khajuraho, India. c. 1000

3.28 (ABOVE) Plan of the Kandarya Mahadeva temple, Khajuraho, India. Main features: (a) *garbhagriha*; (b) cult image; (c) *mandapa*

The ribs of the interlocking network of towers bend inward and hug the towering peak of the *sikara*, reaching magnificent climaxes in the *amalaka* over their capstones as the towers link the terrestrial and celestial realms. Such northern, parabolic *sikaras* stand in stark contrast to the tall, pyramidal *vimanas* of the southern temples. Like an unopened, tightly packed lotus bud, the cluster of engaged towers clinging to the *sikara* seems to be filled with all the potential energy of the Hindu cosmos, ready to blossom forth. The manner in which the architectural forms multiply or subdivide, yet remain part of the overall structural logic and energy of the plan, parallels the way in which the Hindu gods assume manifold, interlocking, and overlapping forms and identities.

Although the builders used masonry techniques to build this temple and image of the Hindu cosmos, it seems to have been conceived as a large, organic piece of sculpture. The sense of massiveness is no illusion—that is what holds the stones together. Indian masons used no mortar and few clamps to secure the stones.

Over eight hundred sculptures on the Kandarya Mahadeva turn and twist on their pedestals in dynamic poses that give a sense of movement to the piers and walls, further animating the masses of the structure. Like the sculptures on the other surviving Chandella temples in and around Khajuraho, the figures tend to be tall, with elongated, tubular legs and bodies, and some are arranged in erotic poses. They may illustrate the ideas of the Tantric (Vajrayana, or diamond vehicle) type of Mahayana Buddhism. This taught that the female force (*shakti*) was the prime one in the universe because it could activate the male force. Consequently, the female consorts of the male gods assumed new importance in the religion and its art. Images of sexual union represent the fusion of female wisdom and male compassion. Devotees link, symbolically, with Shiva and achieve a sense of unity and wholeness through sexual union with one another. Thus, the sculptures on this and other temples around Khajuraho, which are famous for their eroticism, would appear to reflect Hindu metaphysical speculations about the reconciliation of opposites, the cosmic unity of all beings, and the desire to bond with Shiva. Descriptive accounts of the art of love were recorded in the *Kama Sutra* (fourth century CE), but no known text explains the erotic sculptures at Khajuraho in this light, and scholars have assumed only that they are Tantric metaphors for the linking of the human soul with the divine.

The Tantric joy found in the human body may be evident in the figures of Vishnu and Lakshmi from the Parsvanatha temple (FIG. 3.29). Their idealized bodies are unified in a single, long, C-shaped curve, a swaying, dancelike pose as Vishnu clutches Lakshmi's breast and presses his groin against her buttocks. The manner in which the thin scarves and ribbons accent the smoothness of their flesh and the gracefulness of their movements makes this figure group one of the masterpieces of Khajuraho sculpture.

THE SPREAD OF HINDU ART

Hindu art of the Gupta period spread from India southeast to Myanmar and Cambodia, where it developed a new and distinctive imperial character under the patronage of the Khmer (Cambodian) monarchs. As a *devaraja* (king of the gods), a Khmer ruler was deified during his own lifetime. By the twelfth century, the powerful monarchs, ruling out of Angkor (a Khmer word meaning city or capital), about 150 miles (240 km) northwest of Phnom Penh, controlled an area that included portions of Thailand and Vietnam. The city of Angkor, crossed by an extensive network of broad avenues and canals, covered about 70 square miles (180 sq km). The royal palaces, built of perishable materials, have long disappeared, while the temples, constructed out of brick and stone, remain in a relatively good state of preservation.

The largest of these temples, Angkor Wat (temple of the capital), was built during the reign of King Suryavarman II (1112–c. 1150). Its central spire is about 200 feet (61 m) tall and the moat surrounding the complex is over 2 miles (3.2 km) in circumference (FIG. 3.30). The broad moat and the outer wall symbolize the oceans and mountains ringing the edge of the world. Within, the five towers stand for the

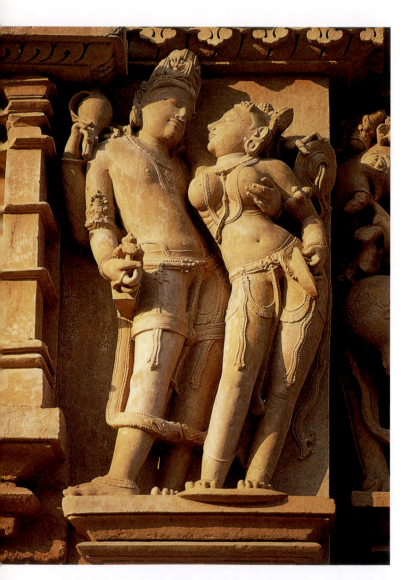

3.29 *Vishnu and Lakshmi*. Parsvanatha temple, Khajuraho, India. c. 1000. Stone, height c. 48" (1.22 m)

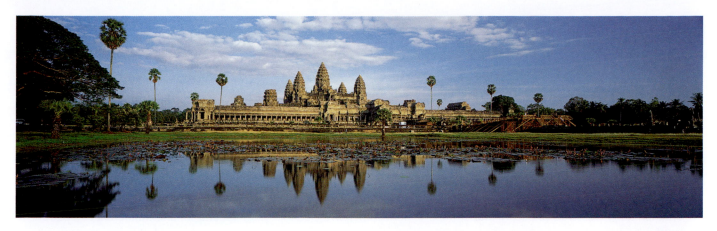

3.30 Angkor Wat, Cambodia. Early 12th century

peaks of Mount Meru, the heart of the Hindu universe. The temple is oriented so viewers passing through the western gate at sunrise on June 21, the beginning of the Cambodian solar year, would see the sun rise directly over the central tower. This orientation may further tie the architecture and deified king with the cosmos.

It is startling to note that the entire complex, with a detailed, symmetrical plan and fitted with miles of reliefs, was built in the short span of about thirty years. Even more astonishingly, this and the other lavish Hindu temples constructed by the mid-twelfth century failed to satisfy the needs of Suryavarman's son and successor, Jayavarman VII (ruled c. 1150–c. 1218). He expanded the empire to its greatest dimensions by conquering portions of Malaysia, Thailand, and Laos, and founded a new royal city for his court, Angkor Thom, with Buddhist and Hindu monuments. Like the rest of the city, the Bayon, the massive mountain-shaped Buddhist temple in the center of the city surrounded by temples and palaces, is now in ruins (FIG. 3.31). It was dedicated to the *bodhisattva* Lokeshvara, a manifestation of Avalokitesvara, of whom Jayavarman believed he was an embodiment. The famous giant smiling faces with their broad rounded features on the towers at Angkor Thom blur the line between sculpture, architecture, and the person of the ruler. They represent the ruler as the *bodhisattva*, looking outward in all directions from the architectural cosmos in the center of his great kingdom. The multiplication of heads radiated the presence and power of the divine king in every direction toward every province in his empire. These locations were included in the temple inscriptions in the chapels, which were provided with statues of the favored local provincial deities.

The temple-mountain is a giant mandala, one appropriate to the complexities of Mahayana Buddhist thought. The Bayon, like Mount Meru, is surrounded by tall walls (mountain ranges) and a moat (the oceans of the world).

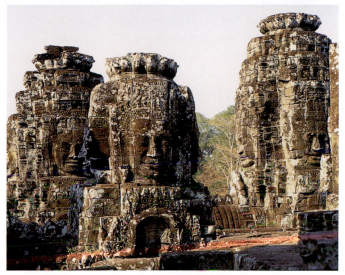

3.31 The Bayon temple. Angkor Thom, Cambodia. c. 1200

The Bayon owes more to Hindu sources than Buddhist ones and illustrates how these two religions exchanged ideas, insights, and art forms throughout their history. The city was unfinished when Jayavarman died around 1218, and the kingdom was soon being pressured by the all-conquering Mongols from the north and from Thailand. Eventually, the court retreated and its arts were perpetuated in the folk traditions of this region.

JAIN ART AND ARCHITECTURE

Although only about one half of one percent of Indians are Jainists and very little was known outside India about their religion until recent years, there are many important Jain monuments throughout India (see *Religion: Jainism*, page 88). In Jainist thought, a soul that has achieved the ultimate state of supreme being is called a **jina** ("conqueror" or "victor")—hence the name of the religion. While some Jain art

JAINISM

Jainism is an ascetic tradition without a supreme deity that broke away from the Vedic, Brahmanic, or Hindu tradition. Jainists believe their religion was revealed to humankind by a series of twenty-four *tirthankaras* (pathfinders). The last of these pathfinders, Mahavira (The Great Hero) (599–527 BCE), from northeastern India, lived in the same century as the Buddha. Devotees subscribe to the principle of nonviolence and live in great purity in their quest to join the pathfinders in the realm of pure spirit at the apex of the universe. Jainists believe in *samsara*, the ongoing cycle of birth and death. By living pure lives, they hope to perfect their *jiva* (soul or higher consciousness) and so escape *samsara*. One who does so is called a *jina*.

Jainists do not kill living things of any description and avoid hurting others with abusive language or negative thoughts. Possessions, they believe, enslave them, so they tend to own very little. They form few personal or emotional attachments, even to family members or gods. Jainist monks are famous for their asceticism and indifference to pain. Jainists do not believe in absolute truths, and try to remain open-minded and nonjudgmental. They focus their attention inward and work toward the perfection of their own souls. To conquer oneself is to conquer everything.

resembles that of the Buddhists and Hindus, certain statues of nude, meditating *jinas* standing in stiff military poses are unmistakably Jainist. An ancient Jain text says the standing *jinas* should be shown "with posture straight and stretched, with youthful limbs and without clothes … the fingers reaching the knees." Their fingers are cupped inward but do not touch the legs.

A colossal image of this type of meditating *jina*, about 60 feet (18.3 m) tall, was erected on a high hill in Karnataka in the tenth century (FIG. 3.32). It represents a famous ascetic, Gommata, the second son of Rishabha, the first of the twenty-four Jain **tirthankaras** ("fordmakers" or "pathfinders"), spiritually advanced humans who achieved enlightenment and subsequently became spiritual guides for later Jainists. A Jain text tells how Gommata,

> plunged in the nectar of good meditation … was unconscious of the sun in the middle of the hot seasons … In the rainy season he was no more disturbed by streams of water than a mountain … He was surrounded completely by creepers with a hundred branches shooting up. Hawks, sparrows etc. in harmony with each other, made nests on his body … Thousands of serpents hid in the thickets of the creepers.

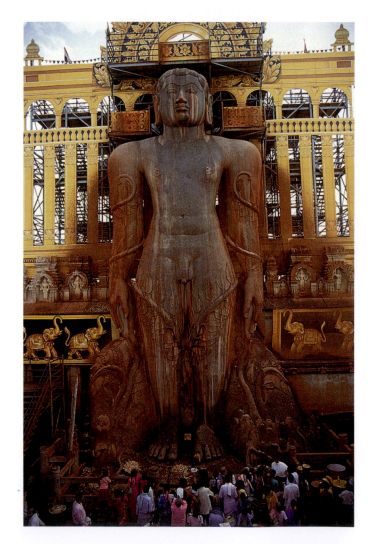

3.32 The Aesthetic Gommata. Indragiri Hill, near Shravanabelgola, Karnataka, India. 10th century. Basalt, height c. 60' (18.29 m)

Many Jainists use this image of Gommata and the many similar statues it inspired to help them in their daily meditation. Every twelve years, groups of nude monks, for whom Gommata is an important role model, bathe the colossus at Karnataka. The nudity of this and other Jain *jinas*, as well as the Digambara monks, is not intended to be sensual. In fact, it expresses quite the opposite—renunciation of the world and indifference to the needs of the body. The rigidity of the pose in which Gommata and the monks meditate, exposed to the elements of nature, expresses the severity of their asceticism and the discipline required to fulfill their religious goals. "Meditate on the oneness of the self alone," says a Jain text. "Thereby you will attain liberation."

While Jainism in its purest form preaches that material possessions enslave their owners, many of the finest Jain shrines and temples are very lavish. Ancient Jain texts explain in detail how the temples were to be built, giving the numbers, names, and proportions of the superimposed layers of the base and walls, and the system by which the compound tower is clustered. All the parts are interrelated by a precise system of mathematically determined ratios. Many Jain temples are cruciform, like those of the Hindus, and they have columned porches or *mandapas* around a small, enclosed sanctuary.

The finest Jain temples, such as those at the important pilgrimage site of Mount Abu, have highly ornate pillars and cusped arches with finely detailed carvings on their domed ceilings. From 1032 to 1233, as the Islamic kingdoms were expanding in India, the Jain artists at Mount Abu created some of the most important Jain monuments on this holy summit. The Jain love of wealth and finery is displayed in spectacular fashion in the white marble sculptures on the ceiling of the *sabha mandapa* (assembly hall) of the Vital Vasahi temple (FIG. 3.33). A profusion of radiating foliate and geometric forms provides a sumptuous background for the sixteen figures of women, the *maha-vidyadevis* personifying knowledge and forms of magic used in Jain rituals. All sense of the architectural structure is obscured by the pearly radiance of the seemingly weightless, embroiderylike white marble filigree. The very slender figures, with tubular limbs, blend well with the ornate background, expressing the Jain belief in the absorption of the individual into the patterns of the cosmos. The Jain sense of purity and lack of interest in sensual and material matters seem evident. The bodies of the *tirthankaras* and dancers in the outer circle are reduced to lean, simplified tubular forms. They are revered as models of existence, but worshipers ask nothing of them. The tremendous sense of concentration on the details of the foliate motifs is a reminder that, in addition to the self-denial practiced by the Digambara monks, the religion was also one of great theological complexity that appealed to royal patrons.

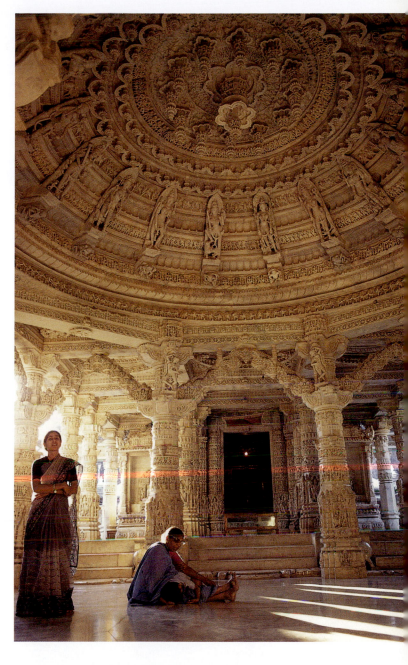

3.33 The Vital Vasahi temple, central ceiling of *sabha mandapa*. Mount Abu, Rajasthan, India. 1031. White marble

ISLAMIC INDIA

Islamic groups from Central Asia moving through the northern passes of the Hindu Kush began arriving in India around 1000 and, by 1200, Islamic dynasties or sultanates ruled portions of northern India from their capital at Delhi. Delhi became a great center for art and architecture as the Muslim traditions of Central Asia and Persia blended with those of India. In the early sixteenth century, a group of Turco-Mongol Sunnis known as Mughals, led by Babur

(ruled 1526–30), established a strong empire in northern India, with their main capitals at Delhi and Agra. They claimed to be descendants of two great conquerors, Tamerlane from Central Asia and Genghis Khan of Mongolia.

The Mughal leaders were temporarily expelled from India (1540–55) and took refuge in Tabriz, Persia, at the court of Shah Tahmasp, at about the time the latter was closing down his artists' workshops. When the Mughals reconquered parts of India, with Tahmasp's help, they returned with Persian manuscripts and artists who could no longer find work in Persia and laid the foundations for the magnificent Indo-Islamic style of manuscript illumination that emerged during the reign of Akbar (1556–1605). Akbar, who had studied Persian art and culture as a youth when his family was in exile in Tabriz, established a school of painting in India run by Persian masters who taught Islamic and Hindu students the techniques of Persian figure painting on paper. It is said that over one hundred artists in his entourage followed him from court to court in India as he reinforced his rule from one region to the next. Akbar also commissioned Mughal writers and artists to create fresh versions of such Persian classics as the *Shahnama*, which became the *Akbarnama* ("History of Akbar's Reign") in India.

In addition to Persian ingredients, the eclectic Mughal style of Akbar's court also reflects the growing presence of European art in India. By the end of the sixteenth century, Europeans had established trading posts there, were mixing with the Mughals at their court functions, and were introducing them to their collections of European art. Seeing these works, the astute Akbar told his artists to study European prints, drawings, and paintings and see what they could learn from them. Rather quickly, they began to use the Western techniques of modeling, shading, and atmospheric and linear perspective on a limited scale. This would seem to coincide with the growing interests of the Mughal artists and patrons in portraiture, nature, and contemporary events.

We see the emergence of these new international ideals in a version of the *Akbarnama* illuminated in the royal workshop (1596–97). *Abu'l-Fazl Presenting the First Book of the "Akbarnama" to Akbar*, by Govardhan, represents a very recent event that had taken place while parts of this same *Akbarnama* had yet to be completed (FIG. 3.34). The geometric structure of horizontals, verticals, and diagonals in the architecture provides a framework for the composition and reflects the style of Bihzad and his Persian contemporaries. But the individual figures do not: These are semi-Westernized portraits of Akbar's entourage that show them gesturing and interacting rather than standing at strict attention at this historic moment. Unlike the flat cutout figures seen in earlier Persian illuminations, their faces and bodies are well modeled and they resemble painted statues.

The Indo-Islamic and Western ingredients that seem to work in harmony in the *Akbarnama* strike a somewhat different chord in a painting two decades later by Bichitr, *Jahangir Preferring a Sufi to Kings* (FIG. 3.35). In it, Jahangir (ruled

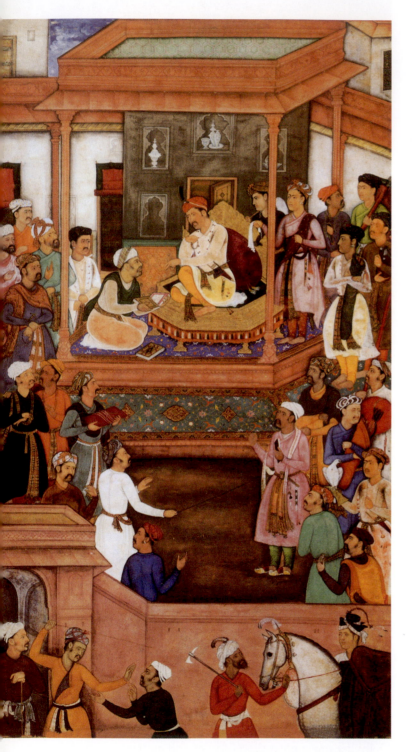

3.34 Govardhan, *Abu'l-Fazl Presenting the First Book of the "Akbarnama" to Akbar*, from the second *Akbarnama*. c. 1596–97. 9¼ × 5¼" (24 × 13.5 cm). Dublin, Chester Beatty Library

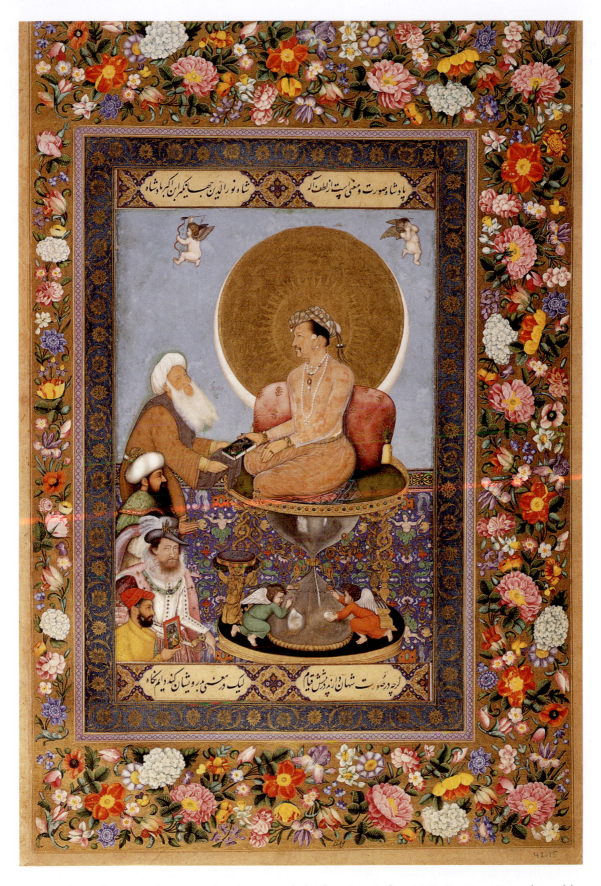

3.35 Bichitr, *Jahangir Preferring a Sufi to Kings*. Mughal, Jahangir period, c. 1625. Opaque watercolor, gold, and ink on paper, 10 × 7⅛" (25.4 × 18 cm). Freer Gallery of Art, Smithsonian Institution, Washington, D.C.

1605–27) is seated against a cushion over a large hourglass tended by a pair of *putti* as he presents a book to Shaykh Husayn, keeper of an important shrine near Jahangir's palace. The halo or nimbus behind Jahangir, which incorporates a flaming sun and crescent moon, is reminiscent of the ones behind the Buddhas of the Gupta period, such as the example from Sarnath (see FIG. 3.13). But, in his attempt to add secondary figures to his narrative, Bichitr has crowded three portrait figures into the lower left-hand corner of the image, so upsetting the balance of the picture. The black-bearded man is an Ottoman ruler whom Timur, Jahangir's ancestor, had conquered about two centuries earlier. Below him is James I of England, copied after an English portrait of the king seen in India. At the very bottom of this "pile" of mismatched and overlapping bust-length figures, the Hindu holding a small image of himself bowing in respect may be a self-portrait by the artist. The scene appears to represent Jahangir making a grand gesture in the presence of these powerful leaders, demonstrating his reverence for the spiritual life over worldly matters. One of the *putti* above turns away from Jahangir, the other covers its eyes in reaction to Jahangir's audacity as he turns to a spiritual leader in the presence of the great rulers.

Examining the sands of time, one of the *putti* writes: "Oh Shah, may the span of your life be a thousand years." But Jahangir, who was addicted to wine laced with opium, died in 1627, about three years after this miniature was completed. The brilliant traditions of Mughal painting began to decline under his son Shah Jahan (ruled 1628–58), who was a great patron of architecture. Although the name of his architect, Ahmad Lahawri of Lahore, is not well known, the tomb he built near Agra in northwestern India, the Taj Mahal, is by far the best known icon of Mughal Indo-Islamic culture (FIG. 3.36).

THE TAJ MAHAL

The Mughals also developed a very distinctive style of architecture, most notably monumental tombs featuring rows of pointed onion-shaped arches and tall bulbous domes set in large gardens with reflecting water channels. Appropriately, it would seem, many of these tombs resemble that of Timur, also known as Tamerlane or Tamburlane, the founder of the Mughal dynasty of rulers. It and many other early Mughal tombs were built largely of unadorned sandstone, a relatively dark and nonreflective stone. That reserved funerary tradition was destined to change after 1631 when Shah Jahan, the son of Jahangir (see FIG. 3.35) and the fifth Mughal emperor (r. 1627–58), lost his third wife, Mumtaz Mahal ("Light of the Palace"). Unlike most earlier Mughal tombs, hers, the Taj Mahal ("Crown of Palaces") (1627–58), is built of gleaming white marble that embodies the "light" she brought to the shah's world. It is also decorated with finely designed calligraphy, abstract decorative forms, and lively, meandering vegetative motifs made of semi-precious inlaid stones.

Sparing no expenses to create his memorial, Shah Jahan appointed an international assembly of thirty-four architects, designers, and artists, which included Ottoman Turks and Persians, who directed twenty thousand workers at Agra using materials transported from the far reaches of the Mughal Empire by a thousand elephants.

Visitors go into the complex through an outer southern gate, an open green area, and then another much larger inner gate, before they enter the large, symmetrically arranged formal gardens with reflecting pools and finally have a full view of the famous mausoleum on a podium flanked by a mosque and large guest house. The outline of the Taj Mahal's gracefully proportioned central dome is echoed by the four smaller domes, the superimposed arches on the corners of the building, and the crowns of the surrounding minarets. The dome, mounted on a tall drum, remains visible as visitors approach the monument, as do the four smaller cupolas around it set on octagonal bases perforated with scalloped arches. The rich network of interlocking domes and the rhythm of the tall, gracefully pointed arches below them give the Taj Mahal a sense of visual unity from all vantage points; it has long been world-famous for this. Seeing the dome reflected in the waters around the tomb, it calls to mind a favorite Hindu motif—a lotus bud floating on the water.

The ground plan suggests a square with beveled corners or an irregular octagon. All the gracefully arched openings lead to intermediate chambers and, ultimately, to the cenotaphs of the shah and his wife under the dome. Approaching them, one moves from the outside spaces, to the partially enclosed and shadowy vaults, to the maze of darker and narrower corridors and rooms within, and, finally, to the funeral chamber where the cenotaphs are enclosed by an octagonal wall. The actual tombs are located on a lower level.

Patterns of floral ornaments around the central arch, inlaid in black marble and semi-precious stones, mix with shadows lightened by reflected sunlight from the marble terraces and the shallow pools, giving the entire structure

3.36 Taj Mahal, near Agra, India. Mughal, Shah Jahan period. Completed 1648
Pollution from a nearby oil refinery is discoloring the white marbles of the Taj Mahal, giving them a yellowish cast. With the decline of the water table in this area, the foundations of the building have also begun to shift, cracking some of the marbles and tilting the minarets.

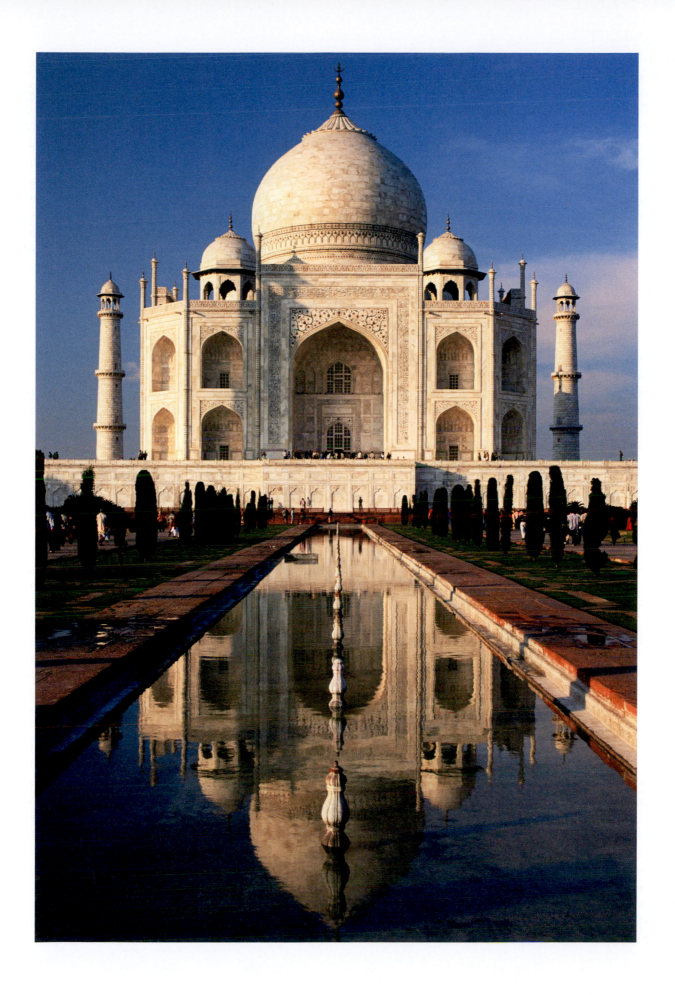

a soft, dreamlike quality. All the color contrasts and decorative motifs—flowering plants in low relief—are highly restrained. The smooth, unpolished white crystalline marble has a translucent quality and reflects the sunlight in such a way that for centuries visitors to the Taj Mahal have insisted that it is blue in the morning sun, white at noon, and yellow at dusk. Qur'anic inscriptions in the Taj Mahal tell us it represents the throne of God over the gardens of Paradise on the Day of Judgment. But no mere mechanical and formal analysis of the monument's design can do justice to the experience millions of visitors have had of its beauty over the ages, which has made the Taj Mahal one of the most admired buildings in the world.

In its seeming perfection, the Taj Mahal is one of those universal monuments that seems to transcend the regional and period style to which it belongs. As the tomb of a woman who was neither descended from the Prophet nor an important political figure, the monument lies well outside the traditions of Muslim patronage in the arts. Moreover, scholars do not agree who designed the tomb. Shah Jahan designed some of the buildings he commissioned and worked with the board he established to design it, but the Taj Mahal does not look like the work of a talented amateur or a committee. Such a subtly integrated mixture of earlier Persian, Turkish, and Hindu architectural features is more likely the work of an inspired master architect. Perhaps it is fitting that this timeless, celebrated monument to the shah's love of a woman and glory of Allah's Paradise continues to escape attribution to the hand of any known human being.

> Like a garden of heaven a brilliant spot,
> Full of fragrance like paradise fraught with
> ambergris.
> In the breadth of its court perfumes from the
> nosegay of sweethearts rise.
> <div align="right">(Shah Jahan on the Taj Mahal)</div>

The original plan included a bridge over the river to connect the tomb with a matching black marble funerary monument for Shah Jahan, which was never constructed. In 1658, when the shah fell ill, his son Aurangzeb took over the throne and confined his father to the Red Fort of Agra. Aurangzeb was a devout Sufi, and after many generations during which Islamic law had been interpreted liberally in Mughal India, he instituted more orthodox forms. Banning music and painting in the court, Aurangzeb forced many musicians and illuminators to leave and look for employment with the provincial Muslim and Hindu governors and nobles. Thus, under Aurangzeb's rule, the Mughal traditions in the arts in India began to decline, and by the early eighteenth century, the great age of Mughal art there was over.

LATE HINDU ART IN INDIA

While Hindu art languished in many parts of India under Muslim rule, it flourished in the south under the Nayak rulers at Madurai in the sixteenth and seventeenth centuries. The Minakshi-Sundareshvara temple at Madurai, with temples to Shiva and the goddess Minaksi, was built under a great Nayak patron of the arts, Tirumalai (ruled 1623–59). It is an enormous complex of columned courts and covered corridors arranged within a network of enclosing walls and containing an estimated 33 million sculptures. As such southern temple complexes were expanded and surrounded by taller and longer walls, the attention traditionally lavished on the central *vimana* was redirected to the *gopuras* (entrance towers) at the cardinal points along the outer walls. *Gopuras* in southern India may be up to 300 feet (91 m) tall, are visible from great distances, and, like the tall towers on Gothic cathedrals, they provide landmarks for pilgrims on their way to worship in the temples. The *gopura* of the temple at Madurai, derived from early *vimanas*, is divided into levels or stories of diminishing size and has graceful concave or bowed outlines that give an impression of great lightness (FIG. 3.37). The latter effect is further created by the fact that the sculptors worked with painted stucco. The iconographic schemes surrounding the thousands of reliefs and sculptures in the round on the *gopuras* may be very complex ones, but, to date, these sculptures have not been photographed in their entirety and studied systematically, so it is impossible to tell just how complex those schemes may be.

While the collective effects of the sculptures and paintings in this and other Nayak temples are fascinating, perhaps the most innovative examples of Hindu art from this late period are painted illustrations accompanying new types of Hindu texts written in the vernacular. In the past, such works had been written in Sanskrit, knowledge of which by this date was restricted to a small audience of priests and nobles of the brahmin caste. But even those who were illiterate could listen to the stories and epics when they were read in the vernacular languages. The content of the new literature was also "popular." Often, it described romantic encounters of the gods and humans, stories interesting in themselves, and ones with important religious messages about the all-important bonding of the human soul with the gods through love. This idea was not new in India: Traditionally, the devotional cults (*bhakti*) had used images to visualize deities and bond with them, but in the vernacular the illustrated narratives had a new appeal.

Two of the favorite lovers in the literature and art of this period were the herdsman-warrior Krishna (a manifestation of Vishnu) and a lovely herdswoman, Radha. Their

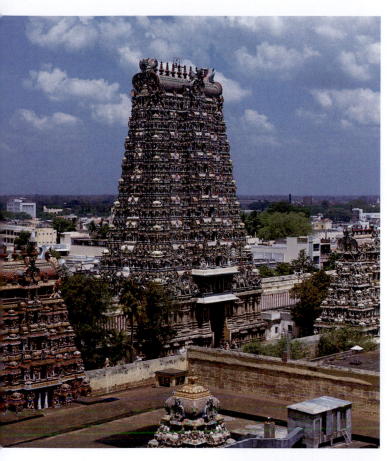

professions enabled the artists to depict the lovers in gorgeous pastoral or bucolic settings, which may have been influenced by the landscapes in Persian miniatures and Western paintings, but only marginally—the artists have added their own sense of fantasy. *Radha and Krishna in the Grove* was painted in Kangra in the Punjab hills during the rule of Sansar Chand (1775–1823), a great patron of miniature painting (FIG. 3.38). The lovers lie on a bed of plantain leaves in a grove near a river. As they touch one another, nature blossoms forth around them. To the left, a vine that has wrapped itself around a tree in another act of coupling rises toward pairs of lovebirds in the branches.

In 1805, when Chand's kingdom was under attack by mountaineers from Nepal, he appealed to the British for help. The British East India Company had been gaining power in India since the eighteenth century. This and subsequent military involvements in the country strengthened the British position there and laid the foundations for the official British rule of India (1858–1947), which introduced new ideas that challenged the traditional forms of native Indian art and culture. While the Hindus and Muslims in India continued to produce traditional forms of art in colonial India, as Western influences grew, some artists created hybridized Eastern–Western works of art that reflected that period of rapid cultural change.

3.37 (ABOVE) *Gopura* from the Minakshi-Sundareshvara temple, Madurai, India. 17th century

3.38 (RIGHT) *Radha and Krishna in the Grove*. Kangra, India. c. 1780. Paint on paper, 5⅛ × 6¾″ (13 × 17 cm). Victoria and Albert Museum, London

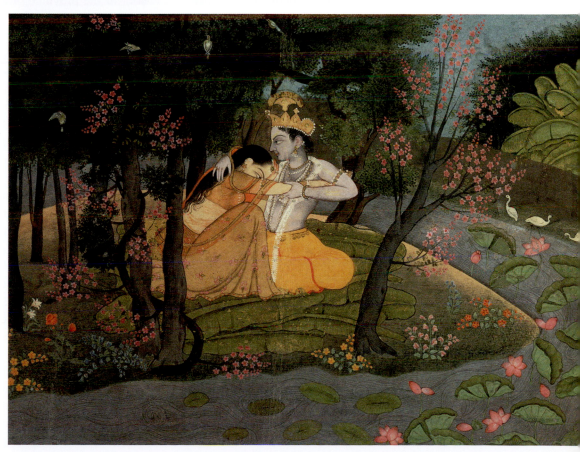

COLONIAL INDIA

In 1858, Queen Victoria assumed the title Empress of India and, for nearly a century thereafter, native Indian artists were forced to deal with myriad issues created by the presence of the British as rulers of their country. Under the Mughals, European art had been an exotic curiosity that was imported and enjoyed without being properly understood or fully incorporated into the culture. Under the British, however, art became part of a much broader program to Westernize and Anglicize India. With the industrial and technological superiority of the British, along with their political hegemony and actions as patrons of the arts, came a tacit assumption that everything British, not least in the arts, was superior to its Indian equivalent. In the late nineteenth century, the most influential British artists and patrons in India had a strong preference for portraiture and historical painting, commissioning aggrandizing images of events from the past that carried moralizing or ethical messages. When it came to domestic architecture, many wealthy Britons wanted to live in palatial Neoclassical homes that expressed the authority of Greco-Roman and European thought, including the philosophy of colonialism.

As in many parts of Asia and elsewhere in the non-Western world where colonial European governments were established at this time, the native artists were pulled in several directions. Was it best to become fully Westernized, or should they ignore the foreign traditions and continue to work in their traditional native styles? Or were there ways to select the best from both traditions, to find some middle ground where they could satisfy the needs of both cultures? But was this middle path progress, or a form of capitulation? Could they become partially Westernized and maintain their self-respect? Indian art underwent many changes as it tried to tackle these issues, a process that cannot be viewed in simplistic terms, e.g., as reflecting an inferior tradition attempting to assimilate and imitate a superior one. The artists and their patrons in India were not passive and had many, varied individual responses to the art of their foreign rulers.

Many late nineteenth-century Indian artists were English-speaking, pro-Western thinkers who embraced European art. Art schools teaching Western techniques and ideals were established as part of the British effort to spread their traditions of learning, "improve" native tastes, and generally "humanize" India. Students, mainly young men from upper-caste families, made drawings and paintings after Western works or art, including copies of masterpieces, and plaster casts of famous sculptures. Working with oil paints or exploring printmaking, many found that the European techniques of linear perspective, anatomical rendering, and modeling allowed them to make images of the world around them that would have been impossible to create using traditional Indian painting techniques and materials. Even the perception of the artist's status in India changed as the aristocrats who controlled matters of taste replaced traditional artisans with highly skilled individuals pursuing their own ideals. Meanwhile architects began to work in the Neoclassical style, creating mansions for the rulers, who often filled them with European art.

Within this milieu, one artist rose to great prominence. Although he has since been criticized by some for making work that is overdramatic and sentimental, he had a profound influence on Indians' perceptions of the great national epics and the gods. Ravi Varma (1848–1906), who was called a "prince among painters and a painter among princes," did not work in the traditional Indian manner, as an artisan tied to a powerful patron and a single region. Instead, he became a European-style artist-entrepreneur, a professional society portrait painter who was at ease among all classes, Indian and British. Using a network of agents and associates, he moved about the country, and his work was always in demand wherever he went. In essence, Varma succeeded in building a bridge between the Indian and European traditions and created a new and popular image of the modern Indian artist.

Born in the province of Kerala to an aristocratic family related to the rulers of Travancore, Varma saw examples of Indian and European art as a youngster and took painting lessons from an uncle. His early works from the 1870s tend to be flattened and matter-of-fact in style, like those of many other Indian painters of the early colonial period, without the chiaroscuro, richness of illusion, and the drama of the paintings that would follow after 1880. Varma's British and Indian audiences alike admired his romanticized historical paintings based on the Sanskrit classics for the grandness of their style and the loftiness of their messages. In *The Triumph of Indrajit*, Varma adopts the time-honored figure types, gestures, and compositions of European history painting to illustrate a narrative from a Sanskrit classic (FIG. 3.39). The characters, their dress, and the architecture are Indian, but composition and technique owe much to European history painting, especially the British painters of fancy-dress oriental fantasies. For Varma, an avid theater-goer who enjoyed Indian and British dramas in Bombay and Madras, this European genre helped him restore the dignity of his people's past.

A genius at self-promotion, Varma was the first major Indian artist to use inexpensive printing techniques. With them, he reproduced his images of Hindu deities and legends which thus found their way into almost every home in India. His interests in popularizing Hindu thought were

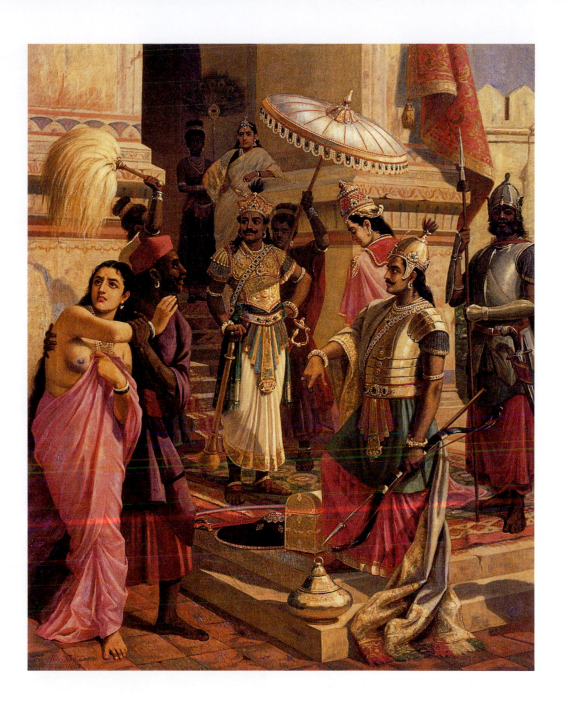

3.39 Ravi Varma, *The Triumph of Indrajit*. 1903. Oil on canvas. Sri Jayachamarajendra Gallery, Mysore

part of a growing pan-Indian nationalism and, along with his millions of prints, the Indian gloss he added to European salon-style historical paintings contributed immensely to the development of twentieth-century Hindu identity. So great was the fame of this well-connected image-maker that his own life became surrounded by myths as colorful as those he painted. As the romantic image of the artist-hero who forged new paths through the colonial world, triumphing over all obstacles, Varma became the model for many Indians searching for their identity in a changing world.

The death in 1906 of this national hero who had transcended class, region, and ethnicity ended the so-called "optimistic phase" of colonial art in India. In the rapidly changing political and social climate of early twentieth-century India, Varma's posthumous fame proved very short-lived.

Well before his death, advocates of *swadeshi* (Sanskrit, "own country" or "self-sufficiency") were part of the Indian independence movement, which began in the nineteenth century and culminated in the work of Mahatma ("Great Soul") Gandhi. They were battling against the Eurocentric thinking of the British who generally held Indian culture in low regard. Many of them opposed Varma and others who embraced Western art so willingly and lovingly. Some of the writers who were part of the Bengal Renaissance, centered in Calcutta, called for artists to reject European conventions, to examine their own past, and to find new,

optimistic Hindu-Indian identities within their own heritage. In their search for a modern Indian identity, Bengal writers and others were also beginning to question some ancient Hindu ideals such as the caste system.

One of the champions of the *swadeshi* movement in the visual arts, Abanindranath Tagore (1871–1951), was the son of a wealthy, high-caste family in Calcutta. Raised among the literati of the Bengal Renaissance, who included members of his family who were devoted to the recovery of ancient Indian culture, Tagore inherited a love of traditional Indian cultural forms, including book illustration. Most of the imagery he employed was drawn from the rich past of Indian literature, Hindu legends, and myths, but, unlike Varma, he did not turn to the techniques of Western art to illustrate them. Instead, he developed a hard-edged style of painting, essentially colored drawings, featuring Hindu subjects based on Mughal and Hindu miniatures, folk art, and ancient Indian murals. Tagore was interested in other Asian cultures and studied Japanese paintings and woodblock prints, becoming fascinated by the way they simplified and abstracted forms to their very essence. Works such as *Bharat Mata*, an image of Mother India as a Bengali lady, provided the *swadeshi* movement with icons around which it could crystallize its beliefs and feelings (FIG. 3.40). Living under British rule, its followers had a strong romantic, primitivist longing to recreate a pre-industrial and purely Indian society. As for Tagore, his legacy goes beyond his own art—he was famous as a teacher and his pupils became some of the most influential artists, teachers, and art-school administrators in early twentieth-century India.

Like Varma, Tagore's eminence in the arts was soon eclipsed, and well before his death. In the 1920s, abstract styles of European modernist painting and sculpture arrived in India. Since these avant-garde works were part of a Western rebellion against the classical traditions of the past—values that were part of the philosophy of colonialism in India—the abstract art styles were welcomed and widely imitated by the emerging avant-garde in India.

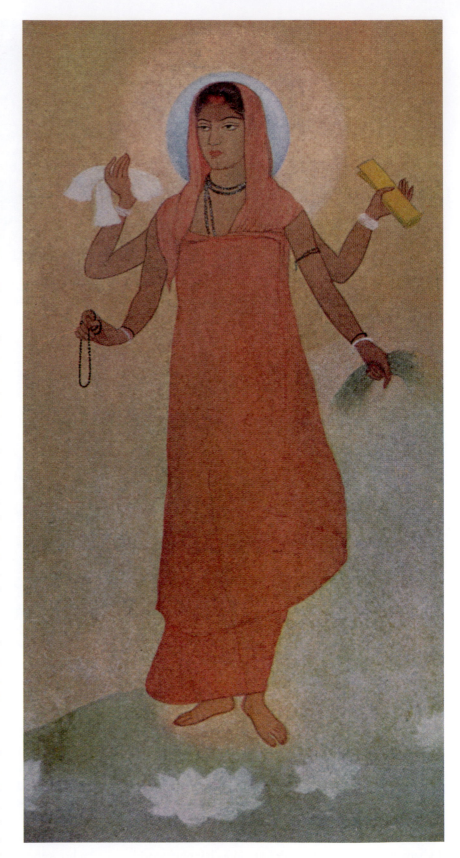

3.40 Abanindranath Tagore, *Bharat Mata*. 1903–04. Watercolor on paper, 10½ × 6″ (25.67 × 15.24 cm). Rabindra Bharati Society, Calcutta

MODERN INDIA

Following India's independence in 1947, art students trained in these Western forms of abstraction and the more recent ideals of Abstract Expressionism began to add ideas and forms from their own heritage to their practice in an attempt to develop styles that were both authentically Indian *and* modern. Perhaps the most prominent of this group was an artist called Maqbool Fida Husain (1915–2011). He studied calligraphy and worked as a filmmaker, illustrator, and sculptor of children's toys before concentrating on painting. The toys he created are part of an ancient folk tradition in India in which villagers make pottery, simple images of local spirits, and other inexpensive works for sale in the neighboring markets.

We see these folk images along with others drawn from many periods of Indian art history in Husain's 1994 painting *Vedic* (FIG. 3.41). Figures including a seated, cross-legged one meditating to the right, a wind-tossed rider on a pair of elephants, and men battling a giant serpent are arranged on a shallow, stagelike space, and act out the epic of modern India's past. But Husain's works are never simple illustrations of the Indian ethos of his day; they are dreamlike, surreal images that reflect a collective cultural memory in which the artist uses the "isms" of Western art schools to create an authentically Indian and modern style of painting.

Film has also become an important modern art form in India, which is home to the largest movie industry in the world. Centered in Mumbai (formerly known as Bombay), it has been nicknamed Bollywood after Hollywood, but it is in no way an imitation of the U.S. film industry. Its films deal with specifically Indian social issues and generally feature traditional Indian forms of music and dance. As such, film has become part of a much broader attempt in India to bring traditional elements of the land's deep cultural heritage into modern life.

Around 2000, the Indian government inaugurated a program called "India Vision 2020," which was designed to make the country fully competitive in the global marketplace by that date. To publicize the ambitious project, Dr. A.P.J. Abdul Kalamby, president of India at the time, commissioned a monument that would tell the world that India was no longer the tradition-bound nation of the past, but that it was progressive, modern, and ready to become a major global player. The enormous Akshardam Swaminarayan Temple Complex in New Delhi was completed in 2005, and very quickly began attracting more visitors than the Taj Mahal (FIGS. 3.42, 3.43).

The basic plan of the new temple resembles that of many great Hindu temples of the past. That, however, is where the similarities end. The twenty-first-century temple does not honor Shiva like the Kandarya Mahadeva temple in

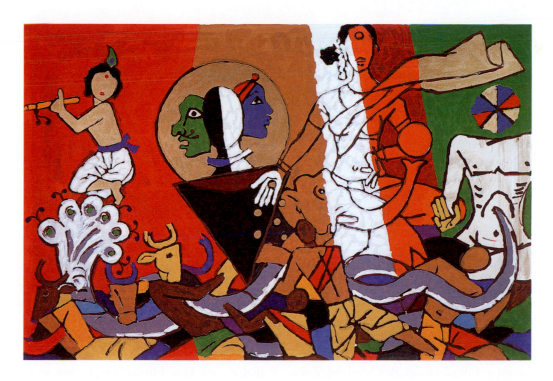

3.41 Maqbool Fida Husain, *Vedic*, from the *Theorama* series, 1994. Limited-edition color print, 23½ × 36" (60 × 92 cm). Private collection

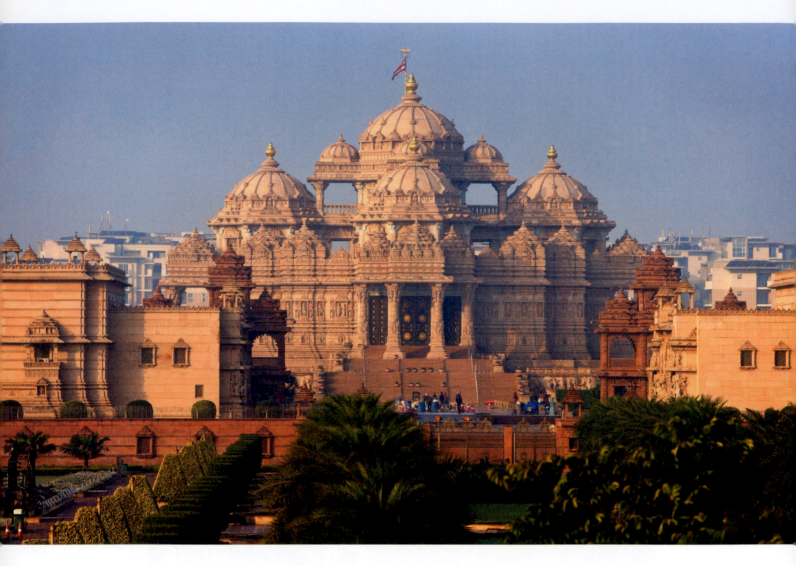

3.42 The Akshardam Swaminarayan Temple Complex, New Delhi, completed in 2005. Dedicated to Swaminarayan (1781–1830), a holy man who created a new, modernized sect of Hinduism while India was under British rule

Khajuraho; rather, it is dedicated to Swaminarayan (1781–1830), a holy man who created a new, modernized sect of Hinduism.

A member of the brahmin or priestly caste, Swaminarayan was schooled in religion and philosophy at an early age and recognized as a sage or *yogi* at age seven. In his teens, he undertook a seven-year pilgrimage to visit the great masters and monuments of Hinduism. Thereafter, he ministered to the poor, spoke against the ancient and restrictive caste system, said that all people are equal in the eyes of God, and condemned the ancient rite of *sati* (burning widows on their husbands' funeral pyres) as an unholy form of suicide that was not sanctioned by the Vedas. During his lifetime, Swaminarayan's followers included Muslims, Zoroastrians, and officials in the British imperial government who embraced his severely ascetic but highly tolerant sect of Hinduism. After his death, Swaminarayan was regarded as a divine incarnation of Krishna or Narayana. With such universal appeal, the hard-working, deified Hindu humanitarian was a perfect icon for India to promote in its quest to be seen as a modernized Hindu nation and player in the global marketplace.

In traditional Hindu fashion, the Akshardam Swaminarayan temple rests on a high plinth supporting a small forest of pillars carved with images of flora, fauna, musicians, dancers, and deities. All the work was done under the watchful eyes of *sadus* ("good" or "holy men"), many of whom were *yogini* and authorities on the *Vastu Shastra* or *Vastra Veda* ("Science of Construction"), ancient Hindu texts that dictate how Hindu temples are to be oriented, constructed, and embellished with works of art. The decorated pillars support a ring of vaulted roofs and domes encircling

a high central dome, under which images and symbols of important Hindu gods are normally displayed. In the Khajuraho temple, this all-important place in the very heart of the structure houses a Shiva *lingam*. Here in the Swaminarayan temple, however, we find a monumental *murti* (devotional statue) of Swaminarayan ringed by statues of deities and gurus (inspired teachers with supreme knowledge of god and creation).

Not far from the *murti*, a 27-foot (8.2 m) image of the young Swaminarayan stands outside the Hall of Values where robotic figures and dioramas tell the story of his pilgrimage years. Nearby, an IMAX theater shows visitors a short film of that holy venture. Displays in the Garden of India represent important Hindus from the past, including women and children, reminding visitors that Swaminarayan said that all people are equal in the eyes of God. Quotes from famous people throughout history whose wisdom

supports that of Swaminarayan are engraved on stones in a sunken lotus-shaped garden, located near the Akshardam Center for Research in Social Harmony, where scholars work in accordance with Swaminarayan's universal values and ethics. Peacock-shaped boats carry visitors along an artificial river through displays of Indian history tied to the ministry of Swaminarayan. The trip concludes with a message of hope that links the wisdom of the great *yogi* with the politics of "India Vision 2020."

SUMMARY

The major religions developed in India—Brahmanism, Hinduism, Buddhism, and Jainism—derive from the Indian philosophical writings of the first millennium BCE. Members of all the religions use yoga, a form of meditation and discipline for the mind and body. As part of their meditation, many of them practice *darsana*, visualizing the gods. Indian art, which gives visual form to these gods, likewise helps worshipers in this process of visualization. Temples and other places of worship not only provide homes for images: They are microcosms of the Buddhist, Hindu, and Jain worlds. Viewing the art, meditating, and moving through the temple spaces, devotees can make symbolic journeys along spiritual paths through these religious universes, transcend the material world of illusion, and enter the transcendental realms.

With their powerful messages and spectacular forms, the arts of India spread in all directions north as far as Afghanistan and Tibet and southeast to Indonesia. Some Buddhist art in Afghanistan along a spur of the Silk Road influenced the art of China in the fifth century CE, when that country was first embracing Buddhism.

While the arts of India spread beyond its borders, the country's art and architecture were also influenced from outside. For more than nine hundred years, Muslim art has been a very important part of Indian history, and under British rule the arts of India were heavily influenced by European styles and techniques. Indian artists found many productive ways to combine their heritage and Western art in a series of movements leading up to India's independence in 1947 and following it in the late twentieth century. In the twenty-first century, with "Vision India 2020," India has expressed its desire to be part of the global art world, and is once again blending the traditions of its past with its dreams for the future.

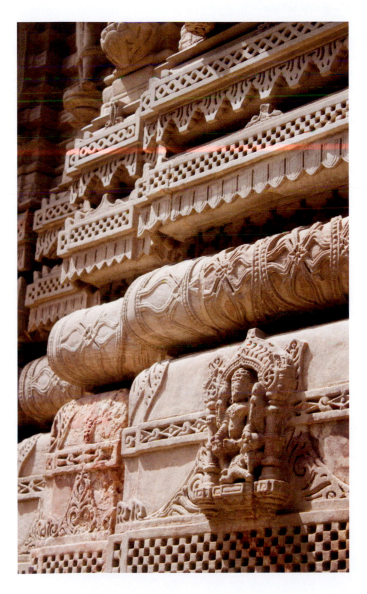

3.43 Detail showing decoration on the Akshardam Swaminarayan Temple Complex in New Delhi

GLOSSARY

ATMAN The interior self or soul within all sentient beings that returns to earth again and again through its reincarnation in human or animal form.

BHAGAVAD GITA Meaning the *Song of the Lord (Krishna)*. This seven hundred-verse scripture discusses many ideas basic to HINDUISM, including YOGA, *KARMA*, and *BHAKTI*.

BHAKTI Sanskrit, "To share in or belong to." A form of spiritual tranquility coming from one's bond with the deities through art. Also, the belief that freedom from the cycle of rebirth, *SAMSARA*, is possible through personal devotion to a deity.

BODHISATTVA Literally, "one who has *bodhi* (wisdom) as his goal." A *bodhisattva* is a Mahayana BUDDHIST who has forsaken the attainment of personal *NIRVANA* to help humankind.

BRAHMAN In Indian thought, an all-inclusive, universal, and eternal spiritual reality that extends to all temporal and divine beings. It is closely related to *ATMAN*, the self in all sentient beings, and *MAYA*, the illusory nature of all creation.

BRAHMANISM A term often used to refer to the ancient religious traditions in India based on VEDIC rituals. HINDUISM grew out of BRAHMANISM and other indigenous religious traditions. In part, the BUDDHIST and JAIN traditions are reactions to BRAHMANISM.

BRAHMINS An ancient, highly trained class of priests dating back to Vedic times who perform many of the Hindu sacrifices and rituals.

BUDDHA See under BUDDHISM.

BUDDHISM A religion that developed out of the teachings of Siddhartha Gautama (563–483 BCE) of Nepal, later called the Buddha ("the Enlightened or Awakened One" or "one who has gained wisdom"). He taught that, through meditation, one could achieve *NIRVANA*, the release from all earthly desires. The Buddha also developed a code known as the Eightfold Path (right views, right aspirations, right speech, right conduct, right livelihood, right effort, right mindfulness, and right contemplation). His teachings were a reaction against the older VEDA-based BRAHMANIC law with its caste system and hereditary class of priests. The early Theravada (School of the Elders) or Hinayana (Lesser Vehicle) type of Buddhism has long been associated with monastic communities. The Mahayana (Greater Vehicle) type of Buddhism, which appeared around 1 CE, is less severe and has long had mass appeal. Tantric Buddhism, also known as the Vajrayana (diamond vehicle) variety of Buddhism, taught that the female force (*shakti*) was the prime one in the universe because it could activate the male force. Lamaism is a Tibetan form of Buddhism adopted by the Mongol leaders of the Yuan period.

CHAITYA A BUDDHIST assembly hall and place of worship. Originally, rooms with tall vaulted roofs of bent saplings. Later, rock-cut cave-*chaityas* retained many of those features.

DARSANA Sanskrit, "sight" or "vision"; more specifically, a vision of the divine. It can also mean "to see with reverence and devotion."

DHARMA The natural law, its practice, and justice. In HINDU thought, it refers especially to duties performed for their own sake.

GARBHAGRIHA The central, cubic space (literally, "house of the womb") of a HINDU temple housing the primary image of that structure.

GOPURA An entrance gate to a HINDU temple. Often surmounted by a tall tower decorated with many superimposed levels of sculptures.

HINDUISM The name used since about 1800 CE for the many ancient and related Veda-based philosophical, religious, and cultural ideas that continue to flourish in and around India to this day. It is a collection of many sects with many names and belief systems, which at its core has sets of distinctive religious ideals shared by about a billion people who identify themselves as Hindus. Also, since the twelfth century, "Hindus" has been a cultural term used to designate the people of the Indian subcontinent.

JAINISM A religion founded by Mahavira (599–527 BCE), the last of twenty-four *TIRTHANKARAS* ("pathfinders") or *JINAS* ("conquerors" or "victors") from whom the religion took its name.

JINA ("conqueror" or "victor"). In JAINIST thought, a soul that has achieved the ultimate state of supreme being. Images of *jinas* usually show them standing in stiff military poses.

KARMA A Sanskrit word meaning "actions" performed in this life. Also, the cosmic record that determines the present and future status of an *ATMAN* in the cosmic cycle of *SAMSARA*.

LINGAM (plural, *linga*). Literally, "sign." A phallus, manifestation of Shiva. It may appear in the *GARBHAGRIHA* of a Hindu temple with a *yoni*, a female symbol.

MANDALA A symbolic diagram of the cosmos. In India, two- and three-dimensional mandalas are parts of the religious iconography of all the major religions. See also *GARBHAGRIHA* and STUPA.

MANDAPA An enclosed colonnaded porch in a HINDU or JAIN temple.

MAYA HINDUS believe that the material world around them, *Maya*, is an illusion.

MOKSA HINDU term for spiritual freedom from *SAMSARA*, the endless round of the *ATMAN*'s rebirth into human or animal bodies.

MUDRA Sanskrit for "mark" or "gesture." One of a repertoire of symbolic hand and full-body gestures by the Buddha and some *BODHISATTVAS* that convey certain ideas such as teaching, setting the Wheel of the Law in motion, blessings, and meditation. Also part of HINDU and JAIN thought, YOGA, and dance in India.

NIMBUS A large sun orb, often shown around the head of the seated Buddha, representing his universal spirit and the light the Buddha brings to the world. A device symbolizing spiritual power common to many religions and art traditions around the world. Also known as an aureole, glory, or gloriole.

NIRVANA Sanskrit, "to extinguish" or "blow out." The end of all earthly and afflicted

states of mind such as greed, hatred, or obsessive fixations. A BUDDHIST term for enlightenment, the awareness that all existence is impermanent and that one is no longer attached to it.

RASA A central concept in HINDU thought, referring to the emotions of joy and pleasure that the beholder may experience in response to the visual arts, music, poetry, and drama. Through *rasa*, the beholder becomes one with the creator and the art.

RATHA Literally, "chariot of the god." A HINDU temple or shrine.

SAMSARA Sanskrit for "continuous flow." A system of reincarnation in HINDU thought described in the *Brahmanas* and UPANISADS (c. 800–600 BCE) in which the *ATMAN* (interior self or soul) within all sentient beings returns again and again in human or animal bodies.

SANSKRIT An ancient Indo-Aryan language that occupies a position in Indian culture similar to that of Greek and Latin in the West.

SIKHARA Sanskrit, "mountain peak." The central tower of a Hindu temple. Often shaped with gently curving sides and resembling a tall, thin mountain. See also *VIMANA*.

STUPA BUDDHIST shrine and symbolic World Mountain or MANDALA, diagram of the Buddhist cosmos. A large hemispheric mound of earth enclosed by stone or terracotta brick used as a reliquary. It is ringed by one or more "railings" or "fences" (*vedikas*) with gates (*toranas*) and crowned by a square fence (*harmika*) enclosing a pole (*yasti*) supporting three-tiered umbrellas (*chattras*).

SUTRA Sanskrit, "thread" or "line." An aphorism, a concise, often cleverly worded statement, or a collection of aphorisms in the form of a manual. Often attributed to the Buddha or later followers. Sutras also appear in Hindu and Jain literature.

THANGKA Literally, "rolled-up cloth." A portable hanging scroll that could be rolled up and easily moved from one remote BUDDHIST monastery to another in the sparsely populated Tibetan highlands.

TIRTHANKARA "Pathfinder." See also JAINISM.

TRIBHANGA Literally, "three bends." A dynamic figure type in which the body is twisted to suggest tension and movement.

UPANISADS Sacred writings (c. 800–600 BCE) that extend the BRAHMANIC religious tradition of the VEDAS beyond the rituals performed by priests to include individual responsibility for one's relationship to the gods and life, including the practice of YOGA to discipline one's mind and body to secure release from the cycle of SAMSARA.

VEDAS Sanskrit for "knowledge." Aryan hymns and other ritual texts (c. 1400–1000 BCE) honoring the gods who control the forces of nature and human existence.

VIHARA Refectories and cells for Buddhist monks, occurring in both freestanding and rock-cut CHAITYAS.

VIMANA The high pyramidal or conical tower above the sanctuary in a southern Indian HINDU temple. Compare *SIKHARA*.

YAKSHI (*Yaksha*, male). Female fertility figures found in BUDDHIST and HINDU traditions and art.

YOGA A type of discipline of mind and body that may include exercise and *prana* (breath control). Yoga is common to many traditions in India and is designed to enhance mental control of the body and wellbeing.

QUESTIONS

1. How are the Hindu terms *rasa*, *bhakti*, and *darsana* related, and how do they explain the various ways the visual arts may be aids to worship?

2. Greco-Roman images of male gods and cultural heroes are usually athletic figures modeled after champions in the Olympic Games. By contrast, Indian images of the Buddha show him as a very soft and relaxed being. How does this express the power embodied by the Buddha?

3. The leaders of modern India revived and updated many time-honored ideas about religion and art from their Hindu past when they built the Akshardam Swaminarayan Temple Complex. Until the twentieth century, revivals of styles from the past had been important aspects of movements in the arts. Is there aesthetic potential in this twenty-first-century revival of Hindu art and architecture?

4. Yoga has been part of religious practices in India for over 2,500 years. Today, it is also a nonreligious practice. Are the purposes and benefits of the practice the same in both cases?

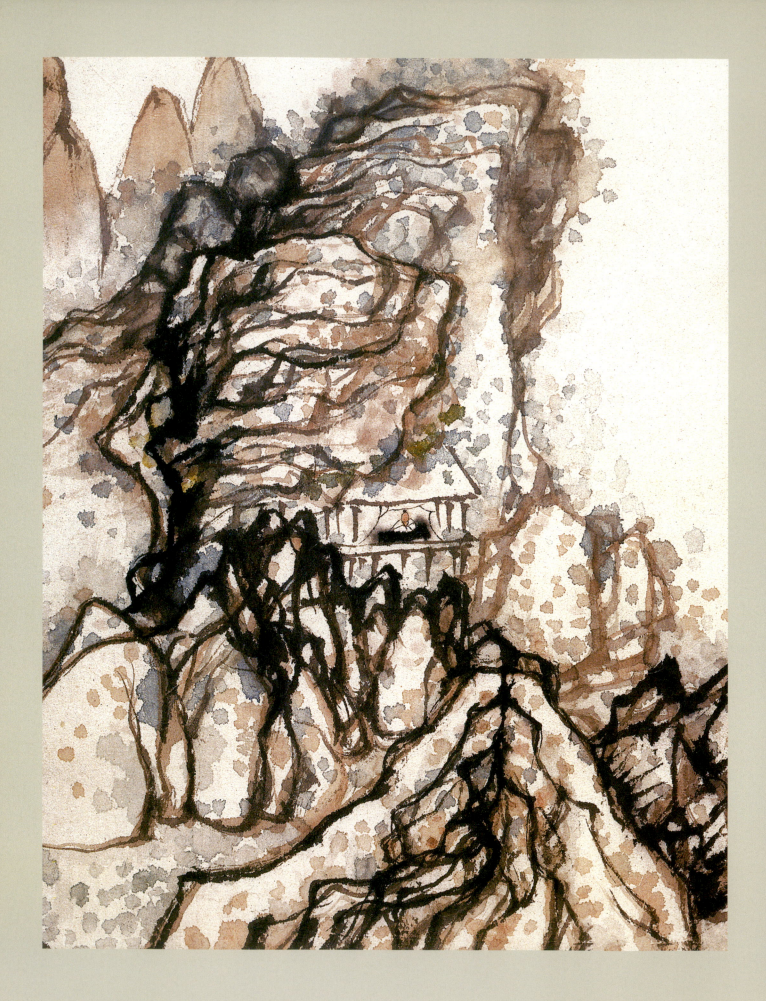

4 | China

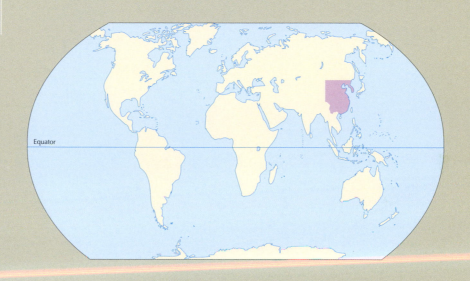

Equator

Introduction 108

The Neolithic Period
(c. 7000–2250 BCE) 110

The Xia Dynasty (c. 2205–1700 BCE)
and the Shang Dynasty
(c. 1700–1045 BCE) 111

The Zhou Dynasty (1045–480 BCE) 114

The Period of Warring States
(480–221 BCE) and the
Qin Dynasty (221–206 BCE) 115

The Han Dynasty (206 BCE–220 CE) 118

The Period of Disunity: Six Dynasties
(220–589 CE) 121

The Sui Dynasty (589–618 CE) and
the Tang Dynasty (618–907 CE) 124

The Five Dynasties (907–60) and
the Northern Song (960–1127)
and Southern Song Dynasties
(1127–1279) 128

The Yuan Dynasty (1279–1368) 132

The Ming Dynasty (1368–1644) 134

The Qing Dynasty (1644–1911) 138

Modern China (from 1911) 143

Summary 145

China

The traditional Chinese name for the country, Zhong-guo (Middle Kingdom), may date back to the Xia dynasty (c. 2205–1700 BCE). It envisions China as the middle or hub of the world, the place through which all power flows. The emperors, sons of heaven, mediated between the hub of the world, humankind, and the heavens. The modern name, China, comes from the name of the first imperial dynasty, Qin (pronounced "chin"), established in 221 BCE. The word "Sin" may also be derived from Qin and means "Chinese." Sinology is the study of Chinese art and culture.

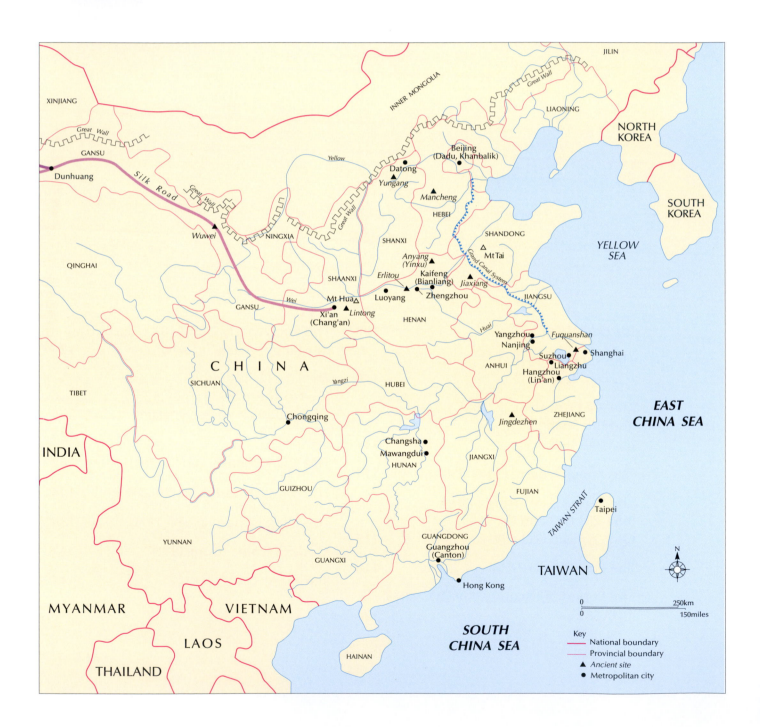

TIME CHART

Neolithic period (c. 7000–2250 BCE)

Xia dynasty (c. 2205–1700 BCE) [disputed, traditional dates]

Shang dynasty (c. 1700–1045 BCE)

Yinxu (Anyang), last capital of Shang dynasty (1300–1045 BCE)

Tomb of Lady Fu Hao (died c. 1250 BCE)

Zhou dynasty (1045–480 BCE)

Lao Zi (born c. 604 BCE) writes *Dao de jing* ("The Book of the Way")

Confucius (c. 551–479 BCE)

Period of Warring States (480–221 BCE)

Qin dynasty (221–206 BCE)

Qin Shihhuangdi (First Emperor) establishes Qin dynasty (221 BCE)

Capital at Xianyang, near Chang'an (modern Xi'an)

Han dynasty (206 BCE–220 CE)

Gaozu establishes Han dynasty (206 BCE)

Sima Qian, historian (136–85 BCE)

Period of Disunity: Six Dynasties (220–589)

Wei dynasty in northern China (388–535)

Wei capital moved to Luoyang (494)

Xie He writes, *Gu hua pin lu* ("Classification Record of Ancient Painters") (c. 500)

Sui dynasty (589–618) and Tang dynasty (618–907)

Capital at Chang'an

Invention of block printing in China (c. late eighth century)

Five Dynasties (907–60)

Northern Song dynasty (960–1127)

Capital at Kaifeng until 1127

Jin Tartars conquer northern China and capture the emperor-artist Hui Zong; surviving members of his court flee south and establish themselves at Hangzhou (1127)

Southern Song dynasty (1127–1279)

Genghis Khan unites Mongols (1206)

Polo family in China (1275–92)

Kubilai Khan conquers Hangzhou and establishes Mongol capital at Dadu (present-day Beijing) (1276)

Yuan dynasty (1279–1368)

Mongols subdue rebel remnants in the south and establish the Yuan dynasty (1279)

Ming dynasty (1368–1644)

Yongle emperor (ruled 1403–24)

Ming capital of Beijing established on the ruins of the Yuan capital, Dadu (1407–21)

Xuande emperor (ruled 1426–35)

Portuguese arrive in Canton (1514)

Qing dynasty (1644–1911)

Manchurians establish Qing dynasty (1644)

Opium Wars open ports to foreign trade (1839–42)

Taiping Rebellion (1851–64)

Boxer Rebellion (1900)

Modern China (from 1911)

Chinese Republic ends dynastic system (1911)

Chinese People's Republic established (1949)

Great Proletarian Cultural Revolution (1966–76)

The dynastic names given to historical periods are not the family names of the imperial lines. Some are names of locations identified with the establishment of the dynasty or the territorial title of the dynasty's founder. For example, the name of the Han dynasty comes from the official title "king of Han" (a region now in Sichuan province), which the first Han emperor held before he united the country and established his imperial line—as a result, the dynasty he founded was the dynasty of Han. Other dynastic names such as Yuan ("Primal"), Ming ("Bright" or "Brilliant"), and Qing ("Clear" or "Pure") refer to ideals that the particular dynasties felt they represented. Similarly, the names of emperors are titles representing ideals, such as the Xuande ("Proclaiming Virtue") emperor. This emperor's actual name was Zhu Zhanji, but his imperial reign title was Xuande. Before the Ming dynasty, an emperor might change his reign title several times in the course of his reign; therefore, pre-Ming emperors are not known by their reign titles, but by the titles given to them after their death and engraved on their ancestral temple. The Mongol emperor Kubilai Khan had two reign titles, Zhongtong (1260–64) and Zhiyuan (1264–94). History therefore calls him by his temple title, the Shizi emperor, and his two reign titles are used to denote eras within his reign; hence phrases such as "during the Zhiyuan era of the reign of the Shizi emperor."

INTRODUCTION

Note: This text uses the Pinyin ("spelled sound") system of transliterating the Chinese language adopted by the People's Republic of China in 1958, and later in Taiwan, where it is called the New Phonetic System. Pinyin has largely replaced the older Wade-Giles transliteration system.

Little remains of the ancient river-valley civilizations that developed along the Indus in present-day Pakistan, the Tigris–Euphrates in Iraq, the Nile in Egypt, and the Yellow, Wei and Yangzi rivers in China. In China, however, this early culture, with its centers in the north along the Yellow (Huang Ho) and Wei rivers and in the southeast near the Yangzi river mouth, has managed to survive in some form to modern times. It has often been said that the Chinese attached such value to their ancient cultural traditions that they were able to absorb or **Sinicize** (acculturate to Chinese ways) the foreigners who tried to conquer them, although it has to be noted that China's own art and culture changed greatly over the centuries as it absorbed foreign ideas and redefined its own traditions in light of them. China has traded with its neighbors by land and sea and has been invaded and ruled by foreign powers, and for nearly five hundred years Chinese artists have been exposed to outside art, including the modernist, abstract styles of the West and the Socialist Realist style originated in the Soviet Union and endorsed by the People's Republic. As a result, Chinese art has changed constantly, and each of the many periods in its long history has its distinct character. We can see the changing interests of the Chinese artists and their patrons in the archeological record, ancient inscriptions, and philosophical writings on art from the fifth century CE to the present day. To examine this developing tradition, we must look first at a number of important ideas about art, religion, and culture in general that developed at different times, ideas that will then be reintroduced and studied in detail where they apply in the pages that follow.

The Chinese believe that their deceased ancestors continue to exist in a spiritual form and that this gives their descendants access to the gods. Since the ancestors remain powerful after death, the living need to pay them respect and provide for their upkeep in the spirit realm. Today, this often takes the form of paper models of food, luxury goods, and money, which are burned so that they are transmuted to the spirit world. This tradition grew out of a much older one that by at least the Shang period (c. 1700–1045 BCE) required the furnishing of graves with all the implements that the deceased would need to carry on their lives in the next world. While the cities and palaces of the living from this period have long since vanished, tomb art remains plentiful, and much of what scholars know about early Chinese life comes from these "homes" for the dead.

This respect for tradition and other aspects of Chinese morality as it developed over the centuries from Shang times was codified in the teachings of Master Kong, known in the West as Confucius (c. 551–479 BCE). Confucius was born during a period of civil unrest when the Chinese were looking for ways to rebuild their ancient society, which they believed had been a reflection of a higher, universal order in nature. Confucius taught that people could regain this earlier sense of order by self-discipline, following the proper codes of behavior, and paying homage to spirit ancestors who had access to the wisdom of the gods. He called this ideal of perfect harmony **li**. Confucius's concept of *ren* ("human-heartedness") is embodied in his image of the ideal Chinese gentleman—an educated, broad-minded, loyal, respectful, and just individual with empathy and good etiquette or deportment. Confucian respect for age, authority, and morality made this philosophy a popular one among Chinese leaders and the artists they patronized for centuries to come.

While **Confucianism** might govern individuals' public life, **Daoism** ("The Way") provided important principles to guide their private or spiritual life. Daoism is a general term for the animistic beliefs that lie at the core of the Chinese understanding of the world and that seek an intuitive balance with nature. Daoist priests were often court diviners and shamans, and at various times the ideals of Daoism have been applied to a variety of local religious practices. The principles of Daoism recorded by Lao Zi ("Old One") (born c. 604 BCE) and elaborated by later writers teach one how to live in harmony with nature and the universe. Lao Zi's *Dao de jing* ("The Book of the Way") explains that the *dao* is embedded in the heart of nature. To experience the *dao*, one must find release from one's ego and become attuned to the flow of life. Through contemplation and spontaneity, Daoists may find this harmony with their natural instincts. In **ming**, the ultimate inward vision, the two vital forces of nature, the **yin** and the **yang** (female and male principles, represented by the moon and the sun), become one as the Daoist's sense of self and outer world dissolve into an experience of the oneness of all creation. The *yin* and *yang* are interconnected opposites that represent the ever-present principles of duality in existence, an idea that lies at the heart of Daoism and many other philosophical systems around the world. Together, the *dao* and *li* express complementary ideals of inward-spiritual and outward-societal harmony. Neither Confucius nor Lao Zi, however, commented directly on the arts and how the *dao* and *li* might shape them.

Buddhism, which arrived in China in the first century CE and became widespread by the fifth, introduced the Chinese to a new view of the cosmos, another pantheon of divine beings, and Indian styles of painting and sculpture. By the sixth century, a new sect of Buddhism, called Chan (later Zen in Japan), had appeared in China, which like Daoism stressed the importance of meditation, instinctive actions, and living in harmony with nature.

The works of the first Chinese art critics and aesthetes have been lost, but some of their thinking may be reflected in the earliest extant treatise on the philosophy of art by a painter named Xie He (active c. 479–502 CE). (See *In Context: Xie He and His Canons of Painting*, page 123.) His *Gu hua pin lu* ("Classification Record of Ancient Painters") includes a set of canons or principles of Chinese painting. The first calls for a "sympathetic responsiveness" to the **qi**, which in this context refers to the character or spirit of the painting. It is manifest in an artist's brushwork and expresses that individual's harmony with the flow of nature. The remaining canons stress the importance of instructing artists in the traditional techniques of Chinese painting so that they can become innovative within these traditions.

But how was it possible for Chinese art critics and philosophers such as Xie He to tell if an artist had a "sympathetic responsiveness" to the *qi* and was aesthetically superior to other artists? Over the next 1,500 years the independent amateurs and professional artists working for patrons often had differing opinions on this matter. The amateurs were almost always drawn from the Chinese elite, scions of great or wealthy families who had received an extensive education in preparation for careers in government service. These "scholars" were known as the **wenren** (**literati** or scholars), and many of them painted as an expression of their cultural refinement, given voice through their *qi*. They tended to denigrate the work of painters who worked for hire and who, while technically proficient, painted works devoid of *qi*. Some literati were Daoists and Chan Buddhists who believed they were enlightened instruments through which the spirit of nature could work. (See *Religion: Chan (Zen) Buddhism, Enlightenment, and Art*, page 129.) They believed that the academic court painters recorded nothing more than the simple, external appearance of nature while their own expressive works captured the very essence of nature, the *qi*.

The art of writing, calligraphy, developed concurrently with painting; a talented painter would often be an equally accomplished calligrapher. Using the same brushes as painters, calligraphers developed scripts that enabled them to work freely, often, as in painting, in a manner that allowed inventive "accidental" effects to happen, ones that gave their calligraphy meaning (revelation of the *qi*) beyond that of the words they "painted." For the owner of such a work,

displaying a fine example of calligraphy held the same prestige as displaying a fine painting.

Traditional Chinese calligraphers often work very slowly, then, after prolonged periods of meditation, they may break forth in sudden flashes of inspiration, wielding their brushes with the speed and skill of professional swordsmen. A new script developed in the eighth century CE was called "crazy drafting script" because its long, meandering, fragmented, or "running" characters were often scarcely legible. But examples of this script were highly valued because, in their freedom, they suggested a sense of oneness with the flow of nature—that the calligraphers were following the *dao* and responding sympathetically through their *qi*.

Similarly, the finest Chinese ceramics almost always have something of this sense of spontaneity and revelation about them, especially those made in the twelfth century for the courts of both the Northern (960–1127) and the Southern (1127–1279) Song dynasty. These imperial wares were simple but highly refined in form, and coated with thick glazes of subdued colors that took on distinctive **crackle** patterns after firing in the kiln. As in calligraphy, the "accidental" firing effects appealed to refined Chinese tastes, and they were often valued above vessels that had been meticulously painted with detailed and colorful images.

Four of Xie He's principles stress matters of technique and the importance of copying works from the past and show Xie He's respect for Confucian values. These values are manifest in the Chinese architectural traditions where each new Chinese temple is a close copy of older temples.

Few ancient Chinese buildings have survived, but clay models have been preserved in early tombs from the Han period (206 BCE–220 CE), indicating, for instance, that the basic design of the Foguangsi temple at Mount Tai in Shanxi was already a very old one when it was constructed in 857 CE (FIG. 4.1). The latter is a post-and-lintel structure. Rows of evenly spaced posts or poles support elaborate sets of brackets, which in turn support the lintels on which the ceramic tiled roof with its curved, upswept eaves is mounted. Over time, the bracketing system became more complex; the inner rows of poles in the Foguangsi temple have four such brackets, and the outer poles carry sets of levers that reach out beyond the brackets to support the overhanging roof and its heavy tiles. The carefully fitted brackets, along with the upturned or flared tips of the roofline, are enduring characteristics of Chinese architecture through the ages. The structural parts are joined with **mortises and tenons**, an ancient and very simple method of connecting two pieces of wood in which a tenon, or projecting part, from one piece is inserted into a mortise, or cavity, of corresponding size and shape in another. The two pieces may be pinned, glued, or wedged to make the connection permanent. As

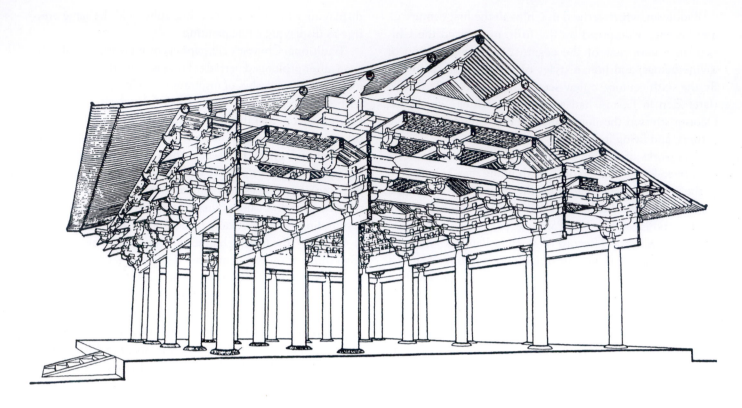

4.1 Isometric view of the timber-framing, Main Hall, Foguangsi Buddhist Temple. Mount Tai, Shanxi. c. 857 CE

such, the fittings are not perfectly rigid, and the temple will give slightly in high winds and earthquakes, thus remaining in harmony with the elements of nature and not breaking in the face of them. Nearly a thousand years later, the imperial builders at Beijing followed the same canonical rules of design and construction—they too obeyed Xie He's directive to copy the masters of the past.

Thus we see calligraphy and architecture reflecting two sides of Xie He's thought that incorporate the ancient Daoist and Confucian ideals. Though new scripts were being developed and calligraphers might work through flashes of inspiration, the fundamentals of the Chinese system of writing remained much the same. As architects experimented with details of the architectural order illustrated in the Foguangsi temple, the basic elements of the post-and-lintel system of construction changed little. Builders, calligraphers, and painters alike, respecting the *dao*, *li*, and importance of the *qi*, created aesthetic variations within ancient lines of thought. This spirit of search, discovery, and refinement within traditional parameters would seem to characterize the ideals of the Chinese artists throughout the ages. Artists found ways to sustain elements of ancient Chinese traditions of thought and technology within the changing world around them and thus created a long-lived tradition that has lasted for over four thousand years.

THE NEOLITHIC PERIOD (C. 7000–2250 BCE)

The transition from a nomadic hunter-gatherer existence to a sedentary one based on farming began around 7000 BCE with the domestication of millet, rice, and pigs. Many of the early Neolithic Chinese societies developed in the warm and humid southeast, around the mouth of the Yangzi River, and in the north along the Yellow and Wei rivers. The Yellow River is so named for the large quantities of yellowish silt it carries much of the year.

Neolithic ceramists in the north working with clays deposited by the Yellow River painted a wide variety of golden-brown vessel types with dark brown geometric forms and schematic images of animals. But the most spectacular works from this time are the nephrite (commonly known as jade) carvings of the Liangzhu culture in southeastern China. These included beautifully colored jade animals, replicas of functional weapons, and two abstract geometric forms, which later Chinese writers called the **bi** (circular) and the **cong** (rectangular). The hardness of jade, which could be worked only slowly through a laborious and time-consuming process of slicing and drilling with abrasives, made this stone a symbol of religious and

secular power in later times. We might guess that it was used in religious rituals and other ceremonials in Neolithic times, and associated with ideals of power, but we do not know the precise meanings the *bi* and *cong* held for their original audiences.

Perhaps the most mysterious of these jades is the *cong*, a rectangular stone with a large hole through its center and boxlike registers at its corners (FIG. 4.2). Unlike most early Chinese jades, the *cong* is not a copy of any known everyday Neolithic object. In some cases, the registers frame the heads of monsters with large round eyes, broad noses, and fangs. Occasionally, a schematized human figure may appear behind a monster head as if holding it. Similar head types appear in later Chinese art and may represent guardian figures. While it is tempting to interpret the early art of China or any other culture in terms of what is known about the later art of that tradition for which written documents may exist, cultures change over time and this is therefore not a safe practice. In the absence of written records for Neolithic art, the meaning of the *cong* and other jade pieces may never be known.

4.2 Jade *cong*. Liangzhu culture, from Fuquanshan, Jiangsu. c. 2000 BCE. Width 6″ (15 cm). Fuquanshan, Jiangsu

THE XIA DYNASTY (C. 2205–1700 BCE) AND THE SHANG DYNASTY (C. 1700–1045 BCE)

The Bronze Age in China began around 2205 BCE with the rise of the semilegendary Xia dynasty in northern China around the Yellow and Wei rivers near present-day Kaifeng and Zhengzhou. The Xia (c. 2205–1700 BCE), whose historical existence remains clouded in uncertainty, may have developed the technology to cast bronze (an alloy of tin and copper) and built walled palace cities such as Erlitou. Chinese records tell of a King Tang who overthrew the Xia and established the Shang dynasty (c. 1700–1045 BCE).

The Shang used an early Chinese script that is the direct ancestor of the one in use today. Their religion combined veneration of animistic deities and shamanistic rituals with a very strong cult of ancestor worship. It may have included sacrificial rituals to appease the dead spirits and enlist their help. Shang royalty may have been linked with a supreme god, Shang Di, who lived in *Tian* (heaven) and controlled the forces of nature.

The massive earthen walls of an early Shang metropolitan center (c. fifteenth or fourteenth century BCE) lie beneath present-day Zhengzhou. The ancient city was more than 1 mile (1.6 km) in diameter and had special districts for artisans. However, little remains of this and the other great ancient capitals of China. With plentiful supplies of timber and other perishable materials, but very little good building stone, the imperial cities so praised by writers throughout Chinese history regularly fell prey to fires and vandals. Thus, ironically, in the country that has many of the oldest surviving cultural traditions in the world, virtually nothing remains of its many large capitals, some of which rivaled their well-known contemporaries (Babylon, Athens, Rome, Constantinople, Cairo, and Paris) in size and splendor. Much of our information about early Chinese art comes from royal tombs, which have yielded rich treasures, including thousands of lacquered items, paintings, and sculptures in wood, stone, jade, bronze, and other precious metals.

The last Shang capital and royal burial center at Yinxu (modern Anyang) (1300–1045 BCE) had palaces or temples on raised platforms, and it has provided the only known undisturbed royal tomb from this period. It belonged to a consort of King Wu Ding, Lady Fu Hao (died c. 1250 BCE), whose name appears on bronze vessels and inscribed bones.

By the Shang period, the Chinese envisioned the afterlife as an extension of this life and equipped their royal tombs to be functioning homes for the deceased. Tombs such

as that of Lady Fu Hao were deep pits over which walled buildings were constructed to house rituals honoring the dead person. For many centuries, treasure hunters have used long, pointed metal poles to probe the rockless silt in this region and search for unmarked graves, damaging or simply destroying invaluable archeological resources. Fortunately, they did not find the tomb of Fu Hao. Its scale and opulence give a sense of what other royal tombs of this early period may have once housed. It contained horses, dogs, about 440 cast and decorated bronzes (originally containing food or drink), six hundred jades, chariots, lacquered items, weapons, gold and silver ornaments, ivory inlaid with turquoise, and about seven hundred cowrie shells (a Shang form of coinage). Silks found in Shang tombs may have been shrouds for the deceased. (Sericulture, the complex techniques for rearing silk worms and producing silk, was perfected in China by about 4000 BCE.) Skeletal remains of twenty-two men and twenty-four women (executed servants or captives?) were also discovered in Fu Hao's tomb along with the axes used to behead them.

The magnificence of this royal burial illustrates the wealth and power of the Shang leaders and the reverence they owed to their deceased royal ancestors and the past. Grave goods from this period often included Neolithic jades and replicas of other pre-Shang art forms. Bronze vessels used in banquets where offerings were made to the ancestors and gods were buried with high-ranking dead so that they could continue these rituals of life after death as they acted as intermediaries between the natural and supernatural realms of existence. (See *In Context:* Chinese Writing, opposite.)

The Shang leaders who so admired metal art probably controlled the workshops that designed and cast over thirty distinctive types of ritual bronze vessels. Many of the bronzes were derived from existing ceramic or wooden prototypes, while others appear to be Shang inventions. Given the religious importance of the bronzes, the complexity of the techniques by which they were manufactured, and the wealth of their symbolically charged decorations, it is possible that bronzeworking masters had the status of shamans or priests. (See *Materials and Techniques:* Chinese Piece-mold Casting, page 114.)

Like many Shang bronze vessel types, the popular ***ding***, a vessel with three feet for cooking, is derived from a well-known Neolithic ceramic type (FIG. 4.3). The rounded, rectangular scrolls and animal forms on this and other Shang bronzes, as well as the ceramics and small hard stone sculptures of this period, may have been developed in pre-Shang times for use on wooden objects painted with lacquer. A highly stylized face type on this and many other Shang bronzes, the so-called ***taotie*** (ogre or glutton mask), may

represent a number of gods and monsters—guardians that protected people from evil spirits or masks worn by shamans who claimed to be able to transform themselves into such ogres. The mask, which is formed by the conjunction of two profile faces with prominent beady eyes, can also be read as a flattened face viewed from the front. The reappearance of this frontal-profile face in the much later arts of the Maori of New Zealand and the Native Americans of the northwest Pacific coast and Mexico raises an important question: Was it diffused across the Pacific, or reinvented independently in the South Pacific and the Americas? So-called diffusionists, who believe there were significant contacts between Asia and the Americas through the Pacific, say the former. But, in some areas of the Americas, there is archeological evidence for a separate local line of development, and many scholars believe the forms were invented independently in several areas. The question thus remains open.

The blue, green, and reddish **patinas** so loved by modern collectors of ancient Chinese bronzes are an accidental phenomenon; they result from the interaction of the bronze with minerals in the soils around the tombs. Originally, the bronzes would have been highly polished; some were also brushed with black pigments that remained in crevices to accent the lustrous colors of their reflective metal surfaces.

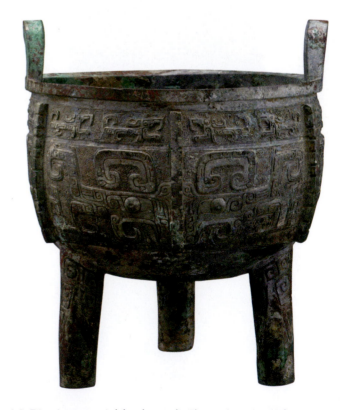

4.3 *Ding* (ceremonial food vessel). Shang dynasty, 11th century BCE. Bronze, height 8⅜" (21.27 cm). Seattle Art Museum

CHINESE WRITING

Before the rise of modern societies and widespread literacy, the written word and the ability to read were signs of religious and secular power. An early shift in Chinese culture that replaced military leaders at the center of government with an elite group of educated, literate officials endowed writing, art, and philosophy with a special importance in Chinese society. The value of writing as a tool to organize and unify China, which often had a large empire, was magnified because of the unusual nature of written Chinese. Unlike Western systems of writing, it is not alphabetic; Chinese characters or signs combine pictographic, ideographic, and phonetic devices that stand for words and ideas, and not for sounds.

Because writing was not tied to any of the different language groups and diverse dialects of Chinese, individuals who could not communicate through speech could do so through writing. Today, the thousands of Chinese signs can be understood by speakers of all the Chinese languages and dialects, many of which are not mutually intelligible. And although both spoken and written Chinese have changed over time, the written language has provided a strong thread around which elements of Chinese thought have been preserved. This script, which crossed linguistic and historical barriers, made it possible for all Chinese to share religious, philosophical, and artistic traditions with each other and subsequent generations. The durability of Chinese culture may be tied in part to this unique system of writing and thought.

Early forms of the script are found on Neolithic pottery and oracle bones (often chicken bones, shoulder blades of oxen, or pieces of tortoiseshell) in Shang tombs (FIG. 4.4). After being marked with written messages and questions such as "Will the king be victorious in battle?" they were heated in fires until they cracked. The crackle patterns were then examined by **shamans** who could divine the future through them. Many of the earliest written characters are pictographs that resemble objects in nature, but by historical times they had become more stylized and abstract.

If, as the many surviving examples of writing on oracular bones and shells suggest, writing emerged in China as a means of divination and communication with the spirit world, for a time thereafter, as in many societies around the world, it most likely remained the prerogative of an elite within the ruling minority. By the time of the first empire of Qin Shihhuangdi, literacy had almost certainly spread to the merchant classes. The Chinese script in its traditional form was codified in the Qin and Han periods (c. 221 BCE–220 CE). The tremendous importance attached to the written word and its appearance might also explain why calligraphy emerged as an early and lasting art form of major importance in China.

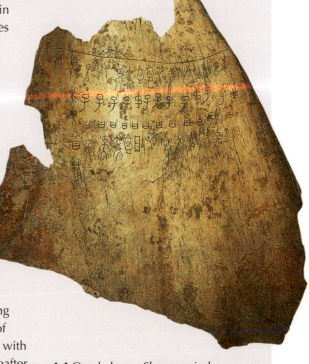

4.4 Oracle bone. Shang period, c. 1766–1122 BCE. The British Library, London

Unlike the simple lines of the *ding*, another bronze form called a **yu** usually has a very complicated sculptural form, using intricately entwined human and animal figures, decorated with miniature scrolls and serpentine forms. The ultimate source of this decorative vocabulary may be the so-called "Animal Style" of Central Asia. Central Asia is a vast region of deserts, mountains, and arid lands stretching over 4,000 miles (6,440 km) across the largest landmass in

CHINESE PIECE-MOLD CASTING

The Chinese techniques of piece-mold casting appear to have been developed independently from the lost-wax method used in Western Asia, the Mediterranean, and China after about 600 BCE (FIG. 4.5). To make a bronze vessel, the sculptor began by producing a fully detailed clay model of the vessel. After the model had dried and hardened, pieces of soft clay were pressed against it to create a negative mold of its shape and decorations. When dry, the mold was removed in sections, touched up, and fired to give it greater strength. The model was then shaved down and the pieces of the negative mold were reassembled around it, leaving a thin space between the model and the mold. Mortises, tenons, and spacing devices were used to hold model and mold in place. Another outer layer of clay was added to strengthen the mold and ducts were cut to receive the molten bronze and release gases as the bronze was poured into the cast. The molten bronze filled the spaces between the model and mold,

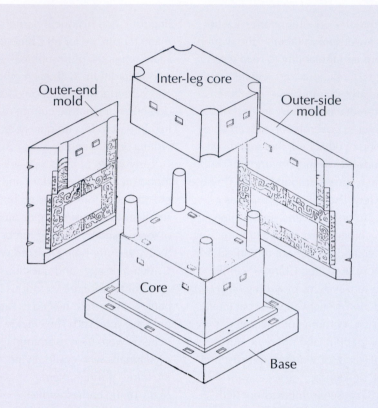

the spaces corresponding to the thin layer of clay that had been shaved off the model. After the metal cooled, the outer cast was removed and the surface of the bronze was touched up and polished with abrasives. Even

4.5 The piece-mold casting technique

among modern industrial societies, few bronzecasters have been as skillful at piece-mold casting as the Shang technicians.

the world, from Mongolia and western China to the Black Sea. The systematic study of the art of the early nomadic and seminomadic peoples living in this sparsely populated land is still in its infancy, and little is known about the earliest phases of its development.

The patterns and rhythms of the decorations are carefully arranged and integrated to accent and complement the shapes of these vessels, enhancing their appeal as tense, compact, and energetic sculptural forms. Such sophisticated forms, coupled with the skillful use of the complicated bronzecasting techniques, represent the climax of a long period of formal and iconographic development that may date back to pre-Shang times.

THE ZHOU DYNASTY (1045–480 BCE)

An inscription on a Zhou bronze says that Wu Wang, a Zhou leader from the west, conquered the Shang dynasty in 1045 or 1050 BCE. The Zhou established their capital at Xi'an on the Wei River. Under Zhou rule, Chinese culture was transformed from a mixed agricultural-hunting society with an animistic form of religion dominated by shamans to a highly organized urban and feudalistic society with a hierarchy of priestly and secular authorities. Absorbing the artistic traditions of the Shang, the Zhou gradually changed

the fluid contours of the Shang bronzes into much larger vessels with boldly projecting three-dimensional forms and decorative inlays of precious metals. This love for expansive and dynamic forms, already evident in the late Shang period, is carried to extremes in a tall *yu* of the tenth century (FIG. 4.6). Zhou sculptors created many such new forms with increasingly complex and irregular profiles that expand the formal vocabulary of the Shang tradition. In the eighth century BCE, the Zhou lost some of their western lands to foreign invaders. The following period, as regionally based aristocratic families started to create their own kingdoms, proved highly creative, particularly for work in bronze and jade.

Even though most of the Chinese jades were imported from Central Asia and Siberia, in ancient times as well as modern, jade has been closely associated with the mainstream of Chinese art and philosophy. By the late Zhou period in the time of Lao Zi and Confucius, the Chinese philosophy of jade was fully developed. An ancient Chinese text called the **Yijing** ("The Book of Changes"), widely known as the *I Ching* in the Wade-Giles system of transliteration and containing wisdom dating back to at least the Zhou period, as well as explaining early Chinese views of the cosmos, discusses the

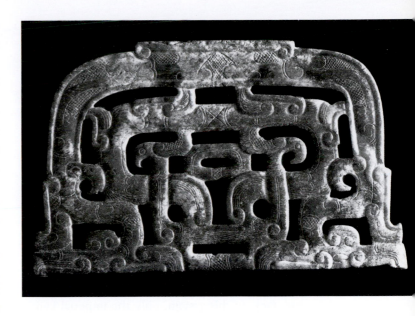

4.7 Plaque with interlaced dragons and birds. Eastern Zhou dynasty. Jade, width 1¾ × 3″ (4.8 × 7.5 cm). The Cleveland Museum of Art

divine qualities of jade, which is thus said to be the perfect material for the carving of objects used in religious rituals. Confucius summarized the importance of jade in the **Liji** ("Book of Rites"), explaining that the ancients had equated the gleaming surface of jade with benevolence, its luminous quality with knowledge, and its unyielding nature with uprightness. He also said that jade is compact and strong, like intelligence, that it symbolizes truthfulness because it does not conceal its own flaws, and that it is like moral leadership because it can pass from hand to hand without blemishing.

All of these qualities may have been understood by the artist who carved this plaque with interlaced dragons and birds (FIG. 4.7). The late Zhou hook motifs covering the web of scrolls on the plaque are derived from those used on Chinese bronzes for more than a thousand years before. Its design can be read in a twofold manner: The solid areas may represent the undulating bodies of dragons, while the interacting pattern of the open spaces can be read as a grinning *taotie*.

THE PERIOD OF WARRING STATES (480–221 BCE) AND THE QIN DYNASTY (221–206 BCE)

After the Zhou rulers lost some of their western lands to nomads from the west in 771 BCE, they moved their capital east to Luoyang on the Yellow River. By 480 BCE their rule was effectively at an end, and China entered the Warring

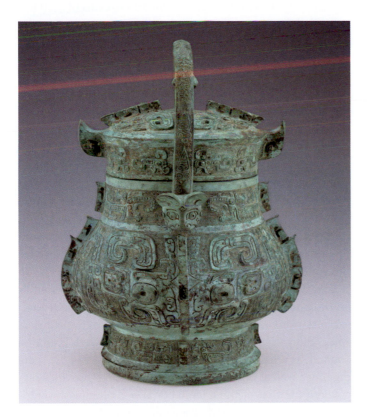

4.6 *Yu*. Early Zhou dynasty, c. 10th century BCE. Bronze, height 20⅛″ (51 cm). Freer Gallery of Art, Smithsonian Institution, Washington, D.C.

States period (480–221 BCE) as feuding regional Chinese warlords battled for control of the country. Eventually, China was reunited in 221 BCE under King Cheng of the Qin kingdom from the western edge of the old Zhou kingdom. Cheng and his associates followed a harsh philosophy or school of law known as Legalism, which had grown out of the turmoil of the Warring States period. It was an extreme form of absolutism—unquestioned devotion to the king—which eventually broke the power of the feuding regional factions. Cheng's empire was roughly twice the size of the old Zhou state, and he took the name Qin Shihuangdi (August First Emperor of Qin). Once Cheng had conquered all the feudal kingdoms that had comprised the old Zhou state and its neighbors, he established a new form of government in which power was centered completely on himself as emperor and was not shared with the landed feudal aristocracy. In this system, only the imperial family had true hereditary governing privileges. Within the Qin imperial government there was an aristocratic class, as there would be in all successive imperial dynasties, but its privileges and titles were determined not so much by birth as by the emperor's whim. Qin Shihuangdi also instituted a structure of ruling through government bureaus whose sole loyalty was to the imperial throne. From the Qin period onward, these officials would increasingly be chosen on the basis of their merit—their knowledge and experience—rather than their birth. In time, this would entirely erode the concept of hereditary aristocracy, as those able to pay for the education required to qualify as a government official were drawn from all classes, not simply from the great landed families.

The emperor's bloody conquests were followed by a period of extreme totalitarianism. He executed some of his political opponents and established other ruling families in replicas of their palaces in a district 7 miles (11.25 km) long near his capital west of modern Xi'an, where they could be closely watched. Qin Shihuangdi banished some of the Confucian scholars, buried others alive, and burned Confucian writings that did not support his new political program. The rich literary past of the Shang and Zhou periods was thus forced underground, where it survived in oral traditions and hidden texts as the emperor instituted history's first recorded literary inquisition. Under the subsequent Han dynasty, the *Shiji* ("Record of the Historian") by Sima Qian (died c. 86 BCE) salvaged what remained of these ancient works; Sima Qian also wrote a history of the Qin dynasty and the first part of a history of the illustrious Han dynasty under which he served.

On the positive side, as an absolute imperial sovereign or emperor, Qin Shihuangdi was able to mobilize resources on a much larger scale than any of his predecessors. He established standard forms of script and coinage and set up a system of government that lasted, with some variations, until the twentieth century. Qin China may also have been the first country in the world to base its economy on large-scale factories in which workers performed specialized tasks to mass-produce goods. A slightly later record from the fourth century CE lists the tasks of twelve workers and supervisors involved in the production of a lacquered and painted wooden cup decorated with gilt bronze.

Since China was vulnerable to attacks by Mongolian horsemen to the north, the emperor united and enlarged the sections of walls built by earlier feudal lords along the frontier dating back to the fifth century BCE, laying the foundations for the creation of the Great Wall of China (*changchen*, "Long Wall," as it was known locally), which was greatly enlarged in the dynasties that followed.

THE TOMB COMPLEX OF QIN SHIHHUANGDI

According to Sima Qian, the construction of the tomb of Qin Shihuangdi employed 700,000 workers and was marked by a mound over 600 feet (183 m) high. Sima Qian also said the emperor's tomb contained a network of underground rooms with mountains and streams of mercury propelled by waterwheels and ceilings representing the heavens. Although the tomb has not been opened since its rediscovery in modern times, the description is plausible. The tradition of building funerary buildings beside tall mounds over deep, multiroom tombs dates from late Zhou times. Some emperors in the Han period (206 BCE–220 CE) built tombs with two or three high-vaulted chambers that resembled sections of the palaces in which they had lived. Qin Shihuangdi's funerary mound, originally surrounded by an inner and outer wall, also follows the concentric and symmetrical pattern of construction used in the Chinese imperial cities, including that of Beijing, which was built 1,700 years later. As such, the tomb precinct reproduced the Qin image of the cosmos, the world of the gods where the emperor lived on after death.

Like Homer's *Iliad* and *Odyssey*, which were regarded as mythological fantasies about early Greek leaders and their exploits until modern archeology proved their historical value, Sima Qian's descriptions of the tomb were long discounted as reflecting colorful legends. But, in 1974, workers digging a well at Lintong near Xi'an in Shaanxi province discovered the first of three large burial pits filled with sculptures from the Qin period near a tall mound. Before the roof collapsed in what is now known as Pit 1, the army, numbering over eight thousand lifesize, polychrome, terracotta soldiers, stood at attention, in correct formation, according

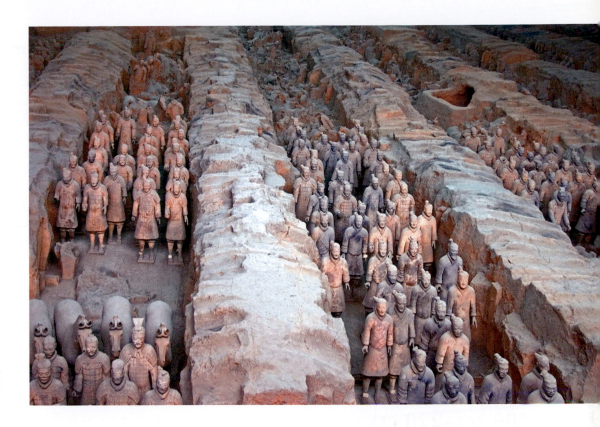

4.8 Tomb of Emperor Shihhuangdi, with terracotta, lifesize figures. Lintong, near Xi'an, Shaanxi. 221–206 BCE

to Chinese military procedures described in contemporary texts (FIG. 4.8). The somewhat smaller Pit 2 contained more than 1,400 chariots (some inlaid in gold and silver), bronze horses, archers, infantrymen, and cavalry (FIG. 4.9). A much smaller group of elite special forces was discovered in Pit 3.

The artists and helpers called upon to produce this incredible spectacle used a modular system of production and prefabricated molded body parts. The plinths, legs, torsos, arms, hands, and heads were cast separately, painted, and joined. Finishing touches were added to the costumes

4.9 Four-horse chariot and driver from the tomb of Emperor Shihhuangdi. Lintong, near Xi'an, Shaanxi. 221–206 BCE. Painted terracotta, bronze, gilt and gold; 10'6" × 3'2" (3.2 × 0.96 m)

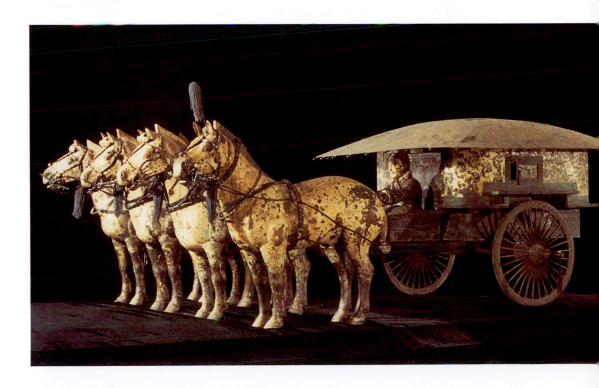

and faces in a thin layer of fine moist clay on the surfaces of the mold-made parts. The simplified volumes and rigid poses of the four horses drawing the gilt-bronze chariot seem to express the militarism of the emperor's reign, which did so much to reorganize war-torn China and establish its cultural and political traditions.

Many of the faces seem to be studies of the diverse ethnic types that made up the imperial forces, drawn from throughout the empire. Were these statues conceived as actual portraits so that the spirits of the individuals shown would accompany the statues and serve the emperor? The emperor seems to have wanted his entire court and army to accompany him in effigy in the afterlife. However, shortly after Qin Shihhuangdi's death in 206 BCE, the citizens of the empire revolted against his harsh but weak successors. Undaunted by the emperor's protective army of effigies, rebels entered the tomb pits, burned the wooden poles and roof, and buried the soldiers along with the memory of the short-lived dynasty.

THE HAN DYNASTY (206 BCE–220 CE)

In 202 BCE, Liu Bang, a peasant, was elevated to the status of emperor and became known as Han Gaozu (Exalted Emperor of Han), the founder of the Han dynasty. Building on the imperial ambitions of Qin Shihhuangdi, the Han dynasty went on to create an empire that reached into Central Asia and rivaled the size and splendor of the roughly contemporary Roman Empire in the West. The Han designed large capital cities (long since vanished) aligned to the points of the compass and conceived as diagrams of the universe. The noble residents of these cities moved around the palace and the emperor, who, like the sun, occupied the center of the Han cosmos.

Zhang Qian, an envoy to Central Asia (138–126 BCE) for Emperor Wu Di (ruled 141–87 BCE), helped open the trans-Asian Silk Road, a 5,000-mile (8,000 km) trail connecting the heartland of China to India, Iran, and the ports of Tyre and Antioch on the Mediterranean Sea. Over this road, caravans of two-humped Bactrian camels transported enormous quantities of silk and lacquered goods to the West in exchange for silver and gold. The Han emperors also opened up sea routes to Burma and India.

Like their Roman contemporaries in the West, who gave Europe a shared language and visual culture, the Han rulers shaped the character of the region's art and culture for centuries to come. While the West continues to write with the Latin alphabet and script, the modern Chinese say they use "Han characters." And while the Romans were converting

Hellenistic thought into the philosophy of Roman imperialism, Han intellectuals were reviving the pre-Qin teachings of Confucianism and Daoism and fusing them into doctrines that supported the ideals of their imperial leaders as other aspects of Chinese thinking about religion and art became increasingly complex. While little remains of the wooden palaces, temples, and murals in the great Han capitals mentioned in the literary sources documenting these changes, the tombs of this period have preserved important examples of the Chinese pictorial arts. In them, the philosophies of Confucianism and Daoism, as well as Chinese legends and folklore, clearly provided artists with their inspiration as the visual arts expanded in scope and scale to express the grandeur of Han rule.

THE TOMB OF THE LADY OF DAI

One of the best examples of Han painting, an image of the Han cosmos, comes from the tomb of the Lady of Dai, near the city of Changsha in Hunan south of the Yangzi River. ("Lady," a Western term, indicates the roughly equivalent European rank of this Chinese woman.) The tomb is not a single deep pit, as in the Shang burials, but a set of rooms resembling a dwelling. The literature from this period suggests that such tombs were envisaged as entryways to the land of the dead where powerful individuals such as the Lady of Dai could interact with the spirits of the deceased.

The body of the Lady of Dai, sealed within a multilayered coffin and robed in many layers of finely woven silks, was miraculously well preserved when the tomb was opened in 1972. The painted, T-shaped silk banner found in the innermost of the nested coffins may have been a personal name banner and symbol of the deceased around which mourners assembled for her funeral and the procession to her grave (FIG. 4.10). The inventory list found in the tomb calls this a "flying banner," perhaps because it was designed to help elevate the soul to the upper world. In Han times, the Chinese believed that one part of the soul, the *po*, stayed with the body (as long as it was preserved and provided with ample offerings) while the other, the *hun*, undertook a long and perilous journey to paradise.

The banner represents the elevated position of the Lady of Dai within the Han conception of the cosmos. Near the center of the banner, two kneeling figures face the lady, who holds a thin walking stick and wears an elegant silk robe with swirl patterns. Three female attendants stand in a straight line behind her. The group is arranged on a platform supported by open-mouthed dragons and cloud forms, which rise up beside them. Over their heads, a foreshortened batlike creature hovers below a canopy supporting long-tailed birds. Above, a pair of figures at the base of the

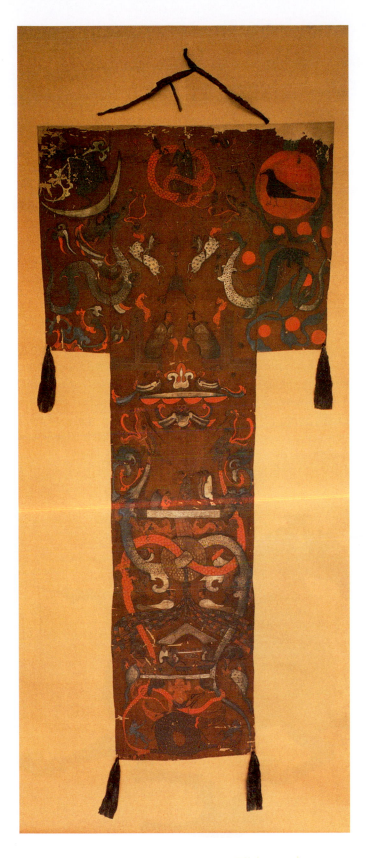

4.10 *Lady of Dai with Attendants.* Painted silk banner from the tomb of Dai Hou Fu-ren, Mawangdui Tomb 1, Changsha, Hunan. Han dynasty, after 168 BCE. Silk, height 6′8¾″ (2.05 m). Hunan Museum, Changsha

crossbar of the T-shaped silk banner squat beneath a large bell. These may be the officials who performed a funeral ceremony known as the "Summons of the Soul." This was an attempt to call the part of the soul headed on the perilous route to paradise back to the tomb for its own protection. The heavenly realm in the crossbar of the "T" contains a crow silhouetted against the sun (right side) and a toad on the crescent moon (left) flanking a man entwined within a long, scaly serpent tail. The lines recited by the officials warned the soul to avoid the "water-dragons [that] swim side by side, swiftly darting above and below." These monsters and the "coiling cobras … rearing pythons and beasts with long claws and serrated teeth" also described in the summons may be the creatures around and below the platform supporting the lady and her courtiers. A canopy in the underworld suspended from the circular jade *bi*, through which the serpents loop, covers a platform supported by a dwarf and holding ritual bronze vessels with food and drink for the lady. This may represent a portion of the tomb itself, the lady's home in the afterlife with all its luxurious provisions.

The artists have paid great attention to the sinuous qualities of the long, flowing, whiplash outlines and forms that unify this composition and image of the cosmos. The flat patches of brilliant color added within the outlines are used decoratively, not structurally, in the organization of the composition. Even at this early date, in Chinese art we see the primacy of these lines in the narrative and expression of religious and philosophical ideals and the secondary role played by the added colors.

THE CULT OF SACRED MOUNTAINS AND THE *BOSHAN LU*

As lavish as the Lady of Dai's burial might have been, those of the members of the Han imperial clan were much more impressive, reflecting their elevated status in Chinese society. When Liu Sheng (king of Zhongshan; died 113 BCE), son of Emperor Jingdi (ruled 157–141 BCE), was buried, he was encased in a suit made from over two thousand pieces of jade and fastened with golden cords. The suit was designed to preserve his body and provide a permanent home for his *po* while the other part of his soul went to paradise. Han thinkers had a number of images of paradise, one of which may be represented by a bowl-shaped container on a stem with a conical lid and gold inlay that was found in Princess Tou Wan's tomb (FIG. 4.11). It is known as a *boshan lu* (hill censer) and it represents the sacred rivers that descend from the mountains and the Isles of the Immortals in the Eastern Sea, where Daoist philosophers may achieve immortality.

Many of the mystic and cosmic powers in Chinese thought are associated with mountains, where the realms of earth and

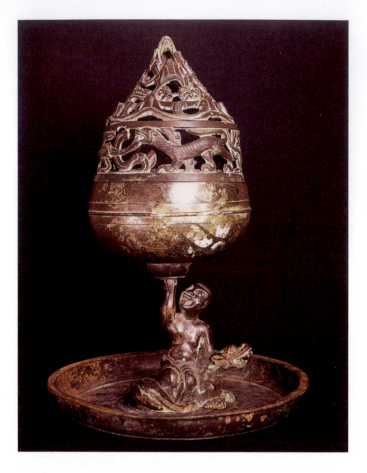

4.11 *Boshan lu* (hill censer), from the tomb of Princess Tou Wan, Mancheng, Hebei. Han dynasty, late 2nd century BCE. Bronze with gold inlay, height 12¾" (32.4 cm). Hebei Provincial Museum

into three dimensions to create this lively image of the Daoist Isles of the Immortals.

To complete the illusion of the mountain-river image, such a *boshan lu* was often set in a shallow basin of water when the incense within was lit. Small holes behind the pinnacles allow curling ringlets of smoke to rise from them, giving the impression of vapors wafting among the mountain peaks. Together, the *yunqi* motifs on the burner and the *yunqi*-shaped curls of the smoke symbolize the spirit, force, or *qi* of the sacred mountains.

This same taste for energetic lines and forms combined with the elasticity and "vital spirit" of nature animates the movements of a small bronze horse discovered in the tomb of General Zhang at Wuwei in Gansu (FIG. 4.12). Writers from this period tell how Zhang and other Han emissaries traveled to Ferghana in Western Asia to buy this "celestial" or "blood-sweating" breed of barrel-chested horse with flaring nostrils. While military men such as the general depended heavily on the strength and speed of their horses to maintain the empire, artists of the Han period were fascinated by the lightness and agility of the horses' movements. The stiffness of the horses standing at perpetual attention in the tomb of Qin Shihhuangdi has been replaced by a new sense for movement as the airborne beast balances as if weightless on a single hoof resting on a swallow.

sky are united. Daoist hermits flocked to the mountains to be close to the spirits of the immortals, and many Confucian scholars went there to escape the pressures of city life. In a prayer to the sacred mountain of Heng, Emperor Taizong (ruled 626–49 CE) of the Tang dynasty said that, there, the "dragons rise to heaven ... rainbows are stored ... Its rugged mass is forever solid ... Its great energy is eternally potent, in the span from the ancient to the future."

This cult of the sacred mountains may have inspired the censer found in the tomb of Princess Tou Wan. The mountains on this and other similar censers are indicated in shallow relief, and here the profusion of wavy mountain peaks rise upward like tongues of fire. The undulating, whiplash shape of the metal inlays is known as the **yunqi** (cloud spirit or force). The style of the tiny, wiry lines and elegant flowing rhythms of the painting in the tomb of the Lady of Dai seems to have been expanded

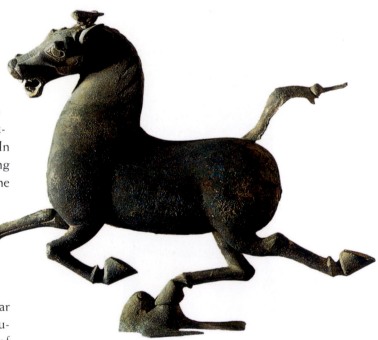

4.12 *Flying Horse Poised on One Leg on a Swallow*, from the tomb of General Zhang at Wuwei, Gansu. Late Han dynasty, 2nd century CE. Bronze, 13½ × 17¾" (34.5 × 45 cm). National Palace Museum, Beijing

THE PERIOD OF DISUNITY: SIX DYNASTIES (220–589 CE)

Like the Warring States period, the years following the fall of the Han dynasty witnessed the rise and fall of many regional Chinese governments and ongoing, bloody civil wars. Central Asian groups conquered portions of northern China, forcing many locals to leave the greater Yellow River area for the southeast. In this turmoil, many Chinese, especially those who had been dispossessed, felt that the time-honored ancestor cults and Confucian ethics had failed to meet their political, social, and spiritual needs.

This period also saw the spread of Buddhism in China. Although it had appeared in China by the first century CE, it was not until the fourth and fifth centuries that Buddhism became widespread. Buddhism borrowed notions from Daoism to make it easier to communicate its own ideas to the Chinese, while in turn Daoism assumed some of the institutional character of Buddhism in order to consolidate and maintain its place in Chinese society. In time, the new Sinicized version of Buddhism helped the ruling dynasties of China unify their ancient culture and rule their subjects, and gave Chinese artists a wealth of new subjects and styles to enrich their ancient artistic traditions. Very little architecture of any kind from the Period of Disunity remains in China but Chinese-inspired temples in Japan such as the Horyu-ji (seventh century) have survived and will be examined in the following chapter in context with Japanese Buddhism (see FIG. 5.7).

THE WEI DYNASTY IN NORTHERN CHINA (388–535 CE)

The Central Asian Wei, who ruled portions of northern China after 388 CE, created important Buddhist religious centers with cave-temples and monumental sculptures. Moving east along the Silk Road, the Wei established their first capital in northern China at Datong, west of present-day Beijing, on the very edge of northern China by the Great Wall. Living near the eastern end of the well-traveled Silk Road, the Wei rulers maintained contact with Central Asia. They also played host to Buddhist monks and artists who were familiar with the sculptural traditions of Bamiyan and the other rock-cut cave sites along the spur of the Silk Road leading to India.

The influence of these impressive Buddhist monuments may be evident in the colossal Wei sculptures and cave-temples near Datong at Yungang (Cloud Hill), begun around 460 CE. Some earlier rock carvings had been done in China, but nothing on the scale of the Indian rock-cut temples had been attempted here before. The carvings were commissioned around 460 by Emperor Wen Cheng, whose Daoist

father had persecuted Buddhism with great vigor from 446 to 452. Now, in a tremendous outburst of energy aimed at atoning for the new emperor's father's acts, a workforce led by monks and nuns, many of whom had no connection with the court, carved fifty-three caves along about 1 mile (1.6 km) of the cliffs. The Wei rulers, who considered themselves embodiments of the Buddha, may have seen these colossal images as self-portraits and protectors of the Wei kingdom.

The façade of the rock-cut temple that once stood in front of the Buddha in FIG. 4.13 has fallen, exposing a 45-foot (13.7 m) statue, which was intended to be seen in the darkness of its enclosed niche. The face, long ears, *ushnisha* (a knot of hair over the head symbolizing superior spiritual knowledge), and pose of the seated, cross-legged Buddha—with the *mudra* or hand position signifying meditation—reflect the stylizations of the Gandhara Buddhas of this period (see FIG. 3.11). With its sharply cut features, inscrutable mask-face, and colossal scale, the Buddha has an authoritative presence that symbolizes the spirit and strength of the religion that joined the Daoist and Confucian traditions to bolster the authority of the Wei and shape Chinese art for centuries to come.

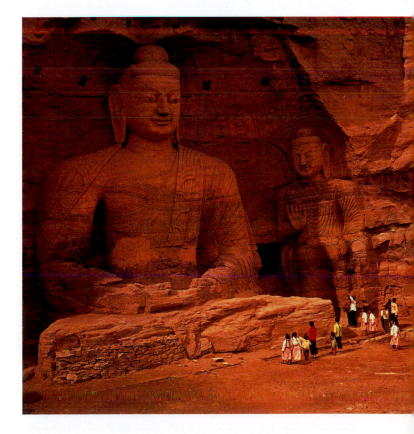

4.13 *Colossal Buddha.* Cave 20, Yungang, Shanxi. Late 5th century. Stone, height 45' (13.7 m)

PAINTING AND CALLIGRAPHY

The large murals from Period of Disunity palaces have not survived, but it is still possible to get some sense of their style from later copies of hanging and hand scrolls from this period. The small segment of a tenth-century copy of *Admonitions of the Instructress to the Ladies of the Palace* by Gu Kaizhi (c. 344–406), who worked in the court of the southern Jin dynasty at Nanjing, illustrates a text by a Confucian poet, Zhang Hua (232–300) (FIG. 4.14). The text and image explain the virtues of a good wife and the behavior expected of the women attached to the court, including those in the imperial harem.

The painting is on silk, which was woven in long narrow bands, about 12 inches (30 cm) wide and up to 30 feet (9.15 m) long, for use as hand scrolls, which were designed to be rolled between spindles and read segment by segment by a small group of admirers. The images and text were to be experienced slowly, over a period of time, like music or drama. Working over a preliminary sketch of thin, pale red lines, the artist responsible for this copy demonstrates his mastery of traditional Chinese brushwork. Portions of the instructress's robe seem to flutter before unseen forces. The artist has created a composition of well-matched, long, flowing lines that capture the melodic character of Zhang Hua's poetry and the atmosphere of the luxurious but well-disciplined court.

While the date of this *Admonitions* copy remains debatable, it is of a very high quality and seems to reflect some important concerns of fourth-century Chinese painters such as Gu Kaizhi and their courtly patrons. Artists of that period used very fine lines to detail facial features and supple lines for their subjects' hair, clothing, and bodies which were capable of conveying a person's inner feelings and

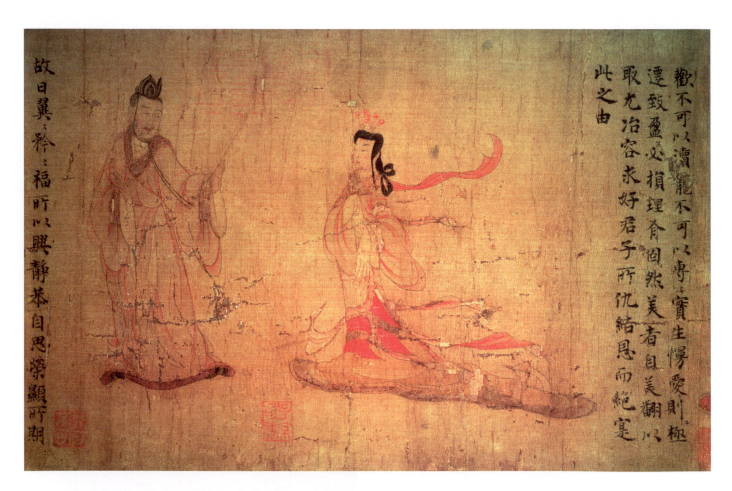

4.14 Portion of the hand scroll *Admonitions of the Instructress to the Ladies of the Palace*. Possibly a 10th-century copy after Gu Kaizhi (c. 344–406). Six Dynasties period. Ink and color on silk, height 9¾" (24.75 cm). The British Museum, London
Many artists added inscriptions to their paintings giving a title, date, patron, other commentaries on the work, and a signature seal. Seal or colophon inscriptions, usually impressed in red and indicating ownership, appear by the seventh century. Later, to give a work their "seal of approval," connoisseurs affixed their own seal marks to this and other paintings. While some viewers might find these seal marks intrusive, to traditional Chinese collectors the "autographs" of owners and respected critics give a painting added value.

character. Long, flowing scarves helped amplify the subtlest arm and hand gestures. When Xie He, who worked in Nanjing about a century after Gu Kaizhi was active there, wrote that a good painting must be full of vital energy (*qi*), harmonious (*yun*), alive (*sheng*), and full of motion (*dong*), he was almost certainly referring to compositions such as Gu Kaishi's *Admonitions* scroll. (See *In Context:* Xie He and his Canons of Painting, below.)

Traditionally, the types of brush used by painters were also used by those practicing the art of fine writing or calligraphy. The latter became an accepted art form in China during the Period of Disunity, and in the last thousand years it has generally been regarded it as the country's principal form of artistic expression. At times, important pieces of calligraphy were the most expensive works of art in China.

In Shang times, the Chinese inscribed characters on bones used in religious rites of divination by their leaders. (See *In Context:* Chinese Writing, page 113.) This tie connecting writing, religion, and government—that the written characters were to be seen by the gods and leaders—may help account for the tremendous importance the Chinese attached to written characters and their appearance. Though writing has often been a tool by which an elite has exercised control over society in many parts of the world, including China, here, at an early date, individuals outside the court were able to challenge the court's hegemony over the prevailing styles of calligraphy.

Characters in the Seal script (developed c. 1200 BCE) are carved in reverse on clay seals and are highly formalized. The Clerical script (c. 200 BCE), brushed in ink made of soot, glue, and water on bamboo or strips of silk, was less formal. Paper was invented in China around the second century BCE and by the first century CE many artists and calligraphers were working with ink on absorbent papers that were capable of capturing the subtlest nuances of brushwork. In step with these materials, the Chinese developed new rounded or cursive forms of writing. The Cursive script (fourth century CE) allowed writers the freedom to be highly inventive when forming their characters and became the classic form of Chinese writing. The later Drafting script (seventh

IN CONTEXT

XIE HE AND HIS CANONS OF PAINTING

In the late fifth century CE, a painter named Xie He, active around Nanjing, wrote the earliest extant treatise on the philosophy of art in China. In much the same way that medieval and Renaissance artists and writers on art in the West accepted Christian ideas about God as the Creator, Xie He followed the Chinese ideas of his day about nature and Creation. His *Gu hua pin lu* ("Classification Record of Ancient Painters") includes a set of canons or principles of Chinese painting. They are:

1. Sympathetic responsiveness to the *qi*;
2. Structural method in the use of the brush;
3. Fidelity to the object in portraying forms;
4. Conformity to kind in applying colors;
5. Proper planning in the placing of elements;
6. Transmission of experience of the past in making copies.

Xie He's first and foremost principle revolves around the concept of *qi*, a word rich in meanings, from "breath" and "spirit resonance" to "rhythm" and "character." At the same time, the word carried other notions about the natural world and how it worked. It could refer to the circulation of water vapor and the energy from which life arose. Thus, an artist's *qi* was manifest in his body movements, especially the motions of his brushwork as it expressed a harmony (*yun*) with nature.

While the first canon stresses the importance of an artist's personal character and spontaneity, the others address the need to develop technical skills. Many of these skills were learned by studying and copying works by past masters. But even here the emphasis was on learning techniques that would free artists to be creative. Xie He probably wasn't the first writer on art to express some of these ideals. But while it is tempting to think that his canons reflect earlier writings and can be applied to earlier styles of Chinese art, the degree to which Chinese art and culture had changed in the centuries immediately preceding Xie He's time make it dangerous to apply his thinking retrospectively.

century), with its spirals and flowing forms, provided calligraphers with even more opportunities for creativity. Works in the "crazy drafting script" are so inventive that the texts are almost illegible but capture a Daoist sense of revelation, the very essence of the *qi*. The calligrapher working in this spirit goes far beyond the basic ideas expressed by the characters in search of brushwork effects capable of expressing broad and deep philosophical ideals that enhance the text. With the development of "poem-paintings" in the eleventh century, images painted with ink and brush might be accompanied by a related poem. Thus, the linking of the two art forms (painting and calligraphy) was complete.

The importance attached to writing and the exchange of personal correspondence among the literary elite made calligraphy the most important and widely practiced art form in China. Works by the recognized masters of calligraphy were well known in literary circles by the third century. Some of the early practitioners who were responsible for elevating the status of calligraphy to an art form and teaching it to students were upper-class women, such as Lady Wei (272–349). Except for a small fragment of one text, these early works have perished. They are known, however, through the work of later calligraphers who often copied masterpieces as part of their training, just as Renaissance masters and later Western artists learned by copying examples of Classical art from antiquity. Each canonical Chinese master was regarded as having his own *ti* (style) and *fa* (methods). Once a calligrapher had mastered his favorite style, he would exercise it in his own personal way, much as a Western composer might produce new melodies while working in a Classical or Romantic style. The long history of Chinese literature gave each character a wealth of associations that encouraged scribes to treat the individual characters like relics or icons. Many people around the world today communicate by email and text messages, seldom writing anything by hand, and so may find it difficult to grasp the importance attached to calligraphy as an art form in China and elsewhere. But it should be remembered that, until well into the twentieth century, fine handwriting was still regarded as an art form and was a widely accepted sign of the "cultivated" individual in most of the world.

THE SUI DYNASTY (589–618 CE) AND THE TANG DYNASTY (618–907 CE)

The short-lived Sui dynasty (589–618) reunited China under a single emperor and paved the way for the Tang emperors, who ushered in a golden age characterized by a sense of majesty, dignity, and confidence in all the arts. By expanding their frontiers east into Korea, south to Vietnam, and west through Central Asia to the Caspian Sea, the Tang rulers created an empire that was larger, wealthier, and stronger than that of their Muslim contemporaries with whom they traded. The emperors maintained diplomatic relations with Persia and began the construction of the Grand Canal system that linked the Yellow, Huai, and Yangzi rivers. Supported by trade along the caravan routes—the Silk Road to the West through Dunhuang and Turkestan—the size and splendor of the Tang capitals at Luoyang and Chang'an (modern Xi'an) became legendary. With a population estimated variously at one to two million, including Korean, Japanese, Jewish, and Christian communities, Chang'an was the most cultivated metropolitan center in the world. Literature, the arts, philosophy, and religion, including new forms of Buddhism, flourished in the liberal atmosphere of Tang prosperity. The doctrines of some of the new religious sects often bore little resemblance to the original teachings of the Buddha.

PAINTING

Many of the delicate and innovative paintings on silk from this period have disappeared, and works by such celebrated masters as Li Zhaodao (670–730) and Wang Wei (c. 700–60) are known only through later copies. Some of the best-preserved and most important paintings and sculptures were found in the cave shrines at Dunhuang, Gansu, in western China (fifth to eleventh centuries). This site was an important stopping place on the Silk Road. Originally, there may have been a thousand cave shrines carved into the soft gravel cliffs, but only about half of them have survived. While much of the Buddhist art along the trade routes in this area was destroyed by a succession of anti-Buddhist uprisings and Muslim invaders in the eleventh century, the remoteness and arid climate of Dunhuang protected its wall paintings and sculptures, many of which thus remain in good condition.

Some of the paintings illustrate themes central to **Pure Land Buddhism**, a sect in which the faithful were promised a place in the Western Paradise of the Amitabha ("Infinite Light") Buddha. In the tradition of the rock-cut and painted cave-temples of India such as those at Ajanta, the artists showed the Western Paradise in an opulent, courtly manner (FIG. 4.15). **Amitabha** is seated among *bodhisattvas* in a celestial garden filled with other *bodhisattvas*, elegant birds, a collection of devotees around a magnificent carpet, and musicians. Smaller, framed *jatakas*, scenes from the life of the Buddha, surround the main image. Pavilions illustrated in the Dunhuang mural, with upturned roofs, reflect the building styles

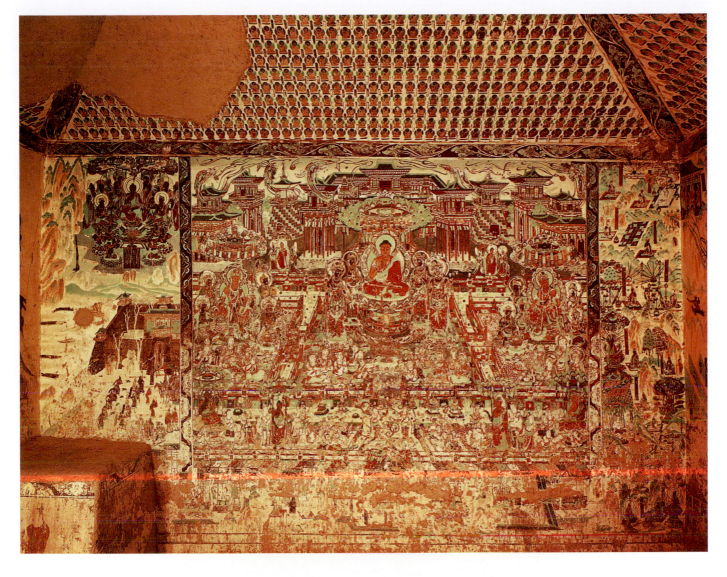

4.15 *Western Paradise*. Section of a wall painting, Dunhuang, Gansu. Tang dynasty, late 8th century

of the Six Dynasties and Tang periods. Together, the courtly gathering and architectural background may represent the opulence of court life in contemporary Chang'an as an earthly reflection of the Western Paradise.

Guanyin, a *bodhisattva* of mercy who had been revered at an earlier date in Central Asia, became popular in China at this time. Traditionally, *bodhisattvas* are sexless; in the case of Guanyin, the androgyny is deliberate and expresses a universal or celestial form of love unlimited by issues of gender. In a tenth-century painting on silk from Dunhuang, *Guanyin as the Guide of Souls*, the elegant *bodhisattva* is swaddled in finely patterned, semitransparent silks, a costume the Chinese artists thought might be appropriate for a wealthy Indian prince (FIG. 4.16). The painter has devised a magnificently orchestrated set of soft, flowing lines in the *bodhisattva*'s soft, fluttering draperies and the curling clouds beneath

the *bodhisattva*'s feet. Together with Guanyin's gestures, these create an image of princely dignity and utter calm.

One of the finest surviving works reflecting the culture and authority of the imperial court at Chang'an, the *Scroll of the Emperors*, was painted by Yan Liben (died 673) (FIG. 4.17). Yan Liben was a high-ranking official who served as prime minister to the emperor and was equally skilled at architecture, sculpture, and painting. His images of the great emperors of the past are accompanied by moral lessons. The ancient Chinese traditions of ancestor worship and Confucian regard for authority figures encouraged the production of such portraits with accompanying texts. Yan Liben's broader forms make his figures appear much fuller and more massive than those of Gu Kaizhi. Although the modeling is limited, it is skillfully and consistently applied. Facial types are idealized, not idiosyncratic or individuated,

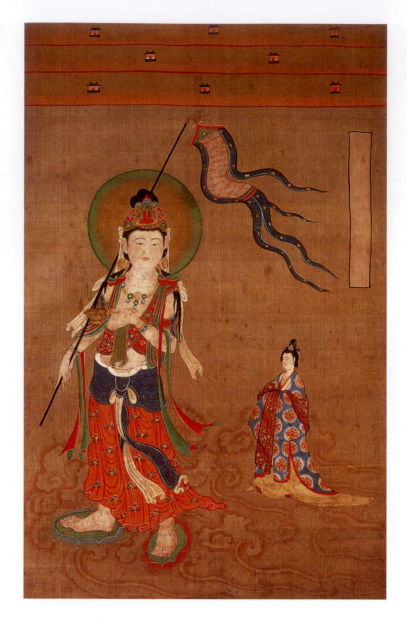

4.16 *Guanyin as the Guide of Souls*. Dunhuang, 10th century. Painting on silk, 31 × 21" (79 × 53 cm). The British Museum, London

and regalia, along with inscriptions, are used to identify rank. This tradition of painting idealized portraits of royalty achieves its classic form in the Tang period.

The late Tang dynasty was a period of rapid and momentous change that gave rise to new kinds of expression previously unseen anywhere in the world. Chan (or Zen) monk-artists began to flout the "rules" of art and decorum by painting wildly, sometimes using their hair or feet. Writers such as Han Yu (768–824) and Bai Juyi (722–846) advocated more vernacular styles of writing, expressing new forms of social consciousness. Liu Zongyuan (773–819) wrote a scathing critique of hereditary privilege and argued that the only stable form of government was one based on merit.

These rebels criticized the corruption and special privileges enjoyed by the Buddhist community, which worked hand in hand with the ruling aristocracy, mirroring the close relationship between church and state in Europe at this time. Buddhism had become a powerful force in Chinese society by the ninth century; these criticisms ultimately led to its violent proscription in the 840s, when thousands of monks were defrocked, temples were closed, and serfs governed by the temples were released from their bondage. Although the persecution lasted only a few years, Buddhism never recovered its wealth and status within Chinese society. Likewise, by the end of the Tang dynasty, the hereditary nobility had all but disappeared from government ranks.

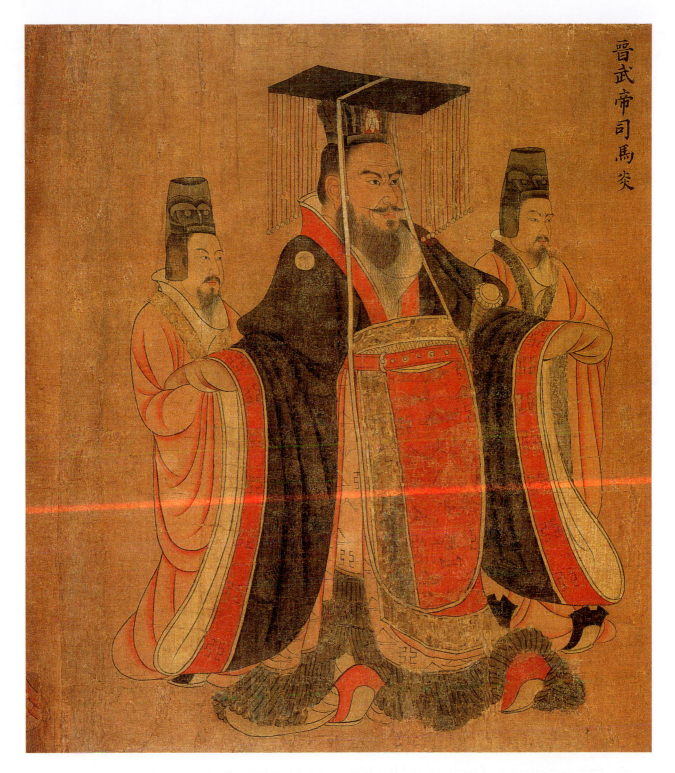

晋武帝司馬炎

4.17 Yan Liben (attributed), *Emperor Wu Di*. Portion of the *Scroll of the Emperors*. Tang dynasty, 7th century (11th-century copy). Hand scroll. Pigment, ink, and gold on silk, height 20⅛" (51 cm). Museum of Fine Arts, Boston

The earliest wall paintings in China appeared around 1100 BCE. Screen paintings and hand or horizontal scrolls date from c. 100 CE, hanging or vertical scrolls appear after 600 CE, and album-leaf or screen paintings date from c. 1100. Unlike wall paintings, which were very popular up to the Tang period and could be seen by a relatively large audience of courtiers, the smaller, portable scroll paintings were designed for occasional viewing by a small audience. Chinese ink (cakes of animal or vegetable soot mixed with glue) and pointed brushes made of bound animal hairs glued into a hollow end socket of a holder appear around 1200 BCE. The Chinese began painting with water-based pigments on plastered walls about this time, on silk around 300 BCE, and on paper c. 1000 CE. The artists' brushes, inks, inkstones, and papers became known as the "four treasures."

THE FIVE DYNASTIES (907–60) AND THE NORTHERN SONG (960–1127) AND SOUTHERN SONG DYNASTIES (1127–1279)

With the collapse of the weakened Tang dynasty in 906, China entered another period of civil war and anarchy that lasted for much of the tenth century until the Song dynasty came to power at Bianliang (present-day Kaifeng) in 960. In 1126, the Jurchen tribes of Manchuria, who took the dynastic title of Jin, captured the Song capital at Kaifeng and imprisoned the emperor. Surviving members of the court moved southeast to Lin'an (meaning "temporary safety"), present-day Hangzhou, and established the Southern Song dynasty. Under the Song, southern China became the world's greatest producer of iron and boasted maritime trade routes reaching Southeast Asia, a flourishing merchant class, and four cities with at least a million inhabitants.

While the merchant class prospered and grew, the nobles, many of whom had depleted their resources by fighting one another in the late Tang and Five Dynasties period, were on the decline. Some merchants sent their sons to schools, where they could study from books including encyclopedias illustrated using the newly developed woodblock printing technique. Many of these young merchant-class scholars excelled in the government examinations and thus entered the ranks of officialdom, often displacing members of aristocratic families. This new class of scholar-official contributed to the Song-period philosophy of government, which stressed the ideals of efficiency and civility and the belief that a well-run society reflected the higher and unchanging principles of moral order.

In the Song period, as merchants and scholar-officials outside the court gained wealth and power and began collecting art, China developed a commercial art market that was increasingly independent of the courts. Earlier imperial collections had often been assembled as emperors looked for ways to legitimize and represent their power. The Tang nobility, for example, had collected technically refined and brightly colored paintings showing religious and mythological subjects, their own aristocratic activities, and beautiful women of the courts—that is, art that reflected life in the courts around them. Conversely, the new nonaristocratic patrons of the Song period wanted art that reflected the ideals of their own world. Some artists began portraying solitary figures in rugged mountain landscapes and wintry scenes, deploying roughly brushed strokes of black ink with little or no color. Instead of glorifying the fickle manners and political ideals of the court, which included many corrupt aristocrats, these artists celebrated nature, which they saw as a map of an unchanging moral order. Some artists moved to barren mountain regions, studied nature at first hand, and made images that showed the integrity of those who chose to pursue austere existences close to nature. Painting a landscape, or simply contemplating one, was a spiritual act for city- and country-dwellers alike. The taste for simplicity and natural forms extended to ceramics as artists began producing vases with mat monochrome glazes and simplified shapes.

This strong contrast between the "refined and superficial beauty" of the Tang court and the "rugged integrity" of the new breed of mountaineer artists and their patrons is discussed in a very important Five Dynasties text, *Notes on the Art of the Brush* by Jing Hao (c. 870–c. 930). This work epitomizes the spirit of the strong anti-aristocratic sentiments of the period and the association of the mountaineer's lifestyle—in which only the determined could succeed—with "integrity."

Of all the Buddhist sects, **Chan Buddhism** best survived the persecutions of the ninth century. (See *Religion:* Chan (Zen) Buddhism, Enlightenment, and Art, opposite.) As a religious philosophy that stressed the importance of discipline and self-reliance, it reflected the new era's ideals.

PAINTING

The new interests in painting are well illustrated in the work of Fan Kuan (active c. 990–1030), a hermit and mountain-dweller who was renowned for the sternness of his character. His *Travelers amid Mountains and Streams* is one of the best-known Chinese paintings (FIG. 4.18). Fan Kuan was one of the first artists to develop a characteristic type of textured stroke. He was the master of the raindrop or *cun* (wrinkle) brushstroke, which was used inside ink contour lines to shade, model, and texture forms. *Cun* strokes were used to make forms appear tangible and to give them greater mass.

Fan Kuan's painting shows a thin shaft of water falling from a crevice in the cliffs, which feeds the mist-shrouded lake that cascades through the boulders into the stream below. The inspiration for this and many other paintings, not to mention poems, comes from a group of towering, picturesque breadloaf-shaped peaks along the Yangzi River in Anhuan province west of Shanghai, which have long been admired by locals and travelers alike. The pack-horses at lower right are easily overlooked as the ancient Chinese cult of mountain worship finds one of its most memorable expressions in Fan Kuan's work. The landscape is not conceived in the Western tradition, as a backdrop for human activities, but as the vast Daoist context

CHAN (ZEN) BUDDHISM, ENLIGHTENMENT, AND ART

Chan is related to a Sanskrit word, *dhyana*, meaning "contemplation" or "meditation." Chan Buddhism, which emerged in China in the seventh century CE, is better known by the name of its Japanese equivalent, Zen (the Japanese pronunciation of "Chan").

While followers of the Pure Land variety of Buddhism repeated formulaic prayers, and Esoteric or Tantric Buddhists performed elaborate rituals, Chan Buddhists stressed meditation. In the tradition of Daoism, Chan Buddhism teaches that one can find happiness and success by achieving harmony with nature. Therefore, enlightened Chan Buddhist artists and poets become instruments through which the spirit of nature might be experienced and expressed. Dispensing with the traditional and official trappings of Buddhism—the scriptures, rituals, and monastic rules—Chan Buddhists taught that the Buddha was a spirit that lived in everyone's heart. Because the Buddha belonged to the internalized world of thought, Chan Buddhists used the yoga techniques of the brahmins to strive for a oneness with the *dao* (way) and the Confucian *li* (innate structure of nature).

Chan artists paid little attention to the traditional Indian and Chinese images of the Buddha and his many *bodhisattvas*. Instead, they often portrayed Chan masters in moments of inspiration and enlightenment, along with images of nature with which the masters had achieved a sense of oneness. To capture this sense of revelation, Chan painters had to work in the Chan spirit, creating images spontaneously, in moments of great insight.

within which people are but a small part in nature's much vaster overall scheme.

The ever-changing body of nature, exploding with energy, is softened by enveloping veils of cloud and fog. Rising powerfully like a cluster of giants with trees for hair, the broad-shouldered pinnacles with *cun*-stroke detailing seem to take on a life of their own. The sense of monumentality conveyed by this painting, which is nearly 7 feet (2.1 m) high, comes from its scale and from the contrast between the smallness of the figures in the foreground and the vastness of the mountains emerging from the mists. Allowing our eyes to move past the figures in the foreground, the rocks and water in the middle ground, through the mists and up the cliffs past the thin waterfall, we move from the human and terrestrial realm of existence to the celestial realm above the mountains in the sky.

Many of the now-admired Song artists were known as the *wenren* (literati). They were part of the highly educated, upper-class scholar-official class, and most of them did not have to sell their art to make a living. Often, the literati used the austere monochrome technique of **shi mo** (ink painting) and absorbent papers that could capture the subtlest nuances of their brushwork. Writers of the day attached great value to this kind of independence—the fact that they did not work (as court artists) like hirelings or servants—and regarded these lofty-minded literati as the intellectual elite of the art world, free thinkers who valued inspiration, spontaneity, and creativity, and looked beyond external appearances to capture the very essence of their subjects.

Nevertheless, some literati painters did work for the court. Perhaps the most famous is Ma Yuan (active c. 1190–1225), who worked at the painting academy of the Southern Song court at Hangzhou. He came from a prominent family, and his father had also served in the academy. Thus Ma Yuan was a government official and a gentleman, but his profession was painting. Until the twentieth century, Ma Yuan and those who followed his distinctive style were generally reviled by the Chinese literati painting establishment for their ties with the court; Ma Yuan's paintings were frequently used as examples of how not to follow Xie He's canons. In spite of that, his work seems to have been highly prized by almost everyone else, and in Japan formed one of the prime references for the emerging school of Japanese literati painting. In *Scholar Contemplating the Moon* Ma Yuan has captured the immensity of nature with the simplest of means (FIG. 4.19). The moon hangs within the vast, open chasm of space unfolding behind the single most clearly defined form in the composition, the jagged limb of a pine tree. Exploiting the power of suggestion by using empty space to represent water, mist, and sky, Ma Yuan captures the cosmic rhythms of the Daoists in this image of the vast, empty silence of infinity. In this and other surviving

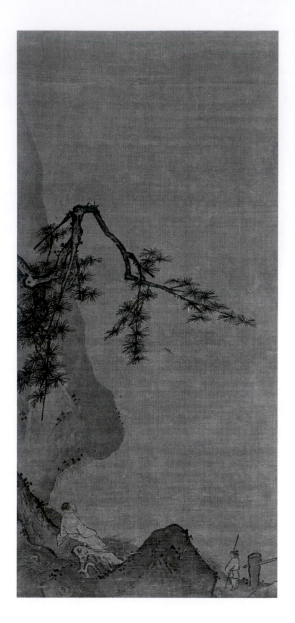

4.19 Ma Yuan, *Scholar Contemplating the Moon*. Southern Song dynasty, c. 1200. Hanging scroll. Ink and color on silk, height 22¾" (57.5 cm). MOA Museum, Atami

masterpieces of literati ink painting, long-standing Chinese interests in calligraphy, linear description, and landscape are combined in a new, spare visual style that pushes the idea of pictorial suggestion to its seeming limits. Principally associated with Ma Yuan and his contemporary Xia Gui (active c. 1180–1224), it is often called the Ma–Xia style.

By the thirteenth century, increasing numbers of Chan Buddhists were living in the spirit of Ma Yuan's contemplative scholar, as hermits cloistered in remote mountain retreats. Working in this manner, Liang Kai (active in the early thirteenth century) shows *Hui Neng, the Sixth Chan Patriarch, Chopping Bamboo at the Moment of Enlightenment* (FIG. 4.20). According to legend, Hui Neng passed beyond all

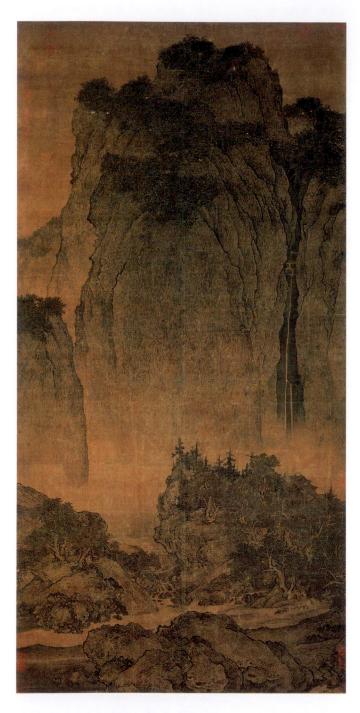

4.18 Fan Kuan, *Travelers amid Mountains and Streams*. Northern Song dynasty, c. 990–1030. Hanging scroll. Ink on silk, height 6'9¼" (2.06 m). National Palace Museum, Taipei, Taiwan

limits of rationality and received enlightenment while he was performing this routine task. The painting, too, seems to have been painted in a sudden flash of insight, with spontaneous stabbing, chopping strokes of the brush. The brushwork in the hastily executed images of the bamboo, the broken washes defining the tree in the background, and the sketchy rendering of the patriarch's folded limbs are filled with "happy accidents" that work in perfect harmony. It is the creation of a master so attuned to his subject and materials that matters of technique have become second nature and his hand and brush can respond directly to his *qi*. Ultimately, the influence of Ma Yuan, Liang Kai, and other Chan painters of the Southern Song period reached outside China to Japan, where they remained strong in the centuries to come.

In many ways, *Six Persimmons* by Mu Qi, who is better known in China as Fa Chang, has long been considered the consummate expression of the spontaneous mode and Chan Buddhism in the visual arts (FIG. 4.21). Here, Mu Qi works with very limited means. Slight changes in tone, shape, and size give each piece of fruit its individual character; small variations in spacing prevent the composition from taking on a mechanically precise appearance. The dark diagonal brushstrokes of the stems also make the persimmons look part fruit, part Chinese characters. The slightest change would destroy the subtle sense of balance, repetition, and variety in this enigmatic work. One historian has called it "passion … congealed into a stupendous calm." This small painting is, at once, simple and complex, artless and skillful, terse and meaningful, and has the spirit of a Chan Buddhist question, a *gong an* or **koan** (such as "What is the Buddha?"; answer: "Three *jin* of flax"). These *koans*, which cannot be answered or understood by rational means, are designed to break down traditional patterns of thought and create a breakthrough to oneness with the universe.

4.20 Liang Kai, *Hui Neng, the Sixth Chan Patriarch, Chopping Bamboo at the Moment of Enlightenment*. Southern Song dynasty, c. 1200. Hanging scroll. Ink on paper, height 29¼" (74.3 cm). National Museum, Tokyo

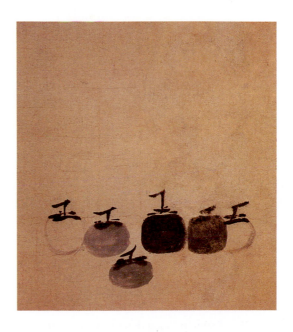

4.21 Mu Qi, *Six Persimmons*. Southern Song dynasty, after 1279. Ink on paper, width 14¼" (5.6 cm). Daitoku-ji, Kyoto

CERAMICS

Like Tang paintings, Tang ceramics were often very colorful and had complex shapes. Although this tradition persisted in part into Song times, the most celebrated works from the Song period express the ideals of sobriety and simplicity discussed above in relation to painting. In what some scholars consider the culmination of the Song tradition, the ceramists produced wares with glazes that are nearly monochromatic (off-whites, soft blues, grayish-greens, and pale green-buffs) for the imperial court. A rare Northern imperial ware, *Ru*, produced for a short time before the demise of the northern branch of the dynasty, inspired the Guan ("official") ware in the south that has come to be known as the "classic" expression of the Chinese ceramists. As on *Ru* ware, ornamentation applied to Guan ware tends to be minimal, and the understated vessel shapes, glazes, and decorative patterns are perfectly integrated. Like some other courtly styles of **porcelain**, Guan ware simulates the appearance of jades and its lustrous mat surface appeals to the sense of touch.

The very distinctive crackle pattern in the glaze on this bottle vase appealed to the refined, educated taste of the day in China, just as it does to that of many contemporary viewers (FIG. 4.22). A pattern such as this may develop after the glazed ware has been fired in a kiln when the glaze contracts slightly more than the clay body beneath it during the cooling process. With age, the crackle or crazing pattern may continue to develop. Although this process is predictable to some extent, the precise patterning of the crazing cannot be controlled. The Chinese saw aesthetic value or beauty in such serendipitous effects, as they did in the semi-accidental effects of the brushwork of painters and calligraphers. The ornamental qualities of the crackle work in harmony with the basic sculptural qualities of the vessel in a manner that reflects the aesthetic, introspective, and meditative spirit of thinkers around the Southern Song court. The final effect is that of a lustrous glaze suspended on a dematerialized body, an experience that complements the effects of Song paintings. The interplay of the prescribed form and irregularity of the crackle—mixing intention with accident, rationality with instinct—has a parallel in Chan Buddhist thought. In the post-Song period this kind of delicate balance of forms and ideals fell out of favor as ceramists moved toward a wider variety of brighter glazes and sharper, more defined decorative motifs.

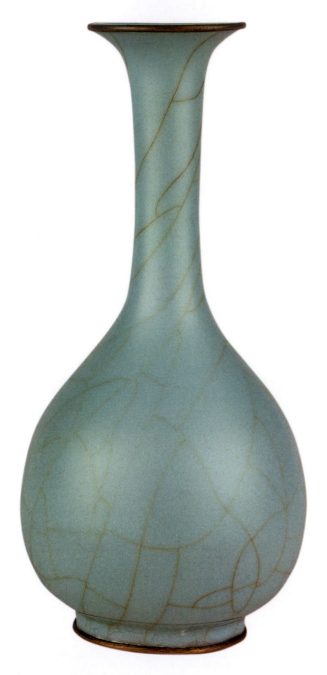

4.22 Bottle vase. Southern Song dynasty. Guan porcellaneous stoneware, height 6⅝" (17 cm). Percival David Foundation of Chinese Art, London

THE YUAN DYNASTY (1279–1368)

The Yuan dynasty came from Mongolia, north of the Great Wall. Groups of Mongol horsemen had been making sporadic forays into China since the eighth century, but in 1206 they were united by Temuchin, or Temujin, known in the West as Genghis Khan (1162–1227). Under Genghis and his successors, the Mongol cavalry swept across Asia, conquering lands from the Pacific to the Danube and creating an empire larger than that of the Romans, Arabs, or earlier Chinese. By 1279, Genghis's grandson, Kubilai Khan, had

overrun China, where he ruled as the first Yuan emperor until 1294, relocating the capital to Khanbalik (present-day Beijing) in the far north, close to his Mongolian homeland.

Mongol leaders following the Tibetan form of Buddhism, Lamaism, and esoteric forms of Daoism formed a separate class at the apex of Chinese society. Chinese art and culture had long played an important role in the lives of the Mongols, but the Yuan leaders distrusted the wisdom of Confucianism and so abolished the traditional literary examination for administrative officials, giving many of these positions to Mongols and other non-Chinese allies. Under these circumstances many of the educated Chinese turned away from government service to the visual arts and writing.

The Yuan leaders commissioned large quantities of religious and secular art, and were particularly interested in carpets, metalwork, and ceramics. The sister of Emperor Renzong (ruled 1312–20), Princess Sengge Ragi, established a large royal collection that artists belonging to the Yuan aristocracy could study. Breaking the Confucian hold on writing, the Mongol leaders encouraged would-be authors to produce popular forms of non-Confucian drama, music, and poetry that their Mongolian and non-Chinese associates might enjoy. They also imported large quantities of foreign goods over the ancient Silk Road, all of which lay at that time within the protective boundaries of the Mongol Empire. (See *Cross-Cultural Contacts:* Marco Polo and the Mongol Court, below.)

PAINTING

Though some writers regard the Yuan period as a dark age, others feel that the Mongols had relatively little influence on Chinese art and culture. The art of the well-educated, upper-class literati scholar-artists in the southeast around Hangzhou, far removed from the Mongol court in the north at Beijing, continued to reflect traditional Chinese values. In accordance with Xie He's sixth canon ("Transmission of experience of the past in making copies"), they studied older styles of Chinese painting (Tang-dynasty art in particular) and produced historically based paintings. Many of them reacted against the softness of Southern Song painting as a manifestation of the highly refined aesthetics and passivity of the leaders who had allowed successive foreign invasions to take place. Working mainly on paper, not silk, and sweeping away the veils of mist, they created a solid, hard-edged tradition of ink painting that seems to express these reactions to the Southern Song traditions.

Zhao Mengfu (1254–1322), an eleventh-generation descendant of the first Song emperor, was a favorite of Kubilai Khan. Although he worked with the Yuan government and was seen by many of his Chinese contemporaries as a traitor, posterity nevertheless gives Zhao great credit as a writer and artist. In addition to being a master calligrapher and painter of traditional studies of bamboo, he was a painter of horses, which made him popular among the equestrian-minded Mongols. In a section of a short hand scroll that belonged to the

CROSS-CULTURAL CONTACTS

MARCO POLO AND THE MONGOL COURT

Kubilai Khan, who generally distrusted his Chinese subjects, enlisted the services of many non-Chinese, including three Venetian merchants of the Polo family. Bearing a letter of introduction from Pope Gregory X (pope 1271–76), the latter had traveled along the Silk Road through Mesopotamia and Afghanistan to China. The Mongol conquests of Muslim-held areas in Central Asia made such travel possible for Europeans. Marco Polo (c. 1254–1324) was about twenty-

one when he arrived in Beijing in 1275 with his father and uncle, and he served Kubilai Khan as an ambassador until 1292. He spoke in glowing terms about Chinese civilization and called Hangzhou the grandest city on earth. He was also impressed with the grid pattern of streets in the new capital in the north, a plan the future city of Beijing retained when it was built in Ming times on the ruins of the Yuan capital.

With the disintegration of the

Mongol Empire and conquests by the Ottoman Turks in the fourteenth century, overland trips to the East became increasingly difficult, stimulating European explorers to search for sea routes to Asia. Until they found them, Marco Polo's *Travels*, written after he returned to Italy, constituted arguably the only eyewitness account of China available in Europe. Since Marco Polo's times, however, many scholars have doubted that he actually saw many of the marvels he chronicled.

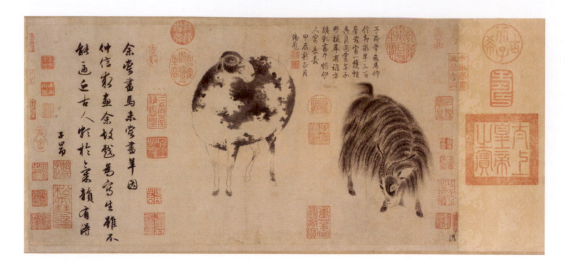

4.23 Zhao Mengfu, *A Sheep and Goat*. Yuan dynasty, c. 1300. Hand scroll. Ink on paper, length 19″ (48 cm). Freer Gallery of Art, Smithsonian Institution, Washington, D.C.

former imperial collection, *A Sheep and Goat*, Zhao shows his amazing ability to capture the contrasting characters of the animals (FIG. 4.23). Using his skills as a calligrapher, Zhao emphasizes the differences between the motionless sheep with its benign expression and thick, dappled coat, and the intensely curious goat with its long, flowing hair.

THE MING DYNASTY (1368–1644)

A succession of weak Mongol rulers enabled native Chinese leaders to drive them out, with the result that a new Chinese dynasty called the Ming took power in 1368. They ruled out of Nanjing until 1420, when they moved their capital north to Beijing to keep a close watch on the still-dangerous Mongols. **Neo-Confucianism**, a somewhat eclectic philosophy that had been developing since the Tang period, incorporating elements of Daoist and Buddhist thought, became the official ethical and metaphysical philosophy of the Ming court. In his efforts to purge the country of Mongol influences, the first Ming ruler, the Hongwu emperor, now instituted the most radically despotic government in Chinese history. Untold numbers of workers perished as they were put to work enlarging the Great Wall as the Ming emperors prepared to defend their lands against future attacks from the north. With its Ming enlargements, the interconnected sections of cut-stone masonry, earthen ramparts, and natural features such as steep hills and rivers run for about 5,500 miles (8,800 km) across northern China. Even though it has not always proved a successful deterrent against marauders, the Great Wall has become

an internationally recognized symbol of the durability and timelessness of Chinese civilization.

Many of the artists who had suffered under the Mongols found their freedoms even more severely restricted under home rule. While the traditional Confucian civil service examinations for government posts were reinstituted, many artists preferred to live and work outside the imperial and regional courts.

With the decline of the Mongol Empire, which had protected the Silk Road, the Yongle emperor (ruled 1403–24) launched exploratory expeditions in the Indian Ocean that reached the Arabian Peninsula and east coast of Africa a century before the European maritime powers began to establish trading posts there. The Yongle emperor also undertook two enormous projects at home: the compilation of an authoritative 11,095-volume encyclopedia of Chinese learning, and the construction of the Imperial Palace in Beijing over the ruins of Kubilai Khan's capital. (See *In Context:* Guan Yu and the "Romance of the Three Kingdoms," opposite.)

CERAMICS

The first Ming emperor established a new kiln at Jingdezhen designed to produce high-grade porcelain for his court. Jingdezhen was named for the Song emperor Zhenzong, who founded the ceramic industry there around 1004 CE and whose reign title at the time was Jingde Dazhongxiangfu. The region has exceptionally fine porcellaneous clays and a good wood supply for firing the kilns, and is close to the Yangzi River, where boats could bring materials and export the wares. Most of the wares produced at Jingdezhen were mass-produced in workshops or factories and

GUAN YU AND THE "ROMANCE OF THE THREE KINGDOMS"

In the fourteenth century, Luo Guanzhong wrote the first Chinese prose novel, *Romance of the Three Kingdoms*, a long, detailed saga about the civil wars at the end of the Han Dynasty that today represents the most widely read of the great classics of Chinese literature. The most important character in the novel, a military hero named Guan Yu, became a deity in Chinese folk religion, a *bodhisattva* in Buddhism, and a guardian deity in Daoism. By the Ming period, the emperors had given him the title "The Saintly Emperor Guan, the Great God Who Subdues Demons of the Three Worlds and Whose Awe Spreads Fear and Moves Heaven." Through his apotheosis, the original historical figure has become a national symbol of loyalty, honor, and righteousness, as well as an important figure in the visual arts.

We see him in *Guan Yu Captures an Enemy General*, by Shang Xi (early fifteenth century), with one knee pulled up, seated majestically, like a *bodhisattva* (which he was in Buddhist thought) (FIG. 4.24). He wears a flowing blue-green robe over his armor. This great cultural hero, shown here as a powerful and defiant warrior, and much larger than his four henchmen, looks at his captive while two soldiers bind the man and stake him to the ground. Shang Xi emphasizes the difference between the calm demeanor of the sublime hero and the tense, contorted muscles of his captive. With their brilliant colors, enhanced by sharp-edged detailing, the figures of Guan Yu and his entourage look like cutouts, as if they are not fully part of the everyday world that surrounds them.

This is a magnificent example of courtly historical painting, a patriotic image that has been admired by Chinese audiences for nearly six centuries. But, until very recently, this type of popular painting was overlooked by scholars and connoisseurs who focused instead on the works of the literati painters, those experimental individualists who worked in accord with Xie He's first canon, "Sympathetic responsiveness to the *qi*." The situation has parallels in the West with the large and meticulously detailed historical and religious paintings of the nineteenth century that were so popular in their day but that have gone out of fashion over the last century. Periodically, as the pendulum swings and tastes change, the more formal, academic, and government-supported art forms around the world are recognized for what they are—documents representing important currents in mainstream national thought. In this case, we are dealing with a saga that is part of a tradition that has preserved ancient Chinese thinking while similar works from the other great early civilizations in the world—Egypt, Mesopotamia, and the Indus Valley—have perished.

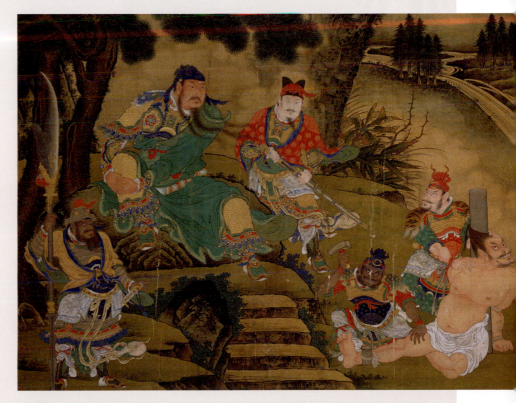

4.24 Shang Xi, *Guan Yu Captures an Enemy General*. Early Ming dynasty, 15th century. Hanging scroll. Silk, 6'6¾" × 7'9¼" (2 × 2.37 m). Palace Museum, Beijing

designed for everyday use in Southeast Asia, the Middle East, China, and, later, the West. During the Yuan dynasty, the kilns started producing porcelain for these markets on a massive scale. With the establishment of the new Ming works, Jingdezhen became arguably the single most important kiln site in the world.

The Ming painters often painted detailed, hard-edged images using the rich cobalt-blue glazes the Mongols had discovered in Kashan, Persia. In the famous Ming blue-on-white designs, the blue (water and cobalt oxide) designs are painted as underglazes onto the surface of unfired vessels, covered with a layer of white glaze, and fired in the kiln. This tradition of Chinese blue and white painted porcelain continues to be an important part of Chinese art to this day. (See *Materials and Techniques: Porcelain*, below.)

Many of the ceramic painters working during the reign of the Xuande emperor (1426–35) created clearly outlined and detailed images such as the scaly, wide-eyed monster that floats weightlessly among scattered clouds around the silky-smooth glazed surface of each of the vases in FIG. 4.25. With his bony claws, razor-toothed spine, and long, serpentine whiskers, the mythic monster is part of a long tradition of creatures depicted in Chinese art from Shang times onward. To the populace, the dragon was a bringer of rain and an emblem of the emperor.

LACQUER

A similar but more detailed dragon appears on a lacquered chest made at this time (FIG. 4.26). The imperial patrons who purchased great quantities of porcelain also had a taste for lacquerwork of extraordinary richness. First developed

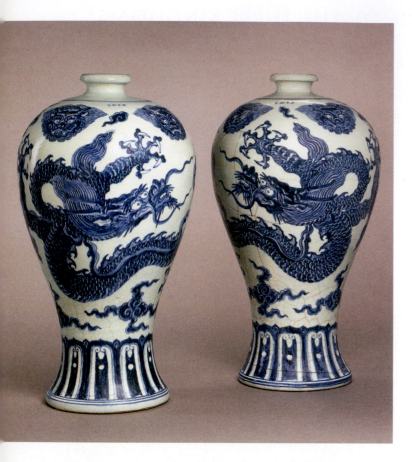

4.25 A pair of porcelain vases painted in an underglaze of cobalt blue. Ming dynasty, Xuande period (1426–35). Height 21¾" (55 cm). The Nelson-Atkins Museum of Art, Kansas City

MATERIALS AND TECHNIQUES

PORCELAIN

The Chinese may have developed the techniques of firing clay in ovens, or kilns, at high temperatures to produce what is known as porcelain while working with bronzecasting techniques. While porcelaneous wares were known in Tang times, the classic examples of porcelain come from the Yuan and later periods. Porcelain, a fine white hard-paste ceramic, is made from volcanic porcelain stone clay (containing the minerals quartz, kaolin, and feldspar) and other clays rich in kaolin. When these clays are fired or heated in kilns at very high temperatures (1100–1300°C), they develop needle-shaped mullite crystals and a high amount of body glass. Thin, glass-rich porcelains transmit light and make a clear ringing sound when struck. Glazes used on porcelains and other wares contain silica, the primary glass-forming oxide, alumina, minerals for coloring, and fluxes to lower the melting temperature.

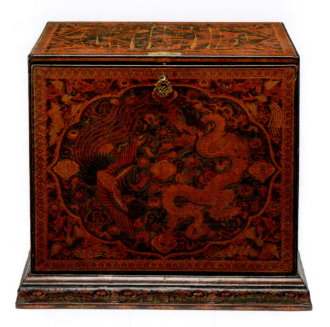

4.26 Chest. Ming dynasty, Xuande period (1426–35). Lacquer with incised and gilded design, width 22⅜″ (57 cm). Victoria and Albert Museum, London

in the Neolithic period, lacquerwork reached the height of its popularity around the fifteenth century. **Lacquer**, made from the sap of the Chinese tree *Rhus verniciflua*, is a clear, natural varnish-sealant. A lacquer finish will make wood, textiles, and other perishable materials airtight, waterproof, and resistant to heat and acid. The lacquer is applied in many very thin polished coats, each of which may take up to a week to dry. The resulting thick, smooth, glasslike lacquer surface can then be carved or inlaid. Carving through layers of lacquer may produce exciting marbleized effects. The multicolored lacquered surface of this Ming chest has incised detailing and gilding, and has been sealed with final, very thin layers of highly polished clear lacquer. In its richness, the well-embellished dragon, bird, and surrounding floral and cloud motifs reflect the rich patterning of Ming textile designs as well as ceramic paintings.

PAINTING

Dong Qichang (1555–1636), a late Ming bureaucrat, teacher, artist, calligrapher, art historian, and member of the literati, wrote that there were two parallel traditions in Chinese painting: one that was conservative, academic, formal, decorative, and courtly; and another that was progressive, innovative, expressive, and free. The second and superior tradition was represented by Wen Zhengming and others, including Dong Qichang himself. Dong Qichang emphasized the abstract nature of painting, its distinctness

from nature, and said that the quality of a painting lay in the expressive character of its brushwork. Although many critics from Dong Qichang's time to the present have felt that his two-schools theory was over-simplistic, his thinking influenced artists well beyond the Ming period.

Many of these ideals are illustrated in his own works, such as *Landscape in the Manner of Old Masters* (FIG. 4.27). This is not intended to be a topographically accurate and recognizable image of Jingxi. The open spaces among the large rocks and clusters of trees are not to be understood as real space in a real landscape. The artist has followed a line of thinking in Chinese art articulated in the tenth century by Su Shi, which valued "natural genius and originality" and a rustic lifestyle. The emphasis here is not on illusionism, but on the quality and style of Dong Qichang's brushwork and on nature as a place for retreat and meditation.

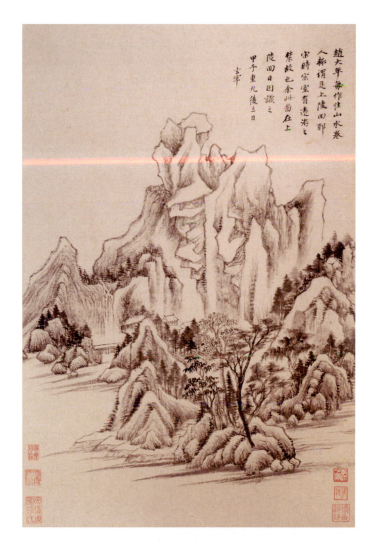

4.27 Dong Qichang, *Landscape in the Manner of Old Masters*. 1611. Hand scroll. Ink on paper, 22 × 14″ (56.2 × 35.6 cm). The Nelson-Atkins Museum of Art, Kansas City

THE QING DYNASTY (1644–1911)

As the political and economic power of the Ming dynasty declined, China was once again occupied by foreigners from the north—the Manchus, or Manchurians, who captured Beijing in 1644 and held it and the rest of the country until 1911. The Qing Manchus had enjoyed the benefits of Chinese culture for centuries prior to 1644, and by 1680 they had begun supporting and encouraging traditional forms of Chinese art and thought. While the Qing rulers summoned many artists to work for periods at court, the art market in China was changing. Many of the "court" artists now did most of their work for wealthy patrons in their home cities.

The Qing imperial collection of art (now divided between the National Palace Museum in Taipei and the Palace Museum in Beijing) grew enormously under the long rule of the Qianlong emperor (1736–95). The tastes of that era determined which arts from the past were preserved and indeed shape present views of Chinese art.

ARCHITECTURE AND GARDENING

While the Imperial Palace in Beijing may preserve many of its Ming features, the current structures were largely rebuilt in the eighteenth century under the Qing emperors (FIG. 4.28). In fact, the basic plan of the palace complex is a traditional one in China, and elements of it date back to Chang'an of the Tang period and the earlier structures of the Han dynasty. Beijing and Chang'an were both walled cities laid out on a grid plan along a north–south axis with imperial south-facing compounds at the north end. (See *Analyzing Art and Architecture: Feng Shui,* opposite.) The scale of the project is enormous: The high walls and towering brick gateways surrounding the halls of state protecting the royal family from the outside world are 15 miles (25 km) long. Following a tradition dating from at least the Han period, the Imperial Palace itself covers about 240 acres (97 hectares) and is built on a rectilinear plan, oriented to the points of the compass. The entire structure, built around a central axis and focused on the ritual activities of the emperor, was conceived as a microcosm of the universe; its order and symmetry, as a reflection of those qualities in the makeup of the cosmos, emphasize the closeness of the emperor to the gods.

Those who were permitted to enter the palace came in through the Meridian Gate and over one of five bridges crossing the Golden Water River to a bow-shaped court. Beyond it lay the Gate of Supreme Harmony, a rectangular

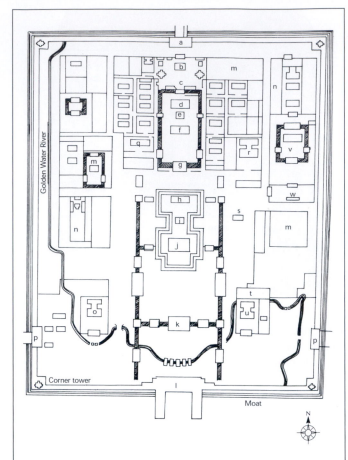

4.28 Plan of the Imperial Palace, Beijing. Begun 17th century. Letters keyed to major features:

(a) Gate of Divine Pride;
(b) Pavilion of Imperial Peace;
(c) Imperial Garden;
(d) Palace of Earthly Tranquility;
(e) Hall of Union;
(f) Palace of Heavenly Purity;
(g) Gate of Heavenly Purity;
(h) Hall of the Preservation of Harmony;
(i) Hall of Perfect Harmony;
(j) Hall of Supreme Harmony;
(k) Gate of Supreme Harmony;
(l) Meridian Gate;
(m) Kitchens;
(n) Gardens;
(o) Former Imperial Printing House;
(p) Flower Gates;
(q) Palace of the Culture of the Mind;
(r) Hall of the Worship of the Ancestors;
(s) Pavilion of Arrows;
(t) Imperial Library;
(u) Palace of Culture;
(v) Palace of Peace and Longevity;
(w) Nine Dragon Screen

FENG SHUI

Feng shui (literally, "wind and water") is a colloquial Chinese name for a Daoist belief that people and nature are linked in an invisible dialogue. Certain "dragon lines" of energy or *qi* flowing along the surface of and within the earth are believed to have the power to influence the lives of people near them. The flow of this *qi*, which may run from mountains along the outlines of hills and watercourses, is not static; it may vary every two hours or at other intervals across a sixty-year cycle of time in the Chinese calendar. Moreover, the flow of the existing *qi* of a locality may

be altered and improved through landscaping, plantings, and the building of canals.

Looking ahead, builders throughout Chinese history have consulted with *feng shui* experts to determine the proper location and orientation of a tomb, building, or city, or the best way to arrange furniture in a room. Since the emperors were divine and closely connected to cosmological forces, the practice of *feng shui* was especially important in site selection and the planning of their imperial cities. Since Zhou times, imperial cities have been arranged on a north–south axis,

with the imperial enclosure at the north end of a walled, grid-planned complex in order to place the evil forces and spirits of the north at the emperors' backs.

The principles of *feng shui* reflect the Chinese belief in the wholeness of the universe and the necessity of living in harmony with nature. In theory, *feng shui* provides a means of defining one's position in the physical universe by understanding this harmony and invisible dialogue. In practice, *feng shui* is a complex combination of mystical knowledge, common sense, and aesthetics in which the Chinese still have great faith.

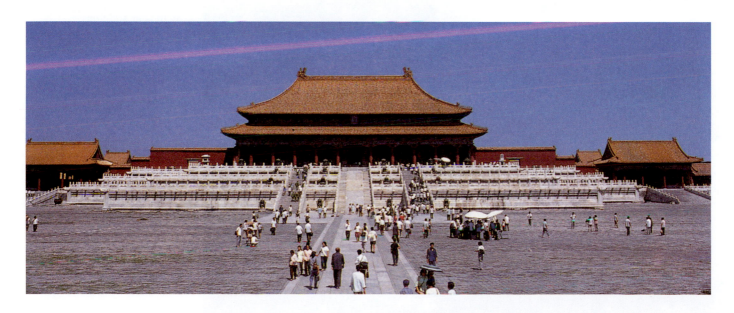

4.29 Hall of Supreme Harmony, Imperial Palace, Beijing. Begun 17th century

court, and the Hall of Supreme Harmony (FIG. 4.29). The latter housed the throne of the emperor, and ceremonies celebrating the winter solstice, the new year, and the emperor's birthday were performed here. The hall and buildings behind it, elevated on a three-level, white marble platform, are approached by gently sloping stairways. Behind the three raised halls the Gate of Heavenly Purity leads to an enclosed complex housing the emperor's Palace of Heavenly Purity and the empress's Palace of Earthly Tranquility. The buildings, many of which have been refurbished since

the fifteenth century, follow traditional patterns of post-and-lintel construction and decoration dating back to the Shang or Zhou periods.

The true weight of the enormous tiled roof of the Hall of Supreme Harmony and the other buildings in the city is disguised by the playful, festive quality of their flaring corners and the glowing yellow of their glazed tiles (a color reserved for imperial structures). In a manner similar to traditional Chinese painting, where conspicuously bright colors were often applied to a linear structure, the structural parts of the buildings are highlighted with blazing colors. The broad, upswept eaves are supported by a complex system of decorative yet functional brackets resting on the lintels, which often extend out beyond the posts holding them. The complex collection of brightly lacquered, cantilevered brackets rises out of the slender columns like the branches of a severely pruned and shaped tree. Reaching out to support the upturned eaves, these energetic forms have the gestural qualities of the finest Chinese calligraphy and repeat many of the decorative shapes used on Shang and Zhou bronzes while drawing attention to the roofs. The walls are little more than thin membranes strung between the solid posts that support the brackets and wing-shaped roofs.

Traditionally, the imperial family seldom left the complex, so, to provide them with views of nature, designers built large, complex gardens—labryrinthine walled and enclosed spaces—that harness the strength of the *qi* in nature (FIG. 4.30). Their furnishings reflect a taste for all that is old—rugged trees and craggy rocks that have been eroded and perforated by time, so that some now look like miniature mountains or fantastic animals. Unlike the famous Zen gardens in Japan, which are designed to be seen from the outside, from viewing platforms and walkways behind railings, the Chinese gardens encourage us to walk through them and become part of the environment and its *qi*—to participate in what is at once a secular, metaphysical, and religious experience. The gardens are also microcosms of nature and represent a Daoist paradise called the Isles of the Immortals. It is by walking through the Chinese garden, being "in" it, that one understands the fundamental principle—*li*.

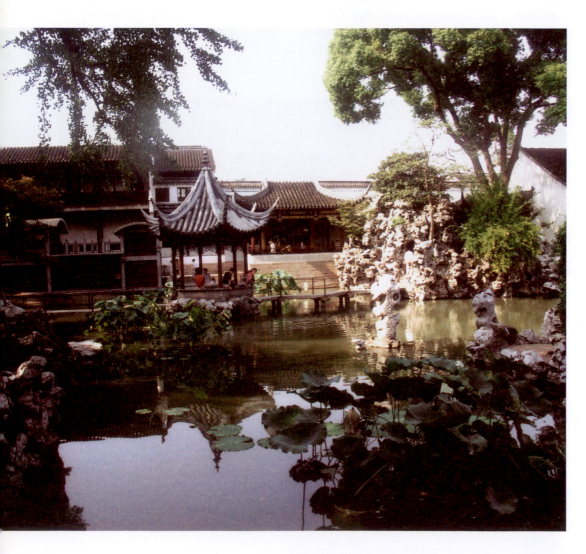

4.30 Lion Grove Garden. Suzhou, Jiangsu, China, view west to Heart of the Lake Pavilion. Yuan dynasty, 1342, with later additions

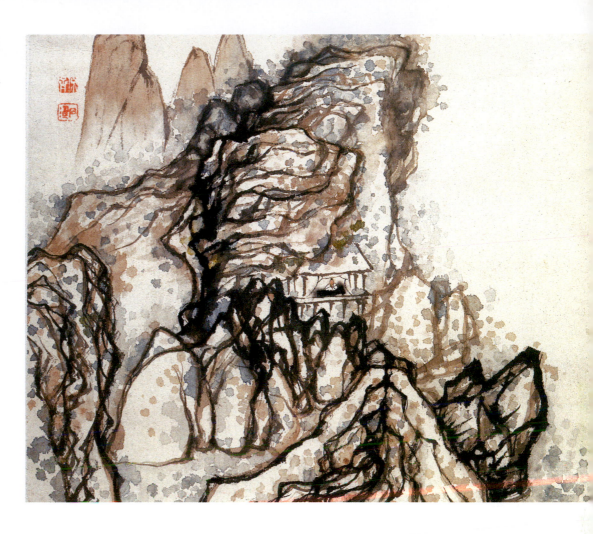

4.31 Shitao, *Landscape*. Qing dynasty, c. 1700. Leaf from an album of landscapes. Ink and color on paper, 9½ × 11" (24.1 × 28 cm). C.C. Wang family collection

PAINTING

The traditional distinction between professional and literati painters continued into Qing times, but the literati label does not fully describe a new group of artists who became known as the **Individualists** or the Eight Eccentrics of Yagzhou. Some of the most original Individualists were Ming loyalists, who resented the hegemony of the new, foreign dynasty and retired to Buddhist or Daoist mountain retreats to escape its influence. There they painted and wrote, attacking the Manchurians as well as the old Chinese order that had allowed the country to fall under outside rule. Kun-Can, also known as Shiqi (1612–73), painted a symbolic portrait of himself in a tree with an inscription that reads: "I am living high up in a tree and looking down. Here I can rest free from all the trouble like a bird in its nest. People call me a dangerous man, but I answer: 'You are like devils.'"

Kun-Can's fellow Individualist—and his equal as a revolutionary—Shitao, also known as Yuan-Ji (1641–1707), was a descendant of the last Ming emperor. Together, these two are known as the Two Stones because of their hard-headedness and the character *sih* (stone) that appears in both their names. Shitao wrote: "I am what I am because I have an existence of my own. The beards and eyebrows of the ancients cannot grow on my face." He did not revere the time-honored philosophy of such "ancients" as Xie He, who talked about the "transmission of experience of the past in making copies." Shitao said: "Though on occasion my painting may happen to resemble that of so-and-so, it is he who resembles me, and not I who willfully imitate his style." This unpredictable Individualist worked under at least two dozen pen or "brush" names, including "The Pure One," which he adopted after converting to Daoism.

In his writings, Shitao, who also designed gardens, talks about the fundamental unity of people, the landscapes in which they live, and all creation. As in the art and writing of Kun-Can, we see the philosophy of the outspoken Shitao at work in paintings such as *Landscape* from about 1700 (FIG. 4.31). Here, the Individualist monk is seated in an elevated and remote place, in a tiny cabin near the crest of a rocky mountain. The rocks, like Kun-Can's tree limbs, are alive with energy and look as if they are about to tumble down upon the monk and his fragile place of solace. The painter, seldom lifting his brush from the paper,

EUROPE AND "CHINOISERIE"

The first Portuguese trading ships arrived in China in 1514, and by 1715 the major European shipping nations all had offices and warehouses at the Chinese port of Canton. While some Jesuit missionaries were making systematic studies of Chinese culture and such major European thinkers as Dr. Johnson and Voltaire were intrigued by the egalitarian spirit of the Chinese civil service examinations, for many Europeans, conflicting reports on China gave rise to exaggerations of all kinds, both positive and negative.

The porcelains, reverse paintings on glass, wallpapers, carved ivory fans, boxes, lacquers, and patterned silks taken to Europe by traders created a vogue for **chinoiserie** (French for "Chinese-style things") that was part of this infatuation. Chinese porcelain, or "china" as it came to be known in the West, was especially popular in Europe. To meet the rising demand for it, ceramists at Meissen near Dresden, Germany, learned how to make their own porcelain in the early eighteenth century.

Chinese art and European reproductions of it influenced the development of the Rococo style in France. In 1742, François Boucher painted an idealized blue-on-white fantasy (resembling a Chinese porcelain) in which an obsequious Chinese man with a broad-brimmed straw sun hat is shown paying homage to a European woman with a parasol (FIG. 4.32). The porcelain vase on the stand beside her is shaped like an ancient Chinese bronze. Above, a cross-legged and portly Buddha-like figure is seated on a tall platform with Asian palms near a Chinese hut with upturned eaves.

Chinese gardens of the Qing period were greatly admired in Britain and France. As early as 1700, Sir William Temple wrote how Chinese gardeners prized irregularity and imagination over symmetry and beauty in their designs. By the mid-eighteenth century, James Cawthorn was lampooning the English fascination with Chinese aesthetic ideas in a satirical poem describing a "Mandarin":

> Whose bolder genius, fondly
> wild to see
> His grove a forest, and his
> pond a sea,
> Breaks out—and whimsically
> great, designs
> Without shackles or of rule or
> lines.

By the end of the eighteenth century, many of the ideals of Chinese aesthetics had been assimilated into the Romantic movement. Today we are in a unique position to revisit the history surrounding these East–West interchanges and appreciate its complexity and cultural richness.

4.32 François Boucher, *Le Chinois galant*. 1742. Oil on canvas, 41 × 57" (1.04 × 1.45 m). David Collection, Copenhagen

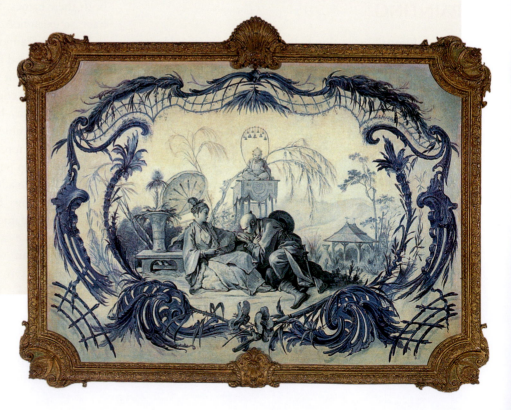

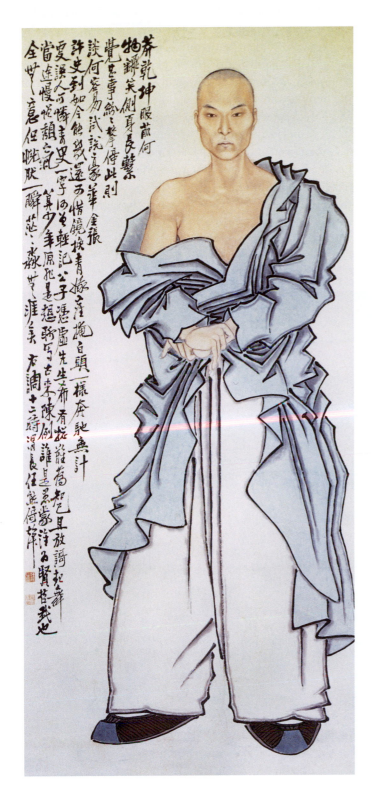

uses long, continuous, undulating lines that make the heavy rocks look like cresting waves that are about to wash over the tiny refuge. At times, the curious Yuan-Ji splattered his paintings with dots in a manner reminiscent of the U.S. Abstract Expressionist Jackson Pollock, just to see what forms or ideas they might suggest. This vision of nature in turmoil reflects the artist's sense of the underlying unity of all creation as well as the anxiety and frustration of a Ming loyalist trying to find a safe place for himself under the rule of the powerful Manchurians. (See *Cross-Cultural Contacts: Europe* and "Chinoiserie," page 142.)

Contacts with the West and its art intensified in the nineteenth century in the late Qing period. Some Chinese painters trained by resident Europeans became fully Westernized and worked outside native traditions. Others in the newly emerging southeastern commercial cities such as Shanghai looked for ways to mix their native traditions with Western art. Elements of the old and new mix in the work of Ren Xiong (1823–57), a member of the Shanghai School of literati painters. Following Britain's victory in the First Opium War (1840), China was forced to open the port at Shanghai to foreign traders, and in the aftermath of the bloody Taiping Rebellion (1851–64), the country's economy and cultural traditions were in such disarray that some writers nicknamed the once-powerful nation the "Sick Man of Asia." With his homeland in dire straits, Ren's self-portrait might be read as an image of China (FIG. 4.33). With his pale, thin torso and pensive, brooding face, the "sick man" peers out from his bulky robe, a great maelstrom of forces that crumple around him like sheets of folded metal. In places, the brushwork of his robe looks like the energized brushmarks of the calligraphy beside him, reminding us of the traditional linkage between the arts of painting and writing in China. The untraditional self-portrait, along with the accompanying poem that suggests the artist was not entirely loyal to the Qing dynasty, has many possible readings that might explain Ren's alienation from the world of political and economic decline around him. China, with all its ancient values, as Ren and his ancestors knew it, was in the process of folding in upon itself, and the artist, caught in that trap, stands before us with no answer to the plight in which the ancient empire now found itself.

MODERN CHINA (FROM 1911)

The West's victory in the Opium Wars (1839–42) and a series of rebellions engineered by Chinese peasants and secret societies seriously weakened the power of the Chinese emperors in the nineteenth century and further opened the country up to Western trade and influences. The Boxer

4.33 Ren Xiong, *Self-Portrait*. 1850s. Hanging scroll. Paper, 5′9⅝″ × 6′6¼″ (1.77 × 1.99 m). Palace Museum, Beijing

Rebellion (1900), which attempted to push out the foreigners who were reducing China to colonial status, presaged the overthrow of the Qing dynasty in the Republican revolution of 1911. The arts played a prominent role in the heated debates that followed this revolution as the Chinese looked for ways to synthesize the best parts of their traditional culture with modern Western thinking to create a new China. This philosophical ideal of blending East and West was inculcated in the educational approach of the new art schools, museums, and government-sponsored exhibitions of art. Not all artists, however, were seeking an East–West synthesis. Some conservatives continued to work in time-honored historical styles, while an avant-garde including artists who had studied in Europe worked in the modernist styles of their instructors.

This openness to Western thinking in the arts was stifled by the civil war between the Communists and Nationalists, the Japanese invasion of China (1937), World War II, and the establishment of the People's Republic of China (1949). Traditional Chinese art now came to be seen as a symbol of the feudal society that the People's Republic wanted to eradicate. Central governmental control of the art world also marked the end of private patronage and the commercial art market that had existed in China since the ninth century. In the mid-1950s, Russian painters came to China, taught the principles of their Socialist Realist style, and encouraged the best Chinese students to go to Moscow for advanced study. The visual arts became a propaganda machine in the service of the People's Republic. The traditional styles of Chinese painting and abstract works of the avant-garde were ill-suited to this task and were virtually swept aside. Efforts were also made to destroy and hide the long history of Chinese art during the Cultural Revolution (1966–76) launched by Mao Zedong (1893–1976), when the infamous Red Guard is reputed to have destroyed thousands of buildings and works of art.

Some artists were picked out and encouraged for political purposes, so that the government could claim them as part of the "New China." Many, however, were simply installed in artists' collectives where their work was absorbed in communal forms of expression. The large Socialist Realist paintings produced by these communes often show happy Chinese workers serving the state along with an image of Chairman Mao raising his hand, making a grand gesture over his state and its future. Indeed, so many prints and inexpensive statuettes of Mao were made by the collectives and circulated in China and around the rest of the world that the ruler's face has become an icon for this era in Chinese history. They depict the full-faced, mature Mao as the supremely confident leader of his people, smiling benignly, as if promising prosperity for all. The large sculpture of Mao commissioned for his mausoleum shows him as a man of the people, seated in a large upholstered chair, wearing his usual thick-weave uniform and sturdy shoes (FIG. 4.34). The Chinese dictator is seemingly happy in the knowledge that a Communist utopia is just around the corner. But after his death, artists began to parody Mao, until these earlier images advertising his political success began to embody the exact opposite to many viewers—the signature smile of a man who had engineered the destruction of so many of China's great traditions.

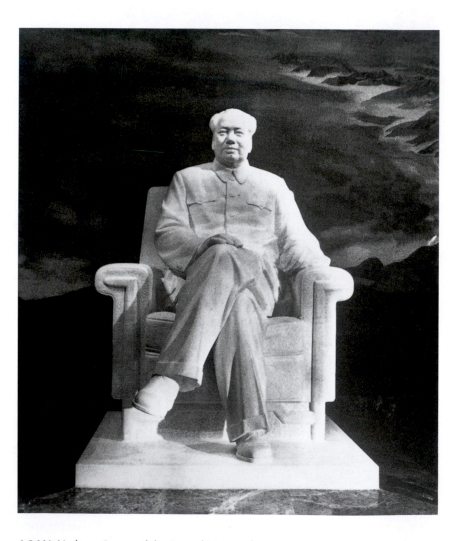

4.34 Ye Yushan, *Statue of the Seated Mao Zedong*. 1976. White marble, height 11′5¾″ (3.5 m)

With the death of Mao and subsequent arrest of many of his close associates in 1976, the state's interest in controlling the activities of artists declined. Many who had been assigned to go to the countryside to learn from the peasants during the Cultural Revolution were now free to return to the cities, where they could reconnect with the surviving remnants of the old Chinese art world. In the outburst of creativity that followed in what was called the Beijing Spring, artists began to reemerge from their long period of suppression and experiment widely with new and more sophisticated ways of combining traditional Chinese and new Western ideals in art.

One of the artists sent to the provinces after he graduated from the Sichuan Academy in 1968 was Luo Zhongli (born 1950). He made sketches of the peasants during the decade of his isolation before returning to teach art in Chongqing in 1978. His much-publicized, over-lifesize portrait based on these sketches, *Father* (FIG. 4.35), which won first prize in the National Youth Exhibition of Beijing in 1980, was inspired in part by Photorealist paintings by the U.S. artist Chuck Close that he had seen in magazines. It represents an aged Chinese peasant with dark, weathered, wrinkled skin and provides something of a contrast to the large, officially sanctioned, eternally smiling images of Mao surrounded by romanticized images of adoring peasants that had hung everywhere in China only a few years earlier. The artist seems to be saying that, after a generation of promises by the paternalistic Mao, the "father" of China, the life of this particular *Father* was little changed or improved. The ballpoint pen behind the subject's left ear was added at the request of the director of the Sichuan Artists' Association to "modernize" the man and placate critics who found the work upsetting. If anything, however, it further emphasizes the distance between the fiction and reality of peasant life.

4.35 Luo Zhongli, *Father*. 1980. Oil on canvas, 7'5" × 5'⅝" (2.27 × 1.54 m). Chinese National Art Gallery, Beijing

SUMMARY

The long history of Chinese art extending from the Neolithic period (c. 7000–2250 BCE) to the present day is exceedingly complex. Periods of stable rule by native Chinese dynasties alternated with times of anarchy and foreign rule. Trade along the Silk Road and by sea kept China open to new developments throughout Eurasia. While the Chinese attached great value to their existing cultural traditions and managed to Sinicize many foreign ideas, their art and culture were in a constant state of change. The great religious and social philosophies operating in China that helped inspire the arts—Daoism, Confucianism, and Buddhism—have never been static modes of thought. Patronage of the arts in China has also changed over the years as social changes have taken place within the country. Up to about the tenth century CE, the court dictated matters of taste. After that time, many of the nonaristocrats who gained wealth and power became important patrons and artists. Moreover, Chinese artists of the last five hundred years have had to deal with Western influences. As a result, the art of each period in China has a distinct character and the history of Chinese art is as complex as that of the art of Europe.

Little remains of the ancient Chinese cities, including the palaces and their decorations. Although the practice of collecting art in China was an ancient one, the works of many early masters of painting and calligraphy whom we know by name have been preserved only through later copies. Much of the oldest Chinese art that has come down to us was preserved in tombs. Likewise, the works of the earliest Chinese art critics and aesthetes have been lost. Where such material has been preserved, as in the case of the literati and their opposition to the styles of the professional court painters, its philosophical depth is often astonishing and illuminating. As China makes its way further into the twenty-first century, some artists are preserving traditional forms of Chinese art and thought. Others have become part of the international world of art and will be discussed in this context in Chapter Nine.

GLOSSARY

AMITABHA BUDDHISM Also known as Pure Land Buddhism. To enter paradise, all a devotee need do is call out the name of the Buddha. Its art forms tended to be relatively simple and populist compared to those of the Esoteric Buddhist sects discussed in Chapter Five with the art of Japan and Korea.

BI Chinese, "circular." See *CONG.*

CALLIGRAPHY From the Greek *kallos,* "beauty," and *graphos,* "writing." Literally, "beautiful handwriting." In China, the art of fine handwriting developed concurrently with painting, and practitioners of one art form were often accomplished in the other. They used the same brushes and inks and tended to work in flashes of inspiration to capture the *QI* and give their marks meaning beyond the words or subjects they illustrated.

CHAN BUDDHISM *Chan* derives from the Sanskrit word *dhyana,* meaning "contemplation." A mystical form of Buddhism that seeks harmony with the vital spirit of nature through meditation. In the West, it is better-known as Zen, the Japanese pronunciation of "Chan."

CHINOISERIE French term meaning "Chinese-style things." The vogue for Chinese art in the West beginning around 1700.

CONFUCIANISM A moral philosophy dating back to at least Shang times, which was codified in the social ethics and teachings of Master Kong, known in the West as Confucius (c. 551–479 BCE). It paid homage to one's spirit ancestors who had access to the wisdom of the gods which the Confucians used in their attempts to recreate the perfect order of the spiritual world here on earth. Confucius called this ideal of perfect harmony with nature and the spirits the *LI.* Confucius believed the ideal Chinese gentleman – a broad-minded, loyal, respectful, and just individual with empathy and good etiquette or deportment – embodied the *li* and concept of *ren* (human-heartedness). Confucian respect for age, authority, and morality made this philosophy popular among Chinese leaders and the artists they patronized for centuries to come. However, Confucius did not comment directly on the arts and how his principles might be manifest in them.

CONG Chinese, "rectangular." Along with the *BI,* one of two important geometric forms made from jade and dating from the Neolithic period.

CRACKLE A distinctive type of pattern of cracks that develops in the glaze on a piece of pottery owing to the fact that the glaze and clay body of the vessel contract at unequal rates during cooling after the fired vessel is removed from the kiln. Also known as crazing.

CUN The raindrop or "wrinkle" brushstroke used inside ink contour lines to shade, model, and texture forms to make them appeal to the sense of touch and appear to have greater mass. Chinese writers identify about twenty-five varieties.

DAOISM Chinese, "The Way." A philosophy derived from the *Dao de jing* ("Book of the Way") by Lao Zi ("Old One") (born c. 604 BCE) that explains how the *dao* is embedded in the heart of nature. A general term for the animistic beliefs that lie at the core of the Chinese understanding of the world and humankind's quest for harmony with nature. Through contemplation, the Daoist seeks to release his or her ego or natural instincts and achieve this harmony with the flow of nature and the universe. In contrast to CONFUCIANISM, which guides one's communal or outer life, Daoism is a private inner and spiritual philosophy. Daoist priests were often court divinators and shamans. Together, the *dao* and *LI* express dual and complementary ideals of life; the inner and outer worlds of existence.

DING A three-legged bronze vessel type produced in the Shang and later periods, developed from Neolithic ceramic prototypes.

FENG SHUI From the Chinese for "wind" and "water." A colloquial Chinese name for a DAOIST belief that people and nature are linked in an invisible dialogue and that certain "dragon lines" of energy or *QI* flowing along the surface and within the earth have the power to influence the lives of people near them. The flow of this *qi* is not static and may vary every two hours or at other intervals throughout a sixty-year cycle of time in the Chinese calendar.

INDIVIDUALISTS Also known as the "Eight Eccentrics of Yangzhou." A group of late Ming artists who would not acknowledge the authority of their new Manchu overlords. They followed the Song traditions of painting, as well as inventing some new ones of their own.

KOANS "Questions" or "exchanges" with a Zen master designed to break down traditional, rational patterns of thought, sharpen one's intuitions, and create a breakthrough to enlightenment and sense of oneness with nature.

LACQUER A clear, natural varnish obtained from the *Rhus verniciflua* (lacquer tree). It is generally applied in many layers with impregnated color, forms a hard and long-lasting body when dry, and may be carved.

LI The "innate structure of nature" in Confucianism. Similar in concept to the *dao* ("The Way") of Lao Zi (see DAOISM) and the *QI* of Xie He.

LIJI "Book of Rites." CONFUCIUS's summary of the late Zhou philosophy of jade.

LITERATI See *WENREN.*

MING The ultimate inward vision in which the two vital forces of nature, the *YIN* and the *YANG,* become one in DAOISM's experience of the oneness of all creation. Also, the name (meaning "bright") of a Chinese dynasty of rulers (1368–1644).

MORTISE AND TENON A method of joining two pieces of wood or stone in which a tenon, or projecting part, from one piece is inserted into a mortise, or cavity, of corresponding size and shape in the other. The two pieces may then be pinned, glued, or wedged together.

NEO-CONFUCIANISM An eclectic Chinese philosophy that had been developing since the Tang period, incorporating elements of DAOIST and Buddhist thought. The official ethical and metaphysical philosophy of the Ming court.

PATINA A discoloration of bronze caused by prolonged exposure to minerals. The main patinas appearing on Chinese bronzes are blue (azurite), green (malachite), and red (cuprite). Similar color effects can be created more quickly using solutions of acids.

PINYIN Chinese, "spelled sound." A system of transliterating the Chinese language adopted by the People's Republic of China in 1958 and later in Taiwan, where it is called the New Phonetic System. It has largely replaced the older Wade-Giles system.

PORCELAIN A fine white hard-paste and translucent pottery made from volcanic clays containing the minerals quartz, kaolin, and feldspar. Also made of other clays rich in kaolin. One of the major centers of production in China was established at Jingdezhen around 1004 CE, a region with exceptionally fine porcellaneous clays close to the Yangzi River along which the wares were exported. By the Ming period, Chinese painters were creating the hard-edged blue cobalt and white designs on porcelains for which China became famous.

PURE LAND BUDDHISM See AMITABHA BUDDHISM.

QI The vital spirit embedded in nature, mentioned in the canons of Xie He. An artist's *qi* is manifest in his body movements, especially his brushwork, which expresses his harmony (*yun*) with nature. The WENREN artists from the cultural elite in China believed that through their cultural refinement they could express their *qi* in their works, while the professional academic painters who worked for hire in the courts could not.

SHAMANISM A widespread belief that certain individuals known as shamans are able to enter self-induced trance states and communicate with the celestial world. They perform a variety of functions—healing, spiritual, etc.—assumed by priests, preachers, magicians, actors, doctors, and others in larger, more industrialized societies.

SHI MO An austere style of painting with ink, but no color, on absorbent papers capable of capturing the subtlest nuances of brushwork.

SINICIZE To acculturate or convert to Chinese ways. Often used in reference to the way the Chinese have absorbed successive waves of foreign intruders into the mainstream of their culture. Sinology is the study of Chinese civilization.

TAOTIE Varieties of ogre or monster masks formed by the conjunction of two profile faces with prominent beady eyes. Used to decorate Shang bronze vessels. Possibly related to SHAMANISM.

WENREN Also known as literati painters. Highly educated, upper-class scholar-officials who emerged in the Song period who did not attempt to make a living from their art. Many writers of the time praised them for their lofty-mindedness, inspiration, spontaneity, and creativity, and said they were superior to the professional court painters associated with the academies.

YIJING "The Book of Changes." A divination text (c. 200–100 BCE) that explains early Chinese views of the cosmos and discusses the qualities of jade.

YIN AND YANG The female and male principles of nature in DAOIST thought. The *yin* (female) is associated with darkness, softness, and passivity, and the *yang* (male) with brightness, hardness, and action.

YU A type of ornate bronze vessel made in the Shang and Zhou periods.

YUNQI Literally, "cloud spirit" or "cloud force." A rhythmic, curvilinear scroll form that embodies the energy of the *QI*. It is often associated with the cult of sacred mountains.

QUESTIONS

1. It has been said that, together, Daoism and Confucianism shaped the character of Chinese thought over the ages. What did each line of thought contribute, and how are those ideals expressed in Xie He's canons of painting (c. 500 CE)?

2. Calligraphy, the beautiful penmanship of cultivated individuals from the past, is something of a lost art in contemporary society. Why was it so important in China? Have any contemporary forms of "writing" taken its place in the digital age?

3. *Feng shui*, the Daoist-derived idea that people and nature are closely interlinked, has become very popular around the world. Do you know anyone who practices *feng shui* and is vocal about its philosophy? What do they say about it? Do you think *feng shui* is a valid line of thought?

4. How might the arts in China develop in response to the recent economic liberalization of the country? What role will political liberalization (or otherwise) play in this evolution?

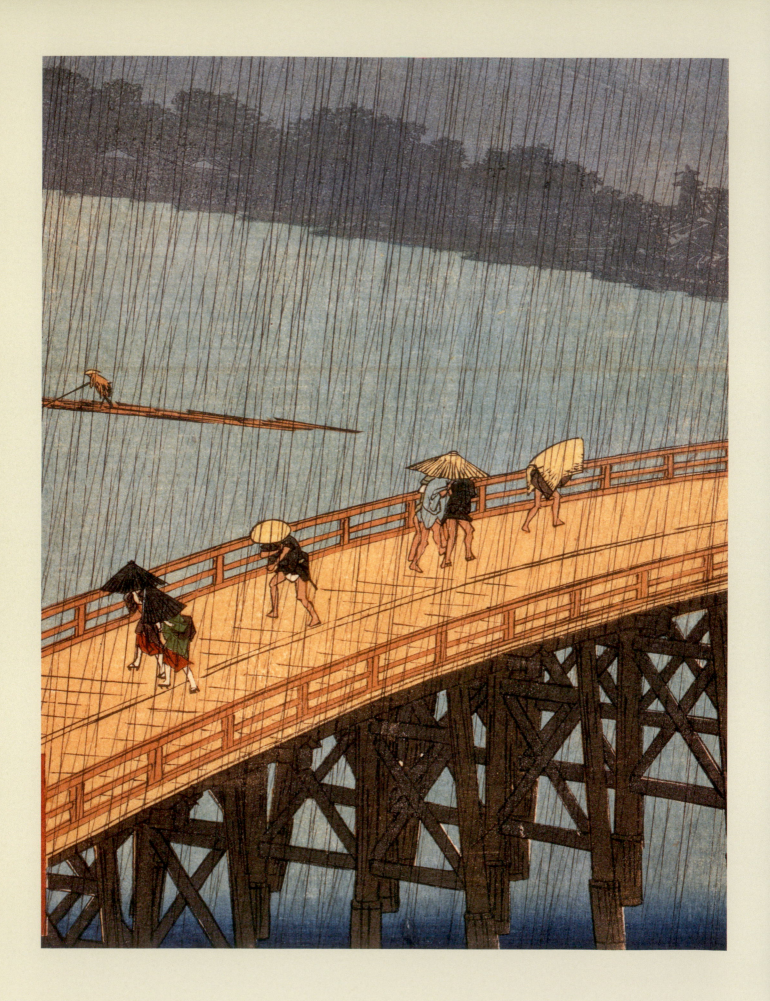

5 | Japan and Korea

Equator

Introduction 150

The Jomon Period (c. 12,000/10,500–300 BCE) and Yayoi Period
(300 BCE–300 CE) 152

The Kofun Period (300–710 CE) 153

Korea: The Three Kingdoms Period (57 BCE–688 CE) 156

The Asuka Period (552–645 CE) and Hakuho Period (645–710 CE) 158

The Nara Period (710–94 CE) 161

The Heian Period (794–1185) 162

The Kamakura Period (1185–1333) and Koryo Korea (918–1392) 167

The Muromachi (Ashikaga) Period (1392–1573) 170

The Momoyama Period (1573–1615) 173

The Tokugawa (Edo) Period (1615–1868) 182

The Meiji Restoration (1868–1912) 187

The Modern Period (from 1912) 192

Summary 197

Japan and Korea

The most important Japanese works of art come from Honshu, the largest island in the Japanese archipelago. The major art centers there are located in the vicinity of Nara, Osaka, Heiankyo (present-day Kyoto), and Edo (present-day Tokyo). Many of the most important art centers in Korea are in the eastern coastal regions facing Japan. No single set of dates for the Jomon, Yayoi, and Kofun periods is accepted by all scholars of Japanese art. Because the cultural patterns in outlying areas tended to persist longer than those in the major political centers, some periods—such as the Kofun and Asuka— overlap. Historic periods are often named for the ruling family or their capital.

INTRODUCTION

Korea and Japan—one on a peninsula, the other on an archipelago along the northeastern seaboard of Asia—are included together because their cultures have been linked in many ways for more than two thousand years. Korea, midway between northern China and Japan, became part of the Chinese Han Empire in 108 BCE and transmitted elements of pre-Buddhist Chinese culture to Japan. These included skills such as weaving, bronzecasting, working on a potter's wheel, and cultivating rice. The Koreans also adopted the Chinese system of writing, the philosophy of Confucianism,

and, later, Buddhist culture with its authoritarian forms of government, all of which they passed on to Japan.

From their earliest recorded history, the Japanese followed an ancient, native set of beliefs, known today as **Shinto**, from the Chinese words *shin* (divine) and *dao* (way). Shinto has also been called the Sacred Way or Way of the Gods. The Shinto religion has preserved a taste for art forms that reflect the most ancient rural traditions in Japan, ideals of rusticity, humility, and simplicity with a touch of nostalgia for the distant past. With its shrines, places of worship, priests, and metaphysical dimensions, it has long been an enormously popular, institutionalized form of religion. But Shintoism had no powerful gods with which the Japanese emperors could associate, nor did it promise a glorious afterlife for its followers, all of which was available through Buddhism.

Information about Buddhism had been trickling into Japan for centuries, but the religion did not really take root there until the sixth century CE when the Koreans began sending Buddhist art and envoys to the Japanese imperial court. That first imported version of Buddhism became a highly ritualized, state-oriented status symbol for the country's leaders, but it was not popular throughout the country. A second elitist form of Buddhism, the Shingon and Tendai sects of **Esoteric Buddhism** (*Mikkyo* in Japanese) from northern India, Nepal, and Tibet, arrived in Japan during the Heian Period (784–1185). It placed a high value on mandalas, complex diagrams of the Buddhist cosmos, which they used to instruct and enlighten the faithful. It was not until a highly evangelical movement discussed in the previous chapter, Pure Land Buddhism, arrived in Japan that the religion became widespread there. In this sect, known as **Jodo** in Japanese, all a devotee need do to enter paradise was call out the name of Buddha, "Amida" in Japanese. However, none of these varieties of Buddhism entirely replaced Shintoism in Japan and, to the present day, many Japanese combine elements of both religions in their belief systems.

In time, many Japanese leaders felt the need to separate the art and culture arriving from mainland Asia from their foreign roots and develop specifically Japanese forms of expression in their arts and daily lives. Closing the borders of their islands to the outside world in the ninth century, they devised new Japanese forms of Buddhism, courtly styles of art, and a new social order. In this process the emperors eventually lost most of their powers to the **daimyo** and **shoguns**, secular leaders who stood at the apex of a complex feudal society. The imperial court remained the bastion of Japanese traditions, but many of the new forms of art were designed for the nonroyal, secular tastes of these shoguns, their subordinates, and the military.

In the twelfth century, Chan Buddhism from China arrived in Japan, where it was called **Zen** (based on the Japanese

TIME CHART

Jomon Period (12,000/10,500–300 BCE)

Yayoi Period (300 BCE–300 CE)

Kofun Period (300–710)

Korea: The Three Kingdoms Period (57 BCE–688 CE)

Asuka Period (552–645)

Hakuho Period (645–710)

Nara Period (710–794)

Heian Period (794–1185)

Korea: Koryo (918–1392)

Kamakura (1185–1333)

Muromachi (Ashikaga) Period (1392–1573)
 Francis Xavier arrives in Japan (1549)

Momoyama Period (1573–1615)
 Father João Rodrigues (1562–1633) active in Japan
 Oda Nobunaga (1534–82; ruled 1573–82)
 Sen no Rikyu, tea master (1521–91)
 Toyotomi Hideyoshi (1536/7–99; ruled 1582–98)

Tokugawa (Edo) Period (1615–1868)
 Tokugawa Ieyasu (1543–1616; ruled 1603–16)
 Foreigners expelled from Japan (1638)

Meiji Restoration (1868–1912)

The Modern Period (from 1912)
 World War II in Japan: 1941–45
 Occupied Japan: 1945–52
 The Gutai group: 1954–72

pronunciation of "Chan"). Like Esoteric Buddhism, it sought enlightenment, but not through intellectual means and complex mandalas. It advocated silent meditation, in the manner and tradition of the Buddha. Zen supported this idea with two pillars of wisdom: transcendental naturalism and spontaneous intuition. The first concept says that we are one with the cosmos; artists therefore should not attempt to portray nature, but to become one with it. The second ideal says that we cannot express this oneness by rational means; we must allow our intuitions free rein. In the arts, this philosophy favored painting over sculpture because painters, using the limited means of black ink and brush, could make a few quick strokes and complete their works in sudden moments of inspiration in keeping with Zen ideals.

In literature, this aesthetic contributed to the development of two types of poetry, the thirty-one-syllable **tanka** and seventeen-syllable **haiku**. In drama, it inspired **Noh** ("talent or performance") theater with its minimal plots and highly restrained actions. Zen's emphasis on discipline and the concentration of one's energies into compact, explosive actions also made it very popular with the **samurai**, the elite class of highly trained Japanese warriors who served the shoguns.

The intensification of the specifically Japanese elements in the arts continued after Japan closed its doors to the outside world for a second time from the mid-seventeenth century. After reopening their ports in the mid-nineteenth century, the Japanese made a determined and self-conscious effort to take what they could from the world around them while preserving the most important elements of their ancient traditions, which included a great reverence for the emperor and strong ties to Shintoism as well as Japanese forms of Buddhism.

These periods of isolation in which the Japanese refined their traditions in the arts, synthesizing indigenous and imported traditions, created high distinctive national styles. We may approach their aesthetics through a set of four basic ideals that still remain important in Japanese thought in the visual arts to this day. They are the importance attached to (1) suggestion, that which is not fully shown, said, or done but understood; (2) perishability or impermanence, the fleeting or ephemeral nature of existence that adds a tragic note to art; (3) irregularity, which gives art a natural and somewhat accidental look; and (4) a type of apparent simplicity that often belies the true complexity of a work of art. As we will see in the pages that follow, Japanese art owes much to China and Korea, but in the end it has been Japan's ability to adapt and personalize all that came to its shores that has made its art such an enduring and magnificent expression of its culture.

THE JOMON PERIOD (c. 12,000/10,500–300 BCE) AND YAYOI PERIOD (300 BCE–300 CE)

The name Jomon (meaning "cord markings") comes from the decorative cord marks the early hunting-gathering culture made on its pottery. The earliest known inhabitants of Japan arrived by land around 30,000 BCE, during the most recent Ice Age, when the sea level was lower and the Japanese islands were part of mainland Asia. Some of the oldest known ceramics in the world come from Jomon sites. Unlike Western Asia, where pottery is associated with the rise of agriculture, Jomon pottery was made by pre-agricultural people dependent on fishing, hunting, and gathering as early as 12,000 BCE. They did not begin cultivating domestic plants and living in communities until c. 5000 BCE.

The Jomon culture made pottery using the coiling technique, in which long rolls of moist clay are coiled one upon another to form the walls of a vessel. The vessels were decorated by pressing more rolls or ropes of clay against them while they were still moist and by rolling fiber cording across the soft surfaces. As was the custom in many early societies, most of the pottery was probably made by women. By the Middle Jomon period (2500–1500 BCE), these cord decorations had become abstract, asymmetrical sculptural forms with luxuriant, curling shapes (FIG. 5.1). The walls of a Jomon vessel often appear to leap up from its base and

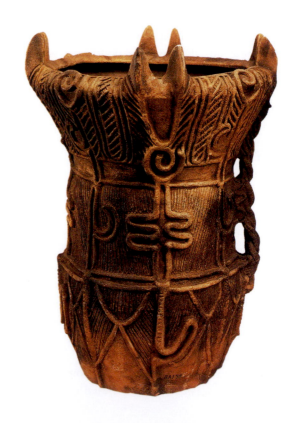

burst with energy like tall cresting waves, leafy plants, or tongues of fire. The decorative vocabulary includes ovals, scrolls, hatching, longer parallel lines, zigzags, lozenges, triangles, scallops, and freeform cordlike meanders that resemble eddying currents in water. While there are some repeating motifs in the patterns, some of which imitate basketry, the compositions are asymmetrical. This taste for free, asymmetrical forms over more regimented, symmetrical compositions has remained an important feature throughout the history of Japanese art. Along with some clay figurines, such Jomon ceramics with irregularly curved and spiral cord-patterned surface designs are some of the most spectacular examples of Neolithic art anywhere in the world. In the Final Jomon period (1500–300 BCE) the flamboyant character of the earlier decorations was replaced by restricted forms and precisely rendered patterns of incised curves that do not have the vitality of the earlier works.

The Yayoi period (300 BCE–300 CE) is named after the Yayoi district in Tokyo, where the first objects from this time were found. The techniques of weaving, bronzecasting, and working on a potter's wheel were introduced from Korea at this time. As the cultivation of rice became widespread, communities overseeing the rice paddies increased in size and complexity. They developed hierarchical forms of government and a stratified society that would ultimately produce an aristocracy and the imperial family that would rule Japan in the centuries to come. The *Wei zhi*, a third-century CE Chinese chronicle, says that Queen Himiko of Yamatai unified Japan around 180 CE, near the end of the Yayoi period. According to Japanese records, she was descended from the first emperor, Jimmu Tanno (c. 660 BCE) of the Yamato clan, who traced his ancestry back to Amaterasu-no-Omikami, the Shinto sun goddess. This genealogy, from 660 BCE to the present, represents the longest recorded unbroken dynastic lineage in world history.

THE KOFUN PERIOD (300–710 CE)

The Kofun period is named for the many large hill-shaped tombs known as **kofun** (*ko* means "old" or "ancient" and *fun* means "grave mound") built during this time. The culture of the mounted warriors from Manchuria or Korea who built the *kofun* provided the base on which much of the subsequent development of Japanese culture took place. Regional chiefdoms were consolidated under the imperial family, which traced its origins to the Shinto sun goddess and ruled out of the Osaka–Nara area.

BURIAL MOUNDS

The largest of the imperial *kofun* mound-tombs illustrate the tremendous power vested in these early Japanese emperors. A *kofun* near Osaka belonging to Emperor Nintoku (fourth to fifth centuries CE), in the shape of an old-fashioned keyhole, is protected by a double moat and covers about 458 acres (185 hectares) (FIG. 5.2). It would have taken a thousand workers about four years to build a *kofun* of this size. Originally, it may have been further "protected" by circular rows of **haniwa** (from *hani*, "clay," and *wa*, "circle"). It has been estimated that as many as twenty thousand *haniwa* (hollow terracotta cylinders supporting three-dimensional models of shields, singers, armored warriors, ladies, fish,

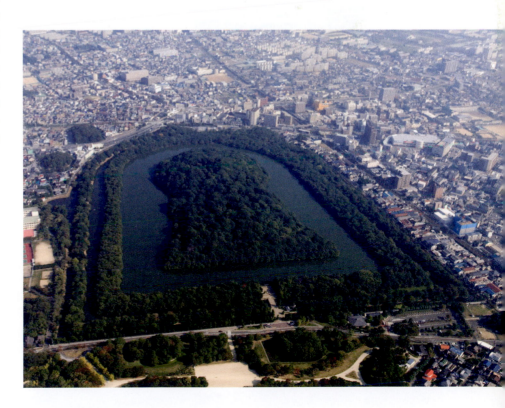

5.1 (OPPOSITE) Vessel. Middle Jomon period, 2500–1500 BCE. Earthenware, 23⅔ × 13¼" (58.5 × 33.6 cm). Tokyo National Museum

5.2 (RIGHT) Mound-tomb of Emperor Nintoku. Sakai, Osaka prefecture. Late 4th–early 5th century CE

birds, miniature house models, and horses with gear) were set on the mound with their bases plunged into the earth. The earliest *haniwa* were simple cylinders, followed later by objects such as boats or houses, and finally by images of people and animals. They appear to have marked the boundary between the lands of the living and those of the dead, between this life and the next.

The warrior in FIG. 5.3 illustrates the prehistoric Japanese taste for simple forms and textures that emphasize the inherent qualities of the clay. This type of respect for the nature of materials—being in harmony with nature—continued to be a major feature in Japanese art in later periods. Because the Imperial Household Agency in Japan prohibits the excavation of *kofuns* belonging to emperors, some of the finest *haniwa* may still remain buried.

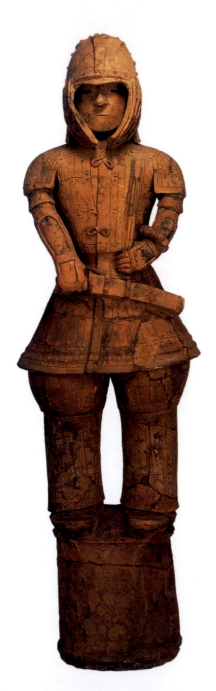

5.3 *Haniwa* figure of a warrior. Kofun period (300–710 CE). Gumma prefecture. Terracotta, height 49" (1.25 m). Aikawa Archaeological Museum, Isezaki

SHINTO AND SHRINES

Because Shinto developed among tillers of the soil in Japan, it was and remains very closely tied to the Japanese landscape. Followers of Shinto worship a large number of male or female spirits (**kami**) at sacred places (**iwakura**) where those spirits live in the rocks, trees, water, and other objects. Some of the *iwakura* have simple gates and one or more small buildings. Often, they are near water so worshipers can cleanse themselves before entering the precinct where they bow, as a sign of obedience, pray, and make simple offerings to the *kami*. Many of the *iwakura* are in highly picturesque locations in the mountains and forests, where the power and beauty of unspoiled nature symbolizes the strength of the *kami* and the oneness of the physical and spiritual worlds in Shinto. Before the Kofun period, few if any of the *iwakura* had temples or shrines. The earliest shrines, which began to appear around the Kofun period, have long since perished, but some of their features are preserved in such famous Shinto shrines as Ise (FIG. 5.4).

Because Shinto is so closely tied to the Japanese countryside, it has little presence outside Japan, except among Japanese living abroad. The Japanese are born into Shinto—and even after the arrival of Buddhism and philosophical systems of thought such as Daoism and Confucianism, Shinto remained an essential part of Japanese identity. Shinto has survived in this fashion because the Japanese have long assumed that religions should supplement and give strength to one another. Therefore, there is no inherent contradiction in paying allegiance to some or all of them.

While Buddhism has its dogma and spiritual rewards, Shinto preserves the traditional values of early rural and agrarian Japan—**wabi** (purity and humility), and **sabi** (stillness and rusticity). Some scholars use the term *wabi-sabi* and discuss the terms as a single concept or worldview. All of these values combine in the Japanese respect for nature, their elders, ancestors, and the emperor, who has long been regarded as the keeper of Shinto thought and its shrines. The imperial family is especially devoted to the shrine at Ise where women from the family serve as high priestesses (see FIG. 5.4). Legend has it that the original shrine housed the sacred mirror of Amaterasu-no-Omikami, the sun goddess and ancestor of the Japanese emperors. Together with the sword and jewel that the goddess gave to Emperor Ninigi

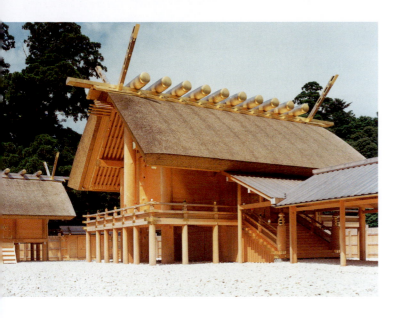

5.4 Grand Shrine, Ise. Founded in Kofun period, 6th century CE. Present reconstruction, 1993

no Mikoto, the mirror became part of the official Japanese imperial regalia, symbolizing the emperors' divine right to rule. Under Suinin, the legendary eleventh emperor, the mirror was enshrined at Ise, one of Japan's two major imperial shrines.

The original wooden buildings constructed at this shrine have long since vanished, but the main structure at Ise today preserves some or all of their features. Every twenty years since about 600 CE the building has been dismantled, destroyed with great ritual care, replaced by a new one, and rededicated in the presence of the imperial family. Although the building is relatively small and simple, workers have used much of the time during those twenty-year periods to handcraft the new versions of the shrine. Every step of the rebuilding process involves prayers, rituals, and periods of meditation. For example, all the logs used in the construction of the shrine are carefully chosen for their ideal proportions. After they are cut in the spring, when they are full of sap, they are allowed to "rest" so that the indwelling *kami* have ample time to find new homes. Later, Shinto craftsmen shape and rub the sap-filled logs with a red-orange persimmon juice until they turn a rich gold-brown. The woodworkers do not nail or bolt them together: they use mortise-and-tenon joints, treating the entire building as if it were a finely crafted piece of furniture. The component parts in each of the many joints are cut and shaped so carefully that the lines between them are nearly invisible. In the final phases of construction, the builders trim the many layers of brown, smoked thatch on the roof to make it look like a very plush, textured carpet. This approach to the use

of materials reflects the respect Shinto has always paid to nature and how that respect is manifest when the Shinto-inspired designers make anything from the smallest artifacts to the largest buildings.

Originally, the wooden weights along the ridgepole (*katsuogi*) and diagonal crosspieces extending from the gables (*chigi*) had functional roles in the construction, but here they are primarily decorative, extending the diagonal accents of the roofline and giving the building a lively "crown." By contrast, the pattern of horizontals and verticals in the colonnades and porch has a great sense of stability and anchors the shrine in the earth where the *kami* reside.

The Shinto leaders tried to preserve the design of the original shrine, derived from Asiatic mainland prototypes of the sixth century CE. Some scholars believe they succeeded. Others, however, suggest that over the years builders have incorporated later features of Buddhist architecture. Stages in this evolution are evident in other buildings in the Ise shrine complex. Thus, while retaining some of the ancient Shinto architectural traditions, the present structure may be the product of a long process of aesthetic and technical refinement. In this regard, the shrine may be said to be like Shinto itself, which has changed with the times while preserving its essence.

Visitors approaching the shrine follow a winding pebble path through a forest leading to two **torii** (gates). These sacred gateways in the outermost of the four wooden fences around the structure may be derived from the *toranas* of the Indian stupas (see Chapter Three). For Shinto pilgrims, passing through the *torii* is a symbolic act of spiritual rebirth. Like some of the other major Shinto shrines, Ise is to be seen and venerated by the Shinto community from the outside.

The rhythmic, crisp intersection of the horizontal, vertical, and diagonal lines of the building's structural parts, the contrasting textures and colors of the wood, thatching, and gravel, and the interplay of the patches of sunlight and shadows as they move across the exterior are tuned to perfection in this ancient system of shrine construction. The deceptively simple, rustic appearance of the temple is part of the highly sophisticated Shinto philosophy of beauty. It is a manifestation of an early Shinto-based sensitivity to forms and the native qualities of materials that remains part of Japanese thinking in later periods in the arts associated with Zen Buddhism and the highly ritualized tea ceremony. The intimate, natural character of the shrine and its garden-like context within the woods resemble that of the rustic houses used in these tea-drinking ceremonies. The purity and dignity of the simplified means of construction can best be appreciated in the manner in which the shrine was meant to be seen—as an object of veneration to be contemplated and adored with reverence.

In an effort to fuse Shinto with Buddhism, the Japanese began creating Ryobu (double-sided) Shinto in the eighth century CE. After two centuries of isolation from the outside world, in the Meiji Restoration of the emperorship (1868), State Shinto then promoted nationalism and patriotism and honored the emperor as a *kami*. After World War II, the emperor became the head of the Association of Shrine Shinto, with responsibility for the country's roughly eighty thousand Shinto shrines. In the midst of all these changes, Shinto values have proved remarkably adaptable to changes in Japanese society. Millions of Japanese today continue to adapt and extend the ancient values of Shinto to the highly industrialized and urbanized world of their country, keeping it up to date and vital.

It is easy to see how Buddhism, with its well-established temple and figure types for artists to copy, changed the course of Japanese art when it arrived in the sixth century. But it is more difficult to see the impact of Shinto on Japanese art, even though it has arguably been just as great. The influence is twofold: Certain ancient Shinto art forms were retained after the arrival of Buddhism, and thereafter the Shinto aesthetic worked within the Buddhist traditions in the arts, refining and reducing the arts to reflect its love for purity, simplicity, and rusticity. Even the wealthiest ruling families in Japan, who built lavish palaces and temples for public display, retained a taste for the deceptively simple and rustic arts of their ancestors. The enduring Shinto aesthetic—a deeply felt love for unspoiled nature, natural materials such as clay and wood, asymmetry rather than symmetry in compositions, and certain forms of handmade objects such as teapots and cups—provides a key for our understanding of Japanese art of every period.

We may understand the Shinto aesthetic even better by looking briefly at some traditional forms of Japanese literature and drama that will be discussed in more detail later in this chapter. The most popular type of Japanese poetry, the *haiku*, consists of three lines with five, seven, and five syllables. Within that spare form, the best poets were able to frame images of nature that are astonishing in their spareness. *Noh*, Japanese courtly drama, moves very slowly, with long pauses in the action. The highly ritualized tea ceremonies held in small, sparsely furnished rooms or in specially built tea houses, are likewise marked by long periods of silence for contemplation. Japanese paintings often have large, open, and seemingly empty passages, and the most famous ceramic vessels used in the tea ceremonies are simple, rugged wares that embody the virtues of *wabi* and *sabi*.

All of these forms of Japanese expression—poetry, drama, painting, sculpture, architecture, and ceremony—are designed to be experienced slowly, thoughtfully, in the same manner that they were conceived and created. Often,

the cessation of all imagery and action becomes the most important "activity" of the artist and observer. The state of inactivity is designed to stimulate the imagination and bring the observer into the world of the artists who created the images and buildings illustrated in this chapter. The affection the Japanese have always had for seemingly simple but deceptively complex arts that stress essential forms and acts of contemplation is linked in spirit to their veneration of the Shinto *kami* and remains a poignant symbol of the Shinto basis of Japanese art and thought.

KOREA: THE THREE KINGDOMS PERIOD (57 BCE–688 CE)

The Korean peninsula, midway between northern China and Japan, transmitted many elements of Chinese art and culture to Japan. However, after arriving in Korea, Chinese art interacted with the native Korean traditions to create distinctly Korean styles of ceramics, sculpture, metalwork, and painting, unlike those from mainland Asia and Japan.

The Koreans learned the techniques of agriculture and metalworking from the Chinese and became part of the Han Empire in 108 BCE. After the fall of the Han, in the Period of Disunity (220–589 CE), the Chinese gradually withdrew from Korea, leaving behind their philosophies of Daoism, Confucianism, and Buddhism (which arrived in 372 CE), as well as their system of writing. During this time, the Three Kingdoms Period, Korea was divided into the Koguryo kingdom in the north, the Paekche kingdom in the southwest, and the Silla kingdom around the Naktong River drainage area facing the Sea of Japan.

Of these three kingdoms, the Silla was the most remote from China, both geographically and aesthetically, and many of the most important Korean works of art from this period come from this area. Kyongju, the Silla capital for almost a thousand years, is dotted with huge tumuli marking the tombs of the rulers. The golden crowns, earrings, necklaces, rings, bracelets, and belts from these royal graves indicate that the Silla were some of the most accomplished and innovative gold artists in Eastern Asia in the fifth and sixth centuries CE. The gold crowns, made of thin hammered and cut sheets of embossed gold, are too delicate for regular use and may have been created for special ceremonials, such as inaugurations, or they may have been made specifically as grave goods. The headband in FIG. 5.5 supports antler- and tree-shaped projections decorated with small gold disks and curved, comma-shaped pieces of jade. The Old Silla gold artists may have learned their techniques of goldworking via works of art that arrived from the Mediterranean world along the Silk Road.

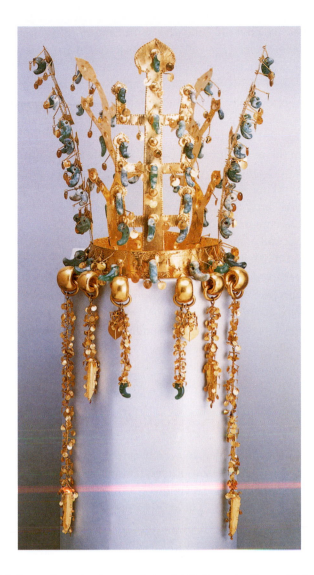

5.5 Crown from north mound, tomb 98, Kyongju, Korea. Old Silla period, 5th–6th century CE. Gold, height 10¾" (27.5 cm). Kyongju National Museum

Sculptors of this period, working shortly after Buddhism had become the official religion of the country, created the most famous surviving Korean Buddhist statue. It is an image of the *bodhisattva* Maitreya, the Buddha of the Future, who would come to Earth and bring enlightenment to everyone (FIG. 5.6). Maitreya was a favorite of an elite group of young aristocratic warriors, the Flower Youths, whose leader claimed to be an incarnation of the *bodhisattva*. Like the historical Buddha Shakyamuni, who discovered enlightenment through prolonged meditation, Maitreya is shown far removed from this world, deeply absorbed in a state of meditation. All the formal elements contribute to this sense of inner peace and oneness. The manner in which the sculptor has organized Maitreya's pose and treated his body parts emphasizes this ideal of otherworldly thought.

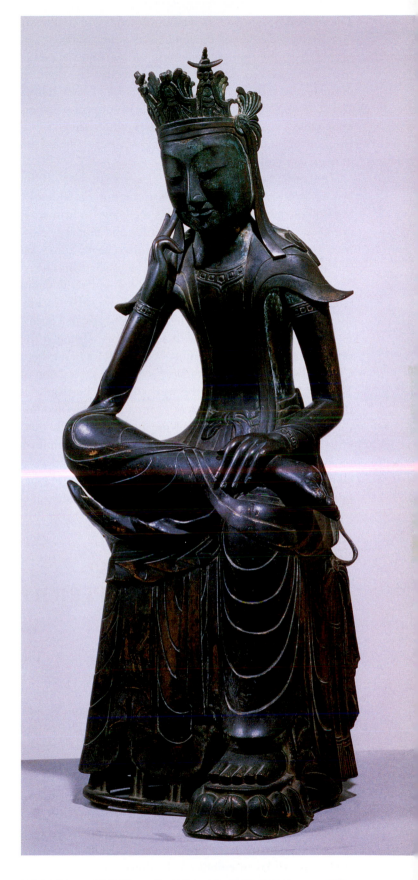

5.6 *Maitreya*. Old Silla or Paekche period, 6th–7th century. Gilt bronze, height 30" (76 cm). National Museum of Korea, Seoul

The refined beauty and harmonious interplay of Maitreya's high-arching eyebrows, the long crescent lids of his down-turned eyes, the thin, delicate nose bridge, and the gentle set of his lips convey a sense of utter serenity. The rhythms in the neatly spaced and folded cloth falling in vertical lines and dovetail pleats over the chair, lying in patterns of hyperbolic curves on his left leg, likewise reinforce this ideal of quiet introspection, the slowed-down and near-timeless act of deep meditation.

The pose itself expresses the ideal of strength within beauty. It is organized around the strong horizontal line of the figure's right leg, which divides the image in half, separating the vertical lines of the other leg and drapery below from the softer lines of Maitreya's torso, head, arms, and the long tubelike fingers with which he touches his cheek. This effortless, pensive gesture, symbolizing deep thought, engages the viewer with the *bodhisattva's* otherworldly thoughts as he transcends the terrestrial and celestial realms to exist in eternal oneness with all creation. Although the style owes much to sixth-century Wei sculpture in northern China, the smoothness of the forms and the abstraction of Maitreya's features reflect the work's Korean heritage. Of the surviving Korean images of Maitreya and the Buddha, this work best summarizes the Korean contribution to Buddhist sculpture in Korea itself and in Japan. In the centuries to come, Korean art would continue to be important on its own terms and contribute to the later development of Japanese art, and we will return to Korea to look at additional works in the periods that follow.

THE ASUKA PERIOD (552– 645 CE) AND HAKUHO PERIOD (645–710 CE)

The Asuka period, named for a Japanese capital of this time, is also known as the Suiko period, after the powerful empress who reigned from 593 to 628. It was a time of great change as new Korean forms of art, technology, and religion totally transformed Japanese society. The period begins in 552, the year the Buddhist ruler of the Paekche kingdom in Korea sent a bronze image of the Buddha to Kimmei, the emperor of Japan. Unlike Shinto, Buddhism had a hierarchical structure, stressed the doctrinal authority of the Buddha's teachings, and offered the faithful a happy afterlife. Seeing how these features of Buddhism had helped the Korean rulers unify their country, Kimmei and his successors in Japan embraced Buddhism and campaigned to make it their official national religion. They hoped it would weaken the feuding nobles' ties to their regional clan deities, which it did, and after half a century of civil war the nobles embraced the elaborate ritualism and arts of Korean Mahayana Buddhism. Buddhist art arrived in Japan along with other forms of continental and Korean Buddhist culture—philosophy, government, Chinese writing, medicine, music, and city planning—which proceeded to revolutionize Japanese society.

For the next three centuries, most of the artists and architects in Japan were Korean or Japanese trained by Koreans, working in Buddhist styles derived from China. In the pictorial arts, artists used thin, delicate, flowing lines in an international Buddhist-Asian style that had come from China, and some of the best surviving examples of "Chinese" architecture from this period may be seen in Japan.

Perhaps it was because Mahayana Buddhism was so different from Shinto that the two forms of thought were able to coexist and complement one another. Therefore, even though Japan was officially Buddhist and strongly Korean in character, the spirit of Shinto lived on as part of the country's intrinsic system of aesthetics within the newly accepted forms of Buddhist art.

TEMPLES AND SHRINES

Unlike the Shinto deities, which were venerated in nature or at most in modest-sized shrines, Buddha and his host of *bodhisattvas* required the faithful to construct large temples and religious complexes. The most important surviving temple complex of this period, the Horyu-ji (*ji* means "temple"), is located at Nara, the cradle of Japanese Buddhist civilization (FIG. 5.7). It was founded in 607 by Prince Shotoku Taishi (574–622), an early champion of Buddhism in Japan, and first rebuilt in 670. Many of the artists and architects working in Japan at this date at Nara were Korean or trained by Korean masters. As a result, the tiled roofs with upturned eaves of the buildings and the symmetrical plan of the complex reflect the contemporary building practices of the Six Dynasties Period in China and the Three Kingdoms Period in Korea—and do so better than any surviving buildings on the Asiatic mainland.

Visitors to the complex proceed along a pebble-strewn avenue leading to the **chumon** (middle gate) in the wall and covered corridor around the precinct. Inside the gate, the **Kongo Rikishi**, fierce guardian deities, protect the tall **pagoda** and the **kondo** (golden hall) within. The inspiration for the pagoda, a Chinese architectural form, remains a matter of debate. It may derive from Han watchtowers, which are known through terracotta models preserved in tombs, the tower stupas of Gandhara with their tall *yasti* (umbrellas), or metal **reliquaries** (elaborate containers holding valued religious relics). Whatever its source, to many Western

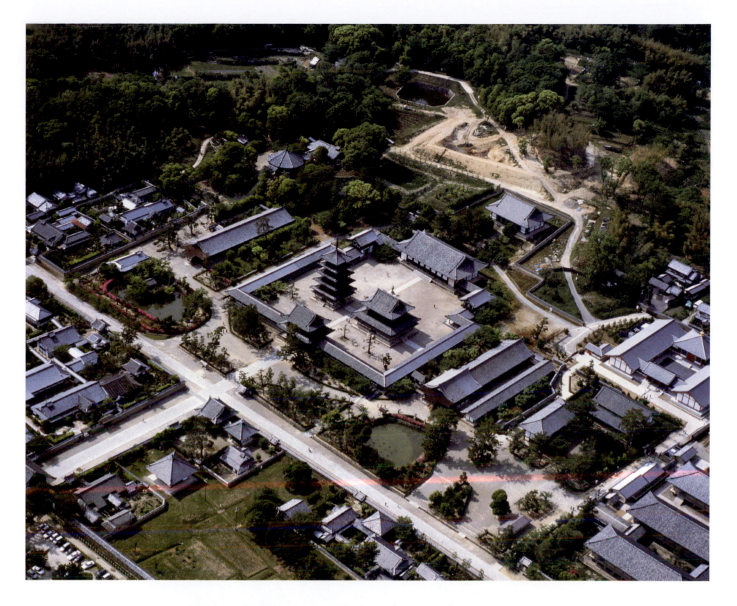

5.7 View of existing compound, Horyu-ji. Nara prefecture. 7th century
In 1949, the two-story kondo *in the center of the enclosed court was damaged by fire and heavily reconstructed from photographs. Luckily, a number of building parts had been temporarily removed for repairs and thus escaped damage.*

observers the pagoda is the most immediately recognizable form of Far Eastern architecture. Worshipers may enter the *kondo*, which houses many important early Buddhist treasures. Conversely, the pagoda, like other Japanese pagodas, must be venerated from the outside as stupas are. They are reliquaries holding sacred objects and symbolize the vertical pathway uniting the terrestrial and supernatural worlds. The Horyu-ji pagoda has four sculptural tableaux on the ground floor, which may be seen through the four doors. There is no access to the upper parts of the pagoda. The lecture hall, library, bell house, and dormitories catering to the everyday needs of the monastic community lie outside this sacred enclosure.

Generally, a *kondo* is filled with statues on a raised platform around which pilgrims walk in a clockwise direction. An intricate system of flexible, interlocking brackets allows the wooden supports under the roof to expand and contract with changes in the weather as they transfer the weight of the wide, upturned tiled roofs onto the thin engaged posts below. The porch on the lower levels is a Japanese addition to the structural type found on the mainland, one that will remain an important feature in Japanese palaces and temples.

A portable cypress and camphor wood replica of a seventh-century *kondo* (c. 650) in the Horyu-ji Treasure House, known as the Tamamushi Shrine, may have been

made in Korea, or fashioned by Korean artists working in Japan (FIG. 5.8). It gives another view of early Buddhist Japanese architecture. The shrine is roofed by a gable over a truncated hipped roof with broad flaring eaves supported by sets of long bracket arms. The crescent-shaped decorations rising over the ends of the ridge pole (*shibi*) may represent dolphins. It is the earliest known surviving example of an **_irimoya_**, the traditional Japanese hip-and-gable roof type. In addition to its historical and architectural value, the Tamamushi Shrine is decorated with important examples of early Japanese Buddhist lacquer paintings. The style, with many types of thin, delicate flowing lines, is an international Asian one that accompanied the spread of Buddhism from China through Korea to Japan.

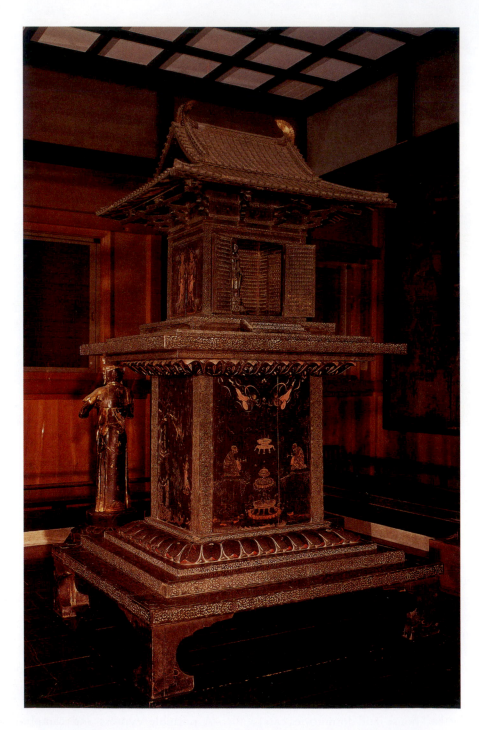

5.8 Tamamushi Shrine. c. 650. Cypress and camphor wood with lacquer, height c. 7'8" (2.34 m). Horyu-ji Treasure House, Horyu-ji

THE NARA PERIOD (710–94 CE)

This period is named for the Japanese capital, Nara (finished in 710), built for Empress Gemmei, the fourth of eight women in Japanese history to hold that title. Little remains of this first permanent center of government in Japan, which is said to have been built along the lines of the Chinese Tang capital at Chang'an. Before that time, each successive emperor had built a new court on a new site, to escape the impurities caused by the death of the previous ruler and to highlight his or her own ascent to power. While earlier Chinese influences in Japan had arrived mainly via Korea, the highly cosmopolitan, imperial court of the Tang dynasty (618–907) in China had a direct influence on Nara and Japanese society. Like their Tang contemporaries, the Japanese emperors of this period gained effective control over all their domains and dominions. Using the Chinese script, the Japanese began recording early myths and historical records. The *Kojiki* (712) and the *Nihon Shoki* (720) explained how the imperial clan had the right to rule the country.

ARCHITECTURE

The name of an important temple at Nara, the Toshodai-ji ("Temple Brought from Tang"), underlines the strength of the Tang Chinese influences at this time. The quadrilateral complex, oriented to the points of the compass, was designed to give visitors the impression that Japan was ruled by a strong, centralized government. However, this ideal, a reality at Chang'an in China, remained an elusive dream in Nara. The splendor of the palace (which has not survived) is reflected in the Todai-ji (Great Eastern Temple) complex (c. 759 CE). The *kondo*, known as the Daibutsuden (Great Buddha Hall), is many times larger than its Horyu-ji counterpart from the previous century (FIG. 5.9). The present version of the Daibutsuden is about two-thirds the size of the original structure, which burned down in 1180. It was 285 feet (87 m) long, 154 feet (47 m) tall, and housed a 52-foot (16 m) gilded sculpture of the Buddha with a large golden halo. Yet the present Daibutsuden is still one of the largest wooden structures in the world. The plan includes porches where noble and wealthy laypeople could assemble

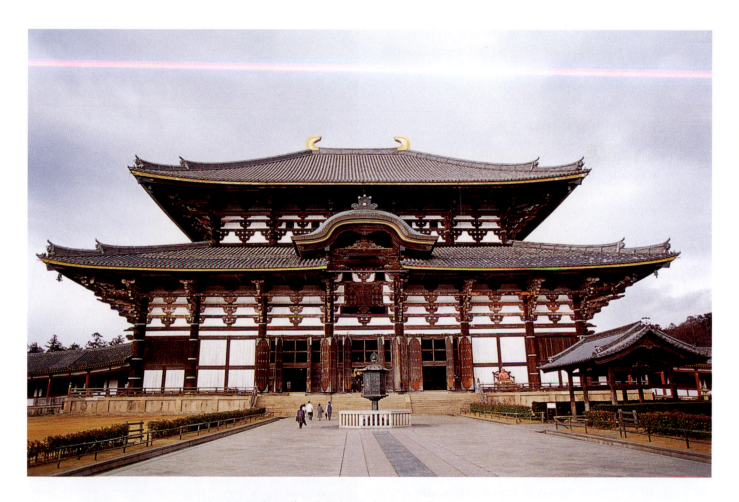

5.9 Daibutsuden (*kondo*), Todai-ji complex. Nara. c. 759

to listen to the rituals being conducted within. Large screens were set behind the figures on the altar in a brightly painted space that is still capable of housing images up to 60 feet (18 m) high.

THE HEIAN PERIOD (794–1185)

In 794, Emperor Kammu (ruled 781–806) moved his capital from Nara north to Heiankyo (Capital of Peace and Tranquility), modern Kyoto, the site after which this period is named. The late Heian period (897–1185) is also called Fujiwara, after the ruling clan that came to power in the late ninth century. In Kyoto the emperors could escape the weighty, entrenched political power of the Buddhist monks and Confucian authorities in Nara, a miniature clone of Chang'an drenched in the traditions of Tang China. Later, in this rising spirit of independence from mainland Asia, as Tang power declined during a period of civil unrest during which Buddhists were persecuted in China, Japan closed her doors to contact with the Chinese (838) and made a concerted effort to develop native forms of art and culture. New forms of Buddhist art arose in response to changes in Buddhism in Japan. Equally innovative revolutions took place in the secular arts in the aristocratic circles of Kyoto and are reflected in a sense of courtly refinement and elegance that has seldom been equaled anywhere in the world.

ESOTERIC BUDDHIST ART

As the Buddhist temples in Nara began to lose their importance, new Buddhist reform movements started to surface among the aristocrats in Kyoto. The Tendai and Shingon sects are part of Esoteric Buddhism (*Mikkyo* in Japanese) from northern India, Nepal, and Tibet. In both, the universal Buddha (*Dainichi* or Great Sun) presides over a complex and colorful pantheon of deities. To explain the complicated interrelationships and the attributes of each deity, Buddhist artists created cosmic diagrams called mandalas and some astonishingly dramatic images of deities in all their fury. In this silk image the terrifying Fudo (the Immovable) is seated on a rock before a wall of flames and holds a dragon sword symbolizing lightning (FIG. 5.10). He and one of his youthful attendants have fangs and intensely glaring, beady eyes. The expressive quality of this fearsome deity is enhanced by the quality of the finely brushed lines that describe the beautiful jewelry he wears over his princely robes.

5.10 *Red Fudo*. Early Heian period (794–897). Color on silk, height 61½" (1.56 m). Myo-o-in, Koyasan, Wakayama prefecture, Japan

PURE LAND BUDDHIST ART

In the late Heian period, Pure Land Buddhism (*Jodo* in Japanese), which had none of the metaphysical and iconographical complexity of Esoteric Buddhism, became very popular among the masses in Japan. In *Jodo*, the Amida Buddha ruled over the regal Western Paradise that was easily accessible to everyone. Traveling evangelists spread the cult, explaining that to enter paradise all one needed to do was chant *Namu Amida Butsu* ("Hail to the Amida Buddha"). The most zealous priests repeated this "magic" name thousands of time a day, and their visions of Buddha answering their call helped

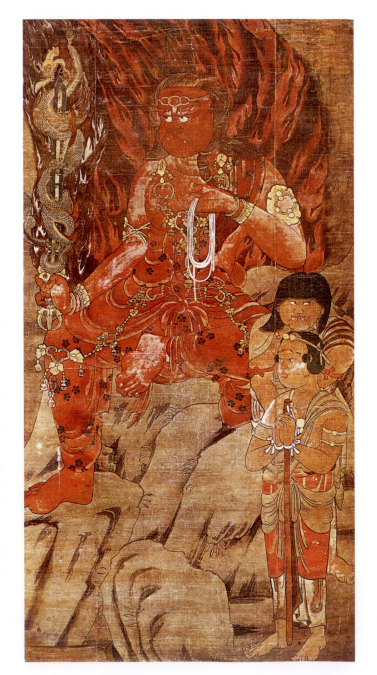

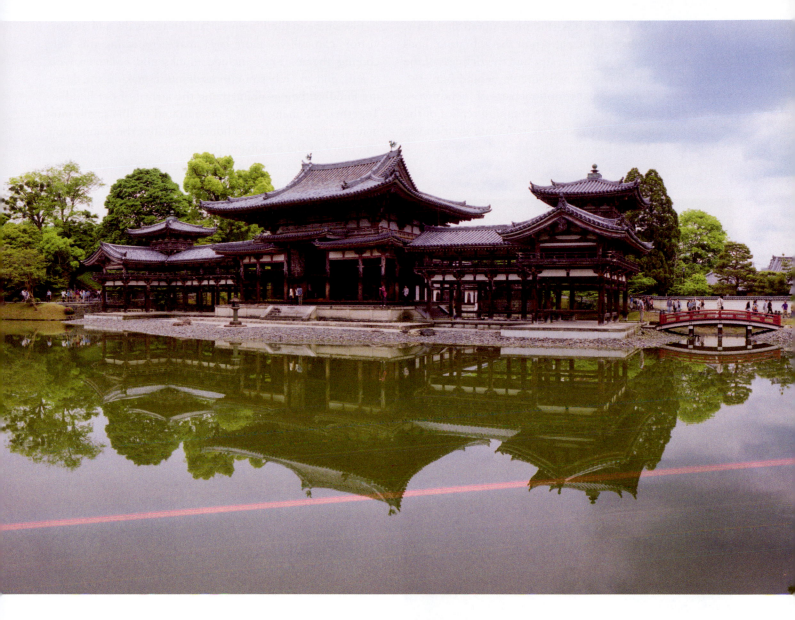

5.11 *Ho-o-do* (Phoenix Hall), Byodo-in, Uji. Late Heian period, 11th century

inspire a new type of *Jodo* image in painting and sculpture called a **raigo** ("welcoming approach"). This shows the Amida Buddha descending to Earth in glory to welcome souls into his Western Paradise. A *raigo* may be a single sculpture or painting, or a more complex installation, a dramatic fusion of many art forms. Originally, the *raigo* image was a small, subsidiary part of a mandala; the new emphasis on it in its own right underlines the difference between the coldness of the remote Buddha worshiped by the Esoteric sects and the graciousness of the very approachable Amida Buddha.

Portions of a *raigo* sculptural installation, completed in 1053 by the artist Jocho (died 1057) are housed in an eleventh-century structure known as the *Ho-o-do* (Phoenix Hall), on a semidetached island with a reflecting pool in the Byodo-in complex near Kyoto (FIG. 5.11). The Phoenix Hall was originally part of a much larger villa that belonged to a Fujiwara official who was the head counselor to the emperor. The hall takes its name from the bronze sculptured phoenixes on its roof (symbols of the empress) and the dramatic upswept lines of the roof, which resemble the outspread wings of a large bird. When soft winds float over the pond, the gentle waves they create put these "wings" in motion, like those of a bird taking flight. That pond, shaped like the Sanskrit letter "A" (symbol of the Amida Buddha), is also the earthly counterpart of the great waters in the Western Paradise where the Amida Buddha watches over the newly arriving souls of the faithful, reborn within lotus buds, as they blossom forth to their new life in paradise.

The utter repose of Jocho's smooth-featured Buddha is emphasized by the complex pattern of the "vibrating" lines in the lotus throne on which he sits, and the richness of the decorations in the flame-shaped aureole behind him (FIG. 5.12). When all the original sculptural parts of Jocho's work were in place, the installation was a stunning replica of the Western Paradise in an elegant style reflecting the richness of the lands to which believers were headed.

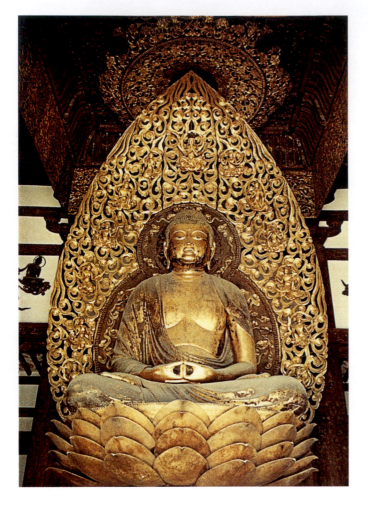

5.12 Interior of *Ho-o-do* (Phoenix Hall) of Byodo-in, with Amida figure by Jocho. Uji. 1053. Gilded wood, height 9'8" (2.94 m) *Unlike earlier sculptors, who usually carved their sculptures form a single block of wood, Jocho used a joined-wood technique in which he used multiple blocks of wood in one sculpture. Blocks were hollowed, roughed out, and joined by glues and pegs before the finishing details were carved and painted. Sculptures made using this method are lighter than works carved from a single, solid piece of wood and less susceptible to cracking and warping as the sap within dries and the wood contracts. Also, a master sculptor can assign individual blocks to assistants who might be specialists in the carving of certain parts of the image, thus speeding up the laborious process of sculpting.*

Elsewhere in the Phoenix Hall, on the walls and a door, visitors can still see more *raigo* images repeating this welcoming theme. They include monks and *bodhisattvas* on clouds, and an orchestra-chorus of music-making and dancing Buddhist beings dramatizing the arrival of the Buddha. Together, the many *raigos*, concentrated in this small, intimate space that was once a home, dramatize the compassion and glory of the Buddha in this popular sect of Buddhism. Such lush and compelling images were also designed to be memorable, so that, in their dying moments, wherever the faithful might be, they would be able to recall these images and envision the welcoming Buddha coming to Earth to retrieve them. Although Jocho's original *raigo* installation is no longer complete, it is still an important image for modern members of *Jodo* Buddhism, the most popular Buddhist sect in Japan today.

LITERATURE, CALLIGRAPHY, AND PAINTING

Chinese was the official language of scholarship in Korea and Heian Japan, and remained so until the nineteenth century. However, for some forms of writing, such as poetry, the Japanese of the Heian period began using their native language. To do this, they created syllabaries (systems of writing in which a sign stands for a syllable) based on the idiosyncrasies of the Japanese language and used traditional Chinese-style brushstrokes to create Japanese characters. The technical problems in this process of adaptation were considerable, but over time the Japanese calligraphers developed a formal and somewhat angular script for official documents (*katakana*) and a very graceful and cursive script for personal and literary use (*hiragana*), also known as *onade* (feminine hand) (FIG. 5.13). In its undulating, flowing lines, which "feel" so right for poetic verse, we see no sign of the traditional architectonic or blockish forms of the Chinese characters with which the Japanese scholars of the day worked.

Courtly women were seldom taught Chinese, the language of scholarship, but this restriction may have done more to help than hinder them as a group. In the late Heian period, many Fujiwara noblewomen working in their native Japanese became accomplished calligraphers and creative writers, and were able to be far more personal and expressive in their writing than their male counterparts working in Chinese, which remained a second, foreign, and somewhat restrictive language for them. Here, one can see a Western parallel as Church Latin, the venerable language of theology and Scholasticism in the Middle Ages, remained the official European language of learning for centuries while the national languages spoken by the people provided the bases for the many vital, vernacular traditions.

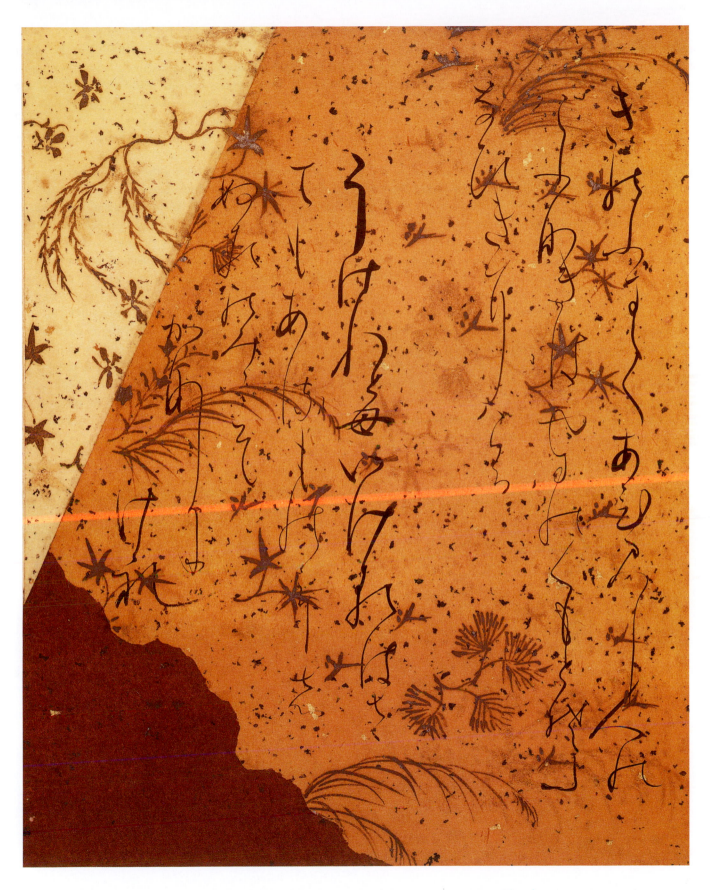

5.13 Album leaf from the *Ishiyama-gire*. Late Heian period, early 12th century. Ink with gold and silver on decorated paper, 8 × 6⅜" (20.3 × 16.2 cm). Freer Gallery of Art, Smithsonian Institution, Washington, D.C.

Like Chinese, Japanese is read in columns, from top to bottom and right to left. Some Heian-period anthologies of poetry were written on papers of contrasting colors bearing woodblock-print designs and flecks of gold and silver. At times, these elegant, sprawling, and asymmetrical marks made by the courtly calligraphers have such a strong sense of energy and movement that they seem to dance across the page. Together, the writing format, the loosely flowing inked lines, the decorative setting, and the content of the poetry created a distinctively Japanese and Heian literary and artistic experience.

By Heian times, the emperor, a venerable symbol of Japanese culture, had little effective political power. Some Heian courtiers had administrative duties , but others had very few day-to-day chores. With so much leisure, many of them developed highly refined tastes in the arts and became known for their extreme aestheticism. They might play the **koto**, a thirteen-string instrument with a long (c. 71" or 180 cm) wooden soundbox that has become the national instrument of Japan, or excel in the art of calligraphy, writing *tankas*, thirty-one syllable poems using nature as a mirror for their emotions. These musicians and writers included many important women, such as Lady Murasaki, who wrote the *Genji Monogatari*, known in the West

as **The Tale of Genji** (c. 1000–15). She learned to write by accompanying her brother to his writing lessons. After being widowed, Lady Murasaki became a lady-in-waiting in the court of the empress-consort Teishi (976–1001), where she gathered much of the material for *The Tale of Genji*. The lengthy story, featuring over four hundred characters and generally regarded as the world's first novel, immortalizes the intrigues of Heian courtiers.

Lady Murasaki's story follows the actions and inner psychological life of Genji, the Shining Prince, who tries to retain the support of those in power while indulging in numerous affairs. As the story reflects on the fleeting nature of life's pleasures, it is tinged with sadness. Much of the story takes place in the shaded, cloistered atmosphere of a **shinden**, a Heian-period country home with a central hall, some smaller buildings, a network of covered walkways connecting them, and ponds, bridges, and gardens.

In early illustrations of the story, these distinctively Heian architectural forms provide a backdrop for the narrative. They are painted in the native **Yamato-e** or Japanese style. The name comes from the Yamato Plain, on which the city of Nara was built. There are two subtypes of the *Yamato-e* style, the popular *otoko-e* (men's pictures) and the courtly *onna-e* (women's pictures), of which FIG. 5.14 is an

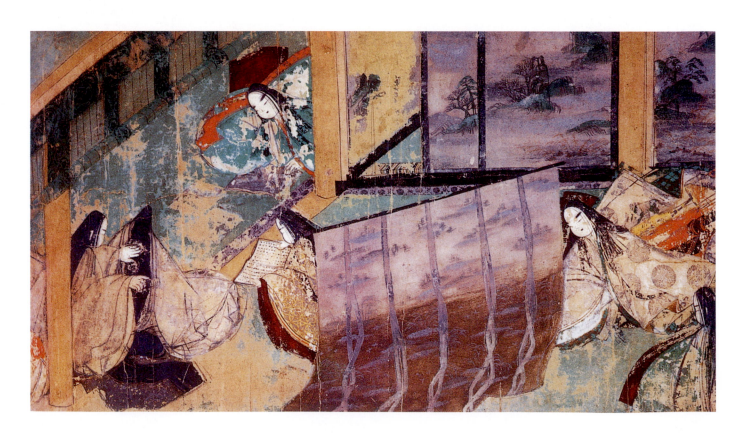

5.14 First illustration to the *Azumaya* chapter of *The Tale of Genji*. Late Heian period, 12th century. Hand scroll. Ink and color on paper, height 8½" (21.6 cm). Tokugawa Museum, Nagoya

example. This twelfth-century **emakimono** scroll painting was painted with ink and water-based colors on paper made from the inner bark of the paper mulberry tree and other fibers. Such hand scrolls were designed to be viewed segment by segment as they were unrolled from right to left so that the story would literally unfold and pass before one's eyes. This was normally done at a very leisurely pace, often with a scholar present to read the text and explain its subtleties to the viewers. Stopping to contemplate the text and images in each section of the twenty-four scrolls covering all fifty-four chapters of *The Tale of Genji* would have taken many sessions.

Sections of Lady Murasaki's text alternate with painted episodes from the novel, which are pictured from an elevated point of view, providing us with a kind of peep-show, as if Lady Murasaki had removed the roof of the *shinden* so that the world beyond the Japanese court could see what was happening inside its walls. Often, the complex perspectives of this oblique, bird's-eye view seem to reflect and emphasize the many twists and turns in the story. One maid reads to entertain Nakanokimi, while another combs her freshly washed hair and Ukifune, Nakanokimi's half-sister, looks at a picture scroll.

Nakanokimi, a strikingly beautiful country girl and the wife of a high-ranking noble, was attempting to secure her own position in society through her role as a lady of the court. The illustrations, like Lady Murasaki's narrative, emphasize the decorative and anecdotal details of the highly ritualized patterns of behavior in the court; this picture gives no indication that Ukifune is recovering from an attempted seduction a few hours earlier. The women of the court are shown as flat patterns of richly decorated drapery, with stylized faces consisting of little more than short lines for eyebrows, eyes, and mouths. At times, emotion might be suggested symbolically, but that level of content is generally communicated through the accompanying text. Also, we see scenes where conflicts are coming to a head, but little of the resulting action is shown because these images were designed for a society that appreciated restraint and the power of suggestion.

The very way in which the *shinden*-styled architecture encloses and restricts the characters seems to symbolize the way the highly formalized court etiquette of this period determined what the courtiers could do and which emotions they could—or could not—express. The viewer sees the events of the novel as if he or she were observing the private world of court life from off to the side, with a certain polite detachment—as Lady Murasaki had for years.

Here, in the illustrations to this famous Japanese tale, we may be reminded of the four basic principles of Japanese art discussed in the Introduction to this chapter: suggestion,

that which is not fully shown but understood; the fleeting, tragic nature of existence; irregularity and the accidental look; and an apparent simplicity that belies the true complexity of the art.

In summary, there is considerable evidence to connect the highly refined Fujiwara aesthetic with the women of the court. Many of these illustrations of Lady Murasaki's work were created by women, whose names are known, and the readings of the scrolls were often organized and attended by women, including the women artists who painted these and other, lost works that documented their world within the courtly circles of Japan.

By about 1180 the refined Fujiwara courtly world was drawing to a close. The Fujiwara forces proved no match for those of the powerful feuding clans in the Genpei Civil War (1180–85), which reshaped the art and culture of Japan for centuries to come.

THE KAMAKURA PERIOD (1185–1333) AND KORYO KOREA (918–1392)

At the conclusion of the war, the emperor gave Yoritomo (1147–99) of the Minamoto clan in Kamakura the title of *Seii-tai Shogun* ("Barbarian-quelling General"). A long series of military leaders in Japan would operate under this title until 1868. Kyoto, largely destroyed in the civil conflict, retained its ceremonial status, but real power now lay in the clan headquarters at Kamakura, south of Edo (present-day Tokyo). Freed from many of the weighty traditions of the Japanese past, the Kamakura rulers rejected the refined aesthetics of their Fujiwara predecessors in Kyoto as they attempted to bring order to Japanese society and find new values in life and art. As such, the restrained actions and sentiments of Lady Murasaki's *Tale of Genji* give way to novels about heroic warriors, feuding clans, and violent deaths.

PAINTING

No single work of art better demonstrates the changes that took place at the beginning of the Kamakura period than *Night Attack on the Sanjo Palace* (FIG. 5.15). This scene is from an action-packed novel published in 1220, the *Heiji Monogatari*, which uses very plain, direct, and descriptive language, close to that of spoken Japanese. The writers and artists responsible for the scrolls express the robust spirit of the Kamakuran warrior society, which has few of the refined mannerisms or sentiments of the Fujiwara court painters.

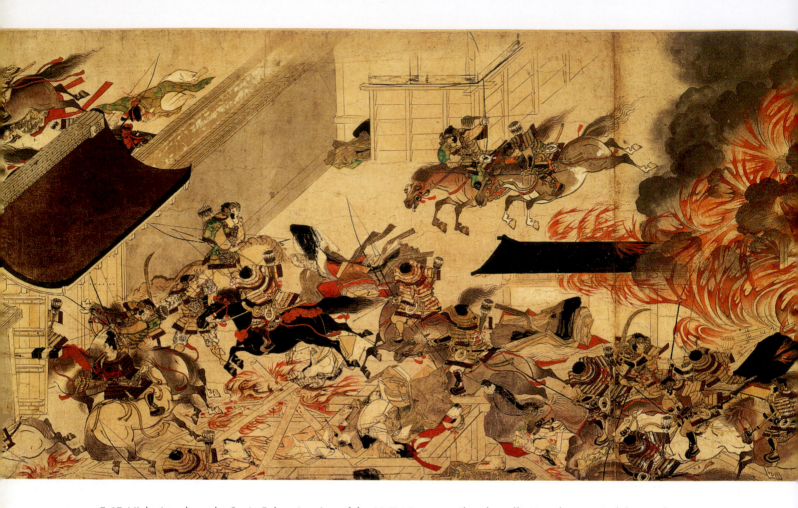

5.15 *Night Attack on the Sanjo Palace* (section of the *Heiji Monogatari* hand scroll). Kamakura period, late 13th century. Hand scroll. Ink and colors on paper, height 16¼″ (41.3 cm). Fenollosa-Weld Collection, Museum of Fine Arts, Boston

The viewer looks down on the brilliantly colored masses of stylized flames and surging horsemen as they destroy the wooden buildings of the palace complex. The action moves from right to left at a furious pace, in swirling forms that echo the tongues of fire licking away at the old palace timbers. The draftsmen and painters included a wealth of detail showing the warriors' weapons, armor, and horse gear that is not visible in this reproduction but may be examined by those fortunate enough to see the original. This glorification of military force stands in marked contrast to the contemplative, philosophical paintings by the literati painters in China of this period and the sensibilities of the Fujiwara courtiers in Lady Murasaki's famous novel. Using fast-flowing lines, ultimately derived from ancient Chinese traditions of calligraphy, the artists here have captured the drama of one of the firestorms that consumed most of the Chinese and Japanese buildings of this period. Fortunately, with their precise architectural detailing in works like this, the painters of this period have preserved a wealth of information about these buildings that would have otherwise been lost when they were destroyed.

THE SHOGUNS, DAIMYO, AND SAMURAI

The shoguns could not rule Japan without the support of the warrior nobles, the *daimyo* and *samurai*. The *daimyo* commanded the *samurai*, well-disciplined swordsmen who were trained to be indifferent to sensual pleasures, physical pain, and death—and totally devoted to their noble patrons. The ethics governing the conduct of the *samurai* were as complicated as the contemporary code of chivalry operating in Europe, and included the ritual of *seppuku* (known in the West as *hara-kiri*), a noble act of suicide performed by a *samurai* accused of cowardice or disloyalty.

Yoshida Kenko (1283–1350), a lay priest from a family of Shinto diviners working for the imperial family, seems to have summarized the spirit of the Kamakura period: "If man were never to fade away like the dews of Adashino, never to vanish like the smoke over Toribeyama, but linger on forever in the world, how things would lose their power to move us! The most precious thing in life is its uncertainty."

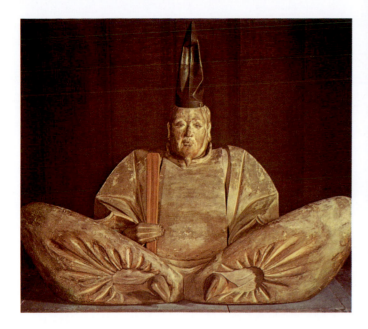

5.16 *Portrait of Uesugi Shigefusa*. Kamakura period, 14th century. Painted wood, height 27½" (70 cm). Meigetsu-in, Kamakura, Kanagawa prefecture, Japan

SCULPTURE

The Kamakuran leaders commissioned artists to produce realistic portraits and narrative art forms to commemorate their political and military achievements. Combined with the much older ideas of ancestor worship, the philosophy of self-discipline and meditation helped shape the militaristic character of this fourteenth-century sculptured portrait of Uesugi Shigefusa (FIG. 5.16). Rigidly frontal, the body of the military lord disappears within the ballooning fabrics of his courtly regalia, which emphasize his status in the feudal society. The portrait, which was carved and installed in a family shrine a century after Shigefusa's death, may not provide an exact record of his features, but it captures the spirit of a *daimyo* to whom a host of well-disciplined *samurai* dedicated their lives.

This interest in distinctive character types extended to the work of the most famous sculptor of the day, Unkei (1163–1223), who carved many highly realistic painted wooden portrait statues of priests with inlaid crystal eyes. He was also capable of producing dramatic works that express the militaristic spirit of the Kamakura society of the shoguns and made a pair of colossal wooden guardians nearly 30 feet (9.1 m) tall for the Great South Gate of the Todai-ji temple compound in Nara (FIG. 5.17). Unkei's *Kongo Rikishi* (1203) was made using the joined-wood technique, so he was able to extend the arms, legs, and flowing draperies of this enormous figure into space, giving viewers the impression that the muscular, demonic creature was in motion, making

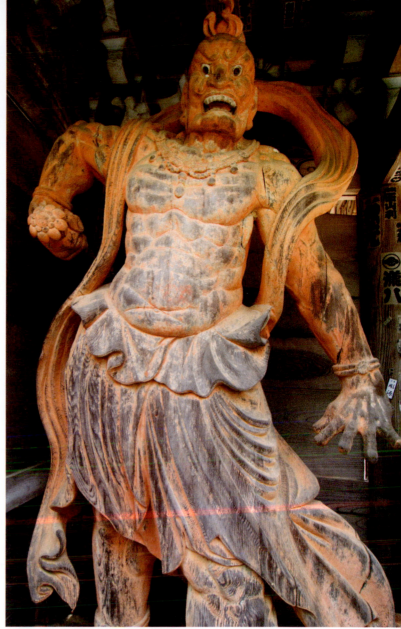

5.17 *Kongo Rikishi*. South gate of Todai-ji, Nara. Kamakura period, 1203. Wood, height 26'6" (8.07 m)

spontaneous and violent gestures. (Some of the places where the wood joints have separated are visible in the photograph.) In terms of the way the sculptor has externalized the fury of the angry *Kongo Rikishi*, there are few comparable pieces of statuary to be found anywhere in the world. The energetic, animated quality of its gestures and the weightless, flowing banners fluttering over its head work well in concert with the wooden bracketing and wing-tipped eaves of the surrounding temple roofs. The overwrought expression of the tense, colossal guardian figure, verging on the grotesque, would seem to express the militarism and single-mindedness of the *samurai* who guarded and sustained the shogun who commissioned this addition to the ancient temple complex.

KORYO: KOREA

The Silla, who extended their rule over all Korea after 688, were deposed by the Koryo dynasty (918–1392), after which modern Korea is named. They modeled their capital at Kaesong on Chang'an, imported Chinese Song ceramists, and, in the twelfth century, developed a distinctive Korean **celadon** ware with beautifully clear glazes over incised designs filled with black and white slips. The term "celadon," which is of disputed origin, refers to a type of glaze invented in China and is commonly used to describe vessels with glazes of this kind. Though they may be whitish or yellow in color, the classic celadon glazes resemble pale-green or greenish-blue jades and are highly valued for that association. The Korean ceramists invented some new celadon vessel types never made in China or Japan, such as the ewer in FIG. 5.18. Since the design was incised on the body of the vessel, the glazes over those recessed areas are thicker and appear darker. The overlapping lotus petals with very delicately incised veins fold over the vessel's gracefully swelling body and reflect its outlines and those of the curved handle and flaring spout. The lid is composed

5.18 Celadon ewer with lid. Korea, Koryo period, c. 1100–50. Ceramic, stoneware with underglaze slip decoration, height 9⅞" (25 cm). The Brooklyn Museum

of an unfurling lotus blossom knob set over an inverted and opened blossom with more shapes that repeat those of the petal on a smaller scale. The "kingfisher blue" glaze is very thin and highly transparent; as with other fine Korean celadons of this period, variations in the glaze from one part of the vessel to another give it an informal and handmade quality. The ceramist also used a pointed brush to apply dots of white slip along the edges of the leaf sprays on the body of the vessel and the petals on the lid to add subtle and contrasting highlights. After the Koryo dynasty fell under the control of the Mongols in 1231, the Buddhist leaders in Korea became increasingly corrupt and weak, and the celadon tradition eventually declined.

THE MUROMACHI (ASHIKAGA) PERIOD (1392–1573)

In 1274 and again in 1281, the Kamakurans successfully repelled invasions by Kubilai Khan's Mongol forces. But the cost of victory was high and Japan was left impoverished. As the strength of the Kamakurans waned, Japan entered a long period of civil strife that ended with the rise of the Ashikaga shogunate in Kyoto. This period is known as the Ashikaga, after that family of shoguns, and the Muromachi, for the area in Heian (present-day Kyoto) where they lived. In actuality, the Ashikaga shoguns had little more power than the emperors, and Japan was ruled by a number of feuding provincial *daimyo*.

For the most part, the *daimyo* of this period, known as "Sudden Lords" for the rapidity with which their fortunes often rose and fell, and their *samurai* swordsmen, were uncultured political upstarts who had very little appreciation for many of the traditional forms of Japanese art. However, they did appreciate the directness and simplicity of the Daoist-influenced teachings of Zen and its affiliated art forms. With its lack of courtly ritual, emphasis on immediate and intuitive perceptions, mental and physical discipline, and self-reliance, Zen appealed to the most basic instincts of the Sudden Lords. Furthermore, since Zen philosophy was taught, like the martial arts, through a tightly bonded master–disciple relationship, it blended well with the extremely militaristic *samurai* lifestyle. Zen monasteries were some of the most important educational centers of the day as Zen became the dominant philosophy and religion of the feuding factions in war-torn Japan. (See *Religion*: Zen Buddhism, page 172.)

PAINTING

The rise in popularity of Zen Buddhism was accompanied by a renewed interest in Chinese art, especially the Chan Buddhist painters of the Song period. This was fueled in part by the arrival in Japan of Chinese Song artists who were fleeing the Mongol invasion of China at the end of the thirteenth century, and resulted in a new style of Japanese landscape painting.

To study Chinese landscape painting at first hand, Sesshu Toyo (1420–1506), a **gaso** (Zen priest-painter), traveled in China (1468–69) and made copies of paintings by old masters, including Ma Yuan (late twelfth–early thirteenth century). Sesshu, who could work in a variety of styles, became the master of the traditional Chinese Song style of painting with its soft, wet, and highly simplified brushmarks. This mode, which emulates the most extreme forms of monochrome painting by the Chinese Chan Buddhist painters, is called **haboku** ("broken ink") in Japan. Painters working in this style believed there were traces of spiritual inspiration to be found in the accidental and spontaneous patterns formed by ink splashed onto the paper in this way. In *Haboku Landscape for Soen*, Sesshu uses very loose brushwork, yet by creating sharp tonal contrasts through a variety of washes and strokes, through a few carefully placed marks he is able to capture the spirit of an entire landscape with its rocks, mists, and deep spaces (FIG. 5.19). Although careful analysis might reveal how each mark contributes to the representation, the picture is not the product of any kind of premeditated calculation of this sort. As stated in the Introduction to this chapter, the two pillars of wisdom in Zen are transcendental naturalism and spontaneous intuition—artists should not attempt to represent nature, but to be one with it, and be creative in sudden flashes of energy. An inscription on the painting by the artist says: "My eyes are misty and my spirit exhausted." The painting must be understood in the Zen manner and be appreciated for its intuitive character and simplicity, as a dialogue between the memories of the artist and the presence of his brush, paper, and ink.

At times, however, the hostile nature of the feudal society in Japan that led to the Onin War (1467–77), which destroyed much of Kyoto, made it difficult for Sesshu and other Japanese artists to find a quiet, peaceful, and harmonic rapport with nature. Sesshu's landscapes, painted on a **kakemono** (wall-mounted, hung scroll), are often rendered

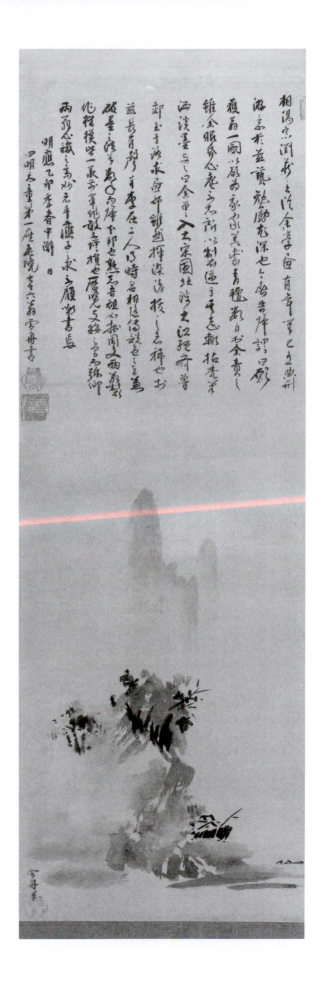

5.19 Sesshu Toyo, *Haboku Landscape for Soen*. Muromachi period, 1495. Section of a hanging scroll. Ink on two joined sheets of paper, height 58¼" (1.48 m). Tokyo National Museum

ZEN BUDDHISM

At the end of the twelfth century the militaristic *daimyo* and *samurai* were attracted to the Daoist-inspired form of Chan Buddhism from China. Chan (pronounced "Zen" in Japanese) Buddhism de-emphasized the traditional scriptures and rituals of Buddhism and placed new emphasis on self-discipline and self-denial. In some respects, Zen marked a return to the original teachings of the Buddha—that individuals could achieve enlightenment through discipline and meditation. Unlike China, where Chan Buddhism played a limited role in the culture after the thirteenth century, in Japan Zen was the dominant religious philosophy by the fifteenth century, and Zen monks were often as devoted to art as they were to meditation and teaching.

Zen Buddhism, with its emphasis on austerity, simplicity, intuitive thought, and appreciation of beauty in nature, meshed well with the traditional values of Shinto. Operating in the Shinto manner, using few formal texts, liturgies, or shrines, Japanese Zen masters sought enlightenment through intuitive thoughts and actions, uncluttered by the complexities of reasoning.

Zenga, the word that Japanese Buddhists have used to describe the art of Zen monks since about 1600, is an aid to meditation, and it epitomizes the essence of Zen. It is bold, often rough, sometimes humorous, and always an immediate translation of the inner experience of the artist's mind into an external form.

In their search for the meaning of life and death, Zen Buddhists meditated while seated in a yoga position, with straight backs and crossed legs. They also studied *koans* (questions or exchanges) with a master (discussed in Chapter Four). These *koans*, stories, dialogues, and questions, are designed to work outside rational lines of thought, teaching students to create intuitively, and to experience a oneness with all creation (**satori**). Many books of *koans* and their answers have been published, but, ironically, that helpful, rational approach to their explanation violates their essence and purpose.

with jagged, slashing brushstrokes in a style known as *shin*. *Shin*, a term that originally referred to the standard style of calligraphy, contrasted with the cursive draft script. These alarming and strident notes of discord that violate the sense of tranquility so cherished by the Chinese landscape painters are meaningful, and remind us why Zen art and thought was so important to thinkers living in these troubled times in Japan.

ZEN GARDENS

In addition to painting landscapes, Japanese artists of the period also recreated them, in a symbolic and miniaturized fashion, as gardens. One of the finest examples of these Zen gardens, the Daisen-in in Kyoto, is attributed to the painter Soami (died c. 1525) (FIG. 5.20). At first glance, it may appear to be no more than a casual combination of uncarved rocks, sand, pebbles, and trees. It is, in fact, the exact opposite; the garden's construction and maintenance involve as much planning and effort as the most formal gardens being created in Renaissance Europe at the time.

In some gardens, irregularly placed flagstones provide paths for visitors to walk along. Entry to others, such as the Daisen-in garden, is restricted to the Buddhist monks who tend them; visitors must view them from porches and platforms, as if they were attending a theatrical performance or viewing nature in the distance from a mountainside. However, we may enter Soami's garden spiritually, move about, and meditate upon it. Some students of Japanese culture see the stones as stones and the sand as sand—no more. For others, the gardens represent landscapes with mountains, cliffs, islands, bridges, rivers, lakes, and oceans. It is as if the imagery of a Sesshu or Soami painting had been lifted out of the pictorial realm and recast in three dimensions as a microcosm on which viewers can meditate and envision the unbounded nature of the universe. For the Buddhist monk or other serious viewer who can look upon the rocks and sand for what they are but still imagine them as great mountains in the seas and mists, the radical changes in scale and meaning parallel experiences in meditation—like the meeting of the inner mind and outside world. Also, the idea that rock is mountain and sand is sea can be seen as another Zen Buddhist *koan* of

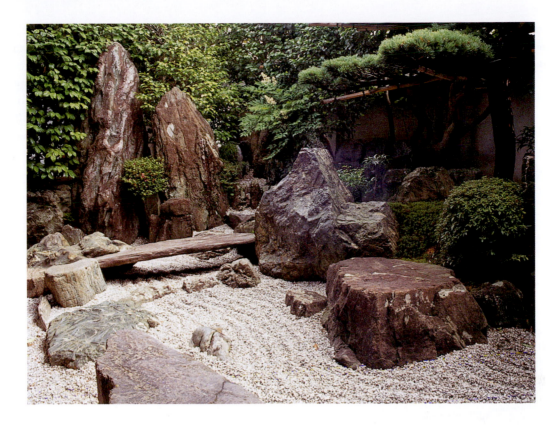

5.20 Attributed to Soami (died c. 1525), Garden of the Daisen-in of Daitoku-ji, Kyoto. Established Ashikaga period, c. 1513. Kyoto, Japan

the type used to deconstruct the rational patterns of thought and sharpen the instinctual minds of Buddhist monks in search of enlightenment and harmony with the universe. (See *In Context:* Japanese Poetry and Drama, page 174.)

Once again, we are reminded of the four basic principles of Japanese art listed in the Introduction to this chapter. Landscape forms in this great monument to stillness are not directly represented, but suggested in the most abstract terms; it is perishable—a single footprint in the raked pebbles would ruin the illusion; it is not regular or symmetrical; and its apparent simplicity certainly belies its true complexity. These aesthetic values contrast, strongly, with the mainstream of thought in the West, with its enduring love for permanence, perfection, symmetry, and grandeur.

Because Zen values intuitions and experience over the logic and reason of language, it is nearly impossible to explain it verbally. Zen masters have long told their students that words get in the way of understanding that which is beyond words, and to achieve enlightenment they must unlearn what they have learned about life and reality through words. Objects, too, tie a person to conventional ideals about life. Thus, Zen monks live lives of great austerity and, as far as possible, try to avoid possessions and commitments. This retreat from the traditional anchors in life

and acceptance of its transient qualities may be tinged by a certain spiritual melancholy because the monk knows that he too is part of that impermanence and that, for all his philosophical understanding of the matter, he will pass away.

Zen thinking grew out of native roots in Japan and ideas imported from the Asia mainland. The temple at Ise, which in all its successive manifestations has simplified the elements of Chinese Buddhist architecture to their most basic forms and geometries, reflects the indigenous values of Japanese Shintoism. It is also related to the ancient spiritual practice in China called Daoism, "The Way." The latter seeks harmony with nature and says we must practice *wu-wei*, restraint, and not pressure things to happen. That thinking helped shape the aesthetic that permeated almost every aspect of Japanese thought after about 1300 CE.

THE MOMOYAMA PERIOD (1573–1615)

The Momoyama (Peach Hill) period takes its name from an orchard of peach trees planted on the ruins of a castle south of Kyoto that once belonged to the dictator Toyotomi Hideyoshi. The name of this picturesque and popular

place for excursions in modern-day Japan offers an appropriate visual metaphor for this era, which has been called the Golden Age of Japanese art. However, this short and colorful period of Japanese history was also a time of unrelenting endemic warfare. During the Momoyama period, Japan's decentralized medieval feudal society, which had been run by a dazzling array of feuding *daimyo* and Buddhist leaders, became a powerful, centralized, and highly secularized state under the rule of military dictators.

The Momoyama period began when Oda Nobunaga (died 1582) triumphed over the last Ashikaga shogun in 1573, and lasted until Tokugawa Ieyasu consolidated his control of Japan in 1615. As Nobunaga permitted the Westerners who had been in Japan since 1543 to spread Christianity there—and allow their muskets to fall into Japanese hands—the foreigners added to the social and political complexity of the period. (See *Cross-Cultural Contacts:* Westerners and Christianity in Japan, opposite.)

JAPANESE POETRY AND DRAMA

The Japanese developed a number of highly ritualized institutions and art forms that provided something of a counterpoint to the chaotic political upheavals that rocked the country from the twelfth through the seventeenth centuries. In spirit, the art forms seem to reflect and update the ancient Shinto rootstock of Japanese thinking. The fourteenth- and fifteenth-century *Noh* dramas enjoyed by the Japanese elite moved at a snail's pace. Every word, restrained movement, note of music, and detail of costume was to be contemplated and savored by the audience. However, the prolonged silences in a *Noh* drama and in Zen meditation—what one might call their "negative spaces"—are filled with significant content and meaning. Through the imagination, the viewer is brought into the empty spaces of a drama and becomes an active participant in the art form.

The Japanese poets who worked with a severely limited number of words and syllables were masters of the art of stimulating their listeners' or readers' imaginations. From about the fourteenth century, Japanese *tanka* poets used images from nature to create melancholic and reflective moods, often love laments, in verses consisting of five lines containing thirty-one syllables in total.

The best-known form of Japanese poetry, the *haiku*, became popular in the fourteenth century. It does not have the accented meters and rhyming lines of Western poetry, and to those unfamiliar with the art form, the *haiku*'s apparent lack of finish may make it look or sound like a throwaway sketch for a "real" poem. However, behind the *haiku*'s seeming simplicity lies a surprisingly complex structure. A *haiku* consists of three phrases of five, seven, and five syllables (or *moras* or *ons*, linguistic units in Japanese that may be equal in length to or shorter than syllables in English). A *haiku* must also include a *kigo*, a word or phrase to suggest a season, and a *kireji*, a word at the end of a phrase that "cuts" the flow so the reader may contrast and compare two events, images, or situations. Working within these rules, poets around the world are experimenting with the *haiku* today in what is yet another international form of *japonisme*.

The *haiku* assumes special importance in the visual arts of Japan because its imagery is simple and nature-oriented, like the ink brushwork of the painters in the Chinese literati tradition and their counterparts in Japan. It also embodies the two ideals of Zen mentioned in the Introduction: oneness with the cosmos and spontaneous intuition. Matsuo Basho (1644–94) is often regarded as the master of the *haiku*. He wandered the Japanese countryside for years, finding inspiration for his work; after his return to his home, he instructed novices and received other poets at his small hut near present-day Tokyo. His most famous *haiku* was written in 1668.

furu ike ya/ kawazu tobikomu/ mizu no oto
An ancient pond/ a frog jumps in/ the splash of water

Reading the original Japanese version of the poem, and its English translation, one sees that the former has patterns and rhythms that are difficult to replicate in translation. Basho's contemporaries enjoyed such subtleties and this poem in particular prompted them to hold a contest to see who could compose the best new *haiku*—about frogs.

WESTERNERS AND CHRISTIANITY IN JAPAN

The first Portuguese traders landed in Japan in 1543; six years later Father Francis Xavier arrived with his Jesuit priests and an oil painting of the Virgin and Child. Initially, the imperial Japanese court welcomed the Jesuits, hoping that Christianity would help the court curtail the political power of the Buddhists and unify the feuding warlords. Moreover, the Western traders brought firearms and other supplies that were valuable in the ongoing civil wars. Guns, which had not previously existed in Japan, revolutionized Japanese warfare and helped Oda Nobunaga to take control of the country in the 1570s. During his rule (1573–82), the Westerners significantly expanded their mercantile activities in Japan.

However, his successor, Toyotomi Hideyoshi (1536/7–98), wanted to unify the *daimyo* of Japan around Confucianism and saw the Catholics, who had converted about 150,000 Japanese by the 1580s, as a threat to his authority. He thus began the persecutions that ultimately led to the expulsion of the Westerners in 1638. Thereafter, a few closely supervised Protestant English and Dutch traders with the Dutch East India Company were allowed to reside on a small artificial island in Nagasaki harbor on the southern island of Kyushu and trade with Japan, but to all intents and purposes, Japan had sealed itself off from the rest of the world.

Before they were expelled, however, the Jesuits taught some of their Japanese students how to paint with oils and make copper engravings so that they could create their own religious images. Some Japanese painters made copies of Western paintings, imitating their modeling techniques with great facility, and developed a kind of Occidentalism—a fascination with Western art and culture. Even though the Dutch traders were henceforth cloistered off the shore of Nagasaki, the influence of realistic *ranga* (Dutch painting) continued to influence Japanese painting. After 1720, the shoguns allowed illustrated Dutch books and oil paintings (provided they were without Christian content) into Japan, and Nagasaki became the major center for *rangaku* (Dutch learning).

Although this was a violent period of intense civil strife during which Buddhist support for the arts declined, the militaristic Momoyama dictators proved enthusiastic patrons. Recognizing that the arts could further their political ambitions, they constructed imposing castles with audience halls, shrines, and private rooms decorated with painted screens and furniture embellished with gold leaf, brass, and glowing lacquer. They often employed the most respected and famous Japanese artists and workshops of the day. Kyoto, the largest city in Japan, was once again becoming a magnificent capital filled with castles, shrines, temples, gardens, and palatial homes. It was also a festive city because the Momoyama shoguns, who were trying to consolidate their control of the country, sponsored many grand public events. Some of these spectacles were documented in large screen paintings with gold-leaf backgrounds. The color gold, used sparingly in earlier Japanese art to reflect the glory of the Buddhist paradise, became a defining emblem of this age and was used in abundance to symbolize wealth, majesty, and secular power.

Along with this rising interest in showy, public forms of art, the leaders also cultivated the traditional rustic Shinto-based arts in their private lives. This was manifest most clearly in new forms of the tea ceremony. The extreme contrast between the rulers' taste for public display in the arts and the restrained, private world of their unpretentious tea houses reflects the complexity of Japanese art and thought as Japan emerged as a unified and powerful nation.

ARCHITECTURE AND PAINTED SCREENS

With the arrival of guns and gunpowder from the West, the Japanese leaders needed to build large, heavily defended castles to house their families and courtiers. The ostentatious grandeur of the large castles remaining from the roughly forty tall strongholds built during this time stand as lasting symbols of the colorful warlords who united Japan. Although these popular landmarks are architectural responses to Western technology—the stone ramparts even have narrow openings for musketeers—their designs

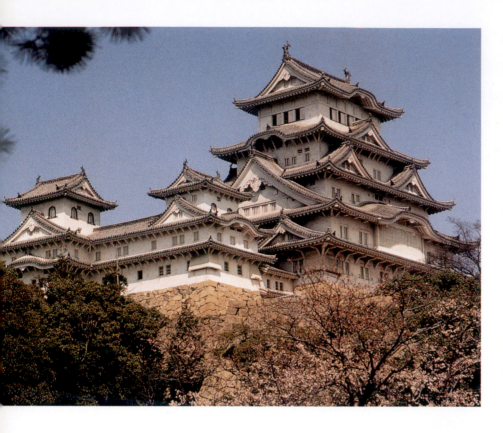

5.21 (LEFT) Himeji Castle, Hyogo prefecture. Momoyama period, begun 1581. Enlarged 1601–09

5.22 (BELOW) Interior of the audience hall, Nishi Hongan-ji, Kyoto. Momoyama period, c. 1630

Traditionally, Japanese palaces and homes had no Western-style furnishings: beds, chairs, tables, etc. People sat on mats on the floor, served food on low pedestals, and slept on futon bedding. Tatami, thickly woven reed mats (c. 3 × 6'; 90 × 180 cm) were used to cover the entire floor after the Heian period. Interior spaces were measured in units of tatami. By Western standards, the interior spaces of traditional Japanese homes are sparse, as "empty" as the unpainted white spaces in a Zen painting and as uncluttered as a haiku poem. This attitude toward the beauty of unused space finds substance in the insubstantial and fullness in emptiness, and had a profound influence on the development of Japanese architecture.

are fundamentally Japanese. Himeji Castle near Osaka, begun in 1581 by Hideyoshi, was rebuilt in its present form between 1601 and 1609 (FIG. 5.21). It is commonly known as the White Heron Castle because of its tall, white, plastered walls and wide, uptipped winglike roofs lined with rows of beautiful tiles. The storage areas for military provisions and weapons, barracks for troops, and apartments for the owner's family to use in times of siege rest on tall stone walls that were designed to resist cannon fire (first used in Japan in 1558). No single still photograph can replicate the experience of visitors as they move around the exterior of the castle and see the many complex and changing views of the gently bowed walls and curved, tiled roofs interacting with one another from different angles.

The tall central portion of the castle is surrounded by a complex set of multiple and interlocking outer walls, additional living quarters, gardens, and a moat. Even today, visitors to the castle must approach it through a maze of narrow, angular paths, fortified gates, and narrow ladders designed to slow down and confuse would-be attackers.

Many of the most celebrated Momoyama castles were destroyed in the early seventeenth century by the Tokugawa shogunate to deter any possible rivals to their power; others were torn down later, after 1854, when Japan was undergoing modernization in response to its growing contacts with the West. Some gates, shrines, tea houses, and small pavilions from this period remain, but most of the great audience

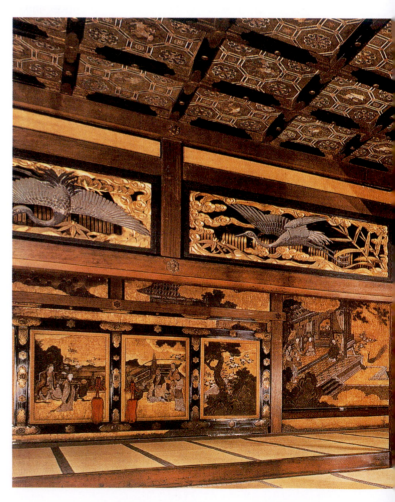

halls where the shoguns entertained influential guests and plotted their political and military tactics are gone. To get a general idea of what the White Heron Castle's audience hall, and those of other castles from this period, would have looked like, we might study the slightly later Nishi Hongan-ji in Kyoto (FIG. 5.22). Its rectangular hall is divided into three parts by two rows of wooden pillars. The colors of the beige reed mats (**tatami**), black lacquered woods, bronze trimmings, and the reddish-brown wooden beams framing the rooms blend well with the ubiquitous gold-leaf highlights. To complete the image, it is important to imagine the hall filled with portable works of art, courtiers dressed in colorful, embroidered silks, the aromas of flowers, and music.

The imperial household, temple leaders, *daimyo*, and shoguns of this period commissioned artists to paint portable folding screens (**byobu**). These were usually made in pairs, with two, six, or eight panels, and were about 5–6 feet (1.5–1.8 m) tall. Some of the finest screens were painted by the talented descendants of Kano Masanobu (1434–1530). The style of the so-called **Kano School** crystallizes in the work of Masanobu's great grandson, Eitoku (1543–90), who converted the Southern Song Chinese–Japanese tradition of painting relatively small monotone ink landscapes into a distinctive Japanese style with bold, overall decorative patterning, rich colors, and gold-leaf backgrounds. The Kano School remained the dominant style of painting in Japan until the Meiji period.

Cypress Trees, attributed to Kano Eitoku, originally created as a set of sliding doors or panels, is now mounted as a folding screen (FIG. 5.23). Japan has many picturesque locations of the kind shown here, with long seashores and rocky cliffs where travelers can see old, knurled trees on precipices overlooking small rugged islands. The long-branched tree in the foreground is very close to the picture plane and draws the viewer into the broad panoramic view of the landscape behind. Shown as if looking down from a high cliff, or from a bird's-eye view, the image has no horizon line to give it depth and anchor its panorama in reality. The brilliant golden clouds contrast with the dark but rich patches of green rocks, blue water, and the reddish-brown earthen tones of the tree and endow this and other Kano School panels with a sense of overall decorative and pictorial unity. Such large, architectural-scale paintings, on folding or sliding panels, gave viewers in rooms with small windows or distant light sources a sense of being outside, literally surrounded by nature. The undulating cloud formations and winding tree limbs unite this magnificent, sweeping view of nature and create a fantasy world that is as much a sign and symbol of the Momoyama age as the towering castles of the great lords.

The subject matter of the Momoyama period screens is highly diverse. In addition to picturesque images of rocky cliffs and water, some represent panoramic views of people gathered in the countryside, cityscapes seen from a bird's-eye perspective, dramas from the theater, battles, mythological scenes, and the curious spectacle of the Europeans with their large ships. The Japanese called the Europeans

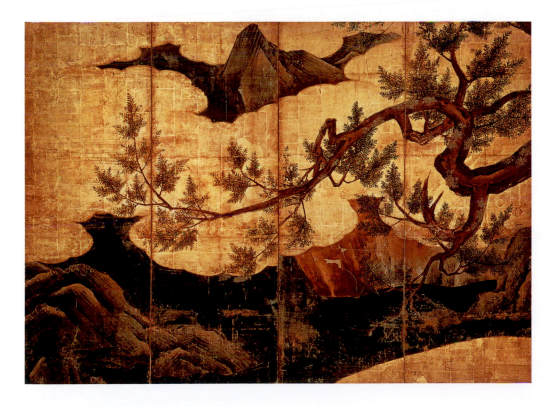

5.23 Kano Eitoku (attrib.), *Cypress Trees*. Momoyama period. Eight-fold screen. Gold leaf, color, and ink on paper; height 67" (1.7 m). Tokyo National Museum

the *namban jin* (southern barbarians) and the screen paintings of them are known as **namban byobu** ("screen paintings of barbarians"). One such early seventeenth-century folding screen shows Portuguese traders transporting goods from their ship anchored in the harbor to the Japanese merchants and other observers on the shore nearby (FIG. 5.24). In the typical fashion of the *namban byobu*, the artist shows the Westerners wearing colorful hats, garishly patterned cloaks, and puffy pants. The water and land are surrounded by brilliant golden and puffy, cloudlike decorative forms that give the otherwise rather commonplace scene cosmic dimensions as well as a sense of drama. Japanese painters often made sketches on the spot in the bay at Nagasaki, and some of them continued to make *namban byobu* screens depicting Westerners in combinations of Eastern and Western styles of painting well after the foreigners had been expelled from the country in 1638. The mixed emotions of awe and distrust experienced in the face of the Westerners and their large vessels and the complexities of Japan's attempt to isolate itself from Europe and Asia are discussed in *Cross-Cultural Contacts:* Westerners and Christianity in Japan on page 175.

THE TEA CEREMONY: ARCHITECTURE AND CERAMICS

Castles and palaces of this period were usually accompanied by informal gardens and *chashitsu* (tea houses). There, members and guests of the court could participate in the **chanoyu** (literally, "hot water for tea"), an event or ritual generally known as the tea ceremony. As part of a long-standing Chinese Buddhist tradition, monks drank tea as a stimulant to keep them alert during prolonged ceremonies and periods of meditation. Eventually, some cultivated Japanese shoguns and nobles began drinking tea and building small garden tea houses out of unpretentious natural materials such as unfinished wood or bamboo, and floored with earth-colored *tatami* mats that reflected the monastic origins of the temple-bound ritual.

Tea ceremonies may last up to four hours. Very little is said while the guests partake of tea served with what appear to be the simplest implements, which include the tea kettle, caddy, bowls, scoops, whisks, napkins, and the tea box in which the utensils are stored. These are, in fact, carefully

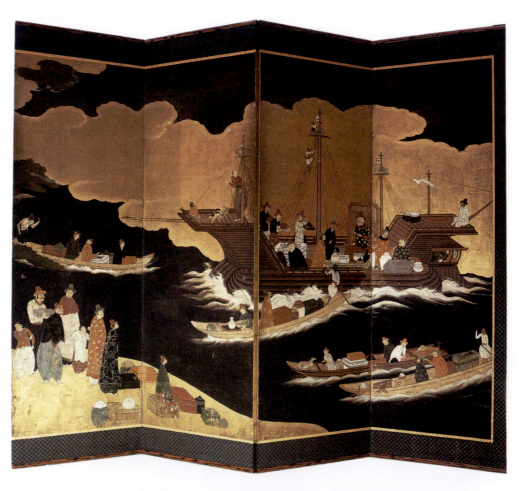

5.24 *Portuguese Merchants and Trading Vessels*. Part of the screen. Early 17th century. *Namban byobu* paper screen. 70⅛ × 144⅛″ (178 × 366 cm) H.M. De Young Memorial Museum, San Francisco

crafted, with deceptively subtle forms and textures. Nothing in the ceremony is precisely planned, yet the rules governing the performance of the tea ceremony dictate every movement, word, and thought of the participants. The tea ceremony is a sublime ritual that appears outwardly simple, but that, like almost everything about Zen thinking, is actually very complicated. The ceremony combines the highly refined aesthetics of *Noh* theater, *tanka* and *haiku* poetry, the arts of gardening, architecture, painting, sculpture, theater, and Japanese etiquette to stand as a ritualized expression of the finest Zen sensibilities. It is also a kind of performance art that stresses the importance of the participant group and its bonding around a refined shared experience, creating a stable microcosmic society and experience separate from the larger, unstable social order of the day.

Many writers have suggested that the orderliness and values inculcated in the tea ceremony reflected the needs of the Japanese leaders living through the prolonged civil wars of the Muromachi and Momoyama periods. The ceremony, which began to develop in the Muromachi period, reached its classic stage of its development under Sen no Rikyu (1521–91), tea master to the warlords Nobunaga and Hideyoshi. Sen no Rikyu explained that the ceremony fostered harmony, respect, purity, tranquility, and an appreciation of natural beauty without artifice. It was designed to teach participants Shinto-based virtues that remain fundamental to Japanese thinking today: *wabi* (humility, honesty, and integrity), *sabi* (a preference for stillness and the old and rustic over the new), and **shibui** (that which is bitter but pleasing). These terms and ideals are fundamental to the understanding of Japanese aesthetics, refinements that separated the cultured members of Japanese society from the Sudden Lords and the underclasses in Japan with their gaudy tastes. If the writers of this period are correct, in his own life Rikyu personified the virtues of the ceremonies he directed to the very end—when he committed suicide at Hideyoshi's request.

The significance of the ceremony was explained from a Western point of view by Father João Rodrigues (1562–1633), a Portuguese Jesuit priest who spent most of his adult life in Japan. It was, he wrote, "to produce courtesy, politeness, modesty, moderation, calmness, peace of body and soul, without pride or arrogance, fleeing from all ostentation, pomp, external grandeur and magnificence."

Sen no Rikyu may have designed the Tai-an tea house for his own garden in Tokyo around 1582 (FIG. 5.25). Later it was moved to a nearby Buddhist temple, the Myoki-an. The house is very small, about 9 by 9 feet (2.7 × 2.7 m), and the area occupied by guests, 6 feet (1.8 m) long, is dimly lit by three small, paper-covered windows. In the spirit of the ancient Shinto shrines, the house is modest in scale and perfectly integrated with its surroundings. To enter

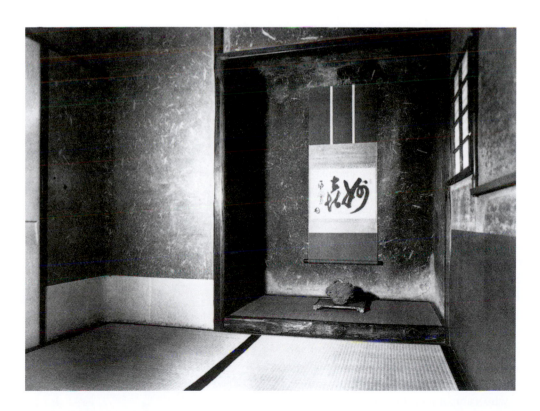

5.25 Sen no Rikyu (attrib.), interior and *tokonoma* of the Tai-an tea house. Myoki-an, Kyoto prefecture, Japan. c. 1582

it, visitors must stoop and crawl inside—ritual gestures of humility. The conservative design and size of the Tai-an tea house, reflecting pre-Buddhist Japanese aesthetics, stands in marked contrast to the festive atmosphere of the upturned eaves and ridge poles of such Buddhist-inspired buildings as the Phoenix Hall at Uji and the White Heron Castle.

The men and women invited to attend ceremonies at the Tai-an and other tea houses normally approached the houses along winding flagstone paths which led through the shrubbery and moss-covered rocks of surrounding gardens. Following an old Shinto tradition, participants in the ritual washed their hands and mouths in natural springs or creeks before entering the house. Paths through the gardens to tea houses were usually narrow, winding, and enclosed, with a sense of scale that prepared guests for the tiny tea house. That already small interior space was further subdivided and the area where the host prepared for the tea ceremony was hidden from the view of guests. The actual brewing of the tea was part of the ritual and was thus performed in the presence of the guests. Tea houses had very small windows, and were therefore quite dark, like architectural caves—fully enclosed worlds divorced from the spaces around them.

While waiting for the host or hostess to arrive, the guests, seated on mats, would have the opportunity to contemplate a floral arrangement and a small painting or calligraphy on a hanging scroll in the **tokonoma**, a shallow alcove or niche. Connoisseurs in the Momoyama period often cut up works by earlier calligraphers, saved the pieces in albums, and displayed them in the *tokonoma*. Like the shrine at Ise, the exposed wood surfaces would have been painstakingly rubbed and polished to bring out their natural beauty. All of the textures and colors of the walls, woods, and mats on the floor worked in unison to create an unpretentious atmosphere of utter simplicity. In the words of Father Rodrigues, the gardens and tea house had to be "as rustic, rough, completely unrefined, and simple as nature made [them]." The iron kettle, bamboo tea scoop, whisk, water dipper, tea bowls, and ceramic caddy for the astringently bitter, yet pleasing powdered green tea used in the ceremonies were to be commonplace objects that have a natural sense of beauty.

During the sixteenth century, Japanese tea masters began using peasant wares and, later, imported peasant rice bowls from Korea. Compared to the highly sophisticated Ming vases of this period, the folkish Japanese and Korean ceramics have a casual quality; when well-trained, technically proficient ceramists produced wares for the tea ceremony, they collaborated with the tea masters and cultivated certain accidental effects. These were highly admired by Japanese officers under Hideyoshi, who campaigned in Korea in the 1580s and brought Korean ceramics and ceramists back to Japan.

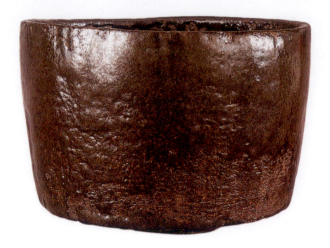

5.26 Hon'ami Koetsu, tea bowl titled *Mount Fuji*. Edo period, early 17th century. *Raku* ware, height 3⅜" (8.6 cm). Freer Gallery of Art, Smithsonian Institution, Washington, D.C.

To the members of a traditional *chanoyu* ceremony, **raku** ("happiness ware") such as *Mount Fuji* by the honored calligrapher, tea master, and ceramist Hon'ami Koetsu (1568–1637) embody the virtues of *sabi* and *wabi* (FIG. 5.26). With its irregular shape (which fits well in two hands), subtle coloration, and crackle pattern, it exemplifies the values of the ceremony in which it was used.

Such hand-shaped vessels were made from balls of clay that were pinched and stretched, fired at low temperatures, and allowed to cool in the air or under water. In marked contrast to the smooth and perfectly shaped Chinese and Japanese porcelain wares of the day, the imperfect shapes, rough incisions, and loosely splashed glazes of *raku* reflect

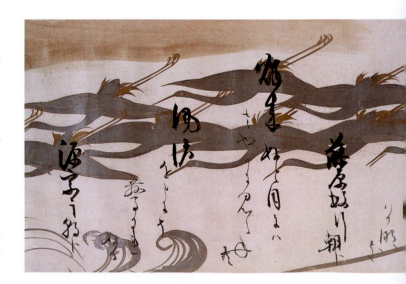

the folk traditions of the ancient Korean and Japanese potters. Near the conclusion of the ceremony, the host might display the other utensils used in the performance for the inspection of the guests. The fact that many of the famous tea bowls had names and were called by them underlines their importance and sense of individuality.

In keeping with the spirit of Zen, there is no liturgy or script for the ceremony, but strict rules of decorum govern every movement made in the serving and drinking of the tea. Nothing is planned, yet everything must be perfect, and each action takes on a sacramental or iconic quality. Conversations might center around matters of philosophy or aesthetics and have "empty" periods of silence that are as meaningful and important as any words. No two tea houses or tea ceremonies are identical; within the traditionally accepted rules of order, the ceremony must be staged with creativity because the ceremony is, first and foremost, a living work of art. At every stage of this ritual, on the path and inside the house, the participant's contact with the everyday world is severely limited—what is not seen is as important as what is. In its utter simplicity, the ceremony would appear to be the single greatest expression of the aesthetics of the Japanese elite.

The tea ceremony was equally popular among the elite in Korea, where many highly specialized utensil types were developed for the many varieties of the tea ceremony. Some implements were elegant and refined, but the simplest ash-stone glazed wares with their rough surfaces were the most highly prized by the true masters who found the randomness of the wares emphasized the "now moment of reality" in their ceremonies. In recent times, the ancient tradition has been revived and women as well as men can study the art of tea in Seoul at a degree-granting institution, the Panyar-o ("Dew of Enlightened Wisdom") Institute for the Promotion of the Way of Tea.

SCROLL PAINTING AND CALLIGRAPHY

The Momoyama period produced many masters of calligraphy who revived the older styles of writing, particularly those of the Heian period. One of these artists, Hon'ami Koetsu, who produced the *raku* bowl mentioned above, was an avid student of the tea ceremony and added verses from famous Japanese poets of the past to Tawaraya Sotatsu's background imagery in *The Crane Scroll* (FIG. 5.27). He was widely regarded as one of the most accomplished calligraphers of his day in Japan. The portion shown here represents only a very small section of the complete hand scroll, which is over 50 feet (15.2 m) long. Some of Sotatsu's elegant silver-colored cranes stand and stretch their wings while others fly and glide against the golden clouds in the background. Most of the birds move from right to left, the direction in which the scroll was to be viewed as it was unrolled. The gold is not bright, like that used by the Kano School screen painters, and, along with the soft silver-gray of the cranes, it provides a hazy background for the calligraphy of Koetsu, whose semicursive characters, seemingly brushed with great ease, have the same wonderfully gentle, gliding sense of motion as the cranes that unify this long composition of image and text. The two artists continued to work closely together and collaborate on projects for another decade in an art colony supported by Tokugawa Ieyasu.

5.27 *The Crane Scroll.* Calligraphy by Hon'ami Koetsu under painting by Tawaraya Sotatsu. c. 1605–10. Hand scroll. Ink, silver, and gold pigments on paper, 13½ × 56" (34 × 135 cm). Kyoto National Museum

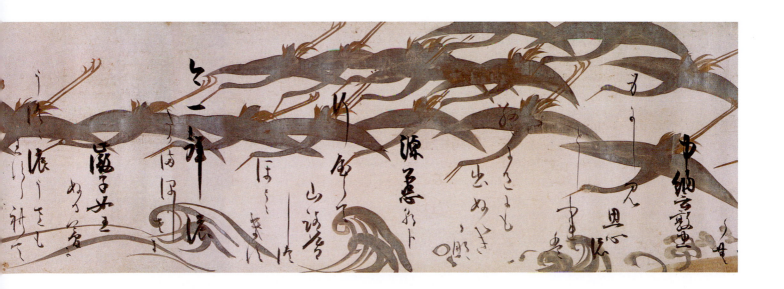

THE TOKUGAWA (EDO) PERIOD (1615–1868)

The Tokugawa period is named for its founder, Tokugawa Ieyasu (1543–1616), who became shogun in 1603, but it is sometimes also called the Edo period after his new capital (present-day Tokyo). Tokugawa Ieyasu's castle in Edo (destroyed in 1657) was 192 feet (58.5 m) tall and had about 181 acres (73.25 hectares) of grounds. Edo housed Ieyasu's entourage of about fifty thousand *samurai* and their staffs and the mansions of roughly 260 *daimyo*. Keeping these influential men in Edo, away from their homes in the provinces, for half the year, or for a whole year every second year, weakened them politically and helped centralize and stabilize the shogunate, which followed a Neo-Confucian philosophy that demanded unquestioning loyalty to the shogun and state. The government did not allow Japanese to travel outside the country and was often very repressive, but the period was nonetheless relatively peaceful and highly prosperous. It saw the growth of large cities, a money economy, the rise of literacy, and a new middle class that included many merchants. Although Kyoto had been badly damaged in the late fifteenth century wars, by the early Tokugawa period Kyoto had once again become a major Japanese cultural center where many of the older courtly traditions in the arts flourished. The merchants at Edo, catering to the shogun's large community of conscripts, prospered, and by the eighteenth century, Edo (population about one million) may have been the largest city in the world.

While many of the traditional Japanese art forms flourished at Kyoto and Osaka, some of the arts at Edo reflected the new realities of life in the bustling capital. The pictorial arts often illustrated life in the local entertainment or pleasure district, with its *kabuki* theaters, eating and drinking establishments, and prostitutes. This district was frequented by many of the prosperous businessmen of Edo and the shogun's men, whose families were often far away in the provinces. In contrast to the refined aesthetic of the elitist *Noh* dramas, the *kabuki* theater appealed to the tastes of the merchants and *samurai*, whose forced idleness had eroded their interests in Zen discipline and culture. Literature in Edo tended to be light reading—romances, tales of the supernatural, and travel guides. Some of the leading Edo poets created *kyo-ka* ("crazy verse"), which parodied the traditional forms of Japanese poetry still venerated in the tradition-bound cities of Kyoto and Osaka, the Buddhist monasteries, and the imperial court. To produce large numbers of inexpensive and colorful images that reflected the new realities of this world, the Japanese developed a magnificent tradition of woodblock printing.

ARCHITECTURE

The dual practice of the Momoyama-period shoguns in creating lavish buildings for public display and adopting more modest styles of architecture for private use continued in the Edo period. For many contemporary viewers, the few surviving examples of the profusely decorated early Edo gates are not as interesting as the far less ostentatious noble country homes and tea houses of this period. The enduring Japanese interest in refinement—the reduction of elements to their most essential forms—seems to reach its zenith in the Katsura Detached Palace, also known as the Katsura Imperial Villa, in an ancient villa district in the western suburbs of Kyoto. The villa, which is still used by the imperial family today, has never been a full-time residence; it was first created to provide an elegant retreat for a seventeenth-century prince, where he and his entourage could stroll in the gardens, have tea ceremonies, and use the moon-watching platforms to enjoy the night sky (FIGS. 5.28, 5.29).

Unlike a lot of earlier country homes, temples, and religious complexes, which were laid out along symmetrical lines, this was asymmetrical and irregular in plan. The Katsura Imperial Villa consists of three rectangular units or **shoins** built at different times and joined at the corners. The word *shoin* translates as "study" in English, but here the *shoins* include a variety of spaces with movable walls that can be reconfigured as desired to house many different activities. The proportional relationships of all the parts are based on the *tatami*, or reed-mat module—about 3 by 6 feet (90 × 180 cm)—and, working with this system, designers created a wide variety of spaces.

Approaching the palace, visitors may notice that the doorways and windows are not centered in the walls or symmetrically arranged, and there is no grand palatial façade to tell them where to enter. Inside, there is no grand hallway or hierarchy of spaces leading one to a single, all-important destination, such as a grand audience hall. In fact, the idea of a fully enclosed hall or room with four walls hardly exists here, and, moving from one semi-enclosed space to another in U- and L-shaped patterns, the visitor cannot anticipate what will come next. The spaces are remarkably open and flow one to the other, in part because the Japanese sit and sleep on the floor, using very little furniture. This openness is further enhanced by **fusuma** (sliding panels) set in wooden frames so that they can be moved to open or close off areas. Thus, the occupants of the palace have the freedom to reconfigure the design of each section of the villa to meet the needs of any day or moment.

Moving through the palace, the visitor experiences a constantly shifting composition of open and closed spaces within the palace, and the great variety of exterior

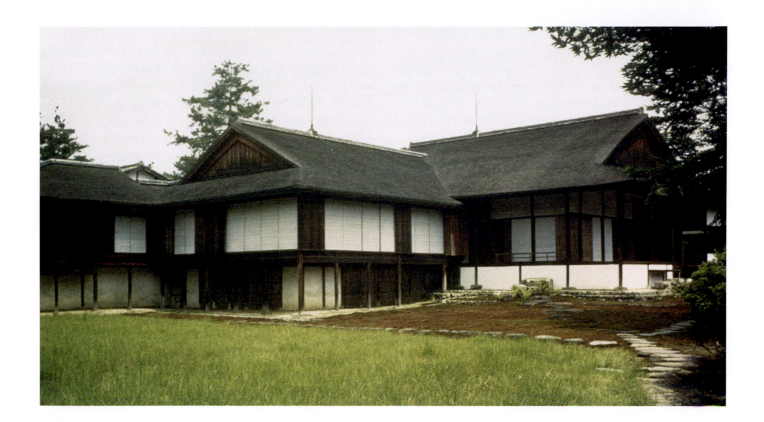

views through the surrounding gardens and small, rustic tea house-style buildings nestled within them. With its many verandas under broad overhanging roofs, there is often no clear distinction between inside and outside spaces. The verandas, designed to offer the imperial family a wide variety of views of nature as it changes with the seasons, reflect the interests of the *haiku* poets, who recorded elegant images of their experiences of nature.

Asymmetrical compositions such as the Katsura Detached Palace have an inherent vitality that captures the spirit of life, growth, and change. Its design invites the viewer to be an active participant in an experience of it. In fact, the vibrancy and openness of these "empty" spaces may be the "fullest" and most important experience the palace has to offer, seeming to reflect the Japanese belief that all things flow freely through the past, present, and future. Again, we are reminded of the four principles of Japanese aesthetics mentioned in the Introduction (see page 152). The prince's retreat also reminds us that in the Japanese aesthetic, time does not march on in linear fashion to a steady beat. Nothing is predictable—only change is certain; the events in one's life are not part of a grand and logical plan. These important cultural ideals seem to be deeply embedded in the design of the palace. No single part of it tells a visitor what the rest of the palace will hold, and his or her individual and sequential movements through it are not part of a grand architectural plan.

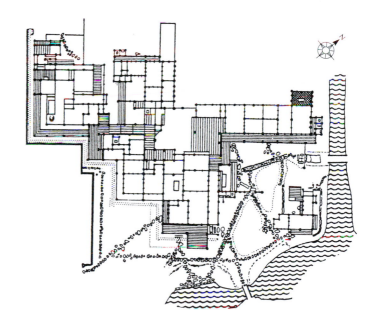

5.28 (TOP) Katsura Detached Palace, Kyoto. Edo period, early 17th century

5.29 (ABOVE) Plan of Katsura Detached Palace

The Tokugawa (Edo) Period (1615–1868) 183

While the quality of the woodworking throughout is astonishing, and every detail of the palace is finished like a fine piece of furniture, the overall feeling of the building reflects the values of the tea ceremony, of quiet simplicity, reticence, and a quest for harmony with unspoiled nature. For many students of Japanese art, the Katsura Detached Palace is the quintessential example of the Japanese view of space and form in architecture.

DRAWING AND EVERYDAY LIFE IN KOREA

Populist and secular thinking in the pictorial arts grew in Korea at this time as well, and Kim Hong-do (1745–c. 1814) became well known for his lively drawings of everyday life in Korea. In FIG. 5.30 the students seated on the right are reading aloud or laughing at the boy with his back to the bearded master. Unable to remember his lesson, the frustrated boy, who appears smaller and younger than some of his classmates, bursts into tears. The three students on the far left are more respectful as they look at their texts and

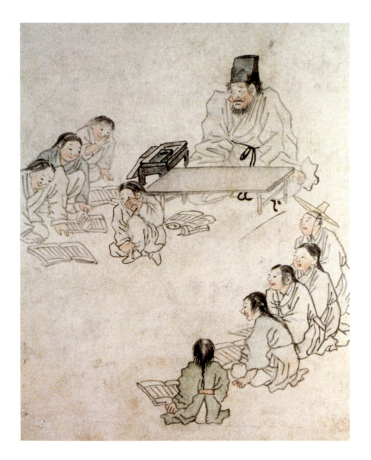

5.30 Kim Hong-do, *Schoolroom*. c. 1814. Ink and light color on paper, 11 × 9½" (28 × 24 cm). National Museum of Korea, Seoul

wait their turns to be tested. Kim Hong-do excelled at such genre scenes, drawing them in a very spontaneous manner, often using circular compositions, seen from above as if he and his audience were on balconies overlooking events. In such details as the comic expression on the face of the befuddled master, he captures "snapshot" details of daily life in Korea such as this embarrassing moment in a young student's life without glamorizing or mythologizing it as part of the country's educational program.

PRINTMAKING AND THE *UKIYO-E* STYLE IN JAPAN

"Just in floating, floating, caring not a wit for pauperism staring us in the face, refusing to be disheartened, like a gourd floating along with the river current: this what we call the floating world (*ukiyo-e*)."

From Asai Ryoi, *Tales of the Floating World*,
translated by Richard Lane

To maintain their authority, the Tokugawa shoguns embraced Confucianism and its social ethics, giving relatively little support to the Buddhist leaders outside Edo. With the growth of literacy in Edo and elsewhere, the Buddhist monasteries and imperial court began to lose their long-held monopoly on literacy and art. A new tradition of book illustration, along with the production of individual prints, appeared among the emerging bourgeoisie of Kyoto who were excluded from the elitist world of *Noh* dramas and tea ceremonies. The inspiration for this movement came in part from the slightly earlier tradition of illustrations of city life developed in the commercial centers of southeastern China: Hangzhou, Suzhou, Canton, and Shanghai. Large screen paintings depicting cities from bird's-eye viewpoints had been enormously popular in Japan since the sixteenth century in part because viewers could entertain themselves identifying popular landmarks, including, perhaps, their own streets and houses. Generally, the screens were composite images, glorified fictions that showed buildings from the past that had been destroyed, as well as festivals, pageants, and parades that happened at different times. This anecdotal genre, known as *Rakuchu-Rakugaizu* ("scenes in and around the city") paved the way for the less formal and more intimate images of the floating world.

The earliest Japanese prints of the activities and pleasures of everyday life were relatively simple black and white images. As the tradition took root to the north in Edo, the printing techniques changed rapidly—as did the themes the artists illustrated. The name for the new style of printmaking, **ukiyo-e** (pictures of the floating or passing world), comes

JAPANESE WOODBLOCK PRINTING

Woodblock printing, a Chinese invention dating from the Tang dynasty, appeared in Japan by the eighth century. Black and white prints, some then hand-colored, had been used to illustrate books (also printed) and duplicate works of art in Japan for centuries before printmaking emerged as a highly specialized art form in the late seventeenth century. By the 1760s, the production of multicolored prints was a thriving industry involving publishers, artists, engravers, and printers.

Publishers would commission artists to do line drawings in ink. Sometimes the artists would make notations indicating which colors should go where, but often the wood engravers and printers were responsible for color selection. The engravers would paste the original drawings face down on a hardwood (preferably cherry) key block and coat the drawings with oil to make them transparent. Then they would begin the difficult task of reproducing the drawn images by removing the wood on either side of the lines with a sharp knife. Next, the rest of the area between the lines would be cut away so the thin raised lines would stand out in relief while the "white" areas of the drawing were recessed. Prints from this key block reproducing the artist's line drawing were used to cut additional blocks where the relief corresponded to areas to be printed in a given color.

The printers began their work by brushing black water-based ink over the relief on the key block with the image of the artist's original line drawing. Next, they covered the inked block with a lightly moistened paper, and rubbed it from the back with a pad until the paper absorbed the ink. The most popular type of paper, *hosho*, was made from the bark of the mulberry tree. Once the paper was removed from the block and the ink had dried, the printers could begin printing additional colors on the paper from other blocks. All these blocks had registration marks in exactly the same places, so the printers could place the paper on each of them in precisely the same position, making certain the colors fitted perfectly into the design from the key block. Graduated or rainbow color effects were created by inking the blocks with brushes carrying two or more colors of ink or wiping some of the ink off sections of the block before printing. Prints might be given a luxurious finish of thin glue sprinkled with mica dust. In the end, the quality of any print depended on the combined skills of the papermaker, artist, blockcutter, and printer.

from a Buddhist term describing the transience or ephemeral quality of earthly existence discussed on page 152. It was originally applied to paintings of such subjects before inexpensive printing techniques were developed to make images of that type available to the public at large. In this new context, however, *ukiyo-e* also means images of the ephemeral "modern" or "fashionable" world, including erotic and risqué subjects that might be enjoyed as long as they lasted.

Building on a native tradition of *Yamato-e* painting and popular religious prints, *ukiyo-e* prints illustrated scenes from daily life, particularly in the pleasure quarters of cities—the restaurants, baths, brothels, and *kabuki* theaters. Colorful prints of attractive young women and famous male actors from the *kabuki* theater often now replaced the more traditional images of the Buddha, noted *samurai*, and Zen masters meditating among the misty mountains.

No subculture had ever previously seen its interests and tastes expressed with such refinement. The *ukiyo-e* prints are magnificent representations of the tastes, desires, and pressures of an expanding social class within the hermetically sealed society that severely restricted its contact with the outside world. While *ukiyo-e* prints are now highly valued and eagerly collected around the world, originally they were priced so the working public in Japan could easily afford them. In the mid-nineteenth century, a print might cost about as much as a worker's meal. (See *Materials and Techniques:* Japanese Woodblock Printing, above.)

UTAMARO

In the hands of Kitagawa Utamaro (1753–1806), the Japanese print rises above the level of anecdote and narrative. Utamaro had access to a wide cross-section of Edo's intellectual elite and the most progressive thinking in the city through his publisher, Tsutaya Juzaburo (1748–97). He used bold lines and monumental figures to create idealized images of Japanese women that combine beauty with a sense

of confidence and power. *Woman Holding a Fan*, from a series of prints called *Ten Aspects of Physiognomy of Women*, is a classic statement of a cultural ideal (FIG. 5.31). The appeal of the style results from the contrasting areas of smooth and richly brocaded patterns and Utamaro's well-orchestrated flowing lines: traditional curves inspired by the ancient techniques of calligraphy and drawing in the Chinese–Japanese traditions. Yet, in comparison with many of the earlier styles of painting in Japan and China, the subject matter and casualness of the composition are revolutionary—a kind of Pop Art. The upper classes in Japan at this time did not hold such prints in high regard as works of art.

Utamaro's woman is wearing a **kimono**, a T-shaped, straight-lined robe with a collar, wide sleeves, and sash that ties at the back. Men as well as women wore kimonos when participating in tea ceremonies, and to this day sumo wrestlers wear them because they symbolize the ancient roots of their craft in Japanese culture. However, the wearing of kimonos fell out of favor as Western forms of dress became increasingly popular in the twentieth century, although they are still worn in certain ceremonial and everyday contexts and remain a universally recognized symbol of traditional Japanese culture.

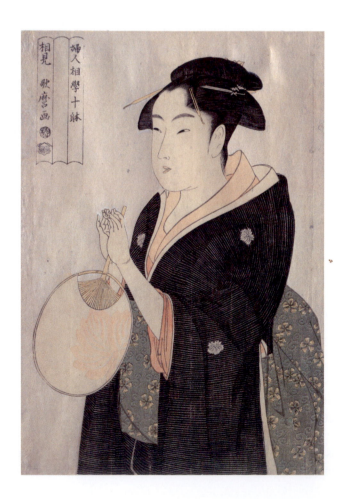

5.31 Kitagawa Utamaro, *Woman Holding a Fan*, from *Ten Aspects of Physiognomy of Women*. Tokugawa period, 1793. Full-color woodblock print, 13½ × 9½" (34.6 × 24.2 cm). The Cleveland Museum of Art

HOKUSAI

Around 1800, as more Japanese traveled to and from Edo for business and pleasure, publishers opened shops along the major roads around the city, selling images previously restricted to books: single-sheet maps, guides, and views of popular landmarks. This intensification of the traditional Japanese interest in *meishoe*, images of famous places with poetic associations, is well illustrated in the work of Katsushika Hokusai (1760–1849).

Many earlier Japanese artists had designed prints with landscape settings, but the emphasis was always on the figure, not the landscape. By contrast, Hokusai's print *The Great Wave of Kanagawa*, from the *Thirty-Six Views of Mount Fuji*, shows a giant, cresting wave rising high over three slender boats in a trough below (FIG. 5.32). Hokusai and many others considered Fuji, a venerated volcano that had erupted in 1707, to be a source of immortality. Against the distant backdrop of the sacred yet dangerous mountain, the wave in the foreground breaks into a multitude of tiny streams of suspended water and foam that reach out like claws to threaten the boatmen below. The monstrous mountain of water dwarfs everything in the picture, even the wave-shaped peak of Mount Fuji in the distance.

The Great Wave has long been admired as a classic statement of the *ukiyo-e* aesthetic and it is widely regarded as a symbol of Japanese culture, encapsulating many features of Japanese thought that have been discussed in this chapter. In the spirit of Zen, the obedient oarsmen, *samurai* of the sea, move and bend in unison with the terrifying powers of the frothing, roaring waters. Working in harmony with the tremendous powers of nature and the sea, they are reminders of the long, unbroken lineage of imperial rulers who have sustained themselves throughout Japanese history, as well as of the *samurai* code of honor, ideals that persisted within the chaotic feudal society of Japan. This understated image of discipline and persistence in the face of violence and chaos provides a fitting metaphor for this period of Japanese history as the unity of Japan as a nation had become a reality. From a later historical perspective, about a generation after Hokusai published this print, Japan was threatened by a great "wave" of cultural pressures arriving from outside its borders and the iconic print may be read as a symbol and harbinger of things to come in Japan during the Meiji Restoration.

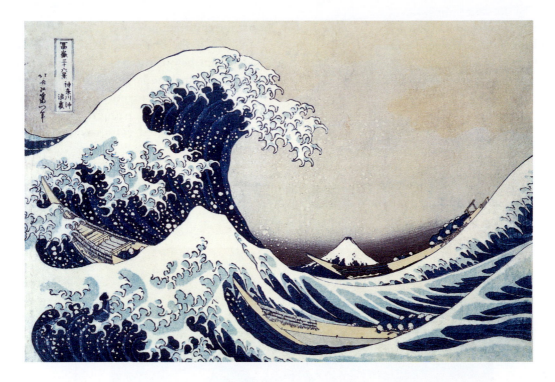

5.32 Katsushika Hokusai, *The Great Wave of Kanagawa*, from *Thirty-Six Views of Mount Fuji*. Tokugawa period, c. 1823–39. Full-color woodblock print, 10⅛ × 14¾" (25.8 × 37.5 cm)

THE MEIJI RESTORATION (1868–1912)

On July 8, 1853, Commodore Matthew C. Perry arrived in Japan with a United States naval squadron of four ships and 560 men to establish trade relations with Japan. This piece of gunboat diplomacy led to the fall of the shogunate and the Meiji ("Enlightened Government") Restoration (1868), which reinvested political power in the emperor. These events underlined the superiority of Western technology and inspired the somewhat astonished Japanese government to begin to modernize the country, reject the colonial status to which much of the East had been reduced, and become an independent world power. A Japanese national charter oath in 1868 stated: "Knowledge shall be sought throughout the world so as to strengthen the foundation of imperial rule."

Between 1862 and 1910, Japan participated in thirty-six international exhibitions where it acquired a wealth of accurate and up-to-date information about Western art and industry. The Japanese talked of combining "Eastern ethics and Western science," but assimilating the Western traditions while maintaining a Japanese identity proved a great challenge. Japan wanted to blend the best of its traditions with modern ideas from the West, to gain a whole new world of technology without losing the world of its past.

European artists and architects arrived to work and teach in Japan, and Japanese students matriculated in the West. For Japanese artists, this commitment to "blend" two such dissimilar worlds of thought created certain unavoidable problems. Many of the time-honored Japanese art forms, such as Kano School-style screen painting, *ukiyo-e* print-making, and calligraphy, continued to be practiced in Japan after 1868, but while those practitioners might be recognized as preservers of the Japanese heritage and cultural treasures within Japan, would they be recognized around the world as artists in their own right? Could a Japanese artist be acknowledged as such outside Japan without breaking ties with these venerable Japanese traditions? Some artists began where the painters of the *namban byobu*, screens representing Westerners and their ships, had left off after the Europeans were expelled in the early seventeenth century and looked for ways to incorporate Western subject matter into *ukiyo-e*-style prints. Others studied with Western teachers, learned how to work with oils, and painted modernist images of Japanese subjects.

At the same time that the Japanese were struggling to find ways to accommodate the myriad of other cultural changes being thrust upon them, the West was having its own reaction to the long-hidden cultural wonders of Japan. The sudden vogue for Japanese art in the West was known by the French term ***japonisme***, and the intense aesthetic

dialogue between Japan and Europe over the next half-century would have a major influence on the development of both Eastern and Western art. (See *Analyzing Art and Architecture:* Van Gogh and "Japonisme," page 190.)

PRINTMAKING AND PAINTING

Given the importance of printmaking in Edo Japan, it is not surprising that the medium continued to interest Japanese artists of the Meiji Restoration. Japanese artists schooled in the *ukiyo-e* traditions of printmaking flocked to Yokohama,

a harbor and trading center near Edo (renamed Tokyo in 1868), where the first main East–West contacts were being made. Even before the Meiji Restoration, some Japanese artists began making large and detailed topographic views of the rapidly expanding port. Others, working in the tradition of the *namban byobu* painters, made images of the "black ships" (steam-powered vessels with smokestacks) and the exotic foreigners who sailed them.

A print by Hasimoto Sadahide (1807–78/79), *Foreigners in Yokohama*, presents an image of daily life in the international sector of that city (FIG. 5.33). A tall Westerner with bony

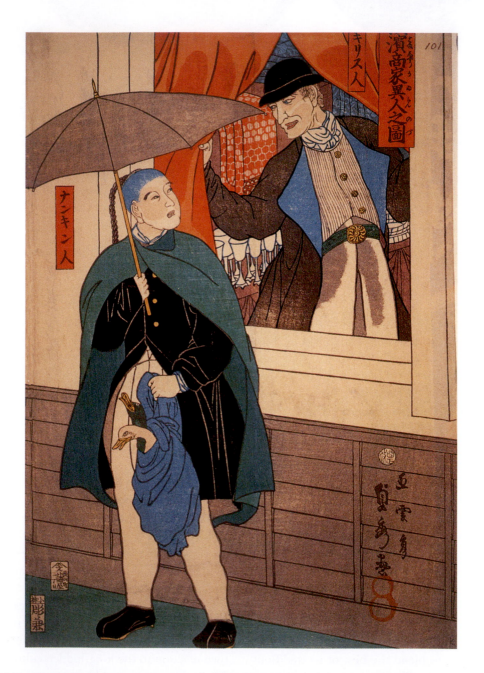

5.33 Hasimoto Sadahide, *Foreigners in Yokohama: Igirisujin (Englishman) and Nankinjun (Chinese)*. 1860s. Full-color woodblock print, 13⅝ × 9″ (5.5 × 3.5 cm). Victoria and Albert Museum, London

cheeks, prominent nose, and pointed chin, wearing a long frock coat and loosely tied cravat, pulls back a pair of window curtains to look out upon a much shorter Chinese man with a parasol and a pair of ducks. This image of Eastern and Western gazes meeting at close range would have been commonplace in Yokohama at this time now that the *namban jin* (southern barbarians) who had long been restricted to their offshore trading quarters shared this part of the bustling mercantile center with the Japanese.

With the end of the Tokugawa and the Meiji Restoration in 1868, the sphere of Western influence in Japan expanded from Yokohama to Tokyo and other metropolitan centers. Japanese printmakers began to incorporate more visual information from photography and Western graphics as they documented such topics of interest as the activities of the imperial family and military actions in the Japanese wars with China and Russia at the turn of the century. However, it was not until late in the twentieth century and the rise of postmodern criticism, which accepted inconsistency and contradiction as integral parts of contemporary thought, that the eclecticism of these artists' works was generally accepted as a positive feature.

Western influences became even more pronounced when Japanese artists studied with European teachers working with oil paints in Tokyo and Europe. The Japanese had been introduced to oil painting before the Europeans were expelled in 1638, but in essence the medium and its potentialities were new to Japan. The Western sources for most of the Japanese painters in this period of extreme eclecticism and experimentation are quite obvious, but in some cases artists such as Aoki Shigeru (1882–1911), a graduate of the Tokyo School of Fine Arts, found more innovative ways to build on those sources. In his best-known work, *Paradise under the Sea* (1907) (FIG. 5.34), Shigeru has illustrated an ancient Japanese legend in which Prince Fire-fade visited the Palace of the God of the Sea and fell in love with his daughter. The composition, showing two women holding a vase in a tall narrow frame, and the theme, a romantic mythological narrative, reflect Shigeru's interest in the English painters known as the Pre-Raphaelites. However, Shigeru worked much more like the French Impressionists, using light, feathery brushstrokes and making sketches from nature. While planning the *Paradise*, Shigeru went a step further in the study of nature than the Impressionists; he used a diving suit and helmet to make sketches of light and color effects of objects under the sea in the Bay of Nagasaki. Amazingly, the brushwork

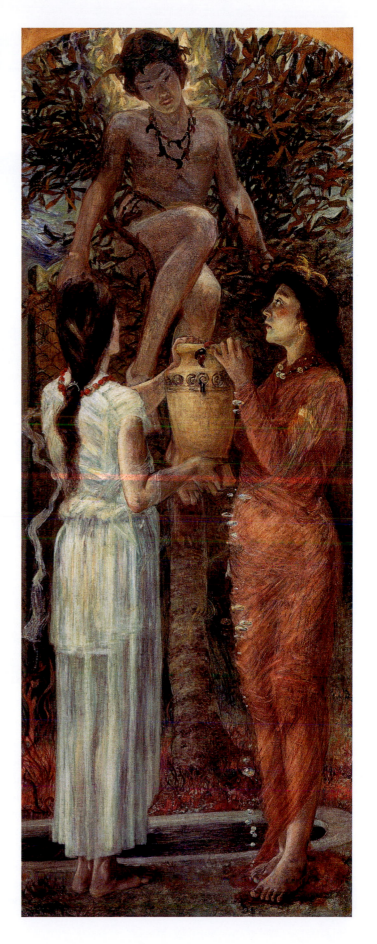

5.34 Aoki Shigeru, *Paradise under the Sea*. 1907. Oil on canvas, 71½ × 27⅝″ (182 × 70 cm). Ishibashi Museum of Art, Ishibashi Foundation, Kurume

VAN GOGH AND "JAPONISME"

When Japan began trading with the outside world, many Europeans, and later Americans, became fascinated by the country's art and culture. This vogue became known as *japonisme*. Many of the leading painters working in Britain and France assembled large collections of Japanese prints, which had little monetary value in Japan—indeed, they were often used as packing and wrapping paper for other Japanese export goods. The Western artists were fascinated by their brilliant colors, unorthodox points of view, asymmetrical compositions, and images of everyday life, some of which were erotic. This new style of image-making was particularly appealing to artists who were discontented with the Classical and academic traditions governing the late nineteenth-century art world in Europe. Many of the best-known Impressionists and Post-Impressionists, the recognized founders of modernism in the West, were deeply influenced by Japanese art. In fact, much of what we think of as distinctively European and modern about the color use and compositional sense of these artists was inspired by Japanese woodblock prints.

The attitudes behind *japonisme* differed from those which created the vogue for *chinoiserie* (see Chapter Four). That earlier interest in the exotic and fantastic aspects of Chinese art seldom if ever led artists to a deeper understanding of the aesthetics and cultural values underlying the work. By contrast, Vincent van Gogh (1853–

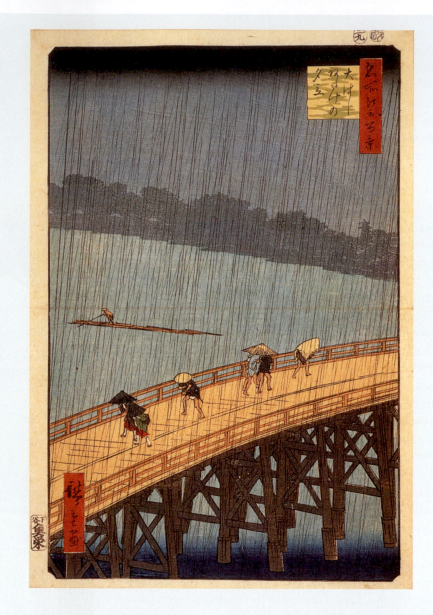

90), who owned many Japanese *ukiyo-e* prints, wanted to understand the creative impulses behind Japanese printmaking, especially the joy with which the artists used color. This led him to make some "interpretive" copies of prints by Ando Hiroshige (1797–1858), Hokusai's younger contemporary.

Hiroshige had taken advantage of the new opportunities in Japan to travel. His sets of *meisho-e*, images of famous places along the most-traveled Japanese roads, were purchased by a public that also enjoyed the new novels and *kabuki* plays about on-the-road adventures. Hiroshige's final set of topographic prints, *One Hundred Famous Views of Edo* (1856–59), appeared while Japan was opening its doors to outside

5.35 (OPPOSITE) Ando Hiroshige, *Ohashi Bridge in the Rain*, from *One Hundred Famous Views of Edo*, 1857. Full-color woodblock print, height 13⅞" (35.5 cm). Fitzwilliam Museum, Cambridge

5.36 (RIGHT) Vincent van Gogh, *The Bridge in the Rain*. Copy after Ando Hiroshige, 1887. Oil on canvas, 28¾ × 18¼" (73 × 54 cm). Van Gogh Museum, Amsterdam

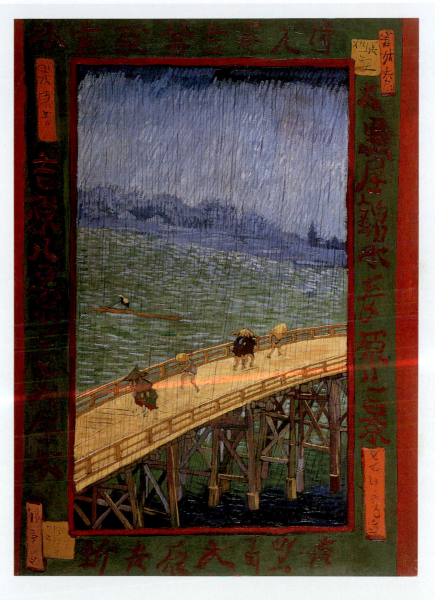

trade and many of them reached Europe. Vincent van Gogh made copies of works from this set, the best known of which is *Ohashi Bridge in the Rain* (FIG. 5.35). Pedestrians crossing a bridge, caught in the rain, scurry in both directions for cover. The composition is organized around the diagonal accents of the bridge, tree-lined shore, and the thin, dark lines of falling rain that connect the black rain clouds in the sky with the dark, shadowed water under the bridge. Making his copy, van Gogh intensified the blueness of the sky and the brownish-yellow of the bridge while adding green and white wave patterns to the water (FIG. 5.36). He added yet more green to the red-trimmed frame he invented for the work, but removed the rectangular cartouches from the main image. Along with the bold patterns of brushwork in the painting and red calligraphy on the frame, the changes that van Gogh made in his "copy" of Hiroshige's print are part of his study of Japanese color use and his search to find ways of using Japanese art to enhance the expressive qualities of his own painting.

in the *Paradise* does, in fact, capture these fleeting effects of reflected and diffused light in water in the women's wet dresses and the shadowy skin of the prince. While incorporating ideas from Impressionism, Shigeru combines his scientific knowledge of aquatic light with Japanese counterparts to the narratives of the Pre-Raphaelites to produce one of the masterpieces of Meiji Restoration art.

THE MODERN PERIOD (FROM 1912)

Many Japanese artists continued to study in Europe or in Japan with European-trained artists and to experiment with the most up-to-date modernist styles until the 1930s. At that time, the Japanese government began to view the avant-garde with suspicion, linking it with subversive left-wing politics and Communism. Thereafter, the progressive art world in Japan was essentially dormant through World War II (1939–45) and the American occupation of Japan (1945–52). Following nearly two decades of war and suppression, a new generation of postwar Japanese artists with relatively thin ties to their native past burst onto the scene and established Japan as one of the major centers of mid- and late twentieth-century art.

ARCHITECTURE

Frank Lloyd Wright (1867–1959), who had been deeply influenced by Japanese architecture as a young man in the 1890s, had just finished the Imperial Hotel in Tokyo when the earthquake of 1923 hit the city. Wright had visited the Columbian Exposition of 1893 and been deeply impressed by the Japanese exhibition, which included a replica of the eleventh-century Phoenix Hall near Kyoto (see FIG. 5.11). This inspired Wright to visit Japan in 1905, collect Japanese woodblock prints, and design buildings that combined elements of Eastern and Western aesthetics and technology. Wright's Imperial Hotel, built of reinforced concrete, survived the Tokyo earthquake, which leveled most of the large buildings in the city, and inspired a generation of young Japanese architects to study Western architectural engineering. They looked for ways to use the Western ideals that respected the traditional Japanese interest in modular forms, open and flexible spaces, and love of natural materials in buildings that were fully integrated with their surroundings in nature.

Following the Allied bombing raids near the end of World War II, new buildings of every kind were needed. Tange Kenzo (1913–2005) was one of the architects of the postwar period who rose to meet this challenge—to combine the traditional Japanese ideals with the new materials and technology. When Tokyo was awarded the 1964 summer Olympic Games, Tange created a magnificent indoor stadium that became the centerpiece for this international gathering of nations (FIG. 5.37).

Many indoor arenas built before this time had used massive pillar roof supports that invariably interfered with spectators' views of the sporting events staged in them. Tange suspended the roof of his stadium from heavy steel cables, giving it an elegant, tent-shaped outline that reflected the tall, peaked profiles of ancient Shinto shrines. This system of engineering also enabled Tange to remove the troublesome interior pillar supports and give spectators a new sense of being part of the spaces and the actions they were watching. Here, materials are used in a way that respects their integrity, spaces are fluid, and the roof lines make sweeping gestures across the landscape, uniting the stadium with the spaces around it in a dynamic manner that cannot be conveyed in a single still photograph.

PAINTING, FILM, AND VIDEO

In 1954, Yoshihara Jiro (1905–72), an avant-garde Surrealist painter of the 1930s whose work had been suppressed by the government, reemerged to establish the Gutai Bijutsu Kyokai (Concrete Art Association) in Osaka. A year later the Gutai group staged the Experimental Outdoor Exhibition of Modern Art to Challenge the Mid-Summer Sun in the beachfront town of Ashiya, near Osaka. The exhibition included sculptures made of machine parts mounted in the sand, a pink sheet of vinyl flapping in the wind, and a long painting tied to trees. "Create what has never existed before," Jiro told his Gutai group. During its eighteen-year history, the group experimented with new forms of visual expression, making indoor and outdoor installations and working with film, action events, theater, and music in an attempt to combine ideas from the Japanese past with new ideas emerging in Western art.

Many of their performances were semiscripted, in the manner of an earlier type of European experimental, improvisational form of theater developed by Dada groups around the time of World War I. Later, these performances were christened Happenings after an event in New York City in 1958. In place of traditional narratives with their logical, linear structures, the Gutai directors of Happenings gave their casts minimal instructions so they were forced to make unexpected and creative things "happen." The productions and experiences were conceived to be as enigmatic and incomplete as any other events in life and, hopefully, to raise the consciousness of the performers and audiences—about life generally, as well as about the interrelationships between their lives and art.

5.37 Tange Kenzo, Olympic Stadium, Tokyo. 1964

The thousands of such works were produced by the Gutai artists, although very few have been preserved, except in photographs. To demonstrate the importance of process in their thinking, the moment of creation, and the preeminence of the philosophy inspiring the works, the artists deliberately destroyed the materials used in the First Gutai Exhibition in 1955 after it closed.

At the Second Gutai Art Exhibition in Tokyo (1956), Shiraga Kazuo (born 1924) was photographed doing a performance piece, painting with his feet (FIG. 5.38). He is shown working on the floor, in a manner similar to that of the contemporary American Abstract Expressionist and action painter Jackson Pollock. Moving in dancelike patterns, Shiraga creates massive black forms or "characters," a monumental but illegible sort of calligraphy that ties his work to that important Japanese art form while embracing

international trends in modernist art in the 1950s. Kazuo's work also recalls the *so* or *haboku* style of Sesshu and the long-standing Japanese belief that accidental patterns of "splashed" ink can be spiritually inspired.

Some of the ideals of the movement are expressed in its name: Gutai (*gu*, "tool" or "means," and *tai*, "body" or "substance") means "concreteness" and symbolizes the concrete nature of the actions and objects in the Gutai works. Yoshihara said it was his desire to "give concrete form to the formless." In regard to forms and all objects in nature, the group espoused a Shinto-derived respect for their natural or innate qualities as expressed in the Shinto temples and tea ceremony. They also had a Zen Buddhist respect for spontaneity and the "accidental" effects that might take place in the moment of creation. They saw their work as an interaction between the concrete and spiritual realms, as an

5.38 Shiraga Kazuo, performance at the Second Gutai Art Exhibition. Ohara Kaikan Hall, Tokyo. October 1956

expression of a universal human consciousness made with a childlike sense of freedom and purity.

This philosophy was created in large part by their leader, Yoshihara Jiro, the former Surrealist painter. Surrealism, which originated in Europe in the 1920s, incorporated the theories of Sigmund Freud and Carl Jung, who believed that artists could express certain deep-seated emotions and universal ideas residing in their unconscious minds. This Surrealist concept, combined with the Buddhist conception of the universal nature of the Buddha, inspired the Gutai group to find ways to express this Eastern–Western concept of universal ideas through their art by uniting and releasing the combined powers of mind and matter.

To a degree, like other movements in the arts of this period, the Gutai philosophy was also a reaction to the brutality and futility of World War II, which ended with the awesome spectacle of the atomic blasts in Japan at Hiroshima and Nagasaki. But, unlike those of many Tokyo-based artists of this time, the Gutai events and exhibitions were not overtly

political in nature. Instead, they pointed to the idea of rebirth and the freedom of Japan from the totalitarian rule of its imperial government, the hardships of the war years, and the psychological shame inflicted by the postwar occupation. In the first edition of the group's journal, *Gutai*, Yoshihara wrote: "Our profound wish is to prove concretely that our spirits are free." Writing in English, he called out to the West, asking readers to see his group as part of the international art world. Historians continue to debate the degree to which modernist movements in the West, including the Happenings that became popular in the 1960s, may have been influenced by the Gutai group.

In 1960, many young Japanese dramatists, writers, and artists were outraged when the Japanese government renewed the U.S.–Japan Security Treaty, which allowed the United States to retain armed forces in Japan. The politically active "post-Hiroshima generation" revolutionaries drew on childhood wartime memories and themes of suffering and death from Japanese legends and folklore to make what became known as Obsessional Art. Often, their obsessions with madness, sex, and primitive passions were presented in grotesque ways that were, by design, deeply upsetting to audiences.

This expressionistic side of postwar thought in Japan became manifest in the New Wave film movement. One of most widely circulated and influential of these films, *Suna no Onna* ("Woman of the Dunes"), made in 1964 by Hiroshi Teshigahara, is based on Kobo Abe's existential novel of that name (FIG. 5.39). Produced for the modest sum of $100,000, the film won first prize at the Cannes Film Festival (1965) and was nominated for an Academy Award as the best foreign-language film that year.

In the film, villagers in a desert capture a man from the outside world (Niki, played by Eiji Okada) and lower him into a pit in the dunes. A nameless woman there, played by Kyoko Kishida, spends each night digging in the sand, filling a bucket on a rope which the villagers raise so the sand will not engulf her and her small house. Although Niki had been unhappy with what he regarded as the artificiality of his socially constructed identity before being imprisoned in the pit, he tries repeatedly to escape. Gradually, Niki realizes that he is trapped in the pit, in the same way that he had been trapped in society, and he begins to accept his new life.

The film depends heavily on the viewer's understanding of its symbolism. Sand, portrayed as a constantly moving and changing force that can destroy people, represents society. Using extreme depth-of-focus shots, Teshigahara captures the enormity of the sandy wasteland and the smallness of the people within it.

A strong anti-Western, antirational, and antimodernist reaction in Japan was growing in the face of the pseudoheroism of Abstract Expressionism and the commercialism of Pop Art and other product-driven, New York-based movements of the early 1960s. Artists loosely associated with the Japanese School of Metaphysics combined the Eastern aesthetics and nonlogical approach of Zen Buddhism with the anti-art, anti-establishment ethics of Dada, a Western antiwar movement born out of World War I. As part of this strong Neo-Dada movement, Japanese artists played important roles in two of the movements reacting to the mercantile hegemony of New York City and other Western art capitals: Conceptual Art and **Fluxus**.

The American composer, performer, aesthetician, Neo-Dadaist, and student of Daoism and Zen Buddhism John Cage (1912–92) influenced members of an international group called Fluxus (c. 1960–78), which included Japanese artists. George Maciunas (1931–78), founder of Fluxus (Latin for "flowing"), said it attempted to "promote living art" and to counter the "separation of art and life." With its many active Asian members, Fluxus debunked some of the Euro-American modernist myths about the transcendent character of art and gave new meaning to the rituals of ordinary daily living. Fluxus also broke down geographic barriers and demonstrated convincingly that movements in the arts could be fully universal and need not depend upon the support of New York City's network of galleries and museums.

The Tokyo-based Fluxus group of the early 1960s included Cage, Yoko Ono, and Korean-born Nam June Paik (born 1932), who had studied aesthetics at the University of Tokyo and worked with the German Fluxus group before returning to Tokyo in 1963. Yoko Ono was one of the first artists to use prescriptive language as an art form, putting instructions on the wall of a gallery for a "painting to be constructed in your head." Other such postings by Yoko Ono included *koans* like those used by Zen masters to lead students to enlightenment.

A meeting with Cage in 1958 led Paik to see the potential of television and, later, video as art forms capable of expressing ideas that united Eastern and Western lines of thought. Later, Paik said that, just "as the collage technique replaced oil paint, the cathode ray tube will replace the canvas." Video differs from film in some important respects. The video image is formed by a series of rapidly moving points of light striking the inner surface of a monitor screen. Therefore, unlike with film, photography, painting, and other two-dimensional media, the observer is unaware of a material surface other than the glass window upon which the light is projected. Video art may also differ from cinema and television in what is shown and the conditions in which it is viewed. Video arts may use multiple monitors, create new spatio-temporal dimensions, and through the use of other electronic devices, particularly computers, create images that are readily distinguishable from those in television and cinema.

Working with Shuya Abe, a Japanese engineer and inventor, Paik developed a video synthesizer that could alter colors and shapes and superimpose them to create electronic video collages. Pushing the available technology of video to its limits, Paik discovered ways to make the technical circuitry behave in statistically random and "human" patterns. Assembling large numbers of television sets in the shape of pyramids, triumphal arches, and billboards, with complex patterns of changing images keyed to or counterpointing loud electronic scores, Paik produced complex video installations that became powerful and

5.39 Hiroshi Teshigahara, *Suna no Onna* ("Woman of the Dunes"). 1964. Film still

all-encompassing visual experiences. Some of his smaller installations are equally impressive for their subtle wit, Dada-style puns, Cage-inspired Zen *koans*, and theories of communication.

Paik's *TV Buddha* (1974) is seated before a video camera and watches his own image on a monitor (FIG. 5.40). The installation is a Dada/Zen-style *koan*-pun on the achievement of the original historical Gautama Buddha, who found enlightenment through contemplation and withdrawal from the culture around him. It also juxtaposes the timelessness of the Buddha's teachings with the instantaneous nature of television and puts the Buddha on a screen where modern audiences normally watch such non-Buddhist programs as sitcoms, soap operas, and sporting events.

With the death of Emperor Hirohito in 1989, the Showa era that began in 1926 came to an end. Soon after, the Japanese economy collapsed and the Nikkei stock index lost nearly half its value. In the crash, some prominent Japanese figures were indicted for illegal financial activities and the Liberal Democratic Party, symbol of Japan's postwar economic boom, was defeated in elections in 1993.

The death of the emperor, who was once considered divine, opened the door to public debates about his role in the imperial wars (1931–45) and other acts of Japanese aggression toward its neighbors that had been hidden behind the power of *tenno-sei* (the modern emperor system). The art of the post-Hirohito era in Japan soon began to confront some of the myths about this system. Some artists satirized the way the Japanese had "bought" culture during the boom years; others created images that combined the style of *ukiyo-e* prints (see FIG. 5.33), images of that earlier "floating world" of Japan, with modern Western images to comment on the rapid state of change in Japanese society at the end of the century.

Hinomaru Illumination (Amaterasu and Haniwa) by Yanagi Yukinori combines symbols of imperial power from several historical periods to express many of these concerns (FIG. 5.41). Terracotta tomb sculptures, replicas of the *haniwa* tomb figures from the Kofun period that encircled royal tombs (see FIG. 5.3), face a billboard-size neon sign resembling the Japanese Rising Sun flag. Although the flag has been banned since World War II, it remains a symbol of Japanese imperialism and the reign of the Showa emperor. The manner in which the powerful red sun symbol controls the *haniwa* figures seems to symbolize the way in which *tenno-sei* inspired a spirit of nationalism among the mid- and late twentieth-century Japanese and their drive for military and economic power.

5.40 Nam June Paik, *TV Buddha*. Video installation with statue. 1974. Stedelijk Museum, Amsterdam

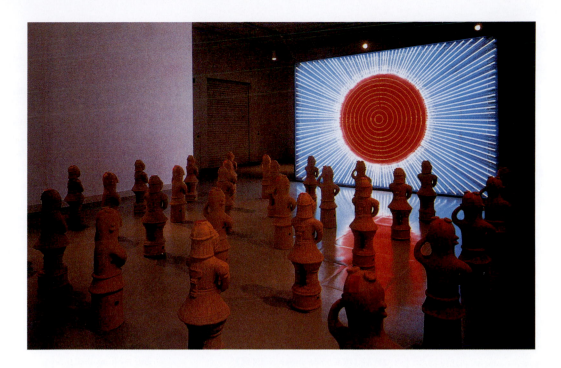

5.41 Yanagi Yukinori, *Hinomaru Illumination (Amaterasu and Haniwa)*. 1993. Neon and painted steel, with ceramic *haniwa* figures; neon flag 118 × 177⅛ × 15¾" (300 × 450 × 40 cm), each *haniwa* height c. 39" (99 cm). The Museum of Art, Kochi

SUMMARY

The ancient aesthetic of Shinto ingrained in the history of Japanese art and architecture remain part of Japanese thinking to this day. This religious philosophy emphasizes purity, harmony with nature, a respect for the intrinsic nature of materials, simplicity, rusticity, obedience, and the value of tradition. The Buddhist arts of China and Korea that arrived in Japan in the sixth century underwent many changes as they were refined and adapted to this Shinto-based aesthetic.

The influence of this aesthetic on the arts of Japan over the years has been tremendous: Painting may have many open, seemingly empty spaces, Shinto shrines continue to be built like ancient village granaries, Japanese poems may be very terse, elite forms of drama are highly restrained and formalized, and the famous Japanese tea ceremonies include many long periods of silence for contemplation.

In their subtlety and refinement, the apparently simple forms of Japanese art are actually deceptively complex. They demand that the viewer take an active part in their appreciation, to contemplate and experience them slowly and literally to meditate on them, as their makers did when they conceived them. In this process, the slowing of action, or even inaction, becomes a very important "activity" for both artist and observer.

Japanese art has survived many foreign influences, from Korea, China, and, recently, the West. After Japan reopened her doors to the outside world in the 1850s, Japanese art entered into an ongoing dialogue with the art and culture of the West. While traditional forms of art are still being produced in Japan, the avant-garde there has made many important contributions to the international art world.

Today, Japan and South Korea are both international centers for the arts, and, as in the past, the differences in those arts reflect their distinct national identities. Korea lived under Japanese rule from 1910 to 1945), the country was divided into South and North Korea in 1945, and both Koreas were physically and spiritual challenged by the Korean War (1950–53). Thereafter, South Korea instituted sweeping reforms and by the end of the twentieth century had become an economic powerhouse and a rising cultural center.

The Gwangju Biennale, begun in 1995, has become a focal point in South Korea for international art and a gathering place for artists from around the world. Contemporary Korean art and culture have spread around the world in a phenomenon known as *Hallyu*, or the Korean Wave. This includes a flourishing film industry and websites that offer Korean-language television shows, and works through social media sites such as Facebook, YouTube, and Twitter. The Korean Wave has also spread to North Korea, albeit underground; the official style of art in the government-supported Mansudae Artist Studio in Pyongyang remains Socialist Realism, generating images of North Korea as a prosperous and happy nation.

GLOSSARY

BYOBU A decorative folding screen.

CELADON A term of disputed origin referring to a glaze developed in China and used elsewhere in Asia, particularly Korea and Japan. The classic celadon glaze colors are pale greens and bluish-greens that resemble those of jades. The term is also used to refer to any vessel with a celadon glaze.

CHANOYU A highly ritualized tea ceremony that combines the philosophies of many Japanese movements in the arts. The ceremony fosters a set of SHINTO-based ethics embodied in the principles of *WABI* (honesty, integrity, reticence, quiet simplicity) and *SABI* (a preference for the old and rustic over the new). It also advocates *SHIBUI*, a taste for that which is bitter but pleasing, a prominent quality of many teas used in the ceremony.

CHUMON The "middle gate" to a Japanese Buddhist temple compound. Often containing *KONGO RIKISHI*, large sculptured images of fierce guardian deities.

DAIMYO "Great names." Powerful feudal lords, commanders of the *SAMURAI*.

EMAKIMONO Literally, "rolled picture." A horizontal scroll associated with a narrative style of painting that emerged in the Heian period. Also called *emaki*.

ESOTERIC BUDDHISM *Mikkyo* in Japanese. A highly intellectual and elitist sect that placed a great value on mandalas to instruct and enlighten the faithful in the complexities of that sect. It includes the Tendai and Shingon sects from northern India, Nepal, and Tibet.

FLUXUS Latin for "flowing." An international group of artists (c. 1960–78) that promoted "living art" in which there was no separation of art and life. A fully universal movement that was not dependent upon the support of the New York City galleries and museums.

FUSUMA Painted paper-covered sliding panels or doors mounted in slotted wooden tracks in temples, castles, and other large Japanese buildings. Generally associated with the Momoyama period to the present.

GASO A ZEN priest-painter.

HABOKU "Broken ink." Also known as *SO*. A style of Japanese painting associated with ZEN BUDDHISM that uses dramatic ink washes. Inspired by Chan Buddhist paintings of the Song period in China.

HAIKU The most characteristic form of poetry in Japan since the fourteenth century, consisting of three lines of five, seven, and five syllables. Previously, the *TANKA* format (consisting of thirty-one syllables) had been the most popular form of poetry in Japan.

HANIWA See under *KOFUN*.

IRIMOYA The traditional Japanese hip-and-gable roof type. It may support *shibi*, crescent-shaped decorations at the ends of the ridge pole.

IWAKURA See under SHINTO.

JAPONISME The vogue for Japanese art and culture in the West beginning in the late nineteenth century.

JODO The Japanese name for Pure Land Buddhism, which came to Japan from China. Focussed on the Amida Buddha, it first gained a widespread following during the Heian period.

KAKEMONO A hanging scroll.

KAMI See under SHINTO.

KANO SCHOOL A distinctively Japanese style of painting developed by members of the Kano family in the sixteenth century and known for its bold, overall decorative patterning, rich colors, and gold-leaf backgrounds. It remained the dominant style of painting in Japan until the Meiji period.

KIMONO A T-shaped, straight-lined robe with a collar, wide sleeves, and sash that ties at the back.

KOFUN From *ko*, "old" or "ancient," and *fun*, "grave mound." These large mound-tombs, erected by the rulers of the Kofun period, were surrounded by rows of *HANIWA* (*hani*, "clay and *wa*, "circle"), terracotta images of shields, singers, armored warriors, ladies, birds, and horses, which marked the boundary between the land of the living and the dead.

KONDO "Golden hall." An area of active worship in a Buddhist temple compound. Also known as a *hondo*.

KONGO RIKISHI See under *CHUMON*.

KOTO The Japanese national musical instrument, similar to a zither. A long wooden instrument with thirteen strings (to be plucked) and thirteen movable bridges set over a wooden soundbox.

NAMBAM BYOBU Japanese, "screen paintings of barbarians." A type of Japanese screen painting made in the sixteenth and seventeeth centuries representing Westerners and their ships. At the time, the Japanese called Westerners the *nambam jin* ("southern barbarians").

NOH Literally, "talent or performance." A form of Japanese drama with restrained actions and prolonged silences patronized by the noble classes.

PAGODA A name derived from a Portuguese word of undetermined origin. A tall, slender tower with accented, upturned eaves that may derive from Han watchtowers known through terracotta models in tombs, or the *yasti* on stupas. An internationally recognized architectural symbol of Asia.

RAIGO Japanese, "welcoming approach." An image or installation that shows the Amida Buddha of *JODO* Buddhism descending to earth to welcome souls into his Western Paradise.

RAKU Literally, "happiness wares." Low-fired ceramic wares whose imperfect shapes, rough incisions, and loosely splashed glazes reflect the ancient folk traditions of Japan and Korea.

RELIQUARIES Elaborate containers designed to hold valued religious relics.

SABI See under *CHANOYU*.

SAMURAI (Or *bushi*) A noble and professional class of feudal warriors. The samurai code included *seppuku*, a ritual of suicide known in the West as *hara-kiri*.

SATORI Japanese, "understanding" or "to see into one's true nature"; commonly translated as "enlightenment." To have a deep spiritual experience of oneness with all nature.

SHIBUI See under CHANOYU.

SHINDEN Heian-period country houses with central sleeping areas and smaller buildings linked by covered walkways around gardens and ponds.

SHINTO From the Chinese words for "Sacred Way" or "Way of the Gods." The pre-Buddhist religion of Japan that venerated the KAMI, nature gods, at sacred places (IWAKURA), where those spirits live in the rocks, trees, water, and other objects. The religion encouraged the development of apparently simple and rustic, but deceptively complex art forms and rituals. Many Japanese worshipers combine elements of Shintoism and Buddhism in their belief systems.

SHOGUN "Military Pacifier of the East." The twelfth-century title for successive dynasties of military rulers Japan (until 1868).

SHOIN Japanese for "drawing room" or "study." An architectural form that emerged in the Momoyama period. The proportional relationships of all the parts are based on the

TATAMI module. Known for its asymmetry and variety of open, flowing spaces, which can be reconfigured though the use of FUSUMA (sliding panels).

SO See HABOKU.

TALE OF GENJI, THE Also known as the *Genji Monogatari*. A novel (c. 1000–15) by Lady Murasaki, often illustrated in the YAMATO-E style of painting by women artists.

TANKA See under HAIKU.

TATAMI Woven reed floor mats about 3 by 6 feet (90 × 180 cm). Proportional relationships in traditional Japanese architectural planning are based on the *tatami* module.

TOKONOMA A shallow alcove or niche in a tea house where a flower arrangement and small painting or hanging scroll might be displayed during a tea ceremony.

TORII A gateway to a SHINTO shrine.

UKIYO-E "Pictures of the floating world." A generic tradition of painting dating from about 1600 representing daily life and the *kabuki* theater. Mass-produced through the inexpensive medium of woodblock printing.

WABI See under CHANOYU.

YAMATO-E Literally, "Japanese style." A native style of painting that emerged in the Heian period. Named for the Yamato Plain where the city of Nara was built.

ZEN BUDDHISM The Japanese equivalent of Chan Buddhism in China. The name is based on the Japanese pronunciation of "Chan." It arrived in Japan in the thirteenth century and has two pillars of wisdom: transcendental naturalism, the idea that we are one with the cosmos; and spontaneous intuition, the idea that we must express this oneness intuitively, with an economy of means. The painting style associated with ZEN is called ZENGA.

ZENGA See under ZEN BUDDHISM.

QUESTIONS

1. The discussions of Shintoism in this chapter stress its devotion to traditional values. What are these values and how are they manifest in the Grand Shrine at Ise (FIG. 5.4), the tea ceremony, the Tai-an tea house (FIG. 5.25), and the tea bowl in FIG. 5.26?

2. The Introduction to this chapter listed four important characteristics of Japanese art and thought that were mentioned later in the discussions of artworks: suggestion, perishability (or impermanence), irregularity, and simplicity. Can you find a work of art in this chapter that illustrates all of these features?

3. How are the questions at the ends of the chapter in this book different from the so-called questions known as *koans* that Zen masters asked their students? What purpose does that difference serve?

4. The art of Chan Buddhism in China, and its offshoot, Zen, in Japan, manifest some ideas that are very hard to express in words. What are the two pillars of Zen wisdom and how can you explain them through FIGS. 4.20, 5.19, and 5.20?

5. Discuss the *ukiyo-e* woodcuts as an early form of Pop Art. What are the basic features of Western Pop, and how are they present (or not) in the *ukiyo-e* prints? How have the ideas of the Gutai group impacted on art in the West?

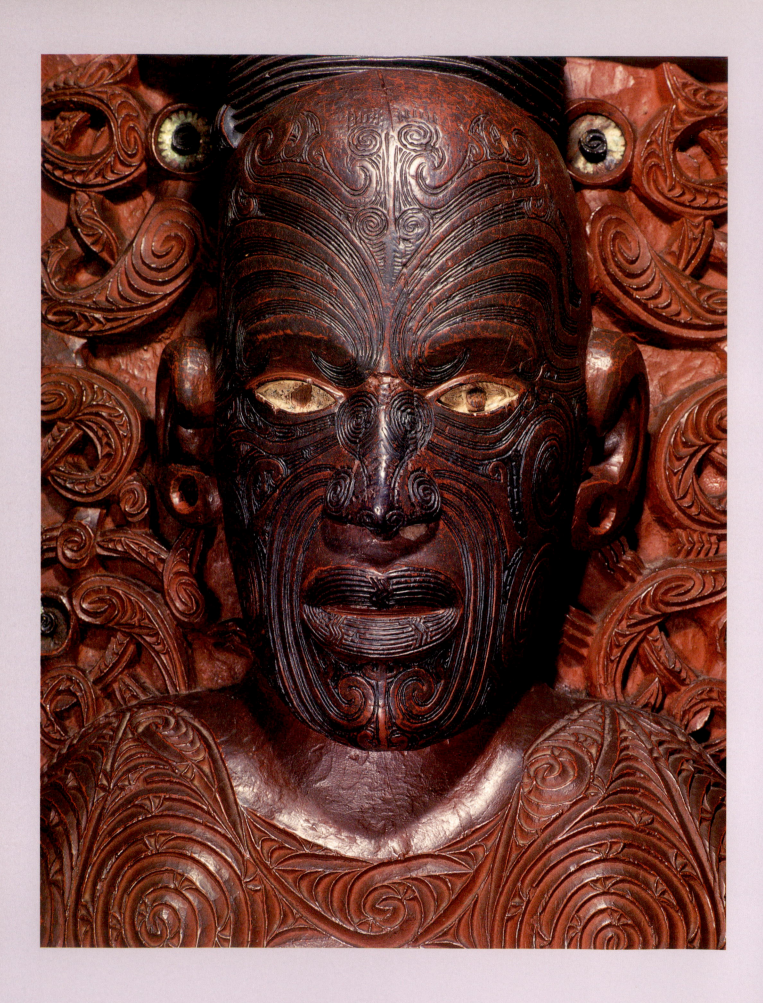

6 | The Pacific

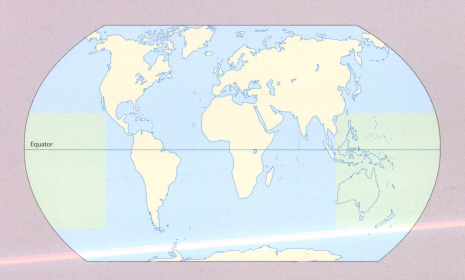

Equator

Introduction **203**

Australia **204**

Melanesia **207**

Micronesia **211**

Polynesia **214**

The Pacific Arts Festival **224**

Summary **225**

The Pacific

This survey of the art of the Pacific includes portions of northern Australia, Melanesia, Micronesia, and Polynesia. Melanesia (meaning "Black Islands") is composed of a long crescent of relatively large, closely spaced islands west of Indonesia and north of Australia. Many of the islands of the region to the immediate north, Micronesia ("Small Islands"), were formed by coral reefs growing over submerged volcanoes. To the east, Polynesia ("Many Islands") is a large triangular area defined by New Zealand, Easter Island, and the Hawaiian archipelago. Melanesia and Micronesia are also known as Near Oceania, while Polynesia is sometimes called Far Oceania.

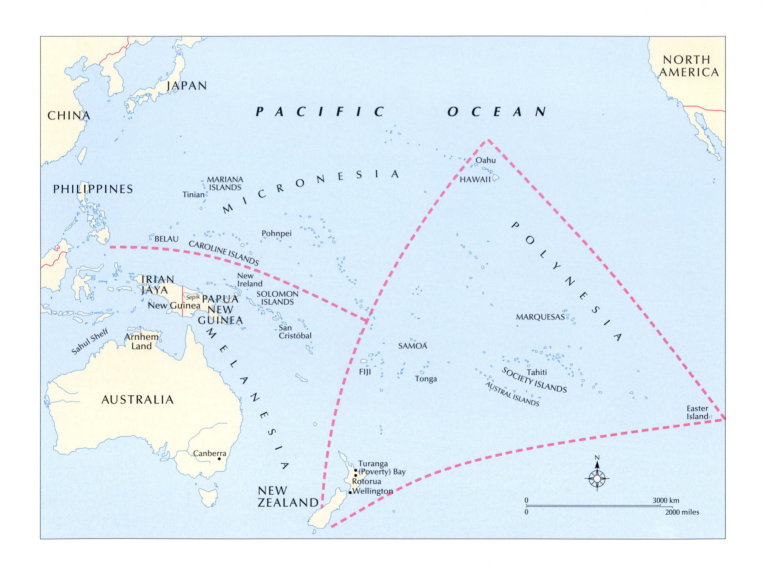

INTRODUCTION

After the West learned about the Pacific world through the expeditions of Captain Cook, Louis-Antoine de Bougainville, and others, writers such as Jean-Jacques Rousseau (1712–78) began creating highly Romantic images of the "noble savages" there enjoying lives of endless bliss in a tropical paradise. They portrayed them as innocents cut off from the harsh realities of existence elsewhere in the world, leading charmed lives like Adam and Eve in their Edenic island gardens. At the end of the nineteenth century, the French painter Paul Gauguin, who had become disillusioned by the "decadence" of European society, went to Polynesia in search of inspiration among these "unspoiled primitives." (See *Cross-Cultural Contacts: Paul Gauguin and Polynesia*, page 214). What Gauguin found was hardly such an Eden, but to this day images of the Pacific Islands designed for the tourist trade continue to feed on the old myths about the idyllic world of the "South Seas." To see beyond these myths, we must make a concerted effort to look at the art of the Pacific with fresh eyes and try to understand it in terms of the realities in and for which it was created.

Around 1900, a small group of avant-garde European artists and dealers began collecting art from the Pacific Islands. Some of them were moved by an unusual sense of power they found in it. That conception of power was equally important to many of the Pacific Islanders who made and used the art. It was part of a complex cultural ideal that is called in many locations **mana** (sacred power). Individuals, works of art, and a wide variety of other objects can all have certain quantities and types of *mana*. In some areas of the Pacific, *mana* is envisioned as an invisible but forceful spiritual substance, a manifestation of the gods on earth that can link people with their ancestors and the gods. By extension, it is a power that enables artists to be creative and imbue works of art with that power.

People may acquire *mana* in several ways. Since a chief may descend from the gods, he and his immediate family are said to be born with sizable quantities of *mana*. The amount of *mana* other nobles receive depends upon how closely related they are to the chief's family. A noble might increase his or her *mana* through skillful and courageous deeds, or decrease it by cowardice or enslavement. The *mana* residing in a person or object is protected by **tapu**. This is not a law as such, but indicates a state of restriction, that an object or person cannot be touched or a space entered. Violating a *tapu* (the root of the English word "taboo") can seriously reduce the *mana* of a work of art or an individual.

The *mana* in works of art made in the service of the gods comes from the *mana* in the materials from which they are made, the *mana* of the artist, the care and correctness with which the rituals attending the production of that art are performed, and the quality of the workmanship. Later, the *mana* in a work of art can be increased by the status or *mana* of its successive owners and the importance of the rituals honoring the gods and ancestors in which it is used. Valued heirlooms passed down from one generation to the next in royal families can accumulate tremendous quantities of *mana*.

Many Pacific Islanders believe the human body is the meeting place of this world of everyday existence and the divine world of the ancestors and gods. Therefore, the body occupies a central position in this concept of *mana*. Individuals of high rank can increase the *mana* they have inherited

TIME CHART

Aboriginals arrive in Australia (c. 40,000 BCE)

Earliest Aboriginal art (c. 30,000 BCE)

Emergence of the Lapita culture in New Guinea (c. 4000 BCE)

Emergence of Aboriginal "X-ray" or "In-fill" Style (c. 2000–1000 BCE)

Fiji, Tonga, and Samoa occupied (1150 BCE)

Marquesas Islands occupied (c. 200 BCE)

Hawaii occupied (c. 300–400 CE)

Easter Island occupied (c. 400–500 CE)

New Zealand occupied (c. 900 CE)
Nga Kakano—The Seeds (900–1200)
Te Tipunga—The Growth (1200–1500)
Te Puawaitanga—The Flowering (1500–1800)
Te Huringa—The Turning (1800–present)

Easter Island, Ahu/Moai phase (1000–1500)

Easter Island, Decadent phase (1500–1722)

Height of New Zealand Poverty Bay School (1840–75)

and gained through deeds by wearing certain items of noble dress such as cloaks, belts, and headdresses, and through body art—scarifications and tattoos.

Certain locations were believed to have unusually large quantities of *mana*. On many Polynesian islands, sacred places known as **marae** were focal points for rituals dedicated to the gods and ancestors. *Marae* might be walled precincts with platforms or ledges to display works of art, altars for sacrifices, and storage buildings for precious objects. In the nineteenth century, as New Zealand was becoming increasingly Westernized, the Maori there began building meeting-houses at their *marae* with structural parts that symbolized areas of the cosmos where they venerated the gods and their royal ancestors. This symbolism, along with the houses' many ritual functions, made them magnificent constructs of power, great seats of *mana* in a society struggling to maintain itself in the face of European colonial control.

When *mana* is manifest in objects of great beauty—works that Westerners call "art"—the Pacific concept of spiritual power seems to be linked to Western ideals of beauty. At such times, Pacific and Western concepts may coincide, but the pervasive quality of *mana* cannot be entirely explained and understood by this analogy with Western art. Only as one examines where, when, and how *mana* is manifest in Pacific art does the full, rich complexity of this magnificent cultural ideal of otherworldly power really begin to unfold. It marks the most important rites of passage, explains an individual's accomplishments and status in life, and enables the living to contact their ancestors and gods. It can lift the individual from one station in life to another and from this world to the otherworld of the spirits. Like the artists and collectors a century ago who sensed and appreciated this special and pervasive power in the art of the Pacific, we will focus upon this idea of *mana* as we study the art in terms of the ideals through which it was created. (See *In Context: The Spread of Art and Culture in the Pacific*, below.)

AUSTRALIA

In the past decades, the Aboriginals of Australia, who currently account for less than 2 percent of the overall population, have produced many of the country's most respected and internationally famous artists. Their art today reflects

THE SPREAD OF ART AND CULTURE IN THE PACIFIC

Around 50,000 BCE, during the last Ice Age, which began about 2.5 million years ago, the oceans were about 330 feet (100 m) below their present level. Large portions of Melanesia—including New Guinea, New Britain, New Ireland, and Australia—were a single landmass or continental shelf, which scholars call Sahul. This was separated by a narrow passage of water from Sunda, another continental shelf linking Indonesia and the Philippines. Successive waves of people from Southeast Asia reached portions of Sunda and Sahul by 40,000 BCE. After a long hiatus, the appearance of the seafaring Lapita culture around 4000 BCE enabled ancient voyagers to use the islands as stepping-stones to populate the Pacific. Through a combination of deliberate journeys, exile voyages, and accidental drifts, they crossed broad expanses of uncharted waters to reach Fiji, Tonga, and Samoa by 1150 BCE. There they developed the basic forms of the Polynesian language and culture that exist today. By around 200 BCE, the voyagers discovered the Marquesas Islands, from which they sailed to the more remote Polynesian outposts of Hawaii (c. 300–400 CE), Easter Island (c. 400–500 CE), and New Zealand (occupied c. 900 CE).

In some areas, neighboring Indonesian islands influenced the art of Melanesia. Some scholars look for influences from the other direction as well and believe that the Polynesians made contact with the Americas. At present, however, there is no concrete evidence to prove this theory. For the most part, the styles of art in Oceania developed regionally, on islands or island groups, in step with religious beliefs and associated rituals which included forms of oratory, poetry, dance, and music. Together, these systems of communication enabled the Pacific Islanders to interact with the supernatural forces and operate their societies. Given the vast distances separating archipelagos and individual islands, it is not surprising to find many distinct regional cultures there, with distinguishable belief systems, rituals, and art styles, many of which remain vital parts of everyday life.

some very ancient traditions, which have survived to the present day in all their amazing complexity. The Aboriginals may have arrived in Australia as early as 40,000 BCE, when the sea level was lower and Australia was part of a landmass easily accessible from Southeast Asia. As they spread across much of Australia, they developed a variety of regional cultural patterns based on a hunting-and-gathering economy. They left a permanent record of their existence in rock art, the earliest examples of which in central Australia are more than thirty thousand years old. These belong to the Upper Paleolithic period (c. 40,000–9000/8000 BCE). (*Paleo* and *lithic* come from Greek words for "old" and "stone"; in common usage, the Paleolithic is called the "Old Stone Age.") The Australian works have special importance because they may predate most of the oldest known Paleolithic cave art in Europe. They are also plentiful: The World Heritage Kakadu National Park in the Arnhem Land Plateau in northern Australia includes more than five thousand rock art sites.

The vast Australian Outback where most of the Aboriginals have lived has long been regarded by the rest of the world as an inhospitable and uninhabitable wasteland. The Aboriginals have never seen it this way. They not only inhabit the land; in spirit they are part of it. To them, there is no difference between nature, humankind, and culture—they, as a people, do not exist apart from the land. This belief, very much alive today, continues to inspire many of the most important Aboriginal works of art.

THE DREAMING: THE SPIRITUAL WORLD

Traditionally, the Aboriginals had no permanent architecture, but many groups had natural sites that were sacred to them and where they held their seasonal rituals. During these communal gatherings, they made feather and fiber objects, rock engravings and paintings, portable sculptures, and ground markings, did body painting, and painted on the bark from the stringbark tree (*Eucalyptus tetradonta*).

To understand how these art forms reflect the Aboriginal worldview, it is important to examine their myths about creation and the land around them. In ancient times, as the immortal, mythic Aboriginal Ancestor Spirits traveled, they created the land, became part of it, and remain within the rocks, flora, and fauna to this day. Dwelling there, the Ancestors continue to create, causing the changes the Aboriginals see around them every day.

Some Aboriginals call this all-encompassing immaterial or spiritual world *Jukurrpa*, which translates as "the **Dreaming**" or "Dream Time," which to the Aboriginals signifies the otherworld created by supernatural beings and their Ancestors, along with its associated religious ceremonies, laws, and art forms. It is a kind of landscaped-based mythology that ties the individual to a place and its spiritual powers, which come to life in myths, rituals, and arts.

To live among the physical manifestations of these spirits, and to survive, the Aboriginals must communicate through dance, song, and art with the Dream Time spirits. Art and ritual are the conduits through which the Aboriginals link or bond with the spirits of their Ancestors and the land. "Creativity" in the Western sense—which is usually tied to the discovery of new forms of expression—is not part of the process. The Aboriginals believe that the spirits are attracted to traditional and recognizable forms of art from the past. In the course of this bonding (*balga*), the Aboriginals also believe they are moving to a higher spiritual level and becoming more genuinely who they are than they could ever be in everyday life. They refer to this as *jimeran*, "making oneself." Works of art take on their full power in rituals, but afterwards, when their work is done, the owners might destroy the art or allow it to decay. Traditionally, only those items known as *tjurungas*—receptacles for the Dream Time spirits—would be preserved.

In traditional Aboriginal thought, the spirits of the Ancestors, the manifestations of the Ancestors' power in this world, from Creation to the present, and Aboriginal society are all parts of a seamless fabric. Each Aboriginal is linked to a particular episode or part of the Dreaming and has certain rights and obligations to that segment of the Dreaming's lands, myths, rituals, and arts. A work of art can be made by an individual artist or group of artists who share in the rights to that portion of the Dreaming.

In Aboriginal thought, the artist does not invent or create art—the original designs created by the Ancestral beings are given to artists who transmit or copy them for others to see. In this sense, the Aboriginal artist represents (literally "re-presents") the power of the spirits and the Dreaming in the form of earthly images. In this system of belief, which denies humankind the creative powers of the supernatural beings, the challenge for the artist is to find ways to rediscover, copy, and reactivate the images of the Dreaming. In so doing, the artist performs a very important function for his or her community, giving form and presence to that which was formless and timeless in the Dreaming.

MIMI AND THE "X-RAY" STYLE

According to Arnhem legends that have survived to modern times and been collected by ethnologists and other field workers, spirits called the **mimi** made the earliest rock paintings and taught the art of painting to the Aboriginals. In FIG. 6.1, a *mimi* figure spears a kangaroo whose backbone and organs are visible, as if its hide were transparent. This

technique of making conceptualized see-through images, known as the In-fill or **X-ray Style**, may date back to about 2000–1000 BCE. The technique was still being practiced when European settlers arrived in the nineteenth century. The powers of the *mimi* and the Ancestors are released through such works of art and their associated rituals, songs, oral literature, and dances, which establish contact between the present and the past. Although more than two centuries of European contact have changed many aspects of Aboriginal society, this traditional philosophy survives and continues to inspire contemporary works of art and ceremonials.

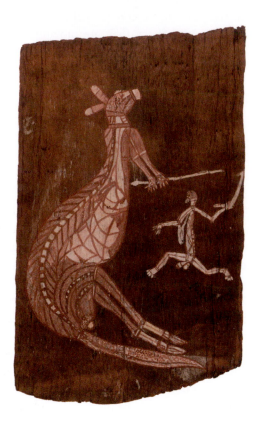

6.1 *Hunter and Kangaroo.* Oenpelli, Arnhem Land, Australia. c. 1912. Paint on bark, 51 × 32″ (129 × 81 cm). Museum Victoria, Melbourne, Australia
Problems surrounding the production and sale of Aboriginal Australian art have been mounting for decades. One authority on the matter recently said: "The material they call Aboriginal art is almost exclusively the work of fakers, forgers, and fraudsters." To curb this growing problem, in 2009, the Australian Indigenous Art Trade Association drafted a document called "The Indigenous Australian Art Commerce Code of Conduct." It deals with issues common to most art markets, many of which are particularly pronounced in Australia because business transactions often take place in remote areas and involve artists who are not familiar with metropolitan business practices. As a result of all this, many studies of Aboriginal Australian art use images of the kind shown here which are older and, arguably, more authentic than the work being produced today.

RECENT ABORIGINAL PAINTING

In the 1920s, Western anthropologists began giving crayons and paper to the Aboriginals and encouraging them to transcribe images from the Dreaming. It was not until 1971, however, when artists of the Western Desert began working with acrylic paints on canvas and bark, that the true scope and magnificence of their Dreaming imagery were revealed. Soon, Aboriginal artists working with outside advisors began exhibiting their large and colorful acrylic paintings around the world, often touring with them and publicizing the Aboriginal philosophy of art and culture.

The art of the present-day Aboriginals, like that of their predecessors in ancient times, stems from the Dreaming, and artists working with their part of the Dreaming attempt to rediscover and recreate the images created by the Ancestors. The complex symbolism of one such modern Aboriginal painting, *Sacred Places at Milmindjarr*, by David Malangi from Central Arnhem Land, represents the mythic

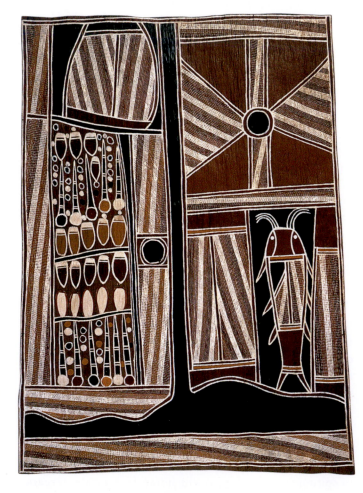

6.2 David Malangi, *Sacred Places at Milmindjarr.* Central Arnhem Land. 1982. Ocher on bark. 41 × 31″ (104 × 79 cm). South Australian Museum, Adelaide

geography of his clan's homeland (FIG. 6.2) and relates to the Djan'kawu sisters, who traveled by canoe and walked over the land, creating the people, their languages, water holes, the landscape, and the ocean. Malangi's networks of dots and repeating patterns of abstract lines may resemble the formal features of some twentieth-century Western styles of abstract and nonobjective painting, but here these elements are not "empty," decorative motifs; they have complex cultural meanings in Aboriginal thought. The brightness of the cross-hatching patterns, for example, reflects the spiritual powers of the Ancestors who are manifest in the paintings. Also, the artist's method of telling the story is conceptual as opposed to purely perceptual; the geometric forms in the work follow complex rules that are not understood outside Aboriginal society. The main features of the myth, therefore, are not immediately apparent to all viewers.

Paintings such as Malangi's are exciting to international audiences. Not only are they authentic expressions of a very ancient culture, but they also appeal to the tastes or aesthetics of Western viewers. They explain a traditional worldview, untainted by Western thinking, in abstract or nonobjective forms similar to those used in some modernist movements—forms that seem to have a universal appeal.

MELANESIA

As early as 25,000 BCE, portions of Melanesia as far east as San Cristóbal were occupied by speakers of a Papuan language. At that time, most of Melanesia was part of Sahul, a large continental shelf within easy reach of the Asian mainland. (See *In Context: The Spread of Art and Culture in the Pacific*, page 204.) A new culture of seafaring Austronesian language speakers appeared in Melanesia around 4000 BCE. The culture, which scholars have named Lapita, may have come from Indonesia or the Philippines, or developed locally in Melanesia. It is known for its distinctive style of ceramic decoration. Lapita artists use a wide variety of concentric circles, spirals, and parallel lines, some of which are made with toothed stamps. These decorations may have also been used by Lapita textile and tattoo artists whose works have not survived. In FIG. 6.3, an oval set within a symmetrical composition of triangles and bands of stamped circles may represent a human head with a stylized body. The Lapita culture spread through much of the western Pacific, and elements of this design can be found in many later examples of Melanesian and Polynesian art.

Many of the most significant surviving works were originally displayed in or near large communal men's houses,

6.3 Detail of a design from a Lapita pottery vessel. Gawa Reef Islands, Solomon Islands. c. 1000–900 BCE

where the most important village rituals took place. Often, these centers have tall, peaked roofs that tower over the other storage, cooking, and sleeping structures in the village; on account of their size alone, they suggest their central position in the community. The use to which such houses are put varies within New Guinea and across Melanesia. Often, during rituals, men within the house are seated according to clan, moiety (a group of clans), and social rank. The rituals performed within the house include rites of passage in which youths are taught the skills and ritual knowledge they need for manhood, fertility ceremonies, and funerals. During these important ceremonies, elaborate installations inside or near the houses, including statuary and other sacred objects, are created to commemorate the rituals and gods attending them.

NEW GUINEA

New Guinea, the second largest island in the world, has an extremely wide range of climates, cultures, languages, and regional art styles. At present, it is divided into Irian Jaya, a province of Indonesia, in the west and Papua New Guinea in the east. Many of the earliest coastal settlements were submerged as the ocean rose, and some of the oldest known works of art on the island come from the highland regions. Road builders and farmers in Papua New Guinea have unearthed many small stone figures that may date from around 8000 BCE. One of the best-preserved examples, known as the Ambum Stone, represents a creature (possibly

an anteater?) with an elongated snout and humanoid body (FIG. 6.4). All the volumes are stylized in matched sets of simplified curves suggesting the original shape of the unworked stone, giving the image a sense of grace and power that may reflect the spiritual power of this other-worldly, hybrid being.

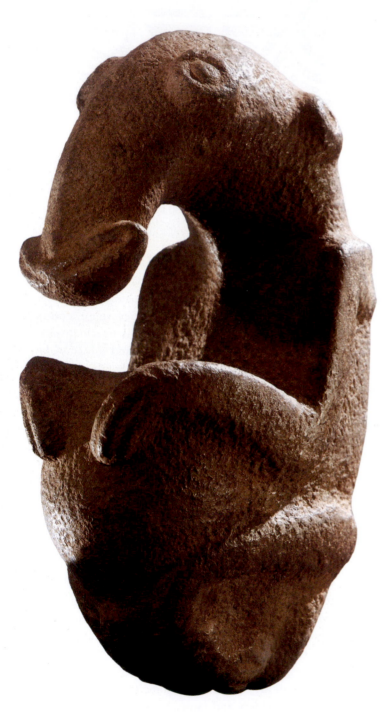

6.4 The Ambum Stone. Ambum Valley, Western Highlands Province, Papua New Guinea. c. 8000 BCE. Igneous rock, height 7⅝" (18.4 cm). National Gallery of Australia, Canberra

PAPUA: THE SEPIK RIVER AREA

The Abelam people in the East Sepik province of Papua New Guinea are known for the elaborate displays of art and ritual objects that they install in ceremonial houses to initiate young farmers into their agricultural cults. To have the power and magic needed to grow full-size yams, which may be up to 7 feet (2.1 m) long, an Abelam farmer must pass through a series of instructive ceremonies. Initiates and their instructors enter the ceremonial house through a small entryway behind the tall triangular façade, which leads to several small rooms housing images of clan ancestors and a large main room with an elaborate installation. The centerpiece of the house in FIG. 6.5 is a larger-than-life manikin of a dressed and masked ancestor made of wood and reeds seated before a large feathered crest bearing a stylized image, possibly a mythical being. The Abelam believe that if these works of art are properly consecrated, spirits from the otherworld will take up residence in them and communicate with those taking part in the rituals. This power of art to unite the terrestrial and celestial worlds gives these spectacular installations great importance in Abelam society.

Elders explain the ritual significance of all these objects, including the paintings on the walls and the sacred leaves, stones, shells, and fruits on the earthen floor behind the low, curved wooden fence, to the initiates. Instructing them in the presence of these images with their dramatic appearance gives the youths a sense of reverence for the ancestors and Abelam traditions.

While the size and decoration of ceremonial houses declined during the colonial period, recently, in many communities, the houses, their rituals, and their arts have enjoyed a revival. However, as elaborate, time-consuming, and expensive as the installations in the houses may be, they are not permanent. After the objects assembled in an Abelam house such as this have fulfilled their purpose, their ritual value is spent. It is not regarded as a sacrilege among the Abelam for members of a community to destroy or sell them to collectors, who may then reinstall them elsewhere.

IRIAN JAYA: THE ASMAT

The rituals surrounding the aggressive act of headhunting once inspired many groups in Irian Jaya, such as the Asmat, to create works of art. According to Asmat legend, a cultural hero named Fumeripits carved their earliest images of ancestors from sago palms. The identification of humans with trees and the importance of the sago palms, the main Asmat source of food, are illustrated in the linked practices of headhunting and cannibalism.

The Asmat believed that by capturing and displaying the head of an enemy, the seat of his power, and eating his or

Each stage of the pole's preparation symbolized an act in the process of headhunting. The tree was cut (decapitation of the enemy), bark removed (skinning the enemy), and the sap (blood) was allowed to run before the pole was taken to the village (returning home with the corpse). The tree was then carved with images of superimposed figures at or near the *jeu* (men's house) in preparation for the *bisj mbu* ceremony. The *bisj* poles represent deceased ancestors, contain other head-hunting symbols, and emphasize the Asmat identification of humans with trees. Birds carved on the poles eating fruit from the trees symbolize the headhunter who eats the brains of his captive. Cavities at the bottoms of the poles were designed to hold the heads of enemies. The tribal ancestors above, with bent knees like the praying mantis (a symbol of

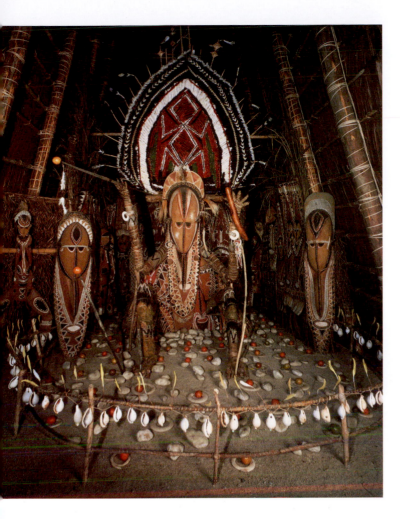

6.5 Interior of a ceremonial house of the Abelam people. Bongiora, East Sepik Province, Papua New Guinea. Collected by G.F.N. Gerrits in 1972–73. Museum der Kulturen, Basel, Switzerland

her body, they could possess the strength of that vanquished foe. Traditionally, an Asmat boy could not be initiated and become a man until he had participated in a raid or taken a head. Headhunting also helped ensure the fertility of the crops, especially the sago palms. To lose a family or community member to headhunters was to lose power that might then be regained by conducting a successful headhunting expedition against the guilty parties. Meanwhile, since the deceased had not had a proper burial so that its spirit could be sent to Safan, the realm of the dead in the west, the spirit might linger about the community and upset the clan's rapport with the ancestral spirits. The wandering spirit could be appeased and harmony between life and death reestablished through the **bisj mbu** ceremony, which involved the erection of a tall sculptured *bisj* pole and the organization of a punitive expedition to avenge the death (FIG. 6.6).

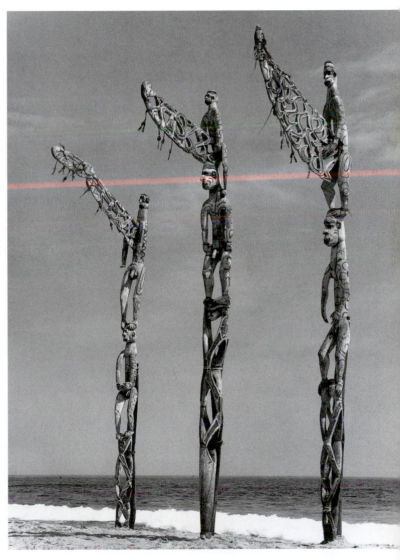

6.6 Ancestral poles. Asmat, New Guinea. 1960. Wood, paint, and sago palm leaves, heights c. 17′3″, 17′11″, 17′9¾″ (5.25, 5.46, 5.43 m). The Metropolitan Museum of Art, New York

headhunting), have long, crescent projections from their groins that look like ship prows. They are called *tsjemen* (literally, "enlarged penises") and symbolize the virility of the group's male ancestors, the strength of the avenging warriors, and the power they will regain for the community when they return with the head of an enemy.

The *bisj* are first erected on mounds near the men's houses, where dances and rituals to appease the spirits take place so the figures on the pole can observe them. During the ceremonials they reset the poles to face the nearby river, the "road" to the sea and the ancestors. In this way, the *bisj* act as ritual canoes to take the deceased to Safan. Later, they move the *bisj* to a grove of sago palms, where they will decay and nourish the palms.

NEW IRELAND: THE *MALANGGAN*

Northeast of New Guinea, the artists of New Ireland carve highly ornate poles, figures, and boats for mortuary rituals to honor the recent dead and send their spirits to their final resting place with the ancestors. The sculptures and the complex communal memorial rites performed in special houses or enclosures in which the art is used are called **malanggan** or *malangan*. *Malanggan* may also refer to works made for the initiation ceremonies of boys entering adolescence (replacing dead ancestors). Works of art created specifically for that occasion are displayed on the façade of a ceremonial house along with bundles on the ground containing the bones of the deceased. Preparations for *malanggan* ceremonies and the production of *malanggan* art forms may be very expensive and time-consuming, so they may use a single ceremony to celebrate the deaths of many persons over a period of several years.

In a modern museum recreation of one such *malanggan* installation, twelve works and a drum are presented on a facsimile of a porch from a house that was open to the public in New Ireland (FIG. 6.7). As in the case of most *malanggan* sculptures, each of the tall and elaborately decorated figures is carved from a single piece of wood. The sculptors have cut deeply into the core of the wooden blocks used for the bodies, fragmenting the wood into light, thin slivers of projecting forms which represent stylized palm fronds, feathers, birds, snakes, and fish. The complex openwork carved designs are painted with an equally complex pattern of contrasting colors, which gives the works a sense of brilliance and richness that reflects the symbolism of the stories associated with them and the many levels of meaning woven into the ceremonials. The New Ireland artists often mix various species of animals, such as birds and fish, with decorative motifs to create ornate, hybrid creatures. These animals may have special meaning for the clans who organize the *malanggan* festivals. By painting the multilayered

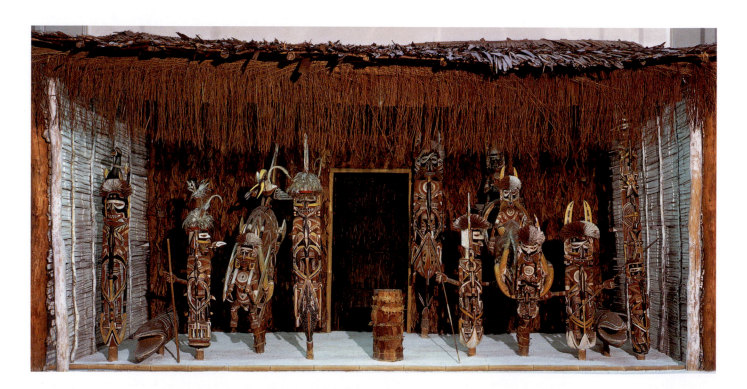

6.7 *Malanggan* tableau. New Ireland, Melanesia. Early 20th century. Bamboo, palm and croton leaves, painted wood, approx. 8'6" × 16'6" × 10' (2.44 × 5 × 3 m). Museum der Kulturen, Basel

and interlocking sculptured forms with superimposed geometric patterns in reds, yellows, blues, and whites, the artists further enhance the already lively surface patterns to make the figures bristle with life.

The artists and their community believed that the spirits of the figures came to inhabit their images as they performed the *malanggan* ceremonies to send their spirits to the ancestors. Traditional forms of woodcarving and the associated ceremonials survive in parts of New Ireland. At times, when a carver is available, a *malanggan* image will be installed on a grave alongside a Christian marker. By custom, many *malanggan* sculptures were deliberately destroyed, recycled, or set up in open areas to decay after the ceremonies were completed.

MICRONESIA

Micronesia, a long crescent of small and widely spaced islands north and east of Melanesia, was first occupied around 1500 BCE. Micronesian societies tend to be very complex and hieratic and use the arts to explain or maintain the social status of individuals or groups. Architecture may be designed to show the wealth and power of a community or group of rulers. The portable arts—textiles, body ornamentation, beads, pottery, basketry, and inlaid shellwork—along with other goods, chants, and dances are widely traded or given as gifts to substantiate family ties and diplomatic bonds.

POHNPEI: THE CEREMONIAL COMPLEX OF NAN MADOL

The ceremonial complex of Nan Madol on Pohnpei ("Stone upon an Altar") is a colossal administrative and ceremonial center that was built by the Saudeleur (Lords of Deleur), who ruled there from about 1200 to about 1700 CE. The complex of ninety-two artificially walled and terraced islets in a shallow lagoon offshore from the island, covering about 170 acres (69 hectares), may be the most picturesque archeological site in the Pacific (FIG. 6.8). The complex was protected from the sea by thick walls up to 15 feet (4.5 m) high and 30 feet (9 m) thick, with openings for canoe traffic and tidewater. A central canal divides the administrative side of the complex, with palaces and tombs, from the ritual side, with priests' quarters and tombs. Some of the islets are more than 100 yards (92 m) long and have massive stone walls made of prism-shaped basalts and boulders. At present, the site cannot be adequately photographed because it is choked by a thick mangrove swamp.

Perhaps the most impressive site along the canal is the landing and entryway to the islet of Nandauwas, a large

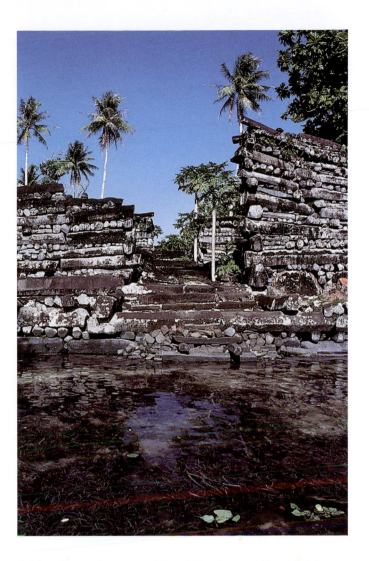

6.8 Landing and entryway, islet of Nandauwas, Nan Madol, Pohnpei, Micronesia. c. 1200–1700

funerary district with two sets of concentric walls, up to 25 feet (7.5 m) high, courtyards, and an outer walkway. These areas are connected by an avenue above the boat landing, which leads to a crypt roofed with basalt stones in the heart of the complex. These basalts, also used in stacks for the walls, were shaped by natural forces. One basalt cornerstone is estimated to weigh about 50 tons (50,000 kg). The outer walls of the islet flare upward near the corners, which helps integrate the strong horizontal accents of the precinct with the choppy, scalloped lines of the sea.

In essence, the magnificence of the complex celebrates the wealth and power of its builders and their favor in the eyes of their gods. It is possible that the complex had very intricate and subtle forms of cosmic symbolism, but the oral traditions of the rulers at Nan Madol have not been preserved. Similar complexes with flared walls appear elsewhere in Micronesia and await further exploration.

ARCHITECTURE IN THE MARIANA AND CAROLINE ISLANDS

When Ferdinand Magellan arrived in the Mariana Islands in 1521, the builders there were elevating their houses with matching sets of tall, well-carved stone supports. These groups of tapered, square or trapezoidal limestone posts with hemispherical capitals are known as **latte** sets (FIG. 6.9). The largest known collection of *latte*—forty-seven sets arranged in groups end-to-end at Mochong—follows the curve of the coastline. The builders of the house of Taga on the island of Tinian carved a set of *latte* 16 feet (4.9 m) tall (c. 1600), and an even taller set of unfinished *latte* still lies in a quarry on the island of Rotan, near Mochong.

On the evidence provided by the nineteenth- and twentieth-century houses in this area, the superstructures of these Mariana Island houses were probably made of lashed poles and had tall peaked, thatched roofs. This large house type, which may derive from the men's meeting-houses in Indonesia, can be seen in a contemporary **bai** (community house) on Belau, a volcanic island in the Caroline Islands, near the western edge of Micronesia. The house, called the Bai-ra-Irrai (*bai* at Irrai), is one of two such large and important meeting-houses remaining on Belau (FIG. 6.10). It has been continually repaired and refurbished since it was built around 1700, so it remains a lasting status symbol of its owners and their ancestors.

The Bai-ra-Irrai is used for dances, feasts, and council meetings, and to lodge visitors. At certain times, it is now used by groups of women who had their own *bai* in the past when such structures were more plentiful. Such large, nondwelling structures are common throughout much of the Pacific, but those of Micronesia such as the Bai-ra-Irrai are distinguished by the solidity of their construction and the richness of their painted bas-reliefs. The *bai* are also famous for their cosmic symbolism. During ceremonies, clan leaders, the "pillars" of the community, are seated at the corner posts or pillars of the *bai*. The women elect the men to these positions, so they share in that power and symbolism. These ideas are explained in painted storyboard images placed on the tall pointed façades of the *bai* for all to see.

A group within a community wanting a new *bai* will contract a *dach el bai* (master builder) to supervise its construction. The hardwood poles, planks, and beams are shaped and joined with removable pegs at a preliminary construction site near the builder's home. Later, the *bai* will be dismantled, moved to its permanent home, and reassembled there. At this time, the *dach el bai* will subcontract the carving of

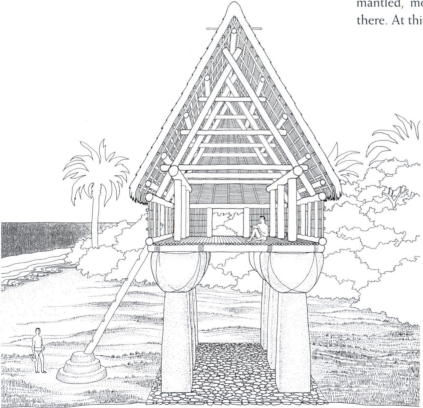

6.9 Reconstruction drawing of the House of Taga resting on *latte*, Tinian, Mariana Islands, Micronesia. c. 1600

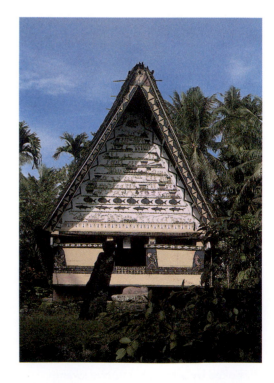

6.10 The Bai-ra-Irrai. Belau, Caroline Islands. First built c. 1700

the bas-reliefs to a *rubak* (village storyteller), who will supervise the work of several carvers. They will illustrate the *rubak's* stories taken from myths, legends, and important historical events. Most carvings include symbols known to the community and a rich variety of decorative forms, all of which may be brightly painted in a variety of earthen colors, black, and white.

A Belau carver literally owns his own style: Another artist who uses that style without paying for the right to do so may be sued in a village court. The current storyboards on the Bai-ra-Irrai illustrate the legendary history of the community and underline the importance of clan history. A *dach el bai* whose *rubak* and carvers fail to work together to decorate his *bai* with painted reliefs that are well textured, elaborate, and easily visible to all will be subject to communal criticism. Traditionally, an unsuccessful *dach el bai* will not be asked to supervise the construction of another *bai*.

The Bai-ra-Irrai is an essential part of the social hierarchy and conception of the Belau cosmos. Men are seated within the house according to rank, with the four most important men at the loadbearing corner-posts, symbolizing their supportive role in the community. The *bai* themselves are also seen as the "corner-posts" of the community, and the four most important communities on Belau symbolize the corner-posts of the island. Thus, certain ranking individuals, the *bai*, and the most important communities are interlocking parts of the grand scheme that defines the Caroline Islands cosmos. It is said that the first *bai* was installed as part of this grand cosmic structure during Creation, when the sun was first placed in the sky.

TEXTILES

The men in Micronesia and most of the Pacific are in charge of the art and architecture used in the most important public and communal rituals. However, the arts of women, particularly the felted cloth they make from tree bark and plant fibers, are essential to the operation of the island societies. In some areas, the preparation of cloth is sacred, and each step of its production is supervised by high-ranking women. Attractively decorated cloths made from fine materials worn by men and women in communal rituals are important indicators of rank and wealth. Highly valued cloths used as trade goods and gifts play a significant role in the maintenance of good social and political relationships. The act of wrapping oneself in a textile, removing it, and wrapping it around another person provides a direct means of reinforcing friendships and alliances.

The women of the Carolines have the most highly developed traditions of loom weaving in the Pacific, a tradition that they probably inherited from the Indonesians but that

they say was a gift from the gods. Traditionally, they have used mineral and plant dyes to color fibers from the banana palm and bark of the hibiscus. Their favorite motifs are patterns of symmetrically arranged, repeating straight-edged geometric forms that may be highly stylized images of natural objects. In some parts of Micronesia, women own certain decorative patterns that function like family crests to indicate their status in these highly stratified societies.

The association of the **machiy** (sacred burial shrouds) with chiefs, ancestors, and guardian spirits makes such fabrics sacred (FIG. 6.11). Numerous taboos surround their production and use. By the early twentieth century, the new fashions in dress introduced by Western missionaries caused many traditional techniques of weaving to decline.

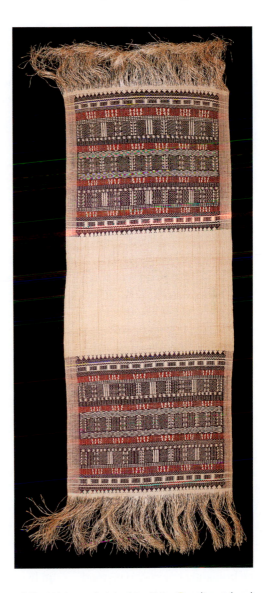

6.11 Josephine Waisemal, *Machiy*. Fais, Caroline Islands. 1976–77. Banana and hibiscus fiber, 2'2¾" × 6'10⅝" (68 × 210 cm). On loan from Donald Rubinstein to the Peabody Essex Museum, Salem

POLYNESIA

The voyagers from the Tonga and Samoa archipelagos who began to populate eastern Polynesia around 200 CE carried with them the cultural rootstock of the Polynesian culture that eventually developed into the regional art styles in this vast expanse of the Pacific. The Polynesians generally have highly stratified societies and very complex, multilayered pantheons of gods. These usually include the primary figures of the earth (female) and sky (male), secondary gods, legendary heroes, deified ancestors, and spirits. The noble relatives of the chiefs serve as priests, artists, and warriors, and rule the commoners. Most of these noble titles and stations were hereditary and, on ceremonial occasions, a noble using knotted cords and other mnemonic devices might justify his rank by tracing his genealogy back through thirty generations to his deified ancestors, the gods, and Creation. Works of art in noble families, passed on through the years, helped facilitate the transfer of *mana* to each successive generation. As these works of art grew older and more venerated, they gained more and more *mana*. Sanctified places of worship where works of art were displayed for all to see enabled the rulers to demonstrate their *mana* in elaborate public rituals. Many of these sacred open-air ceremonial centers known as *marae* were walled and paved with platforms and had pits for sacred refuse, dancing areas, storage buildings to protect rituals objects and works of art, and altars where these images were displayed.

FRENCH POLYNESIA: TAHITI AND THE MARQUESAS

To commemorate the glory of her son, an aristocratic woman, Purea of Tahiti in the Society Islands, built a sacred religious center or *marae* called the Mahaiatea (FIG. 6.12). This structure of eleven superimposed platforms measuring 68 by 252 feet (20.7 × 76.8 m) at the base and 40 feet (12.2 m) in height was dedicated to the worship of her ancestors and the god Oro. The altars were used for rituals

CROSS-CULTURAL CONTACTS

PAUL GAUGUIN AND POLYNESIA

In the 1880s, Paul Gauguin (1848–1903), who had spent part of his childhood in Peru, resigned from his job and left his wife and five children to become a full-time painter. Gauguin believed he could find inspiration for his art outside Europe in the unspoiled, pre-industrial societies that still lived in harmony with nature. In 1891, he sailed to the Pacific and settled in the French colony of Tahiti. After returning to France for two years (1893–95), Gauguin went back again to the Pacific, where he spent the last eight years of his life observing and painting Polynesian life.

Gauguin created many images of the brilliantly colored, patterned textiles worn by the Polynesian women in paintings that mix ideas and images from Europe and the Pacific Islands. He blended these textile patterns, inspired by the local flora, into the richly colored patterns of the Tahitian landscape. Gauguin owned pictures of many early or ancient styles of art, including those of Greece and Egypt, and would also have seen photographs of Japanese painting and the sculptural reliefs on the Buddhist stupa-temple at Borobudur in Java. He borrowed forms and ideas from all these sources, and mixed them with the images he discovered in Tahiti.

There were many Europeans with whom Gauguin could have socialized in Tahiti, but his purpose in living there was to escape Europe and mix with the native society. However, even though many Tahitians had become Christians and their society was not as cohesive as it had been a century earlier, Gauguin remained an outsider among the people he painted and studied. They saw Gauguin, who did not speak the native languages, as a member of the ruling colonial society.

Despite this problem, though Pacific works of art were being displayed in European museums and writers were publishing studies in scholarly journals, it was largely through Gauguin's work that the art of the Pacific Islands came to the attention of the art world in the West. He was the only major artist of the day who was thoroughly familiar with the art of the Pacific, and he incorporated insightful images of Pacific art and life into his work which continue to intrigue contemporary audiences today.

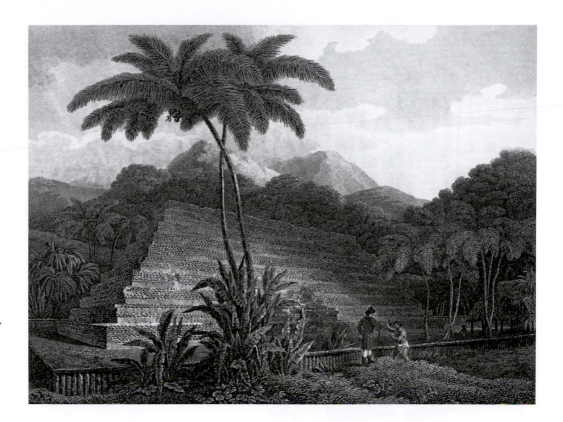

6.12 Great *Marae* of Temarre, the Mahaiatea, Pappara, Tahiti. 1796–98. Steel engraving from William Wilson's *A Missionary Voyage*, London, 1799

that included human sacrifices to pacify the ancestral spirits and the gods. Captain Cook, a late eighteenth-century English explorer, witnessed one such human sacrificial ceremony in a *marae* as the Tahitians paid homage to their war god in preparation for a battle against their neighbors on the island of Eimeo. He wrote: "The *marae* is undoubtedly a place of worship, sacrifice, and burial, at the same time. At the entrance there are two figures with human faces. Its principal part is a long oblong pile of stones … under which the bones of the Chiefs are buried." Later, in the nineteenth century, many of the stones from this *marae* were removed and burned for lime to build a nearby bridge. Although virtually nothing remains of Purea's *marae* and its decorations, monumental stone sculptures of deities have been found in association with other *marae* in French Polynesia.

One of the most important rituals and art forms in Polynesia, tattooing, was done in the Marquesas by *tatau* artists who carried the title *tuhuka* or *tuhuna* (master) and enjoyed the same rank as other artists and priests. Our word "tattoo" comes from the Tahitian *tatau*. The practice developed out of body painting, one of the oldest art forms in the world. Tattoos and scarifications could be widely displayed as art forms enhancing the status, beauty, and *mana* of their owners. As indicators of status that are inseparable from the body, which is one's link to the ancestors and the otherworld, tattoos have large quantities of *mana*. Some Pacific Islanders still believe tattoos protect them from harm in everyday life and in battle. Some island groups also think tattooing connects the human body with the spirit world of the gods. Thus, it is an intensely spiritual activity that is sanctioned and encouraged by the gods and society at large. As a measure of its importance as an art form, the government of the Society Islands, where the Festival of Tattooing is held, has commemorated the art form in a series of postage stamps. Today, Samoan men with the financial means, and a willingness to endure considerable pain, may be tattooed from their thighs to their waists. Normally, their clothing covers most of these tattoos, but they may be willing to display their trophies when they want to impress others with their wealth and bravery. Facial tattooing was a sacred act, reserved among the Maori for high-born men of chieftain rank. Each design was individualized, and in the nineteenth century copies of facial tattoos could be used to authorize documents.

An early nineteenth-century engraving of a tattooed Marquesan warrior shows how the *tuhuka* subdivided the man's body into registers of geometric parts by a network of straight lines and body-shaped curves (FIG. 6.13). Accenting joints, the crests of muscles, and the outlines of the skeletal structure beneath the skin, the curvilinear decorations are very skillfully adapted to the irregular contours of the human body. The highly stylized motifs symbolize a wide range of ideas, including warfare and killing. The long, painful process of adding this complex network of abstract

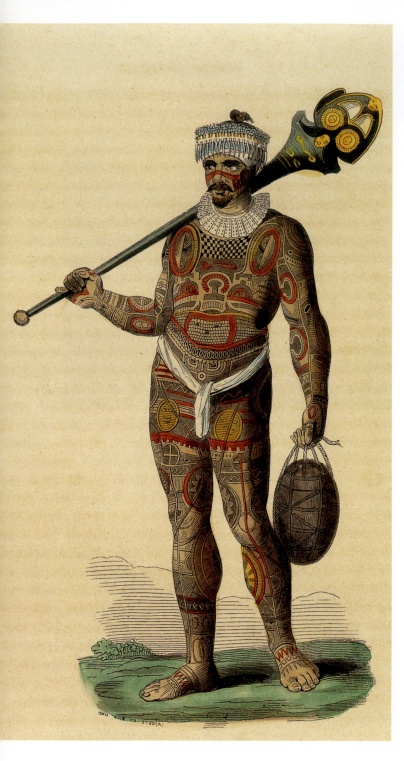

6.13 Tattooed Marquesan warrior. Engraving of Noukahiwa in N. Dally's *Customs and Costumes of the Peoples of the World*, Turin, 1845. Musée des Arts Décoratifs, Paris

decorations according to a well-organized and preconceived plan was part of a lifelong ritual to make the warrior's body a living work of art. The striking end of the *u'u* (war club) he carries is a stylized head with large, circular eyes. Together, the emblematic body markings and *u'u* document this warrior's bravery and status within his society.

In Tahiti, a spectacle called the *heiva Tiurai*, a major cultural event held every July, includes costumed dance competitions, reenactments of *marae* rituals, walking on fire, and tattooing. Some of the ancient rituals have survived into modern times, but sketches made by Captain Cook's artist when *heiva* dances were performed for them in 1768 and other first-hand observations from precolonial times have helped the Tahitians reconstruct other ancient ceremonies. One of the most important aspects of this revival has been the reintroduction of body tattooing. To enhance the authenticity and drama of his dancing and express pride in his heritage, Teve Tupuhia, a professional Austral Islands dancer working in Tahiti, decided to have a full-body Marquesan-style tattoo, made by a Samoan artist, Lese Li'o. Tattoo artists may work in several regional island styles so that they can provide appropriate island-style tattoos for their subjects.

WESTERN POLYNESIA: TONGA AND SAMOA

In western Polynesia, the making and decoration of bark cloth are sacred activities carried out under the direction of the highest-ranking women. Women on Tonga decorate their bark cloth with printed and freehand designs. A cloth placed over a piece of carved wood and rubbed with dye will take the pattern of the woodcarving, which may be highlighted with bold hand-painted designs (FIG. 6.14). Bark cloth and finely woven mats, also made by women, are very important commodities on Tonga, Samoa, and elsewhere in western Polynesia. They are given and exchanged to celebrate rites of passage and establish important social and political alliances. Each woman has her own distinctive style of decoration and the beauty of her work determines its value as a means of exchange. Being in charge of these transactions, for themselves and the men in their families, women have considerable power in western Polynesian societies.

At some time in the distant past, artists in Tonga made plaited mats with abstract designs that recorded family genealogies and embodied the spirits of their ancestors. Thus, these mats, **kie hingoas**, have great power and have long been reserved for the most important ceremonial occasions (FIG. 6.15). Queen Salote of Tonga (ruled 1918–65) had a *kie hingoa* that had been used in royal proceedings for

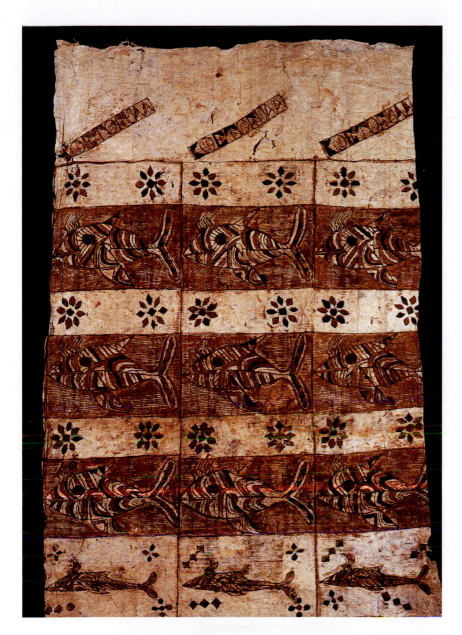

about six hundred years. She was a noted poet, songwriter, dancer, and high-profile representative of Tonga and the Pacific Islands in the West. She wore the *kie hingoa* at her coronation in 1918, again in 1953 when the British monarch, Queen Elizabeth II, visited Tonga, and on a limited number of other important ceremonial occasions thereafter. In twentieth-century royal weddings on Tonga, the brides and grooms have worn as many as ten *kie hingoas* to multiply the powers they contain.

6.14 (LEFT) Bark cloth with naturalistic impressions of fish. Tonga. Collected between 1927 and 1932. 14'1" × 4'4" (4.3 × 1.34 m). Auckland Museum, New Zealand

6.15 (BELOW) *Kie hingoa*. Princess Pilolevu dancing in 1975. Tonga

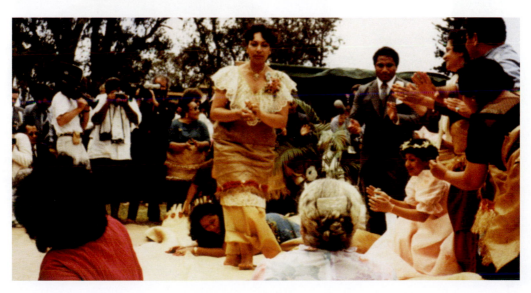

HAWAII

The Hawaiian archipelago on the northern tip of Polynesia may have been populated by Marquesas Islanders around 300 CE and a later wave of Tahitians between 900 and 1200 CE. It became a territory of the United States in 1898 and a U.S. state in 1959. The power of such rulers as Kamehameha I (c. 1758–1819), who consolidated the islands under his rule, is expressed in luxury goods like feathered cloaks and statues of the war god to whom he was dedicated. Surviving traditions in the arts are well represented in the fabrics produced by the women of Hawaii to this day.

SCULPTURE AND FEATHERWORK

Kamehameha I was dedicated to the war god Kukailimoku ("Ku the Snatcher of Islands") and installed images of him in a *beiau* (Hawaiian, "temple enclosure") near his home. A

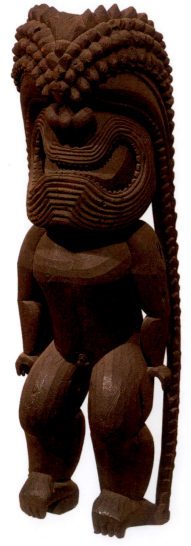

6.16 (LEFT) *Kukailimoku.* Hawaii. Late 18th or early 19th century. Wood, height 7'7" (2.36 m). The British Museum, London

6.17 (BELOW) Feather cloak known as the "Kearny Cloak." Hawaii. c. 1843. Red, yellow, and black feathers on fiber netting, 5'9" × 9'6" (1.75 × 2.9 m). The British Museum, London

well-preserved statue of Kukailimoku shows the war god with thick, flexed arms and legs, and a large head (seat of his *mana*) (FIG. 6.16). He juts out his chin and opens his wide, toothy mouth to unleash a great shrieking war cry. It is a dramatic example of a Polynesian war god in full fury, roaring loudly, to strike fear into the hearts of his enemies. Kukailimoku's wrinkled brow and tall crest of hair seem to vibrate in response to his mighty voice. The artists have attempted to capture the essence of this violent god's bellowing cry to give the statue as much *mana* as possible. This visual image of the screaming god reflects the idea of power in the military hierarchy of Hawaii, wherein warriors were victorious when they degraded (rather than killed) their enemies.

Monumental statues of Kukailimoku and other gods were displayed in the temple precincts where they and warriors carrying wickerwork and feathered images of the god were honored in songs and dances. Feathers were signs of high rank in Hawaii and elsewhere in eastern Polynesia, and some gods had red and yellow (sacred colors) feathered heads. Featherworkers also made feather-covered helmets for the warriors and royal, feathered cloaks with sturdy plant fiber netting backings. Believing that they were robing themselves in the protective feathered bodies of the gods, the warriors wore the feathered garments in preparation for battle. Women of high rank were allowed to wear smaller cloaks and other feathered ornaments as well as human hair, which was considered to be rich in *mana* because it came from the head, the seat of a person's *mana*.

When the brightly colored feathered cloak in FIG. 6.17 was worn, it became a tall conical form with the yellow crescents meeting at the seam. To increase the *mana* of a long

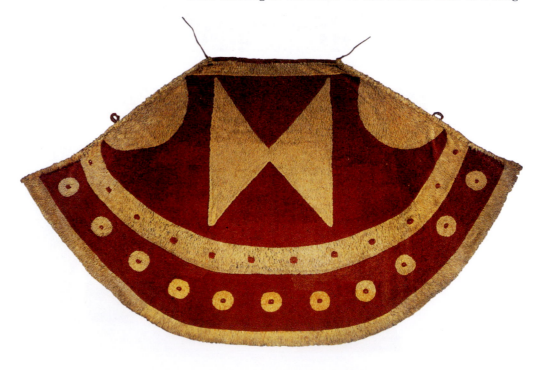

feathered cloak such as this, the featherworkers recited the genealogy of the royal recipient for whom it was intended as they made it. The cloak, which took the yellow feathers of about ninety thousand honeyeater birds, was very expensive, and men of lesser rank and wealth usually wore shorter capes. When the Hawaiian leader removed his cloak and gave it to Captain Cook in 1779, he was parting with a very highly valued and sacred heirloom.

EASTER ISLAND

Of all the artworks in the Pacific, none has piqued the imagination of Western public and scholars alike more than the monumental sculptures found on Rapa Nui, also known as Easter Island (FIG. 6.18). Early visitors referred to the sculptures as "heads" because many of them were buried up to their necks. In actuality, they are waist-length half-figures with large heads, short torsos, and pipestem arms. For centuries, the residents of the island carved these giant works, known as **moai**, moved them on rollers, and mounted them on platforms (**ahu**) so the *moai* could "look out" over the island's grassy, wind-swept hillsides. While theories about the sculptures and the demise of the people who made them abound in the literature about the region, we know relatively little for certain about these enigmatic "sphinxes" of the Pacific because clan warfare, epidemics, and slave raiders destroyed most of the original population and their oral traditions well before scholars arrived in the twentieth century.

It appears that, about 1200 CE, Polynesian sailors from the Marquesas or Gambiers Islands crossed roughly 2,000 miles (3,200 km) of open water and discovered this small and isolated volcanic "dot" rising out of the Pacific. The Norwegian ethnographer Thor Heyerdahl and others have noted some similarities between certain cut-stone walls on Easter Island and those built by the Inca in Peru, South America around 1500 CE and believe that the island was colonized from there. Few major authorities, however, accept this theory or that there were other significant contacts between the Pacific Islands or Asia and the Americas.

Shortly after arriving on Easter Island, the new residents began using basic stone tools to carve their large *moai* out of

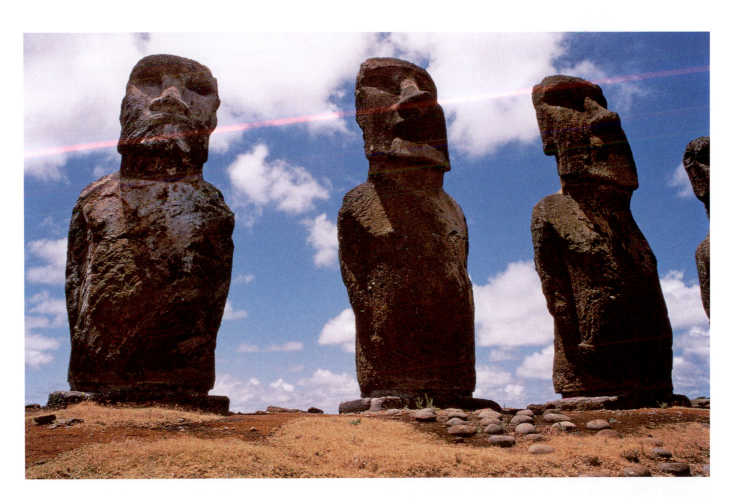

6.18 *Moai*. Easter Island. Pre-15th century CE

the relatively soft basaltic tuff in an extinct volcanic crater, Rano Raraku. Working from the front of the face and torso on the top of the outcrop, they carved around the sides of the stone to its back until only a thin ridge of stone below the *moai's* spine connected it to the rock and earth. After cutting a *moai* loose, the islanders began the difficult task of dragging that enormous stone on sledges or rollers from the volcanic crater to its designated platform. A few of the rutted pathways along which they moved their *moai* are still visible. It is believed that they used levers and ropes to set the *moai* upright before adding the coral and stone inlays to their eyes to "open" them so that they could "see" the surrounding landscape. Many heads were also crowned with stone *pukao* (topknots) that weigh over 5 tons (5,080 kg). In recent decades, engineers using an industrial crane have found it a challenge to replace some of these topknots.

Over the years, the Easter Island sculptors carved 887 monumental works, many over 30 feet (9.1 m) tall and weighing up to 80 tons (81,280 kg). In the process, they developed a distinctive head type with very strong features; the very long faces have heavy brows, inlaid, "all-seeing" eyes, strong noses, tense, pursed lips, sharp jawlines, and stout necks. Nowhere else in Polynesia do we see this authoritative head type, or such a large number of monumental carvings on one island or island group. To understand what triggered this tremendous outburst of creative energy and why Easter Islanders invested so much time and energy in this ongoing project, we need to look at the remaining fragments of the oral traditions and belief systems on the island.

The head and subsidiary chiefs on the island were descendants of Hotu Matu, the first chief and founder of the island society. The clan divisions were apparently very strong and they separated the island and quarry in the volcano into distinct clan zones. To mark and protect their territories, clans set up boundary stones and, we believe, carved the monumental *moai* representing their deceased chiefs as spiritual beings and installed them on platforms ringing the island, making them face them inward so they could watch over their clan properties. Local traditions also imply that the residents of Rapa Nui believed the island was connected with the spirits of the seas by an umbilical cord, so the *moai* spirit sculptures ringing the coast may have been links between the realms of the living and the honored dead beneath the sea.

The earliest *moai* are relatively small and have rounded eyes similar to face types used in the Marquesas Islands. They contrast with the far more plentiful, later *moai* type developed on Easter Island that seems to symbolize sight, protectiveness, and authority. It must have been a highly satisfactory symbol because, once the people of Easter Island established this ideal type, they made very few changes to it over the centuries and produced a very long series of nearly identical heads and torsos.

When warfare broke out in the eighteenth and nineteenth centuries, rival clans began toppling each other's guardian statue-spirits and symbols of clan authority. Many of them were thrown face down so they could not "see" and thus protect the lands of their descendants. With the *moai* deposed in this way, the victorious warriors created a "birdman" cult in which they were the ones who communicated with the spirits of chiefs past. About this time, the people of Easter Island developed what is known as the *rongorongo* script in which they may have recorded some of their endangered oral traditions, including their many long and very important genealogical lists that would have included the names of the leaders represented by the *moai*.

As a guardian, any given *moai* almost certainly had an abundance of *mana*, from the character of the ancestral chief it represented, its sheer scale, and its vantage point on the *ahu*. There was probably *mana* as well in the time-honored, formulaic body and face type that symbolized "honored ancestor-spirit." Societies around the world have created idealized types to portray their gods, culture heroes, leaders, and other individuals of distinction, and in time these well-known types become synonymous with power. That said, we must remember that we lack the good, detailed ethnographic data about the island's ancient oral traditions to prove or disprove many of the details in the narrative above. Although many of the pieces in the puzzle seem to fit, the Polynesian sphinxes may never give up their riddle.

NEW ZEALAND: THE MAORI

The Maori, who arrived in New Zealand around 900 CE, may have come from Tahiti, but their origins remain a subject of debate. They called their new home Aotearoa ("Long White Cloud"). Modern Maori scholars have established a chronology for their culture with period names that translate as "The Seeds" (900–1200), "The Growth" (1200–1500), "The Flowering" (1500–1800), and "The Turning" (1800–present). The early European chroniclers were astonished at the engineering of the Maori agricultural terraces, their lavishly decorated houses protected by tall wooden palisades, and the size of their dugout war canoes with large carved prows and sternboards. They were also impressed by the Maoris' oratory, poetry, and storytelling, literary ideals that still find expression in their visual arts today.

New Zealand has an abundance of good soft woods (the totara conifer and kauri pine), which are easier to work than the hard woods found on many Polynesian islands. Working with these, the Maori became excellent woodcarvers and transferred their skills to carving ivory, greenstone,

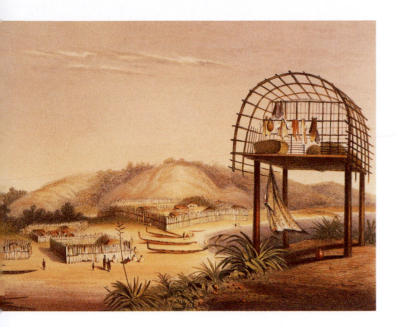

6.19 Maori storage house on stilts, Cook Strait, New Zealand. c. 1844. Lithograph in George French Angas's *New Zealanders*, 1847

bone, and whale teeth. Many of the scrolls and complex spirals used in Maori carving appear elsewhere in the Pacific Islands, but nowhere else do artists combine these decorative forms with solid, three-dimensional sculptural forms to create such a powerful sense of *mana* in their work.

Many of the finest surviving wood sculptures were originally placed on canoes, village palisades, or houses. Storage houses were often raised on pilings to protect their contents from moisture and marauding animals (FIG. 6.19). By later standards, the precontact storage houses and homes of chiefs were very small; visitors had to stoop to enter through their tiny doors.

The somewhat larger meeting-houses that began to appear in the early nineteenth century became the most distinctive architectural achievements of the Maori in the Turning period. As tensions mounted between the Maori and the European colonists (*Pakeh* in Maori), some Maori communities began building these large meeting-houses at their *marae* so that the noblemen would have a place to meet and discuss pressing political and social matters. This idea of having large, decorated assembly places may have been inspired by the early nineteenth-century Christian churches of the colonists, but the symbolism throughout reflects some of the most important Maori ideals as they struggled to maintain their ancient traditions under colonial government.

THE TE HAU-KI-TURANGA MEETING-HOUSE

The Te Hau-ki-Turanga (Spirit of Turanga) meeting-house (1842–45), built as part of a *marae* complex and now preserved in the National Museum of New Zealand in Wellington, is one of the most important and astonishing monuments in the history of Polynesian art (FIG. 6.20). It was constructed and decorated by Raharuhi Rukupo (c. 1800–73), a warrior, priest, and tribal chief, in honor of his late brother from whom Rukupo inherited the chieftainship of his tribe at Turanga (Poverty Bay). Raharuhi Rukupo was regarded as the leading master carver in Poverty Bay in the mid-nineteenth century. Earlier Maori carvers had used basalt and greenstone chisels and drills, but Rukupo and the eighteen Poverty Bay carvers who worked on the Te Hau-ki-Turanga house used Western metal tools. These enabled them to work more quickly than their predecessors, but the new technology did not change the fundamentals of their traditional Maori style of carving. Earlier, precontact houses may have had some interior decorations, but it is unlikely that they were as lavish as the Te Hau-ki-Turanga house. Bound together by the strict codes of *tapu*, Rukupo and his assistants created a national Maori treasure. Traditionally, Maori carvings and houses under *tapu* cannot be repaired and are left to decay. However, the Te Hau-ki-Turanga house was restored

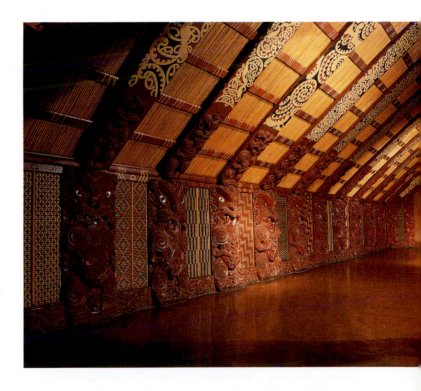

6.20 Interior of Te Hau-ki-Turanga Meeting-house, Poverty Bay, New Zealand. Maori. 1842–45, restored 1935. Wood, shell, grass, flax, and pigments. National Museum of New Zealand, Wellington

in 1935 by artists using traditional techniques and installed in the National Museum in Wellington, where the public can enter it. Thus, the meeting-house, one of the most complete collections of Maori carving, representing a high point in Maori art history when the traditional forms were first being carved with metal tools, is one of the most accessible and well-preserved Maori treasures. (See *In Context*: Maori Images of "Art," "Artist," and "Art Criticism," opposite.)

Learned Maori such as Rukupo, his assistants, other noblemen who gathered there, and some of the public would have understood the complex symbolism of the structure as an image of the Maori universe. The ridge-pole and rafters represent the backbone and ribs of the sky father, and the carved face boards along the sloping roofline are his outstretched arms. However, in typical Polynesian and Maori fashion, the thinking and imagery have multiple levels of meaning. The ridgepole also represents the chief's lineage, and the rafters symbolize the passage of that lineage through time, linking the family of the chief with the body of the sky father. In some cases, the ridgepole over the porch supported images of the sky father and earth mother in sexual union, linking the already complex symbolism of the house with the creation of the cosmos.

Inside the house, the freestanding poles (*poutokomnanawa*) and wide panel-shaped side posts (**poupou**) supporting the roof (the sky father and royal lineage) are carved to represent venerated ancestors (see FIG. 6.21). To a Maori master carver such as Rukupo, the symbolism of this supportive role was obvious—these noble ancestors had upheld the laws and traditions of the gods and royal lineage in the past. They were there now to protect and comfort the occupants of the meeting-house. Because they controlled the *mana* passed on to their descendants, such ancestors were often more revered and honored in the arts than the gods.

The short-bodied, stylized images of ancestors are called **tiki**, the name their creator god, Tane, gave to the first person he created. A *tiki* is a human figure with additional animal features (bird or lizard) that may represent an ancestor, god, or spirit. Small jade or greenstone *hei-tiki* (suspended *tiki*), ranging from about 1 to 7 inches (2.5–18 cm) in height, worn on short flax fiber cord necklaces, represented ancestors and were often family heirlooms. The large-headed *poutokomnanawa* with inlaid eyes were painted with burned red-ocher pigments and rubbed with clay and shark-liver oil until they turned a reddish-brown color. The ancestor, with a beaked mouth and three-fingered clawlike hands, thrusts out his tongue in defiance to ward off evil or taunt an enemy—a menacing gesture to outsiders, but not to members of the community.

In typical Polynesian fashion, the head of the figure (seat of its *mana* and spiritual power) is large compared with the rest of its body. Along with this, the bent-knee pose and the swirling forms in the reliefs suggest the idea of mobility, strength, and *mana*. While similar forms appear elsewhere in Polynesia, especially in the tattoos of the Marquesan artists, the complexity of these decorative patterns is a hallmark of Maori art. Two of the Maori names for these spiral motifs, *pitau* and *tete*, also refer to the young, curled fern frond, a staple food source in New Zealand and a symbol of chieftainship.

One of the figures on a wooden side post in the meeting-house is a self-portrait by Rukupo (FIG. 6.21). His face is covered with a recognizable Maori style of facial tattooing known as *moko*, which is characterized by long, elegant, flowing lines that follow and accent the contours and features of the sculptor's face. While each set of facial tattoos was an original work of art, many of them shared some of the basic features of Rukupo's tattoos. Sets of parallel curved lines following the jowls connect pairs of small spirals on the sides of the nostrils with the chin. Larger spirals are placed over the cheekbones and the base of the jaw. A fan-shaped set of curved lines radiates upward and outward from the brow. To the contemporaries of the young and freshly tattooed Rukupo, these patterns of repeating, dark blue lines radiating out from the center of his face would have given the youth a sense of authority and strength. As he aged, the tattoo patterns mixed with his facial wrinkles, adding to his noble character. Women traditionally wore less elaborate tattoos on their lips and chins. Such tattoos were highly personal and, as mentioned before, in historic times could be copied and used as signatures on documents.

Rukupo's carvings are remarkable for their vitality, which comes from the crispness and complexity of his lines, their strong rhythms, and the way he integrates those linear patterns with the three-dimensional forms they decorate. The sense of an individual subject, visible in Rukupo's long face and full, pursed lips, is absorbed in the conventions of the Poverty Bay style of carving, in which his small, schematized body and large head emphasize the seat and source of his *mana*. Working within the conventions bequeathed him by the gods, Rukupo gives his head an individuality and dignity that reflect his high rank and place in Maori society. As a carver who used the new technology to give Maori art fresh vitality, Rukupo was a very important artist of the Turning period, and through this well-preserved self-portrait, he will be remembered as one of the "faces" of this time of struggle.

The side posts alternate with weavings known as **tuku-tuku**, made by high-ranking women working with plant stalks and slats of wood tied with grass or fibers from a flax plant with leaves up to 7 feet (2.1 m) long. Some of the

MAORI IMAGES OF "ART," "ARTIST," AND "ART CRITICISM"

To understand Maori art, it is essential to see it as it was seen by the Maori who created or commissioned it. They were members of an integrated society in which their everyday lives, rituals, religious beliefs about the gods, ancestors, and cosmos, and the arts were part of a seamless fabric enveloping them.

According to Maori legends, the first artists were the Maori gods. In time, they allowed certain high-ranking men with distinguished ancestors to become vehicles through which they, the gods, could create art to be used in rituals to venerate them and the ancestors. A *tohunga whakairo* (skilled woodcarver) of noble status in New Zealand might operate a workshop employing young noblemen apprentices who made the portable sculptures, war canoes, and important buildings. The term **tohunga**, used by itself, means "expert," but in general usage it denotes a priest. Maori artists who had been thoroughly trained in the religious rituals governing the creation of works of art operated like priests under the watchful eyes of Tane, the god of the forests, craftsmen, and creation.

As an agent or representative of the gods, the traditional Maori artist was not an isolated individual acting alone. He had to follow strict ritual guidelines governing every phase of his work. To perform these exacting duties, a *tohunga* had to possess large quantities of *mana*. The tools, works-in-progress,

and artists themselves were sacred. Generally, objects made by nobles were imbued with so much spiritual power that it was forbidden for those of lower rank to touch them.

The Maori definition of "art" and the language used to describe individual works' quality reflect their belief that the art belongs to the gods and Ancestors. They may call one of the carvings illustrated here (see FIG. 6.21) a *taonga whakairo* (prized decorated object of quality) or a *taonga tuku iho* (prized heirloom). They recognize qualities in these objects that rise above the mundane and reflect the world of the gods who worked through the artists to create them and their *mana*.

Not every carving by a Maori qualifies as **taonga**. To achieve this elevated status, the object must have been used in rituals where speeches and incantations were recited over it; it has to have a history of contact with the words, ideas, and *mana* of high-ranking Maori to have *mana* of its own and be *taonga*. In time, some of the nobles who used a given work of art join the ranks of the venerated Ancestors, giving the art they used added prestige. Knowledgeable Maori explain these associations of the art to audiences, repeating versions of the stories and ideas attached to them by the leaders of the past. Once the work of art is linked to the words, ideas, and *mana* of the Maori elite, its own enhanced *mana* gives the art a sense of authority and inspires awe and *ihi* (fear) in viewers. This,

ultimately, is how the Maori judge their art—on the strength of the audience's reaction to it. While their art needs to demonstrate technical skill, and what Westerners call "beauty" or "aesthetic qualities," the proof that these qualities exist comes when the work of art evokes an emotional reaction in viewers. While great emphasis is placed on rituals attending every phase of the art's production and the proper training of the artist, the art is ultimately judged on how well it "works" in the context of Maori society—in ceremonies that link the art and its audience to the Ancestors and the gods who created the first works of art.

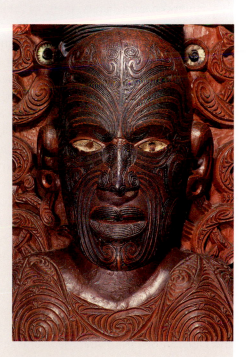

6.21 Raharuhi Rukupo, *Self-Portrait in the House Te Hau-ki-Turanga*. 1842–45. Wood, height 50" (1.27 m). National Museum of New Zealand, Wellington

decorative patterns of the mats represent gods and cosmic features, a reminder that the house is a symbolic and conceptual image of the cosmos and its gods, ancestors, and rulers on earth who form a complex hierarchy of power around the *marae* where this meeting-house was originally located. The Te Hau-ki-Turanga house, created as traditional Maori civilization was being influenced by Western colonialism, is a magnificent and lasting monument to the subtlety and inspiration of Polynesian culture in New Zealand.

Upon finishing the house, the Poverty Bay carvers began working on a very ambitious new project, a Christian church that was to be decorated with wall posts carved in the Poverty Bay style. But the cohesiveness of traditional Maori art was disrupted as Western missionaries encouraged the artists to revise their imagery to fit the tastes and needs of the Christian religion. On the death of Rukupo, the Poverty Bay carvers declined in importance, but other carvers of Maori art remain active to the present day.

COLONIAL AND POSTCOLONIAL NEW ZEALAND

As colonization intensified in the late nineteenth century, traders, whalers, Christian missionaries, and plantationists introduced the Pacific Islanders to alcohol, firearms, and new diseases to which they had no natural immunity. As the numbers and prosperity of the islanders declined and they embraced Christianity, many of their indigenous artistic and cultural traditions withered. Others survived or have been revived and are now part of the postcolonial traditions in New Zealand and other islands, most of which have gained home rule. Currently, much research is being done on the surviving ceremonials and artists working in traditional Oceanic styles.

In the past century, the Maori have searched for ways to sustain their culture and incorporate it into the modern identity of New Zealand. The first Maori art school, established in Rotorua (1910), taught students to carve wood in the style of Rukupo. Additional schools, cultural centers, and festivals have been established, but many Maori have nonetheless become urban English-speaking Christians without tribal associations or connections to the art and culture of their ancestors. When the words and rituals associated with older works of art are lost, knowledgeable individuals and groups of Maori attempt to recreate them and bring the old works back into the context of Maori history and culture. (See *In Context:* Maori Images of "Art," "Artist," and "Art Criticism," page 223.) In these revivals, the contemporary Maori are not trying to turn back the clock or to replicate their past. Instead, they want to sustain a bilingual Maori culture in New Zealand that will work in concert with the Western, English-speaking population and be part of New Zealand's national identity in the future.

THE PACIFIC ARTS FESTIVAL

Like the Maori, most island groups in the Pacific are now wrestling with problems relating to the colonial legacy and other outside influences that have challenged their ancient traditions. Thus, many of the new art and cultural centers in the islands show art derived from both sides of the local artists' heritage and give them places to exhibit their work while they network, exchange ideas, and develop styles that express the world in which they live. The stated goal of the Folk Arts Festival in the Marshall Islands, for instance, is "to stimulate cultural identity; celebrate the traditional; provide an opportunity for contemporary expression; and encourage national self-reliance." The traveling Pacific Arts Festival, which takes place every four years, is the largest gathering of this type and has become internationally renowned.

In premodern Oceania, the arrival of visitors from another island was regarded as a very special event—a time to celebrate, share ideas, and show off your music, dances, and arts to the newcomers. This festive form of interchange helped keep the old customs alive, but, in 1972, seeing that those old customs were dying out under pressure from outside influences, the Secretariat of the Pacific Community created the Pacific Arts Festival. The theme of the tenth edition, held in 2008 at Pago Pago, American Samoa, was "Threading the Oceanic *Ula*," the latter being a necklace symbolizing respect and warmth used to greet guests at events in the Pacific. This perfectly summed up the tone of the whole affair. For two weeks performers and guests from around the world were invited to enter into the spirit of friendly exchange, enjoy the performances, and take part in talks about important issues facing the Pacific community.

The festival is far more than an educational event; it has become the Pacific version of the Carnival in Rio and Mardi Gras in New Orleans. Of the two thousand or so performers who took to the stage at Pago Pago in 2008, some displayed traditional forms of tattooing and body painting and wore colorful costumes based loosely on historical types (FIG. 6.22). Others invented their own over-the-top versions of Pacific punk and Bayside burlesque. Even the audiences got in on the act, arriving in their own carnivalesque outfits and cheering the performers on. There was also a tent town nearby where Pacific artists demonstrated their skills and sold their wares.

It seems fitting to travel full circle through the Pacific and end this chapter where it began, in Aboriginal Australia, by looking at a modern work, *The Aboriginal Memorial* (1988), created for the bicentennial celebrations to mark the European colonization of Australia and offering a powerful counterpoint to the official Anglo-oriented view of that event's accomplishments (FIG. 6.23). The installation, created by a group of forty-three Aboriginal artists, reflects

their ancient and communal beliefs in the landscape-based Dreaming mythology. In these beliefs, the Aboriginals saw, and still see, the landscape as the sacred embodiment of the beings who created it and who still live there. Each Aboriginal is tied to an episode in the Dreaming, and through rituals and art they draw their power from the Ancestors, the spirits, and the land. Thus, in addition to the political and social repression brought about by colonialism, simply having the foreigners on Australian soil violated the sacred spaces upon which the Aboriginals depended for their very existence.

The *Memorial* represents a very specific piece of that sacred landscape—the lands along the Blythe River in Arnhem Land in the far north of Australia. Visitors to the exhibition can pass through the middle of the installation—through the Dreaming—along the course of the river between the two clusters of logs decorated with a dazzling array of patterned designs, many of which incorporate ancient Aboriginal motifs and subjects. Standing tall on the land of the Dreaming, the logs represent the ancient clans, the Ancestors, the spirits, and the land in which they all still live. Each of the logs stands for one year in the two centuries since the first white settlers violated the sanctity of the Aboriginal lands. They also resemble the hollow-log coffins used in Aboriginal society and symbolize the uncounted numbers of Aboriginals who lost their lives in conflicts with the colonial authorities.

The installation is a rare and exemplary work that takes the ancient Aboriginal ideals in art, brings them forward to the present, and casts them in forms that speak to a wide audience inside and outside Australia about a matter of national and international significance. It marks the intersection of the traditional Aboriginal view of the sacred landscape with contemporary art and Australian politics in a particularly poignant manner that forces visitors to stand between the towering symbols of oppression and death as

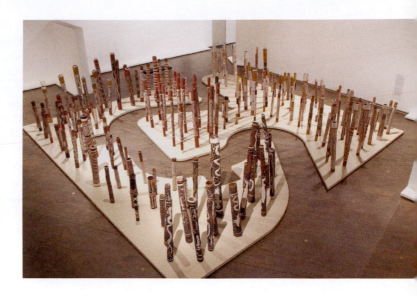

6.23 Paddy Dhatangu, David Malangi, George Milpurruru, Jimmy Wululu, and other Raminginging artists, *The Aboriginal Memorial*. 1988. National Gallery of Australia, Canberra

they pass through the work. *The Aboriginal Memorial* is now on permanent display at the National Gallery of Australia in Canberra, where it continues to comment on the bicentennial and blend its voice with those of other public monuments in the nation's capital.

SUMMARY

People migrating from Southeast Asia began populating portions of the Pacific Islands as early as about 40,000 BCE. By about 900 CE, they had spread throughout Melanesia and Micronesia in the western Pacific and Polynesia to the east. All or most of the art that developed on the many islands in the Pacific embodies the widespread concept of *mana* or spiritual power. This idea is reflected in the towering roofs of the communal men's houses, the sacred nature of the *marae*, the beauty of the textile patterns created by women, and the complexity of the reliefs carved by the Maori of New Zealand.

European explorers had visited most of the islands by the late eighteenth century and ushered in two centuries of colonial domination during which missionaries and governors destroyed much of the islanders' traditional worldview and subsistence patterns. However, in recent years, Pacific culture has enjoyed a renaissance. As many areas came under home rule in the late twentieth century, governments established art and culture centers where artists can embrace postcolonial concerns about their cultural and national identities and create works of art that perpetuate and update their traditions for the new millennium.

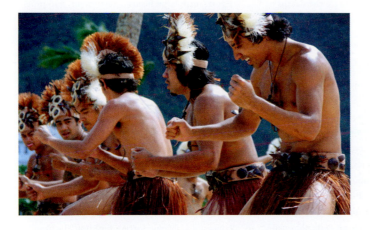

6.22 Dancers at the Pacific Arts Festival held at Pago Pago, American Samoa, 2008

GLOSSARY

AHU Platforms for *MOAI*.

BAI Literally, "community house." Large structures in the Caroline Islands used for dances, feasts, council meetings, and to house visitors. Constructed by a *dach el bai*, "master builder," and decorated with carvings by a *rubak*, "village storyteller," working with woodcarvers. The *bai* are also famous for their cosmic symbolism. During ceremonies, clan leaders, the "pillars" of the community, are seated at the corner posts or pillars of the *bai*. The women elect the men to these positions, so they share in that power and symbolism. These ideas are explained by the painted, story-board images placed on the tall pointed façades of a *bai* for all to see.

BISJ MBU A former ceremony in Asmat, New Guinea that included the erection of tall, sculptured poles to avenge the death of a person killed by headhunters. Since the deceased had not had a proper burial to send its spirit to Safan, the realm of the dead in the west, that spirit might linger about the community and upset the clan's rapport with the ancestral spirits. The wandering spirit could be appeased, and harmony between life and death reestablished through the ceremony. Each stage of the pole's preparation symbolized an act in the process of headhunting. The tree was cut (decapitation of the enemy), bark removed (skinning the enemy), and the sap (blood) was allowed to run before the pole was taken to the village (returning home with the corpse).

DREAMING Also known as "Dream Time." From *Jukurrpa*, an Australian Aboriginal term for their all-encompassing immaterial or spiritual otherworld and mythic time. Not to be confused with the conventional meaning of "dreaming" in English. The concept also includes religious ceremonies, laws, and art forms. To the Aboriginals the word signifies the otherworld created by the supernatural beings and ancestors, along with its religious ceremonies, laws, and art forms. It is a kind of landscape-based mythology that ties the individual to a place and its spiritual powers, which come to life in myths, rituals, and arts. In this process of bonding with the otherworld, the Aboriginals also believe they are moving to a higher spiritual level and becoming more

genuinely who they are than they could ever be in everyday life. The Aboriginals refer to this process as *jimeran*, "making oneself."

KIE HINGOA A type of plaited mat with abstract designs made on Tonga that recorded family genealogies and embodied the spirits of their ancestors. Worn on the most important ceremonial occasions.

LATTE Matching sets of square or trapezoidal limestone posts with hemispherical capitals used by the Chamorros of the Marianas Islands to elevate their houses. The largest known collection of *latte*—forty-seven sets arranged in groups end-to-end at Mochong—follows the curve of the coastline. The *latte* in the house of Taga on the island of Tinian are 16 feet (4.9 meters) tall, and a taller but unfinished set of *latte* lies in a quarry on the island of Rotan, near Mochong.

MACHIY Sacred burial shrouds woven by women in the Caroline Islands that are associated with chiefs, ancestors, and guardian spirits.

MALANGGAN In New Ireland, large sets of highly ornate poles, figures, and boats carved for mortuary rituals and displayed before ceremonial houses to honor the recent dead and send their spirits to a final resting place with the Ancestors. Also created for the initiation ceremonies of young boys reaching adolescence who are being groomed to take over the ritual duties of the elders when the elders die. Preparations for *malanggan* ceremonies and the production of the associated art forms can be very expensive and time-consuming, so a single ceremony may serve to celebrate the deaths or initiations of many persons over a period of several years.

MANA A belief in and around Polynesia that works of art and other objects as well as people may have sacred powers. Since the lineage of a chief may descend from the gods, those with royal blood are born with plentiful quantities of *mana*, which can be increased by good deeds or decreased by poor ones, cowardice, or the violation of a *TAPU* (taboo), a rule that must not be broken. *Mana* is often envisioned as an invisible but forceful spiritual substance, a manifestation of the gods on earth that can link people with their ancestors and the gods. It is also, a power that enables artists to be

creative. Later, the *mana* in a work of art may be increased by the status or *mana* of its successive owners, and the importance of any associated rituals honoring the gods and ancestors. Valued heirlooms passed down from one generation to the next in royal families can accumulate tremendous quantities of *mana*.

MARAE In Polynesia, sacred ceremonial enclosures that may be walled, and include stone platforms with sculptures, sacrificial altars, and buildings to store the sacred objects used in rituals dedicated to the gods and ancestors. In New Zealand, the ritual area may be the plaza area in front of the meeting-house, or the entire complex of buildings associated with that house, with structural parts that symbolize parts of the cosmos. As sacred locations, the *marae* were believed to have unusually large quantities of *MANA*.

MIMI Australian Aboriginal spirits from the DREAMING. Also, a style of painting in which *mimi* spirits are represented.

MOAI The 887 known monumental sculptures carved from volcanic stone on Easter Island. Made between about 1000–1500 CE, they are thought to represent deified ancestors who have become guardian spirits. Many were set on platforms (*AHU*) encircling the island, and some were crowned with stone topknots weighing over five tons. When warfare broke out in the eighteenth and nineteenth centuries, rival clans began toppling each other's guardian statue-spirits and symbols of clan authority. Early visitors referred to the sculptures as 'heads' because many of them were buried up to their necks. In actuality, they are waist-length half-figures with large heads, short torsos, and pipe-stem arms. Of all the art works in the Pacific, none have piqued the imagination of the public and scholars alike as have the Easter Island *moai*—universally recognized symbols of Pacific art and culture.

PALEOLITHIC From the Greek words *paleo* (old) and *lithic* (stone). In common usage, the Paleolithic is called the "Old Stone Age."

POUPOU Carved wooden panels representing venerated ancestors in Maori meeting-houses that act as "pillars of the community" by supporting the roof (the sky father and royal lineage) in a structure that represents the Maori cosmos.

TAONGA Maori, "prized." A quality in an object that allows it to rise above the mundane and reflect the world of the gods who worked through the creator of that object.

TAPU The Polynesian word for something holy or sacred with restrictions regarding its use—hence the English word "taboo." See also under *MANA*.

TATTOO The English word "tattoo" comes from the Tahitian *tatau*. Tattooing in the Pacific grew out of body painting, an art form that connects a person with the ancestors and otherworld. Tattoos could enhance the status, beauty, and *MANA* of their owners. Thus, tattooing is an intensely spiritual activity that is sanctioned and encouraged by the gods and society at large, and it has long been one of the most important art forms in the Pacific. In the Marquesas, *tatau* artists carried the title *tuhuka* or *tuhuna* (master) and enjoyed the same rank as other artists and priests. Facial tattooing was a sacred act, reserved among the Maori for high-born men of chieftain rank. Each design was individualized and, in the nineteenth century, copies of facial tattoos could be used to authorize documents. Today, Samoan men with the financial means (and the willingness to endure considerable pain) may be tattooed from their thighs to their waists.

TIKI General Polynesian term for stylized sculptures of venerated ancestors.

TOHUNGA Maori artists who were thoroughly trained in the religious rituals governing the creation of works of art, and who operated like priests under the watchful eyes of Tane, the god of the forests, craftsmen, and creation. A *tohunga whakairo* (skilled woodcarver) of noble status in New Zealand might operate a workshop employing young noblemen apprentices who made portable sculptures, war canoes, and important buildings. As an agent or representative of the gods, a traditional Maori artist had to follow strict ritual guidelines governing every phase of his work. The tools, works of art in progress, and the artists themselves were considered sacred.

TUKUTUKU Reed mats made by Maori women to decorate house walls.

X-RAY STYLE Also known as the "In-fill Style." A Western name for a technique used by Australian Aboriginal artists in which the inner parts of an animal or person may be visible, as if the outer skin were transparent.

QUESTIONS

1. *Mana* is a complex idea about power that can be expressed in many ways, but Pacific Island sources do not always tell us precisely where it may be found and how it works. Look at some examples of Pacific art and try to find these answers for yourself.

2. What are the mainsprings of Australian Aboriginal art? How have Aboriginal artists responded to incursions into their territories by outsiders?

3. Almost everyone has a very strong opinion about body art, especially tattooing. In many parts of the Pacific, tattoos are badges of honor and sacred. What is the current attitude toward tattooing in your social circles? Have attitudes toward body art changed in recent years, and what do you think the future holds for this very ancient art form?

4. Many museums around the world display Pacific works of art in glass cases, on pedestals, or hanging on walls in hushed whitewashed galleries. Originally, many of these works were parts of multimedia performances that included prayers, music, and dances. Is it *wrong* to take works of art out of their context and display them as isolated objects? If you were a museum director or curator, how would you improve on this situation?

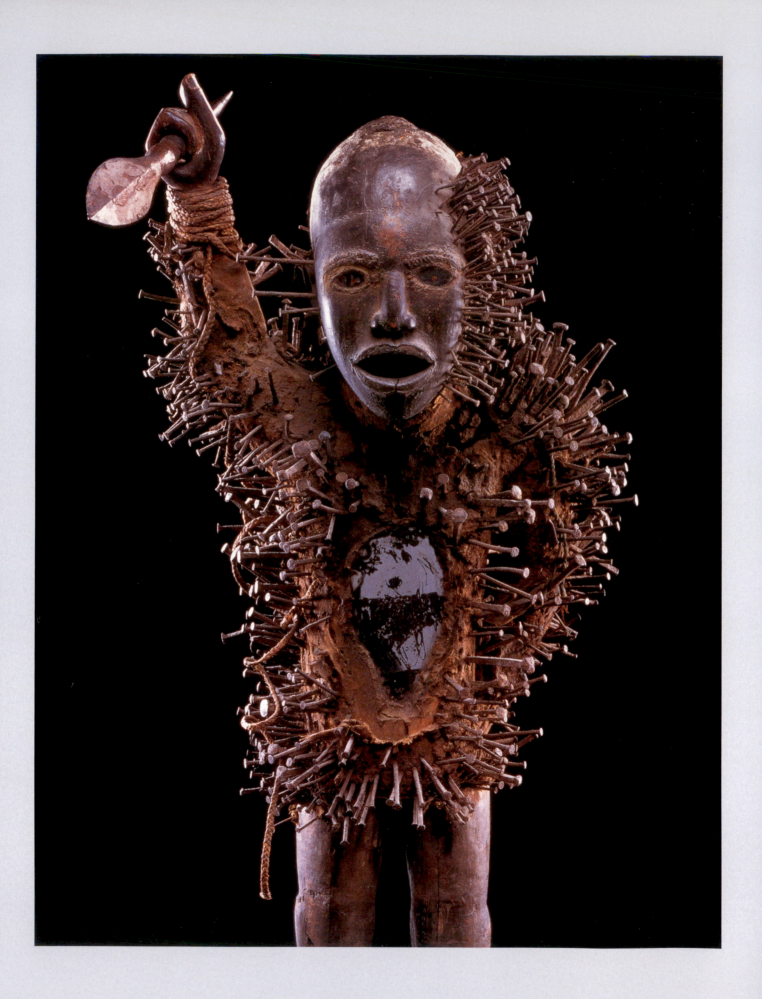

7 | Africa

Equator

Introduction	230
The History of African Art History	233
African Prehistory	233
Southern Africa	235
East Africa	238
Central Africa	240
West Africa	242
Postcolonial Africa and the Quest for Contemporary Identities	258
African-American Art	263
Summary	267

Africa

This chapter covers the indigenous arts of sub-Saharan Africa, which is divided into Southern, East, Central, and West Africa. The arts of North Africa, ancient Egypt, and the Nile River drainage area in Nubia and Ethiopia have traditionally been regarded as parts of the ancient and medieval cultures of the Mediterranean world. As such, they are discussed in this chapter only when they are involved with the art of sub-Saharan Africa. (See *Analyzing Art and Architecture:* What is an Authentic African Work of Art?, page 232.)

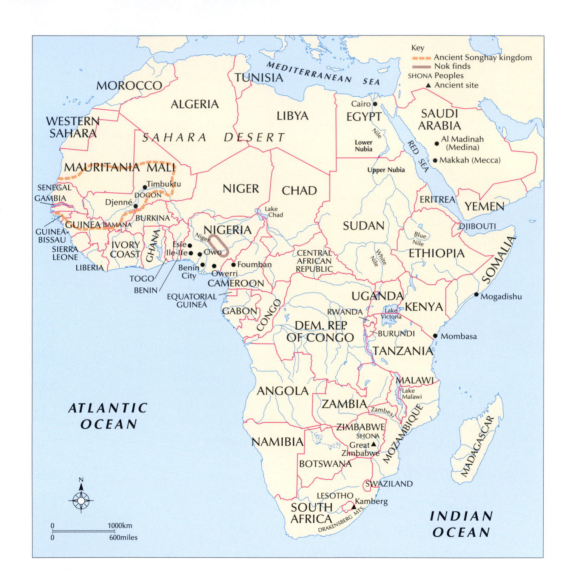

INTRODUCTION

Over the last thirty thousand years, artists living in the vast region known as sub-Saharan Africa, with about a thousand distinct languages, have produced a wide variety of artworks in many distinct styles. No single religious or cultural ideal can explain why so many African cultures and individuals have placed such a high value on art. At best, we can point to some widespread ideas about spirits and their veneration that inspired some of the most important works discussed in this chapter. Many African groups believe in an invisible otherworld of sacred ancestors, spirits, and deities who mediate in the affairs of this world. By conducting

TIME CHART

Beginning of San painting on rock outcrops (c. 27,500 BCE)

Native copper smelted in Nigeria (c. 2000 BCE)

Iron ore smelted in Nigeria (c. 700–500 BCE)

Nok ceramic sculptures in Nigeria (c. 600/500 BCE–200 CE)

The Ghana kingdom, West Africa (8th–11th centuries CE)

Pre-Pavement Era at Ile-Ife (900–1200)

Early Pavement Era at Ile-Ife (1200–1400)

Muslim traders arrive in West Africa (10th century)

Bronze heads cast at Ile-Ife, Nigeria (c. 1100–1500)

Oduduwa, king of Ile-Ife, sends his son Oranmiyan to found a new dynasty at Benin City (13th century)

Zenith of Great Zimbabwe, Shona capital (c. 1250–1400)

The Mali kingdom, West Africa (13th–16th centuries)

Benin: Early Period (1400–1500)

The Songhay kingdom, West Africa (15th–16th centuries)

Iguegha of Ile-Ife brings bronzecasting to Benin (early 15th century)

Arrival of Portuguese in Benin (1486)

Benin: Middle Period (1550–1700)

Benin: Late Period (1700–1897)

Destruction of Benin City by British (1897)

Yoruba artist Olowe (c. 1860–1938)

certain time-honored ritual performances, they believe they can contact them and recreate their past history—the time when their ancestors lived—and communicate with these otherworldly beings. These rituals often take the form of multimedia performances that include costumed and masked dancers representing spirits or deities, music, prayers, and offerings. During the rituals the performers may become embodiments of the otherworldly characters they represent and focal points for the worshipers around them, acting as visible symbols of the union of the past and present, this world and the other.

The African concept of dance is an intensely passionate, all-encompassing vision of dancer, costume, mask, other works of art, and the spiritual heritage of the cultures united in patterns of movement. The isolation and segmentation of body parts in response to the complex rhythmic music emphasize the flexibility, endurance, and power of the dancer's frame. Through their strength, grace, and beauty, the dancers transcend this world and communicate with the spirit sphere. These concerns with power and grace are also expressed in the visual arts. Even the most common static poses of figures in African art—standing, carrying and balancing objects, seated (to convey authority), or kneeling (paying honor)—are icons of power. The bent knees and elbows of African statues accentuate the flexibility, animation, and readiness of the figure to move. Among modern African groups that have been closely studied, such as the Yoruba of Nigeria, the words for movement are often important ones in their philosophies of art. Often, the sculptors attack the wood with strong, staccato strokes that reflect the overlapping multimetric rhythms of African music. Accenting each feature and form with equal intensity, the artists give full strength and vitality to every part of the face and image.

Unlike the traditional Western notion of sculpture as a composition of static forms, African art is often meant to be in motion and depends upon these movements and its ritual context for its meaning. The Dogon of Mali in West Africa display masks, sculpture, and other artworks at dance rituals designed to transport the souls of the deceased out of their villages. The dancers' costumes include bright vests of red broadcloth strips covered in white cowrie shells, beads, brightly colored fiber skirts over indigo pants, and **Kanaga** masks with towering antennaelike head crests (FIG. 7.1).

The long, graceful, spinning and leaping movements of the Dogon dancers are intensified by the tall, double-armed poles on the crests of their masks, which may represent a bird or mythical crocodile. The dances of the Dogon and other groups fuse the reality of this world with the other-world of spiritual beings. Western viewers usually encounter the African masks and headdresses placed against the flat walls of quiet, softly lit rooms in art galleries and museums, or reduced in scale and rendered motionless on the pages of a textbook, but the full meaning and expressiveness of African art cannot be conveyed in the frozen silences of such foreign environments. In these unnatural settings, the sculptures are little more than mute reminders of the religious rituals of dance and music for which there were originally created. Looking at African works of art removed from their cultural context, Western spectators need to make a major imaginative effort to restore them to their original setting.

Many African groups have their own, distinct ideas about beauty in art. Nearly a thousand years ago, the Yoruba at Ile-Ife in Nigeria were placing cast metal and modeled clay heads of royal ancestors and other artworks on altars and honoring the heads in ceremonies of ancestor worship. The heads, a mixture of what Western commentators might call realistic and idealized forms, are universally recognized for their stunning beauty. Some of the ancient principles underlying this sense of beauty may even now be preserved in contemporary Yoruba thinking.

Using rough translations of Yoruba words into English, the modern Yoruba believe that their High-God and Creator is the source of all outer beauty and inner beauty as manifested in one's "character" or "essential nature." To capture that sense of inner beauty and power in images of their royal ancestors, they made heads with a sense of "youthfulness" and "dignity." Beautiful art needs to have "symmetry," "balance," "clarity of form," "clarity of line," "luminosity," "delicacy," and "ornamentation." These ideas and other Yoruba concepts and terms for their art will be discussed in more detail in connection with Yoruba art later in this chapter. (See also *Analyzing Art and Architecture:* Yoruba Aesthetics, page 245.)

Many other African groups have similar terms for aesthetic matters. The Bamana of Mali call art "things that can be looked at without limit," and the Dan of Liberia and Côte d'Ivoire have distinct words for beauty and ugliness in art. Until very recently, African art was little understood or appreciated in the West, but, seeing the distinctive and

ANALYZING ART AND ARCHITECTURE

WHAT IS AN AUTHENTIC AFRICAN WORK OF ART?

The question is deceptively complex. For example, a mask made by an African artist trained by a skilled and recognized artist within that society and that will be used in rituals by his or her society would surely qualify as an authentic piece of African art. But what about a mask specially made by that same artist for sale to an art collector outside his or her African cultural context, a mask that will never be used and given meaning through the performance of rituals? Would not that work lack a certain spiritual dimension that would preclude it from being considered a fully authentic African work? That mask, however, may still

be more authentic than another mask made for the same collector by an untrained artist. What about works by trained African artists imitating styles of other periods and times, and works by African artists raised in the Americas? What if such artists have access to better tools and can work more skillfully than the authentic African artists working in small African communities? Would the technical superiority of their work have any significance in this context? Many examples of mass-produced, so-called **airport** (or tourist) **art** are very well crafted, and many scholars are now taking a fresh look at these traditionally

overlooked art forms. If an African-American artist returns to Africa and studies with a recognized artist there, can that individual recapture certain rights to his or her heritage and create true African works of art? Clearly, one would not consider a work by a non-African for sale to a collector or tourist to be "authentic." But what about all the possible categories in between the genuine article and the out-and-out fake? It would seem that it is difficult or impossible to make firm judgments about the authenticity of many categories of African art that lie between the two ends of this spectrum.

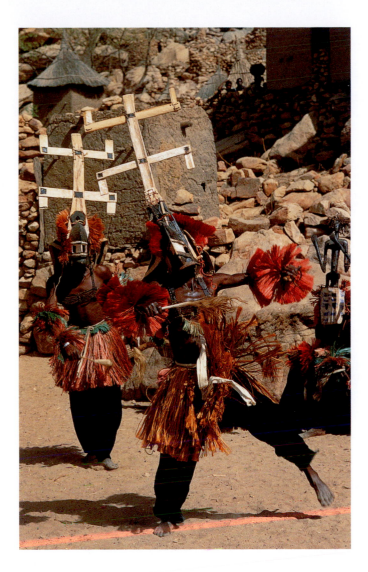

7.1 Masked *Kanaga* dancers. Dogon, Mali, West Africa. Late 20th century

the spread of the colonial religions and the institution of slavery, which uprooted many Africans and reduced them to poverty. In the past, Western commentators generally regarded African art as craft (objects with functional uses) rather than as "fine art." This view limited the appeal of African art to Western art collectors and art historians.

The way in which the colonial powers laid out the present-day countries in Africa, without respect for the continent's existing cultural and political organization, parallels the manner in which African art has been mistreated and marginalized in Western thought. Throughout much of the twentieth century, its style and content were often analyzed in modernist terms by people who knew little about its original cultural context. But in recent years, as archeological and ethnological projects have been gathering new information about African art history and more African scholars have entered the field, African art has begun to be understood and respected on its own terms. The terminology scholars use to discuss African art has also changed radically. Because the names of most African artists are lost, works had long been attributed to groups and seen as the expression of communal thinking. (See *In Context:* Artists and Attributions, page 234.) In recent decades, the traditional image of African art in terms of anonymous masks and statuary has been expanded, and this chapter discusses works created in a wide variety of materials and sizes in ways that reflect the genius of recognized individual African artists.

sophisticated philosophies behind it, Western viewers can begin to recognize the importance of African art and the roles it has played in the life and culture of the continent.

THE HISTORY OF AFRICAN ART HISTORY

African archeology and ethnology are underfunded and still in their infancy, yet scholars are beginning to rediscover the historical dimensions of African art and recognize the cultural diversity of the art-producing groups in this enormous continent. The city of Benin, with its well-documented history, gives some indication of the yet-unreconstructed historical depth of sub-Saharan Africa. For a long time, the inventiveness and subtlety of African art were obscured by

AFRICAN PREHISTORY

At the end of the last glacial period, until about 6000 BCE, the Sahara was a land of lakes, rivers, and grasslands, home to fishing, hunting, and gathering peoples with pottery and tools and weapons of stone and wood. As this region became progressively drier and groups migrated to its edges, many became herders, cultivated domestic varieties of wheat and barley, and settled down in villages. Often, these settlements consisted of round earthen houses surrounding cattle pens. The Nigerians were smelting copper by about 2000 BCE, and they or their neighbors learned to smelt iron ores around 700–500 BCE. With the development of metalworking and other highly specialized professions came the flow of trade goods, the development of larger communities, and more complex societies.

Eventually, the Sahara became a broad expanse of arid desert through which travel became increasingly difficult, but the African lands south of it were never entirely cut off from North Africa and the rest of the world. Long after the pastoralists and their herds had abandoned the Sahara for more hospitable climates, Berber caravans were still

crossing the desert to trade Phoenician, Greek, and Roman goods for African gold. Their role was then assumed by the Muslims, and by the eighth century CE African merchants on the east coast of Africa were exchanging their gold, copper, and ivory with the Arabs, Indians, and Persians for manufactured goods and luxury items that included Chinese porcelains. By the early fifteenth century, European traders were arriving in West Africa, opening the way for the infamous trans-Atlantic slave trade and colonization of Africa in the nineteenth century.

At present, it remains difficult to survey the early history of African art. While we have reports by Arab and European travelers in Africa, there are few written documents by the Africans artists and patrons who understood the art and its cultural context. Missionaries, termites, floods, and fire took their toll on African art, much of which was made with perishable materials, such as wood and fibers. In addition, works that were made for particular ritual purposes were often discarded after those rituals had been completed. As a result, to Western writers, African art often appeared to lack historical depth. But where evidence is available—for instance, when permanent materials such as fired clay and bronze were utilized, as they were in Nigeria, to produce nonperishable works that were then collected in the nineteenth and twentieth centuries—it is clear that their forms derive from very ancient concepts and traditions.

The low status of enslaved Africans outside Africa, the poverty that has persisted in many areas of Africa since the abolition of slavery, and the socioeconomic conditions in Africa during the colonial and postcolonial periods, caused many Westerners to underestimate the sophistication of African art and culture. Also, for many, the abstract nature of much African art seemed (quite incorrectly) to demonstrate a lack of technical ability to render forms in their "correct" naturalistic proportions. Thus, because it diverged so radically from their expectations, the earliest Western audiences failed to appreciate the expressive force of the powerful, rhythmic forms and patterns of African art and its roots in religious thought and ritual performances. Although modern art used abstract forms and gave African art a new sense of credibility among collectors and scholars, modernism did very little to give African art meaning to the general public around the world. Moreover, despite the fact that the African Diaspora spread the knowledge of that continent around the world, and its heritage has been such an important part of American history from Brazil through the Caribbean to the United States, for many, African art has remained incomprehensibly exotic and foreign.

Westerners have looked upon African art for many reasons. African art was attractive to the "Primitivists" of the early twentieth century, who saw it as a potential source of spiritual strength in the renewal of Western civilization. (See *Cross-Cultural Contacts:* Pablo Picasso and African Art, opposite.) From a strictly formal point of view, African art appealed to many non-African artists, collectors, and writers in the twentieth century, but until one understands the thinking and emotions behind it, it remains merely the curious "other." (See *Analyzing Art and Architecture:* Primitivism: An Art-Historical Definition, page 236.)

IN CONTEXT

ARTISTS AND ATTRIBUTIONS

Nobody knows the names of the great Benin artists who created the finest bronzes, but two groups of related pieces have been attributed to artists known as the Master of the Circled Cross and the Master of the Leopard Hunt. When art historians discover a group of related works that appear to be by a single artist, they often name the unknown artist for one of the most characteristic works in the group. As more related works are discovered, these may then be attributed to that same master. Occasionally, the true name of the artist may be uncovered. For instance, works attributed to the Master of Buli (a town in the Democratic Republic of Congo) turned out to be by one Ngongo ya Chintu, who came from a nearby village. Thus, works formerly attributed to the Master of Buli are now credited to Ngongo ya Chintu.

The fact that the Benin and Ile-Ife heads are not signed, however, does not mean that the artists were anonymous or of low status. By creating works of art that were part of ritual and daily life, artists in Africa, Oceania, and other societies without writing were important members of their communities. African artists were thus often fully recognized by their peers, and continue to be well respected in sub-Saharan Africa.

PABLO PICASSO AND AFRICAN ART

African art was little known or appreciated in the West until the early twentieth century. At that time, a small group of artists and writers in Paris began visiting the Musée d'Ethnographie in the Palais du Trocadéro. Pablo Picasso was in Paris in 1907 and, along with other early admirers of African art, he was fascinated by what he called the sacred and magical power of the art, which he described as "a kind of mediation between themselves and the unknown hostile forces that surround them, in order to overcome their fear and horror by giving it a form and image." Picasso said that African art changed his approach to painting, and enabled him to see art as "a form of magic designed to be a mediator between this strange, hostile world and us, a way of seizing the power by giving form to our terrors as well as our desires."

The lack of contextual understanding for African art shown by Picasso persisted throughout much of the twentieth century as scholars worked hard to reconstruct the original thinking behind the art. In fact, Picasso, who focused on his personal reactions to African art, marginalized the importance of Africa when talking about his own painting. He once said that the smells and sights of one exhibition of African art "depressed me so much I wanted to get out fast." Years later, when asked about African art, Picasso said: "African art? Never heard of it!" However, looking at the African masks in such famous works as *Les Demoiselles d'Avignon* and Picasso's later Cubist works that incorporate African motifs, we cannot take his comment at face value.

SOUTHERN AFRICA

Southern Africa is home to the oldest known works of art on the continent. This area includes the present-day countries of Namibia, Botswana, Zimbabwe, Mozambique, Swaziland, Lesotho, and South Africa. A prehistoric African tradition of painting on stone outcrops, beginning around 27,500 BCE, developed independently from prehistoric art in Europe or other parts of the world. These earliest known inhabitants of Southern Africa and creators of Africa's longest-running art tradition are called the San (also known as the Bushmen, a name with negative connotations). They produced paintings and engravings at over fifteen thousand known sites, most of which are located in mountainous regions. These represent complex narratives of conflicts and a variety of daily activities. Repainted and superimposed images suggest that some sites were revisited repeatedly and had special ritual significance.

THE EARLIEST SOUTHERN AFRICAN ART

San folklore was recorded in the late nineteenth century, when the last San painters were active and the culture was in decline, but when many of their traditional ideas about art and culture appear to have been intact. It suggests that San art illustrates the activities of healers who went into trances, made contact with supernatural forces, and used their powers to heal, bring rains, and attract game. As a record of these events and experiences, the art played a part in the ritualism of the San for thousands of years.

The eland, the largest and slowest of the African antelopes, was an important subject in San art. It was a prime source of food and its potent scent symbolized power. A painting from the Game Pass shelter in the Natal Drakensberg shows men taking on eland features as they approach a dying eland that they have impaled with a poisoned spear (FIG. 7.2). As in most known San paintings, the active figures are generally shown in silhouette. According to San informants, at this point the men would begin to tremble and sweat profusely and bleed from the nose—like the poisoned eland—going into deathlike trances as they danced and appropriated the animal's powers. Among other things, the San believed that the power they absorbed from the eland would deflect "arrows of sickness" from themselves. This important theme in San art is depicted in a variety of ways in many locations, and the metaphor of the dying eland and the men leaving this world to enter trances is part of a larger concept of eland iconography in San society, which included various rites of passage.

PRIMITIVISM: AN ART-HISTORICAL DEFINITION

At the end of the nineteenth century, well after the West had accepted Asian art as art rather than as a mere exotic curiosity, scholars and artists in Europe and the Americas were still reluctant to accept the art of Africa, the Pacific Islands, and Native America as "fine" art. Even into the mid-twentieth century, works from these areas were often regarded as artifacts or craft and called "primitive." The term comes from *primitif*, a nineteenth-century French art-historical word used in reference to certain late medieval and Early Renaissance Italian and Flemish painters. Eventually, it was applied to the non-Western art traditions listed above. The term was fully canonized with Frans Boas's *Primitive Art* (1927) and Robert Goldwater's *Primitivism in Modern Art* (1938).

Following the evolutionary theories of Charles Darwin, many late nineteenth- and early twentieth-century writers thought the "primitive" styles of art in Africa, the Pacific, and the Americas contained certain "prime" forms from which Western art had evolved. So little archeological and ethnological fieldwork had been done at this time that they did not recognize the intellectual complexity of this art and its associated rituals. Moreover, the Western theorists also failed to see these traditions as mature lines of thought that were distinct from the Western tradition.

Although the original connotations of the word "primitive," as it was applied to the art of Africa and the Pacific Islands, were intended to be positive, the term itself was misleading, and the more recent connotations that developed outside art history after the mid-twentieth century linked it with technological underdevelopment and poverty. Meaning "early," the term implies that the art of these societies did not pass beyond an early stage in its development. Using Western standards of technological development as a yardstick to evaluate the arts of different peoples around the world, such terms as "primitive" or "barbaric" have strong overtones of colonialism and racism. "Tribal" has since been suggested as an alternative, but along with such terms as "ethnic" and "native," it too has certain negative, emotionally charged connotations. Some writers have capitalized "Primitive" to emphasize its historical character or set it in quotation marks, as here, but its use remains a matter of intense debate.

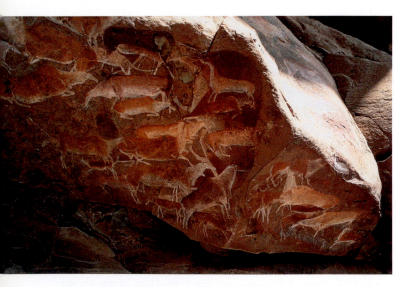

7.2 Scene of men taking on eland features as they approach a dying eland. Game Pass shelter. Kamberg, Natal Drakensberg, South Africa. Undated. Pigment on rock

GREAT ZIMBABWE

By the first millennium CE, groups of Southern African herders began congregating in large villages, often on hilltops for defensive purposes. These inhabitants were also skilled in carving ivory and in smelting and forging metals. With their plentiful supply of flat granite slabs of uniform thickness that break off the rock outcrops, the Shona of present-day Zimbabwe began dry-stacking them (using no mortar) to build walled enclosures called **zimbabwe**. The name comes from the Shona, *dzimba dza mabwe*, meaning "house of stone." In common usage, *zimbabwe* can also mean "ruler's house" or "house to be venerated" because the largest of these structures may have been royal residences. Technically speaking, *zimbabwe* are not houses as such, but sets of gently curved walls that partially enclosed groups of clay and wood houses with thatch roofs.

The largest enclosure group, Great Zimbabwe, was the capital of the Shona kingdom and home of its ruler (FIG. 7.3). The royals there were surrounded by lesser royals,

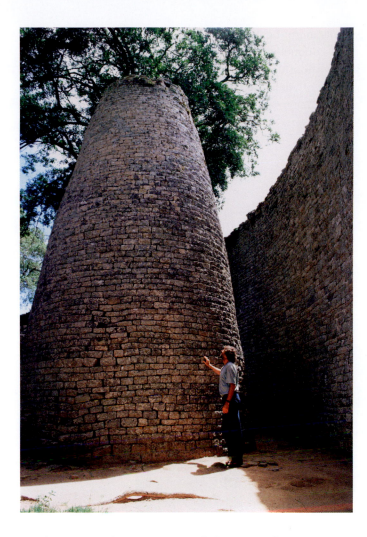

7.3 The Great Enclosure, Great Zimbabwe. c. 15th century CE

items, suggesting that they may have been royal reception chambers. Some fragments of the original clay reliefs on the walls have survived, but treasure-seekers plundered most of the *zimbabwe* in the nineteenth century. As a result, we know very little about the portable arts that might help to explain why the Shona built the *zimbabwe*.

Few *zimbabwe* are complete enclosures with protective doors and these massive constructions lack other military features that suggest they were conceived as protective walls. The idea that these massive walls have no protective function may come as a surprise to some viewers because they are so high, and the lack of any architectural markers such as columns, cornices, or moldings that might scale them to their human occupants further amplifies their massiveness. This austerity may have been intentional: In their lack of human touch and decoration, the walls remain "natural," close in spirit to the outcrops and cliffs from which their stones came. As one walks through the narrow, curving passages defined by the walls, the floor beneath one's feet resembles a trail through the clefts and boulders in the cliffs in the nearby hills. For modern visitors to the *zimbabwe*, it is hard to describe the sensation of moving within this monumental middle-ground environment that exists somewhere between nature and architecture. However, we may find an explanation for this equivocality in Shona thinking.

The Shona believe that the spirits of their powerful royal ancestors still live among them in nature. They own the land, animals, and crops, and act as mediators with the gods, some of whom also live in nature as well. Thus, in the Shona cosmos, the world of the living blends with the spirit world of the ancestors and the gods as they are manifested in nature. There may be parallels between the way the curving walls "grow" out of the ground and hillsides, yet remain part of them, and the Shona cosmos in which their everyday world blends with that of their ancestral spirits and the gods in the earth. The massive curved walls, it would seem, literally wrap and hold the houses of the living in the power of the spirit world.

The Portuguese arrived in sub-Saharan Africa shortly after the political preeminence represented by Great Zimbabwe had passed to other areas in Southern Africa. These outsiders ultimately undermined the economy of the region by disrupting its long-established trade routes to other parts of Africa and such important ports on the Indian Ocean as Sofala. While no more structures on the scale of Great Zimbabwe were built, individual artists continued to produce items for everyday and ritual use. Many of the masks and carved figures used in highly secretive rituals were never seen by the art collectors who arrived in the nineteenth century, so these important works are not preserved in museum collections today.

officials, and other families living in somewhat smaller or unwalled house groups scattered across the countryside. The kingdom reached its zenith about 1250–1450 and, by the nineteenth century, Great Zimbabwe had become an internationally recognized symbol of Africa. The divine priest-king of the Shona received tribute from his dependencies in the form of gold, copper, tin, ivory, cattle, and exotic skins, and traded with the Arabs at the port of Sofala to the east on the Indian Ocean for luxury items such as fine Indian cloth and Ming vases. By the fourteenth century, the trade-rich Shona king ruled roughly a million people in an area about the size of present-day Spain. When Southern Rhodesia won its independence in the late twentieth century, the country took its new name, Zimbabwe, from this imposing monument and the other roughly 250 large stone walled *zimbabwe* that dot the countryside.

Excavations in some of the largest *zimbabwe* have revealed built-in platform seats, sealed subchambers (probably storage places for valued items), and tables to display such

EAST AFRICA

Many of the earliest known human-made tools come from East Africa. Important works of art come from the present-day countries of Mozambique, Tanzania, Kenya, Rwanda, Burundi, Somalia, Ethiopia, and Sudan. While little is known about the beliefs and rituals of the most ancient cultures, in more recent times much of the art from this region has been made to commemorate major events and changes in the life of the community. These rites of passage include the initiation of boys and girls into adulthood, the installation of chiefs, funerals, and other activities honoring the spirits of the dead.

MOZAMBIQUE, TANZANIA, AND KENYA

Many of the masks made by the Makonde in Mozambique and Tanzania were used in their ceremonial initiation dances. The adults would tell the young boys being initiated that a figure wearing a mask with deep-set eyes, long hair, and a fiercely aggressive expression was a spirit who had returned from the dead. The mask was but one part of an elaborate costume that concealed the body of the person dancing. Later, the adults tested the courage of the boys by asking them to attack and unmask the frightening spirit dancers.

The final rite of passage, death, is traditionally surrounded by many complex rituals. Among the Giryama of Kenya, following a funeral ceremony, the deceased may appear to a wealthy kinsman in a dream and ask for a new place to reside outside the graveyard. That relative might then commission a carved funerary post to be erected in a special precinct outside the cemetery or in the village (FIG. 7.4). Memorial poles might also be raised to honor someone whose body was never found and for whom there was no grave. Often the faces are very naturalistic, individualized, and expressive, but they are probably not intended as portraits. The bodies are usually decorated with geometric forms, such as triangles and rectangles, and painted red, white, and black. These forms may refer to events in the life and death of the person being honored. As the ancestors slip from memory, the poles decay and disappear.

The prominence given to the location of the pole in the community might reflect the wealth and power of the ancestor and the individual who commissioned it. Offerings of coconut oil, chickens, and goats might be given to the spirit residing in the pole. It was generally believed that it was safer to conduct these ceremonies in a community of the living than in a cemetery, where potentially dangerous spirits might be lingering. A properly consecrated pole and well-conducted ritual that appeased the deceased ancestor without disturbing other spirits was considered to be a source of vitality and harmony for the community.

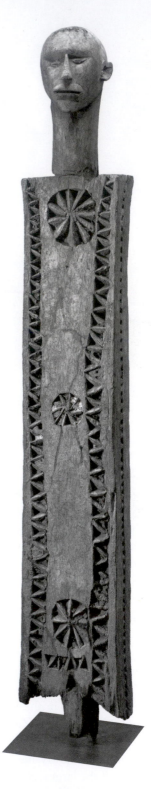

7.4 Funerary post. Kenya, Giryama. Early 20th century. Wood, height 51¼″ (130.2 cm). Private collection

RWANDA

Basketry remains a very important art form in many parts of Africa, including Rwanda, where the women of the ruling Tutsi groups excelled in the production of fine-coiled baskets with precise stitching. Their flat, saucer-shaped trays and round, house-shaped baskets with tall, conical "roof" lids mix the pale gold color of the grass with patterns of blacks and brick-reds (FIG. 7.5). The technique is very time-consuming, but the finished pieces have a monumentality that makes the smallest of them appear much taller than they really are. African techniques and styles of basketmaking continue to be practiced by women living along the southern Atlantic coast of the United States and are discussed with African-American folk art in this chapter (see page 263).

ETHIOPIA

Egyptian and Syrian missionaries Christianized portions of East Africa along the upper reaches of the Nile River between the fourth and sixth centuries CE and introduced varieties of early medieval Christian art. However, Christian art and thought took on an African and distinctive Ethiopian character when they arrived in East Africa as the scriptures were translated from the Greek to the Ethiopian Ge'ez. The early medieval manuscripts may have been illustrated by Ethiopian artists, but unfortunately no examples predating 1350 have survived. A seventeenth-century Gospel showing Matthew with raised hands (a traditional early Christian pose for prayer) and the facing page with his writings in Ge'ez bears little relationship to any of its ancient

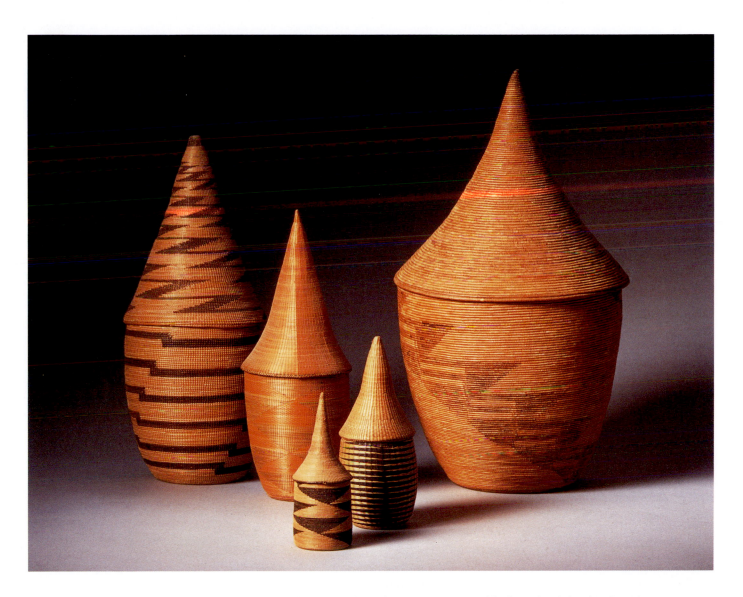

7.5 Five miniature baskets. Rwanda and Burundi, Tutsi. Early 20th century CE. Grass, black, and red dye, height 11" (28 cm), 9" (23 cm), 4³⁄₈" (11 cm), 5½" (14 cm), and 13" (33 cm). Collection of W. and U. Horstmann

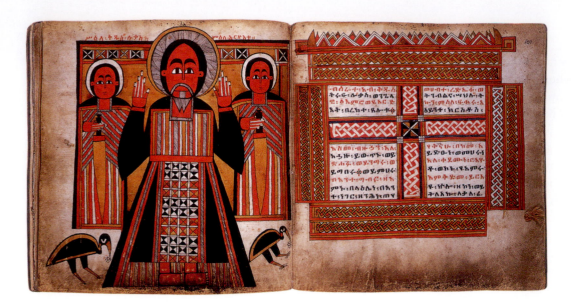

7.6 The Gospel of St. Matthew. Ethiopia, Lasta. 17th century. Parchment, 10½ × 9¾" (26.8 × 24.9 cm). The British Library, London

Egyptian or Syrian sources (FIG. 7.6). Working with bold patterns of red, black, and white ink on dried and treated animal skins, the artist has captured the saint's sense of inspiration and the divinity of his words within the elaborate frame on the facing page.

CENTRAL AFRICA

Central Africa is a vast region of diverse climates, including large rainforests and open and wooded savannas. Many of the most important works of art come from Gabon, Congo, the Democratic Republic of Congo (formerly Zaire), and northern Angola. The present political boundaries established in colonial times bear little relation to the cultural boundaries of the indigenous African groups living in this area.

The veneration of ancestors who may work as intermediaries connecting the living with the gods of the otherworld is an especially important form of worship in Central Africa. The political powers passed down from these ancestors and from one chief to another at their initiation ceremonies are often symbolized by staffs with ornate, carved ivory handles. The kneeling position of this figure (FIG. 7.7), with its hands resting on its thighs, signifies obedience, while the turned head symbolizes watchfulness, attributes claimed by the staff's succession of owners. Many staff figures represent women since the powers of the ancestors and gods are passed down from one generation to the next through female fertility. The sculptor has exploited the smoothness and consistent grain of the ivory and modeled the features of the woman with great delicacy to capture the softness of human flesh along with the cultural ideals of behavior that applied to chiefs and their followers alike.

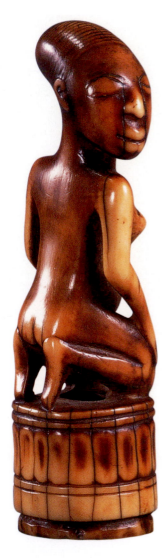

7.7 *Mvuala* (staff handle). Angola/Democratic Republic of Congo, Solongo. 19th or 20th century CE. Ivory, height 4¼" (11 cm). Private collection, Brussels

CHOKWE AND KONGO

The Chokwe, who live around the border between present-day Angola and the Democratic Republic of Congo, are renowned for the skill of their woodcarvers. One of their best-preserved memorial or effigy statues honors a mythical ancestor, prince, great hunter, and civilizing hero named Chibunda Ilunga (FIG. 7.8). It shows him as a powerful man, with large hands and feet, a royal headdress, long beard, staff, and flintlock gun. The miniature figures perched on the ridges of his headdress are helpful spirits on the lookout for game and predators. The bold carving of the prince's exaggerated muscularity gives this figure a sense of monumentality and power that belies its actual size.

Some African rituals are communal festivals; others are relatively private ones in which individuals and religious leaders communicate with the spirit world, often with the aid of works of art. Specially trained priests of the Kongo in the Democratic Republic of Congo use a type of carved wooden statue called a **nkisi nkondi** (FIG. 7.9). The name means something like "hunter" because the priests use such works to "hunt" for solutions to village problems and to

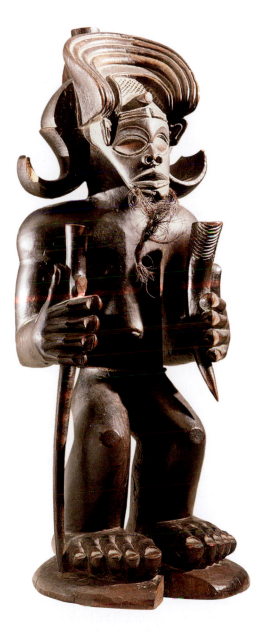

7.8 Figure of the "Civilizing Hero" Chibunda Ilunga. Angola/Democratic Republic of Congo, Chokwe. 19th–20th century. Wood, human hair, and hide, 16 × 6 × 6″ (40.6 × 15.2 × 15.2 cm). Kimbell Art Museum, Fort Worth, Texas

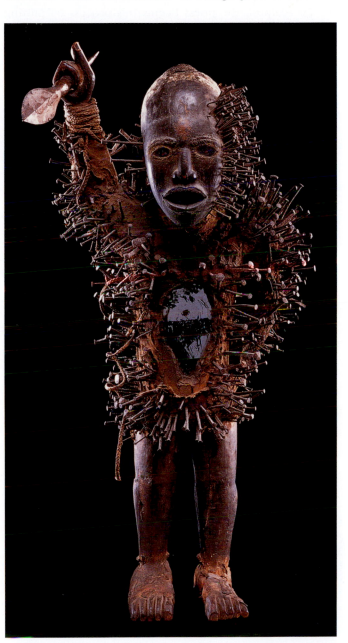

7.9 *Nkisi nkondi* (hunter figure). Democratic Republic of Congo, Kongo. Collected 1905. Wood, metal, glass, and mixed media, height 38″ (97 cm). Barbier-Müller Collection, Geneva

search for wrongdoers, including those who do not keep sworn oaths. A good "hunter" can also solve legal matters, counsel married couples, control the destructive powers of nature, and protect a village from outside enemies. Not all "hunters" are human figures; some are wild animals belonging to the ancestral spirits who could mediate between the living and the dead.

The most potent "hunter" images cannot be stored in ordinary houses; they are carefully guarded in special places by their priest-owners, who know how to unleash and direct their powers. After receiving the carved body and head of a "hunter" from a sculptor, the priest begins this process by putting medicines and fetishes in the container on top of the head and in the box over the stomach. These fetishes may include relics of dead ancestors or bits of clay from a cemetery that help the priest and "hunter" contact the spirits of the dead. The priest may also give the "hunter" a headdress and attach horns, snake heads, or beads to it, drive nails, blades, and other sharp objects into its body, and attach miniature images of the musical instruments the priest will play in the rituals when he unleashes the powers of the "hunter."

A client asking a priest to unleash the power of his "hunter" will swear an oath before the figure and thrust a nail or blade into its body to bind him- or herself to the spiritual forces residing in the statue. Nails are usually not driven into the face or the box over the hole in the torso where potent magical ingredients are stored to attract the spirits. If an animal has been stolen, bits of its hair or a rag the animal has touched may be attached to the "hunter" so that it knows what it is being asked to find.

Pounding new nails, blades, and other bits of metal into a *nkisi nkondi*, invoking it with strong and colorful language, and, at times, insulting the "hunter" by questioning its powers, are supposed to anger the "hunter" and bring it into action. Sometimes the metal pieces are removed after it has found a solution to a given problem. The large number of skewers on the body of the "hunter" and the open holes where old ones have been removed or fallen out show how often the figure has been called upon to work its powers and bear testimony to its effectiveness as a "hunter."

When nails and blades are driven into a "hunter" that is searching for an offender, the Kongo believe that the wrongdoer will begin to suffer intense pain. Thus, someone suffering from a headache or body pains may suspect that an enemy is at work with a priest and "hunter." He or she may then consult another priest with a proven "hunter" to perform a curing ceremony, prescribe medicines, and alleviate the pain.

Although colonial administrators attempted to repress their use after 1920, some "hunters" remain at work today. Many others, with their rough, prickly cloaks of highly decorative skewers, attracted art collectors and have been preserved in museums. In the Western media, these ideas have often been spectacularized and misrepresented as "Voodoo," or "Vodu," which is actually a very serious religious practice, turning all these forms of African worship, inappropriately, into comedy. The full impact and meaning of such pieces cannot be fully appreciated outside the context in which they were originally used, alongside songs, dances, and sacrifices and the spirit of belief that surrounded them among the Kongo.

WEST AFRICA

The most important art-producing areas in West Africa lie along the coast from Cameroon to Senegal and inland around the upper Niger River in Mali and Mauritania. Scholars continue to debate whether the ironworking technology that spread west from the modern Nigerian–Cameroon border around 500 BCE was imported or actually developed in that region. Iron tools made it possible to clear the forest and build productive farms. As food production increased and the population grew, some groups became urbanized and developed highly specialized art and craft traditions. Many of the best-known African works of art come from the sites of Ile-Ife and Benin in Nigeria, Cameroon, and Djenné in Mali.

NIGERIA

Nigeria has been home to a long succession of important styles of sculpture in which the artists explored ways to represent realistic and idealized images of the human head and figure. Following the decline of the widespread Nok tradition (c. 500 BCE–200 CE) of making modeled and fired clay sculptures in central Nigeria, the metal sculptors at the sites of Igbo Ukwu, Ile-Ife (Yoruba), and Benin (Edo) produced a long series of spectacular heads, some of which may be portraits of their rulers. To this day, the Yoruba people have continued to produce important works of art in the ancient Nigerian traditions.

NOK

The Nok style is named for the type-site in northern Nigeria where the first examples of the style were found. Most of the figures are human, but the artists also portrayed snakes, monkeys, elephants, and rams. The Nok people grew grains and used bellows with clay nozzles to ventilate furnaces that were hot enough to fire clay and smelt metal ores. Any works that they may have produced in wood or other perishable materials have long since perished, but it is possible

that the few surviving clay and metal examples were part of a much larger variety of associated art forms.

Although many of the figurines may have been used in shrines, on altars, or deposited in graves, few pieces have been found in these original ritual contexts. The figurines appear to have been washed out of their original settings by floods and no complete figures have been recovered. All known Nok figures have large heads and short stout bodies, the largest of which, about 4 feet (1.2 m) tall, have nearly lifesize heads. These heads were made by hand, without the use of molds, and later joined to bodies. The scale of the heads may reflect a later, widespread African belief that the head, as the site of one's individuality, is the spiritual essence of the body.

The Nok style contains a number of substyles, which may represent regional variations as well as formal changes that took place over the centuries. Within these stylistic variations, most Nok heads share a number of basic features (FIG. 7.10). The pupils in their eyes are usually deep round holes ringed with triangular or circular eyelids. Mouths are normally pursed or open but teeth are seldom shown. Noses may have wide perforated nostrils. Nok sculptors show a preference for closely matched sets of crescent-shaped lines, gently swelling volumes, and smooth, well-finished surfaces.

ILE-IFE AND THE YORUBA STYLE

From c. 1200 to c. 1400 CE, the Yoruba capital at Ile-Ife was the most important art center in Nigeria. This period is called the Pavement Era because the Yoruba paved certain rectangular areas within the city with rows of stones and pottery fragments laid in herringbone patterns. Libations may have been poured into broken vessels in the middle of the paved areas during rituals, in much the same way that rituals are carried out in Yoruba lodges today. Raised platforms at the end of the pavement were probably altars where works of art, including memorial heads of divine rulers and important ancestors, were displayed (see FIG. 1.1). The head, which in Yoruba thought is associated with knowledge, character, and judgment, was the most important image in their art. The possible sources of the Ile-Ife style in the immediate area are many, but none of them is sufficient to explain the blend of realism and idealism, the sense of beauty, developed by the Yoruba in Ile-Ife by about 1200 CE.

The Yoruba developed their style of portraiture making terracotta, stone, and wooden heads in the pre-Pavement Era, and later they applied these skills to the creation of cast-metal portrait heads and figures. They used the **lost-wax method** of casting large hollow figures in bronze (composed of copper and tin), brass (copper and zinc), and related alloys. (See *Materials and Techniques:* Lost-Wax Metal Casting, page 244.) Heads such as that shown in FIG. 1.1,

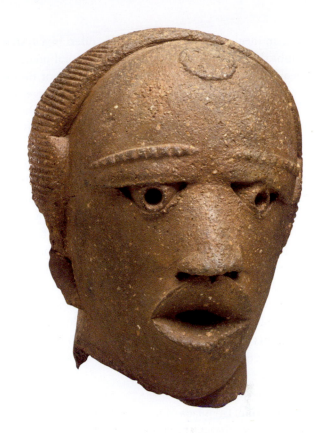

7.10 Head from Jemaa. Nigeria, Nok. 5th century BCE. Terracotta, height 9⅞″ (25 cm). National Museum, Lagos, Nigeria
Any attempt to interpret the Nok figures illustrates the difficulties encountered by archeologists working with early materials for which there are no written records. Images depicting human deformities or diseases may possibly have been used in curing ceremonies, and the double-headed figures could express the male/female duality in nature. Archeologists have also hypothesized that the figures represent important leaders, revered ancestors, or mythological figures that might have been used in connection with ancestral and funerary ceremonies. Further, they could have been set on finials over shrines, on altars, or, in some cases, possibly worn as pendants. To add to the list of unknowns, we cannot determine why the style died out or exactly when and how the Nok techniques of sculpture were passed on (if indeed they were) to later groups in Nigeria.

which was buried with other brass objects at the back of the king's palace at Ile-Ife, may have been used to display the royal regalia in the annual rites of renewal and other ceremonies of royal ancestor worship. The small holes dotting the face were probably used to attach a wig, crown, and neck rings. A beaded veil covering the face may have been attached to a crown. Such veils are still worn by Yoruba leaders to shield their subjects from the power of their voice and presence. The dramatic quality of the man's narrow, piercing eyes, the majesty of his bearing, and his *odo* (youthfulness), suggested by the smooth features, combine

to create an idealized image of the Ile-Ife ruler. In a system of thought that interweaves aesthetics with moral precepts, this ideal stresses the traditional Yoruba themes of honor, respect, and the value of one's *inu* (inner qualities) over the *ode* (exterior self). In essence, modern Yoruba aesthetics center around the phrase *iwa l'ewa* ("character is beauty" or "essential nature is beauty").

This seated figure from Tada, Nigeria (FIG. 7.11) is the finest surviving product of the Yoruba smiths. Although the lower arms and one foot are missing, from the remaining limbs we can see how the sculptor integrated all the body parts in a continuous flow of rounded forms. The face and body have a portraitlike quality, and the figure may have been placed on a low throne and dressed in miniaturized versions of the vestments worn by the leader it represents.

As the late nineteenth-century Yoruba kings began to lose some of their power, the beadwork on their clothing, scepters, and crowns became increasingly elaborate. A guild of beadworkers linked to Obalufon (god of beadworking,

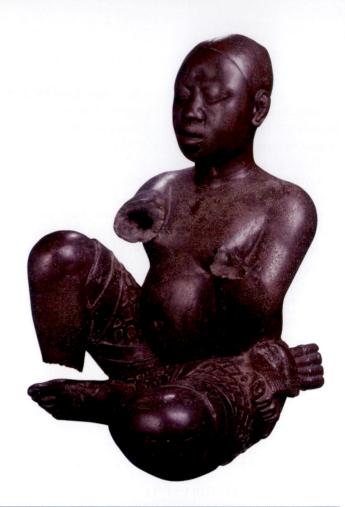

7.11 Seated figure. From Tada. Yoruba, Middle Niger region. 13th–14th century. Copper, height 21⅛" (53.7 cm). National Commission for Museums and Monuments, Nigeria

MATERIALS AND TECHNIQUES

LOST-WAX METAL CASTING

The artists of Nigeria were skilled in the use of the lost-wax (in French *cire perdue*) method of casting large hollow figures in bronze (composed of copper and tin), brass (copper and zinc), and related alloys. The process involves a series of important steps (see FIG. 1.1). First, an inner mold closely resembling the shape of the desired piece, such as a head, is made out of heat-resistant clay. The artists then apply a layer of wax to the clay and detail it to make the desired image. After installing a set of wax rods and a drain cup beneath the head or body to allow the wax to drain out, the wax and clay core are encased in a thick outer clay mold. When it has dried, the mold is heated so that the wax melts, drains, and leaves a thin open space between the inner and outer molds. The mold is then inverted and hot molten metal is poured in through the drain and cavities left by the wax rods to fill the spaces where the wax image of the head was "lost." Once the metal cools, the inner and outer clay molds are removed to reveal the metallic replica of the wax image. The drain rods (now cast in metal) are cut away, along with any other unwanted projections, and the piece is detailed to create the finished work. Because the mold is destroyed while removing the head, multiple copies of the image cannot be made by this method of casting.

Jewelry and small figurines may be cast in solid metal, but the lost-wax, hollow-casting method presents certain advantages when working on a larger scale. The weight and expense of a solid bronze head would be excessive, and large masses of solid bronze tend to crack and distort while cooling. Traditionally, thin-walled cast bronzes, such as the early Benin pieces in Nigeria, have been much admired for their lightness and technical virtuosity.

YORUBA AESTHETICS

Many readers may be surprised to discover that scholars today know more about the Yoruba philosophy of art than they do about the ancient Greeks' thoughts on these matters. While the Greek writings on aesthetics have long since disappeared, some of the ancient thinking about Yoruba art lives on in their oral traditions, and as Yoruba-speaking ethnologists continue to record them, the discrepancy between our understanding of the two traditions grows ever larger.

Many Yoruba terms cannot be satisfactorily translated into English, so they are set in parentheses here following their rough English equivalents. Olórun, the High-God and Creator, is the source of all beauty (**ewà**), including inner beauty (*ewà inú*), a true form of beauty manifest in a person's character and morality, and outer or superficial beauty (*ewà ode*). Olórun gives his power to create (**ashe**) to a select few individuals who can be trusted to make "good" things happen in their community. In many African languages, the same word is used for "goodness" and "beauty." Canons of beauty in Yoruba thought include ideals of symmetry (*didógba*), balance (*ogbogba*), clarity of form and line (**ifarahon**), luminosity and delicacy (**didon**), and ornamentation that enhances beauty (*ohun èso*). Yoruba critics value **odo**, the

depiction of people in the prime of life. Even aged sages, valued for their knowledge, are portrayed as young and vigorous. Many Yoruba terms for art reinforce this idea.

Strictly speaking, Yoruba art is not purely religious, nor is it art for art's sake. It is religious art for life's sake. It is used to praise and please the gods so that they will grant people health, prosperity, fertility, and protection from their enemies. And, as art designed for the eyes of the gods, it has to be beautiful.

While Olórun is not represented in the arts, the lesser gods are shown in symbolic terms that emphasize their characteristics and beauty (*ewà*). A sculpture should contain a relative likeness (**jijora**) and capture the most essential characteristics of its subject without being too realistic or too abstract. Applied to the human figure and face, *jijora* means something like "resembling mankind."

The closely related principle of clarity of form and line (*ifarahon*) requires artists to include all the important information about a subject. Works of art with *jijora* and *ifarahon* that capture the essential and important parts of their subject matter reflect inner sight (*oju-inu*) and inventiveness (**ifarabale**), and are said to be cool (**itutu**). The words for "cool," "good character" (*iwa rere*), and "generosity" (*iwa pele*)

are nearly synonymous in Yoruba and many other African languages. In many parts of sub-Saharan Africa, the widely applied concept of coolness also encompasses notions of moderation, strength, smartness, repose, and peace. As such, it is an all-embracing ideal with social as well as artistic applications. By incorporating small bends and curves (*gigun*) in their work, artists and builders soften, or "cool," the austere qualities inherent in pure, straight lines and geometrical forms.

The critical traditions of judging art and dance among the Yoruba and many African groups are so highly developed that "criticism" is regarded as an art form in itself. Among the Yoruba, a good critic (*amewa*) is "one who knows beauty" or, to use a Western term, an "aesthete."

Other groups in Africa probably have similar philosophical ideals, which have yet to be recorded by ethnologists. For example, the Yoruba's neighbors to the west, the Dan in Côte d'Ivoire and Liberia, have a term, **nyaa ka** ("moving with flair" or "looking right"), that emphasizes the importance of vitality and style in their performances. They also have more general terms for awe or terror (*gbuze*), ugliness (*ya*), and beauty (*se, li,* or *manyene*) in their arts. To express their appreciation for an exceptionally fine performance, they may cry "*yaaa titi*" ("bravo").

weaving, and coronations) or Olokun (god of the sea) worked for the Yoruba royalty or priesthood. The beaded veil covering the face of a Yoruba ruler, Airowayoye I of Orangun-Ila, protects the viewers from the power of his eyes (FIG. 7.12). It hangs from the edges of his crown, the most important part of his regalia, which is tall to emphasize his head, the central place of his power, character, and beauty. Medicines and other ritually potent materials are placed inside such crowns to add to the ruler's power, which he must share with the "mothers" or witches represented by the bird heads on his tall, conical crown. Yoruba kings do not have absolute authority over their domains; groups of respected Yoruba elders select the kings-to-be from the royal families, review them periodically, and have the power to depose them.

7.12 The ruler Airowayoye I of Orangun-ila with a beaded scepter, crown, veil, and footstool. Yoruba, Nigeria. 1977

BENIN

Before the Yoruba city of Ile-Ife ceased to be a major art center in the fifteenth century, its sculptural traditions spread to a number of neighboring sites. These included Esie, Owo, and Benin, 150 miles (240 km) to the southeast, the capital of a highly centralized kingdom of Edo-speakers ruled by an *oba* (divine king). More is known about the art and history of Benin than about any other locality in sub-Saharan Africa.

When the Portuguese arrived in 1486, Benin was a thriving metropolitan center with palace complexes housing altars decorated with metal bells, figures, heads, wooden musical instruments, and carved ivory tusks. FIG. 7.13 is a plan of Benin City in the nineteenth century. The inner city—containing the king's palace, house of the town chief, and the workshops of the royal metal, ivory, wood, and leather guilds—was surrounded by a wall with nine gates and a moat. The palace, at the hub of a network of wide avenues leading in all directions, faced north, the world direction associated with Ogiwu, the god of thunder and power, and overlooked the artists' workshops. Royal councilors, descendants of the first dynasty of kings (the Ogiso, "Rulers of the Sky," c. 900–1250), and keepers of the ancient traditions lived in compounds within the outer city. The palace of the queen mother, a very important councilor to her son (but who was not allowed to see him once he became king), was outside the outer city wall.

An image of a royal procession leaving the palace, based on early descriptions and drawings of the inner city, shows the Benin king in a leopardskin cloak on horseback with his entourage (FIG. 7.14). They are preceded by leopards on leashes and drummers, and followed by members of the court, musicians, and nobles wearing

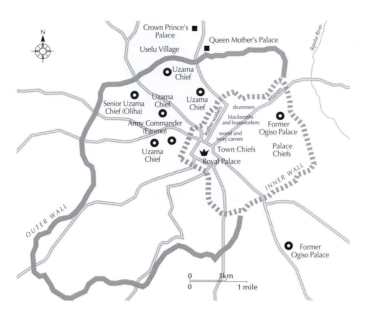

7.13 Plan of Benin City, Nigeria in the 19th century

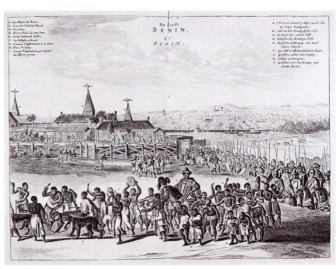

7.14 View of Benin City illustrated in Olfert Dapper's *Naukeurige Beschrijvinge der Afrikaensche* gewesten, 1668

leopardskins. In the background, the large metal birds on the rooftops of the palace may symbolize the king's role as the overseer of the destiny of his people. Giant sculptured pythons (not visible in the illustration) descending the length of these roofs with their mouths over doorways link the sky and earth and suggest that those entering the world of the palace (symbolically entering the python) are moving from the everyday world to another place and time. Inside the palace were altars to the kings and queens and brass relief plaques on the pillars, rafters, and doors depicting such important palace activities as hunting, war, and royal ceremonies. Foreign visitors to Benin before it was destroyed at the end of the nineteenth century talked of its long, wide streets and said its palace was the grandest in West Africa.

The earliest Benin artists working for the first Benin dynasty of kings predating the thirteenth century may have made terracotta heads in the manner of their contemporaries at Ile-Ife. These heads appear to have been the models for the later bronze heads commissioned by artists working for the current dynasty founded in the thirteenth century by Oranmiyan from Ile-Ife. Around 1300, Oguola, the fourth *oba* in that Ife-Benin dynasty, asked the king of Ile-Ife to send him a master metalcaster. Iguegha, the artist Oguola received from Ile-Ife, is still worshiped by the members of the **Iguneromwon**, the Benin bronzecasters' guild that bears his name. Oguola and his successors (to modern times) commissioned members of the Iguneromwon to make a wide variety of important ritual items for their royal altars (FIG. 7.15). With its durability, metal was the ideal material for images of the *obas* and other royal personages,

who were believed to be spiritual as well as physical beings with eternal lives.

Thus we have a long series of metal heads and other subjects from Ile-Ife and Benin spanning a period of about eight hundred years from the eleventh to the nineteenth century. Along with the oral traditions that were preserved and the many written records and drawings of Benin, its people, and its art that were made after the arrival of the Europeans, these survivals give scholars working in this area the raw materials with which to reconstruct the history of the art

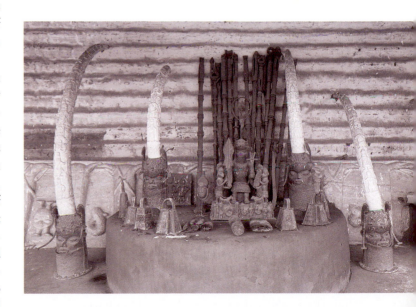

7.15 Altar dedicated to Oba Ovonramwen. Benin, Nigeria. c. 1914

that is lacking in many other parts of Africa, where most of the works are undated and probably come from the past century. This bounty of cultural and historical information is very attractive to art historians, but it also presents some problems and raises important questions. Because there is so much data and we can see styles developing over time as we do in the West, it has been tempting for art historians to focus on Nigeria at the expense of other sub-Saharan traditions that do not have such historical depth, but where we find art forms that are much more typical and representative of African art as a whole.

The sculptural styles at Benin can be observed as they change over a period of four centuries. Although legend says brass heads were cast during the reign of Oba Oguola (late fourteenth century), the earliest known heads may be no earlier than the fifteenth century. Traditionally, all of the bronzes and ivories in Benin produced by members of royal guilds belonged to the divine *oba*, who could loan or parcel them out as favors to his nobles. Even the chiefs and leaders of the bronzecasting guild had to be content with terracotta or wooden heads on their family altars. Altars in the palace were maintained by the specially trained *iwebo*, keepers of the royal regalia. The palace with its altars represented the physical and spiritual center of the Benin kingdom. On the death of an *oba*, his successor commissioned artists to make memorial images of him and his family for a new altar. Through these images, the living *oba* paid homage to his ancestors and maintained the Benin traditions of leadership. This ancient tradition of ancestor veneration, in which deceased leaders continue to have power over the living, remains a vital force in many modern African religions.

The smallest, most highly naturalistic, and thinly cast heads appear to have been made in the Early Period (1400–1500) under strong influence from Ile-Ife. Traditionally, these thin-walled bronzes have been much admired for their lightness and technical virtuosity. Heads became more stylized in the Middle Period (1550–1700), and in the Late Period (1700–1897) they are larger, heavier, and even more highly stylized. While modern collectors prize the early thin-walled pieces for the excellence of their casting, the thickness of the later works may have been intentional, to reflect the wealth that the Benin *obas* accumulated through trade with Europe.

Queen Mother exemplifies the sophistication and dignity of the Early Period of Benin art (FIG. 7.16). As the *iyoba* (queen mother), she would have been the highest-ranking woman in the Benin court. She wears royal coral-bead necklaces and an elegant peaked headdress that sweeps upward in a curve that echoes the forward thrust of her lower face, uniting the profile of the work in a single dominant C-shaped movement. Even in such early works, the Benin sculptors

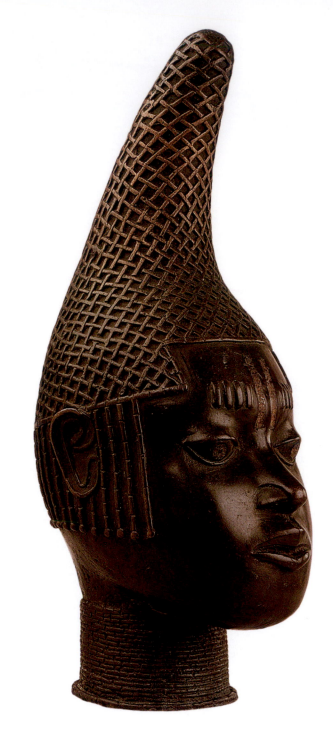

7.16 *Queen Mother.* Benin, Nigeria. Early 16th century. Bronze, lifesize. The British Museum, London

have abandoned some of the realism of Ile-Ife to create idealized or stylized images of such important nobles. The development of these images of power parallels the Benin perfection of the methods of metalcasting. In terms of their technical excellence, the light, thin-walled early Benin bronzes are comparable to the finest works of the ancient Greco-Roman and Renaissance metalsmiths.

In another smaller image of a queen mother carved in ivory, we see how the Benin sculptors adapted their techniques of working fully in the round to that of high relief (FIG. 7.17). The small ivory mask represents Iyoba Idia, mother of Oba Esigie (ruled 1504–50). He may have worn this ivory portrait on ceremonial occasions as a belt pendant and memorial to his mother after she died. There was a special ivorycarvers' guild and, like brass, the material's use was restricted to the king and those to whom he granted his favor. We see the influence of Europe in the subject matter, but not the style of carving. The faces of Portuguese soldiers appear in the crest over her head, where they alternate with mudfish. The fish are symbols of Olokun, god of the sea, wealth, and fertility, who is represented on earth by the *oba*. The portrait is another fine example of the way the sculptors of Benin are able to combine realistic and ideal forms and capture the memory of the queen's face in terms of their long-standing formal conventions, giving her a quiet sense of repose and an air of dignity befitting her elevated position in the court.

The altars remained intact until the palace was burned by a British naval expedition in 1897. The palace collection was confiscated in haste and sold off without first being fully documented, so it is difficult to tell which works were originally grouped together on altars. Later, some of the altars were restored, and the *oba* was reinstated in 1914. The Benin dynasty, representing one of the longest reigns in human history, continues to rule to this day. In 1979, Eredia-Uwa was installed as the thirty-eighth *oba* in the dynasty begun by Oranmiyan in the thirteenth century.

Altars remain important focal points of religious devotion and other activities among Edo-speaking people today. Most households have at least one altar-shrine to Olokun. Worshipers gather there to offer prayers and ask for his blessings. The Edo believe that he can increase a family's wealth and raise a woman's status in the community by giving her more children. The most basic altars are equipped with waterpots, miniature canoes with paddles (symbolizing social mobility), white chalk markings, coral beads, and cowrie shells (a form of currency and symbol of prosperity). In wealthy homes, altars may include carved wooden images of Olokun enthroned in his palace beneath the sea along with his attendants and wives, one of whom may be the central figure in the installation. In FIG. 7.18, Madame Agbonavbare of Benin, wearing a ritual dress decorated with cowrie shells, is seated before her Olokun altar-shrine. This includes a variety of statues, with facial and bodily features reflecting the traditional Nigerian styles of sculpture, and strings of cowrie beads hanging from the ceiling, and it makes strong use of the colors red (sacrifice and blood) and white (purity).

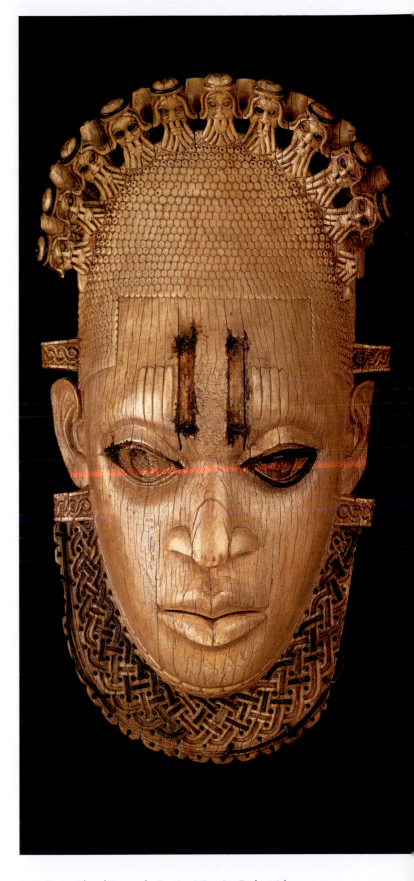

7.17 Pectoral or hip mask, Benin, Nigeria. Early 16th century. Ivory, height 9¾" (25 cm). The British Museum, London

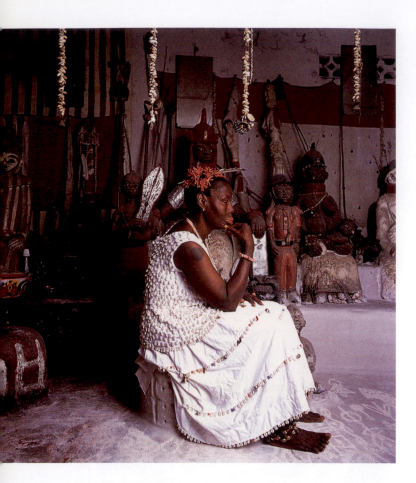

7.18 Madame Agbonavbare of Benin wearing a ritual dress decorated with cowrie shells, seated before her Olokun altar-shrine

Someone who dreams about swimming in the ocean may be a candidate for the Olokun priesthood. Following a period of instruction and initiation, a new priest or priestess is expected to create all the objects needed for an altar. He or she must also infuse all of these objects with life forces and spiritual powers and create songs, dances, costumes, and prayers that are powerful enough to reach the spiritual world, attract Olokun, and ensure his blessings. In this process, each priest or priestess has the "artistic license" to be a multimedia performance artist. Before a ritual, the area around the altar must be swept clean and the objects on it purified with medicines. A priestess such as Madame Agbonavbare will also be purified and robed before she conducts a ritual. Dancing with animated, acrobatic spinning motions, she will enter a trance to attract the spirits to the dancefloor and altar. The ritual will end with slower, resting songs as the spirits depart and the priestess returns to the material world. Altars to the African gods and goddesses are also important in the Americas, from Brazil through the Caribbean to the United States.

THE MODERN YORUBA AND THEIR NEIGHBORS

Although Ile-Ife declined as a major center of the arts, the Yoruba courts continued to commission important works of art. Olowe (c. 1860–1938) spent much of his career at the Yoruba palace at Ise directing up to fifteen assistants, carving posts, chairs, doors, bowls, drums, and other ritual objects for his royal patrons. He created his most famous work, a set of doors (1910–14), while working for the regional king of Ikere Ekiti (FIG. 7.19). The doors separated a veranda where the king sat during certain ceremonies from a shrine displaying an image of the king's head.

The ten panels on the doors document the visit of the British commissioner of Ondo province, Captain Ambrose, to the Ikere Ekiti court in 1897. In the fourth register, the enthroned king with a beaded crown and his principal wife on the left await the arrival of Ambrose (to the right). The commissioner is riding in a litter carried by African porters and accompanied by guards, a flautist, and shackled packbearers. Above the king we see his armed bodyguards; below are military men and more of the king's wives, who appear as witches, symbolizing the king's power. Shortly after Captain Ambrose's visit, a civil war broke out among the Yoruba and the British intervened, resulting in the setting up of a colonial government. Thus, Olowe's door documents a bitter-sweet moment in Yoruba history, a diplomatic prelude to their takeover by Britain.

Working within the Yoruba traditions, Olowe has developed a personal style characterized by the use of figures in high relief, decorative backgrounds, and well-structured rhythms that integrate the narrative content with the shape of the doors. To document the event, Olowe combines the traditional Yoruba figure and face types with the spectacle of the newcomers to express the dignity of his ruler on the eve of the Yoruba's political and social crisis. Olowe's doors were shipped to Britain and shown at the British Empire Exhibition, London, in 1924. Later, in exchange for the doors, the king, whom Olowe shows seated on a spindly folding chair, received a British-made throne.

The much-studied **Gelede** ritual of the Yoruba is performed to serve and honor the women elders or "mothers," ancestors, and deities. As guardians of society, the elders have powers that go far beyond those of fertility and may be equal to or greater than those of the gods. *Gelede* rituals begin with the night songs and dances performed in the marketplace, an area under the authority of a woman on the king's council of chiefs. Many women work in the market, where they can accumulate wealth and status independently of their husbands. The market, at the heart of society, is a Yoruba symbol for the transitory nature of worldly existence. It is also a place of transformation where spirits can

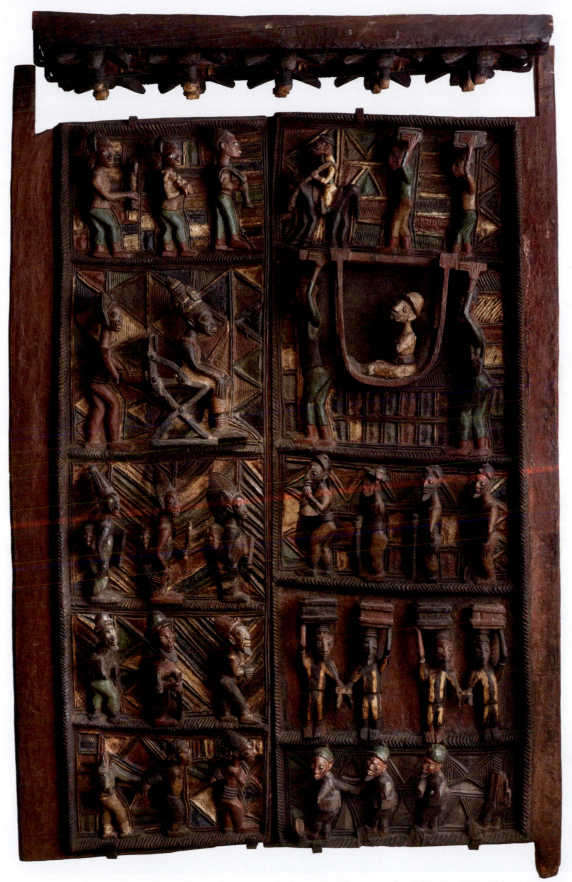

7.19 Olowe of Ise, door from the king's palace at Ikere, Yoruba, Nigeria. 1910–14. Wood, height c. 6' (1.83 m). The British Museum, London

enter our phenomenal world and the "mothers" can make contact with the otherworld.

The calmness of the masks used in the night songs and dances represents the *ori inu* (inner sight) and reflects the balance and patience of the "mothers" (FIG. 7.20). The Yoruba believe that the *ori inu* is the seat of one's *iwa* (essential nature), *iponri* (spiritual essence or individuality), and *ase* (life force), which pervades the cosmos. The masks contrast strongly with the rich, colorful detailing of the performers' costumes and the rhythmic energy of the music to which the pairs of dancers move as they recreate the movements of the gods.

The excitement of the first-night portion of the ritual reaches a climax with the appearance of a male performer, Oro Efe, who chants and dances in stately sweeping, curving, and spiral movements. With an authority granted by the *iyalase*, the female head of the ritual and the "mothers," Oro Efe is able to speak on any matter with total immunity from communal sanctions. At this point and elsewhere in the performance, the *Gelede* has an educational function as it reinforces traditional values, including the role of men and women in Yoruba life. And, as the *Gelede* honors and pampers the powerful "mothers," the ceremonies also attempt to ensure peace within the society by harnessing the patience and indulgence of the "mothers" while "cooling" their potential destructive powers.

The costumes worn in the later afternoon portions of the *Gelede* ritual, in which dancers compete for the attention of the audience, are highly elaborate images of power. In recent years, some of them have incorporated modern imagery, such as airplanes, automobiles, motorcycles, and tourists with cameras. As a lavish, interactive music-and-dance multimedia production that invites and receives audience participation, the *Gelede* is honored in a well-known Yoruba saying: "The eyes that have seen *Gelede* have seen the ultimate spectacle."

In lower Nigeria, among the Igbo around Owerri, complex rituals accompany every stage of the planning and construction of **mbari** houses, or shrines for Ala, their earth goddess (FIG. 7.21). Each stage of the project, from the decision to build the house to its final unveiling, is accompanied by lengthy and elaborate rituals of offerings and prayers. Communities may build a *mbari* house if they have had poor rains or bad harvests, or if people have died suddenly for no apparent reason. These events may indicate that Ala has been neglected and is unhappy and in need of propitiation—hence the need to build her a house that no human will enter after the dedication ceremonies are finished.

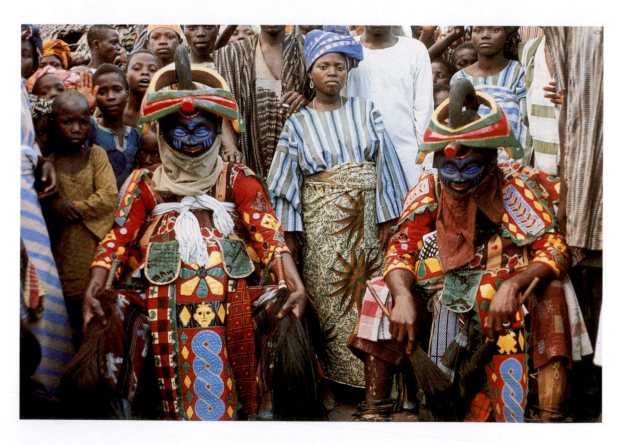

7.20 Costumed performers, *Gelede* ritual. Yoruba, Nigeria

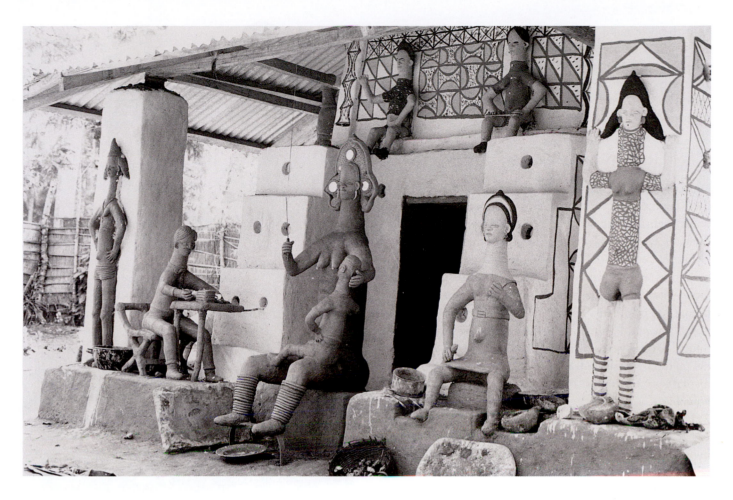

7.21 Igbo *mbari* house. Owerri, Lower Nigeria. Photograph 1982

The decision to build a *mbari* house is a serious one: Its construction can be very expensive, requiring the full-time services of many people for up to two years. The antiquity of the practice is not known, but the rituals and art forms were fully developed by 1900. Since 1946, when the largest recorded house (with 230 sculptures) was built, *mbari* houses have declined in number and size as more Igbo have become Christians and started to attend schools in Europe.

Once the community leaders decide that a house must be built, they select a sacred site and commission an artist/overseer to work with the local priests and diviners. An Igbo artist, *onyeoka* (person of skill), normally serves a six- to ten-year apprenticeship and works with a recognized artist on about fifteen *mbari* houses before becoming an independent master. Even then, an artist will normally have to supplement his income with part-time work such as farming.

Workers are selected from each family or lineage and sequestered in a special compound until the house is finished. The houses are built of clay, wood, and thatch and consist mainly of porches or niches in which sculptured clay figures can be publicly displayed. In addition to the members of Ala's large family, the sculptures may represent generic types from the community. Recently, these have included policemen (to protect the house), football players, boxers, telephone operators, motorcyclists, and other contemporary character types. After the last, most important statue is finished, that of Ala, the sculptures and house are painted. Murals may be merely decorative, featuring large, bold, geometric forms, or they can represent mythological themes related to Ala.

Before the *mbari* house is unveiled to the public, a group of community leaders pays a formal visit to critique it. If they find cracks in the sculptures or smudges in the painting, they will insist that the *onyeoka* make certain changes. Their motives are basic: They want Ala to be proud of her house, to be happy, and to return the favor by providing for the wellbeing of the community. The quality of an artist's work is judged according to the reaction of those who see it and of Ala, who may punish or reward the town. If Ala is pleased and the community prospers, the artist may receive well-paid commissions in the future. We can only guess what the unrecorded philosophy of art or aesthetics of beauty might

be in Igbo thought but, almost certainly, beauty is in the eye of the intended beholder—the all-powerful Ala. Once the *mbari* is finished, the house and sculptures belong to the gods and are not to be repaired by human hands. In time, they will decay and return to the earth to which they were dedicated.

CAMEROON

Directly east of Nigeria, the Cameroon grasslands with their majestic volcanic mountains are home to many kingdoms, including the Bamum. In the early twentieth century, the latter were ruled by a great patron of the arts, King (*Fon*) Njoya (c. 1870–1933). Seeing the power of the Islamic kingdoms and Christian colonists in Africa, Njoya combined elements of their religions with indigenous Bamum thought to create new spiritual doctrines for his people living in this period of great change. While he looked to the future, Njoya also documented the precolonial learning of his culture, established a school to teach it, and restored his father's enormous late nineteenth-century palace at Foumban.

FIG. 7.22 shows Njoya seated on a throne at Foumban in 1912, holding an audience with a man who bows and holds his hand in front of his mouth so that his breath and saliva will not reach the king. This type of Bamum throne, with figures behind the king's seat and a footrest, can best be studied by looking at a very well-preserved throne of this period, which Njoya gave to Kaiser Wilhelm II of Germany

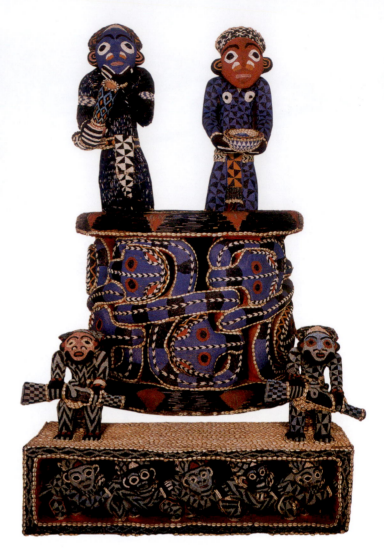

7.23 Throne of King Nsa'ngu. Cameroon, Bamum. Late 19th century. Wood, glass beads, and cowrie shells, height 68½" (1.74 m). Museum für Völkerkunde, Berlin. Staatliche Museen zu Berlin

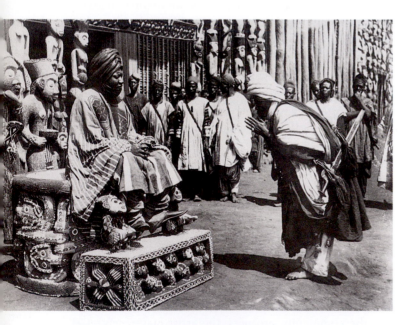

7.22 King Njoya seated on a throne in front of the main portal of his palace at Foumban, Cameroon. 1912

in 1908 (FIG. 7.23). The figures in the back are twins, court guardians, and fertility symbols. The male on the left holds a ritual drinking horn, while the female carries an offering bowl, shapes resembling a phallus and womb, symbolizing the king's role as father of his people. Armed guards on the footrest stand over images of councilors, symbolizing Njoya's use of traditional wisdom in his rule. The double-headed serpents on the seat symbolize his strength in battle. The thick covering of cowrie shells, a form of currency, and bright, reflective beads represent prosperity and the king's duty to use his strength and wisdom to bring good fortune to his people.

Thrones such as this were kept inside the palace and moved by specially appointed royal thronebearers when the king held audiences in front of the palace. When Njoya restored the palace, he added rows of sculptured figures of men and

women wearing royal headdresses to the façade around the main portal. Passing through that portal, visitors entered an enormous complex of courtyards and buildings covering nearly 20 acres (8 hectares) and housing about three thousand people—the king's wives, children, servants, and court officials (FIG. 7.24). The central areas of the palace belonged to the king, those on the right to his wives and the princes, and the left section was the administrative center of his government. In each section, the most private areas associated with the royal family and their rituals were located toward the back of the palace. The most sacred areas were the royal cemetery, throne room, and a room near the king's bedroom where the skulls of the royal ancestors were kept along with the most sacred ritual objects used in court ceremonies.

Spacious as this palace was, in 1915 Njoya commissioned one of his sons to build him another palace at Foumban, a three-story, European-style palace with Roman and Islamic-style arches. Njoya lived there until 1931, when the French placed him under house arrest at the capital, Yaoundé, where he died two years later.

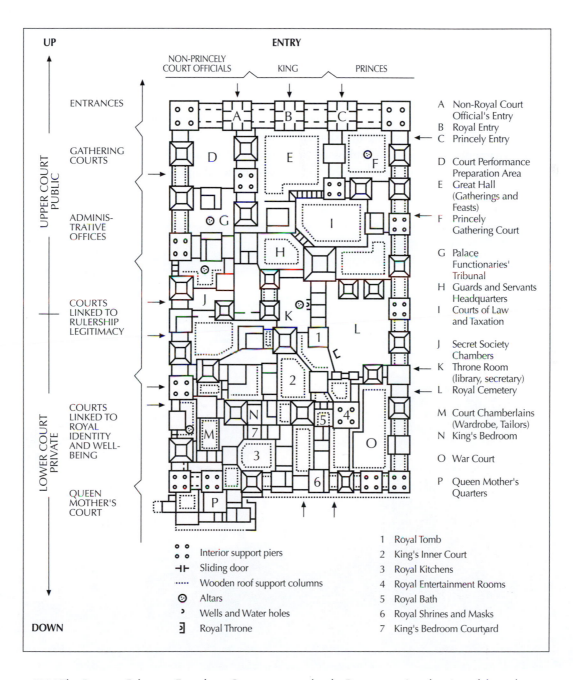

7.24 The Bamum Palace at Foumban, Cameroon grasslands. Reconstruction drawing of the palace as restored in the early 20th century

MALI AND MAURITANIA

From the eighth to the sixteenth century, three large and important kingdoms ruled the upper Niger River drainage area in present-day Mali and nearby Mauritania, also known as western Sudan: Ghana (from the eighth to the eleventh century), Mali (from the thirteenth to the sixteenth century), and Songhay (fifteenth and sixteenth centuries). Ghana (not to be confused with the present-day country of the same name) was already a powerful kingdom when the Islamic faith arrived there in the eighth century with the caravans of traders from Tunisia and Egypt in North Africa carrying textiles, metalwork, and ceramics, which they exchanged for African gold and ivory. Before the discovery of the Americas in the sixteenth century, West Africa was the major source of gold in Europe. As the economy of Ghana flourished, the trade-rich cities there became important centers for Muslim learning and culture. Arab chroniclers tell how "the divine Ghana," or king, presiding in a domed pavilion, wore gold ornaments, had weapons embossed in gold, and rode horses with gold inlay on their hooves.

While the African leaders fused elements of the Muslim religion with their own beliefs and values, artists moving from city to city working for these leaders did much the same with the arts. Perhaps this blending of Islamic art and thought can best be demonstrated by looking at the regional African variety of the Islamic mosque.

The orientation, general floorplan, and towers of the Great Mosque at Djenné, Mali, resemble those of other earlier mosques in North Africa (FIG. 7.25). Many later mosques in the region were based on the original Djenné mosque, which may have been much more lavishly decorated than the second version (c. 1835) and the one (1906–07) that exists today. All three versions were made of puddled clay and **adobe** bricks, a mixture of clay, straw, or other binders set in molds and dried in the sun. Sun-dried bricks are not as durable as bricks fired at higher temperatures in kilns. The protruding wooden poles that give the walls and towers of the mosque a prickly appearance are permanent and functional; they support the workers who replaster it each spring at an annual festival to protect the clay from erosion by wind and rain. The projecting poles also relieve the

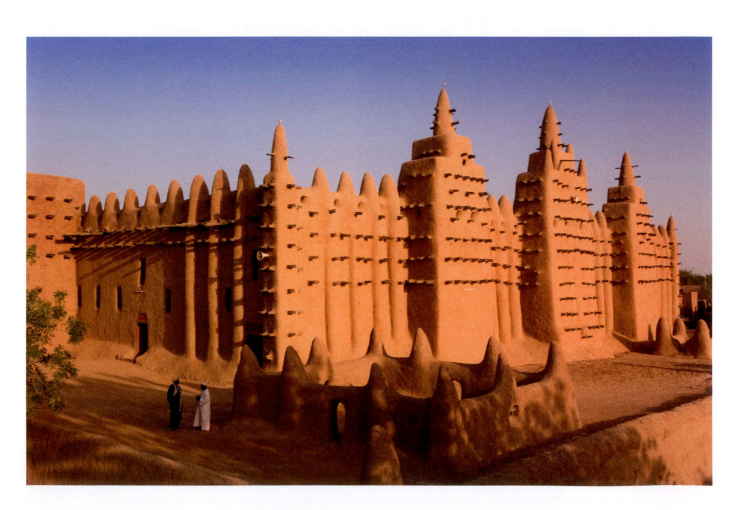

7.25 The Great Mosque, Djenné, Mali. 1906–07

flatness of the mosque's outer face, giving it a decorative quality that reflects the traditional Islamic delight in surfaces embellished with richly colored and textured patterns. Other public buildings and houses in this area have similar shapes and decorations.

The conical shapes are highly functional and durable ones, related more closely to giant African termite mounds than earlier Islamic towers. The tapered towers with their rounded edges and conical summits, the strongly accented rhythms of the projecting buttresses, the textured surfaces, and the decorative effects of the protruding poles express a respect for the utilitarian character of the clay and a locally developed sense of design.

The small rural mosques in Sudan depart even further from the Islamic prototypes in terms of floorplan and elevation to become important expressions of local building traditions. Over the years, mosques became progressively more distinctively sub-Saharan and less tied to Islamic prototypes. In creating this African–Islamic style, the builders have converted the simplest of materials—sun-baked bricks and layers of clay—into magnificent sculptural-architectural monuments. After the French, who ruled this area, built pavilions based on the mosques of Djenné and Timbuktu for a series of early twentieth-century expositions, the Djenné mosque became a universally recognized symbol of western Sudan.

The Islamic traditions continue to exist alongside the indigenous art and dance traditions of the Dogon and other groups, including the Bamana, who create a wide variety of carved wooden headdresses worn by dancers in their ritual performances. Bamana legends explain how the **Chi Wara**, a mythic animal combining features of humans, the antelope, and anteater, brought agriculture to the Bamana people (FIG. 7.26). Wearing antelope headdresses, the young dancers leap and spin, imitating the graceful movements of the antelopes to invoke the favors of the fertility spirits and to instruct the members of the *Chi Wara* society in correct agricultural practices. These dances are performed by the most athletic young men to the accompaniment of drums and women singing praises to the farmers, and designed to ensure the success of the planting season and inspire the workers toiling in the fields. The contrasting angular and curved forms of the *Chi Wara* sculptures have long appealed to art collectors who have known very little about the original meaning of these forms.

Paired dancers with headdresses representing the male and female principles symbolize human fertility and the union of the sun (male) and earth/water (female) in agriculture. With their long, flowing raffia fringes (signifying water), the dancing *Chi Wara* couples combine the ingredients and ideals that give life to the fields. The antelope

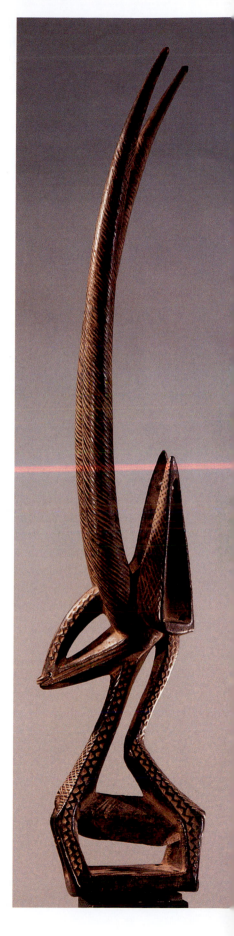

7.26 Male *Chi Wara* antelope headdress. Bamana, Mali. 19th–20th century. Wood. Dallas Museum of Arts
To quote Robert Ferris Thompson in African Art in Motion: *"Africa thus introduces a different art history, a history of danced art, defined in the blending of movement and sculpture, textiles, and other forms, bringing into being their own inherent goodness and vitality. Dance can complete the transformation of a cryptic object into doctrine; dance redoubles the strength of visual presence; dance spans time and space … dance extends the impact of a work of art to make a brilliant image seem more brilliant than could be imagined by ordinary men."*

horns may represent the millet stalk, a staple food of the Bamana. Zigzag motifs along the antelope's neck can symbolize the movement of the sun from solstice to solstice or the angled patterns of the antelope's gallop.

In the ritual dances, the rhythmic energy and sense of implied movement in the long sweeping forms of the headdress come alive and are part of a multimedia performance linking the visual arts with music, prayers, and dance. To Western thinkers accustomed to looking at static, monumental sculptures in stone and metal, the way African art sculptural forms are "danced" into meaningful patterns of form is an aesthetic revelation.

POSTCOLONIAL AFRICA AND THE QUEST FOR CONTEMPORARY IDENTITIES

About the time that slave trading was abolished in the nineteenth century, the "Scramble for Africa" began. The mid-nineteenth-century expeditions of David Livingstone and H.M. Stanley to the interior of Africa opened up the continent and paved the way for the European industrial powers to move inland and establish colonies there. During that period, called the Age of New Imperialism, which ended with World War I, the Scramble became so heated that the German statesman Otto von Bismarck convened the Conference of Berlin (1884) to establish ground rules for the colonization of Africa—to protect the scrambling European powers from one another. The conference drew a new political map of Africa which divided it up into political units that did not correspond with the continent's existing ethnic and economic borders, creating myriads of problems that exist to this day in the process. The "ethics" of the Scramble were justified by the theories of Social Darwinism—the application of Charles Darwin's ideas about the "survival of the fittest" to social dynamics—that it was in the nature of things for strong countries to subjugate weak ones. Although Rudyard Kipling's famous poem "The White Man's Burden" (1899) was not specifically about the European involvement in Africa, it gave the theory a confirmatory layer of literary gloss and moral support.

To show the world how much Africa needed colonial rule, many of the great international expositions in the Age of New Imperialism included African villages in which the occupants were described and displayed as "savages" and "primitives."

Following World War II, many African nations began to win independence, but the postcolonial period ushered in new sets of social and economic problems. The colonial powers had done far more than temporarily take away their subjects' independence and deplete their resources. They had also destroyed their ethnic and national pride, and planted new non-African ideals in their worlds, ones that did not disappear when colonial rule ended. Thus, most nations and peoples in Africa have had a long battle on their road to freedom, self-governance, and prosperity. For example, how do you build new personal and national identities based on self-determination and pride while the old messages of racism and inferiority implicit in colonial thinking still echo around you? If your world is a hybridized native-colonial one, and the colonial element is filled with assumptions that need to be rooted out before you can clear a space for your many long-silenced voices and forge a path to the future? To further complicate matters, not all areas were colonized and hybridized in the same fashion. Those populations closest to the seats of colonial power underwent more changes than their counterparts in more remote areas. Some contemporary artists in the latter areas are still working with traditional precolonial African materials and ideas, albeit in new ways—and in poverty. Meanwhile, many artists in metropolitan centers are using photography, video, and other forms of electronic imaging to connect with international audiences. While there is no pan-African style of postcolonial art that links country to country, there is an important thread that connects most artists at work in Africa today—the need to establish a new personal, ethnic, and national identity.

Around 2000, a traditional type of handmade, dyed, and decorated cloth made in Mali, known as **bogolanfini** ("mudcloth"), became popular as a symbol of national and cultural identity (FIG. 7.27). Traditionally, men wove the cotton cloth on narrow looms and stitched the strips into 3-by-5-foot (0.91 × 1.52 m) sheets. The women then dyed them yellow and painted them with fermented mud from river bottoms, repeatedly, for as much as a year, a process that produced the wide variety of rich brown tones for which the textiles are famous. The white areas are created by bleaching out the unpainted areas of yellow. As the village craft became a national industry, entrepreneurs developed more streamlined methods to mass-produce the cloth for the international tourist market.

Originally, hunters used it as camouflage and women wore it during initiation ceremonies into adulthood because the designs—which represent battles, mythological events, and proverbs—were said to have the power to ward off evil. Today the designs are being applied to a wide variety of export items such as mugs, towels, sheets, and fashionable clothing.

Chris Seydou (1949–94), who is credited with bringing *bogolanfini* into the mainstream as a high-fashion and

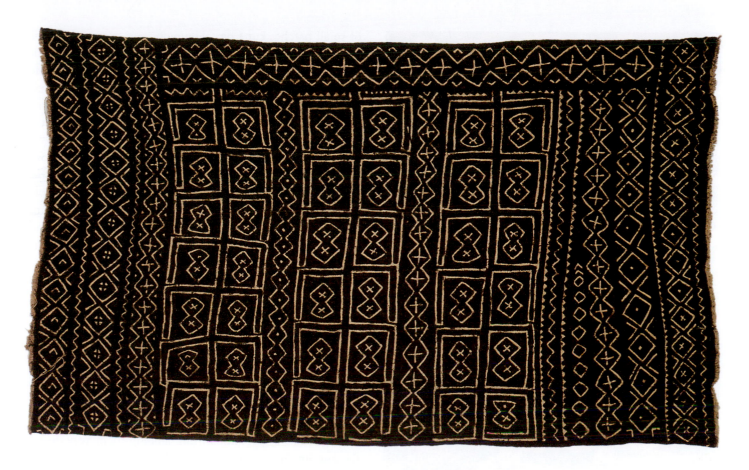

7.27 An example of *bogolanfini* cloth, Bamana, Mali. Cotton cloth with mud and dye. 38¼ × 65¼" (97.15 × 165.7 cm). Seattle Art Museum

national art form, began his career in the tailor shops of Mali before he went to Paris to work with Yves Saint Laurent and other prestigious fashion firms. Returning to Mali, he established the African Foundation of Fashion Design and a workshop that has continued the artist's work since his death. Cinematographers, musicians, and figures in the lively art world of the capital, Bamako, may be seen about town wearing their high-fashion mudcloth outfits derived from Seydou's designs. These fashions are part of a distinctive emerging metropolitan culture in Bamako, with its colorful neo-Sudanic architecture based on the mosques of Djenné and Timbuktu (page 256). It is also a lively center for contemporary African photography, cinema, and music, reflecting the diverse ethnic make-up of the city.

The Akan are a linguistic-cultural group living in present-day Ghana and Côte d'Ivoire. From the fifteenth to the nineteenth century, they controlled the mining and gold trades in these areas and made a wide variety of sculptured gold and brass weights. Today, they are best known for their highly colorful **kente** ("basket") cloth, also known as the "cloth of kings." *Kente* cloth has long been famous for its bold, eye-dazzling patterns, but few non-Akans have ever understood the complex levels of meaning attached to the particular colors and patterns used (FIG. 7.28). Blue, for example, can mean peacefulness and harmony; green, vegetation and spiritual renewal; maroon, mother earth and healing; red, bloodshed, sacrificial rituals, and death; white, purity; and yellow-gold, preciousness, royalty, and spiritual purity. There are over three hundred established patterns, each having a distinct meaning such as "the extended family is a force" or "one person does not rule a nation." However, even for the uninitiated who do not understand this complex iconography, stacks of *kente* rolls with all their highly saturated colors provide a feast for the eyes and senses.

Ghana was also the birthplace of El Anatsui (born 1944), a long-time professor of art at the University of Nigeria in Nsukka who rose to prominence as an internationally renowned multimedia artist in the early twenty-first century. His work comments on the ways Africans today are reconstructing and modernizing many of their old, indigenous traditions that were badly damaged by the slave trade and colonialism—and he is doing this in high-profile ways that are capturing the attention of audiences around the world.

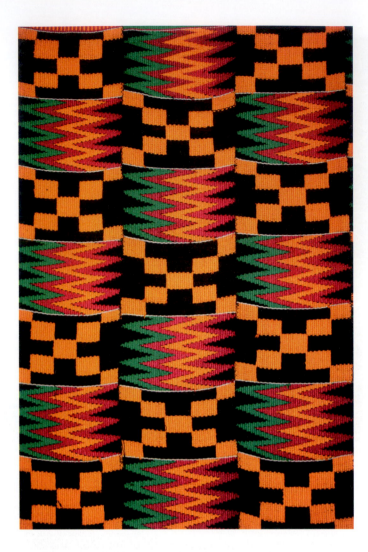

7.28 An example of *kente* cloth, Volta region, Ghana

Anatsui's work is not pictorial or in any way illustrative; he works through the expressive powers of the everyday raw materials he finds around him—used and discarded ones that symbolize Africa's damaged cultures—reconfiguring these cast-offs into bold compositions that have a powerful sense of presence that stand for the new, emerging, and reconfigured world of African culture. The marks Anatsui makes on his wood sculptures with chainsaws and acetylene torches and the sharp metal edges in his so-called "textiles" reference the long history of violence and suffering in African society that he and other contemporary African thinkers are trying to repair.

Having grown up in Ghana in a family of weavers, in a culture where textiles had long been a major art form and an important means of expressing cultural values, Anatsui has created his own very distinctive brand of "textiles." His "threads" and "patches" are not conventional fibrous ones—Anatsui uses copper wire-threads to sew together thousands

of small patches cut from aluminum beer cans with colorful logos along with the metal neck-foils and lids of liquor bottles, all of which reference the barter items used by the slave traders. Thus, these sewn patches—some of the overlooked and discarded remains of our contemporary industrial world—are especially powerful symbols of the African culture that was "discarded" by the traders and colonialists.

In 2009–10, the October Gallery in Bloomsbury, London, displayed one of Anatsui's very large works, *In the World, But Don't Know the World* (FIG. 7.29). The title has multiple possible meanings regarding the complex and often misinterpreted roles played by African culture around the world in recent centuries. The gallery chose this work as part of its efforts to promote the "transvangarde," the emerging transcultural avant-garde in the arts around the world.

Anatsui is clearly part of that large and very important movement, but how do we define and categorize the so-called "metal-textile" medium he has created? The artist says his work has a "Nomadic aesthetic" and is about "fluidity, impermanence, portability, and the interaction of those around the art with it." He also equates the free-flowing qualities of his work with fluid thought and creativity. To make certain his works project these qualities, Anatsui discourages gallery personnel from hanging them as perfectly flat and immobile sheets against their walls, instead giving them license to be inventive in tucking and folding them into bulging three-dimensional forms. Thus, each time one of his works is installed, it may take on a new appearance and find new expressive values. As installed at the October Gallery, *In the World* looks vaguely like a giant, makeshift window covering, a free-form theatrical curtain, a set of fragmented and rumpled tapestries, or a collection of oversized pieces of medieval chainmail. Perhaps it is this fluidity—the way Anatsui's work defies traditional categories and lines of thought and can take on new meaning each time it is displayed—that makes *In the World* such a compelling window onto the emerging world of African thought.

Another group in Ghana, the Ga, has paid less attention to traditional forms of art and developed a new one that gives fresh dimensions to their traditional ideas about religion and the afterlife. The Ga, an ethnic and linguistic group of about two million people living near Accra, the capital of Ghana, have become world-famous for their fantasy coffins (FIG. 7.30). Locally, the coffins are known as **abebun adekai** ("boxes with proverbs"). The Ga workshops carve and decorate them in any shape or form their patrons request. For example, the family of a deceased man who enjoyed eating agouti (a large African rodent) commissioned a coffin for him in the shape of a giant agouti. They even provided the carvers with a dead agouti, which they kept in their studio for a month to serve as a model.

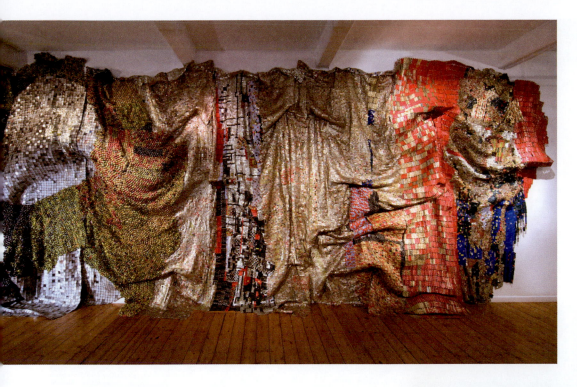

While this art form may look like a form of superfunky, Postmodern Pop, it is not; everything about the carving and the way these sculptured coffins are used in the Ga funerary rituals is very serious. The Ga believe that life as we know it continues after death, and the status of the deceased in the afterlife is determined in part by the spectacle of his or her funeral. The quality of one's coffin had long been a part of that ideal and in the 1950s a carpenter and coffinmaker named Seth Kane Kwei (1922–92) added a new twist to the Ga funerary ceremonies and the role of coffinmaking. When his grandmother died, he carved her coffin in the shape of an airplane: She had always wanted to travel on one, but had never had the opportunity to do so. The giant colorful toylike airplane was a great success at her funeral because, in Ga belief, the spectacle of the elderly, deceased woman traveling to the otherworld in an airplane would raise her status there. It also brought the coffinmaker new business from other members of the Ga community in search of personalized coffins that would improve their funeral and journey into the afterlife as well. Later, Kwei's breakout exhibitions at the Pompidou Center, Paris (1989) and the Museum of Modern Art, New York City (1992) established the fantasy coffins as symbols of Ghana and African creativity.

In 2005, Kwei's grandson, Eric Adjetey Anang (born 1985), took over the workshop. To date, it and other workshops run by its former apprentices have produced hundreds of coffins in the shape of almost every imaginable animal or object known to Ga society. These handmade coffins can

be quite expensive, costing as much as a Ghana laborer might make in a year, but family members will often pool their resources to buy one of these coffin-vehicles to a better afterlife. Certain coffin types, however, are restricted. Royalty and high-ranking priests are the only ones allowed to have coffins in the shape of swords (symbols of might) or chairs ("seats" of authority), and some animals representing family totems are reserved for the heads of those families.

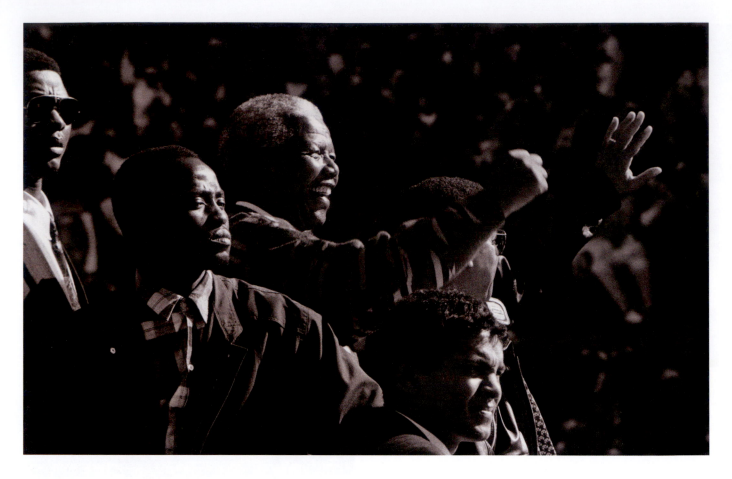

7.31 Photograph of Nelson Mandela from the exhibition *Strengths and Convictions*, South African National Gallery, Cape Town

People attending a Ga funeral do not see the coffin until the ceremony begins, at which time it is unveiled for maximum dramatic effect as the family strives to give the deceased a good sendoff on the road to the otherworld. This idea of using a surprise coffin to enliven events at a funeral contrasts so strongly with end-of-life rituals and traditions in most other parts of the world—where funerals are usually very solemn events—that many people in Africa and beyond have been critical of this new art form.

In recent years, the South African National Gallery, part of the Iziko group of twelve educational museums in Cape Town, has organized a wide variety of photographic exhibitions dealing with the most pressing social and political issues confronting Africa today. For example, in *Borders*, forty photographers and thirteen video artists from Africa and beyond examined the impact of the ill-conceived set of political borders forced upon Africa at the Berlin Conference in the late nineteenth century. The exhibition *US* focused on the current state of South Africa and the rest of the continent as its people search for a postcolonial identity and embrace new-found freedoms following the abolition of the infamous Apartheid system (1949–94). *Strengths and Convictions* focused on the lives and times of the four South African Nobel Peace Prize Laureates who helped destroy that system. Albert Luthuli received the prize in 1960, the Reverend Desmond Tutu in 1984, and F.W. de Klerk and Nelson Mandela both received the award in 1993. More than any monument or speech, it is Mandela's tired but hopeful face that symbolizes the anti-Apartheid movement and spirit of South Africa today (FIG. 7.31).

The South African National Gallery does not depend upon a few blockbuster events to attract international attention; new exhibitions appear nearly every month and include artistic perspectives from throughout and beyond Africa. As such, they rely less on the strength of acknowledged "masterpieces" than the cumulative effect of showing many different points of view, thus echoing South Africa's move to more representative forms of government. The ultimate scatter effect of the National Gallery's many highly diverse exhibitions examining the past and present state of things is to show how South Africa sees itself in the contemporary world. Appropriately, this movement sending a message of hope to its neighbors, some of the poorest nations on earth, is based on the Cape of Good Hope.

AFRICAN-AMERICAN ART

The long history of the African Diaspora began in the ninth century when Arab traders began taking African captives to Western Asia to be sold as slaves. The slave trade intensified after the fifteenth century when the Portuguese and other European maritime powers established trading posts along the coast of Africa. Many of the slave trade routes ran from the western coast of Africa to the Atlantic coast of the Americas—north from Brazil through the Caribbean to the United States. An estimated twelve million Africans were shipped to the Americas alone before the slave trade ended in the nineteenth century. Since that time, the pressures of colonial rule and the political and social problems accompanying postcolonialism have forced millions of Africans to leave their homelands in search of better opportunities in other parts of the world.

As prisoners, slaves departed Africa in chains, without their ceramics, wooden sculptures, metals, basketry, textiles, and other material possessions. However, they did carry some of their technical skills for working these materials with them and applied them as they became the working backbone of the New World plantation economy. Ship manifests often indicated that certain slaves were artisans and therefore of special value on the auction block. Because slaves received little or no pay for their work, plantation owners exploited their skills and trained other slaves to become potters, woodworkers, metalworkers, basketmakers, and seamstresses. A plantation-trained slave was a valuable commodity on the secondary slave market. Booker T. Washington called plantations the nation's first industrial training schools.

Unfortunately, few of the African traditions in the arts survived during the acculturation of the Africans in the Americas. Slaves were trained to make utilitarian Western products, and their religious practices were suppressed as they were Christianized. Many white authorities banned the production of African drums because they feared that the dances would incite riots. Also, until recently, the folk art of slaves was of little interest to serious collectors and much of it perished. There are, however, a few notable examples of African art forms that managed to survive the Diaspora.

Many of the African-Americans living on the long-isolated sea islands of South Carolina and Georgia still speak an African language called Gullah (from Angola). They also make baskets that closely resemble the present-day baskets of coastal West Africa, from which many of their ancestors came.

Slaves working in potteries or shops owned by wealthy white farmers in the southeastern states produced large quantities of wide-mouthed storage vessels decorated with olive-green, gray, and brown slips. A potter from South Carolina, who signed his works "Dave," often inscribed them with rhyming couplets. Other slave potters from this region made vessels with faces on one side. The facial expressions vary greatly: Some are smiling, laughing, or singing; others are growling or malign (FIG. 7.32). Faces with similar wide-eyed expressions appear on wooden statues from Kongo in Africa, the original homeland of many

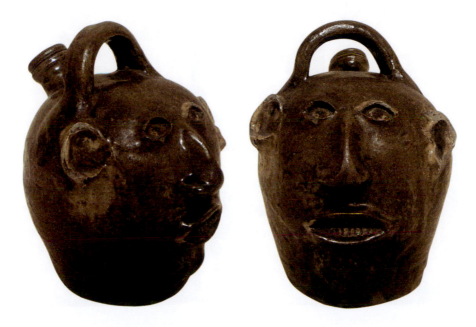

7.32 Face vessel. Bath, South Carolina. c. 1850.
Stoneware, ash glaze, height 8⅜" (21.5 cm). Augusta Museum of History, Georgia

South Carolina slaves. Often, vessels were broken and thrown on new graves, and it is possible that the expressive faces represent protective spirits of African origin who were believed to accompany the deceased to the otherworld. The face vessels have been found over a wide area in the U.S. South, where they were most likely made. They may have also been carried as "protection" by runaway slaves following the escape routes known as the Underground Railroad. (See *Analyzing Art and Architecture:* The Harlem Renaissance and Its Aftermath, page 266.)

Quilting bees or parties were important communal events on the plantations because they allowed slaves to socialize and renew some of their African ties. In quilts, the fabric in the design, the cotton interlining, and the muslin backing are "quilted" or joined through stitching. Some quilts with symbols that were widely understood among slaves were displayed outdoors to let fugitives along the Underground Railroad know they had found a place of refuge. A distinctly African-American type of quilt with large patches, each

representing a story, provided a kind of pictorial "Bible" for slaves, few of whom were literate. After Harriet Powers (1837–1911), a former slave, exhibited a quilt at the Cotton States and International Exposition in Atlanta, she was commissioned to produce a quilt by the wives of Atlanta University professors for the chair of the university board of trustees (FIG. 7.33). The artist explained the images on her quilt in detail when it was purchased by the Smithsonian Institution in 1898.

Five of the ten panels representing Old Testament scenes show Moses, Noah, Jonah, and Job, figures featured in black spirituals who had been delivered from their persecutors. These figures, and the general message of the quilt about suffering and salvation through Christ, reflect the post-Emancipation period preoccupation with deliverance from slavery to freedom. Other panels, such as the central one, showing a shower of stars in 1833 that many observers thought heralded the end of the world and the Second Coming, represent the power of God as revealed though

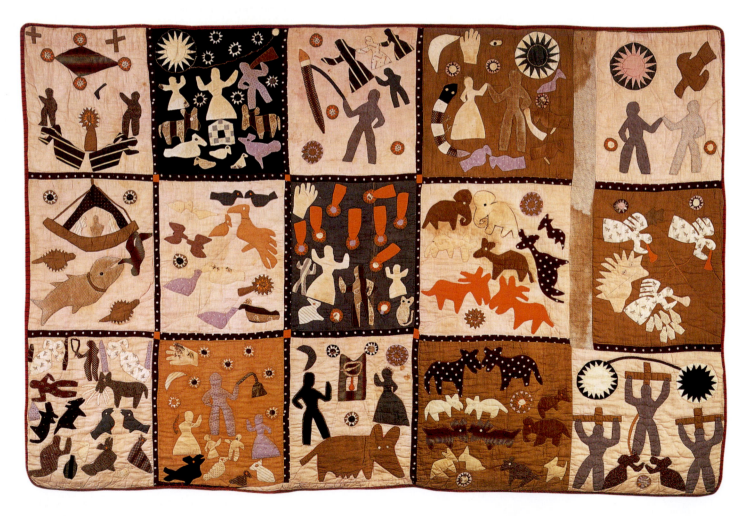

7.33 Harriet Powers, pictorial quilt. c. 1895–98. Pieced, appliquéd, printed cotton embroidered with plain and metallic yarns, 5'9" × 8'9" (1.75 × 2.67 m). Museum of Fine Arts, Boston

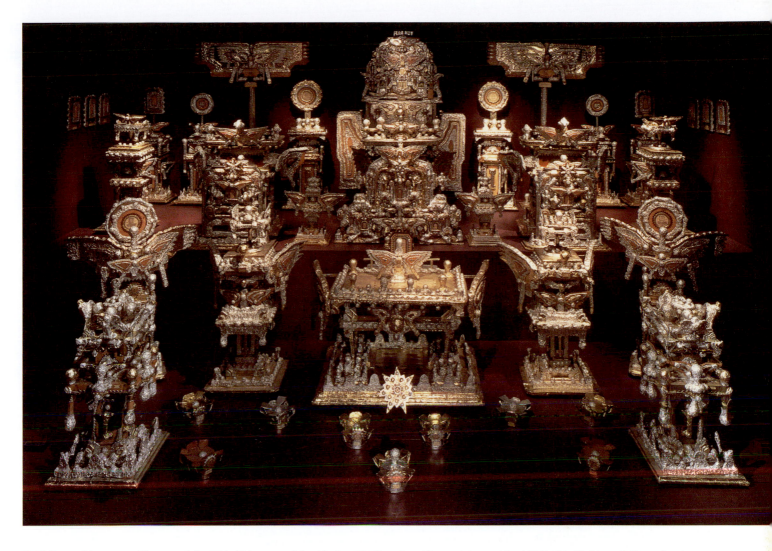

7.34 James Hampton, *Throne of the Third Heaven of the Nations' Millennium General Assembly*. 1950–64. Gold and silver aluminum foil, colored Kraft paper, and plastic sheets over wood, paperboard, and glass, height 10'6" (3.19 m). Smithsonian American Art Museum, Smithsonian Institution, Washington, D.C.

such apocalyptic events and the black Southern folk tales that could be enjoyed in visual terms by a predominately nonliterate audience.

By the late twentieth century, art critics and collectors began to pay serious attention to the African folk arts. However, the work of one very talented folk artist, James Hampton (1904–64), was unknown to the art world during his lifetime. His life project, a spectacular assemblage known as the *Throne of the Third Heaven of the Nations' Millennium General Assembly*, was discovered in a garage in Washington, D.C., after he died (FIG. 7.34). It is a visionary image of the Second Coming based on the last book of the New Testament, the Revelation of St. John the Divine, in which God residing in the Third Heaven is surrounded by shining angels. The Book of Revelation tells readers, "Fear not," and describes a throne set in Heaven, "with four and twenty seats about the throne; elders clothed in white and crowned in gold." To replicate that, Hampton used everyday objects he could afford—lightbulbs, glass bottles, and gold and silver foil.

The centerpiece of this assemblage of 180 individual pieces is a winged throne—an armchair with a red velvet seat behind a pulpit and altar. It is surrounded by other pulpits, vases, offertory tables, plaques, and thrones. The left side refers to Jesus, the New Testament, and Grace, while the right side of the throne represents the Old Testament, Moses, and the Law. To a degree, the composition resembles Romanesque and Gothic portal sculptures on cathedrals in Europe, but here images of the heavenly figures are conspicuously absent. In doing this, Hampton was following an African custom that survived the Diaspora and is still being practiced in the South today. Tombs are often whitewashed

THE HARLEM RENAISSANCE AND ITS AFTERMATH

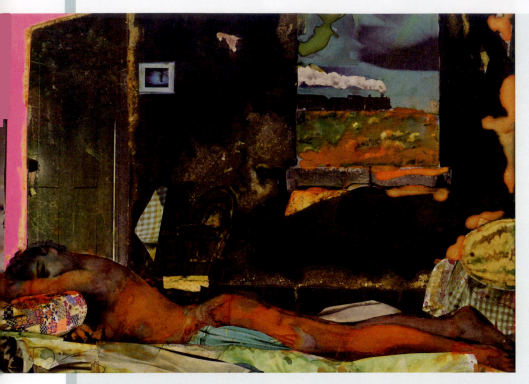

7.35 Romare Bearden, *Mecklenburg County, Daybreak Express*. Collage on board, 10¼ × 14⅞" (26 × 37.7 cm). Private collection

Many African-Americans in the arts took part in the Harlem Renaissance, a rebirth of African art in the Harlem district of New York City, which lasted from about 1919 to the early 1930s. During World War I, large numbers of new arrivals in Harlem were coming from the South where the infamous Jim Crow Laws severely restricted their civil liberties. Langston Hughes became the voice and "poet laureate" of the Renaissance, in which many writers, musicians, and artists suddenly found themselves free to look for their roots and identities as modern African-Americans in a great metropolitan center with a thriving art "scene."

In *The Negro Mother* (1931), Hughes wrote of African-Americans having spent three centuries in the South, where God had placed "a dream like steel" in their souls. The artists of the Renaissance would need that steel in their souls because they faced some very difficult problems. As African-Americans, they wanted their art to reflect both sides of their heritage. They were not living in traditional African societies and could not simply take up where their ancestors had left off, while the racial policies of the day made it difficult for them to join the ranks of the white European-style realists and modernists working elsewhere in New York City. However, many of them, working through the Harlem Art Workshop, found solutions to these and other problems and produced works that dignified their African roots, their roots in the South and in Harlem while speaking of self-respect, self-reliance, and racial pride in modernist terms.

These modern thinkers in the Harlem Renaissance looked upon African art and culture in ways the European advocates of "Primitivism" could not. For Picasso and his contemporaries, that art belonged to a remote, exotic otherworld—but for the participants in the Harlem Renaissance, it represented their own recent past. These artists and writers did not have to appropriate African art under the complicated philosophy and guise of Primitivism—they could claim it directly because it belonged to them.

The scholars and writers of the Harlem Renaissance also had far more information about African art and culture than the European Primitivists had at the turn of the century. Through travel and more recent studies of African art, the Harlem Renaissance thinkers understood more fully how the many masks, statues, and other regalia were used in rituals, often with dances and chants designed to communicate with ancestral spirits. Also, by this time, many museums around the world were displaying important works of courtly Nigerian art, including cast metal heads with idealized faces, that were every bit as regal and striking as the famous portrait heads of antiquity and the Italian Renaissance.

The family of Romare Bearden (1914–88) followed the route taken

by many others, moving in 1920 from North Carolina to Harlem, where Bearden grew up around the art and music of the Harlem Renaissance. In Bearden's collages of photographs, colored papers, and bleeding watercolors, he captures nostalgic fragments of that Old South where he and many of the artists and writers in Harlem had spent their early years. Here, Bearden has constructed a composite memory image—dark gray saltbox houses nestled into the lush foliage of a Southern countryside with gardens, silent pensive figures, and a glowing moon (FIG. 7.35). Bearden was a virtuoso collagist who captured echoes and memories of African-American life in the South that give his work a sense of dignity and universality. Juxtaposing dissimilar textures and using radical shifts in scale, his images have the unreality of an elusive, dimly remembered dream, an almost forgotten world of warm summer nights with silent figures moving through the red-clay, vine-covered backwoods of an impoverished world long hidden from mainstream American society. There is a note of melancholy about times gone by in his work—the Southern heritage of the Harlem Renaissance, the movement's great aspirations, and its ultimate decline in the Great Depression. Bearden's genius lay in his ability to reach back and extract the essence of the African-American experience in the South and bring its strongest humanizing features into harmony with ideas and experiences that are timeless in scope.

and decorated with white, gleaming glass objects and metallic foils to illuminate the soul's path to the afterlife—to help it on its way—and to make certain it does not linger among the living and haunt them.

Hampton, who created his own church, said he was following revelations from God, as had St. John the Divine when he wrote the biblical Book of Revelation. Hampton claimed to have had visions of Moses (1931), the Virgin Mary and Star of Bethlehem (1949), and Adam (1949) in Washington, D.C. An inscription on his work, "made on Guam, April 14, 1945," suggests that Hampton's apocalyptic vision was also inspired by his military service in the Pacific during World War II. Hampton wrote on his works in a mysterious script, like St. John the Divine, whom God asked to record his vision of the Second Coming in a cryptic language.

SUMMARY

The diversity of the art produced in sub-Saharan Africa over the last thirty thousand years reflects the cultural variety of the many groups of people who have inhabited this vast continent. Sculptural styles in Africa range from the idealized portrait heads of the Nigerian courts at Ile-Ife and Benin to the highly abstract wooden masks of the Bamana in Sudan, with their repeating curves and sharply angled forms. The indigenous African architectural traditions include a distinctive style of monumental walled enclosures called *zimbabwe*, which have particular sculptural qualities, as do many of the West African mosques in Mali made of puddled clay and adobe. African art has served many purposes and played important roles in private and public rituals. Alongside prayers, offerings, music, and dance, it was designed to communicate with the unseen spirits and beings of the other world. To be effective, it had to reflect certain ideals of beauty. Among some groups that have been carefully studied, such as the Yoruba, it is clear that these ideals could be highly complex.

In years to come, students in the West will undoubtedly learn much more about the meaning of African art as more African scholars steeped in the traditions of the arts, languages, and cultures of Africa enter this field. African art also continues to inspire contemporary African artists in many parts of the world. Using the process anthropologists call "reintegration," some African artists are incorporating elements of their African heritage with Western styles of art. Bearden addressed this issue by saying, "It would be highly artificial for the Negro artist to attempt a resurrection of African culture in America … The true artist feels that there is only one art, and it belongs to all mankind."

GLOSSARY

ADEBUN ADEKAI Ga, "boxes with proverbs." Also known as storybook or fantasy coffins, carved and decorated in any shape patrons might request. The Ga, living near Accra, the capital of Ghana, believe that life as we know it continues after death, and the status of the deceased in the afterlife is determined in part by the spectacle of his or her funeral and coffin. These handmade coffins can be quite expensive, yet hundreds have been commissioned and represent almost every imaginable animal or object known to Ga society. They have also become recognized symbols of Ghana and African creativity. Certain shapes, however, are restricted. Royalty and ranking priests are the only ones allowed to have coffins in the shape of swords (symbols of might) or chairs ('seats' of authority), and some animals representing family totems are reserved for the heads of those families.

ADOBE Any clay-related earthen building material. Often mixed with grass and twigs and molded into bricks or applied in layers in liquid form. Sun-dried as opposed to kiln-fired clay. Also, buildings made with these materials.

AIRPORT ART Also known as "tourist art." Mass-produced art resembling works in regional and period styles specially made for the tourist trade in locations such as airport terminals.

AMEWA Yoruba, "one who knows beauty." A knowledgeable critic of the arts or, to use a Western term, an aesthete.

ASHE Yoruba, "creativity." A power belonging to the god Olórun, which he gives to a select few people whom he trusts to do good things for their communities.

BENIN CITY More is known about the art and history of Benin than about any other locality in sub-Saharan Africa. It was the capital of a highly centralized kingdom of Edo-speakers ruled by an *oba* (divine king). Benin inherited some of its artistic traditions from the Yoruba city of Ile-Ife. The inner city—housing the king's palace, house of the town chief, and the workshops of the royal metal, ivory, wood, and leather guilds—was surrounded by a wall with nine gates and a moat. It flourished from about 900 CE to the end of the nineteenth century,

and visitors there reported that its palace was the grandest in West Africa.

BOGOLANFINI Literally, "mudcloth." A traditional type of handmade, dyed, and decorated cloth made in Mali that has become fashionable in the twenty-first century. A Malian symbol of national and cultural identity.

CHI WARA A mythic creature that brought agriculture to the Bamana in Mali. It combines features of the antelope with those of other animals. Also, the name of a society that performs dances in honor of the *Chi Wara* in which members wear sculptured images of the *Chi Wara* on their heads.

DIDON Yoruba, "luminosity" and "delicacy."

EWÀ Yoruba, "beauty." *Ewà inú*, inner beauty, is valued above *ewà ode*, outer or superficial beauty.

GELEDE A ritual performed by the Yoruba to serve and honor the women elders or "mothers," ancestors, and deities and to create harmony in the community. As guardians of society, the elders have powers that go far beyond those of fertility and may be equal to or greater than those of the gods. *Gelede* rituals begin with the night songs and dances performed in the marketplace, an area under the authority of a woman on the king's council of chiefs. Many women work in the market, where they can accumulate wealth and status independently from their husbands.

IFARABALE Yoruba, "inventiveness." An aspect of *ASHE*.

IFARAHON Yoruba, "clarity of line and form."

IGUNEROMWON The name of the ancient Benin bronzecasters' guild that survives to this day.

ITUTU Yoruba, "cool." Similar in meaning to *ira rere*, "good character," and *iwa pele*, "generosity." Features a Yoruba artist must possess to receive *ashe* from the god Olórun.

JIJORA Yoruba, "relative likeness."

KANAGA Masks with towering antennae like head crests worn by the Dogon of Mali in

dances designed to transport the souls of the deceased out of their villages.

KENTE Akan, "basket." Also known as the "cloth of kings." A distinctive type of cloth made by the Akan of Ghana and Côte d'Ivoire, known for its bold, eye-dazzling patterns and complex color and pattern symbolism.

LOST-WAX METHOD A technique for casting hollow as opposed to solid metal objects. The desired image fashioned out a material such as heat-resistant clay is coated with a thin layer of wax that conforms to the clay. The wax is then coated with a thick heat-resistant material called a "mold." When the mold is heated, the wax melts, leaving a thin space between the inner and outer molds. Hot molten metal is then poured into that open space where the wax was "lost." When the metal cools, the molds are removed.

MBARI A type of ceremonial house with figural sculptures built by the Igbo of Nigeria as a shrine to Ala, their earth goddess. Complex rituals accompany every state of their planning and construction. Communities may build a *mbari* house if they have had poor rains, bad harvests, or other events that suggest that Ala is in need of propitiation. Their construction is expensive and time-consuming, taking as long as two years to complete. The houses are built of clay, wood, and thatch and consist mainly of porches on which brightly colored sculptured clay figures are publicly displayed. In addition to the members of Ala's large family, recently, these figures have included policemen (to protect the house), football players, boxers, telephone operators, motorcyclists, and other contemporary character types. The largest known house had 230 dedicatory sculptures. After its dedication, no human will again enter Ala's house and the sculptures "living" there will be allowed to decay and return to the earth where the goddess lives.

NKISI NKONDI Kongo, "hunter." Specially trained priests of the Kongo in the Democratic Republic of Congo use this type of carved wooden statue to "hunt" for solutions to village problems and search for wrongdoers. After receiving the carved body and head of a "hunter" from a sculptor, the priest begins the process by putting medicines and fetishes in the container on top of the head and in the box over the figure's stomach. These fetishes may

include relics of dead ancestors or bits of clay from a cemetery that will help the priest and "hunter" contact the spirits of the dead. The priest may also give the "hunter" a headdress and attach horns, snake heads, or beads to it, drive nails, blades, and other sharp objects into its body, and attach miniature images of the musical instruments the priest will play in the rituals when he unleashes the powers of the "hunter."

NOK STYLE A style of ceramic sculpture in Nigeria (c. 600/500 BCE–200 CE). Named for the type-site in northern Nigeria where the first examples of the style were found. Most of the figures are human, but the Nok ceramists also portrayed snakes, monkeys, elephants, and rams. The sculptures may have been used in shrines, on altars, or deposited in graves. Nok heads typically have prominent triangular or circular eyes, pursed lips, and generally flat features rendered in closely matched sets of crescent-shaped lines, gently swelling volumes, and smooth, well-finished surfaces. Any related Nok-styled works in wood or other perishable materials have long since perished

NYAA KA Dan, Côte d'Ivoire, "moving with flair" or "looking right." Having beauty (*se, li,* or *manyene*) as opposed to ugliness, *ya.*

ODO Yoruba, "youthfulness." The depiction of people in art in the prime of life.

PRIMITIVISM A Western art movement that borrowed materials and motifs from non-Western art. This term "primitive"—from the French word *primitif*—was initially used in reference to certain late medieval and Early Renaissance Italian and Flemish painters. Later it was applied to the arts of Africa, the Pacific Islands, and Native America—meaning, in this context, the early or "prime" forms from which later, more sophisticated Western art was thought to have developed. Because of these negative connotations, it is no longer in common use in scholarship.

ZIMBABWE From the Shona, *dzimba dza mabwe,* meaning "house of stone." Also known in common usage as "ruler's house," or "house to be venerated" because some examples were royal residences. Large curved walls made by dry-stacking (without mortar) flat slabs of granite partially enclose groups of clay and wood houses with thatch-roofs. The walls are not effective lines of defense. In their simplicity, they remain "natural," close in spirit to the outcrops and cliffs from which their stones came. Thus, they may embody the spirits of the ancestors who live in nature and literally wrap them around the Shona homes. By the nineteenth century, the largest of these structures, Great Zimbabwe, had become an internationally recognized symbol of Africa.

QUESTIONS

1. Picasso admired African art and incorporated elements of it into his own art. However, the box titled "Pablo Picasso and African Art" on page 235 shows how little he knew about the context of its creation or its meaning. Is it possible for someone to look at works of art, misunderstand them, and yet learn something of importance from them? What did Picasso discover in African art and how did he use it to reshape his own art?

2. Many societies have created idealized faces and figures that express important social or cultural values. The Yoruba and Benin portrait heads represented certain ideals discussed in the text. How do these ideas revolve around the concepts discussed in the text, including those in the box titled "Yoruba Aesthetics" (page 245)?

3. What is a *nkisi nkondi*, how does it work, and how has that concept been popularized and misrepresented outside African culture?

4. How important is it to know the name of the person who made a particular work of art? Does such knowledge make an artwork from Africa more "authentic"? What other considerations affect the authenticity of a piece?

5. This chapter discusses contemporary art forms in Africa such as photography, which is not a traditional African medium and the nontraditional subject matter of the Ga coffins. Do these new art forms represent traditional African ideas and values, and, if so, how do they reflect those traditions as they exist in Africa today?

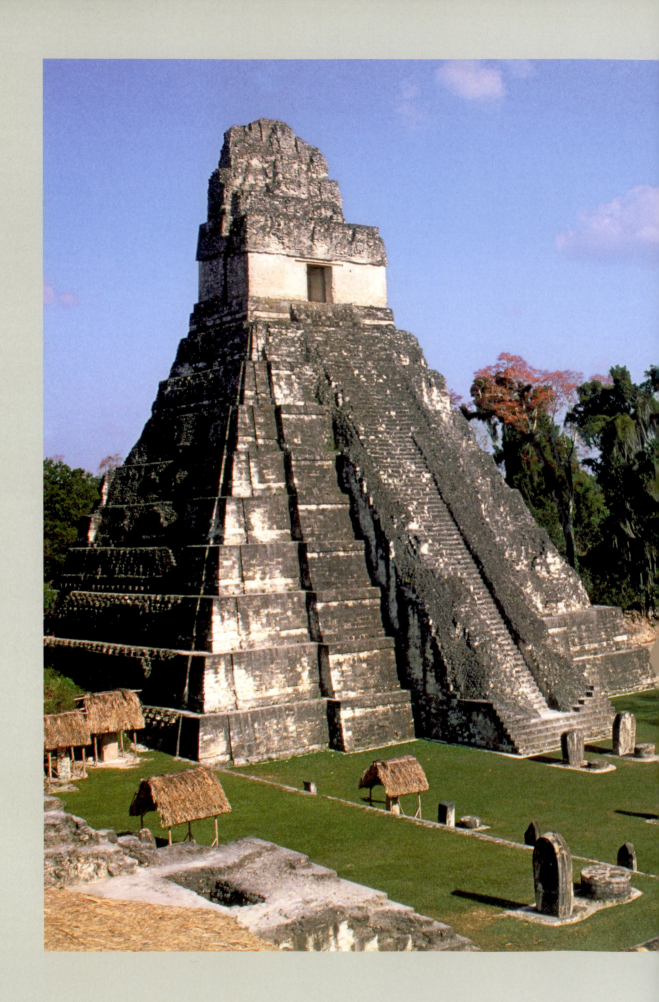

8 | The Americas

Equator

Introduction 272

South America: The Central Andes 274

Mesoamerica 286

North America 312

Native American Art in the Twentieth and
Twenty-First Centuries 338

The Americas

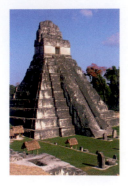

When the first Spanish explorers landed in the Americas in the early sixteenth century, they were astonished to discover societies and empires there that had until then been unknown to them and the rest of the world. At the time, the Aztecs ruled large portions of present-day Mexico and the Inca had a kingdom that stretched across the Central Andes. By the end of the sixteenth century, the Spanish had discovered more indigenous societies flourishing in Latin America and what are now the southern United States, including large numbers of towns or **pueblos** near present-day Santa Fe. Later, as the Northern European powers established colonies along the Atlantic seaboard and the newly formed United States and Canada expanded inland, they continued to discover yet more native populations. New archeological discoveries to this day continue to bear witness to the richness and diversity of the native civilizations in what the West named the New World.

INTRODUCTION

The term **Pre-Columbian** means "before Columbus" and refers to the time period and cultures in the Americas before the arrival of Christopher Columbus and other Western explorers and settlers. Some writers also use the terms "pre-contact" and "postcontact" for the periods before and after the arrival of the Europeans in the Americas. The dates of those contacts vary, from the early sixteenth century to much more recent times. The earliest Pre-Columbian immigrants to the Americas arrived during the last Ice Age. At that time, the glaciers lying across the continents contained so much frozen water that, at their lowest, the oceans were about 350 feet (107 m) below their present level and a 100-mile-wide (160 km) land bridge connected present-day Siberia and Alaska for thousands of years. The new arrivals could have traveled across that land bridge and south along the coast of present-day Alaska and Canada by water or through an ice-free inland corridor that may have been open as early as 30,000–20,000 BCE. However, new and still-controversial findings suggest that other migrations on a limited scale may have occurred at unknown times before that date.

The Americas underwent many of the same transformations as the Old World at the end of the Paleolithic era. Between 7000 BCE and 5000 BCE, residents of the Tehuacán Valley in Mexico began domesticating animals and cultivating plants. The Pre-Columbian American staples included maize, beans, squash, peppers, potatoes, tomatoes, and avocados. Communities in various parts of the Americas had domesticated turkeys, guinea pigs, llamas, alpacas, guanacos, vicuñas, and dogs. Acquisition of dependable food supplies fueled a growth in population and the emergence of hierarchical societies, the construction of ceremonial centers, and the development of specialized art forms.

Around 3000 BCE, people living near the coast of present-day Ecuador and northern Peru were constructing large platformed temples and making fired-clay figurines. By 1200 BCE, the Olmecs on the east coast of Mexico were carving monumental stone sculptures for their ritual centers. After the first century CE, sedentary societies with urban centers and hierarchical societies supported by agriculture and trade were flourishing elsewhere in portions of present-day Mexico, Guatemala, Belize, El Salvador, and Honduras as well as in the Central Andes and portions of the United States.

The Pre-Columbian Americas lacked some of the basic ingredients of the civilizations found in many other parts of the world. While llamas and other indigenous American animals could carry light packs, there were no horses or other beasts of burden strong enough for adult riders. In parts of Mexico, they used small ceramic wheels on toys, but wheels were never scaled up for use on carts or wagons. Soft metals, such as gold, silver, and copper, were known and valued, but the Pre-Columbian Americans did not discover how to process bronze or iron. Wood, stone, bone, and obsidian (a volcanic glass capable of holding a razor-sharp edge) were the preferred materials for weapons and tools. Aside from the Maya, the Pre-Columbian Americans did not develop known and deciphered syllabic/phonetic

scripts through which they could pass on their knowledge to future generations. Yet, the Pre-Columbian Americans constructed enormous elevated platformed temples, moved and cut stones weighing in excess of 100 tons (101,600 kg), and created art styles as astonishing as those seen in other parts of the world where metallurgy, wheels, and beasts of burden were in evidence.

In some parts of the Americas, with large urban populations, courts, palaces, temples, and complex forms of rulership and religion, artists were valued members of those hierarchical societies. They often belonged to the highest social orders and helped the leaders maintain order in this world and the otherworld of the sacred ancestors, spirits, and deities. In the very large Aztec, Maya, and Inca societies, artists were often well-recognized professionals attached to workshops and other government-controlled institutions that operated under the tutelage of patron gods. The same may have been true in the desert kingdoms in coastal Peru and some of the ancient pueblos in the American Southwest. Elsewhere, in many of the smaller societies, where artists supported themselves by other means such as hunting, gathering, and agriculture, they were also highly regarded as caretakers of important sacred information about the otherworld and its powers.

How is it possible to account for the spectacular development of Pre-Columbian civilization in the Americas? The ancient Siberian roots of the original émigrés and the very short-lived eleventh-century Norse colonies out of Greenland in Newfoundland had little, if any, influence on the indigenous American cultures. Some scholars believe that certain aspects of Pre-Columbian civilization derive from Asiatic sources and arrived via ships crossing the Pacific. They believe that the basic concepts of art and culture were created once—in the Old World—and diffused from there around the globe. However, in most cases, the internal lines of development for the art forms in America are well documented. The oldest-known Pre-Columbian works of art may date from about 20,000 BCE, and since there is no evidence that representational works of art were imported from Siberia into the Americas, the idea of representation may well have been invented independently in the New World. Certain ancient concepts, such as shamanism, may have come from Asia to the Americas, and it is not impossible that highly skilled Polynesian sailors could have visited the Americas, but the present evidence suggests that Pre-Columbian American art developed without benefiting significantly from outside influences. (See *In Context: Shamanism and the Arts*, below.)

The art styles in the Americas are highly diverse because of their antiquity and because of the geographic extent of the two American continents. Therefore, no single set of ideas will suffice to introduce all of the art of the many ethnic groups in the Americas, and the art of the major areas will be introduced separately within this chapter.

SHAMANISM AND THE ARTS

The **shaman** played an important role in the ritualism of many Native American groups. The concept of shamanism may have originated in Central Asia and spread to the Americas via Siberia. Shamans have often been called "medicine men" because they perform curing ceremonies. With their wealth of knowledge about the spiritual world, some shamans know which substances have the necessary powers to bring about the desired spirit changes in a patient's body, and they have a mastery of the rituals that make those powers work. While many of the large, urbanized societies around the world have complex religious institutions with hierarchies of priests and other individuals with special skills, in the smaller, less integrated societies such as those in many parts of the Americas, it is shamans who play many of these important roles. In addition to healing the sick, they may assist hunters or warriors, control the weather, foretell the future, and help people find lost possessions.

In these rituals, shamans may go into trances, pass along paths leading from the terrestrial to the celestial world, and meet with the spirit powers there. Many of them have animal counterparts or alter egos and become one with them in the transcendent realms so, for those witnessing the ceremonials, their communication and bonding with the spirit world is very intense and dramatic. In some societies, shamans may also be artists, and even where they are not, they may play an important part in new directions taken by the arts.

SOUTH AMERICA: THE CENTRAL ANDES

When the Spanish conquistadors arrived in the Central Andes in the early sixteenth century, the Inca were ruling a powerful kingdom from their highland capital at Cuzco. The streets of the present-day city are still lined with tall Inca walls made of large, perfectly fitted stones that once housed their imperial temples and offices. The Inca excelled at the construction of fortifications and of canals, roads, and bridges over which they could move troops, goods, and information with great speed. However, they did not invent all the engineering and administrative skills they used to build and run their empire; instead, they inherited much of

TIME CHART: SOUTH AMERICA

Early Horizon: 1000–200 BCE

Early Intermediate: 200 BCE–600 CE

Middle Horizon: 600–1000

Late Intermediate: 1000–1400

Late Horizon: 1400–c. 1535

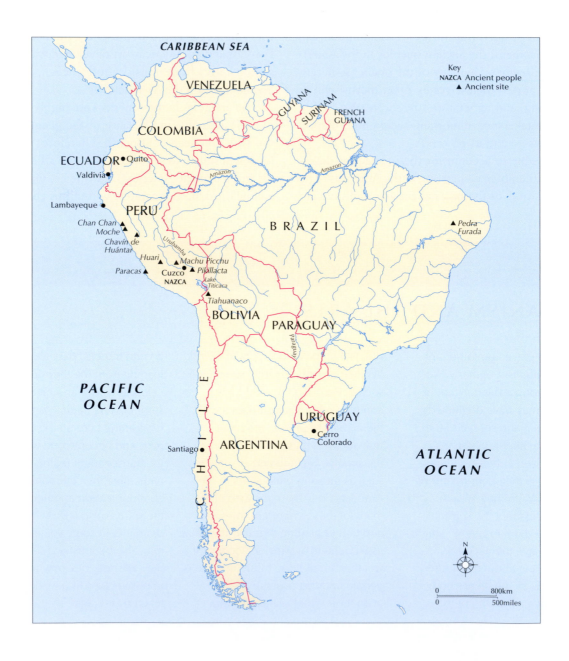

this knowledge and their artistic traditions from the older societies they incorporated into their empire.

The antiquity of the art and cultures found along the coasts of southern Ecuador and Peru is amazing. The earliest phases of the Valdivian culture (3550–1600 BCE) in southern Ecuador, known for its naturalistic clay figures, predate dynastic Egypt and are contemporary with early Sumerian culture in Mesopotamia. By the third millennium BCE, they were constructing large platformed structures using adobe bricks with grass and twig binders and puddled adobe finishes where the wet clay was applied like stucco or plaster. Along the coast, where clays were plentiful, clay sculpture remained an important art form in Ecuador and northern Peru up to the time of the Spanish conquest.

By 3500 BCE, the coastal people were also growing the sturdy cotton fibers they eventually combined with their dyed wools to create one of the most astonishing traditions of weaving and textile art in the world. Many of the earliest designs and styles of representation in this part of South America were developed by textile artists, and they influenced Central Andean artists working in other media for thousands of years to come. (See *Materials and Techniques: Fiber Art and Weaving*, below.)

It is difficult to overestimate the importance of textiles in the Central Andes. The web of the weavers' fabric may be seen as a metaphor for other aspects of Andean life, where they "wove" nets of political alliances and connected the different parts of their world by weaving networks of long, threadlike roads through the mountains. The Inca also envisioned a conceptualized or spiritualized set of lines radiating out from the capital and linking many of the shrines in that area in a giant spiderlike web that covered the heart of the kingdom. In fact, we are dealing with something we might call an Andean "textile aesthetic"—that is, many other forms of art in the Central Andes often reflect textile designs, which in turn reflect certain technical aspects of the weaving process. First, the right-angle grid pattern of the intersecting **warp and weft** encourages weavers to reduce the complex forms in nature to straight lines and simplified curves. In the rare Andean textiles where the threads are very thin, the weavers are able to create smooth curves, but when the thread count is relatively low, as it is when working with thick wool and cotton threads, even the simplest curves have stepped edges that reflect the underlying grid. Laying out their designs on the repeating geometries of a grid pattern also encouraged weavers to divide their designs

MATERIALS AND TECHNIQUES

FIBER ART AND WEAVING

The weavers or fiber artists of the Andes worked with cotton and the wool of llamas, alpacas, and vicuñas. They incorporated their early techniques of knotting, twining, braiding, looping, and wrapping fibers in later works done on **backstrap looms** (developed in the second millennium BCE). With this type of loom, which is still in common use in some parts of the Americas today, the warp (lengthwise threads) is stretched between poles attached to a stationary device (often a tree) and a strap looped around the back of the weaver. The weavers, most of whom are women, control the tension on the warp with their bodies while threading the weft (crosswise threads) through it. Working in the tapestry technique, weavers use special weft threads for each color in the design so that the color pattern is woven into the structure of the cloth. This technique is more laborious and time-consuming than embroidery, in which the design is stitched into a prewoven fabric.

Using combinations of tapestry, embroidery, and the earlier techniques mentioned above, the Andean weavers created some of the world's most complex textiles. In some virtuoso displays of their ability, they interwove as many as five hundred threads per square inch (6.45 sq cm), creating textiles that are so light and smooth they feel much like silk. They developed specialized weaving techniques and textile types for everyday use, ceremonial costumes, and burial shrouds. Textile designs seem to have influenced styles of painting and other two-dimensional art forms throughout Andean history, and some scholars even see parallels between Andean textile patterns and certain city plans. While the fiber arts elsewhere in the world often imitate other media such as painting, the reverse seems to be true in the Central Andes, where the underlying aesthetic basis of the other two-dimensional art forms derives from the long tradition and technology of woven fiber art.

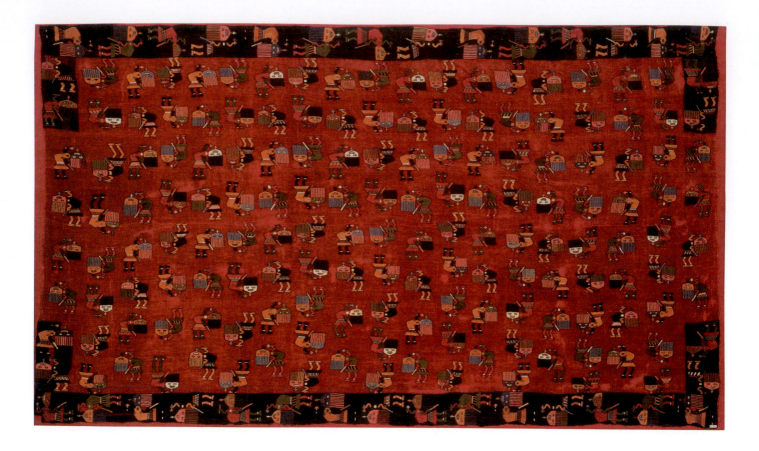

8.1 Embroidered mantle. Paracas Necropolis, south coast of Peru. Late Paracas, 200 BCE–200 CE. Camelid fiber, entire mantle 56 × 95″ (1.42 × 2.41 m). Museum of Fine Arts, Boston

into parts that repeated at regular intervals. Andean weavers might highlight the outlines of their images and add other details with embroidery, but the fundamental shapes of the simplified geometric images remain the same.

These technical determinates influenced early Andean weavers, whose images of animals were often very simplified, and even when they learned to rotate, reverse, fragment, and combine these images in lively and very large abstract patterns, textile designs retained much of their early character (FIG. 8.1). In many of their largest pieces, weavers worked with formal themes and their variations, following what appear to be "hidden" numerical formulas. But, at times, they violated these "rules" by using random patterns, as if to challenge the viewer to decode their puzzles and decipher certain cryptic messages.

CHAVÍN DE HUÁNTAR

Many of the early developments in art and thought in the Central Andes are combined in the arts of Chavín de Huántar, an ancient place of pilgrimage in the mountains and the type-site for the Chavín style (900–200 BCE). The site, now

badly damaged by earthquakes, had open courts, platforms, relief sculptures, sculptures in the round projecting from the walls, and small, secluded rooms. Such rooms, with carved images of guardian figures on their portals, may have been the setting for sacred rituals held in honor of the Chavín deities. The content of Chavín art appears to be taken from many diverse regions—the neighboring coasts, highlands, and the tropical forests. The animals that appear most frequently in Chavín art—jaguars, eagles, and serpents—suggest elements of an Amazonian cosmology, but the diverse origins of the art and religion of Chavín de Huántar remain a matter of debate among scholars.

The Chavín love for abstract patterns and complex subject matter is well illustrated in a bas-relief known as the Raimondi Stela (FIG. 8.2). The **stela** represents a squat, anthropomorphic jaguar deity with a down-turned, snarling mouth, fangs, claws, and serpentine appendages. This composite creature, known as the Staff God, takes its name from the ornate staffs it holds. The decorative forms adorning the Staff God are rigorously organized in a symmetrical fashion, using a well-established Chavín vocabulary of stylized motifs composed according to what appears to be set

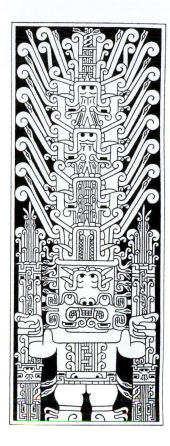

8.2 Drawing of the Raimondi Stela. Chavín de Huántar. c. 460–300 BCE. Approx. 6'5" × 2'5" (196 × 74 cm). Instituto Nacional de Cultura, Lima, Peru

rules of syntax. Through a process of elimination and substitution, the artists create metaphorical body parts, images in which one form is used to stand for another. In Chavín art, a tongue may become an arm, serpents substitute for hair, and a head at the end of a tail can make the tail appear to be a neck. In this manner, using visual "puns," natural forms in Chavín art are altered and repeated in rhythmic and symmetrical sequences. These Chavín rules of order and the abstract images they produce have no counterparts in nature and appear to represent supernatural beings. As in most Chavín sculptures, the straight lines, right angles, and few curves in this piece seem to reflect the way textile designs are organized within the grid formed by the warp and weft.

The Staff God has a square face with large, round upturned eyes. If we invert the image on this page, those eyes are looking down and belong to a second face with a long snout and fangs resembling an alligator or crocodile. Below that face (in the inverted image), we see four more similar long-snouted crocodilian faces. Returning the image to its upright position, this set of faces looks like a towering headdress, but it may actually be a cape (upturned) that

would lie on the Staff God's back. In that position, the heads would be right side up. This image of the Staff God, with a double set of facial features around its eyes, may be a visual pun and symbol of the duality linking the physical and spiritual worlds, or it may be a reference to shamanic transformation, the ritual acts in which shamans pass back and forth between their human and animal identities. References to shamanism are common in Chavín art, as is evidence for the hallucinogens shamans might use.

Why, we may ask, is the art so esoteric and difficult to read? Possibly, to bolster the authority of the leaders who held the keys to the Chavín cult knowledge and used that special knowledge to impress and control the populace they ruled. Chavín de Huántar commanded a large sphere of influence—most of the Peruvian coast—for about seven centuries, and even after its decline, its arts continued to influence later Peruvian groups up to the time of the conquest, a testament to the lasting power of its images.

PARACAS AND NAZCA

In its early phases, Chavín art spread south along the desert coast of Peru, where it influenced the local styles of Paracas (c. 700 BCE–1 CE). By the third century BCE, the textile artists of Paracas were designing garments of alpaca wool and cotton with woven and embroidered designs, which were placed in large, bottle-shaped, rock-cut tombs as part of an elaborate cult of the dead. This region is very arid because the high Andes block moist air coming from the rainforests to the east while the cool Humbolt Current offshore keeps rains over the Pacific from reaching the Peruvian shore. As a result, many of the textiles recovered from the tombs are marvelously well preserved. The deceased were arranged in flexed positions, adorned with jewelry, and wrapped in many layers of cloth. In the necropolis or cemetery at Cerro Colorado on the edge of the Paracas Peninsula, the mummy bundles were buried with unusually lavish offerings. Their wardrobes included as many as 150 well-decorated cotton and wool tunics, scarves, slings, headbands, headdresses, bags, fans, and *mantas* (Spanish, "shawls" or "royal mantles"), none of which showed signs of wear when they were discovered. Such treasures were apparently signs of wealth and status in the afterlife, where the deceased could continue to enjoy the pleasures of this life. The embroidery on the mummy bundles depicts myths, mythical ancestors, zoomorphic beings associated with the earth, sky, and sea, and images of the deceased performing rituals. In this regard, the textiles appear to have played an important role in the passage of their owners from this world to the afterlife. The fact that it may have taken a single artist up to ten years to complete the textiles for one mummy bundle gives some

idea of the importance attached to grave offerings and the cult of the dead among the Paracas élite. (See *Materials and Techniques:* Fiber Art and Weaving, page 275.)

In Paracas textiles, the designs inspired by the embelished and composite animal imagery of Chavín art develop into more complex compositions of richly attired persons, shamans, and other ritual performers carrying weapons and trophy heads (see FIG. 8.1). Basic motifs are enlarged, diminished, reversed, inverted, simplified, and elaborated in inventive variations that follow numerical and geometric rules of order. Color schemes can be reversed and images inset, one within another. Images or motif clusters often appear to have established symbolic meanings and some of their variations may correspond with the output of a workshop or an individual artist.

South of Paracas, we see a related style of image making on the painted vessels from the Nazca area and also in the form of giant **geoglyphs** ("earth writing"). The latter are some of the most publicized and controversial works of art in the Americas thanks to some imaginative writers attributing their creation to visitors from outer space arriving via flying saucers. They date from the third to fifth centuries CE and represent a wide range of animals including ducks, monkeys, reptiles, spiders, seabirds, hummingbirds, whales, and other marine animals, all from our planet (FIG. 8.3). The people of Nazca "drew" the geoglyphs by attaching parallel sets of long cords to stakes in the ground to define pathways and removing the layers of dark surface pebbles along those paths to reveal the lighter sands and gravels below. Some of the animal images are over 400 feet (122 m) long and other straight lines may extend for over 1,000 feet (305 m) and terminate in piles of stones, as if they were connecting shrines or other places of importance. Many of the images and lines overlap, suggesting that the "life" of a given image may have been limited.

Astronomers using aerial photographs and celestial charts have tried to determine if the geoglyphs could have been Nazca constellations, or if they used the lines to make astronomical observations, but their findings have been inconclusive. Other scholars, pointing to later Inca thinking, have compared the lines to the complex network of walkways and imaginary lines with which the Inca connected

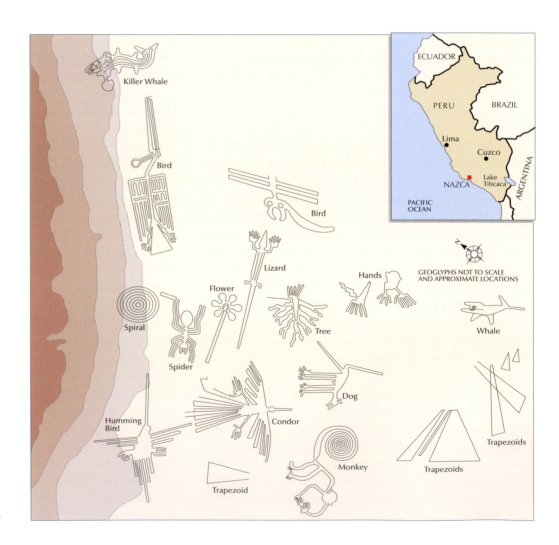

8.3 Line drawing of Nazca geoglyphs, south coast of Peru. 3rd–5th century CE. Geoglyphs not drawn to scale

their shrines to the Temple of the Sun in the heart of their capital at Cuzco. This idea will be discussed in more detail in context with Inca art.

To understand the meaning these large images had for their original audiences, we may need to ask: Who was that audience? It is impossible to see the images with any sense of perspective from ground level, and they are badly distorted when viewed from the nearby foothills. The only way to see them "correctly" is from high in the air. Before the invention of hot-air balloons and airplanes, only the gods at Nazca had that vantage point. Many of the representational geoglyphs resemble subjects on Nazca vessels that were used in ceremonies, so the geoglyphs may have been designed to make those forms visible from the sky—in other words, for the eyes of the gods. It is possible that some participants in these ceremonies walked the circuits of these forms to make them even more emphatic for the celestial "observers." Ceremonial walkers may have also congregated at the piles of stone to make offerings, as some Peruvians do at artificial stone piles to this day.

MOCHE AND CHANCHAN

While the textile artists working in styles derived from the Chavín tradition were providing the elaborate grave goods for burials along the southern Peruvian coast at Paracas and other localities, clay artists on the northern coast were modeling highly naturalistic faces, figures, and figure compositions on vases for their burials. This tradition of modeling naturalistic forms, dating back to early Valdivian times (c. 3550 BCE), reached a high point around the fifth century CE at Moche, the capital of a large kingdom in the coastal deserts. From about 200 BCE to 600 CE, the people of Moche controlled a confederation of cities with irrigated fields along the northern Peruvian coast and developed a tradition of burying their elite with grave goods, which included sculptured vases. These moldmade grave vessels with rounded, stirrup-shaped spouts were hand-finished by sculptors and painted to represent a wide variety of face types, figures, and figure groups. Some of the Moche vases also illustrate deformed faces, images of death, and figures engaged in sacrificial or erotic activities, which may be part of local fertility and death cults. This tradition of naturalism in clay art, which had existed along the northern Peruvian coast since pre-Chavín times, reaches its apogee in the fifth century in a group of about fifty very mature and dignified face types, which may be portraits of Moche rulers (FIG. 8.4).

Unlike the Chavín tradition, which is formal and abstract, the sculptured and painted Moche vessels emphasize details of dress, decoration, actions, and narrative content. The

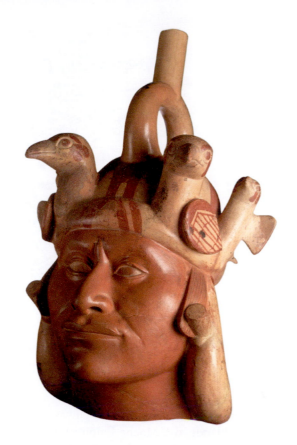

8.4 Moche portrait head vessel. Peru. 400–500 CE. Terracotta with paint, 12½ × 8¾" (31.7 × 22 cm). Museo Arqueológico Rafael Larco Herrera, Lima

paintings show mortals and supernatural beings taking part in dances, races, sacrifices, and burials. Schematic landscapes with rolling hills, mountains, and simplified plant forms provide backgrounds that indicate whether the events took place on the coast, in the deserts, or in the mountains.

Four rituals from the Moche burial cult are illustrated on a single important burial vessel (FIG. 8.5). The image wrapping around the vessel appears flat in this modern reconstruction drawing. Two men (identified as Wrinkle Face and Iguana) are holding ropes as they lower a masked mummy bundle into a shaft tomb chamber with grave offerings that include many recognizable Moche vessel types. The same two men appear again below on either side of the tomb, with other smaller staff-bearing attendants above. Most of their features are rendered in profile, except for their upper torsos and certain items of clothing, which are shown from frontal points of view. On the opposite side of the vase, the men offer bird sacrifices and hold an audience with a ruler, presumably as part of the complex of ceremonies accompanying the burial. Studies of Moche paintings enable scholars to identify Moche gods and rituals, to recognize important ceramic workshops, and to isolate the hands of individual artists. (See *In Context*: The Lord of Sipán, page 281.)

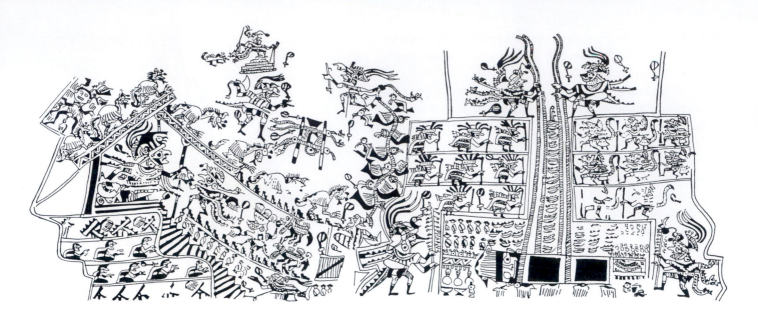

8.5 Reconstruction drawing of a painted stirrup-spout burial vessel. Middle Moche culture. 300–600 CE. Height 12″ (30 cm). Private collection

After a series of natural disasters and invasions by peoples from the highlands, the Moche Empire fragmented; later, their territories were reconsolidated and expanded under the Chimu Empire (1150–1460). The Chimu language, Muchic, may have been derived from that of Moche, and the Chimu revived many other elements of the Moche traditions. However, almost all the Chimu buildings were larger than the counterparts built by their predecessors, and the new overlords of the coastal desert placed a fresh emphasis on the construction of roads, walls, canals, and secular buildings. The Chimu capital, ChanChan, had a population of about fifty thousand and covered about 20 square miles (c. 52 sq km) (FIG. 8.6).

ChanChan, with its abundant supply of freshwater from a network of canals, is the most ambitious example of urban planning in South America. Ten large palace compounds, modeled after late Moche examples, averaging 20 acres (8.09 hectares) apiece, had living quarters for the royal family and its retainers, a royal mausoleum, gardens, and areas for audiences. They were surrounded by walls up to 30 feet (9.15 m) high, decorated with repeating patterns of geometric forms, foliage, animals, and mythical creatures. The compounds appear to be the work of the successive monarchs who ruled the city and kingdom from the late twelfth century to 1460. When the Inca conquered ChanChan in the fifteenth century, they relocated many ChanChan artists to Cuzco, where they blended elements of the coastal and highland traditions to create their own distinctive styles of art and architecture. Two of those earlier highland traditions, at Tiahuanaco and Huari, are discussed below.

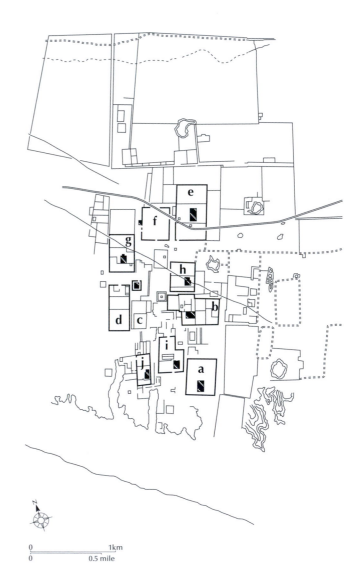

THE LORD OF SIPÁN

Most of the tombs excavated by archeologists have been plundered by grave robbers or *huaqueros* (adobe mounds are called *huacas* in Spanish). In 1987, *huaqueros* working in the Lambayeque Valley near Sipán at Huaca Rajada discovered a cache of antiquities in a temple platform near two large eroded pyramids. When the local authorities discovered the looting, archeologists were summoned to salvage the site and conduct further excavations. They discovered one of the richest and most important tombs ever unearthed in the Americas. The occupant, a warrior-priest about thirty-five years of age (died c. 290 CE), has become known as the Lord of Sipán (FIG. 8.7). His burial treasures included a gold headdress, mask, knife, jewelry, shield, pottery, and some attendants. Two young women (concubines or wives?), two men (enemy warriors?), and a dog may have been sacrificed to accompany the Lord into the other world. Many works similar to those in this tomb have long been known, but finding them here in their original context enabled archeologists to reconstruct Moche burial practices and learn more about their religion and worldview.

8.7 Exploded view of the burial of the Lord of Sipán. Huaca Rajada, Lambayeque Valley, Peru. c. 290 CE. Painting by Ned Seidleer
Major features are keyed to letters in the illustration: (a) Wooden coffin lid; (b) shell and copper bead pectorals; (c) gilded copper headdress with textile fastener; (d) outer garment with copper platelet; (e) gold rattle; (f) copper knife; (g) copper sandals and seashells; (h) gold headdress ornament; (i) gold and copper backflaps; (j) shrouds enclosing contents of the tomb; (k) war club and copper tipped darts.

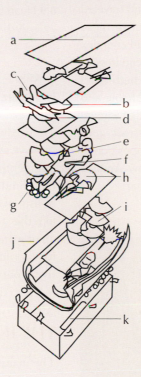

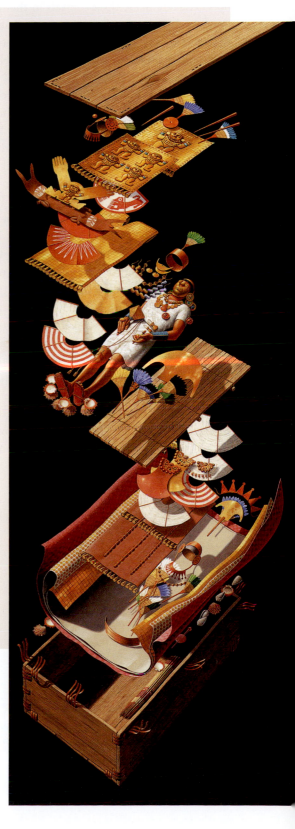

8.6 (OPPOSITE) Map of ChanChan. 1000–1465. Letters are keyed to the major monuments (some of the compounds are named after early excavators): (a) Chayhuac; (b) Max Uhle; (c) Tello; (d) Labyrinth; (e) Gran Chimu; (f) Squier; (g) Velarde; (h) Bandelier; (i) Tschudi; (j) Rivero

TIAHUANACO AND HUARI

The Chavín-style arts of Paracas, Nazca, and other early art centers formed the basis of the textiles, paintings, and relief sculptures of the first large Andean empires created around 600 CE. They made their capitals in the highlands at Huari, Peru, and Tiahuanaco, Bolivia, near Lake Titicaca. While there are few remains at Huari, Tiahuanaco is an enormous complex of platforms and plazas with well-preserved monumental sculptures. It was a religious and cultural center for the Aymara-speakers of this region, who raised llamas and alpacas in the cold, dry Altiplano. The original Aymara name for Tiahuanaco, Paypicala ("The Stone in the Middle"), implies that the city was the center of the Aymara universe. Inca legends also tell how their creator god, Viracocha, made the sun, moon, and stars at Tiahuanaco.

An image of a god who may be the Tiahuanaco equivalent of the Chavín Staff God stands in the center of the shallow reliefs on the Gateway of the Sun (FIG. 8.8). The similarity of the figures shows how the stylistic conventions of Chavín art retained their importance over the centuries and traveled great distances—again, a testament to the power of those early images that gave the gods such intriguing and complex earthly forms. The figure on the gateway has a headdress of serpent-headed projections and a face carved in high relief like a mask, and it holds ceremonial staffs with feline and condor-headed finials. Around him are three rows of winged attendants with falcon and condor faces. The abstract, geometric, and linear style of the figures and the composition of repeating units of form reflect the designs of many Andean textiles, including those of the contemporary Huari.

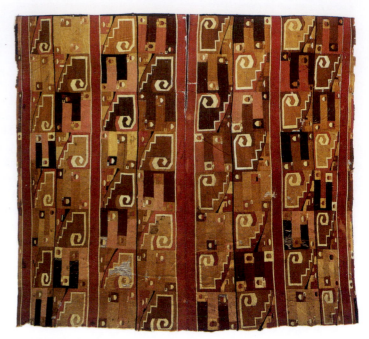

8.9 Huari tunic, Peru. 500–800 CE. Cotton and camelid yarn, 39³⁄₁₆ × 40⁷⁄₈″ (1.01 × 1.04 m). Museum of Fine Arts, Boston

While the Huari tapestries represent subjects based in large part on the winged, attendant deities on the gateway, these basic forms appear in numerous variations (FIG. 8.9). The weavers seem to have delighted in finding ways to be creative within their iconographic constraints, compressing, fragmenting, reversing, and changing the color schemes of their limited number of given forms, retaining the core symbolism of the forms through all their variations. The design, like the structure of the threads in the textile itself, is made up of many elements repeating in a grid pattern. There is no focal point or attempt to organize the elements in distinctive groups. The sameness of the grid pattern throughout is, in itself, the strongest formal expression of the design.

THE INCA

The name "Inca" refers to a group of imperialists who emerged in the highlands of southern Peru and Bolivia around 1300 CE as well as to their deified ruler. Inca legends say that they came from the high stony plains around Lake Titicaca and Tiahuanaco, where their world was created, but, in fact, they may have been native to the greater Cuzco area. In the middle of the fifteenth century, the Inca burst forth and swept across the Andes with an explosive force comparable to that of the armies under Genghis Khan and Alexander the Great. Most of the Inca Empire, which extended from present-day Quito, Ecuador, south to Santiago, Chile, was

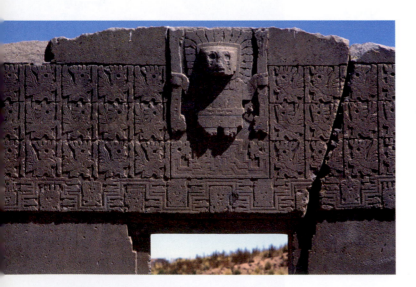

8.8 Gateway of the Sun. Tiahuanaco culture. c. 500 CE. Tiahuanaco, Bolivia

less than a century old at the time of the Spanish conquest in the early sixteenth century. Yet it was a rigorously disciplined political institution unified by a large network of roads and bridges in which the Inca (ruler) presided over a complex administrative hierarchy. Serfs and skilled workers paid their taxes by working on the roads, agricultural terraces, storehouses, fortifications, palaces, and temples. Inventory records and other important government statistics were recorded on *quipus*, sets of knotted cords attached to a central loop. They were mnemonic devices in which the shape, color, and sequence of the knots on each cord encoded information. Relay teams of swift-footed runners could move the *quipus* quickly over long distances along the network of roads and trails leading to and from the capital.

Viracocha, the creator, was the head of a pantheon of gods that included Inti (a male sun god), Quilla (a moon goddess), and the stars. The Inca linked their religious ideals with patriotism and allowed their subjects to worship some of their own regional gods as long as they remained loyal to the empire and its ruler. The Inca also incorporated many of the earlier traditions in the arts, but, as highlanders surrounded by the rocky outcrops of the Andes, they had a special passion for stone, which became an important symbol of their existence and identity. Their myths and legends are filled with stories about the innate spiritual powers of stone. Some creation myths say the Viracocha created humankind from stone—and turned some of his first efforts back into stone. Mano Capac, the first Inca ruler, was also born of stone and turned to stone at his death. Some natural rocks around Cuzco are partially carved, as if they are in the process of coming to life, and many of the large stones in the city walls have slightly recessed edges and convex faces, resembling living forms bulging under the weight of the stones above them. The Inca ruler Pachakuti (ruled 1438–73) installed a group of stones in a temple at Cuzco, which, according to legend, had taken human form to help him in battle. At shrines, the Inca often placed worked stones around large natural stones, as if to illustrate the stones' ability to come to life.

CUZCO

Pachakuti conquered ChanChan, made a thorough study of it and its imperial holdings, and, using the knowledge he had thereby gleaned, began rebuilding Cuzco to make it a fitting capital for his rapidly expanding empire. A figure comparable to the Roman emperor Augustus, who said he found Rome a city of brick and left it a city of marble, Pachakuti was the Inca leader who reshaped the image of Cuzco around stone to make it a grand imperial center. Set in the rocky highlands, the city was laid out on an irregular plan following the local topography. The central plazas, with their palaces, temples, ceremonial halls, and residences for rulers' secondary wives and the chaste women dedicated to Inti, stood at the heart of the city and the Inca cosmos. Inti's temple, the Coricancha, housed the mummies of past rulers and its garden contained lifesize golden images of people, animals, and plants.

The major roadways radiating outward from starting points near the Coricancha and center of the city divided the empire into the Land of the Four Quarters. There were also forty-one imaginary lines, known as *ceques* (the word for "rays" in Quechua, the Inca tongue), that projected outward from the Coricancha to the Inca *huacas*, sacred places such as rocks and streams and the shrines of lesser deities. These *ceques*, some of which were also tied to lines of astronomical observation, linked the *huacas* to the Inca cosmos and expressed the grandness of the society's imperial ambitions. With Cuzco as the hub of a radiating pattern of *ceques* and roads, the conceptual vision of the capital resembles that of a giant *quipu* superimposed upon the mountains. Another set of radiating lines on the Altiplano in western Bolivia, known as the Sajama Lines, are up to 15 miles (24 km) long and connect shrines, burial towers, and villages. They may have been conceived as *ceques*, but they are marked by lines on the ground like the geoglyphs at Nazca.

The massiveness and height of the walls lining the streets emphasize the narrowness of the ancient passageways between the old houses, temples, and palaces in the heart of the city (FIG. 8.10). While the walls at Cuzco appear plain today, originally they supported earth-toned thatched roofs and the streets would have been filled with locals and visitors to the great capital city dressed in colorful dyed textiles. The Inca expressed the ancient textile aesthetic in the abstract geometric patterning of these high walls in which the stones are cut to exacting dimensions. They also combine this ideal with their love for the material and spiritual character of stone; in some cases, the stones take a wide variety of shapes. They began by trimming and shaping the stones they planned to use before dragging them to the building site on rollers. When it was time to place a stone in a wall, they suspended it from a sturdy tripod by strong ropes attached to projecting nubbins on its front and back sides. Swinging it back and forth, lowering it very slightly from time to time, they would grind the suspended stone against the stones below it and to the side until it had ground out its own nest. In many cases, the nubbins are still visible. In a most amazing *tour de force*, some of the stones have up to eleven corners and sides—each one of which had to be ground and shaped by rocking it, or the stones beside it, back and forth. As we look at the stones and try to figure out the sequence in which this happened, we realize that the Inca have created yet another Andean puzzle for

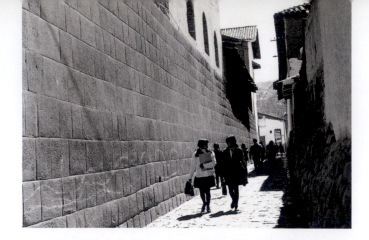

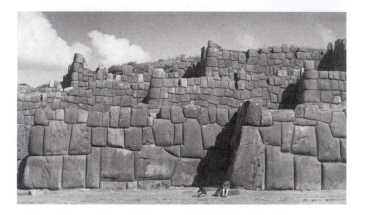

8.10 (TOP) Street in Cuzco lined with Inca masonry. Photograph 1970

8.11 (ABOVE) View of colossal stonework, Sacsahuaman, near Cuzco

us to ponder in which the stones seem to have personalities and spirits of their own.

This love of stone takes on even more astonishing dimensions at Sacsahuaman, a fortress-palace and ritual center in the hills high over Cuzco. Some of the stones here weigh over 100 tons (101,600 kg) and were far too heavy to be suspended from tripods. They were apparently rocked back and forth on the ground and against their neighbors until they were perfectly nested (FIG. 8.11). Here, the textile patterning aesthetic and love of the inherent qualities of stone combine in an expression of Inca imperial power, creating a monument that contains stones that are much larger than those used in the Egyptian pyramids and that fit together as beautifully as the stonework in the finest Gothic cathedrals. The time, effort, patience, and technology required to fit stones in this manner testify to the organizational skills of the Inca. And far from being purely showy, the Inca walls have proven to be very stable and functional. Over the years, earthquakes have rocked Cuzco and many of the colonial Spanish buildings built over Inca walls there have crumbled, but the massive stones in those walls, so carefully fitted and

nested over five hundred years ago, remain unmoved. Thus, in a most amazing way, the Inca have left us a lasting comment on their position as the lords of the Andes.

MACHU PICCHU

Pachakuti also began the construction of Machu Picchu, a ritual center and royal retreat on the frontier of the empire that has become famous in modern times as one of the world's most picturesque archeological ruins (FIG. 8.12). The buildings and network of narrow agricultural terraces cling to the crest of a high ridge overlooking an oxbow curve in the Rio Urubamba, a tributary of the Amazon. The city is remarkably well preserved because, until 1911, its existence was unknown except to a few people living in that region.

A main road passing through a gate in the city wall leads to the Great Plaza in the center of the complex. Many of the buildings around that plaza are similar to those in other Inca cities: It has a Temple of the Sun, a royal palace, barracks, workers' quarters, storehouses, and baths. The Inca reshaped some of the large rock outcrops and incorporated them into the masonry or design of the city. One of these structures, known as the Intihuatana Stone ("Place to Which the Sun [Inti] is Tied"), may have been used as a sundial during celebrations marking the movements of the sun at important dates such as the June solstice (midwinter in the southern hemisphere)—the beginning of the new ceremonial year.

Machu Picchu was spared when Francisco Pizarro, commander of the Spanish forces, arrived in highland Peru and captured Atahualpa, but many of the Inca treasures were not. The Inca offered the Spaniards a true king's ransom in gold and silver. Pizarro's secretary, Francisco de Xerez, wrote:

> Atahualpa feared that the Spaniards would kill him and told the Governor that he would give them … enough gold to fill a room twenty-two feet long and sixteen wide to a white line at half the height of the room, or half again his height. He said that he would fill the room to that mark with various pieces of gold—pitchers, jars, tiles and other things.

In a wholesale destruction of Inca art, the Spanish melted Atahualpa's gold ransom into bullion. With this windfall, and lured on by legends of even greater hoards of gold elsewhere in South America, the Spaniards spent many years in a fruitless search for the legendary El Dorado ("The Golden One"), a king with so much gold that, for certain rituals, he appeared in public painted with gold dust. In an ironic twist, which repeats the legend of the Golden Goose, the Spanish did not realize they had already killed the "Golden One" in the person of Atahualpa.

importance of the military as exemplified by Ignatius Loyola, and in Cervantes' *Don Quixote*, many paintings in this style illustrate archangels dressed as soldiers. Others are devotional images of the Virgin and Child that were displayed on altars with candles and vases of flowers.

This complex mixing of Western and non-Western ideas is well illustrated in the eighteenth-century *Angel Carrying Arquebus* (FIG. 8.13). This type of image, known as a "dressed statue," was inspired by a popular type of richly ornamented statue used for devotional purposes. The manner in which the three-dimensional volumes of the statue are transformed into this flat but magnificently painted image gives the angel an abstract, remote, and iconic quality that recalls the ancient textile aesthetic of the Andes. This integration of native tastes in the decorative arts into those of the Church reflects the Roman Catholic mission in Latin America, which is dedicated to serving the entire population, and illustrates how art from beyond the West helped shape the art of Christendom.

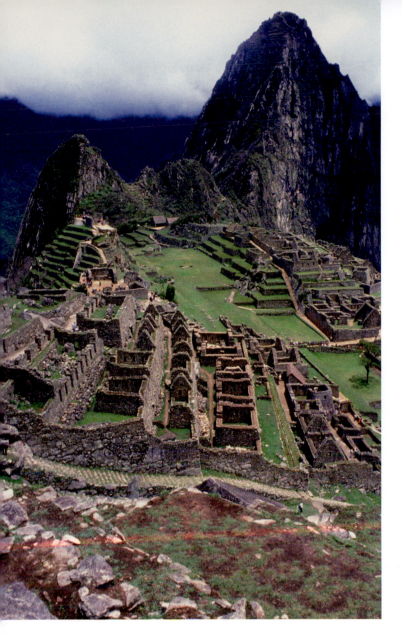

8.12 View of Machu Picchu, with Huayna Picchu in the background. Built c. 1500

POSTCONQUEST CUZCO

The great empire of the Inca was destroyed, but Cuzco in the silver-rich Viceroyalty of Peru remained a key site in the Andes where the Pre-Columbian and colonial cultural traditions mixed. By the middle of the seventeenth century it was the single most important center of painting in South America. The local style was a rich mix derived from Flemish prints, Byzantine icons from Venice, and Inca aesthetics as they had been preserved in regional forms of Inca folk art. Sewing precious metals and jewels to the surfaces of their paintings, along with silver and gold stenciling and gold-leaf appliqué, the colonial artists created richly textured surfaces and images with very little illusion of volume or space. In a Spanish tradition reflecting, perhaps, the

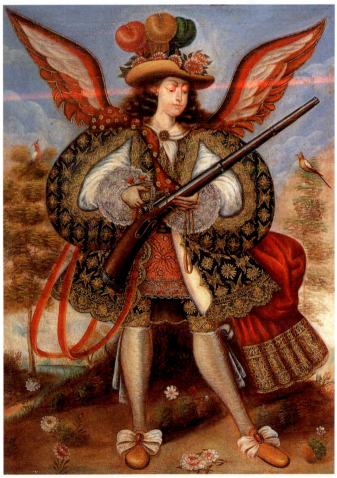

8.13 Cuzco School, Peru, *Angel Carrying Arguebus*. 18th century. Museo Provincial de Bellas Artes, Salamanca

MESOAMERICA

Mesoamerica is an area of high culture extending from central Mexico through the Yucatán Peninsula, Guatemala, and Belize to the western sections of Honduras and El Salvador. Scholars call the art and cultures west of the Isthmus of Tehuantepec Mexican, and the art to the east Maya. At the time of the Spanish conquest, the Aztecs had an empire that covered much of Mexican Mesoamerica, but by that time the Maya were in decline and many of their most spectacular cities had been abandoned. In Pre-Columbian times, the Mesoamericans had little if any direct contact with South or North America, and, as we shall see, the art of Mesoamerica is clearly distinct in style and meaning from that of its neighbors.

The history of Pre-Columbian Mesoamerican art is divided into three major periods: the Preclassic (or Formative), Classic, and Postclassic periods. The term "Classic" was borrowed from Greco-Roman studies by early Mayanists to designate what they considered to be the high point of Mesoamerican art. However, as we shall see, the art of all three periods is compelling and has great historical value.

Throughout this long history, beginning around 1200 BCE, the Mesoamericans built cities that operated like large outdoor theaters where they displayed images that expressed the power of their leaders and the gods for whom they ruled. The Mesoamericans believed the affairs of their world were closely linked to those of an unseen otherworld populated by this host of spiritual powers. Ritual centers were often oriented so that buildings and roads aligned to points along the horizon where the heavenly bodies rose and set at predictable intervals, linking the cities with the otherworld of the heavens. Temples placed on tall, superimposed platforms with inclined sides and resembling mountains were often conceived as surrogate mountains, and the temples on their summits were the "caves" through which the leaders could move from this world to the otherworld and return. The concept of the symbolic architectural mountain designed to connect this world with other worlds, above and, at times, below, is a very ancient and widespread one. We find it in the earliest civilizations in the Old World and throughout Native America, most notably in Mesoamerica and the Southeastern United States. Both American areas had similar views of the cosmos, with a tall tree functioning as an *axis mundi*, "world axis," connecting this world with those above and below.

Many Mesoamerican groups also had a similar ritual calendar of 260 days, in which thirteen distinct gods presided over twenty numbered days. With its combination of a god and a number (each of which had its own symbolic meaning), every day in the calendar had a distinct spiritual character and meaning. By linking this world to the otherworld of the gods, through their architecture, art, rituals, numerology, and calendar, the Mesoamericans hoped to gain some measure of control over the spiritual powers that dominated their existence. The various ways in which these ideas shaped the arts will be examined in context with the major regional styles of art and architecture.

PRECLASSIC ART: THE OLMECS

The people who created the earliest works of art in Mesoamerica on the lower gulf coast of Mexico are called Olmecs, a modern name derived from the Aztec word *Olman* ("The Rubber Country") for the low-lying tropical rainforests along the lower gulf coast, and from Olmeca, the name of the people who lived there in the sixteenth century. The true ethnic and linguistic identity of the ancient Olmecs is still a matter of debate.

The Olmecs are credited with many firsts in Mesoamerican history. If they did not invent the idea of representation, they were certainly the first to work in monumental dimensions, giving their images a sense of great power and drama. The most spectacular of these are the colossal stone heads, ten of which were found at San Lorenzo, the earliest important Olmec center (FIG. 8.14). They are carved from large basalt boulders that may have been imported from the Tuxtla mountains about 80 miles (128 km) southeast of San Lorenzo. Remains of pigment on some of the heads suggest that they were once painted and fitted perhaps with headgear and other perishable decorations. The broadly curved features of this large head are united in a composition of closely related, simplified forms that give it a sense of weight and great authority. Typically Olmec in style, the contours of the intensely somber face reflect the natural shapes of boulders and water-worn pebbles that are found in abundance in the Olmec heartland.

All the colossal heads represent mature men with full features and slightly crossed eyes, yet they all bear traces of individual personalities. This combination of stereotyped

TIME CHART: MESOAMERICA

Preclassic: 1200 BCE–250 CE

Classic: 250–900

Postclassic: 900–c. 1520

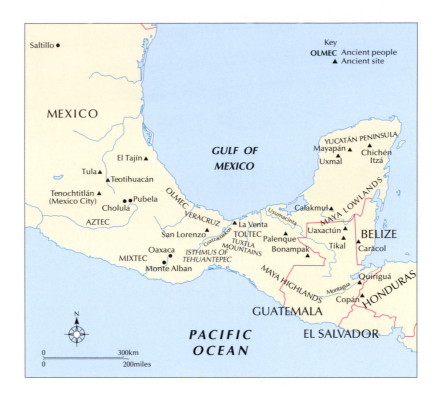

and individualized features suggests that the heads may represent the rulers of San Lorenzo in the guise of the gods, or a special god who was the protector of the throne. If each of the ten heads at San Lorenzo represents an individual ruling on average for thirty years, that time span, three hundred years, would match the three centuries (1200–900 BCE) during which the site flourished. Two of the heads were carved from large rectangular-shaped stones believed to have been used as thrones, in an effort, perhaps, to link the head and face of the ruler with his throne and seat of authority. When San Lorenzo was destroyed, many of the monumental sculptures, including some of the heads, were systematically defaced (ritually "killed") and buried around the edge of the city, as if the conquerors were intent upon destroying all trace of the memory and the power of the kings who had ruled there.

After the destruction of San Lorenzo, La Venta (c. 900–400 BCE), a remote ritual center on a swampy, stoneless island, became the leading Olmec center. The layout of the city, with its platforms and monuments set on the four sides of its open, rectangular plazas, is more carefully planned than San Lorenzo (FIG. 8.15). Moreover, lying along a central axis that points eight degrees west of north, La Venta seems to have been conceived as part of a much larger cosmic plan to link that ritual center with the otherworld of the gods.

The main structure, a 110-foot-high (33.5 m) conical pyramid that has been described as a "fluted cupcake," has no stairway and nothing indicating there was ever a temple on its summit. It appears to be a replica of a Mesoamerican volcano, many of which have deep erosion ditches or flutes on their soft cinder slopes. It is possible that the Olmecs thought of the volcano with its passageway to the underworld as a gateway to the Olmec otherworld. If so, its replica at La Venta

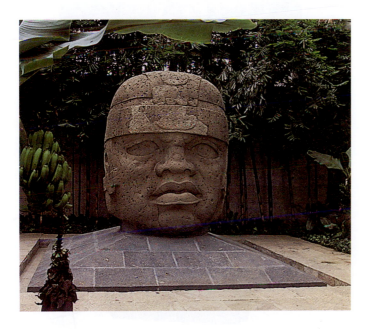

8.14 Colossal head, from San Lorenzo. Olmec culture. c. 1200–900 BCE. Basalt, height 9' (2.75 m). Museo Etnográfico y Arqueológico, Jalapa, Mexico

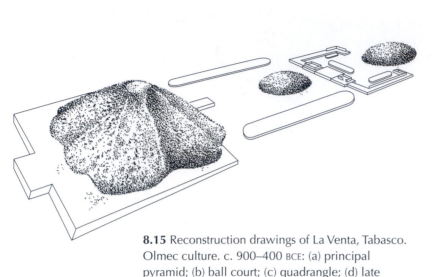

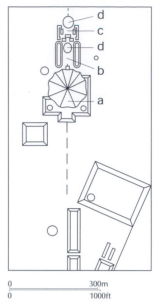

8.15 Reconstruction drawings of La Venta, Tabasco. Olmec culture. c. 900–400 BCE: (a) principal pyramid; (b) ball court; (c) quadrangle; (d) late burial mounds

would have provided the Olmecs with a dramatic image of a portal to the otherworld and the powers therein. Archeologists have not tunneled inside the conical structure, but it may contain the tomb of one of the rulers represented by the four colossal heads found here. Several features of La Venta—the tall symbolic mountain, the plan in which structures are set on the sides of a rectangular plaza, and the external orientation of the center toward cosmic features— became standard ones in the centuries to come, through the Classic and Postclassic periods up to the Spanish conquest.

The Olmecs of San Lorenzo, La Venta, and other cities on the lower gulf coast also carved other types of monumental sculptures and small portable stones they exported to many locations in Mesoamerica. Some of the pieces carved from jadeite and depicting howling human infants with feline eyes and mouths are known as "were-jaguars." Others combine human features with those of reptiles, birds, mammals, and other animal types. Such hybrid creatures may represent certain spirits venerated by the Olmecs, lineage signs, or shamans who have been partly transformed into animals. One such were-jaguar, known as the *Kunz Axe*, beautifully carved from a translucent blue-green jade, combines the gently rounded curves of the colossal heads with incised details that also use the same formal vocabulary of shapes or curves as the large sculptures (FIG. 8.16). In many cases, these delicate, thin-lined images of hybrid faces appear with abstract signs or images that may be parts of a system of writing. This system has yet to be fully deciphered but, as we will see, around 250 CE the Early Classic Maya, building on the work of the Olmecs and others, created a system of writing that was deciphered in the late twentieth century.

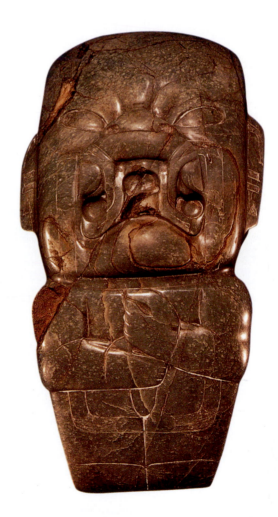

8.16 *Kunz Axe*. Olmec culture. c. 1000 BCE. Jade, height 11″ (28 cm). American Museum of Natural History, New York

CLASSIC ART

By the beginning of the Classic period (c. 250 CE), many regions within Mesoamerica had large metropolitan centers with active workshops of artists who were producing high-quality painted pottery, manuscripts, and sculptures in stone, stucco, and wood. The cultural and artistic differences between the Mexican and Maya halves of Mesoamerica were already marked, but throughout the Classic period they exchanged ideas with one another and their other neighbors as they developed increasingly distinct regional styles of art.

THE MAYA

The Maya lived in three distinct regions: the Central area, extending from the Usumacinta River drainage area through the Petén district of Guatemala to present-day Belize; the southern highlands in Guatemala; and the northern Yucatán Peninsula. At the height of their prosperity, around the late eighth century CE, the Maya lived in about fifty major city-states, the capitals of which featured a wide variety of tall platform temples and palaces decorated with architectural sculptures and murals. City-state rulers representing local dynasties ruled over a complex hierarchy of farmers, merchants, nobles, warriors, artists, and craftsmen. They directed trade, politics, war, and religion, which included the staging of rituals in and around the temples and plazas in the ceremonial centers. Some of the city-states were organized into confederacies. Two of the strongest, headed by the cities of Calakmul and Tikal, had a long-standing rivalry, and no ruler ever succeeded in uniting all the Maya in a single large state or empire. The rulers in these competing city-states were great patrons of the arts because, as we will see, their afterlives with the gods may have depended on how successfully they reflected the glory of those gods as their regents on this earth.

The Maya were the only fully literate people in Pre-Columbian America. Maya scribes painted and carved **hieroglyphic** (from the Greek *hieros*, "sacred," and *glyphein*, "to carve") inscriptions on vases, manuscripts, monumental sculptures, and buildings. Many of the hieroglyphs mix **pictographs**, stylized images of objects, with phonograms, signs for spoken sounds in the ancient Maya language. Recent developments in Maya epigraphy make it possible to read over half of the characters in the ancient Maya hieroglyphic inscriptions. We now have a highly detailed and growing record of who ruled where and when, their accomplishments, and the corresponding activities of the gods in the otherworld (FIG. 8.17). Like the ancient Greeks, the Maya expressed their civic pride through the arts, which included now-lost forms of poetry, music, and drama, and perhaps, given what we now know about the complex

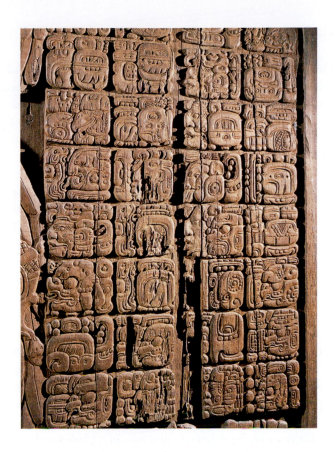

8.17 Maya hieroglyphic inscription from lintel (displayed vertically), Temple IV, Tikal, El Petén, Guatemala. 741 CE. Wood, height approx. 19" (48.25 cm). Museum der Kulturen, Basel

iconography of their art and architecture, a philosophical tradition that dealt with Maya aesthetics.

The Maya also had a remarkably accurate calendar. To mark units of time, they used dots (one) and bars (five) with place values in a modified vigesimal (base twenty) system. They counted their time from a base date, 3114 BCE, when their world was created. Dates in Maya inscriptions can be correlated with those in our calendar system, which makes it possible to tell precisely when certain inscribed Maya buildings and works of art were dedicated, when rulers ascended the throne, and when they died. The most complete records come from the eighth century in the Late Classic period, when the economy and culture of the Maya world reached its peak in the Central area. With the ongoing decipherment of the Maya hieroglyphic script, epigraphers are amassing enough data to be able to write histories of Maya cities, dynasties, and regions that are far more accurate and complete than the accounts we have for most European cities of the same period. While most of our data for Europe comes from later authors paraphrasing now-lost sources, for our study of the Maya we have an abundance of original, precisely dated Late Classic-period documents.

The Maya elite claimed that they had lived with the gods before coming to earth to rule and that when they died they would return to their celestial homes. Like the various forms of the *Book of the Dead* that the Egyptians put in tombs of their nobles to guide them to the otherworld, the Maya elite deposited painted vessels and books in the tombs of their family members to help the deceased on their journeys into the afterlife. That perilous venture began with their passage to Xibalba ("Place of Fear"), a city of the dead at the base of the nine levels of the underworld. It was ruled by the twelve Maya death gods, the Lords of Xibalba, each of which personified distinct forms of suffering such as sickness, starvation, fear, and pain. If the deceased survived the many pitfalls on their way to the court of the Lords, they would be sent from the court to one of the many horrid torture chambers in Xibalba. Those who survived the ordeal were allowed to ascend from Xibalba along a World Tree, or Tree of Life, with roots in Xibalba and branches in the heavens pointing to the star we call Polaris, the Northern Star. There they joined their ancestors, the gods, and guided living rulers who visited in the ways of the heavens.

Xibalba may have been feared but, like Hades and Hell, which gave Western artists a wealth of material with which to work, it gave Maya storytellers and artists marvelous opportunities to create images of the colorful characters and events associated with it. We have thousands of beautifully painted vessels from Classic times illustrating the world of Xibalba and rituals in Maya centers, but only four or possibly five Pre-Columbian Maya books have survived and they were painted in the Postclassic period. These books, or **codices** (singular, codex), are screen-folds of "paper" made from the inner bark of fig trees coated with a fine lime paste. They bear numbers, dates, images of the gods, and a rich mix of historical and astrological data that Maya specialists used to divine or predict which days were auspicious ones for certain activities, and which were not (FIG. 8.18). Although no Classic codices survive, some painted vessels from this period show images of the Maya and their gods seated in front of codices, painting or reading them, so we know that codices already existed at this time. Furthermore, some Classic vessels are said to be painted in the "codex style" because they resemble the style of later codices and they may show us the type of painting one might expect to see if a Classic codex is ever found. The fact that no Classic codices have survived in tombs does not mean they were not plentiful in Classic times. In the hot, damp tropical rainforests, the perishable bark-paper books would not have lasted long underground, and even in the care of Maya scribes and rulers, the fragile codices may have been short-lived.

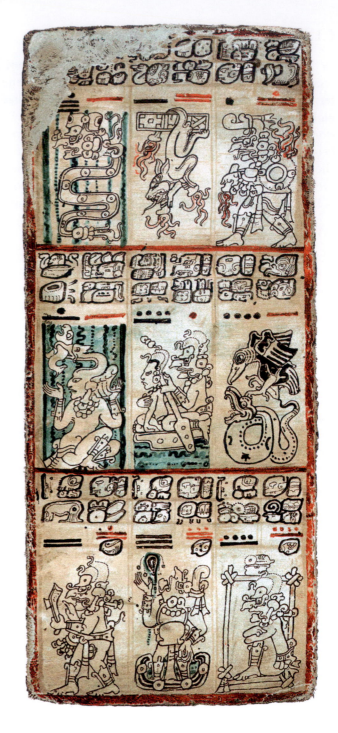

8.18 Section of the Dresden Codex. Postclassic period. Bark paper coated with fine stucco, height 18" (20.3 cm). Sachsische Landesbibliothek, Dresden

The Maya hieroglyphic script was never codified in the manner of the letters and words on this page. Like the medieval European manuscript illuminators who embellished their Latin letters with great flair, Maya scribes exercised a degree of poetic license and repeatedly found new ways to present variations upon the basic hieroglyphic character

types. In this regard, the creation of hieroglyphs was a form of calligraphy and seems to have been regarded as an important art form in its own right. Inscriptions on Maya vases may include the names of the patron or owner of the vessel and the artist-scribes entrusted with the creation of the text and religious images.

We call them artist-scribes because the images and inscriptions on many of the vessels appear to be by the same hand. This observation is confirmed by the Maya language, in which the word meaning both "to paint" and "to write" (*ts'ib*) is the same in all known Maya dialects, and Classic inscriptions refer to *ah ts'ibs* (royal artist-scribes). They were called "royal" because the artist-scribes came from the Maya elite. After the supreme god Itzámna invented writing, he taught the secrets of his creation to a few other gods, including a rabbit, twin monkey-men, and an old god, Pawatun. They, in turn, taught the skills to a limited number of carefully selected humans who could be entrusted to do the gods' work on earth.

We can see how one *ah ts'ib* expressed the divine character of his art and writing on a small incised bone, where a human hand holding a pointed paintbrush emerges from the toothy jaws of Itzámna, the celestial serpent and patron of writing (FIG. 8.19). The hand of the master does its work, very delicately, with index finger and thumb, and pinky in the air. This image seems to say that the elegant hand of the artist comes from the beyond and that his creative powers stem from Itzámna. Thus, the gifts of writing and painting go hand in hand with the divine and its presence on this earth.

One *ah ts'ib*, who signed his work Ah Maxam, said he was the son of the king of Naranjo and the Lady of Yaxha. Paint pots have also been found in the tombs of kings, including Hasaw Chan K'awil, a powerful ruler at Tikal. These may be symbols of their literacy, "diplomas," or perhaps keepsakes of younger days when, like Ah Maxam, they studied art and writing and all the secret, sacred knowledge they absorbed before ascending to the throne and ruling with divine authority.

8.19 Incised bone from the tomb of Hasaw Chan K'awil, Tikal. Burial 116 in Temple I. Late Classic period, 8th century

Since they were surrounded by peoples who were not literate, the ability to read and write was an important identifying feature of the Maya elite and it almost certainly helped justify their claims to being divine. Given that mysterious and magical knowledge that separated them from the masses and their neighbors, the Maya elite guarded their sacred learning carefully, along with other badges that identified them as members of the noble class. To mark their youngsters indelibly with their pedigree, the Maya elite put them in cradleboards with head presses that left the children with sharply receding foreheads and peaked heads. Only the nobles were allowed to practice this ritual deformation, which had to be done in infancy when the head bones were soft. Because of this, it was impossible for enterprising individuals from the masses to fake this sign of royalty and divinity in later life. Thus, royals traveling from city to city could be recognized by other individuals of their rank along the way by their literacy, knowledge of divine matters to which commoners did not have access, and their unusual head shapes.

Young princes studied with royal scribe-artists, including perhaps the most distinguished of them, the *ah k'unun* ("royal librarian" or "royal man of the holy books"). In all likelihood, an *ah k'unun* was the master in charge of the design, production, and restoration of books as well as the training of new artist-scribes at a workshop attached to the court. He may have also been the chief diviner or prognosticator who interpreted the manuscripts for royal patrons. Yet, in the art, we see the *ah k'unun* wearing a simple thong and a head wrap in which he has tucked his pens and brushes. One such divinely empowered *ah k'unun* appears on a vessel called *The Teaching Vase*, where he is shown seated, cross-legged, receiving instructions from Pawatun, the old god of art and writing (FIG. 8.20). Pawatun has large, goggle eyes, a wrinkled nose, and the brush-badges of the artist-scribal profession in his head wrap. Pawatun is pointing to a pair of numbers in the manuscript with a brush as he calls them out—thirteen and eleven in the system wherein bars equal five and dots stand for one. We see the numbers as they would be written in the text that lies at their knees. The thin curved lines—"speech threads" indicating that Pawatun is reciting the numbers—are remarkably similar to the speech lines used with balloons in modern cartoons.

In addition to astrological data, a codex such as the one Pawatun is using probably included historical and mythological narratives. While the Classic-period codices with these legends and accompanying text are missing, we know something about those narratives through the codex-style vessels mentioned above. Their texts, however, do not fully explain the stories; luckily, we also have another source for them. After the fall of the Classical cities, the Maya preserved some of their myths and legends in their oral

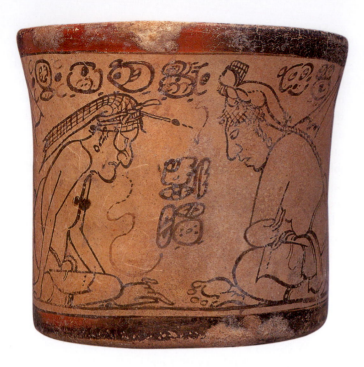

8.20 *The Teaching Vase.* Northern Guatemala? c. late 8th century. Height 3½" (8.9 cm). Kimbell Museum, Fort Worth

traditions long enough to write them down or to dictate them to scribes after the conquest. Most notably, a sixteenth-century book called the **Popul Vuh** ("Book of Council") from the Guatemala highlands preserves some of the storylines that inspired the vessel painters.

In the *Popul Vuh* the gods in Xibalba invite two mortal brothers to join them in a so-called ball game. Even though the **Mesoamerican ball game** was not a sport in the modern sense of the word, the words "game," "team," and "play" are so deeply embedded in the literature on this Mesoamerican ritual that we will use them here—without quotation marks. Throughout Mesoamerica and beyond, we find remains of ball courts where athletic young men competed with one another, hitting a large rubber ball back and forth from one end of the court to another (FIG. 8.21). (See *Analyzing Art and Architecture: The Mesoamerican Ball Game,* page 294.) In the book, the gods triumph, sacrifice the two men, and later repeat the challenge to one of the men's twin sons, Hunahpu and Xbalanque, also known as the Hero Twins. They accept, descend to Xibalba, and defeat the gods in a series of contests. The gods are especially impressed by the way the twins can sacrifice people and bring them back to life and decide to try it for themselves. But after the evil gods sacrifice themselves, the twins do not bring them back to life, thereby curtailing some of the power of Xibalba. They also restore life to their father, Hun Hunahpu, and he becomes the maize god, a symbol of fertility and the cycle of life and death. Some authorities say the twins became the sun and moon, others, constellations of stars. As solar bodies that descend below the horizon to the underworld and return, the twin gods are symbols of life and death. Together, the three gods are also allegories for the transfiguration of the Maya leaders who can leave this earth to commune with the gods, return with oracles, and, in death, join the gods in the heavens.

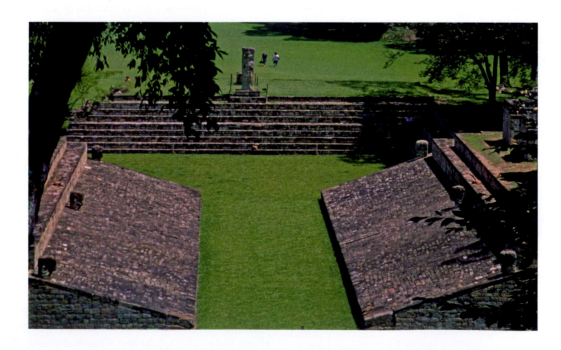

8.21 The Ball Court, Copan, Honduras. Late Classic period

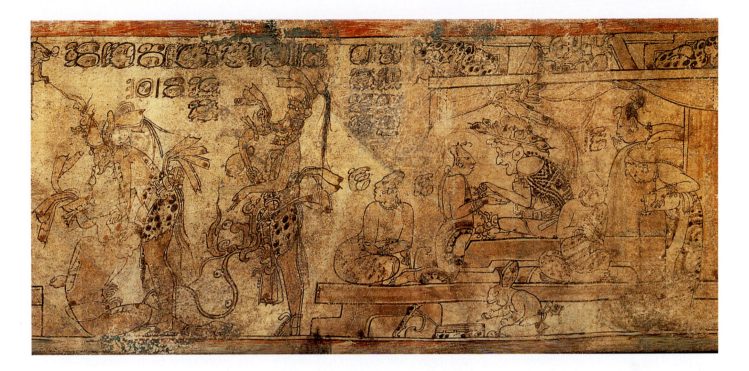

8.22 *The Princeton Vase.* Late Classic period, 8th century. Painted ceramic, 8½ × 6½″ (21.5 × 16.6 cm).
The Art Museum, Princeton University. (Flat reproduction of scene on curved vase.)
As is the case with many finely painted vessels presumed to be Late Classic and from northern Guatemala or its vicinity, the precise date and provenance of this vessel are unknown. The looters who found most of them seldom revealed where they had been working. Thus, the vase is named for the collection in which it is housed and, since we do not know the name of the painter, scholars call him the "Princeton Painter." A number of other known vessels seem to be by the same hand, and hopefully a signed vessel by that hand will one day be discovered so that the Princeton Painter can be known to history by his proper name.

We may see one of the episodes in the adventures of the twins in Xibalba on the well-preserved vessel in FIG. 8.22. The twins, or persons acting out their roles, wearing spotted jaguar-pelt kilts and reptilian masks with long snouts, are about to decapitate a bound man with their ornate knives. They are performing in the presence of God L, one of the aged lords of the underworld. He is seated on a cloth-covered bench within a small building and conversing with one of his five women attendants, whose hair has been plucked, accentuating their distinctive, sloping royal foreheads. The artist captures the elegance of the goddesses' movements, arranging them in innovative but casual poses. One of them turns to look at the twins, while a rotund rabbit, brush in hand and seated before a screen-fold codex in a box lined with a spotted jaguar pelt, appears to be recording the event.

The very fact that tales of the Hero Twins were so popular in Late Classic art and survived until colonial times suggests that they were key figures in Classic Maya thought and stood at the very heart of Maya beliefs about religion and the arts. In fact, the Maya version of the Mesoamerican ball game, which was played in almost every Maya city, may have been a ritual enactment of the Twins' ball game in Xibalba—their conquest of the evil gods—and been part of the allegory of the rebirth of the leaders in the heavens.

XIBALBA AND MAYA ARCHITECTURE

In the manner of the twins, the Maya rulers claimed that they too could travel to the otherworld, commune with the gods, and return to this earth through certain portals or pathways within the temple complexes in their ritual centers. The names they gave their temples and sculptures help us understand how this amazing system of cosmological thinking worked. They called their tall mountain-shaped temples *y-tot* (his or her house), indicating that the mountain-houses belong to the gods and goddesses. At the foot of the "mountains" they erected the large slab-shaped stones with hieroglyphic inscriptions and images of themselves that we call **stelae** (singular, stela). The Maya called them *te tun* (stone trees), where the body of the ruler is the tree's trunk and his headdress, with images of the gods and inscriptions pointing to the heavens, represents the branches. Together, the trees and mountains formed a symbolic landscape, a diagram of the Maya cosmos in which the

THE MESOAMERICAN BALL GAME

Around 1400 BCE, the Mesoamericans began building specialized architectural forms to stage rituals that modern commentators have long referred to as "ball games." The games were widespread and very popular, part of everyday life and religious life throughout Mesoamerica, and almost every city had one or more ball courts. About two thousand of them have been discovered to date and, as excavations progress, the number continues to rise. The games pitted two teams of seven members against one another. The players were probably young, highly athletic aristocrats with some form of priestly status associated with the ball game. In form, most of the courts resemble a capital "I." Each team occupied and defended an end zone (the bars on the top and bottom of the "I") as they volleyed the ball back and forth along the stem of the "I," or alley. In many cases, there were gently sloping platforms or aprons on either side of the alley. Some sources say that the alley, or playing field, was divided in half—like a tennis court—and players were not allowed to cross that divider.

Players wore heavy padding on their hips and legs to protect those body parts with which they hit the ball, often using highly athletic rolling or tumbling full-body motions. They might strike the ball directly down the alley at their opponents or at an angle so that it would bound up one of the sloping platforms, follow a curved path, and roll back into the playing area. Meanwhile, the opposing players would be positioning themselves to make a return volley.

Priests associated with the game (former players?) sat on higher platforms above the court and kept some form of tally as the action progressed. Here, we can see many possible parallels with modern ball games. They may have recorded faults—failures to return volleys past the center line (as in tennis), illegal hits with the hands (as in soccer), and balls that reached an opponent's end zone (a home run in baseball or a field goal in American football and rugby). Some courts had small sculptures on the sloping walls that may have been targets (bowling); others had stone rings mounted to the side walls above the aprons through which a ball might be struck (basketball).

The Aztecs call this ritual-game *ullamaliztli* (*ullama* means "playing a game" and *ulli* "rubber ball"). A variety of their "rubber-ball-game" is still played today in western Mexico and is called, *ulama*. The Maya even had a hieroglyph for the game that translates as *pitzal*, "play ball." With our contemporary passion for ball games, the ancient Mesoamerican game may seem strangely modern—until we look more carefully at what "play" and "gamesmanship" actually meant to them.

Colonial records tell us that the Aztecs wagered on their games, heavily, and that it was a popular form of public entertainment. Also, at times, competing kings might play the game in lieu of fighting a battle, so it could take on an economic and political importance, and in a culture with no separation between church and state, the game had religious

meaning too. In the manner of the Maya temples, which had a dual worldly-spiritual nature, the ball game also had a spiritual dimension. We know from Mesoamerican writings and illustrations that the ball game was associated with the underworld and death, the Maya Xibalba. Skulls and other signs of death are commonplace in ball-court decorations, along with scenes of human sacrifice. Also, looking at the patterns of Maya architecture, we might guess by their design—as apparent clefts in the earth—that ball courts had underworld associations. The field of play was probably regarded as both an entryway to the underworld and the underworld itself. While some priests climbed the mountain-temples to leave this world, players stepping onto the ball courts began a symbolic journey to the otherworld—a trip completed by those who were then sacrificed in the court during the postgame rituals.

In Mesoamerican belief, the gods are in constant battle to keep the cosmos moving in perfect order, and the game might have helped the Mesoamericans "see" and understand what was happening in the cosmos and the otherworld. Watching the patterns in the movements of the ball and the changing scores, the priests may have been able to decipher the wants and wishes of the gods, select the proper sacrificial victim(s), and tailor their ceremonies to the needs of the gods. Thus, the sacrificial victim(s) might not have been the winners or losers of the game, but rather those players whom the priests decided the gods wanted to join them.

small narrow spaces inside the temples at the summit of the "mountains" were caves leading from this world to the other. Using the symbolic powers of art and architecture, in the manner of the twins in the *Popul Vuh*, they were able to move back and forth from this world to the other. The purpose, it would seem, was to return with oracles and other forms of divine knowledge that would help them govern and protect their people, who were assembled before the "mountain" in the plaza among the "stone trees."

TIKAL

The tallest of these mountain-temples are in Tikal, which was occupied from c. 750 BCE to 900 CE. After defeating Uaxactún, its neighbor and archrival, Tikal enjoyed a period of prosperity in the late fourth century CE during which it traded with Teotihuacán in the Valley of Mexico. But, in 562, Lord Water from the Maya city of Caracol conquered Tikal, and the monuments erected there in the years that followed describe a century of anarchy and economic instability. Tikal enjoyed a renaissance under a strong ruler, Hasaw Chan K'awil (ruled 682–734), who expanded Tikal on a grand scale around a network of broad ceremonial roadways up to 80 feet (24.4 m) wide. These roads may have been used on a daily basis, as well as on special occasions by large ritual processions moving through the city and paying homage at the tomb-temples of the deceased kings and queens. Hasaw Chan K'awil built his temple-tomb in the Great Plaza, the very heart of the city, in full view of a new palace there and of many older temples.

His tall and gracefully proportioned temple-tomb, known today as Temple I, or the Temple of the Giant Jaguar, has become *the* symbol of Tikal, the Maya, and modern Guatemala (FIG. 8.23). The king's body was placed in a vaulted tomb with many offerings at ground level, over which the nine-level platform was built, symbolizing the shape of Xibalba. The patterns of the shadows created by the protruding moldings at the top of each platform and the double-stepped recesses on either side of the stairs enliven the towering mass of this tomb, the symbolic mountain, and the king's entryway to Xibalba. The temple at the summit was the focal point for funeral rituals performed in the king's honor after his death. Carved roof beams there illustrate his accession and military prowess. A monumental stucco image at the top of the temple showing the enthroned king with Itzámna looped over his head represents Hasaw Chan K'awil as king of the heavens. Unfortunately, it is badly eroded and not generally visible in photographs. This monument, and the other "skyscraper" temples of Tikal from this period, provided the city with a dramatic skyline that had no equal among European cities of this period.

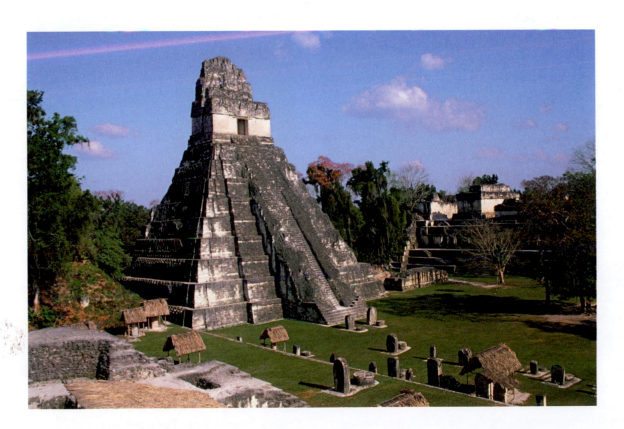

8.23 Temple I (Temple of the Giant Jaguar). Tikal, El Petén, Guatemala. Late Classic period, 8th century

PALENQUE

To see how a Maya ruler was entombed and prepared for the otherworld in more detail, we may turn to another Maya city, Palenque, and the Temple of the Inscriptions, the final resting place of King Hanab Pakal (ruled 615–83 CE). Early in his reign, Pakal begun working on the area around his future tomb, replacing portions of the old palace with light, airy, thin-walled enclosures containing multiple doors and large, decorative vaults. Around 675, when Pakal was in his seventies, he cleared an area adjacent to the palace and began the construction of his mortuary monument (FIG. 8.24). Both the tomb, the "home" of the deified ruler in the afterlife, and the temple above are stone replicas of the traditional type of Maya house still in use in this area. Maya homes are usually made from lashed saplings and have high-pitched roofs covered with many layers of palm fronds to repel the heavy tropical rains. The steeply inclined and flat-sided **corbel vaults** of the temple and tomb below reflect this timeless domestic prototype. Corbeled stone vaults are often called "false" arches to distinguish them from the round arches with keystones used by the Romans and the wide variety of pointed arches used in the Gothic period.

A relief on the lid of the king's sarcophagus shows him at the moment of his death, falling backward like the setting sun into the skeletal jaws of an earth monster on his way to Xibalba (FIG. 8.25). For the king's body, that descent to the otherworld began as he was carried from the temple at the summit of the "mountain" down the stairs through the body of the superimposed platforms to the tomb at ground level. Images of Hasan Pakal's regal ancestors and inscriptions in the tomb indicate that he was descended from a long line of kings and two noble ruling ladies. His grandmother ruled from 583 to 604 and his mother ruled before 615, very possibly as Pakal's regent. In his inscriptions, Pakal praises his mother, calling her the "mother of the gods," and double portraits of the women appear on the sides of his sarcophagus.

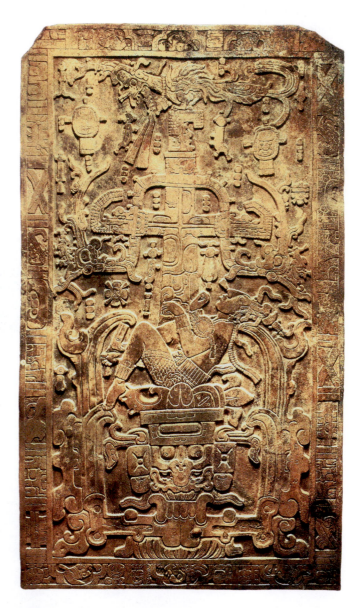

8.25 Sarcophagus lid, Temple of the Inscriptions. Palenque, Chiapas, Mexico. Late Classic period, c. 680 CE. Limestone, approx. 12'2" × 7' (3.7 × 2.2 m)

8.24 The Temple of the Inscriptions. Palenque, Chiapas, Mexico. Late Classic period, c. 670–80 CE
This temple is also known as the Ruz Tomb, for the archeologist who discovered the tomb and excavated it.

COPÁN AND BONAMPAK

While the stonecarvers at Tikal, Palenque, and many other Maya centers normally worked in shallow relief, in styles reflecting those of the vase painters, the sculptors of Copán found innovative ways to unleash the expressive potential of the linear forms of Maya imagery in three dimensions on a monumental scale. Copán ("Place in the Clouds") is located at the southeastern corner of the Maya territory near the Rio Managua and Guatemala–Honduras border. In 695, Waxaklahun Ubah K'awil became ruler of Copán and commissioned a series of "stone trees" and mountain-temples that established Copán as a major center for Maya art. The royal stelae portraits combine the decorative brilliance of Maya painting with a sense for sculptural form that Maya sculptors might have achieved in stucco and wood before this time, but never in stone. Working with andesite, a stone that is relatively soft when first quarried but that hardens on contact with the air, the sculptors were able to carve overlifesize figures of the king that are almost free-standing. A Western parallel for this development might be found in the achievement of the Italian Baroque sculptors whose boldly animated figures added a new dimension of expression to the shallow reliefs and static statuary of their Renaissance forebears.

Waxaklahun Ubah K'awil is portrayed on Stela A in full ceremonial regalia, wearing sandals, garters, a jadeite-studded loincloths, ear plugs, necklaces, and a multilayered plumed headdress (FIG. 8.26). In the crooks of his arms, he holds a bar with serpent heads on either end representing Itzámna, the serpent god of the sky, whose body (in the form of the bar) symbolizes the dome of the sky and the Maya cosmos. In the hands of Waxaklahun Ubah K'awil, the serpent-bar symbolizes the universality of his god Itzamna and his rule as a regent of the gods. The rounded masses of the ruler's feet, long legs, hands, arms, and face burst forth from a background of decorative details that illustrate the basis of his authority and kinship with the gods. The beauty and drama of this sculpture as the pattern of its highlights changes with the movement of the sun are truly astonishing, and we have every reason to think that the Copán sculptors who created such forms would have been fully aware of the dynamic role shadows played in the visual experience. The brilliance of the Copán artists' accomplishments in sculpture is even more remarkable when we remember that they operated on a Neolithic level of technology, carving these stelae with flint and obsidian tools.

While the sculptors at Copán working for the successors of Waxaklahun Ubah K'awil continued to produce new and brilliant works to glorify their reigns, the painters at Bonampak (Maya, "Painted Walls") were at work on a grand set

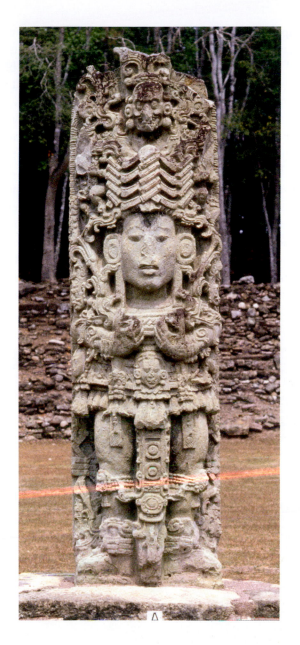

8.26 Portrait statue of Waxaklahun Ubah K'awil, ruler of Copán. Stela A, Copán, Honduras. Late Classic period, 731 CE. Andesite, over lifesize

of murals that celebrated the exploits of their king, Yahaw Chan Muwan, and his queen from nearby Yaxchilán. While other Classic wall paintings of comparable size and quality may have been created here and elsewhere in the Central Maya area, none survives. The murals in one room represent battle scenes, the complexity of which surpasses anything else in the long history of Pre-Columbian art. The murals in the adjacent rooms show nobles paying tribute, the presentation of a young heir apparent to the throne, scenes from palace life, dancers dressing and performing, and Yahaw Chan Muwan with his warriors reviewing a group

of captives (FIG. 8.27). The ruler and his military captain at the center of that composition wear royal jaguar pelts and stand on either side of a kneeling captive. Drops of blood flow from the fingers of some captives, suggesting that they have already been tortured in rituals leading up to this audience. To dramatize the lifelessness of the sacrificial victim at the feet of the king, the artist has arranged his body in a complex, unorthodox pose, with foreshortened arms and legs. In contrast to this slumping informality, the artists have accentuated the formality of the Bonampak nobles through the symmetry of the composition and placement of the ruler's staff directly above the entryway to the room.

The murals at Bonampak were never finished because that city and others in the Central area began to decline at the end of the eighth century. However, during this decline, some Maya cities in the northern area near the tip of the

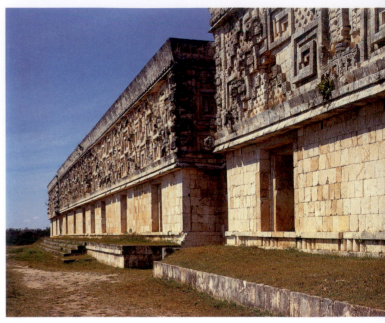

8.28 The House of the Governor. Uxmal, Yucatán, Mexico. 10th century

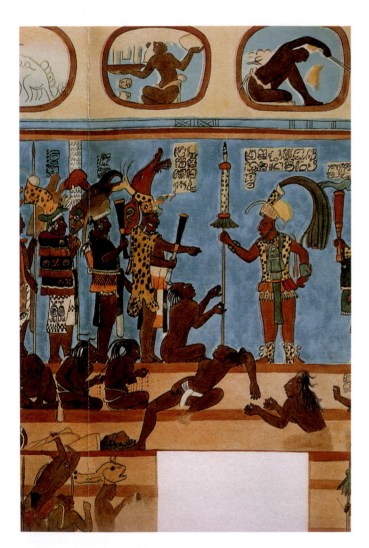

8.27 Detail of Maya wall painting, Room 2, Structure 1, Bonampak. Late Classic period, c. 795 CE. Polychrome stucco, entire wall 17 × 15′ (5.18 × 4.57 m). Copy by Antonio Tejeda

Yucatán Peninsula flourished for a few more generations. The last powerful ruler at Uxmal, Lord Chac, built what may be the finest example of northern Maya architecture in the Classic tradition at this time. The House of the Governor (a sixteenth-century name) appears to be three separate buildings linked by tall, gracefully curved arches (FIG. 8.28). But it is actually a single structure, and the recessed arches are part of the complex, rhythmic design of the façade, which includes sculptures on the upper walls that explain the building's cosmic symbolism. Those reliefs were carved on many small rectangular stones, which were later assembled like bricks in a wall or pieces of a very large mosaic. Lord Chac was originally seated on the throne directly above the central door in the midst of a panoramic view of the heavens with celestial serpents, geometric frets (swirling rain clouds), and rows of rain gods, the Chacs. Chac is a reptilian creature with a long curved nose, open fanged mouth, and large beady eyes (lower right in FIG. 8.29). The Puuc hills are much drier than the rainforests of the Central area, so Chac's life-giving rains were essential to the prosperity of Uxmal. The northern Maya of postconquest times described Chac as a divine force that gathered the storm clouds and drove the rains to the fields. In some places on the façade of the House of the Governor we see Chac heads directly over images of Maya homes, demonstrating how Chac (working with his namesake, Lord Chac of Uxmal) sent the rains to sustain the Maya villages and their fields. In effect, the sculptures unite the authority of Chac with his

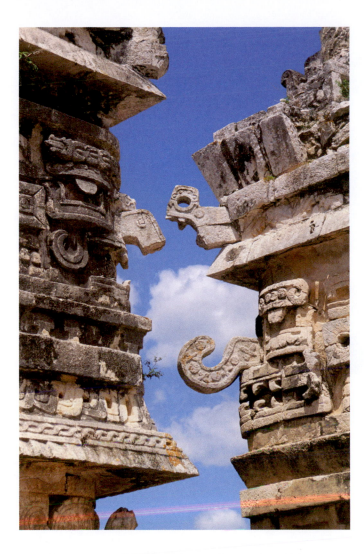

8.29 The Nunnery. Chichén-Itzá, Yucatán, Mexico. 10th century

earthly representative on the throne of Uxmal, who becomes the "bringer of the rains" and source of life for his people.

By the time Lord Chac finished the House of the Governor, most of the Maya cities in the Central area had been abandoned. For reasons that have long been debated, the grand ideology behind the sacred and symbolic mountain landscape complexes and the divinity of the ruling dynasties that sustained them fell out of favor. The artistic and archeological records suggest that battles were not longer being fought to procure sacrificial victims, but to protect the cities, perhaps from Mexican warriors coming from Mexico and the Maya ritual centers that were still functioning.

CLASSIC MEXICO

The dates for Mexican art are less precise than those for Maya art because they had a less accurate and detailed system of counting time. Two distinct Mexican styles emerged in the highlands and the lowlands of the gulf coast, both of which contributed to the art of the Aztecs who ruled Mexico at the time of the Spanish conquest.

TEOTIHUACÁN The Aztecs who ruled out of their capital in the Valley of Mexico in the sixteenth century were impressed by the ruins there and called them Teotihuacán ("Birthplace of the Gods" or "Place Where the Gods Walk"). The Maya have a hieroglyph for Teotihuacán, *puh*, that translates as "Place of Reeds," referring, perhaps, to the lake in the Valley of Mexico south of the city. The Aztecs believed their gods had created this world out of their own bodies and blood at Teotihuacán, which had long since been abandoned when the Aztecs arrived there in the fourteenth century. The power they sensed in the ruins of Teotihuacán continues to inspire awe in the throngs of visitors who flock to see the ancient city to this day.

At its peak, Teotihuacán, which flourished c. 1–650 CE, had over 200,000 permanent residents, which made it the largest and most densely populated city in Mesoamerica of its day. Maya inscriptions and other archaeological evidence tell us that traders and other representatives from Teotihuacán were active in the Maya territory, had political influence there, and may have ruled some of the Maya cities. This great metropolis, a manufacturing center that controlled the lucrative obsidian trade, had over five hundred workshops where painters, potters, and sculptors made the goods they exported throughout Mesoamerica. The city also had shrines that attracted many pilgrims and, thanks to its economic and political clout, Teotihuacán influenced the art and culture of many Mexican and Maya cities of the day. The notion of Mexico as a land ruled out of the Valley of Mexico, which continues to this day, seems to have begun with the rise of Teotihuacán.

With its tall, multilayered sloping faces, the Pyramid of the Sun (a modern name), begun around 100 CE, is the largest structure in Teotihuacán and looks very much like one of the mountains that surround it (FIG. 8.30). A stairway on its west side leads to its summit, where a temple once stood high above the spring and cave over which the massive structure was built. In Mexican, as well as Maya, thinking, caves and springs were often seen as conduits to the underworld, while mountains, and their architectural counterparts—elevated temples on platform structures such as the pyramid—communicated with the heavens. The people of Teotihuacán seem to have envisioned the Pyramid of the Sun as an *axis mundi* (world axis), the center of their world and a gateway to the upper and lower worlds. Built over a spring, it may have been an early expression of an Aztec ideal, the pyramid temple as an **altepetl** (water mountain) at the center or axis of the earth and the cosmos. The Pyramid of the Sun, begun in Preclassic times, seems to have played an important role in the ritual life of Teotihuacán until its

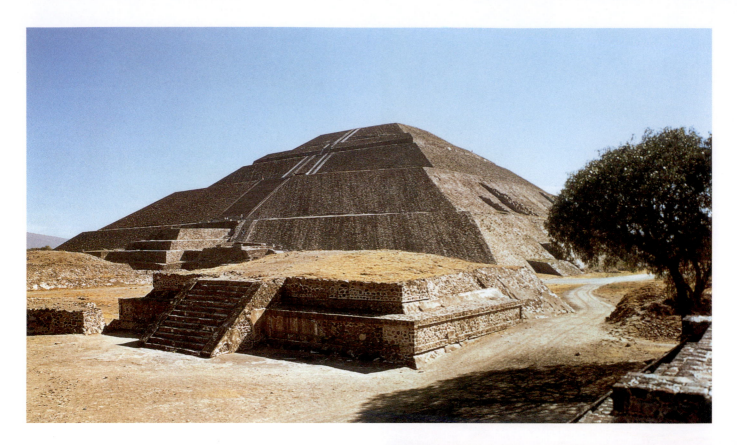

8.30 Pyramid of the Sun. Teotihuacán. Begun c. 100 CE. Base 738 × 738' (225 × 225 m), height 264' (80.5 m)

decline sometime after 650 CE. (For a more detailed discussion of its design and relationship to that of the city around it, see *Analyzing Art and Architecture:* Teotihuacán, City Planning, Pragmatics, and Theology, page 302.)

The finest surviving mural in Teotihuacán covers all four walls of a room in an apartment compound belonging to a wealthy or noble family (FIG. 8.31). The figure, shown frontally in a convention reserved for deities in Teotihuacán, is a water and fertility goddess who appears throughout the city. Her headdress sprouts tall blossoming plants with butterflies, and the waters falling from her outstretched hands and the overturned basin near her feet feed streams from which plants grow. Like the pyramids, she acts as an axis, uniting the earth and sky, and with her pyramid-shaped body, she appears to be yet another expression of the *altepetl*, the Teotihuacan "water mountain."

The costumes of the figures and their surroundings in the mural are filled with a multitude of carefully outlined two-dimensional forms. In marked contrast to the contemporary Maya, who were developing a style featuring sinuous, whip-lash curves, the Teotihuacán artists constructed their images from a limited vocabulary of basic curves and straight lines. Naturalistic forms in the pictorial arts are simplified into

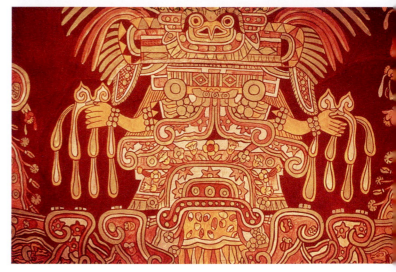

8.31 *The Great Goddess*. Tepantitla, Teotihuacán. Upper portion of mural. c. 650 CE

patterns that integrate with the stark linear geometries and rhythms of the walls on which they are placed, as well as the surrounding buildings and streets of the city. This style of painting is often called **architectonic** because the shapes reflect those of the architectural setting in which they were placed and are fully integrated into the overall visual experience of the city.

THE GULF COAST AND EL TAJÍN During the Early Classic period, a culture with a distinctive style of sculpture and architecture emerged north of the old Olmec homeland in Veracruz. It is called Classic Veracruz or El Tajín ("The Lightning") after the largest art and ritual center in this region, and the style is distinguished by a particular type of banded scroll, which is used to shape a variety of monster heads, each of which may include certain animal or human features. These scroll-formed grotesques may represent the deities in the Veracruz pantheon, some of which are connected to the linked rituals of the ball game and human sacrifice. They may also represent a Veracruz system of pictographic writing, one inspired perhaps by the hieroglyphic script of their Maya neighbors to the south.

Three basic types of portable Classic Veracruz sculptures may have been used in the ball-game rituals. They are thick, U-shaped stones called *yugos* (Spanish, "yokes"), thin, bladelike heads known as *hachas* (Spanish, "axes"), and tall, slender stones with rounded tops and notched bases called *palmas* (Spanish, "palms") for their resemblance to palm fronds. Looters have discovered and marketed many of these small sculptures, but archeologists have also found a few of them during excavations, and there is a suggestion that they may have been buried with ball players or leaders of the cults associated with the game and its rituals. Indeed, the heavy stone pieces may be ceremonial forms of the ball-game equipment, and were perhaps worn before and after the games in rituals that included human sacrifice.

The well-preserved *palma* in FIG. 8.32 represents a man with a coyote mask surrounded by a loop of interlocking scrolls and grotesque heads that follow the flaring, round-topped outline of the stone. The tall maguey or agave plant sprouting from his head is the source of the intoxicating *pulque*, which was probably drunk during ball-game rituals. The coyote-man may be a sacrificial priest, and a scene on the back of this *palma* shows one such priest with a large knife, about to open the chest of sacrificial victim. A monumental version of that scene in the largest ball court at El Tajín shows yet another ball player wearing a somewhat shorter *palma* on a yoke around his waist (FIG. 8.33). A skeletal figure of death with a scroll-formed head descends from the sky as a sacrificial

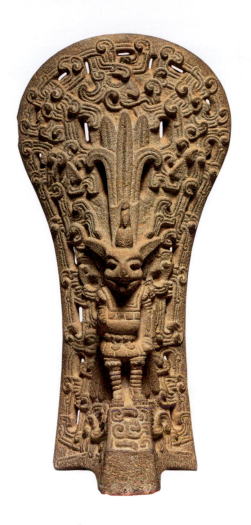

8.32 *Palma* with coyote ball player. El Tajín, Veracruz. Late Classic period, 900–1100 CE. Stone, 19⅓ × 9¼ × 4½" (49.2 × 23.4 × 11.4 cm). Cleveland Museum of Art. Purchase from the J.H. Wade Fund

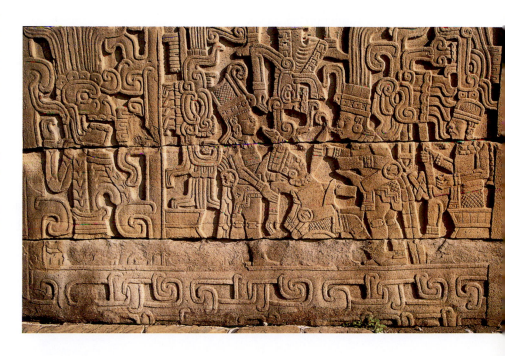

8.33 Relief panel depicting the sacrifice of a ball player. South Ball Court, El Tajín, Veracruz. Late Classic period, 300–900 CE. Stone, 5' × 6'6" (1.56 × 1.98 m)

TEOTIHUACÁN: CITY PLANNING, PRAGMATICS, AND THEOLOGY

The plan of Teotihuacán reflects the cosmological beliefs of its leadership as well as the practical necessities of building and maintaining a large, densely populated, and urbanized city (FIG. 8.34). The main street, the so-called Avenue of the Dead, is a long, narrow, multilevel plaza that runs from the countryside, north through the heart of the city to the plaza in front of the Pyramid of the Moon (another modern name), begun c. 150 CE. As the ancient residents and visitors to Teotihuacán walked up the avenue to the north, they passed long rows of large public buildings. The Citadel with the Temple of the Feathered Serpent (begun c. 100 CE) contained the royal palace and enough open space to hold the entire population of the city. Across the avenue was the Great Compound, a market where traders and political leaders from around Mesoamerica gathered. Farther up the avenue, the Pyramid of the Sun was part of a complex including smaller temples and a large plaza. This and other temple groups along the avenue were dedicated to local gods and, perhaps, those of Teotihuacán's trading partners and allies.

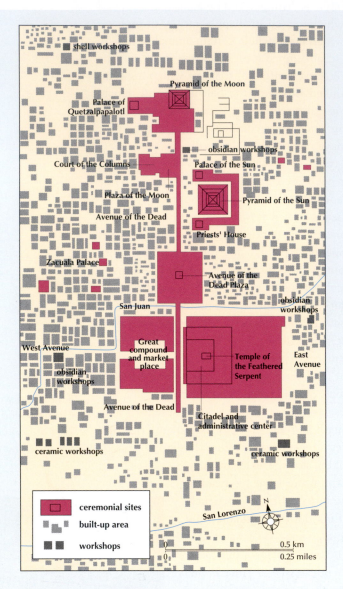

8.34 Plan of Teotihuacán, c. 650 CE. Showing major ceremonial sites and artists' workshops

priest with a long stone knife prepares to open the chest of the ball player and remove his heart. The executioner and his assistant holding the arms of victim also wear yokes and *palmas*. The victim, who has almost certainly been plied with ample quantities of *pulque*, has closed eyes and appears to be in a dreamy state.

The Maya and other groups in Mesoamerica believed that ball courts were entryways to the earth and under-world, as well as sources of water. The abundant references to water and other fluids in this and other ball-court sculptures at El Tajín suggest that the people here shared that belief. The performance of the ball game, the sacrificial rituals in the court, and the acceptance of those offerings by the gods may have ensured the seasonal rains, the success of the farmers, and the prosperity of Classic Veracruz society.

This all-important avenue connecting the most important structures from the Preclassic period provided the central axis for a grid or checkerboard pattern upon which the Classic-period city was organized. The strong, repeating horizontal accents of the multilevel platform structures along the way, and the painted decorations on them, worked together to reflect and emphasize the rectilinear grid plan of the city. Even the course of the San Juan River through the city was diverted to follow the right-angle pattern of this grid.

The pattern is based on a module of about 187 feet (57 m). The Pyramid of the Sun, for example, is four units or modules long and four wide ($187 \times 4 = 738$). Many of the modules roughly correspond to modern city blocks. Many are large, walled apartment compounds that were occupied by extended families or manufacturing groups. These compounds were mass-produced according to certain prescribed principles of design. Many had a centralized, open patio with an altar or a shrine surrounded by buildings on all four sides. Their arrangement also reflects the social structure of the city. The Citadel compound and other centralized, public spaces commanded by the sovereign and his entourage occupied the center of the city. Around them lay the compounds of the lesser nobles and wealthy merchants. Beyond these were the homes and workshops of the artisans and the less skilled workers in the countryside.

Teotihuacán is also designed to reflect the landscape around it. With their sloping sides, the mountain shapes of the Sun and Moon pyramids are unmistakable, as are the hundreds of smaller multiplatform structures throughout the city. The Teotihuacán builders devised standard systems of design to simulate mountain forms by using *taluds* (Spanish, "inclined walls") at the bases of the platforms supporting vertical, framed walls called *tableros* (Spanish, "pictures"), which may have been decorated with paintings or sculptures. These *talud-tablero* combinations resemble the bands of stratified rocks running above the talus slopes along the bases of the many large, rugged, and crumbling mountains in the vicinity.

The Citadel, a valleylike space surrounded by ramparts and small mountain-shaped platform temples, may have been conceived as a replica of the Valley of Mexico or, more specifically, the area around Teotihuacán. Other temple clusters, such as those in front of the Sun and Moon pyramids, may also represent or symbolize the mountain-valley landscape around the city. The Avenue of the Dead points like a giant arrow to a cleft in one of these mountains on the horizon behind the Pyramid of the Moon. This orientation aligns the avenue 15 degrees 29 minutes east of true north, and the Pyramid of the Sun faces the same angle north of true west to a spot on the horizon where the sun sets on April 29 and August 12. This further links the pyramid and city with the sun as it falls from the sky to the underworld.

In summary, the city was designed in an orderly fashion as a manufacturing center to produce goods that would connect Teotihuacán with the other regions of Mesoamerica. It was also designed as a replica of the landscape around it—part of that world with which it traded. Third, it was conceived as a world axis to link it with the celestial realms above and below the city. As a microcosm of the universe, the city was, as the Aztecs said in naming it, a "place where the gods walk."

The relief illustrated in FIG. 8.33 is located near the Central Plaza and Pyramid of the Niches where many of the most important rituals were staged (FIG. 8.35). The pyramid, the tallest and most impressive structure in El Tajín, was built using the Teotihuacán system of placing vertical *tableros* over sloping *taluds*. But here, unlike at Teotihuacán, the *tableros* are not painted: They are divided into a series of deep cut-stone compartments or niches. This type of niche is used elsewhere in this area, and sporadically throughout El Tajín, and we may see its symbolism here at the main pyramid-temple where there are 365 niches, one for each day in the solar year.

In addition to being a solar symbol, the pyramid may have been a symbolic mountain, where leaders could ascend to its summit, enter the temple-cave, and journey to the otherworld. Along with the door to the temple, the niches—the single most characteristic Classical Veracruz

architectural form—symbolized that cave and linked the passages to the otherworld with the solar year and the annual cycles of the heavenly bodies. During rituals, costumed performers or sculptures may have stood on the four niched platforms within the stairways, while other figures ascended to the temple to seek oracles for those assembled in the Central Plaza below. Unfortunately, we do not know what language the people who built El Tajín spoke, but it is possible that they, like the Maya, had symbolic names for their stelae and temples, some of which may be embedded in the scroll-formed grotesque heads with human, animal, and decorative features that we see in their sculptures. At the base of the pyramid and on either side of the stairway, there are fifteen large rectangular stones with deep holes drilled into them where the leaders of El Tajín may have placed poles with banners belonging to the local military and ball-game orders. Two Maya-style stelae of rulers with El Tajín emblems of power stood in this vicinity and were probably the local versions of the Maya "stone trees," which completed this El Tajín version of a sacred cosmological landscape in which the niche is the distinctive and pervasive Veracruz symbol of the gateway to the otherworld.

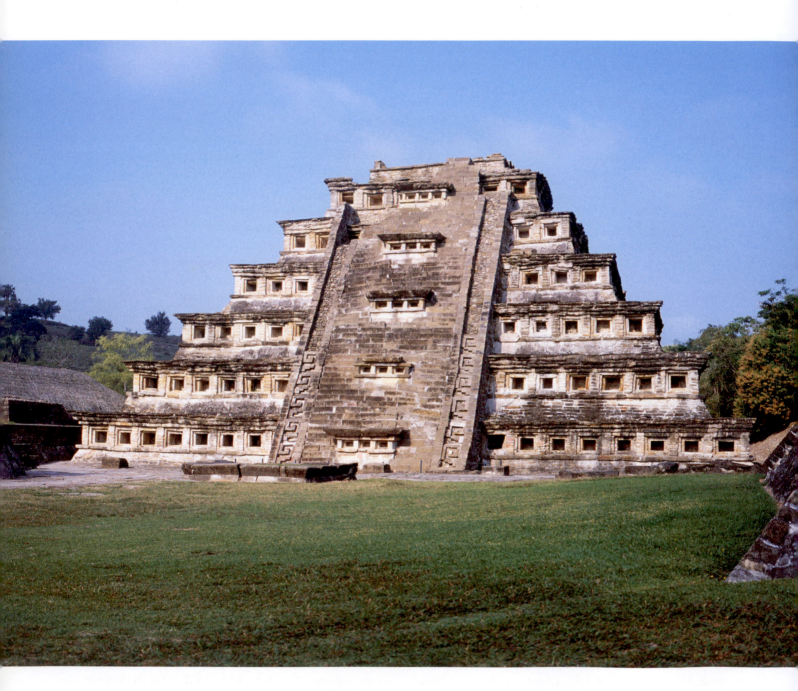

8.35 Pyramid of the Niches, El Tajín, Veracruz. 9th–10th century

POSTCLASSIC ART

By the end of the Classic period, most of the metropolitan centers in Mexico and the Maya territory discussed above had been abandoned and new centers were rising to take their places. Mexican influences appear in Maya art, Maya forms appear in Mexico, and a new style emerges that combines elements of both. This distinctive early Postclassic style appears about the same time at the far ends of Mesoamerica: at Tula, north of the Valley of Mexico, and at Chichén Itzá, near the eastern tip of the Yucatán Peninsula. Some sixteenth-century documents written shortly after the conquest may explain how this happened.

Aztec stories, as recorded by Spanish churchmen, glorify a group of people called the Toltecs. They tell how a crafty character named Tezcatlipoca dethroned Topiltzin Quetzalcóatl ("Feathered Serpent"), the ruler of Tula, and forced him into exile in 986 CE. Postconquest Maya annals tell how a culture hero named Kulkulcan (Yucatán Maya for Quetzalcóatl) arrived there in 986 CE and took over the throne at Chichén Itzá. A god associated with plumed serpents had been known at Chichén Itzá before this time, but with the accession of a king bearing that name, the god seems to have become much more important in the arts. About this time, a new group of buildings appear in Chichén Itzá that resemble ones at Tula. Thus, the documents and archeological record seem to be in agreement.

The Temple of the Warriors (a modern name) demonstrates some of the basic features of the Toltec–Maya style (FIG. 8.36). Visitors approaching it in ancient times walked across the open plaza and into a long covered arcade supported by rectangular piers with reliefs representing Toltec warriors and women bearing offerings. Passing through the arcade, which extended part-way around the building and up the stairs, they arrived at the temple on the summit where a pair of thick plumed serpents descending from the sky framed the door. Their tail rattles support the lintel, while their huge heads with open jaws jut forward menacingly along the floor. Inside, in place of the corbeled vaults and narrow spaces of the temples in the Central Maya area, one entered a spacious room with a flat roof supported by more carved piers. Near the door is a **chacmool**, a lifesize sculpture of a man lying on his back holding a bowl over his stomach, which may have been a repository for the hearts of human sacrificial victims.

Pyramid B, which was built about this time at Tula, Hildalgo, has this same basic set of Toltec–Maya features. The visitor approached it through a similar colonnade of rectangular piers supporting a flat roof that stretched around the pyramid and part-way up the stairs (FIG. 8.37). The large

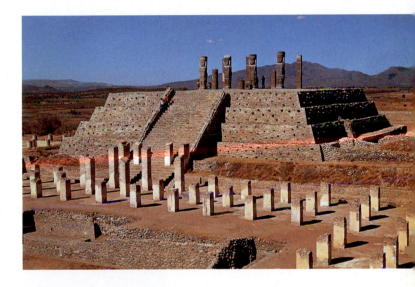

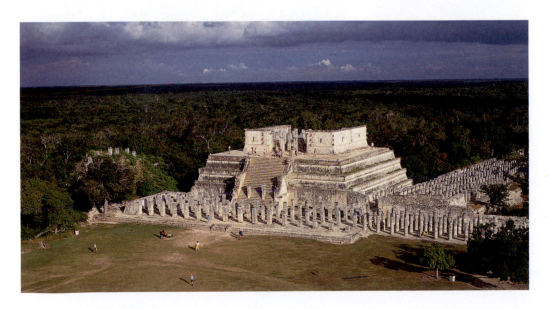

8.36 (LEFT) Temple of the Warriors and Group of the Thousand Columns, Chichén Itzá, Yucatán. Early Postclassic period, c. 1000

8.37 (ABOVE) Pyramid B, Tula, Hidalgo. Early Postclassic Toltec period, c. 900–1200

temple on the summit had a *chacmool*, feathered serpents flanking the door, and carved stone columns and piers supporting its flat roof. Not enough remained of the temple to reconstruct it, but some of the sculptures inside have survived. They include a set of four columns representing Toltec warriors and supporting the ceiling (FIG. 8.38). They carry *atlatls* (spear-throwers) and stare straight ahead and over the people standing or sitting on the temple floor. Enclosed in the shadowy temple, the tall and massive warriors, which were originally painted in bright colors, must have been an awesome sight. While the warriors look nothing at all like Maya figures, some crudely carved stelae with figures in Maya dress in Tula and other sculptures there that resemble the Toltec works at Chichén Itzá indicate that the two cities had close ties.

The later Spanish accounts of the Pre-Columbian history of Mesoamerica cited above suggest that Topiltzin Quetzalcóatl and his entourage, which may have included artists, carried the knowledge of Toltec art from Tula to Chichén Itzá. But the Toltec art forms are much more fully developed and plentiful at Chichén Itzá than at Tula, and Classic Maya influences may be found in many Mexican centers of this period, including Tula. Some scholars have therefore suggested that the influences ran in the opposite direction, from Chichén Itzá to Tula. In either case, Chichén Itzá was plundered and partly deserted in the thirteenth century, and when the Spanish arrived in the Yucatán Peninsula in the early sixteenth century little remained there to indicate that this had formerly been one of the great cradles of literacy and civilization.

THE MIXTECS

The Toltecs of Tula were contemporaries of the Mixtecs ("Cloud People") of Oaxaca, who were highly proficient in all the arts but are best known for their codices, which perpetuate elements of the Teotihuacán style of painting. Many of the codices show figures in ceremonial regalia with hieroglyphic inscriptions in scenes that mix mythological and historical narratives. These manuscripts have made it possible to reconstruct the genealogies of the Mixtec rulers from the late seventh century to well after the conquest, and the Spanish so respected these records that they accepted them as legal evidence in their law courts to settle property disputes.

The Codex Nuttall (c. 1500) is one of several books that document the rise and fall of Eight Deer (1011–63), king of Tilantongo, so named after his birthday in the Mixtec calendar (FIG. 8.39). His name (a profile head of a deer with a string of

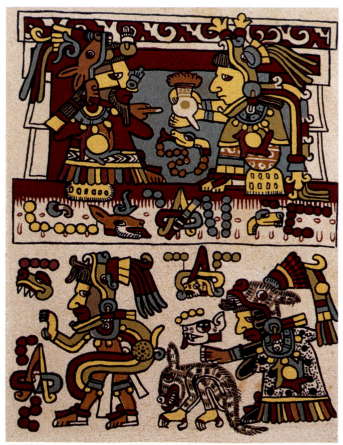

8.39 *Wedding of King Eight Deer to Lady Thirteen Serpent of Flowers*. Detail of page from the Codex Nuttall. Mixteca–Puebla style. Postclassic period, c. 1500. The British Museum, London

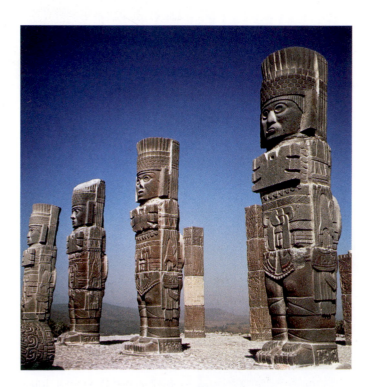

8.38 Atlantean figures, Pyramid B, Tula, Hidalgo. Height 15' (4.6 m)

eight dots trailing from its ear) appears in the lower register. The codex shows important events in Eight Deer's life, including his wedding alliance with Lady Thirteen Serpent of Flowers. The couple takes their vows in Mixtec fashion: She presents him with a bowl of frothing chocolate, a sacred drink, and he accepts it. The bride's name, Thirteen Serpent, is shown below the bowl as a profile serpent accompanied by thirteen dots. Another hieroglyphic sign below her, Twelve Serpent, records the date of the ceremony, which took place in 1051 CE. Later, the codices tell us that the career of Eight Deer took a fatal turn when, in the battles among the competing Mixtec leaders, one of his fathers-in-law killed him.

THE AZTECS

The Spanish conquistadors under the command of Hernando Cortés arrived at the high eastern edge of the Valley of Mexico in 1519. From there they could look down upon the Aztec capital, Tenochtitlán, a thriving metropolitan complex of about 200,000 residents, which had been founded c. 1325. The name is a composite of three Aztec words: *tetl* (rock), *nochtli* (cactus), and *tlan* (place of). During the previous century, Tenochtitlán had expanded and absorbed some of its neighbors to become one of the largest cities in the world. Portions of the island city in Lake Texcoco appear to have been built on a grid plan, like that of Teotihuacán, and were connected to the mainland by sets of causeways with drawbridges for defensive purposes (see FIG. 8.42). The two main avenues of the city's central district met at the walled central temple precinct around the Templo Mayor ("Major Temple"), the palaces, and administrative buildings. Tenochtitlán was not only a working administrative center, but also an *altepetl* (water mountain), modeled after the Aztecs' mythic island homeland and their conception of the cosmos in which a great ocean-river surrounds the earth. In Aztec belief, the Templo Mayor, in the center of the city, was the navel of the universe on the *axis mundi* connecting the midpoints of the lower and upper worlds. The twin temples on its summit were dedicated to Tlaloc (Aztec, "Water and Plenty") and Huitzilopochtli (Aztec, "Hummingbird on the Left"), their war god.

From their modest beginnings as a small band of nomads, the aggressive and warlike Aztecs of Tenochtitlán became the masters of a large kingdom that covered much of the Mexican half of Mesoamerica. The name "Aztec" comes from Lake Aztlan, their legendary homeland, and was not in common use before the eighteenth century. Their own name for themselves was the Mexica, from which the name of the present-day capital and country derive.

Aztec legends say that in the fourteenth century, guided by Huitzilopochtli, their ancestors from the northwest

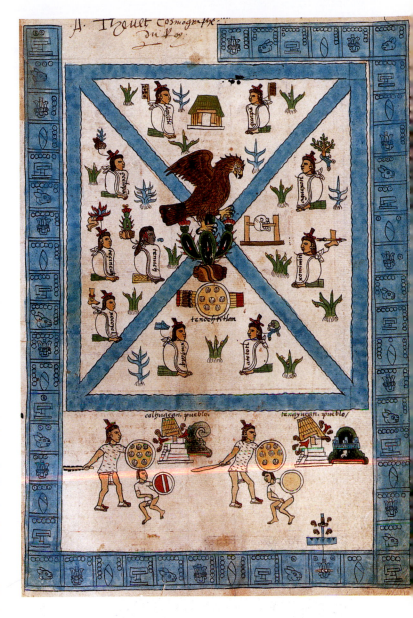

8.40 *The Founding of Tenochtitlán.* Frontispiece to the Codex Mendoza. c. 1541–42. 12⅞ × 8⅝" (32.7 × 22 cm). Bodleian Library, Oxford

arrived in the Valley of Mexico. Huitzilopochtli instructed them to look for an eagle perched on a prickly pear cactus (Aztec, *tenochtli*) and build their capital there. Seeing that vision on a marshy island in the shallow waters of Lake Texcoco, the Aztecs founded their capital on that spot. Ultimately, this symbol—an eagle on a cactus—was adopted as the central image on the modern Mexican flag.

The frontispiece of the Codex Mendoza (1541–42), painted by an Aztec artist after the Spanish conquest, portrays the vision in a hybrid Aztec–Spanish style (FIG. 8.40). An inscription below the shield and spears and the hieroglyphic sign at the base of the cactus indicate that this is

Tenochtitlán, the capital of Mexico and symbolic center of the Aztec cosmos. The hub of the city is surrounded by four canals and men seated on mats with hieroglyphic signs that are place-signs and may represent municipalities or regions subject to the Aztecs. The warriors below, with shields and clubs, as well as the platformed temples in the background, with tilting roofs spouting smoke and flames (damaged buildings burning), represent Aztec conquests. No authenticated preconquest Aztec manuscripts inspired by the Mixtec style of painting survive—under the rules of the Spanish Church, natives found in possession of such "heathen" materials could be executed.

The Spanish who looked down upon Tenochtitlán from the eastern edge of the valley were astonished by its scale and magnificence, but with their horses, gunpowder, and political intrigues they managed to conquer it and extinguish all significant resistance to their presence in Mexico. Most of the arts, crafts, and other material culture of the Aztecs disappeared during the bloody conquest, and much that remained was destroyed in the following colonial period. The Spanish built their capital, Mexico City, over about a square mile (2.6 sq km) of the ruins in the center of Tenochtitlán and set the Cathedral of Mexico City on the foundations of the Templo Mayor, where many of the most important Aztec rituals had been staged. Although modern scholars have made models and reconstruction drawings of Tenochtitlán on the eve of the conquest, none of them is based on entirely reliable data.

AZTEC ART AND THOUGHT As the Aztecs emerged as the dominant military power in the Valley of Mexico under the leadership of Izcoatl (ruled 1427–40), they appropriated ideas and images from the past art styles of the area to express their growing power. As mentioned in Chapter One (see page 18), they developed a taste for the luxury goods we call "art," and they called them *totecatl* after the earlier Toltecs, whom they revered as great artists. The Aztecs said the best Toltec artists had "deified hearts," the ability to open them and receive the gifts of feeling and insight from the gods, as well as "restless hearts" that searched for the eternal truths of the gods so that they might partake of their immortality. In the rising spirit of Aztec nationalism in the early fifteenth century, Izcoatl burned many of the earlier books and commanded his scribes to rewrite Mexican history from an Aztec point of view. This view was developed by an elite group of sages known as the **tlamatinime**, who preserved their metaphysical speculations on art and life in poetry that was written in Nauhuatl (the Aztec language) and Spanish after the conquest. They believed that earthly things were transient and would eventually be destroyed by the wrathful gods. Only "flower and song" (the arts and beauty) were everlasting because they came from the gods. Spiritually enlightened artists who received these sacred revelations from the gods and pleased them with their art could become immortal as well. Art, divinity, truth, and immortality were inextricably linked in this very complex worldview. Although most of the visual artists in Aztec society were drawn from the people they conquered, the *tlamatinime* were Aztecs. As insiders in Tenochtitlán, the voices of these critics, patrons, and aesthetes would be heard in elite circles. Just as artists paint with colors, the *tlamatinime* said, the gods created the world of flowers and songs in which we live.

> With flowers you paint,
> Oh giver of life!
> With songs you give color …
> We live only in your book of paintings,
> Here on the earth.

But the gods were not always perfect in their work. Aztec legends tell us that the first four times the gods tried to create the world they did it imperfectly and had to destroy it. The present world was created on Aztec Day Four, Ollin ("Movement" or "Earthquake"), and this act of creation too would end in an earthquake. Many groups in Mesoamerica shared this concept of successive ages of creation and that was part of their interest in calendars and cycles of time, expressed most dramatically in the calendar system of the Maya. Aspects of the Aztec creation stories were illustrated in two large sculptures, both of which were discovered in the late eighteenth century near the former site of the Templo Mayor where the Cathedral of Mexico City now stands.

One of them, the *Stone of Five Suns*, also known as the *Aztec Calendar Stone*, is not a calendar as such but a diagram of creation (FIG. 8.41). The sign in the center of the stone—four arms surrounding the face of a creature with claws and a tongue in the shape of a sacrificial knife—is Ollin, the day on which creation took place. The small signs between the arms stand for the first four suns. A band around them illustrates the twenty days in the Aztec calendar that combine with the thirteen gods. The outermost band is formed by the bodies of two fire gods with their tails at the top of the stone and heads at the bottom. Between their tails, a date-glyph (13 Reed) represents the year 1427, the birthdate of the present sun and the year in which the Aztec ruler Izcoatl came to power, a conjunction that gave him divine authority.

The Aztecs said the present sun was created at Teotihuacán when two of the gods volunteered to sacrifice their bodies to provide the material for the new world. The remains of this great center, which had been abandoned for nearly seven centuries when the Aztecs arrived in the valley, and their name for it, Teotihuacán ("Place Where the Gods

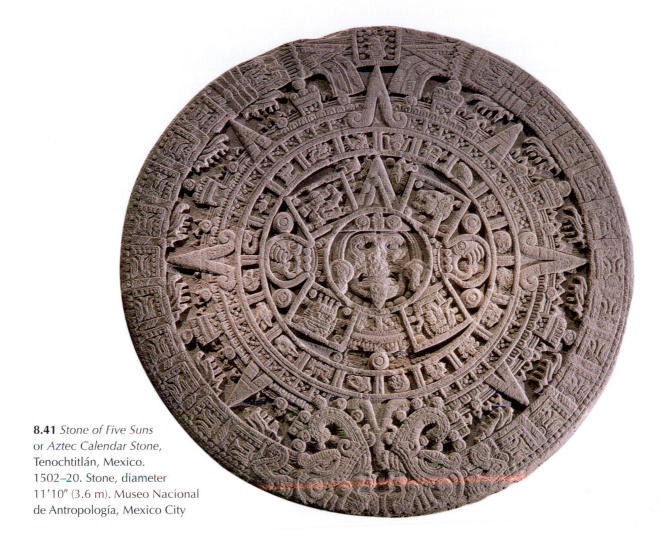

8.41 *Stone of Five Suns* or *Aztec Calendar Stone*, Tenochtitlán, Mexico. 1502–20. Stone, diameter 11'10" (3.6 m). Museo Nacional de Antropología, Mexico City

Walk"), suggest the reverence they had for the large structures. One of the gods ascended the Pyramid of the Sun, the other the Pyramid of the Moon, and after four nights of penance they threw themselves onto a great bonfire, rising the next day as the sun and the moon. Since the world had been created out of their bodies, humankind inherited a debt they had to repay in kind to maintain the fifth sun—an ongoing series of human sacrifices.

The second sculpture, *Coatlicue* (Aztec, "She of the Serpent Skirt"), was discussed in the Introduction to this book along with a history of how Mexican audiences have perceived this important monument through the ages (see FIG. 1.5). It is carved in a radically different style from the *Stone of Five Suns* because the Aztecs had yet to synthesize all the styles of art they had adopted from the people they had conquered and create a single, cohesive style of their own. Coatlicue had been the guardian priestess of a shrine north of the Valley of Mexico, and became pregnant, miraculously, while sweeping it. To restore their family honor, her children banded together and killed Coatlicue. As they were lopping off her body parts, however, Huitzilopochtli

leaped forth and avenged his mother's death. The sculptors have emphasized this dismemberment, showing how large serpents emerge from her groin, shoulders, and neck to form her head.

The earth goddess wears a skirt of plaited serpents and a necklace of severed hands, a skull, and the hearts of sacrificial victims. Massive and clawed, "She of the Serpent Skirt" was a demanding deity who fed on human corpses. The interplay of the richly textured patterns of shadows and highlighted portions of stone add to the emotional impact of the subject matter and make it one of the most impressive Pre-Columbian works of art. This fearsome image of Coatlicue was so unsettling that it was reburied several times before being put on public display. Conversely, the *Stone of Five Suns*, which in earlier times had been a monument to Aztec supremacy and imperialism, was accepted rather quickly when it was rediscovered. Today it is the internationally recognized symbol of Mexico as a nation with dual roots in the Western and Native American worlds. (See *Analyzing Art and Architecture:* Diego Rivera, Frida Kahlo, and Aztec Culture, page 310.)

DIEGO RIVERA, FRIDA KAHLO, AND AZTEC CULTURE

In the Mexican Revolution (1910–20), the philosophy of *indígenismo* ("indigenous orientation") or *Mexicanidad* ("pro-Mexican orientation") espoused by the revolutionaries celebrated the native Pre-Columbian cultures of Mexico. Seeing that some important Pre-Columbian cities such as Teotihuacán, just north of Mexico City, had murals in public places, the revolutionary government of Mexico wanted to revive this art in their attempt to bring the Native American elements of Mexico into the new society. A new generation of artists, led by the *tres grandes*, the "three

great ones"—Diego Rivera (1886–1957), José Clemente Orozco (1883–1949), and David Alfaro Siqueiros (1896–1974)—burst upon the scene with a strong sense of purpose: a pride in being Mexican that had not been felt in four centuries, since the fall of the Aztec Empire in the early sixteenth century. From 1922, the trio directed a multitude of devoted assistants as they created highly politicized pictorial dramas of Mexican history that drew heavily on the country's Pre-Columbian past. As nationalists shaping the image of their people around their own indigenous history, the politically

oriented spokespersons and pageant masters for the new society emphasized the repressiveness of the Spanish colonialists and home rule prior to the revolution and extolled the brightness of the future.

The best-known figure in the Mexican mural movement, Diego Rivera, had spent fourteen years in Europe, where he had made friends with Pablo Picasso and studied

8.42 Diego Rivera, *The Great City of Tenochtitlán*. 1945. Detail of the mural in the patio corridor, Palacio Nacional, Mexico City

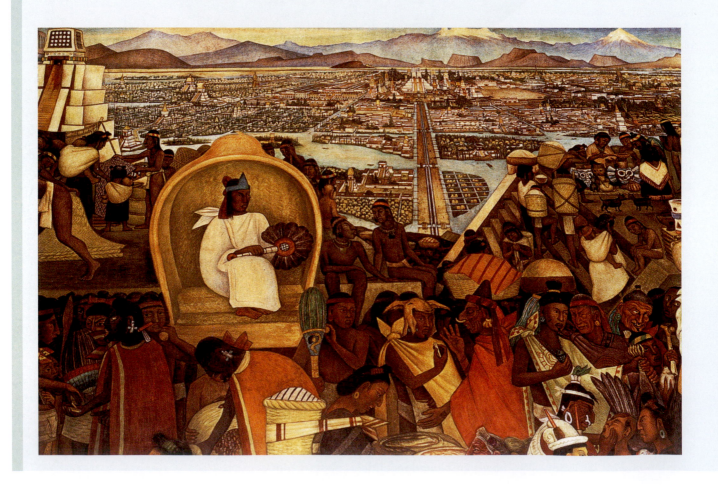

fresco painting in Italy. Working hard to shake off years of education in European modernism in order to become a true spokesman for the people in his native land, Rivera now developed a populist style of Social Realism. His tightly packed, hard-edged forms and narratives filled with Pre-Columbian and colonial figure types in *The Great City of Tenochtitlán*, a mural in the Palacio Nacional (National Palace), Mexico City, incorporate the strength of the native Mexican folk-art traditions (FIG. 8.42). Rivera's style was essentially non-European in spirit and, with his American-based Pre-Columbian subject matter, he repudiated the authority of European modernism and Spanish hegemony in Mexico.

In the early 1930s, Rivera traveled with Frida Kahlo (1907–54), a painter from Mexico City. After a bus accident in which her spine and pelvis were seriously damaged, Kahlo underwent a long series of delicate operations and she spent much of her subsequent life bedridden, confined to a wheelchair, or walking with the aid of elaborate back braces and body straps. Her life was further complicated by her stormy relationship with Rivera, whom she married in 1928, divorced in 1939, and remarried in 1940. More than Rivera and the other *grandes*, Kahlo, of mixed German-Jewish, Hispanic, and Native American descent, symbolized the roots and aspirations of the Mexican people as they struggled with government reforms and their national identity in the modern

world. Kahlo was a great champion of Aztec art and culture as well as Mexican *retablos*, folk images painted on tin that represent miracles in which the Virgin or a saint has intervened in the life of a devout Christian. Adopting the flat, stark, and highly simplified style of *retablos* and Aztec art, Kahlo painted many self-portraits, including *The Two Fridas* (FIG. 8.43). With the hearts of both Fridas exposed, she reminds viewers of her pain-filled life and divorce from Rivera that year (1939). The image of the two figures in contrasting dresses also underlines the deep rifts in

Mexico at that time—its dual Native American and European heritage, its unstable political situation, and its ambivalence toward its wealthy English-speaking neighbors to the north. Many of Kahlo's works are now in the Frida Kahlo Museum, based in her former home in Coyocán, south of Mexico City.

8.43 Frida Kahlo, *The Two Fridas*. 1939. Oil on canvas, 5'7" × 5'7" (1.7 × 1.7 m), Museo de Arte Moderno, Mexico City

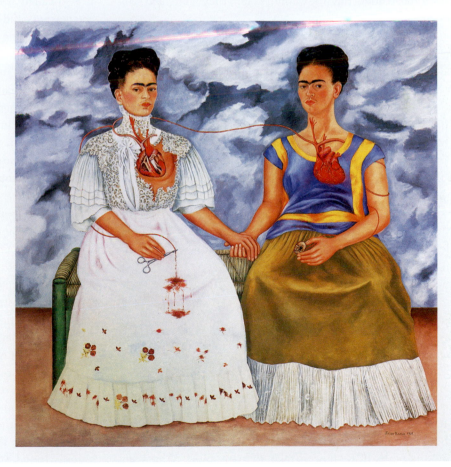

NORTH AMERICA

The literature on Native North American history is filled with many misleading misnomers and clichés. The early Spanish explorers arriving in the Caribbean thought they had reached the East Indies and called the people they met there "Indians." By the late twentieth century, this uncorrected piece of naming and its slang variations had acquired derogatory racial and ethnic overtones, prompting some writers to begin using a new name, "Native Americans." That term is more accurate than "Indian" and is used in this book except in phrases such as "Indian reservation," where the traditional name is deeply ingrained in the language.

Also, the United States and Canadian governments recognize "tribes" and "bands" as the most important Native American sociopolitical units, when in fact those units should be the clan or lineage, a group with a common ancestor. This ancestor is usually remembered as an animal known as a "totem," whose image may be featured in the clan's art. These North American governments also operate "reservations," and "reserves," terms with implications that are problematic. In most cases, the lands set aside for Native Americans did not need to be "reserved": Leftover lands that the homesteaders did not want or claim, they were, and still are, unsuitable for farming.

The way in which Native Americans have been stereotyped in literature, film, and advertising as "braves" and "princesses" has created a romantic fantasy of Native Americans as exotic "others." At the same time, many of them have so long been trapped in poverty on reservations that their social situation has created another, contrasting image of them as inferior "others." Together, those modern myths cloud our attempt to understand their art and culture and we must try to look beyond them to see a clearer picture of Native North American art history.

Some North American groups had trade contacts with Mesoamerica by the start of the Christian era, but they developed their own distinctive funds of knowledge about the world around them and created works of art that reflected those worldviews. Some of these ideals are still important in contemporary Native North American thought today. Many groups share a belief that animals, plants, stones, bodies of water, and other features in the landscape have animate spiritual powers and interact with our lives. Through prayers and rituals, one may learn to work with these forces, but to do so requires great skill and dedication. One has to recognize certain places of juncture, such as shores, crests, and crevices in rocks, which act as channels for the flow of these powers from one realm to another, and learn to follow the paths those powers take. In many North American

cosmologies, a great tree provides one such path from this world to the sky and underworld along which a person may travel through dreams or trances. Those hoping to do so in a so-called "vision quest" may have to fast and endure sleeplessness and isolation for long periods. In some cases, a person needing to contact the spirit world might call on the services of a specialist in such matters, a shaman, whose duties were discussed at the beginning of this chapter. (See *In Context*: Shamanism and the Arts, page 273).

This quest for contact with the spirit world and harmony with its powers in order to find one's proper place in society had a great influence on the visual arts. The Navajo have a word for this ideal of harmony with their neighbors, land, and cosmos—**hozho**. Basically, it means both harmony and beauty. When a Navajo falls out of harmony with some aspect of the world and loses *hozho*, he or she might try to regain it by commissioning a large sand painting created with ritual prayer and song that might last many days. In many parts of North America, someone who has had a successful vision quest might commemorate it by painting, carving, or constructing images of the experience. On the northwest Pacific coast, clans and families erect so-called **totem poles** that display the badges or crests that validate their noble status and long-standing contacts with supernatural animal spirits.

Not only were many Native American groups inspired by their past contacts with the spirit powers, some of them went to great trouble to prepare for the day when they would confront the otherworld after death. Leaders in the eastern United States traded far and wide for luxury goods

The Eastern United States

Late Archaic: 3000–1000 BCE

Woodland: 1000 BCE–1000 CE

 Adena: 1100/700 BCE–700 CE

 Hopewell: 100 BCE–800 CE

Mississippi: 900–1500/1650 CE

Fort Ancient: 1000–1700 CE

The Southwestern United States

Basketmaker: 100 CE–700 CE

Pueblo: 700–present

Navajo: 1300/1500–present

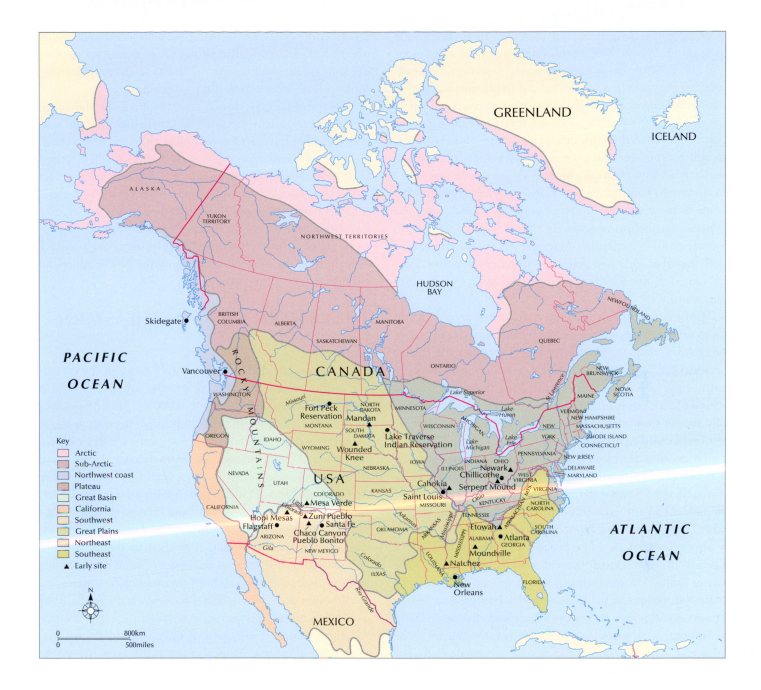

that they might enjoy in life and put in their tombs to identify and assist them in the afterlife. We might guess that wealthy and powerful individuals did what other collectors have often done—display their treasures to impress their peers. Some of the northwest Pacific coast families that erected totem poles carried this idea of display to an extreme and sponsored gatherings called **potlatches** in which they gave away or destroyed enormous quantities of art and other luxury items in order to demonstrate their wealth and power.

Matters of identity in Native American societies became increasingly important in the colonial period as contacts with the West damaged their traditional lifestyles and belief systems. But even before that time, the arts played an important role in the broad search for identity, power, and harmony with the world at hand and the spiritual world beyond. They also reinforced traditional ideas about gender, that certain materials belonged to men and others to women. Often, women worked with clay, basketry, fibers, porcupine quills, and beads, while many forms of sculpture, building, and painting were "men's work." When both male and female skills were needed to complete a project, the two sexes might work together, however, and a man or a woman with skill in an art form belonging to the other sex was often allowed to cross over. In recent decades, these gender restrictions have often been dropped altogether.

Many earlier writers on Native American art betrayed a long-standing bias: The work of men was seen as religious and heroic, while the pottery, basketry, weaving, and beadwork of the women was secular and utilitarian. But such a patriarchal Eurocentric dichotomy that favored public–male forms of art over domestic–female forms had little basis in Native American thought, in which all materials have intrinsic spiritual powers, and women, as well as men, approached their art and its creation through vision quests and other forms of religious ritualism. In many societies, clay is said to come from mother earth and so is highly sacred. Also, the Western distinction between "fine" and "applied" art has no meaning in Native North America: All art was associated with sacred activities so that women's basketry, pottery, and decorated clothing had as much prestige as men's sculptures and paintings.

While artists did not "sign" their works, the people around them often recognized their accomplishments, so the Native North American artist was not as anonymous as many writers have suggested. In fact, the arts were seen as being sufficiently important and valuable for artists often to hold a kind of "copyright" that gave them sole ownership of certain images that they had "invented." Those rights could be granted or sold to another artist.

The historic development of Native North American art was disrupted by the arrival of Westerners and subsequently changed via a succession of epidemics, the work of missionaries, and the establishment of the reservation system while their traditional homelands were allotted to settlers from the eastern states or Europe. In the late nineteenth century, in an effort to document what was seen as the "Vanishing Indian," many museums amassed large collections of Native American art. Unfortunately, being designed to appeal to Western audiences, these did not necessarily present an accurate cross-section of the art valued by those who had actually made it and created an unbalanced view of Native American values in the arts. Nor did these early museum collections usually suggest the historical depth of the Native American traditions or show works in meaningful contexts that would explain them as art. This kind of wholesale collecting also hurt the Native American societies, which consequently no longer had the treasures at hand through which they might sustain their identities. As a result, in recent years, some museums have returned or repatriated works of art to the descendants of their original owners.

The efforts Native Americans are now making to force more such repatriations are part of their larger quest to repair and revive their culture. Gatherings called **Pow Wows** enable artists to hold dance competitions, exhibit their work, and share ideas with artists from other areas. Some contemporary artists work with Western materials such as oil and acrylic paints. Others use installation and performance art to present and critique their culture in broadly understood formats for large audiences outside their communities.

Some of these revivals of Native American art, however, have raised important questions about whether they are "real" and "pure," like the older Native American art in the museums. Traditionally, collectors have valued the so-called "pure," precontact Native American art over the later postcontact works that show Western influences. In recent decades many scholars have challenged this thinking, arguing that change has always been part of the Native American tradition. Moreover, those works reflecting Western ideas are accurate reflections of the influences reshaping the Native American cultures in which they were made.

THE EASTERN AND SOUTHEASTERN UNITED STATES

Scholars have divided the precontact history of the eastern and southeastern United States into the Archaic (ending in 1000 BCE), Woodland (1000 BCE–1000 CE), and Mississippi (900–1500/1650) periods. The tradition of depositing goods in burial mounds and building ritual centers with extensive ramparts and high platforms to elevate houses, temples, and shrines surrounding large, open plazas begins in the late Archaic period and intensifies in two Woodland traditions, the Adena (c. 1100/700 BCE–700 CE) and Hopewell (c. 100 BCE–800 CE). The Hopewell tradition continued in the Fort Ancient Culture (1000–1700), which flourished in the Mississippi period (900–1500/1650) as increasingly large ritual centers and towns appeared throughout the southeastern states

Although dedicated scholars have worked very hard for over a century to reconstruct a detailed picture of Native American culture in the eastern states, we still know relatively little about the history of art in this area. We might guess that the large cities and ritual centers had active workshops that developed distinctive styles of art, but most of the information we need to detail that development has been lost. Many of the ancient mounds and other earthworks were located in good agricultural areas and so were subsequently destroyed by Euro-American farmers and treasure hunters who dispersed the grave goods. That has made it difficult to determine where workshops were located, establish chronologies for regional styles, or reconstruct the trading networks along which raw materials and works of art were moved.

THE ARCHAIC PERIOD (3000–1000 BCE)

One of the oldest ceremonial complexes in the southeast, Poverty Point (c. 1500 BCE) in northeast Louisiana, is also

the largest and perhaps the least understood. Given its stupendous size, it is difficult to understand how or why Poverty Point was constructed. It was a trading center for tool-stones and minerals, and workers there modeled some clay sculptures of pregnant women. But those rather commonplace functions and activities do not explain its vast size. Until a shift in the course of the Arkansas River destroyed about half of the site, Poverty Point consisted of six concentric and roughly circular ramparts divided into eight sections by radiating walkways. The volume of the earth in the original complex was about thirty-five times that of the largest pyramids in Egypt or the Temple of the Sun in Teotihuacán. Normally, works of this size are built by large, well-organized societies with powerful rulers who can command and support hundreds, if not thousands, of workers. But there were no large towns or strong rulers in the area at the time. Nonetheless, the archaeological evidence indicates Poverty Point was constructed in one intensive campaign over a short period of time. One wonders how the scattered groups of hunter-gatherers in the area could have mustered the necessary resources for such a colossal undertaking, and why the site was so important to them. Some of the mounds and ramparts point to the summer and winter equinoxes, but none of these facts explains why or how the few people in the area created them.

THE WOODLAND TRADITIONS: THE ADENA AND HOPEWELL

In the eighteenth century, as frontiersmen and settlers moved west from the colonies along the Atlantic coast, they were intrigued by the many large, artificial mounds they discovered along the way. Seeing the small numbers of Native Americans in these areas at the time, many of whom were seminomadic and had few possessions, the newcomers assumed they could not have been responsible for building such large structures. Moreover, when the newcomers began digging into the mounds to look for treasure, they found artifacts unlike those belonging to Native Americans in their areas. Thus, they began to speculate wildly, attributing the mounds to survivors from the lost continent of Atlantis, the Vikings, Hindus, or the Lost Tribes of Israel. Eventually, by the late nineteenth century, writers and scholars realized that Native Americans from earlier times had indeed built the mounds and created the art within them, but by then most of the mounds had been destroyed and the grave goods dispersed.

Working with this still-foggy picture of the Woodland period, some scholars now believe the Hopewell and Adena styles may represent two related aspects of a single long-lasting cult in which the elite members of society traded raw materials for luxury items to build family or clan collections of art. The artworks may have been status symbols for the living and, as burial goods, served to identify their owners as persons of privilege in the afterlife.

The name "Adena" comes from an important type-site for Adena burial practices in Ohio. It does not describe a single culture but a long-standing mortuary tradition/cult with about five hundred sites in and around Ohio and the upper Ohio River drainage area. Adena grave goods include carved stone tablets, sculptured pipes, and other objects made from stone, copper, bone, and sheets of mica. Most of the mounds in which the grave goods were deposited were built in many stages. In the first cremation burial at a location, they placed a corpse in a small wooden structure, burned it, and then covered the remains with a layer of earth. Later, as a result of additional, superimposed burials and layers of earth, the site grew into a large conical mound. The largest surviving mounds are about 300 feet (91 m) in diameter and up to 60 feet (18 m) high. Some are circular, others are square or polygonal with additional earthen ramparts, which may be aligned to solar phenomena, linking burial spaces on this earth with spaces and spiritual activities in the otherworld. A mound may have belonged to an extended family or clan and been used to hold the cremated bodies of esteemed clan leaders and to provide a focal point for other types of gatherings such as war councils and shamanistic rituals.

A shaman might have used the hollow human-figure pipe in FIG. 8.44 at gatherings to smoke hallucinogens, experience altered states of consciousness, speak to beings in the spirit world, including perhaps the clan ancestors in the mound where the pipe was eventually deposited, and return with messages for those assembled. Pipes filled with tobacco mixed with other types of plants were also smoked for pleasure, and smoking could be a form of prayer in which the user of the pipe might ask the spirits for the power to heal or to affirm old friendships or to form new ones. The face of the man on this pipe resembles those in the paintings and sculptures from Teotihuacán in the Valley of Mexico. While this similarity does not imply direct contact between Teotihuacán and the Adena heartland, it is a testament to the considerable reach of the trading networks in place at this time and the importance attached to works of art in the Adena cult of the dead.

Another Woodland tradition, the Hopewell complex (c. 100 BCE–800 CE), originated in western New York state, spread west across the Adena heartland over most of the eastern United States, and north into Canada. The Hopewell built on the Adena tradition of building funerary mounds and large complexes of ramparts and placed an even wider variety of luxury goods in the tombs of their honored dead. The wealthiest and most powerful families or clans in

any area probably controlled the local trade in luxury and everyday goods along networks of exchange that extended from the Atlantic to the Rockies and the Gulf of Mexico to Canada. Much of the exchange was probably conducted through a series of intermediaries, which would have made works of art from distant locations extremely rare, expensive, and powerful status symbols for their owners.

The Hopewell constructed many mounds in the shapes of animals, called effigy mounds, which may represent clan lineage signs or images of animals that were important in shamanistic rituals. The best known of these effigies, the Serpent Mound in southern Ohio, represents a very long serpent with a coiled tail and open jaws (FIG. 8.45). The body of the undulating serpent was originally about 5 feet (1.5 m) high and 30 feet (9.1 m) wide, and, if laid out as a straight line, about 1,300 feet (396 m) long. As in the case of the Nazca geoglyphs, the effigy can best be seen from the air, suggesting that it was built for the "eyes" of celestial spirit powers. It is slithering along a bluff toward the western horizon where the sun sets at the summer solstice and is about to consume a giant oval. The swallowing of that orb may symbolize the setting of the sun, or the end of its northward progression along the horizon at the summer solstice. No artifacts were found within the Serpent Mound, indicating, perhaps, that this was not a burial site, but a place of gathering to celebrate

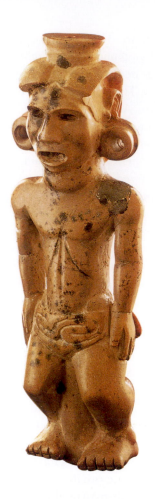

8.44 (RIGHT) Adena artist, human effigy pipe. Woodland period, 500 BCE–1 CE. Stone, height 8" (20 cm). Ohio Historical Society, Columbus

8.45 (BELOW) Serpent Mound, southern Ohio. Hopewell of Fort Ancient Culture. Woodland period, c. 1070 CE

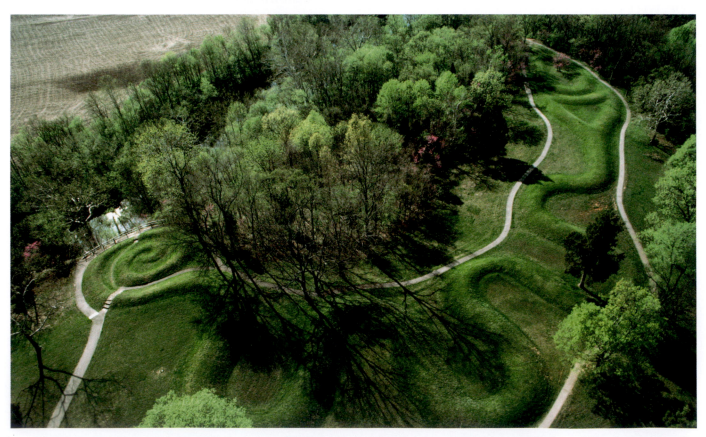

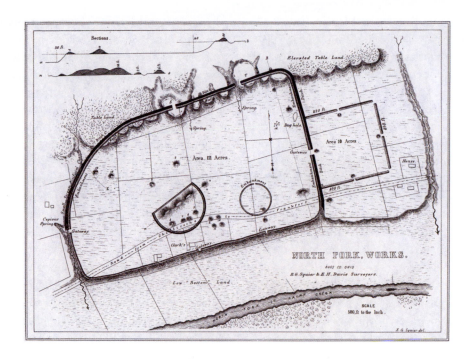

8.46 Map of Hopewell earthworks at Newark and Heath, Ohio. c. 100–800. From Ephraim G. Squire and Edwin H. Davis, *Ancient Monuments of the Mississippi Valley,* published by the Smithsonian Institution of Washington, 1848
This landmark work in the history of American archeology, in which Squire and Davis surveyed and excavated the major earthworks in Ohio, brought the early Native American history of this part of the United States to the attention of the wider public. However, true to the times, the authors did not believe the Native Americans were capable of building such large-scale works.

such astronomical events as the solstice. With the aid of shamans, those assembled might have communicated with the otherworld of the solar bodies toward which the serpent points. However, all such interpretations of Adena/Hopewell art are conjectural because the traditions did not continue into historic times when they could have been documented.

Not far from the Serpent Mound, there is an even larger complex of earthen Hopewell enclosures at present-day Newark and Heath, Ohio (c. 100–800 CE). The structures there include the Great Circle (1,180 feet/363 m in diameter) with an interior moat, the Octagon, and the Wright Earthworks (FIG. 8.46). A road that may have been used for ceremonial processions and trade ran 60 miles (96.5 km) south from Newark to a center near present-day Chillicothe. Portions of the ramparts have been destroyed by the expansion of Newark and Heath and by the construction of the Mound Builder Country Club in the early twentieth century. Recent scholarship suggests the alignments of the enclosures and certain passageways record the points at which the moon rises and sets along the horizon over an 18.6-year cycle. Proponents of that theory say with pride that not only are the alignments at Newark more accurate than those at Stonehenge, they are about one hundred times the size of that other ancient observatory.

THE MISSISSIPPI PERIOD (900–1500/1650)

In the southeast, with its short, mild winters and long, rainy summers, agriculture flourished in precontact times, as it does now. As communities expanded their agricultural practices in the well-watered bottom lands along the rivers, an elite class of powerful rulers supported by a new class of professional warriors was able to expand the extensive trade networks of their predecessors and construct large ritual centers with high platforms supporting homes, temples, and shrines. To impress their authority on the rest of the agricultural society, the rulers created new forms of art and religion, known today as the **Southern Cult**, or the Mississippian Art and Ceremonial Complex.

The largest of these new centers, Cahokia (a modern name), lies in a large, fertile, lowland area along the Mississippi River not far from its junctures with the Missouri and Illinois rivers. Benefitting from plentiful, well-watered bottom lands and easily accessible trade routes up and down the rivers, the city flourished and reached its peak around 1050–1250 CE when it had a population of 20,000–40,000. Cahokia, the largest city in prehistoric North America, with 120 known earthwork mounds and a metropolitan area that covered about 6 square miles (15.5 sq km), was also home

to the largest temple mound north of Mexico (FIG. 8.47). The structure, known today as Monk's Mound, was 790 × 1040 feet (240.7 × 316.9 m) at the base and about 100 feet (30.5 m) high. A large wooden structure on the summit may have been a temple, and/or the residence of the local ruler. Monk's Mound, enlarged over several centuries, had basal dimensions that were somewhat larger than the Pyramid of the Sun at Teotihuacán, but it was not faced with stone and stucco so it has eroded badly, and can best be studied through modern reconstruction drawings. It and many other temples at Cahokia on trapezoidal platforms were located on the sides of large, open plazas, an arrangement that reflects that of many Mesoamerican cities of this time. The people of Cahokia and other Mississippi-period cities that did business with traders from the south probably knew about Mesoamerica and some of its building practices, but the platform-plaza arrangement is such a simple and basic one that its presence alone does not imply close or direct contacts between the Mississippian and Mesoamerican civilizations. The builders at Cahokia also constructed some circular enclosures up to 410 feet (125 m) in diameter. The largest of these circles, with wooden posts set at regular intervals and one near the center, may have been an observatory used to chart the movements of the heavenly bodies. It is known as Woodhenge.

The Mississippi-period cities such as Cahokia had hierarchical forms of government and their leaders identified themselves with the sun, a near-universal symbol of male power. Some of our information for this ideal comes from the seventeenth-century European missionaries and explorers who observed the Natchez in Louisiana north of New Orleans, who had a late form of the Mississippi-period culture. They carried their leader, the "Great Sun," in a litter so that his feet would not be contaminated by contact with the earth, and regarded him as a divine manifestation of the sun and sky. Historical records also tell us the Natchez and other late groups in the southeast kept sculptured images of their leaders in mortuary shines. Many of them may have been wooden and have long since perished, but some large stone sculptures of seated, cross-legged figures leaning forward and resting their hands on their legs have been found at Mississippian sites. Although their faces are conventionalized, they may be portraits of the once-powerful Native American rulers who commanded the Mississippian Art and Ceremonial Complex in this area.

As leaders of the Complex, these rulers probably claimed to have special spiritual knowledge and powers from the gods, which they illustrated in new art forms. Unlike the relatively simple fertility and animistic images of the Woodland period, their art was complicated and esoteric. It included a wide variety of military figures in elaborate outfits, including falcon face decorations, some of them carrying severed heads that might represent conquests or deified ancestors. We also see a wide variety of unearthly winged and horned serpents and other composite beings from another world and many symbolic items set in circular pendants or on shields. Wide-open eyes set in the palms of hands are probably sun symbols intended to celebrate the power of the rulers. These images

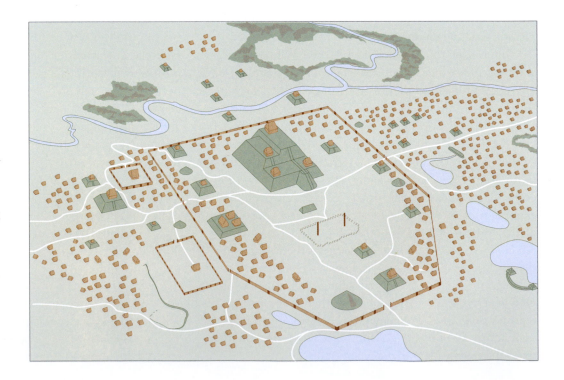

8.47 Reconstruction drawing of the ancient city of Cahokia, near Collinsville, Illinois
Monk's Mound in the center is surrounded by subsidiary mounds in and outside the wood rampart around the main ceremonial area in the city.

are incised on thousands of shells, sheets of copper, and pieces of pottery and wood. Scholars have correlated many of the images with regional Native American myths collected in the southeast in postcontact times. However, once again, most of the Mississippi-period mounds were plundered by treasure hunters so it is difficult to isolate regional period styles and fully understand this intriguing cult that lasted into historic times.

Some of the artwork represents men with sticks, balls, and team uniforms. They appear to be playing an ancient form of Chunkey, a game that is still in existence among some Native American groups in the southeast today. A bowler rolled a disk or ring of stone along the ground and the other participants in the ritual/game threw or placed special types of stripped sticks or spears at the spot where they thought the disk would tip and stop. One such bowler, striding forward, about to release his disk, is incised on a shell that may have been worn as a pendant (FIG. 8.48). His outfit includes a striped Chunkey stick on the right, a pillbox hat, a heart-shaped loincloth that may be a human scalp, and padding edged with large loops that protrude above and below his wide belt. Many military figures in Mississippi-period art wear similar uniforms; we might guess that Chunkey players belonged to competing military groups. As in Mexico, audiences wagered heavily on the game, which was both a religious ritual and a form of public entertainment.

As a large peninsula projecting from the southeast corner of the Southern states, Florida has always played a peripheral role in the history of the area. We see elements of the Mississippian tradition here, including the use of platforms to elevate structures around large plazas, but the most astonishing works in Florida are the highly naturalistic sculptures of local animals found during the excavations of Key Marco. One, a carved wooden image of a deer, has movable ears, which might have been manipulated during rituals or other ceremonials by "puppeteers" to make the highly naturalistic deer appear to be alive (FIG. 8.49).

The Mississippi-period culture began to decline after 1350 in 1830, as the non-Native American population in the southeast grew and the demand for good agricultural land increased, the United States Congress passed the Indian Removal Act. This allowed the military to forcibly relocate Native Americans from the southeast to less productive agricultural lands west of the Mississippi River. Many of the descendants of the people who created the Mississippian tradition lost their lives on the forced march to Oklahoma known as the Trail of Tears (1838–39).

On a final note, in recent decades there have been many disputes over who has the right to occupy and use certain Native American archeological sites. Of late, a conflict has arisen at Newark, Ohio, between the Mound Builder Country

8.48 Mississippian artist, Chunkey player shell engraving. 1200–1450 CE. Diameter 5¼" (13.3 cm). Peabody Museum of Natural History, Yale University

8.49 Deer head with articulated ears. Key Marco site, Collier County, Florida. Wood, 1000–1400. 5⅝ × 7½" (14 × 19 cm). Pennsylvania Museum of Archaeology and Anthropology

Club, which has a long-term lease on large parts of the archeological zone, and some regional archeo-astronomical groups (who study the astronomy of past cultures). The latter want to hold gatherings on the ramparts to observe lunar phenomena and they object to the use of the ancient site as a golf course. For its part, the Country Club does not want the archeo-astronomers trampling its fairways and greens or interfering with golfers on the course. Ironically, if, as is likely, Newark and other Hopewell sites did have early forms of ball games like Chunkey or those played in Mesoamerica 1,500 years ago, the skywatchers and ball-players would have shared many important cultural values and welcomed one another's presence in the great enclosures.

THE NORTHWEST PACIFIC COAST

The prosperous, sea-oriented people living along the 1,500-mile (2414 km) stretch of heavily forested hills on the northwest Pacific coast from the California–Oregon border to the panhandle of Alaska produced some of the finest woodcarvings in North America. In precontact times, this was one of the most densely populated regions in the world without agriculture. By 1900, the precontact population of about 200,000 had dwindled to about 40,000 and the so-called "totem poles" installed in museums had become universally recognized icons of the "Vanishing Indian."

The wealth of the Haida, Tlingit, Kwakiutl, and other groups in this region came from the sea, which is warmed by the Japan Current. During the relatively short summer season (May–September), "cultivating" the resources of the Pacific coast, the northwestern groups were able to put up stores of food to sustain them during the long, dark, and rainy winter months. During the winter, they passed the time retelling their myths, legends, and family stories and recorded them on a wide variety of finely painted, carved, and woven objects. Traditionally, the most accomplished carvers received commissions from distant villages outside their own linguistic groups because their skills were regarded as supernatural gifts and they were honored wherever they went.

Some of the most characteristic features of northwest Pacific coast art—its closely matching sets of interlocking, broadly rounded contours and lines—appear on stone sculptures as early as 1500–1000 BCE. Although the tradition is a very ancient one, we know relatively little about northwest Pacific coast art before the eighteenth century because almost all of the wood sculptures and weavings predating this period have disappeared. In many cases, once a carved pole was erected, it would not be repainted or altered in any fashion; such acts might require as much ritual preparation as the original carving. Many poles that fell were not reset or repaired; they were allowed to decay naturally in the rainy coastal climate. Aside from the monuments that were moved to museums for safekeeping, most of the sculptures and houses that existed in great numbers as late as the 1880s have long since disappeared.

HAIDA TOTEM POLES

Such was the fate of Skidegate, a Haida village that was photographed in the 1880s (FIG. 8.50). The houses were built in rows following the curvature of the beach, with the residences of the chief and high-ranking nobles near the center of the village. The straight grain of the cedar trunks allowed the builders to split the trees into planks up to 40 feet (12.2 m) long. Originally, some of the poles were painted with clan-crest symbols to help visitors arriving by canoe to recognize the homes of their friends, relatives, and enemies—and navigate accordingly. In addition to the poles inside houses supporting rafters and those attached to the façades, tall, freestanding memorial poles and somewhat shorter mortuary poles with hollow cavities to hold burials were set in front of the houses.

All of these so-called "totem poles" display animals and other heraldic signs belonging to the lineage of the family erecting them, along with references to legends that explain how these family badges were obtained. It was important for families to display their crests, emblems, songs, ceremonies, and other art forms to validate their status within the community. As in the European tradition of peerage, wealthy northwest Pacific coast families "owned" certain crests or image-types indicating their moiety or clan as well as personal family crests, and they displayed them on their houses and on the canoes in which they traveled to other communities. The animals in the crests may have had supernatural contact with a mythical ancestor or have taken human form to establish the lineage.

Dissolving naturalistic images into complex decorative patterns, the sculptors created works of great complexity to record the heraldic associations of the important families. The mortuary pole on the left is carved with three crests composed of animals that can be identified by their paws, fins, ears, teeth, and tails. The carvers exercised considerable artistic license in the representation of natural forms, and their compact, stylized forms can be difficult to read. From the bottom to the top, they represent a killer whale with two projecting dorsal fins, a mythological clan ancestor, and a spirit call a *snag*. A second mortuary pole to the right represents a grizzly bear (bottom), a killer whale with a blowhole in its snout and a seal in its mouth, and a wolf or bear at the top.

Aside from the fins and other boards that have been attached to the pole, the sculptured details are bas-reliefs

that follow the rounded contours of the thick cedar trunk. Continuous, primary outlines glide and bend around the pole to form patterns of flowing, interlocking, and inset ovoids, crescents, and U-shaped forms representing decorative motifs and parts of animal bodies and faces. The complex sets of rules or conventions governing the manner in which the artists shaped and colored the forms were handed down from master to pupil for centuries. Only by mastering these principles of visual rhetoric could a northwest Pacific coast artist hope to expand upon them and become creative within the traditional parameters of the style. Not only was such creativity allowed, it was actively expected as the linked ideas of tradition and continuity coexisted with innovation and individuality in the arts.

The oval doors in the poles attached to the house façades, which were often painted to represent animal jaws, were called Holes in the Sky. Passing through them was a symbolic act, representing the arrival of the clan's mythological ancestor in this world or the shaman's journey to the spirit realm. A framework of heavy cedar poles supported the thick plank floors, walls, and roofs of these large communal structures, which were up to 60 feet (18.3 m) wide and 500 feet (152.4 m) long. Large houses were divided into rooms and apartments occupied by matrilineally linked families belonging to the same clan. Everyone in the house shared a central sunken living room with a fire pit, behind which was the home of the highest-ranking family (FIG. 8.51). (See *Analyzing Art and Architecture: A Formal Analysis of the Northwest Pacific Coast Style*, page 322.)

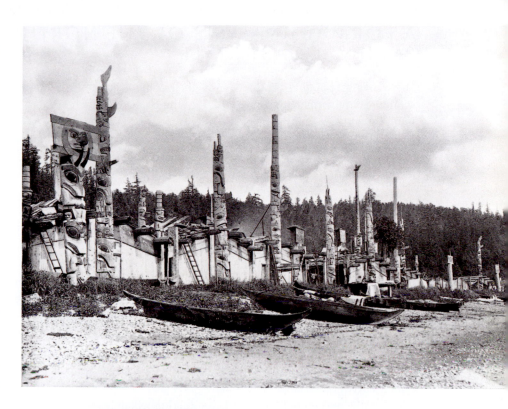

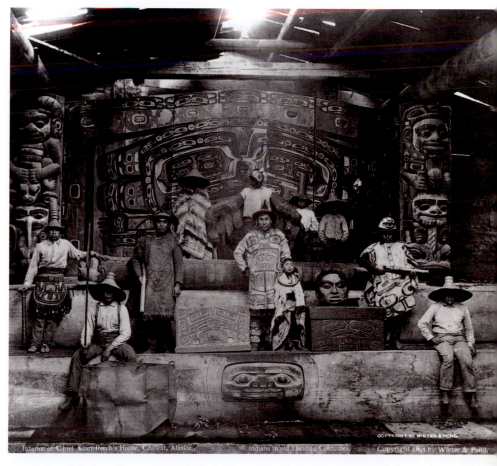

8.50 Mortuary poles and houses. Skidegate, northwest Pacific coast. Photograph, 1888. Royal Anthropological Institute, London

8.51 Tlingit (Ganaxtedi clan) whale house interior, with carved and painted screen, house posts, storage boxes, helmets, hats, masks, decorated clothing, and carved vessels. Photograph, 1888. Courtesy of the Alaska Historical Library, Juneau

A FORMAL ANALYSIS OF THE NORTHWEST PACIFIC COAST STYLE

The weavings, paintings, and sculptures in the richly decorated house in FIG. 8.51 and the blanket in FIG. 8.52 share many features that are recognizable as part of the distinctive northwest Pacific coast style of Native American art. The bold, thick outlines, or formlines, provide paths for the viewer's eyes to follow, ones that can be seen from a great distance. They are bent into a few repeating and closely matched, broadly rounded curves, U-shaped forms, and ovals with flattened sides. These gently sweeping curves with a sense of flowing, controlled movement may change into sharper, tighter curves or terminate in pointed tips. Smaller and more thinly lined ovoid forms may be set inside the larger ovoids. The limited colors, often comprising bluish-green, red, and some yellow, are of low intensity. The organic shapes fit together closely and tightly like the pieces of a jigsaw puzzle. Often, their composition reflects the shape of the object on which they are placed.

Animals are not shown in their entirety, in a naturalistic fashion. Generally, the artists will select characteristic silhouetted forms, such as eyes, eyebrows, tails, claws, or fins, that enable viewers to recognize the species being represented. These forms are fragmented, distorted, and rearranged to fit into the ovoid shapes defined by the formlines. The images present the core of the myths and ideas they represent in flat patterns, without implied space. As heraldic crests or signs, they are highly abstract, but immediately recognizable to the initiated, who know the culture well enough to be able to "read" and interpret the fragmented forms. Often, a single form may be part of two overlapping or interlocking images and must be "read" in two ways, a kind of visual pun.

The flowing compositions of these well-matched curved and organic formlines and shapes have a rhythmic pulse, vitality, and strong sense of unity. To characterize them further, we might say that they are slow-flowing, compact, and forceful, and that they may echo the flora, fauna, and aquatic shapes of this area. Also, there may be an important kinesthetic relationship between these rhythms and those of the music and dances that accompanied them in ceremonies.

Those who have seen many pieces of northwest Pacific coast art find it quite easy to recognize new examples of the style. But while it is possible to feel a certain sense of familiarity with the style, there is always an element of surprise as each new piece is discovered. The artists were able to create seemingly endless formal variations on their favorite forms using the elements of style discussed above.

THE TLINGITS

To prove that he was wealthy and successful, a man of the Chilkat division of the Tlingits would pay his wife or daughter to weave a special ceremonial blanket for him (FIG. 8.52). It might take the entire winter or longer to spin the mountain-goat wool, dye it (black, yellow, and blue-green), and weave the blanket. The Chilkats did not use frame looms for these blankets; the warps were suspended from a horizontal rod and their untrimmed ends became the lower fringe of the finished piece. The Tlingits called these blankets *nakheen* ("fringe about the body"), because the long, trailing fringe on the blanket would emphasize the movements of the owner as he danced in the winter rituals.

The Chilkat blanket designs are symmetrical and feature animals sacred to the clan. This blanket represents a popular theme—the diving whale in pursuit of a seal. As with most northwest Pacific coast reliefs and paintings, the internal organization of the composition emphasizes the shape of the blanket. The faces of the two animals in the center of the blanket are flanked by symmetrical sets of body parts and decorative forms, all of which are composed according to the strict patterns of rhetoric controlling the composition of all Chilkat designs. The blankets, shaped like inverted house fronts, also translate the social symbolism of the architecture to a personal scale and context.

Many important northwest Pacific coast works of art perished over the years during the potlatches—ceremonies with feasts during which families could demonstrate their crests and validate their wealth by distributing or destroying objects of great value. While this ritual might appear to be a destructive one, it has other important and constructive

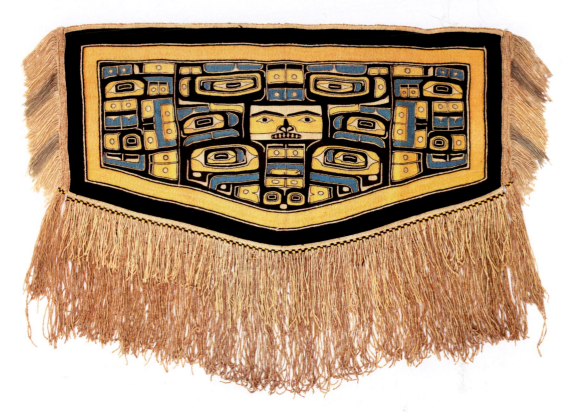

8.52 Tlingit blanket. Alaska. 1870–90. Cedar bast and wild goat hair, width 42" (1.06 m). National Museum of the American Indian, New York. Bequest of Clarence H. Young

reasons for its existence. The potlatch is a festive occasion, a time for feasting, with music, singers, drummers, and dancers, whose movements capture the very heart and soul of northwest Pacific coast life. At times, dance groups perform with paddles, and when they do, one sees the rhythms of their water-world come alive on stage as the performers sway and glide like fish in the sea. In their rolling movements, one may also see parallels to the rounded, rhythmic, and easy flowing lines in their art, another expression of the gently moving waters in the bays and inlets where they live.

When the Canadian government outlawed the potlatch in 1885, it unknowingly destroyed one of the most important political and religious ceremonies in the area. The prohibition contributed to the subsequent decline of the northwest Pacific coast societies. The ban was repealed in 1951, and people outside Native American culture have since begun to understand why the potlatch was, and still is, so important. It is a test of faith—in one's society and environment. It is the bountiful sea that enables individuals to gather more food than they need and accumulate wealth, and then give both away. And to do that, one must believe that the sea will continue to provide for those around you, and that they will provide for you. Thus, the potlatch is an article of faith that links individuals with their waters, people, the past, and their hopes for the future.

In the late twentieth century, some Native American artists, such as Bill Reid (1920–98), developed styles that drew on the artistic traditions they had known as youngsters.

Reid was born to a family of Haida artists that included his great-uncle Charles Edenshaw (1839–1920), the last major Haida artist to work within a traditional, integrated Haida society. Reid, who drew his inspiration from Edenshaw's art, worked as a jewelry maker before he began carving large wooden sculptures. He combined elements of both media in his large, leaping bronze *Killer Whale*, which was installed over a pool of water at the Vancouver Aquarium in Stanley Park (FIG. 8.53). The individual components of the whale's anatomy are rendered in terms of the traditional Haida vocabulary of flowing lines and crescent-shaped forms. But these motifs have been rendered in bronze and applied to the three-dimensional form of the leaping animal. Speaking in the visual language of his ancestors, Reid's monumental bronze captures the sense of clarity and style of traditional Haida art without being a direct copy of any earlier works. *Killer Whale* illustrates how contemporary northwest Pacific coast artists such as Reid have found ways to create innovative works within their traditions and make the mythic past a living force in the present. In doing that here, Reid has also created a truly dramatic and awe-inspiring monument that transcends the parameters of ethnicity and establishes him an important late twentieth-century sculptor.

Working in a spirit that synthesizes the Haida traditions with cultural forces around them, Bill Reid and others have played important roles in the preservation of those traditions. Together, as they revived the arts and ceremonial contexts, they have demonstrated that recent work in their

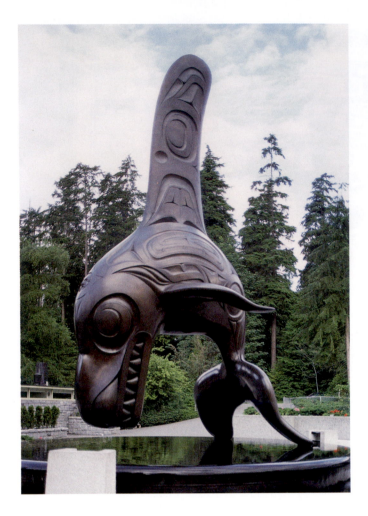

8.53 Bill Reid, *Killer Whale*. 1984. Bronze, height approx. 17' (5.2 m). Vancouver Aquarium, Stanley Park, Vancouver

ethnic and family styles is not inherently inferior to the art produced in previous centuries. Speaking on the importance of traditional Haida ceremonies and songs in his work, Robert Davidson, a great-grandson of Edenshaw, said: "We are now giving new meaning to the songs, dances, crests, and philosophies. We are updating these ideas, which is no different from what our forefathers did."

THE GREAT PLAINS

For many people, their image of the Native American is based on nineteenth-century paintings and photographs of Great Plains warrior-buffalo hunters wearing their long, colorful, feathered headdress, beads, and buckskins (FIG. 8.54). Ironically, that famous image, reinforced by a host of twentieth-century films, comes from a very late period in Native American history and was shaped in part by Western influences. Buffalo hunting was not practiced on the Great Plains on a large scale until the eighteenth century, when

the Native Americans acquired horses from the Spanish and guns from the French fur traders. Before this, the Plains had been sparsely populated because the wide-open, windswept grasslands are frigidly cold for many months in the winter, dry in the summer, and ill-suited to the agricultural practices developed in the southeast. Small numbers of Mandan, Hidatsa, and other groups had been braving the winters on the Plains in their sturdy earthen lodges for nearly a thousand years, but the Sioux, Crow, Cheyenne, Arapaho, and other groups of mounted hunters were relative newcomers to this area when the first European settlers arrived.

Using horses to drag their sledges, which were made of long slender poles, the hunting societies could take their homes and possessions with them in the summer as they followed the buffalo herds. Their summer homes, **tepees** or *tipis*, were large tents, frameworks of long poles covered with painted buffalo hides. The Native Americans of the Great Plains decorated these tepees, as well as individual buffalo hides,

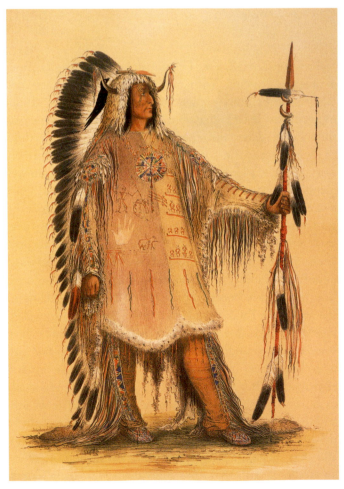

8.54 George Catlin, *Mato-Tope (Four Bears)*. Hand-colored lithograph print, approx. 12 × 17⅝" (30.5 × 44.4 cm). Plate 27 of *North American Indian Portfolio*, 1844

other utilitarian objects, and items of dress, with signs and symbols that spoke of ethnic pride and identity. These metaphors of power played an especially important role in the lives of the people ruled by the chieftains one sees in late nineteenth-century photographs. We must not let these stereotypical images lead us to think that the Plains societies were focused entirely on chiefs, male warriors, and large-scale hunting events. Some women distinguished themselves in battle and earned the right to wear the eagle plumage, the ultimate symbol of courage. Women could also achieve the same respect as men by being skillful in the arts. While the men gathered to share stories about warfare and hunting, groups of women were describing their finest works of art to one other at meetings of their art guilds, organizations that controlled many of the artistic activities of the community. (See *Materials and Techniques:* Basketmaking, page 326.) By comparing stories about their art and how it beautified their world, the women created their own social order. From an early age, mothers taught their daughters the skills they would need to become members of these prestigious guilds.

At times, we can see Native American art and culture in context in the works of such early illustrators on the Great Plains as George Catlin (1796–1872) from Wilkes-Barre, Pennsylvania (see FIG. 8.54). In the last decades before the techniques of photography were developed to make it an effective and portable tool for illustration, the frontier attracted many such artists and naturalists who provided images of it for a curious public. Catlin, who made five extensive trips along the Missouri, returned home with volumes of sketches, produced over five hundred paintings, and assembled a traveling "Indian Gallery" that toured the United States and Europe in the 1830s and 1840s, where the myth of the "noble savage" was already over a century old. Catlin was particularly interested in the Mandan who lived in earth lodges in permanent villages along the upper Missouri River in the Dakotas.

After the Mandan arrived on the plains around 1100 CE, the size and number of their towns increased until the droughts of the sixteenth century reversed their fortunes; by the 1830s, only two Mandan towns remained. However, even in their decline, the earth lodge towns were important trading centers where French traders exchanged their highly prized European goods for hides. For defensive purposes,

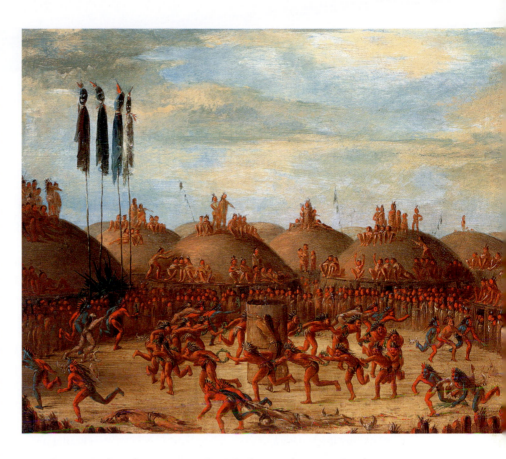

8.55 George Catlin, *The Last Race, Part of Okipa Ceremony (Mandan)*. 1832. Oil on canvas, 23⅜ × 29¼" (59.4 × 74.3 cm). Smithsonian American Art Museum, Smithsonian Institution, Washington, D.C.

the Mandan built their lodge towns on the high bluffs over the Missouri River and ringed them with wooden palisades and dry moats. They constructed their lodges by placing thick layers of loose earth and sod over networks of tree limbs and twigs resting on study pole frames. Many of the homes were 40–60 feet (12–18 m) in diameter and their ceremonial lodges might be up to 90 feet (27 m) long. These large ceremonial lodges and the homes of the leaders had pride of place around the plaza, in the center of which was a round, barrel-like shrine. This belonged to their culture hero, Lone Man, who had saved them from a flood in ancient times. The rest of the town included more homes, storage pits, and various types of platforms on which food was prepared and stored. The Mandan also built smaller, secondary earth lodges near their fields on the floodplains and lived in teepees during their summer hunting expeditions. The shrine to Lone Man is visible within the circle of men in Catlin's *The Last Race, Part of Okipa Ceremony* (FIG. 8.55). The ceremony celebrated creation, the flood, and the coming of the buffalo. It lasted several days and culminated in a grizzly ritual in which the participants hung from the rafters of their lodges on strips of rawhide skewered through their skin.

BASKETMAKING

The techniques of basketmaking in the Americas are very ancient, and date back to at least 11,000 BCE. Moreover, because the techniques for making pottery remained unknown in many parts of North America, basketmaking was both a very important industry and a means of aesthetic expression. The vast majority of basketmakers were women; they gathered their own materials, prepared them, and created their own designs. In some areas, women continued to work as basket artists long after the men had abandoned their traditional art forms.

The two basic techniques of basketmaking are weaving and coiling. The weaving technique uses a warp and weft, as in loom work, which produces a checkerboard pattern. This is also known as plaiting or checkerwork. Using colored materials and varying the weave pattern, basketmakers can create a variety of decorative woven patterns. Weaves in which the warp is ridged are known as wickerwork. In the coiling technique, long bundles of tightly wrapped roots, stems, and other plant materials are sewn or whipped together in an ascending spiral coil. Before metal needles were introduced to the Americas, basketmakers used bone awls to fasten the coils.

The Pomo of California in the mountains north of San Francisco have long been some of the most accomplished basketmakers in North America. In 1579, a member of Sir Francis Drake's expedition along the California coast described a Pomo ceremonial basket with red woodpecker feathers. The finest of the Pomo's woven and coiled baskets are decorated with a variety of such attached materials and illustrate important mythological events. The saucer-shaped coiled basket hanging on strings of tiny white clamshell beads in FIG. 8.56 is a replica of a spirit basket used by the Pomo creator-culture hero, Oncoyeto. He stole the sun from a distant land, carried it home in a basket, and brought light to the Pomo world. To tell the complex story, the artist has used a variety of decorative materials with symbolic meanings understood by other members of Pomo society. The circular abalone disks represent the sun, the crescent disk is the moon, and the arrow-shaped pieces are stars. The fish on shell bead strings below the basket (the island of the earth) swim in the primordial sea where Oncoyeto placed the sun. Colored woodpecker feathers symbolize important virtues: bravery (red), love (black), and success (yellow).

Pomo women often received ideas for their basket designs through visions. Thus, the artists remained spiritually bonded to their works and they owned the designs as well as the baskets. Artists could not use each other's designs because these incorporated intensely personal, spiritualized properties. Since the baskets were so personal in nature, Pomo women might use such elaborate and symbolically meaningful baskets as this while performing routine, everyday tasks, enjoying the beauty of their art and reliving their visions while working. Many of the finest Pomo baskets were worn out in this manner and others were burned with their owners when they were cremated.

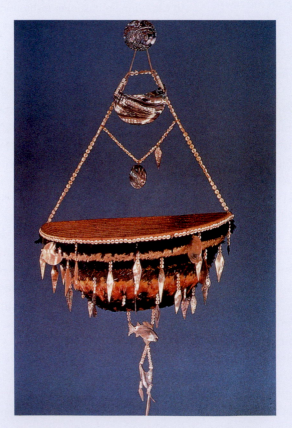

8.56 Pomo hanging basket. Late 19th century. Organic fibers with clamshell beads, abalone, and feathers, diameter 17" (43.18 cm). American Museum of Natural History, New York

Catlin painted two portraits of Mato-Tope (Four Bears), chieftain of the Mandan. He was said to have the courage and strength of four bears and wore outfits that celebrated some of his heroic exploits (see FIG. 8.54). The long war bonnet of eagle feathers symbolizes courage, the large circular sun disk on his chest speaks of his valor in war, and he used the spear he is holding to avenge the death of a brother. The knife in the chieftain's headdress once belonged to an enemy Cheyenne warrior: Mato-Tope disarmed and then killed him with his own knife. Mato-Tope's long shirt of mountain sheepskin is not Mandan; he acquired it and most of the clothing he owned through trade, so within the Mandan community his "imported wardrobe" was highly distinctive.

Catlin said that the Native Americans he painted "are doomed and must perish," so he would "rescue their looks" that they might "live again upon canvas, and stand forth for centuries yet to come, the living monuments of a noble race." The lodges in FIG. 8.55 and in other topographical studies by Catlin have long since disappeared, and in 1837 smallpox decimated the Mandan, making Catlin and others' theory of the "Vanishing Indian" look as if it were coming true. But, elsewhere on the Plains, the Native Americans were not vanishing at all. Many were working in traditional ways, recording successful vision quests on their teepees, buffalo hides, and shields. At times the spiritual powers they encountered on those quests dictated how the images should be made and where they were to be placed. For example, Arapoosh (Sore Belly) (died 1834) was instructed to put his vision on a shield. The dark, grimacing skeletal spirit of the moon silhouetted against a bright orange background—with eagle feathers, tail of deer, and the body parts of the stork—was designed to strike fear into the heart of Arapoosh's enemies when he confronted them in battle (FIG. 8.57).

Many Native groups also created works of art for large communal gatherings or festivals where they feasted, danced, and exchanged the art as gifts, reinforcing social and political bonds. It was, and still is, important to dress appropriately at such gatherings, especially for the competitive dancers. In Native society, the highly popular image of the Plains dancer wearing fringed buckskins, beads, shells, small bells, facial and body paint, and a feathered headdress while performing, is one of great power in motion that can carry the dancer to the realm of the spirits. A Lakota term, *saiciye*, means "being adorned in proper relationship to the gods," and to this day the *Pow Wows* express this ancient belief in the transcendent power of body art.

Some of the most attractive clothing from this period was decorated with glass beads imported from Europe. At first, the beads were used sparingly to accent other objects, such as bones, claws, stones, and quills, attached to animal

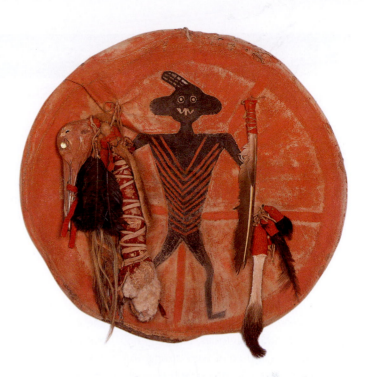

8.57 Arapoosh (Sore Belly), Crow war shield. c. 1820. Buckskin, rawhide, pigments, feathers, deer tail, flannel, diameter 17" (43 cm). National Museum of the American Indian, Smithsonian Institution, Washington, D.C.

hides. Women had long worked with hollow colored porcupine quills, softening, dying, and weaving them in ornamental patterns on animal skins, baskets, and boxes of birch bark. After the establishment of the first reservations in 1869, beadwork became an increasingly important art form in itself. The buckskin dress by Mrs. Minnie Sky Arrow of the Fort Peck Reservation in Montana is beaded on both sides and weighs 7 pounds (3.17 kg) (FIG. 8.58). Proud of her Native American heritage, she wore the heavy dress when she gave piano concerts around the country at the end of the century. (See *Materials and Techniques*: Beadwork, page 328.)

While Mrs. Sky Arrow was beading her dress, members of a new, highly emotional cult inspired by Wovoka, a Paiute priest from Nevada, were decorating a new kind of clothing, **Ghost Dance** shirts. They believed these ritually decorated garments were bulletproof and that wearing them in the Ghost Dance ceremonies tied them to the powers of the spirits and sacred ancestors in the otherworld (FIG. 8.59). The shirts and ceremonies would bring back their ancestors and herds of buffalo, and make the foreigners disappear. The massacre at Wounded Knee Creek on the Pine Ridge Reservation in South Dakota on December 29, 1890 underlined the futility of these dreams and that date effectively marks the end of the buffalo-hunting Plains culture. (See *In Context*: Bury My Heart at Wounded Knee, page 329.)

BEADWORK

Glass beads were manufactured in Europe by glassblowers. They stretched thin bubbles of molten, colored glass into thin, hollow strands, cut them into tiny segments, and polished them in tumblers filled with sand and other abrasives. Beads were sized by number. The Czechoslovakian seed beads (sizes 18/0 to 10/0) were smaller than the Venetian pony beads (8/0 and larger). At the factories, beads of the same size and color were strung on durable threads and crated in barrels for transportation. Traders working on the frontier exchanged the beads and other manufactured goods for the Native Americans' furs, particularly beaver.

Most of the beads were stitched to the tanned hides of deer, buffalo, elk, moose, and caribou. Tanning involved scraping, stretching, drying, and treating the hides with the animal's brains, oils, or other natural ingredients to keep them from spoiling. Before needles and threads were imported, beadworkers stitched using bone awls and sinew from animal tendons. Beadworkers employed a variety of stitches to secure rows of beads to the surface of the hides. Often, glass beads were used with metal beads, tacks, and sequins (stamped and flattened loops of silver), bits of brass, copper, feathers, fur, and paint. But it is the brilliant color, translucency, and reflective qualities of the glass that have made glass beadwork so popular among collectors of Native American art from the Great Plains.

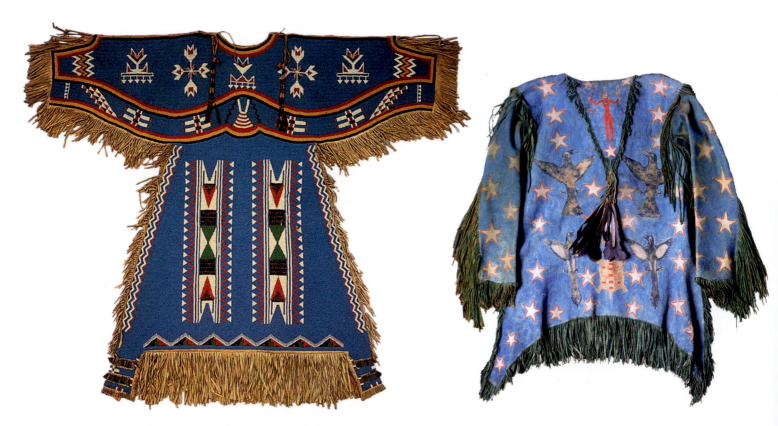

8.58 Mrs. Minnie Sky Arrow, Beaded Dress. c. 1890. Glass beads over buckskin. Fort Peck Reservation, Montana. American Museum of Natural History, New York

8.59 Southern Arapaho Ghost Shirt. c. 1890. Elk hide, paint, and feathers. Buffalo Bill Historical Center, Cody, Wyoming

BURY MY HEART AT WOUNDED KNEE

In the late nineteenth century, as settlers from the eastern states and Europe arrived in the upper Midwestern part of the United States to farm, the government relocated large numbers of Native Americans to reservations, most of which were in arid regions unsuited to farming. South Dakota has the largest concentration of reservations in the Midwest and many of the most notorious frontier conflicts happened in the western half of the state in and around the Black Hills. General Custer helped create the gold rush in the Black Hills, during which many prospectors and settlers staked their claims to lands the government had already given to the Native Americans through a series of treaties.

In the late nineteenth century, after the Native Americans in the United States and First Nations in Canada had lost a series of one-sided wars, some groups began performing a new ritual called the Ghost Dance. In its various forms, this promised to banish the settlers, bring back the buffalo herds, and enable all Native Americans to live together in peace and harmony. Unfortunately, it frightened some of the settlers, which led to the massacre at Wounded Knee (1890) in Pine Ridge County, South Dakota, where the U.S. Cavalry killed a group of women, children, and elders. That tragedy destroyed the last significant Native American resistance to American expansionism. Today, there are about four thousand counties in the United States, and Pine Ridge County, which is found on a reservation of that same name around Wounded Knee, has the dubious distinction of being *the* poorest county in the nation.

A generation after Wounded Knee, the federal government funded a project to carve the heads of four past presidents in the Black Hills on Mount Rushmore, which was sacred to the Lakota as Six Grandfather Mountain and which they had secured through the Treaty of Fort Laramie (1868). After the carving was finished, work began on the Crazy Horse monument on Thunder Head, another mountain sacred to the Lakota. At the same time, the government was building the Oahe and Fort Randall dams on the Missouri River, flooding the good low-lying farm lands on the Cheyenne and Standing Rock reservations.

In the 1970s, members of the American Indian Movement (AIM) staged sit-ins at Mount Rushmore and Wounded Knee on the Pine Ridge Reservation and Dee Brown published his bestseller, *Bury My Heart at Wounded Knee* (1970), from which the title of this box feature is taken. Mary Brave Bird from the Rosebud Reservation described her experiences as a Native American political activist in *Lakota Woman* (1991).

In 1972, Marlon Brando refused his Oscar for Best Actor in *The Godfather* and sent Sacheem Littlefeather in his place—in full Apache dress—to tell the world about the plight of her people on the government reservations. Native American families have been confined to government reservations and isolated there for so long that successive generations have been born and died in the ongoing state of poverty there, without access to any means of effecting change. They, like Wo-Haw (see Chapter One), are trapped between two worlds, unable to step back into a past that is gone, or forward into an often hostile world where they are not always welcome.

It is within the grim realities of this context that Native Americans continue to search for their identities as artists. Despite the efforts of activists, charitable foundations, and government agencies to bring Native American and First Nation artists into the mainstream of the art world in North America, very little has so far been done to resolve the question effectively so many of them are asking, which is "How can I make meaningful artistic statements about who I am when the most basic issues about my identity in my own lands are far from being solved?"

THE SOUTHWESTERN UNITED STATES

Native American art has a long history in the Four Corners region of the American southwest, called after the juncture of Utah, Colorado, Arizona, and New Mexico. The region includes diverse ecological zones, many of which are highly arid today, but before 1300 CE the area enjoyed a somewhat cooler and wetter climate. Enough water flowed through the rivers and creeks to enable residents to develop effective systems of irrigation. The ancient cultures in the southwest include the Hohokam around Phoenix and Tucson, the Mimbres to the east in southern Arizona and New Mexico, and the Anasazi in the Four Corners area itself. Within that region, the northern third of Arizona and New Mexico, stretching from Flagstaff to Albuquerque and Santa Fe, has long been an important center of Native North American art and culture. Southwestern groups traded with others on the Great Plains and in Mexico to the south, but Mexican influences in the arts are indirect and difficult to isolate.

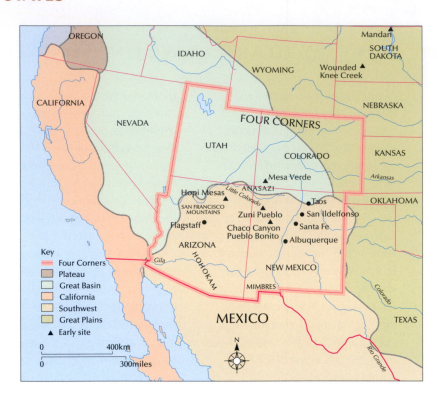

With its snow-capped peaks, broad mesas, deep canyons, and freestanding pinnacles of earth and stone that have been eroded by centuries of winds and rains, there is an awesomeness about the rugged landscape of the southwest. Both the Native Americans who have lived here for centuries and outsiders have long felt a sense of unearthly power and drama in the wide-open vistas of sky and earth that surround them. Here, as much as anywhere in Native North America, the spirit world always seems very close at hand.

Most of the ancient ruins are in the Anasazi area and belong to the Pueblo period (700–present). The period name comes from the Spanish word, *pueblo*, meaning small town or village. When Francisco Coronado of the newly established Spanish government in Mexico came to this area in search of gold and the fabled Seven Cities of Cibola (1540–42), he and his men were disappointed by what they found. The pueblos had no gold, and their most prized possessions were the costumes the inhabitants wore in religious rituals as they communed with the spirits animating the landscape. By this time, the southwest was also home to the Navajos, who arrived from northwest Canada between 1300 and 1500 and adopted some of the indigenous pueblo art forms to their tastes and purposes. The Navajo, who are world-famous for their woven blankets, continue to produce their traditional arts today, as do many of the pueblo artists, some of whom revived the ancient Anasazi styles of ceramic painting around 1900. Santa Fe in particular has been a major center for the reshaping of Native traditions for the last century, and it remains the single most important market for Native American art today.

THE PUEBLOS

The pueblos Coronado visited were late manifestations of the Anasazi (Navajo, "Enemy Ancestors") culture that flourished in the Four Corner area. Under the Spanish, the population in what was then known as the Kingdom of New Mexico, declined from about sixty thousand to about ten thousand. The secrecy that surrounds pueblo rituals today may stem from the period of Spanish occupation, when Spanish missionaries adopted radical measures to eradicate the Native religions and cultures. A densely populated 7-mile (11.3 km) stretch of land in Chaco Canyon near the Arizona–New Mexico border with twelve large pueblos was one of the major metropolitan centers of the Americas in the twelfth and thirteenth centuries. The region was part of a vast trading network that connected it with Central Mexico and the Great Plains. Roads extending over 50 miles (80 km) from Chaco Canyon and connecting pueblos there to others in the southwest suggest that these metropolitan centers were economically, if not politically, interrelated.

The largest of the building complexes at Chaco Canyon, known as Pueblo Bonito ("Beautiful House"), was begun around 900. It has about eight hundred rooms and housed at least 1,200 people in the early thirteenth century (FIG. 8.60).

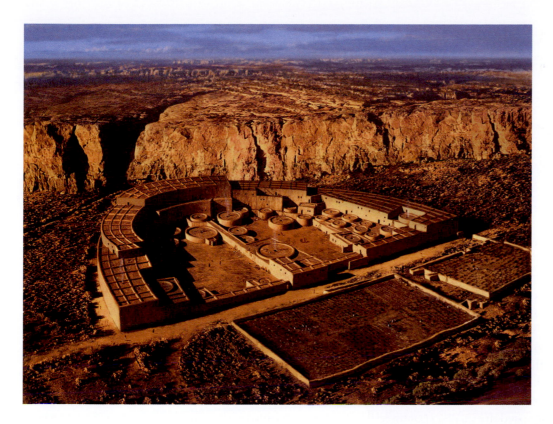

8.60 (LEFT) Reconstruction view of Pueblo Bonito, Chaco Canyon, New Mexico. Great Pueblo period, 13th century

Reliable dates for southwestern archeology have been established through radiocarbon dating and dendrochronology, the study of tree rings. To determine the age of a piece of wood, the pattern of growth rings in it can be compared to master charts of tree-ring growth from prehistoric to present times in that area.

8.61 (BELOW) Cliff Palace, Mesa Verde. Four Corners area, Colorado. 13th century

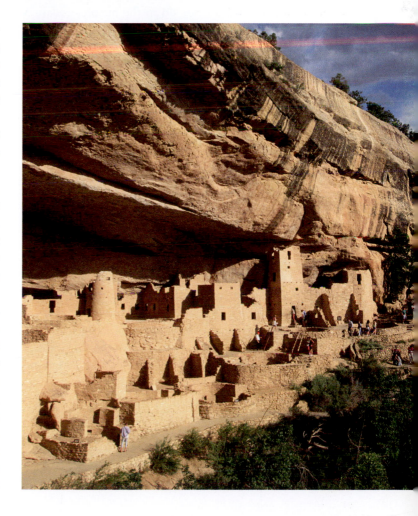

Many sections of the walls were made with thin, well-fitted stones, and the roofs were made of beams supporting saplings and twigs sealed by layers of mud plaster. Groups of as many as fifty rooms were planned and constructed as units, which implies that master masons approaching the status of architects directed the growth of the pueblo.

The most dramatic of the surviving pueblos from this period are at Mesa Verde ("Green Table") in the Colorado quadrant of the Four Corners area. In many places, the sedimentary rock along the steep valley cliffs has collapsed, leaving deep niches or open shelves. Around 1000 CE people living in this area began building individual homes and pueblos in some of the larger niches. The largest and most picturesque of these, the Cliff Palace, was completed in the thirteenth century and abandoned shortly thereafter during the droughts that lasted from 1276 to 1329 (FIG. 8.61).

The cliff dwellings have some advantages as well as restrictions not found in conventional pueblos. Residents had to climb up to their homes on long ladders, but once they retracted those ladders, they were relatively safe from marauding bands. In winter, the enclosures protected them from the chilly winds and the low winter sun could reach to the back of the house and warm them. In summer, the cliffs overhead protected them from the hot sun. But space was always at a premium, and to take full advantage of it the builders set their houses against the very back of the curved cliff walls and built them as high as possible, often touching the "roof."

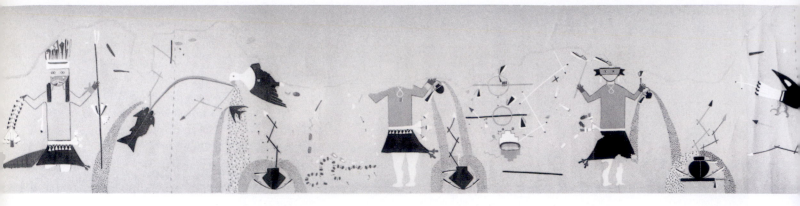

8.62 Replica of wall painting from *kiva* III, Kuaua, New Mexico. c. 16th century

As at Pueblo Bonito, all the homes in the Cliff Palace face the front and center of the community, and this is where they placed their most important and sacred structures—round, semisubterranean enclosures called **kivas**. In pueblo thought, the village is the center of the universe and the *kiva* is the center of the village. Entire clans could meet in the large *kivas* at Pueblo Bonito, while smaller, specialized religious societies may have used the smaller *kivas* there and at the Cliff Palace as they do in the pueblos today. A typical *kiva* has a small entryhole in the middle of the roof and a shallow hole (*sipapu*) in the floor, a symbolic entryway to the subterranean world of the spirits through which the pueblo people ascended to this world at creation. As we will see at Kuaua and many other *kivas*, the vertical faces of the benches and walls were painted and repainted many times. The larger *kivas* have stairs on the north and south sides, so those who enter are immediately aligned to the cardinal directions of the cosmos. As a map of the cosmos, point of entry into the underworld of spirits, and place where the terrestrial and extraterrestrial worlds meet, the *kiva* and dance areas around it occupy a central place in pueblo art, ritual, and thought.

After the long drought lasting from 1276 to 1329, Pueblo Bonito and many other cities from this period were abandoned and new ones were established near more reliable water sources on the Gila, Little Colorado, and Rio Grande rivers. Remains of paintings have been found on seventeen of the eighty superimposed layers of plaster on the walls of a square *kiva* at Kuaua. Fragments of one painted layer have been reconstructed in the Museum of New Mexico at Santa Fe (FIG. 8.62). Using stiff brushes, or their fingers, the painters laid out the basic areas of color and added black, white, or red outlines. The figure (left) holding a prayer stick and an offering of feathers is Kupishtaya, maker of lightning. His stick touches the stream coming from the fish, which is linked to a black and white eagle by a thin rainbow. The

eagle, batlike creature, and vessel below emit streams of seeds or moisture and zigzag-shaped arrows representing lightning. Variations on this theme appear in other reconstructed fragments from this painting. The horizontal bands (not visible here) beneath the figures' feet may represent a rainbow, the boundary between the *kiva* and the underworld of the spirits. Together, these moisture and fertility symbols express the pueblo dwellers' pressing need for rains in a land that was becoming progressively hotter and drier.

Some of the elevated mesa-topped cities of the Hopi (Peaceful Ones) founded around 1100 and flourishing during the time of Chaco Canyon and Pueblo Bonito are still occupied today and remain bastions of the ancient pueblo traditions. The most important spiritual beings in their religion are called **kachinas**. The term applies to the spirits, the masked dancers who impersonate them in ritual dances, and the small doll-like figures Hopi parents give their daughters to teach them about the hundreds of spirits that embody aspects of nature. The tradition of carving *kachina* figures may have been inspired by the images of saints the Spanish displayed in their churches and processions. The Hopi *kachina* spirits said to live on the San Francisco Mountains north of Flagstaff, Arizona; they come above ground during the winter solstice ceremony (December 21) and return to the underworld through the floors of the *kivas* in early July. They visit the mesas in the form of the masked dancers who robe in secret, in their houses or *kivas*, and keep their costumes carefully hidden when they are not in use. When Hopi performers put on the *kachina* masks and costumes and dance, they believe they become one with the spirit of that *kachina* (FIG. 8.63). In Hopi thought, the rituals "allow the god to become a living person."

The rest of the ceremonial year is ruled by non-*kachina* societies, many of which are controlled by the women. The Hopi believe that they will join the *kachinas* in the afterlife, become the rain clouds, and remain important parts

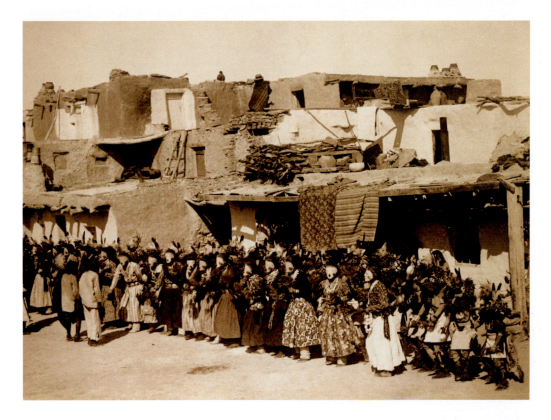

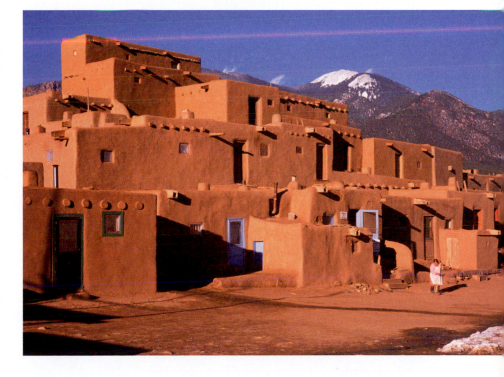

8.63 (LEFT) Hopi *kachina* dance, Shoughpave, Arizona. c. 1903

8.64 (BELOW) North complex, Taos Pueblo, New Mexico. Dating from 1450

of Hopi life on the mesas. The cult of the *kachina* appears to have intensified in the nineteenth century as outside influences began to erode the traditional fabric of Hopi life. (See *Cross-Cultural Contacts:* Two Pueblo Clay Artists, page 334.)

The pueblo at Taos with its multistory house groups is by far the most famous contemporary pueblo and has become a popular icon of Native American culture in the southwest. Unlike Pre-Columbian pueblos, such as Pueblo Bonito and the Cliff Palace, with their stone walls, Taos and other pueblos in this area are constructed from adobe bricks and plastered with layers of moist adobe. The Spanish introduced the technique of making adobe bricks in molds in the sixteenth century. When the pueblo, which is set on an open plain, is seen from the broad dance plaza in front of it, with the mountains and plateaus in the background, the inspiration for the pueblo's multilevel, flat-topped roofs and massive pyramidal outline is unmistakable (FIG. 8.64). The rooftops also have a distinct function; from there, residents can look out over the mesas and mountains around them as well as at the rituals unfolding in the plaza below. No complete floorplan for the pueblo exists because the people of Taos have not allowed such studies to take place. "People want to find out about this pueblo," a Taos man told an anthropologist, "but they can't. Our ways would lose their power if they were known." Many of the former residents of Taos and other pueblos, along with their

TWO PUEBLO CLAY ARTISTS

In the precontact period, Hopi ceramic artists produced large numbers of painted vases. The pueblo potter is a daughter of Mother Earth and offers up prayers, asking for the right to use some of her body. While the women grind the clay, temper it, shape the vases, and fire them, men will often paint the images on them.

In 1895, Leah Nampeyo, a skilled Hopi clay artist of Hano on the First Mesa, saw fragments of the earlier pueblo pottery styles from burials being excavated by archeologists working at nearby Sikyatki (Yellow House). Inspired by them, Nampeyo created her own designs that revived the spirit (but not the details) of the stylized birds, reptiles, and sky bands on the ancient Hopi vessels (FIG. 8.65). Using the traditional decorative motifs of her ancestors—tightly composed patterns of curvilinear forms that echo the globular shapes of her vases—Nampeyo's designs preserve the traditions of pueblo painting in new and innovative forms. During the past century, four generations of women in Nampeyo's family have kept the Hopi revival alive on the First Mesa.

Another of the famous southwestern clay artists who was part of this revival, Maria Martinez (c. 1881–1980) of San Ildelfonso, learned the many skills she needed to find and prepare clay as well as shape and decorate it from older women within her own family. Later, she and her husband, Julian Martinez (c. 1879–1943), developed their distinctive black-on-black wares that made them and their pueblo famous (FIG. 8.66). After firing the vessels in a kiln, the areas where the painted slip had been burnished would become highly glossy and contrast with the matt finish of the unburnished areas. The subtleties of the black-on-black technique appealed to Anglo-American patrons, many of whom were modernists with a taste for abstract and minimal designs, but some of those who paid high prices for signed works were disappointed to discover that Maria was signing works by other potters from her pueblo who were working in related styles so that they could share in her financial success.

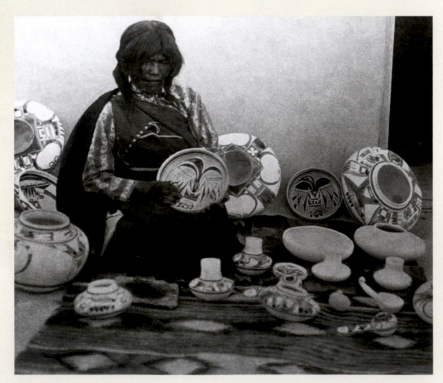

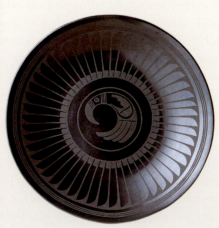

8.65 (LEFT) Leah Nampeyo displays her work. c. 1900

8.66 (BELOW) Black-on-black plate, feather and parrot design. c. 1943–56. Diameter 14¾″ (37.5 cm). Collection of Nadine and Eddie Basha

descendants, live outside the pueblos in homes with more modern conveniences, but they return to the pueblos for special occasions. Taos and other ancient pueblo towns are "shrines" that stand at the center of their spiritual world; here they can renew old friendships and form new ties with other descendants of their pueblo.

THE NAVAJO

The Navajo, who call themselves *Dineh* (The People), acquired sheep from the Spaniards and became herders; to this day, many of them live in small, scattered settlements. Since they lack pueblos and communal gathering places, many of their most important rituals are performed in their homes, or **hogans**, polygonal log structures. The most important rituals include the production of large floor "sand paintings." These large images are not actually painted, but made by pouring thin, finely controlled streams of colored sands, pulverized vegetable, pollen, flowers, and mineral substances in precise patterns on the ground. The first such works were probably elaborations on the diagrams the pueblo people made on their *kiva* floors, but soon thereafter the Navajo elaborated on those designs to create images of their cosmos. The Navajo sand paintings or pourings may be up to 18 feet (5.5 m) across and cover the entire floor of a hogan (see FIG. 1.3). Working from the inside of the design outward, the Navajo artists and assistants will sift the black, white, bluish-gray, orange, and red materials through their fingers to create finely detailed images. Well-trained artists and singers enlist the aid of spirits, the *yee'ii* (Holy People), impersonated by masked performers, and direct the very long and complex chants and detailed paintings used in the performance. The twenty-four known Navajo chants can be represented by up to five hundred sand paintings, which act as mnemonic devices to guide the singers in their ritual songs, which can last up to nine days.

One of the most fundamental purposes and meanings of the sand paintings can be explained by examining a basic ideal of Navajo society embodied in their word *hozho* (beauty, harmony, goodness, and happiness). This coexists with **hochxo** (ugliness, evil, and disorder) in a world where the opposing forces of dynamism and stability create constant change. (See *In Context:* "Hozho" as the Stalk of Life.) When the world, which was created in beauty, becomes ugly and disorderly for one or more of the Navajo, friends and family gather to perform rituals with songs and make sand paintings to restore beauty and harmony to the world so that everyone in their community can once again "walk in beauty." This sense of disharmony is often manifest when a Navajo becomes ill for reasons that are not easily explained. Thus, the restoration of harmony is a curing ceremony and many of the hospitals on the Navajo Reservation allow members of the Navajo community to perform sand painting rituals in patients' rooms.

Men, who personify the stable or static side of life, make sand paintings that are accurate copies of paintings from the past, and in essence recreate the power of the past ages. They compose motionless figures with stiff, unbent torsos in compositions that are often, but not always, symmetrical and circular, representing the shape of the cosmos. The songs sung over the paintings are also faithful renditions of songs from the past. By recreating these arts, which reflect the original beauty of creation, the Navajo bring the beauty of creation to the present world. As newcomers to the southwest, where their climate, neighbors, and Spanish overlords could all be inhospitable, the Navajo created these art forms in an attempt to control the world around them, not just through their symbolism, but through their beauty, *hozho*, so that they could live in beauty.

The paintings generally illustrate ideas and events from the life of a mythical hero, who, after being healed by the gods, made gifts of songs and paintings to humankind. Working from memory, the artists recreate the traditional form of the image as accurately as possible. Although the Navajo at first allowed completed sand paintings used in rituals to be photographed and published, they no longer want these sacred images designed for short lives in private spaces and ceremonies to be permanently documented for the scrutiny of the public, nor do they want existing pictures of sand paintings to be reproduced. From the few authentic images that have been photographed, the sand paintings seem to reflect the Navajo ideals of controlled energy and movement. Some have rotational symmetry; the forms on opposite sides of the circle are reversed as if the whole painting were a wheel and capable of revolving in a circular orbit like the sun, moon, and stars in the cosmos where the *yee'ii* live. Also, radiating, spoke-shaped forms in these designs add to the impression that one is looking at a spinning wheel-like form with everything moving in unison, in balance, with *hozho*. FIG. 1.2 gives some impression of this without violating the sanctity of the work or offending its owners. When the ceremonies are complete, the sand-painting materials are gathered and returned to the desert. Having done their work, the paintings need not be preserved and can once more become part of the desert from which they were taken.

The Navajo are also world-famous for the designs on their woven blankets. The Navajo women own the family flocks, control the shearing of the sheep, the carding, spinning, and dying of the thread, and the weaving of the fabrics. Weaving is a sacred activity for women and a paradigm for their existence. A mythic ancestor, named Spider Woman, wove the universe, a cosmic web that united Sky

"HOZHO" AS THE STALK OF LIFE

The Navajo conceptualize their philosophy of art and life as a corn plant, with *hozho* as the stalk. *Zho* means "beauty," "perfection," and "harmony," and the prefix *ho* means "world," "universe," or "all." Thus, *hozho* means something like "world of perfect beauty," but, depending upon its context in Navajo thought, it can have other meanings such as "happiness," "health," "beauty of the land," and "all things in harmony with one another." The Navajo's main ceremony, *hozhooji*, often translated as "Blessingway" is designed to invoke the powers of the benevolent Holy People and make the world *hozho*.

Unlike in Western thinking, where a small number of people are considered to be gifted with artistic talent—and those who are tend to be marginalized from the cultural mainstream—among the Navajo, almost everyone is an artist, and those who are not (without *hozho*) may be marginalized. Life is art, art is life, and both are part of the solid stalk of *hozho* at the center of all things. Thus, the Navajo do not look for beauty outside themselves; they find it within. *Shil hozho* means "with me there is beauty," and *shaa hozho* "beauty radiates from me." *Hozho* is not an external matter; it is life well lived. In Navajo thinking, there is no separation between mind and body, head and heart, and all notions of goodness, order, harmony, time, space, and wellbeing in the ongoing movements and rhythms of life are embodied in *hozho*.

Hozho coexists with *hochxo*. The stem, *chxo* ("ugly," "imperfect," or "disorder"), and prefix *ho* ("world," "universe," and "all") combine to mean something like "the evil in the world." According to some authorities on Navajo thought, *hochxo* is not part of the natural order; it comes from the underworld and the time before the creation of humankind and is the work of witchlike, satanic deities. When the natural order of things for someone has become *hochxo*, it may be time to conduct a healing ceremony, complete with songs and sand paintings. These concepts are especially important in a survey of Navajo art because *hozho* as the "stalk of life" lies at the very center of the Navajo aesthetic and philosophical system, which distinguishes them from other cultures in the southwest.

Father with Earth Mother, out of sacred materials on a great loom made of cross poles (sky and earth) with a warp (sun rays), baton (sun halo), and spindles (lightning and rain). It was she who taught the Navajo Earth Mother, Changing Woman, how to weave. As they prepare their materials and weave, the Navajo women imitate the transformations of Changing Woman as she creates the ever-changing forms of the world around them.

While men are supposed to create sand paintings that are exact duplicates of certain ancient and sacred prototypes, each time a Navajo woman begins a new weaving, she is expected to create an original work of art embodying the concept of *hozho*. She must begin the process by creating that new design in her mind and then hold it there as she weaves and gives form to her creation on a loom. While the finished work may resemble an abstract modernist composition, that is where the similarity ends. All the forms and their relationships have symbolic values so that the weaving can be "read" by those who understand the Navajo compositional "language." In addition to having meanings within themselves, the many diagonal and zigzag lines and lozenge shapes in this design, augmented by their vibrant colors, point the way and lead one's eyes about the design and suggest the variety of linear and cyclic motions in the dynamics of *hozho*. Contrasting active and static areas in a design further express the idea of controlled movements in life as well as balance and change in the cycles of life and nature. Often, the repeating patterns suggest that that weaving is but a fragment of a much larger cosmic-scale pattern that continues far beyond its edges. The Navajo wear these blanket-statements of Navajo thought not only for their warmth, but as a broader form of protection, as a kind of second skin, so that the blankets become part of the wearer's body and once again reflect the unity of *hozho*.

The Navajo women may have learned their weaving techniques in the seventeenth century from pueblo weavers working in styles influenced by Hispanic art. During the Classic period of Navajo weaving (1650–1865), they incorporated more Hispanic–Mexican motifs, such as serrated diamonds and zigzag patterns, from weavers in the northern

Mexican town of Saltillo. This period came to an end when Colonel Kit Carson incarcerated the Navajo and destroyed their flocks. The arrival of the railroad (1882) and building of the Harvey Hotels, which sold Navajo art to travelers, intensified outside influences in the Transitional period (1865–95). This gave the Navajo weavers access to commercial dyes and yarns, as well as new patrons, some of whom encouraged them to imitate the designs on Persian rugs. A type of blanket known as the "eyedazzler" woven during this period uses repeating patterns of diagonal and zigzag motifs that appear to vibrate and move like pieces of Western Op Art from the 1960s (FIG. 8.67). The period from 1895 to the present is called the "Rug period," because many blankets woven using durable yarns have been marketed as rugs to Anglo-American patrons.

Traditionally, weavers worked with fixed, upright looms made of tree limbs or growing trees, but today most Navajo weavers use portable metal or wooden looms. Some recent designs have been based on genre scenes, Islamic carpets, and Navajo sand paintings. Many of the traditional forms of Navajo weaving were also revived in the 1920s and 1930s at the Chinle and Wide Ruins trading posts. Yet, in the face of outside pressures and the apparent eclecticism of the weavers who have used many types of commercial yarns and dyes, the Navajo weavers have maintained a recognizably Navajo character in their work. Their dazzling designs, which continue to change from year to year, retain the strength of traditional Navajo thought and demonstrate the continuing vitality of the southwestern traditions in the arts. The way in which the weavers have succeeded echoes the larger picture of Navajo history—how the Navajo have continued to absorb outside influences without losing their identity or abandoning their eternal quest for *hozho*, to walk in beauty.

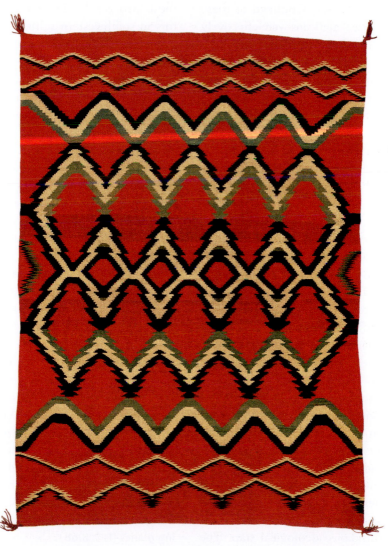

8.67 Navajo "eyedazzler" blanket. 1875–90. Wool, 6′5¾″ × 4′6⅞″ (1.97 × 1.39 m). Natural History Museum of Los Angeles County

NATIVE AMERICAN ART IN THE TWENTIETH AND TWENTY-FIRST CENTURIES

The position of the Native North American artists in the twentieth century was unusually precarious. In the nineteenth century, their ancestors had the misfortune of standing in the path of "progress" and Manifest Destiny, an aggressive quasireligious form of Romantic nationalism in the United States that decreed that the country, under God, was destined to rule from the Atlantic to the Pacific, "from sea to shining sea." Given the enormous cultural gulf between the European and Native American societies, the idea of integrating the "noble savages" into white society as it spread was not given serious consideration. Instead, many Native Americans were forcibly relocated to reservations in the United States and reserves in Canada. Confined to these lands "reserved" for them, Native Americans were effectively quarantined and locked outside the mainstream of modern life and did not benefit from the prosperity of North America in the gilded age from the 1890s to World War I.

To survive, some Native Americans made and sold replicas of their "exotic regalia," including drums, bows and arrows, and peace pipes, which found their way into curiosity cabinets in Victorian parlors. The collectors and their circles romanticized these ethnographic novelties around the tragedy of the "Vanishing Indian" and reinforced the growing stereotypes of "Indianness" and the "other"—the noble-savage-warrior-mystic-artist. Later, in the movies, thousands of "Westerns" intensified this romantic narrative as the U.S. celebrated its national ethos of sturdy self-reliance through the epic battles between "cowboys and Indians." The latter were usually portrayed using gross stereotypes, as unsocialized outdoorsmen and docile princesses, whose rulers were philosophical but ineffective and fatalistic chiefs.

Meanwhile, the "noble savages" were facing some daunting problems. The government was convinced that they could "civilize" youngsters by taking them away from their families and sending them to Christian boarding schools which would erase their attachments to their pagan past. Without the freedom to hunt, gather, and farm on the lands they had known, the Native Americans fell into an unrelenting cycle of poverty, and for the public at large their high rates of alcoholism and suicide confirmed a suspicion that Indians "belonged" on reservations.

Given these assumptions, aspiring Native American artists were caught in an insidious ideological trap. The world their ancestors had celebrated in the arts was long gone, but if they incorporated outside, Western ideas in their art, they were not being true to their heritage. This idea, shared by most Native and Anglo-Americans, appears particularly shortsighted when one looks back and sees how Native Americans had welcomed and used trade goods such as glass beads and paper, as well as drawing and painting materials, and used them to create new forms of expression in the nineteenth century. Native American art and culture had always changed with the times, and there was no good reason why it should not continue to do so in the twentieth century.

Trapped in this Catch-22 situation, Native American artists found themselves floating in the same void between two worlds that Wo-Haw had lamented in the 1870s (see FIG. 1.2). Ironically, however, "Ledger" drawings such as *Wo-Haw between Two Worlds* would play an important role in their escape from this ideological snare because they ultimately inspired a later generation of teachers and aspiring Native American artists who believed there was a way to bridge those "two worlds." Their story begins in 1914 when instructors in southwestern schools began teaching "Indian" art. The most famous of these was the Santa Fe Indian School, also known as the Studio School. Many Native and non-Native instructors alike of that period believed there was an authentic "Indian" way for them to paint their cultural past. Collectively, the schools developed a flat, streamlined, and highly decorative hard-edged style in which they portrayed sanitized scenes of Native American life that soon became internationally recognized as "authentic Indian art." At the time, some outspoken critics of the teaching method called it the "Bambi style" because it had the sweet childish character of the Walt Disney cartoons of the day. In hindsight, many more now see this style, which was very popular from the 1930s to the 1970s and coincided with the heyday of the Hollywood Westerns, as yet another example of cultural stereotyping that did little or nothing to bring Native American art into the world in which the artists lived.

One of the students at the Santa Fe Indian School in the 1930s, Oscar Howe (Mazuha Hokshina, "Trader Boy"; 1915–83), from the Crow Creek Reservation in central South Dakota, would eventually revolt against such stereotyped ideas about what was and was not true "Indian" art. When Howe began teaching at the University of South Dakota in 1957, he looked for ways to put the Santa Fe style behind him and express the spectacle of costumed Native Americans dancing to the powerful rhythms of the large drums at *Pow Wows*. To achieve that, he began incorporating elements of Cubism and Italian Futurism in his paintings, dissolving his moving figures in patterns of abstract, flashing planes (FIG. 8.68).

In his work, Howe captures the essence of the *Pow Wow* as a dance form. We sense the fast, staccato footwork of the

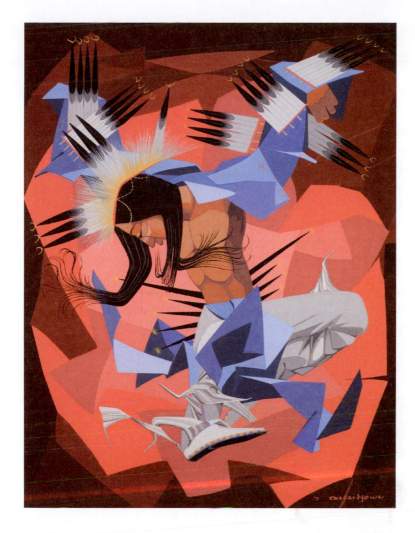

8.68 Oscar Howe, *Eagle Dancer*. 25¼" × 19½" (64 × 49.5 cm). University of South Dakota Art Gallery

dancer—the bouncing step-hop moves from one foot to the other in rapid succession that keep the dancer's feathers and fringe bouncing as if he were a mounted hunter-warrior flying with the wind across the plains, moving up and down with every hoof beat and stride of his horse. In his dance, pounding on the earth, he sends a message to spirits above, and below, that his people are gathered together at the *Pow Wow*, celebrating their ancient connections with the world in which they live. (See *In Context: The "Pow Wow,"* page 340.)

In the 1950s, at the height of the African-American Civil Rights Movement, Howe campaigned across the country for Native American rights. In 1958, he submitted one of his paintings to the jury organizing a show of "Indian" art at the Philbrook Museum in Tulsa; it was rejected because it was not typically "Indian," in the orthodox "Bambi" style that the jury expected to see. In response, Howe wrote a now-famous letter to the committee that summarized the feelings of a century of Native American artists caught between two worlds since the time of Wo-Haw.

There is much more to Indian art than pretty stylized pictures … Are we to be held back forever with one phase of Indian painting, with no right for individualism, dictated to as the Indian always has been, put on reservations and treated like a child, and only the White Man knows what is best for him? No, even in Art, "You little child do what we think is best for you, nothing different." Well, I am not going to stand for it.

Thereafter, the age of "pretty Indian pictures" drew to a close. The powerhouse for this change was the Institute of American Indian Arts (IAIA), founded in 1969 in Santa Fe to replace the old Studio School. Here, the faculty and students explored new and more aggressive images of "Indianness." Concurrently, Native Americans from Canada began attending art schools where they too searched for ways to combine the tools of modernism with their particular needs for cultural self-expression.

THE "POW WOW"

The name *Pow Wow* comes from a Narragansett word, *powwau*, meaning "spiritual leaders." Originally, it was an event in which warrior-leaders danced for the public. Today, all Native Americans and their non-Native guests are allowed to dance at *Pow Wows*, and the ritual, generally associated with the Great Plains, has spread around North America where many Native American groups use it as a means of socializing and self-identification.

A *Pow Wow* usually begins with a Grand Entry procession, and a participant's position in that procession indicates their place and rank in the ceremony. The host drum group comes before the other drum groups, and the leader of each drum group marches ahead of their team of drummers. Well-known and honored dancers competing for prizes and honors enter ahead of the novices and show off the elaborate regalia they have designed and fabricated

for that *Pow Wow*. The lesser dancers that follow often fashion their first dance regalia after those of respected elders. Over time, they will rework their creations, turning them into more meaningful expressions of who they are and how they dance. The professionals who compete in the Fancy Dance competitions wear many layers of long feathers and fringes, swing sticks with tassels, and keep all of them and their bodies in constant motion as they make

athletic leaps and spins, and expend every ounce of energy they have before nearly collapsing as their timed dances end. The best of the extravagant dance outfits are valued works of art that will be preserved in museums and galleries.

Drum groups of four or more performers sit or stand around large kettledrums, pounding out the base rhythms for the songs and dances. Their songs seem to reach the otherworlds above and below the dancing circle, as if it were set on a long axis reaching in both directions into the cosmos. The well-known four-beat phrasing with the accent on the first beat is a Hollywood invention; in practice, the rhythms and phrasing are much more diverse and complex. In many of the largest *Pow Wows*, where they hold high-level Fancy Dance competitions, the pace of the music can be frenzied. Outside the competitions, in recent years many accomplished dancers have been very creative, combining elements of tap, hip-hop, and jive in their choreography. Given the growing popularity of *Pow Wows*, and the ways in which the dancers have responded to contemporary culture, some spokespeople for Native American culture believe that this once-obscure Great Plains spectacle may eventually be accepted as a major American dance form.

The *Pow Wow*, as a ritual for bringing ancient ways into modern life, has become such a popular ideal that when it came time for the Sisseton-Wahpeton College at Agency Village on the Lake Traverse Reservation in northeastern South Dakota to build a new Vocational Education Building in 2005, they decided to commission one that represented and honored a *Pow Wow* drum group. The building, called the "Song to the Great Spirit," is in the shape of a giant drum, with four 50-foot (15.2 m) fiberglass drummer-singers at the corners of the building resembling figure types used in regional styles of painting, who raise their drumsticks high above the roof of the building, as if they were pounding on it (FIG. 8.69). The reinforced roof is large and strong enough to accommodate up to three hundred people for gatherings, which have included *Pow Wows*.

The design was created by Victor Runnels, a consultant on Native American affairs, Dean Marske of Herges Kirchgasler Geisler & Associates, an architectural firm in nearby Aberdeen, South Dakota, and the College Board of Trustees. It reflects the college's commitment to the study and preservation of Native American culture through its Institute for Dakota Studies, established in 1989. The monumental drum group is visible from the nearby *Pow Wow* grounds. Seeing it while the drums resound in the background, one can sense the importance of this ritual as the members of the Oyate search for their identity in the rapidly changing world of the twenty-first century.

8.69 Victor Runnels, Native American consultant, and Dean Marske of Herges Kirchgasler Geisler & Associates architects, The Vocational Education Building, Sisseton-Wahpeton College, Agency Village, Lake Traverse Indian Reservation, northeastern South Dakota. Also known as the "Song to the Great Spirit." 2005. Height of fiberglass drummers 50′ (15.24 m).

GLOSSARY

ALTEPETL Aztec, "water mountain." A temple that marks the center or axis of the earth and cosmos. Part of the widespread Mesoamerican belief that their religious architecture had a dual terrestrial and spiritual existence.

ARCHITECTONIC Having the qualities of architecture. In the pictorial arts, images with tightly composed, simplified geometric forms reflecting architectural ideals.

BACKSTRAP LOOM A portable loom in which the warp threads are stretched between a stationary object and a strap around the back of the weaver.

CEQUES Quechua for "rays." Conceptualized lines radiating outward like sunbeams from the Coricancha, the main Inca temple to Inti, the sun god, pointing to the *HUACAS* and shrines of lesser deities.

CHACMOOL A Postclassic Maya sculptural type representing a recumbent figure with a bowl on its stomach that may have been used to hold the hearts of sacrificial victims.

CODEX Plural, "codices." Mesoamerican screen-fold books made from the inner bark of fig trees coated with a fine lime paste. They contain numbers, dates, images of the gods, and historical-astrological information.

CORBEL VAULT A vault constructed in such a way that each successive layer of stones built up on either side of a room or space projects further into the center of the space until the topmost stones meet in the center.

DENDROCHRONOLOGY The study of tree rings. The pattern of growth in the rings of trees found in archaeological contexts can be compared to master charts of tree ring growth in the area from prehistoric to present times to determine the age of those samples.

GEOGLYPHS Literally, "earth writing." Lines and images created by removing the uppermost levels of pebbles on the desert floor near Nazca, Peru.

GHOST DANCE A late nineteenth-century ritual dance on the Great Plains in which participants wore specially designed and painted shirts believed to have miraculous powers to bring back the buffalo herds, make the white settlers disappear, and enable all Native Americans to live in peace.

HIEROGLYPHICS From the Greek *hieros*, "sacred," and *glyphein*, "to carve." A writing system that may use combinations of PICTOGRAPHS and phonograms.

HOCHXO Ugliness, evil, or disorder. See under *HOZHO*.

HOGAN A Navajo home. The place where rituals are performed with sand paintings and music to communicate with ancestral spirits known as the "Holy People," who may be impersonated by the *yeibichai*, masked performers.

HOZHO Navajo: *zho* means "beauty," "perfection," and "harmony," and the prefix *ho* means "world," "universe," or "all." The Navajo conceptualize their philosophy of art and life as a corn plant, with *hozho* as the stalk. Often seen as the opposite of *HOCHXO*, "ugliness," "evil," or "disorder."

HUACAS Inca sacred places such as rocks and streams and the shrines of minor deities.

KACHINA In PUEBLO culture, a spirit or its representation in the form of a masked dancer or a small wooden doll-like figure. In some pueblos, the *kachinas* appear at the winter solstice ceremony (December 21), and return to the underworld through the floors of the *KIVAS* in early July.

KIVA A place for worship and religious ritual in PUEBLO culture. Normally, a round, semisubterranean enclosure symbolizing the center of the universe. It may have a ladder entryway in the middle of the roof and a shallow hole in the floor, a symbolic entryway to the subterranean world of the spirits.

MESOAMERICA A region of high cultural development in Pre-Columbian times extending from central Mexico south and east through the Yucatán Peninsula and Guatemala, into the eastern parts of Honduras and El Salvador.

MESOAMERICAN BALL GAME A ritual in which opposing teams of athletic performers used their padded legs and hips to volley a large rubber ball back and forth in an alley or court between side walls. The ritual was associated with activities in the underworld and often ended in human sacrifices. It is an important theme in Mesoamerican art.

PICTOGRAPH Also known as "pictogram." An image that conveys its meaning through representation. Often used in writing systems along with phonograms.

POPUL VUH Maya, "Book of Council." An important source of information about Maya iconography, especially the underworld, Xibalba, and its role in the Mesoamerican ball game.

POTLATCH A Native American ceremony on the northwest Pacific coast where families or individuals loan, give away, or destroy large quantities of valuable goods in order to demonstrate their wealth and power. While the ritual might appear destructive, it has long served to create cultural bonds among the participating social groups and communities.

POW WOW From the Narragansett *powwau* meaning "spiritual leaders." A Native American ceremony often associated with the Great Plains but performed elsewhere as well. A gathering with dance, music, and socializing valued as a means of ethnic self-identification.

PRE-COLUMBIAN Literally, "before Columbus." In American studies, refers to the time period and cultures in the Americas before the arrival of Christopher Columbus and other European explorers and settlers.

PUEBLO Spanish for small town or village. A type of large multifamily dwelling made of adobe bricks and puddle clay with wooden roof beams found in Native American communities in the southwestern United States. Also the name of the period in which they were built (700–present).

QUIPUS In the Inca Empire, sets of knotted, colored cords attached to a central loop conveying inventory records and other important government statistics. Carried by relay teams of runners using the Inca network of roads to take information to and from the capital, Cuzco.

SOUTHERN CULT Also known as the Mississippian Art and Ceremonial Complex. A belief system in the Mississippi period (900–1500/1650) in the southeastern United States associated with temple mounds related to those in Mexico. The art forms—incised shells, sheets of copper, pottery, wood, and rare examples of large stone sculptures represent ritual performers, rulers, fantastic animals, and gods.

STELA (or stele; plural, stelae) From the Greek *stele*, "block" or "pillar." Used to designate a variety of relief sculptures on slabs or blocks. The Maya called them *te tun* ("stone trees"), where the body of a ruler or other person depicted on such a sculpture forms the trunk.

TABLERO See under *TALUD AND TABLERO*.

TALUD AND TABLERO Spanish, "inclined wall" and "picture." A combination of architectural forms widely used in Pre-Columbian Mesoamerica in which inclined walls alternate with vertical surfaces that may be painted or adorned with relief sculptures. Superimposed sets of *taluds* and *tableros* may resemble small mountains and, perhaps, be intended to symbolize them.

TEEPEE (or *tipi*) A portable summer home made of buffalo hides set over a conical frame of saplings. Used by many Native North American groups on the Great Plains.

TLAMATINIME An elite group of Aztec poet-sages who speculated on metaphysical matters. They believed that earthly things were transient and would eventually be destroyed by the gods. Only "flower and song" (the arts and beauty) would last forever.

TOTEM POLE A misnomer for several varieties of tall carved poles erected on the northwest Pacific coast displaying animals and other heraldic signs belonging to their owners.

QUESTIONS

1. The Maya were the only people in America who were fully literate and had a highly accurate calendar by which they could organize historical information. How are those two features reflected in the style and content of their art? How do they affect the way we study their art?

2. How did different religious or ritual practices shape the art and architecture of the various peoples discussed in this chapter?

3. The European conquest and settlement of the Americas severely damaged the Native American cultures. How could some of those disasters have been averted? You are in charge—of everything. Rewrite Native American history from the sixteenth century to the present day.

4. Some Native American churches in the pueblos of the southwestern United States display costumed, dancing *kachinas* alongside images of the Christian saints and the Holy Family. While members of these churches accept this juxtaposition as normal, many visitors do not. What are your thoughts on the matter? Is this mix of ideologies a meaningful and significant expression of Native American thinking?

5. How have the technical qualities of the various types of fiber art discussed in this chapter contributed to the development of their styles? Look at the reference to an Andean "textile aesthetic" on page 275, the box on page 275, and FIGS. 8.1, 8.9, 8.52, and 8.67.

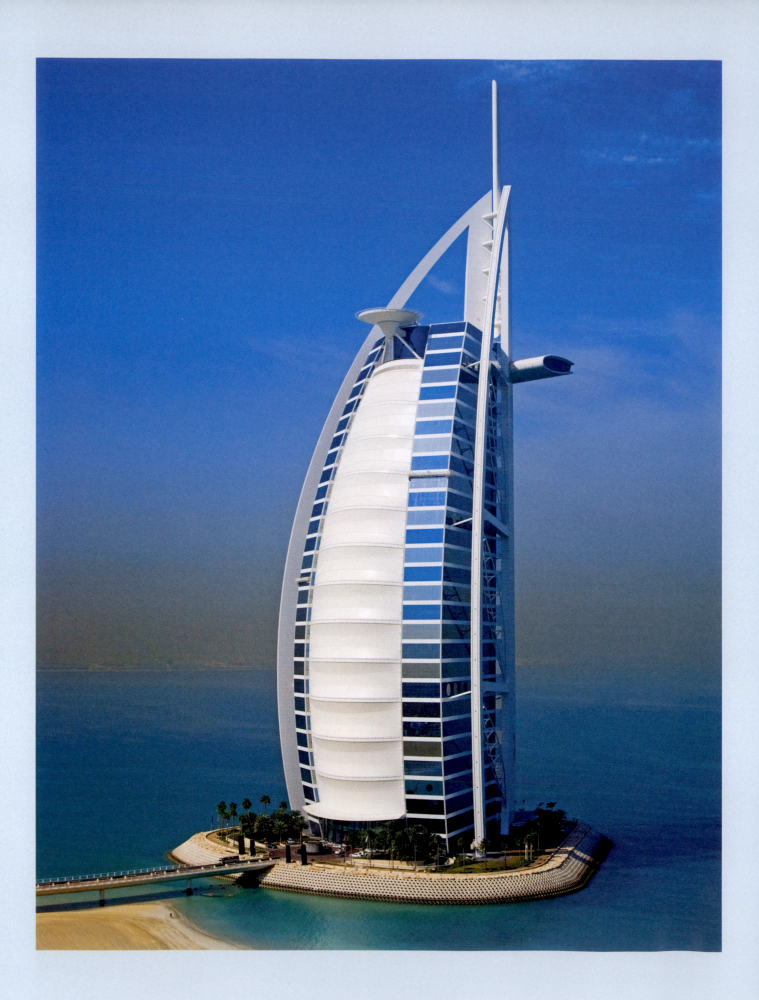

9 | Art Without Boundaries

Equator

Painting and Sculpture	347
Architecture	351
Multimedia Expressions	354
Summary	356

Art Without Boundaries

Chapters Two through Eight of this book surveyed the arts around the world beyond the West, showing how they sprang from a wide variety of ancient religious and philosophical systems of thought that constantly changed and manifested themselves in innovative ways. This process of change, a worldwide phenomenon, resulted from both internal developments and outside influences, and has been the norm for centuries in the areas covered in this text—Asia, the Pacific, Africa, and the Americas.

For centuries, these geographic terms referred to distinct areas and cultural traditions that existed independently of one another and of the West. Today, people use cellphones to talk and exchange pictures, videos, and text messages with one another as they move with ever greater freedom about the globe; as a result, the traditional ideas about time and space that helped to shape the regional and period styles discussed in earlier chapters have been modified and in some cases revolutionized. Not only have the ease and speed with which we travel from one region to another blurred geographic and cultural boundaries, but, increasingly, large populations of people from each of the regions surveyed in this book are moving and living in areas beyond their original cultures.

Thus, the geographic and cultural definitions around which the earlier chapters in this book are organized have less and less meaning as the twenty-first century proceeds. This is most apparent in the work of some of the contemporary artists who originated in the geographic areas covered by this text but who now reside outside them, often in the West. Such artists challenge every category art historians of the past created for them and force us to reevaluate the process of change by which they and their cultures have become part of the contemporary world.

In the late twentieth century, as Westerners began to take a fresh look at non-Western art and culture, many of the old preconceptions about the "other" world and its arts started to change. Even as such highly problematic terms as "primitive" and "tribal" gave way to the slightly less objectionable "Third World," "developing nations," and the like, many people still assumed that the arts of Native America, the Pacific, and Africa were inextricably tied to ancient ethnic and religious traditions. Notions of Asian art similarly remained linked to the integrated religious societies that created the works there before the arrival of Western influences. From this perspective, it was assumed, automatically, that the arts in these non-Western cultures could not exist outside these traditional contexts and would be incapable of sustaining their vitality if they were mixed with Western notions of art. Knowledge of other traditions and styles, especially Western ones, was seen as a kind of pollution that compromised the "purity" of the arts and their frameworks of thought. As we saw in Chapter Eight, in 1958, the work of Oscar Howe was rejected by the jury of an important exhibition of Native American art because it incorporated elements of Cubism and Futurism. Such a view tried to limit Howe and others' expressive potential and left no room for artists to depart from traditional modes of representation in order to create works of art that engaged with the world around them in new ways.

Before the late twentieth century, many potential patrons in the West might have rejected works of art by non-Western artists that openly displayed Western influences, preferring "pure" works that were not "hybridized." While some writers have suggested that the adoption of Western styles irreparably weakened cultural traditions, it is also possible to look at this development as merely another episode in the long cycle of change that has been part of every such tradition from time immemorial. For example, as Buddhist art and thought spread from India to Southeast Asia, China, Korea, and Japan, it changed the course of art history throughout Asia. Western attitudes toward artistic and cultural "purity" changed definitively with the emergence in the 1970s of Postmodernism, a comprehensive worldview that embraces variety, discontinuity, disjunction, and flux, and questions some of the key modernist ideas about "originality" and "creativity" that were dominant from the late nineteenth to the late twentieth century.

Many of the final works of art discussed in the foregoing chapters incorporated ideas drawn from outside the

indigenous traditions of their makers, though they stopped short of entirely erasing the concept of cultural boundaries. It took some time for the Faisal Mosque in Pakistan (see FIG. 2.28) to be accepted by the majority of Muslims in the vicinity because its innovative design departed from that of traditional mosques in that area—and elsewhere in the Muslim world for that matter.

Signs of a new internationalism are evident in other works. The Akshardam Swaminarayan Temple Complex in New Delhi (see FIGS. 3.42, 3.43) combines elements basic to many traditional Hindu temples with contemporary forms and ideas that put forth new interpretations of some time-honored Hindu thinking. Nam June Paik's *TV Buddha* (see FIG. 5.40) and Yanagi Yukinori's *Hinomaru Illumination* (see FIG. 5.41) use sculptural images belonging to an earlier age in nontraditional ways to comment on late twentieth-century social issues. The many images of Mao Zedong created around the 1970s draw on the tradition of Social-ist Realism imported from the Soviet Union as they comment on his "New China" (see FIG. 4.34) while *Father* by Luo Zhongli puts another face on that idea (see FIG. 4.35). The fantasy coffins of the Ga in Ghana (see FIG. 7.30) look nothing like the coffins made by their ancestors, but their meaning is nonetheless closely tied to their traditional religious beliefs about funerals and the afterlife. Much of the clothing worn by performers in the recent Pacific Arts Festivals and Native North Americans in their *Pow Wows* are made from modern materials, and the purpose of such events is avowedly to maintain a strong cultural identity in line with the past while bringing those art forms into the contemporary world (see FIG. 6.22).

The works investigated in this final chapter go a step further, however, erasing all cultural boundaries and taking on global dimensions. We will thus look at works drawn from many parts of the non-Western world that are part of the global market and that are designed for consumption by international audiences.

PAINTING AND SCULPTURE

Under the leadership of Deng Xiaoping from the late 1970s, China began opening its doors to outside influences. At the same time, in a reversal of the efforts of Chairman Mao's Cultural Revolution to destroy the art of China's past, wealthy Chinese collectors began traveling to galleries and auction houses around the world to buy back Chinese works of art that had been sold abroad in the nineteenth and twentieth centuries. The Chinese contemporary art scene also began to boom. It did not take long for Hong Kong, already an international city, to build the infrastructure it needed

to join the global market in the arts. In Beijing, meanwhile, entrepreneurs converted a decaying industrial area into the 789 Arts Zone, providing a home for artists' studios, galleries, trendy shops, and festivals.

At present, there are over 200,000 students enrolled in about 300 highly selective university-level art programs in China; millions of others are also aspiring to build careers in the arts. They are being encouraged in this ambition by the success of the many relatively new, but large and active arts districts in metropolitan centers around the country where contemporary works often sell for very high prices. The contemporary art world in China has few such external ties. Nor does it have strong ties to the very ancient traditions of China's past. Instead, the works of art produced in China today reflect many of the diverse and highly complex social and political issues there, all of which are changing, rapidly, as the nation becomes a world power on its own terms.

A few small modernist groups emerged before Deng's economic reforms in the late 1970s, but most of this phenomenal growth and change in the arts took place after 1980, and did so under less than favorable conditions. To this day, the government continues to lay down constantly changing sets of rules and regulations in its attempts to control what artists say and do. Despite this, some artists have managed to weave their way through this seemingly impenetrable obstacle course and have created a new chapter in the very long history of Chinese art—a revolutionary one with constantly shifting parameters and great subtleties that are little understood outside China.

To get an idea of the way the Chinese art market has soared, we might look at the sales record of a work titled *Execution* (1995) by the Beijing artist Yue Minjun (born 1962) (FIG. 9.1). It was first sold for $5,000 in 1996; twelve years later, in 2008, it fetched $5,900,000 at auction in London. The painting represents a row of gunmen firing at a second line of figures who are laughing wildly. Many commentators see it as a scathing comment on the brutal killings in Tiananmen Square in 1989 and have applauded the artist for his courage in illustrating an event the Chinese government does not like to discuss. Yue, however, describes *Executioner* as a general image of human brutality. This is typical of the artist, who seldom explains the specifics of his work—especially his artistic trademark or signature, those glossy pink self-portraits with wide toothy smiles that we see in *Executioner*.

Why has Yue portrayed himself as this enigmatic laughing character, and what does it say about the relationship between the ancient cultural roots of the artist's craft and his commitment to reach a wider audience? What we see here is not the gentle, all-knowing smile of the enlightened Buddha or a contented Confucian sage that serves as an icon of the

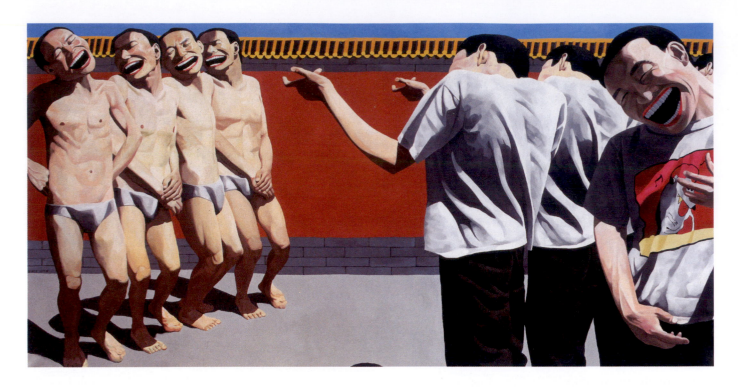

9.1 Yue Minjun, *Execution*. 1995. Oil on canvas, 59⅛ × 118⅛" (150 × 300 cm)

wisdom and strength of ancient Chinese civilization. Do these strange devilish creatures refer instead to a dark side of modern Chinese thought as it assumes a new role in the world economy? Or, in making art for audiences around the world, does Yue see himself in terms of an old Western stereotype, the ever-smiling, obsequious Chinese servant? Or, again, could this be a parody of Communist Socialist Realism, with its endless images of a grinning Mao and beaming peasants? Is this China today, Yue's art world, looking back at the Cultural Revolution in horror that has turned to crazed laughter? Perhaps Yue is thinking in terms of a group in China called the Cynical Realists (even though he says he is not part of that group) and has broken out in uncontrolled, hysterical laughter at China's penchant for consumerism, its love affair with Western technology, and the litany of social problems faced by the rapidly changing nation. Or might these faces be laughing because the often-caricatured "Sick Man of Asia" has turned the economic tables and begun to dominate the nations that once dominated it? Or, again, is this a variation on the Chan Buddhist *koan*, something that cannot be answered or understood by rational means, that is designed to break down traditional patterns of thought and lead one to enlightenment? Unexplained, these smiling images appear to know something we do not.

In interviews the artist says little, which only adds to the enigmatic quality of his work. Maybe the answer is a very simple one. Yue, the heir to a long tradition of inkbrush painters

in China who made modest livings working for conservative Chinese patrons, makes a much better living than they did by selling his art to foreigners. If Yue is following the wisdom of Deng Xiaoping, who said, "To grow rich is glorious," his self-portraits may simply show him laughing all the way to the bank.

While Yue's comments on Chinese society and politics are enigmatic and oblique, those of Ai Weiwei (born 1957) are extremely direct and—in the eyes of the Chinese government—often politically incorrect. He is the son of Ai Qing (1910–96), one of China's most famous modern poets, who spent many years in prisons and on labor farms in provincial exile for his anti-establishment political views. Following his father's lead, Weiwei has become one of present-day China's most outspoken dissidents. He has been arrested and allegedly beaten or tortured on several occasions, and Western journalists have called him "the most dangerous man in China."

As a young artist, Ai Weiwei became part of the emerging avant-garde in China during the so-called "Beijing Spring" in the late 1970s, before moving to New York City in 1981. There, he was attracted to Conceptual Art and Dada as potential vehicles for the expression of his political ideals. Back in China in 1993, he began to apply his new, radical views on art to national cultural issues, debunking some iconic images from China's past.

In one photograph, he posed a woman flashing her skimpy bikini panties in front of a monumental poster of

Mao's familiar smiling face. In another, Ai is seen dropping and smashing a valuable urn said to date from the Han dynasty. He also established a firm called the Fake Design Cultural Development Ltd., through which he collaborated with the Swiss architectural firm of Herzog & de Meuron in the design of the Beijing National Stadium for the 2008 Olympics. The structure, which appeared on television many times during the Olympics and was quickly nicknamed the "Bird's Nest," is entirely outside the traditions of Chinese architecture.

Following the Sichuan earthquake in 2008, when many of the newly built government schools in the area collapsed, killing thousands of students, Ai and other dissidents accused Chinese government officials of taking bribes from contractors in return for approving their substandard building practices. In a retrospective exhibition of his work, *So Sorry*, at the Haus der Kunst in Munich, Germany (2009–10), Ai created an installation on the façade of the museum called *Remembering*. Using 9,000 student backpacks, he wrote the words of a grieving mother—"She lived happily for seven years in this world"—in Chinese characters.

In his 2010 installation at Tate Modern in London, *Sunflower Seeds*, the artist created a work that is far less direct and obvious in its approach to his many issues with Chinese culture and politics (FIG. 9.2). Ai covered the spacious floor of the Turbine Hall with a thick layer or bed of over 100 million small lozenge-shaped pieces of porcelain. Each one was painted gray, with creamy white stripes, to resemble a sunflower seed. The "seeds," all 150 tons of them, were fabricated in workshops at Jingdezhen, a major center for Chinese porcelain production for almost a thousand years. They were then hand-painted by about 1,600 participants in and around Jingdezhen, working in shops and in their homes.

The installation would seem to have multiple but related levels of meaning. One is reminded of an image from the Cultural Revolution in which Mao's face was regarded as the sun and the people of China turned their heads to face his radiance as his adoring sunflower plants. Building on this equation of the seeds with the masses, the fact that they were fabricated in Jingdezhen porcelain, a material long known around the world as "china," the "seeds" take on another level of symbolic meaning as individuals in Chinese society. When one viewed the installation from the gallery, with the individual seeds blending facelessly into the whole of the gray bed, the installation seemed to comment on the way in which China has long used massive numbers of nameless individuals to create its great monuments and national symbols such as the Great Wall, the Grand Canal, and, more recently, the Three Gorges Dam. In that process, the individuals (seeds) disappear within the larger picture of China, Ai's vast gray seed bed. The manner in which over a

9.2 Ai Weiwei, *Sunflower Seeds*. 2010. Tate Modern, London

thousand people were enrolled to carry out the routine labor of painting the "seeds" also calls to mind the familiar phrase "Made in China," and how the productivity of the Chinese masses in recent years has launched that country into an increasingly prominent position in the global economy.

This installation's focus becomes particularly poignant when one looks at Ai's current position in China. He has stepped far beyond his prescribed destiny to act as a small seed, one of the nameless masses in China who toil to make things for the rest of the world, and has become a hero to an ever-growing international audience of observers concerned about human rights and freedom of speech around the globe. For his efforts, as a role model for potentially creative individuals working under adverse conditions, *Time*

magazine named him as a runner-up in its 2011 Person of the Year competition.

To broadcast his ideals, Ai is making extensive use of the most up-to-date communication devices. Commenting on them, the Internet in particular, and his role in the art world today, Ai said, "In the past, only the very powerful could make their voices heard. Today, anybody with clear thinking or a special way of understanding will be recognized." Appropriately enough, when the Chinese authorities arrested and jailed him in 2011 for a variety of alleged crimes, supporters of Ai around the world helped secure his release by using many of the same social networking sites that Ai had used earlier to publicize information about the tragedy in Sichuan and other matters that led to his arrest.

A Japanese contemporary of Yue, Takashi Murakami (born 1962) produces work that is equally complex and multifaceted. An entrepreneur marketing his work and advertising and press-related services around the world, he blurs the line between traditional fine art and contemporary brand-based merchandising. As he has said: "Japanese people accept that art and commerce will be blended; and in fact, they are surprised by the rigid and pretentious Western hierarchy of 'high art.'"

Murakami may be best known as a spokesperson for *otaku*, contemporary youth culture in Japan. *Otaku* refers both to the culture itself and the individuals involved in it; the term means something like "geek" or "nerd" in English. As a culture, *otaku* is closely associated with internationally recognized styles of illustration—*anime* (animated film), *manga* (comics and cartoons), and video games. Murakami calls his work *Poku* (Pop + *otaku*). Pop here refers to the movement in the arts that emerged in the West in the late 1950s, but as we will see, *otaku* is no mere clone of Western Pop and addresses some very important social issues that are specifically Japanese.

Adopting the model pioneered by the American Pop artist Andy Warhol, who called his studio "The Factory," Murakami named his workshop the "Hiropon Factory." As it grew in size and scope, he renamed his production and artist-management operation Kaikai Kiki Co., LLC. It soon had several branches in Japan and the United States, where over 100 assistants fabricate works based on Murakami's ideas and designs, even inventing some of their own, and merchandising the resulting work as everyday consumer products: Murakami has designed everything from T-shirts and key chains to $5,000 Louis Vuitton handbags. Kaikai Kiki also stages the GEISAI art festival, held twice a year, in Tokyo and in Taipei in Taiwan. This displays and sells Murakami's *Poku* products as well as other artists' work in everyday environments that contrast with those of most high-end galleries and museums.

In 2010, Murakami exhibited his work in France, in the Hall of Mirrors and royal apartments of Louis XIV at the Palace of Versailles near Paris, the epicenter of European political power in the late seventeenth and early eighteenth centuries (FIG. 9.3). The elaborate décor designed to underscore the absolutist rule of Louis XIV, the Sun King, and his holy alliance with the heavens is still in place in Versailles. The palace's ceilings, which reveal the heavenly hosts welcoming Louis and his cohorts, float above the Neoclassical architecture, sculptures, and paintings, creating a world of privilege and absolute authority. Into this rarefied sphere burst Murakami's gleefully gleaming, oversized candystore creatures in a carnivalesque, tongue-in-cheek assault on high art and Versailles' well-behaved Neoclassical forms. What a contrast of ideals—gaudy, synthetic polymer and plastic *Poku*-for-the-people monuments from halfway around the world running amok in the Sun King's most sacred and private spaces. However, behind the fun-loving

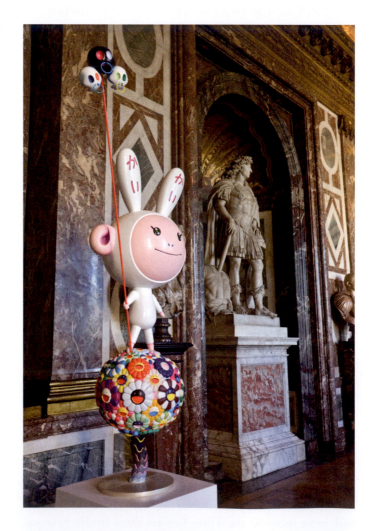

9.3 Takashi Murakami, *Kaikai*. 2010. Exhibition at the Palace of Versailles, France

surface of Murakami's work, there are other, more serious levels of meaning.

Anime, manga, and video games often deal with sexual fetishism, pornography, and violence. In his "Tokyo Pop Manifesto" (1999), Murakami made an explicit link between Japan's recent political history and such adolescent obsessions: "Postwar Japan was given life and nurtured by America. We were shown that the true meaning of life is meaninglessness, and were taught to live without thought. Our society and hierarchies were dismantled. We were forced into a system that does not produce 'adults.'"

Otaku was among the products of this Western-enforced infantilization and neutralization, though Murakami sees the process not merely in negative terms, but also as a source of creativity. Moreover, Murakami sees the *otaku* subculture as a defining chapter in his country's long struggle to step beyond the tragedies of World War II and Japan's postwar occupation. Commenting on Japanese art at the end of the twentieth century, Murakami said: "The art scene existed as a shallow appropriation of Western trends." Kaikai Kiki and its many activities, he says, are aimed at building a "vital and sustainable art market in Japan" and trying to help "young artists to survive in today's art world." It is a testament to Murakami's global popularity and cultural power that, in 2008, he was the only artist on the U.S. magazine *Time's* list of the 100 most influential people in the world.

ARCHITECTURE

Like India, Malaysia in Southeast Asia has a "Vision 2020," which in Malaysia's case consists of a program to rebuild the business district of its capital, Kuala Lumpur, and fully modernize the nation so that it can compete effectively in the international marketplace. Over the centuries, Buddhists, Muslims, and Hindus, as well as the Portuguese and British, have ruled this area, so Malaysia has a very rich cultural heritage. However, it also had a comparatively low international profile. Like India, as part of its own "Vision 2020," Malaysia wanted to create an architectural signature piece that would reflect its identity and catch the attention of the world. It did exactly that with the construction of the new headquarters for Petronas, a Malaysian oil and gas corporate giant (FIG. 9.4). When finished in 1999 the Petronas Towers, at 1,483 feet (452 m), was not only the tallest building in the world, but the striking beauty of the streamlined structure with its shimmering skin of glass and subtle Asian overtones made it an instant sensation with critics and public alike. Suddenly, tiny Malaysia could boast that it had the tallest and most exciting skyscraper in the world.

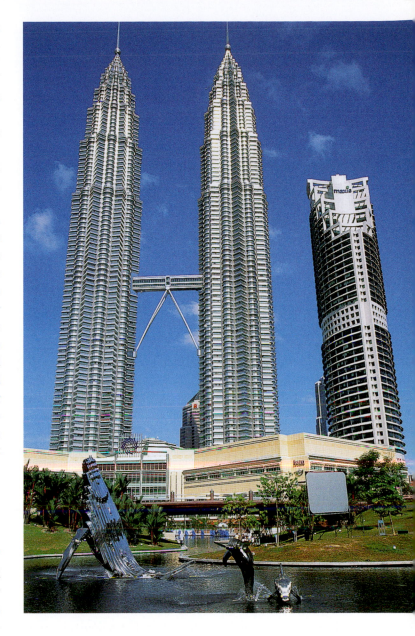

9.4 Cesar Pelli and Associates, Petronas Towers, Kuala Lumpur, Malaysia. 1991–97. Height 1,483' (452 m)

At the beginning of the project, Petronas was keen to find an architectural firm with state-of-the-art engineering know-how that would be willing to work with other international firms and local designers to give its headquarters a look that would be both distinctively Malaysian and international. It found such a firm in Cesar Pelli and Associates of the United States. As additional architectural consultants, designers, engineers, building contractors, and other technical firms joined the project, the list of participants began to look like a who's who of the international construction business. Remarkably, the final design is neither distractingly eclectic nor overcomplicated.

The interior of the Petronas Towers, which includes a mosque, is decorated with a wide variety of Islamic motifs. This symbolism "leaks" through the walls onto the exterior where the cross sections of the towers are based on an Islamic decorative motif, an eight-point star formed of superimposed squares. The rounded tips of those stars provide strong vertical accents that carry viewers' gazes up from the ground, through the series of small setbacks that culminate in the gracefully tapered crowns at the summit. Similar setbacks were used on such classic American skyscrapers as the Empire State Building, but the way they increase in frequency toward the top of the Petronas Towers creates profile reminiscent of earlier Buddhist and Hindu temples in India and Southeast Asia. The design also references the long tradition of twin-towered façades on Christian churches from medieval times to the present, heroic symbols of Western power now borrowed to suggest the rising strength of Malaysia in the global economy.

The Petronas Towers, still the tallest twin-tower structure in the world, has been featured in documentaries, video games, and movies—most notably, *Entrapment* with Sean Connery and Catherine Zeta Jones—and is rapidly taking its place alongside the Taj Mahal and Great Wall of China as an international icon of Asian culture as well as being a symbol of Malaysia's "Vision 2020."

Like Malaysia at the end of the twentieth century, the United Arab Emirates (UAE), a group of seven small oil-rich states on the eastern tip of the Arabian Peninsula, were in search of national symbols to express their newfound power in the international marketplace. In quick succession, Dubai built the Burj (Arabic, "tower") Al Arab Hotel (completed 1999) and the Burj Khalifa (completed 2010), two skyscrapers that carried the emirate's (and the UAE's) name around the world.

In the late twentieth century, Dubai had a flourishing oil-based economy, but knowing its oil reserves would expire around 2030, it began to diversify into financial services, real estate, and tourism. Flush with capital, it began to turn the city of Dubai, a provincial desert town of less than a million people, into an ultramodern urban spectacle in an act of transformation that has been compared to that responsible for creating another boom town in the desert—Las Vegas. The construction of the Burj Al Arab Hotel was the emirate's first step toward attracting international attention (FIG. 9.5). Rising 1,053 feet (321 m) above a small artificial island in the gulf near Dubai, the five-star hotel, which boasts mansion-sized suites—up to 8,000 square feet (743 sq m) in size—may be the most opulent, expensive, and instantly recognizable luxury destination in the world. The structure consists of a steel exoskeleton wrapped around a reinforced concrete core. Two wings extend in a "V" formation, making

9.5 WS Atkins PLC, Burj Al Arab Hotel, Dubai. Completed 1999. Height 1,053 feet (321 m)

the exterior of the building look like a gigantic, billowing white sail—more specifically, a type of tall-masted Muslim sailboat called a *dhow*. Thanks to its location on an island that is otherwise so low and small that it is scarcely visible from the land, the hotel does indeed appear to be a giant yacht with wind-filled sails moving along the coast. While the very obvious nautical symbolism was intended as a tribute to Dubai's seafaring heritage, many visitors and writers quickly saw another meaning in it—a symbol of Dubai and the UAE "sailing" forth to take their places as powerful players in the new global economy.

With its palatial interiors and theatrical excesses, many commentators have seen parallels between the sailboat-hotel

and those other storybook architectural spectacles along the Strip in Las Vegas. Both have been derided as gaudy and overblown by their critics, but applauded—loudly—by vacationers in search of new and exciting travel experiences.

With travelers suddenly flocking to Dubai to see this triumphant landmark symbolizing the small emirate's voyage to international prominence, the government took the next steps in its unprecedentedly rapid modernization program. Under the direction of Sheikh Mohammed bin Rashid Al Maktoun and Emaar Properties, an international property investment and development company in Dubai, reconfigured the heart of the emirate's capital was reconfigured as a large, mixed-used space, a 500-acre (200 hectare) maze of terraced streets, parks, water features, hotels, malls, and high-end housing developments. That space also includes a $217 million geyser-fountain illuminated by 6,600 lights that shoots water 490 feet (149 m) in the air. They also began building suburbs—as had been the case with the Burj Al Arab Hotel—on artificial islands along the Persian Gulf. Very quickly, this once-provincial desert town had more skyscrapers and high-rises than any other city in the world. At one point, thirty thousand construction cranes were hard at work in Dubai to make this miracle in the desert a reality.

The centerpiece of this $20 billion urban-renewal project, designed to outstrip the wonders of Las Vegas and the forests of skyscrapers popping up in China and other international cities around the world, was the Burj Khalifa, a project that would dwarf all the great skyscrapers and symbols of power from the past and rewrite the record book of architectural statistics (FIG. 9.6). Rising more than half a mile—2,717 feet (828 m)—above the once-desolate, wind-swept desert near the Persian Gulf, the Burj has quickly become a universally recognized symbol of Dubai, the UAE, and the growing power of the Arab world in general. It is twice as tall as the Empire State Building in New York City, and nearly three times the height of the Eiffel Tower in Paris, those earlier high-profile tower-symbols of Western economic power. In fact, the Burj is so tall that photographs of the shimmering glass shaft tend to look like computer-generated sci-fi images depicting a distantly futuristic world of fantasy. However, the story of the Burj's conception and construction is illustrative of some very down-to-earth realities about modern technology and the boom-and-bust economy of the early twenty-first century. In fact, the story of this half-mile-high wonder may be one of the classic tales by which the first decade of the twenty-first century will be remembered.

When finished, it was not only the world's tallest building, it exceeded the former record-holder, the Taipei 101 in Taiwan, by 1,000 feet (305 m), a record in itself. It also had the world's fastest elevators (40 miles/64 km per hour), the highest open observation deck (1,483 feet/452 m), and the largest number of occupied floors (160). The builders used 43,000 tons (43,688 tonnes) of steel to reinforce 430,000 cubic yards (328,950 cu m) of concrete, some of which they pumped to a new record height of 1,920 feet (585 m). The 194 massive pilings, 5 feet (1.5 m) in diameter, stand on bases set nearly 200 feet (61 m) below the ground, and are in themselves considerably taller than the first skyscrapers built in the United States in the late nineteenth century.

The Burj rises from a "Y"-shaped base around a central hexagon enclosing the building's many elevator shafts. This footprint is based on the leaf of the *Hymenocallis*, a local desert plant, but, like the other regional and Muslim motifs incorporated into the design of the Burj, its symbolic presence

9.6 Skidmore, Owings and Merrill, the Burj Khalifa, Dubai. Completed 2010. Height 2,717 feet (828 m)

is overpowered by the technical marvels of the structure. Setbacks at prescribed intervals on the three wings give the building a tapered profile so that it rises in a dynamic spiral pattern, creating perspective effects that make it look even taller than it actually is.

The cast of important individuals and firms involved in the construction and decoration of the Burj is impressive. Dubai's Emaar Properties commissioned Skidmore, Owens and Merrill (SOM) in Chicago to design the structure. That firm had already designed five of the ten tallest buildings in the world, including the Willis Tower (originally known at the Sears Tower) in Chicago. Adrian B. Smith (then with SOM) was the principal designer and William F. Baker, the chief engineer. Emaar Properties also hired Hyder Consulting, an international engineering, environmental planning, and management firm based in London, to work with SOM. After Samsung C&T from Seoul in South Korea completed the Taipei 101, it joined forces with Besix, another international firm based in Belgium, to construct the Burj.

Much of the interior design work was done by Brash Brands, a London firm with offices in Dubai, Shanghai, Singapore, and London. It worked closely with Giorgio Armani of Milan, Italy, whose name is synonymous with high fashion and couture. In addition to producing clothing and cosmetics, Armani outfits hotels, resorts, boutiques, cafés, restaurants, and nightclubs around the world. His Armani Hotel in the Burj Khalifa, with its 304 guestrooms, suites, and residences occupying the first thirty-nine floors, was quickly acclaimed around the world for its chic and opulent minimalism. With their muted colors, Armani's plush spaces in the Burj offer a calm, soothing retreat from the world outside, a teeming city surrounded by the sun-baked desert. They also contrast strongly with the baroque appointments in that other famous Dubai caravanserai, the Burj Al Arab Hotel.

The construction of the world's tallest building was not without its problems. The global financial crisis hit while it was still being built, and Dubai was forced to turn to Khalifa bin Zayed Al Nahyan, president of the UAE and emir of Abu Dhabi, for financial assistance. As a result, the tower, originally intended to be dubbed the Burj Dubai, was renamed the Burj Khalifa in his honor. While the engineers' reach had not exceeded their technical grasp, the financial planners had gone beyond their monetary resources, but in the end the dreams of Dubai came true. The Burj Khalifa has taken its place beside earlier national architectural icons like the Empire State Building and the Eiffel Tower.

Seeing the impression the Burj Al Arab Hotel, the Burj Khalifa, and the rest of the urban updating in Dubai have made on the rest of the world, we might ask: What impact will this and other enormous internationally oriented projects in the Islamic world have on traditional forms of art there? What message does the Burj Khalifa, with its Brash Brands and Armani decorations, give to Muslim artists looking to the magnificent decorative arts of their heritage, the arabesques, interlaces, and architectural *muqarnas* for which Islamic visual culture is celebrated the world over? Should individual artists follow the global lead given by these megastructures, or continue to explore the ancient artistic traditions of their ancestors, which are tied to strong religious and cultural convictions?

Now that the modernization program in the emirate is largely finished, visionary architect-engineers in many parts of the world are already working hard to dethrone Dubai and create their own attention-grabbing symbols of power. Dubai's neighbor, Abu Dhabi, has elaborate construction projects in progress that may upstage those of Dubai, and Saudi Arabia has commissioned Adrian B. Smith, the head architect on the Burj Khalifa, to design and build a mile-high skyscraper in its own capital, Riyadh, to be called the Kingdom Tower. As a result, we might ask: How long will the Burj Al Arab Hotel and Burj Khalifa hold the coveted titles of the world's most opulent hotel and tallest skyscraper, and what will it do to their value as grand symbols of the small emirate if and when they lose those titles?

MULTIMEDIA EXPRESSIONS

Yoko Ono (born 1933), mentioned in Chapter Five for her association with the Tokyo-based Fluxus group, came from a prominent banking family that resided jointly in Japan and the United States and was one of the first notable artists from beyond the West to embrace internationalism unhesitatingly. In so doing, she helped spread an understanding of contemporary Japanese aesthetics around the world.

In the mid-1950s, Ono became involved with the avant-garde art and music worlds in New York City; for over half a century since, she has been at the cutting edge of many contemporary international movements in the arts (FIG. 9.7). Nevertheless, Ono has remained somewhat independent of those movements and continues to resist all attempts by critics to define her in terms of contemporary "isms." John Lennon, with whom she had a personal and working relationship from 1968 until the former Beatle's death in 1980, called her the world's "most famous unknown artist."

The reason for her high-profile obscurity stems in part from the complexity of Ono's thinking, which has been influenced by the minimalism of Japanese thought as manifested in *haiku* poetry, *Noh* theater, and the tea ceremony, as well as by the provocative riddles and paradoxes of Zen Buddhism. Ono's aesthetics also reflect the Existentialism of

French philosopher Jean-Paul Sartre and the ideals of Dada/Fluxus, which posit that the everyday world around us should be the site and source of all art. Ono has long called for art to come down from its walls and pedestals so that it can be part of life and its audiences can be active participants in the aesthetic experience. She has also long opposed the artificiality of the conventional borders between art forms as well as the philosophical limitations of various social and artistic movements. Ono has championed feminist ideals, though her conceptualism hardly fits the mold of the standard political critique of the "establishment." Instead, she finds ways to use idea, language, wit, and wonder to evoke poetic beauty and empower us to imagine, wish, dream, and envision change.

Commenting on her position in the art world, Ono said: "I have always felt like an outsider, that people did not understand me. In a way, I created a power as an outsider … you should never be in the center. Center is a blind spot … you are seen, but you can't see anybody." From the start, Ono's ethnicity and gender automatically placed her on the periphery of the avant-garde in both Japan and the West. But, turning these potential disadvantages to her benefit, she has articulated a philosophy in which being a woman and an outsider, the "other," has given her the freedom to "see" more clearly than insiders and to break any and all sociocultural conventions and taboos in the arts. Building on ideas about women artists as the "others" in the art world that Simone de Beauvoir explored in *The Second Sex* (1949), Ono continues to find many still-unexplored avenues in her attempt to define her role as a contemporary multimedia artist.

Ono speaks for a new art world that no longer calls for singularity and linear development but embraces diversity and contradiction. In that world, artists are no longer restricted by traditional ideas of cultural geography because the overriding emphasis once placed on the "purity" of geographically and ethnically prescribed cultural traditions has been undermined by a growing appreciation of the creative power of the hybrid. While Western aesthetics and other ideologies remain in some circles the norms against which the rest of the world is being measured, Ono and other artists who have had the courage to see the power inherent in their position as "outsiders" are now playing a major role in the international contemporary art world.

The difficulty of categorizing Ono's work has confounded critics and made it difficult for them to assess her position in the art world. Moreover, as a conceptual and performance-oriented artist, in the spirit of John Cage and Marcel Duchamp, she has produced few readily marketable objects that can be taken out of their original context to be framed, set on pedestals, or otherwise sold. She is best

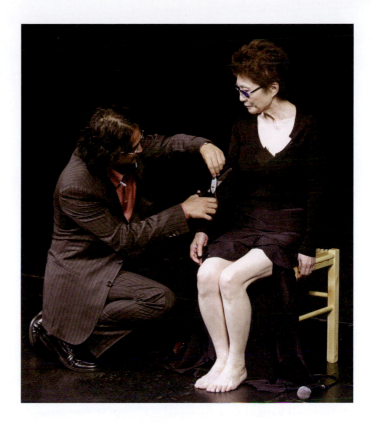

9.7 Yoko Ono, *Cut Piece*, Paris, September 2003
Ono watches as her son Sean Lennon uses scissors to cut off a piece of her dress. Later, members of the audience were invited on stage to cut off further pieces and send them to loved ones.

known for her physical performance aimed at creating new forms of consciousness.

In FIG. 9.7, Ono watches as Sean Lennon, her son, uses scissors to cut away pieces of her clothing. *Cut Piece* is a Happening (for Happenings, see page 192), a loosely scripted event where each individual performance may take new directions. Ono first performed it in 1964 at the Sogetsu Art Center in Tokyo, where she walked on stage, knelt on the floor, and asked audience members to cut small pieces off her dress and send them to someone they loved. By the end, she was naked. Ono has explained the work in many ways, in particular as part of her lifelong quest for identity, which she says the audience helps her find by cutting away her garment.

However, the creator or director does not have full control over the meaning of any Happening. *Cut Piece* may be best remembered by the reactions of its audiences, which have ranged from quietly curious in Japan to near-riotous in London, when security had to be called after spectators stormed the stage to claim souvenirs of the event. As Ono continues to create new works, and new versions of old ones, in the spirit of Yoshihara Jiro and the Gutai group, she has continued to "Create what has never existed before."

SUMMARY

The works of art in this chapter were selected because they represent examples of art from beyond the West that are not tied to the specific areas and traditions discussed in Chapters Two through Eight. Today, the contemporary arts of Asia, the Pacific, Africa, and the Americas no longer necessarily reflect the ancient and still-powerful traditions that determined the earlier output of artists in those areas. Not only do people travel with ease and speed from one area to another, many of them live in areas far beyond the borders of the cultures into which they or their ancestors were born. This mobility challenges many of our traditional ideas about culture and ethnicity and shows how Western and non-Western cultures can interact and produce works of art without diluting the power and "integrity" of either source. Artists are departing from traditional frameworks of thought in order to create works of art that engage with the world around them in new ways that could not have been imagined in the distant or even the recent past.

The final works of art discussed in Chapters Two through Eight demonstrated the beginnings of this process as artists began to reach beyond their cultural borders and incorporate ideas from beyond. The works in this last chapter go a step further and represent bold attempts to adapt regional traditions for a much broader international audience. Yoko Ono was one of the first notable artists from beyond the West to embrace internationalism and to use it as a means of spreading the aesthetics of her native Japan around the world. Since then, Yue Minjun of China and Takashi Murakami of Japan have created paintings and sculptures for that ever-expanding global art market that comment on their own cultures. While the skyscrapers in Malaysia and Dubai illustrated and discussed on pages 351–354 reflect certain local ideals and traditions of those who commissioned them, first and foremost they are high-tech marvels designed and constructed by individuals and firms working in an international style for a global audience.

The diverse collection of individuals, industries, organizations, and works of art discussed in this chapter may at first sight appear to have little in common, but they share at least one thing—a defiance of all the old ideas about art and thought having national or cultural boundaries. As we have seen in this chapter, such works are often hard to interpret, and it is difficult, if not impossible, to predict what new directions such unbounded art may take in the future. Architecture in particular would seem to have many surprises in store for us in the coming decades. The Shanghai Expo 2010 emphasized the importance of green technology and spoke loudly about the need for everyone to work together and interact more positively with the world's ecosystems. Green thinking tells us that a new building must do more than work efficiently, as a self-contained machine; it must also work in context with everything else so that it does not deplete our natural resources, damage the ecosystem, or diminish its biodiversity. However, looking at the current global building boom, particularly in Asia, one must ask: In these terms, will the next wave of megastructures prove beneficial to the world as a whole?

In conclusion, we see non-Western artists around the world producing some of the most exciting art in the world today. Though they are drawn from widely different cultural backgrounds and perspectives, they are part of a new international culture. Together, they attack the notion that the art of any part of the non-Western world must conform to outdated ideals, and provide us with images that are variously memorable, complex, nuanced, thought-provoking, and humorous. None is circumscribed by a sense of a geographically determined cultural identity, and their works show them using all the tools at their disposal, without reference to national boundaries, in order to create meaningful statements about the increasingly globalized world in which we live. Similarly, we, the viewers, must develop a new flexibility in order to move in imagination between cultures and ideas and be in a position to understand the full meaning of these new works as they emerge.

BIBLIOGRAPHY

CHAPTER 1

ABIODUN, ROWLAND, HENRY JOHN DREWAL, and JOHN PEMBERTON, III, *Yoruba: Art and Aesthetics*. Zürich: Reitberg Museum, 1991

ANDERSON, RICHARD L, *Calliope's Sisters: A Comparative Study of Philosophies of Art*. Upper Saddle River, NJ: Pearson Prentice Hall, 2004

BAHN, PAUL, and JOHN FLENLEY, *Easter Island: Earth Island*. London: Thames and Hudson, 1992

BRAVMANN, RENE, *African Islam*. Washington, D.C.: Smithsonian Institution Press, 1983

DREWAL, HENRY JOHN, and MARGARET THOMPSON DREWAL, *Gelede: Art and Female Power Among the Yoruba*. Bloomington, IN: University of Indiana Press, 1983

DUFFEK, KAREN, and BILL REID: *Beyond the Essential Form*. Vancouver: University of British Columbia Press, 1986

LEE, SHERMAN E., *A History of Far Eastern Art*. 5th edn. New York: Harry N. Abrams, 1994

MUNROE, ALEXANDRA, *Japan After 1945: Scream Against the Sky*. New York: Harry N. Abrams, 1994

SATO, TOMOKO, and TOSHIO WATANABE, *Japan and Britain: An Aesthetic Dialogue 1850–1930*. London: Lund Humphries, Barbican Art Gallery, and the Setagaya Art Museum, 1991

TOWNSEND, RICHARD, *The Aztecs*. London: Thames and Hudson, 1992

SCHELE, LINDA and DAVID FREIDEL, *A Forest of Kings, the Untold Story of the Ancient Maya*. New York: Morrow, 1990

CHAPTER 2

ATIL, ESIN, *Renaissance of Islam: Art of the Mamluks*. Washington, D.C.: Smithsonian Institution Press, 1981

—, *The Age of Sultan Süleyman the Magnificent*. Washington, D.C., and New York: National Gallery of Art and Harry N. Abrams, Inc., 1987

ATIL, ESIN, ed., *Islamic Art and Patronage: Treasures from Kuwait*. Washington, D.C.: The Trust for Museum Exhibitions, 1991.

BEACH, MILO CLEVELAND, *Early Mughal Painting*. Cambridge, MA: Harvard University Press, 1987

BLAIR, SHEILA S., and JONATHAN M. BLOOM, eds., *Images of Paradise in Islamic Art*. Hanover, NH: Hood Museum of Art, 1991

BLOOM, JONATHAN M., AND SHEILA S. BLAIR, *The Grove Encyclopedia of Islamic Art and Architecture*. New York: 2009

BREND, BARBARA, *Islamic Art*. Cambridge, MA: Harvard University Press, 1991

BURCKHARDT, TITUS, *Art of Islam: Language and Meaning*. Bloomington, IN: World Wisdom, *commemorative edn.*, 2009

ESPOSITO, JOHN L., *Islam: The Straight Path*. New York and Oxford: Oxford University Press, 1991

ETTINGHAUSEN, RICHARD, *Treasures of Asia: Arab Painting*. New York: Rizzoli, 1977

ETTINGHAUSEN, RICHARD, and OLEG GRABAR, *The Art and Architecture of Islam, 650–1250*. New York: Viking Penguin, 1987

FERRIER, R.W., ed., *The Arts of Persia*. New Haven and London: Yale University Press, 1989

FRISHMAN, MARTIN, and HASAN-UDDIN KHAN, eds., *The Mosque: History, Architectural Development and Regional Diversity*. London: Thames and Hudson, 1994

GOLOMBEK, LISA, and DONALD WILBER, *The Timurid Architecture of Iran and Turan*, 2 vols. Princeton: Princeton University Press, 1988

GOODWIN, GODFREY, *A History of Ottoman Architecture*. New York: Thames & Hudson, 1987

GRABAR, OLEG, *The Formation of Islamic Art*. New Haven: Yale University Press, 1987

GROVER, SATISH, *The Architecture of India: Islamic (727–1707)*. New Delhi: Vikas, 1981

HADDAD, YVONNE YAZBECK, BRYON HAINES, and ELLISON FINDLY, eds., *The Islamic Impact*. Syracuse: Syracuse University Press, 1984

HILLENBRAND, ROBERT, *Islamic Art and Architecture*. London: Thames and Hudson, 1998

HOAG, JOHN D., *Islamic Architecture*. New York: Abrams, 1977; Rizzoli, 1987

IRWIN, ROBERT, *Islamic Art in Context*. New York: Prentice Hall and Abrams, 1997

KOCH, EBBA, *Mughal Architecture: An Outline of Its History and Development, 1526–1858*. Munich: Prestel Verlag, 1991

KUHNEL, ERNST, *Islamic Art and Architecture*. London: Bell, 1966

LEAMAN, OLIVER, *Islamic Aesthetics: An Introduction*. Notre Dame: University of Notre Dame Press, 2004

MOZZATI, LUCA, *Islamic Art*. New York: Prestel, 2010

ROSSER-OWEN, MIRIAM, *Islamic Arts from Spain*. London: Victoria and Albert Museum, 2010

SCHIMMEL, ANNEMARIE, *Islam in India and Pakistan*. Leiden: Brill, 1982

STANLEY, TIM, *Palace and Mosque: Islamic Art from the Middle East*. London: Victoria and Albert Museum, 2004

TITLEY, NORAH M., *Persian Miniature Painting and Its Influence on the Art of Turkey and India*. Austin: University of Texas Press, 1984

TUCKER, JONATHAN, *The Silk Road: Art and History*. Chicago: Art Media Resources Ltd., 2003

WELCH, ANTHONY, and STUART CARY WELCH, *Arts of the Islamic Book: The Collection of Prince Sadruddin Aga Khan*. Ithaca and London: Cornell University Press, 1982

CHAPTER 3

ASHER, FREDERICK M., *The Art of Eastern India, 300–800*. Minneapolis: University of Minnesota Press, 1980

—, *Art of India: Prehistory to the Present*. Chicago: Encyclopedia Britannica, 2002

BEACH, MILO CLEVELAND, *Mughal and Rajput Painting*. New York: Cambridge University Press, 1992

BEGLEY, WAYNE, and Z.A. DESAI, eds. *Taj Mahal: The Illuminated Tomb*. Cambridge, MA: University of Washington Press, 1989

BEQUIN, GILLES, *Buddhist Art: An Historical and Cultural Journey*. Bangkok: River Books Press, 2009

BLURTON, RICHARD, *Hindu Art*. Cambridge, MA: Harvard University Press, 1993

COLLINS, CHARLES DILLARD, *The Iconography and Ritual of Shiva at Elephanta*. Albany: State University of New York Press, 1988

CRAVEN, ROY C., *Indian Art: A Concise History*. London: Thames and Hudson, 1997

DAVIES, PHILIP, *Splendors of the Raj: British Architecture in India, 1660 to 1947*. London: John Murray, 1985

DAVIS, RICHARD H., *Lives of Indian Images*. Princeton: Princeton University Press, 1997

DEHEJIA, VIDYA, *Indian Art*. New York, Phaidon Press, 1997

FISHER, ROBERT E., *Art of Tibet*. London: Thames and Hudson, 1997

—, *Buddhist Art and Architecture*. London: Thames and Hudson, 2002

GHOSH, SANKAR PROSAD, *Hindu Religious Art and Architecture*. Delhi: D.K. Publications, 1982

GRAY, BASIL, ed., *The Arts of India*. Ithaca, NY: Cornell University Press, and London: Phaidon, 1981

HARLE, JAMES C., *The Art and Architecture of the Indian Subcontinent*. London: Penguin, 1990

HUNTINGTON, SUSAN L., *The Art of Ancient India: Buddhist, Hindu, Jain*. New York and Tokyo: Weatherhill, 1985

JESSUP, HELEN I., *Art and Architecture of Cambodia*. London: Thames and Hudson, 2004

KRAMRISCH, STELLA, *The Art of India*. 3rd edn. London: Phaidon, 1965

LA PLANTE, JOHN D., *Asian Art*. 3rd edn. Dubuque, IA: Wm. C. Brown, 1992

LEIDY, DENISE PATRY, *The Art of Buddhism: An Introduction to its History and Meaning*. Boston: Shambhala, 2008

MEISTER, MICHAEL W., ed., *Encyclopedia of Indian Temple Architecture. Vol. I, pt. I, South India, Lower Dravidadesa 200 B.C.–A.D. 1324*. New Delhi: American Institute of Indian Studies, and Philadelphia: University of Pennsylvania Press, 1983

MICHELL, GEORGE, *The Majesty of Mughal Decoration: The Art and Architecture of Islamic India*. London: Thames and Hudson, 2007

—, *Hindu Art and Architecture*. London: Thames and Hudson, 2000

MITTER, PARTHA, *Art and Nationalism in India: 1850–1920*. Cambridge: Cambridge University Press, 1994

—, *Indian Art*. New York: Oxford University Press, 2001

PAL, PRATAPADITYA, *Buddhist Art: Form and Meaning*. Delhi: Marg Foundation, 2007

RAWSON, PHILIP, *The Art of Southeast Asia*. London: Thames and Hudson, 1990

ROWLAND, BENJAMIN, *The Art and Architecture of India: Buddhist, Hindu, Jain*. 3rd edn. Baltimore: Penguin Books, 1967

SIVARAMAMURTI, CALAMBUR, *The Art of India*. New York: Harry N. Abrams, 1977

STRACHAN, PAUL, *Imperial Pagan: Art and Architecture of Burma*. Honolulu: University of Hawaii Press, 1989

WELCH, STUART CARY, *India: Art and Culture 1300–1900*. New York: The Metropolitan Museum of Art, 1985

—, *The Emperors' Album: Images of Mughal India*. New York: The Metropolitan Museum of Art, 1987

WILLIAMS, JOANNA G., *Art of Gupta India, Empire and Province*. Princeton: Princeton University Press, 1982

ZIMMER, HEINRICH, and JOSEPH CAMPBELL, eds., *The Art of Indian Asia: Its Mythology and Transformations*, 2 vols. Bollingen Series 39. Princeton: Princeton University Press, 1983

CHAPTER 4

BILLETER, JEAN FRANÇOIS, *The Chinese Art of Writing*. New York: Rizzoli, 1990
BROWN, CLAUDIA, and JU-HSI CHOU, *Transcending Turmoil: Painting at the Close of China's Empire, 1796–1911*. Phoenix: Phoenix Art Museum, 1992
CAHILL, JAMES, *The Compelling Image: Nature and Style in Seventeenth-Century Chinese Painting*. London and Cambridge: Harvard University Press, 1982
CHANG, LEON LONG-YIEN, and PETER MILLER, *4000 years of Chinese Calligraphy*. Chicago: University of Chicago Press, 1990
CHASE, W. T., *Ancient Chinese Bronze Art: Casting the Precious Sacral Vessel*. New York: China House Gallery, 1991
CLUNAS, CRAIG, *Superfluous Things: Material Culture and Social Status in Early Modern China*. Urbana and Chicago: University of Illinois Press, 1991
—, *Chinese Export Art and Design*. London: Victoria and Albert Museum, 1987
—, *Art in China*. 2nd edn. New York: Oxford University Press, 2009
FONG, WEN C., *Beyond Representation: Chinese Painting and Calligraphy, 8th–11th Century*. New York: The Metropolitan Museum of Art, and New Haven and London: Yale University Press, 1992
GRAY, BASIL, *Sung Porcelain and Stoneware*. London and Boston: Faber and Faber, 1984
LAWTON, THOMAS, *New Perspectives on Chinese Culture during the Eastern Zhou Period*. Princeton: University of Princeton Press, 1991
LOEHR, MAX, *The Great Painters of China*. New York: Harper and Row, 1980
MUNAKATA, KIYOHIKO, *Sacred Mountains in Chinese Art*. Urbana: University of Illinois Press, 1991
POWERS, MARTIN J., *Art and Political Expression in Early China*. New Haven and London: Yale University Press, 1991
RAWSON, JESSICA, *Ancient China: Art and Archaeology*. New York: Harper and Row, 1980
—, *Chinese Bronzes: Art and Ritual*. London: British Museum Press, 1987
—, ed., *The British Museum Book of Chinese Art*. New York and London: Thames and Hudson, 1992
SICKMAN, LAWRENCE, and A.C. SOPER, *The Art and Architecture of China*. 4th rev. edn. London, 1971
SULLIVAN, MICHAEL, *The Three Perfections: Chinese Painting, Poetry and Calligraphy*. New York: George Braziller, 1980
—, *Art and Artists of Twentieth-Century China*. Berkeley: University of California Press, 1996
—, *The Arts of China*. 5th edn. Berkeley: University of California Press, 2009
TREGEAR, MARY, *Chinese Art*. London: Thames and Hudson, 1997
WU HUNG, *The Wu Liang Shrine: The Ideology of Early Chinese Pictorial Art*. Stanford: Stanford University Press, 1989
ZWALF, W., ed., *Buddhism: Art and Faith*. London: British Museum Press, 1985

CHAPTER 5

ADDISS, STEPHEN, *The Art of Zen: Painting and Calligraphy by Japanese Monks, 1600–1925*. New York: Harry N. Abrams, 1989
—, *How to Look at Japanese Art*. New York: Harry N. Abrams, 1996

CLARK, TIMOTHY, and DONALD JENKINS, *The Actor's Image: Printmakers of the Katsukawa School*. Chicago: The Art Institute of Chicago, and Princeton: Princeton University Press, 1994
ELISEEF, DANIELLE, and VADIME ELISEEF, *The Art of Japan*. New York: Harry N. Abrams, 1985
GUTH, CHRISTINE, *Art of Edo Japan: The Artist and the City, 1615–1868*. New York: Harry N. Abrams, and London: Weidenfeld and Nicolson, 1996
HICKMAN, MONEY L., *Japan's Golden Age: Momoyama*. New Haven and London: Yale University Press, 1996
INOUE, MITSUO, *Space in Japanese Architecture*. New York and Tokyo: Weatherhill, 1985
KIDDER, J. EDWARD, *Early Japanese Art*. London: Thames and Hudson, 1969
LA PLANTE, JOHN D., *Asian Art*. 3rd edn. Dubuque: William C. Brown, 1992
LEE, SARAH, *Who's Afraid of Freedom, Korean-American Arts in America*. Newport Beach: Newport Harbor Art Museum, 1996
MASON, PENELOPE E, *History of Japanese Art*. Upper Saddle River: Pearson-Prentice Hall, 2004
MEECH-PEKARIK, JULIA, *The World of the Meiji Print: Impressions of a New Civilization*. Tokyo and New York: Weatherhill, 1986
MUNSTERBERG, HUGO, *The Arts of Japan: An Illustrated History*. Rutland and Tokyo: Charles E. Tuttle, 1957
PAINE, ROBERT TREAT, and ALEXANDER SOPER, *The Art and Architecture of Japan*. 3rd rev. edn. Harmondsworth: Penguin, 1981
PARENT, MARY NEIGHBOR, *The Roof in Japanese Buddhist Architecture*. New York: Weatherhill, 1983
PEARSON, RICHARD, et al., *Ancient Japan*. New York: Braziller, Boston: Arthur Sackler Gallery, and Washington, D.C.: Smithsonian Institution, 1992
ROSSBACH, SARAH, *Feng Shui: The Chinese Art of Placement*. New York: E.P. Dutton, 1983
SMITH, JUDY, *Arts of Korea*. New York: Harry N. Abrams and The Metropolitan Museum of Art, 1998
STANLEY-BAKER, JOAN, *Japanese Art*. London: Thames and Hudson, 2000
SWANN, P., *A Concise History of Japanese Art*. New York and Tokyo: Kodansha, 1979
TAKASHINA, SHUJI, and J. THOMAS RIMER, with GERALD D. BOLAS, *Paris in Japan: The Japanese Encounter with European Painting*. Tokyo: The Japan Foundation and St. Louis, 1987
TSUDA, NORITAKE, *Handbook of Japanese Art*. Rutland and Tokyo: Charles E. Tuttle, 1988
WICHMANN, SIEGFRIED, *Japonisme: The Japanese Influence on Western Art in the 19th and 20th Centuries*. New York: Harmony Books, 1981
YOUNG, DAVID E, *The Art of the Japanese Garden*. Clarendon: Tuttle Publishing, 2005
YOUNG, DAVID E, *The Art of Japanese Architecture*. Clarendon: Tuttle Publishing, 2007

CHAPTER 6

BAHN, PAUL, and JOHN FLENLEY, *Easter Island: Earth Island*. London: Thames and Hudson, 1992
BARROW, TERENCE, *An Illustrated Guide to Maori Art*. Honolulu: University of Hawaii Press, 1984
BELLWOOD, PETER S., *Man's Conquest of the Pacific*. New York: Oxford University Press, 1979
BERLO, JANET CATHERINE, and LEE ANNE WILSON, *Arts of Africa, Oceania, and the Americas: Selected Readings*. Englewood Cliffs: Prentice Hall, 1993

BRAKE, BRIAN, JAME MCNEISH, and DAVID SIMMONS, *Art of the Pacific*. New York: Harry N. Abrams, 1980
BRETTELL, RICHARD R., *The Art of Paul Gauguin*. Washington, D.C.: National Gallery of Art, and Boston: New York Graphic Society Books, 1988
CARUANA, WALLY, *Aboriginal Art*. London: Thames and Hudson, 1995
CONTE, ERIC., *Tereraa: Voyaging and the Colonization of the Pacific Islands*. Papeete: Collection Sorval, 1992
COX, J. HALLEY, and WILLIAM DAVENPORT, *Hawaiian Sculpture*. Rev. edn. Honolulu: University of Hawaii Press, 1988
D'ALLEVA, ANNE, *Art of the Pacific*. London: Weidenfeld and Nicolson, and New York: Harry N. Abrams, 1998
—, *Arts of the Pacific Islands*. New Haven: Yale University Press, 2010
DARK, PHILIP J.C., and ROGER G. ROSE, *Artistic Heritage in a Changing Pacific*. Honolulu: University of Hawaii Press, 1993
FELDMAN, JEROME, and DONALD H. RUBENSTEIN, *The Art of Micronesia*. Honolulu: The University of Hawaii Art Gallery, 1986
FORMAN, WERNER, *The Travels of Captain Cook*. New York and Toronto: McGraw-Hill Book Company, 1971
HAMMOND, JOYCE, *Tifaifai and Quilts of Polynesia*. Honolulu: University of Hawaii Press, 1986
HANSON, F. ALLAN, and LOUISE HANSON, *Art and Identity in Oceania*. Honolulu: University of Hawaii Press, 1990
HERLE, ANITA et al., *Pacific Art: Persistence, Change, and Meaning*. Honolulu: University of Hawaii Press, 2002
KAEPPLER, ADRIENNE LOIS, *The Pacific Arts of Polynesia and Micronesia*. New York: Oxford University Press, 2008
—, *Arts of the Pacific Islands*. New Haven: Yale University Press, 2010
KIRCH, PATRICK, *On the Road of the Winds: An Archaeological History of the Pacific Islands before European Contact*. Berkeley: University of California Press, 2000
LEE, GEORGIA, *An Uncommon Guide to Easter Island*. Arroyo Grande: International Resources, 1990
LEWIS, DAVID, and WERNER FORMAN, *The Maori: Heirs of Tane*. London: Orbis, 1982
LINCOLN, LOUISE, *Assemblage of Spirits: Idea and Image in New Ireland*. New York: George Braziller, and Minneapolis: Minneapolis Institute of Arts, 1987
MAY, PATRICIA, and MARGARET TUCKSON, *The Traditional Pottery of Papua New Guinea*. Sydney: Bay Books, 1982
MEAD, SIDNEY MOKO, ed., *The Maori: Maori Art from New Zealand Collections*. New York: Harry N. Abrams, 1984
MEAD, SIDNEY MOKO, and BERNIE KERNOT, *Art and Artists of Oceania*. Palmerston North: Dunmore Press, 1983
MORGAN, WILLIAM, *Prehistoric Architecture in Micronesia*. Austin: University of Texas Press, 1988
MORPHY, HOWARD, *Aboriginal Art*. London: Phaidon, 1998
NEWTON, DOUGLAS, *Art Styles of the Papuan Gulf*. New York: Museum of Primitive Art, 1961
PENDERGRAST, M., *Feathers and Fibre: A Survey of Traditional and Contemporary Maori Craft*. Auckland: Penguin Books, 1984
ROCKEFELLER, MICHAEL C., *The Asmat of New*

Guinea: The Journal of Michael Clark Rockefeller. Greenwich, CT: New York Graphic Society, 1967

SCHNEEBAUM, TOBIAS, *Embodied Spirits: Ritual Carvings of the Asmat*. Salem: Peabody Museum of Salem, 1990

SMIDT, DIRK A., *Asmat Art: Woodcarvings of Southwest New Guinea*. New York: George Braziller, and Leiden: Rijksmuseum voor Volkenkunde, 1993

STARZECKA, DOROTA C., ed., *Maori Art and Culture*. Chicago: Art Media Resources, 1996

THOMAS, NICHOLAS, *Oceanic Art*. London: Thames and Hudson, 1995

WEST, MARGIE, *The Inspired Dream: Life as Art in Aboriginal Australia*. Queensland: Queensland Art Gallery, 1988

CHAPTER 7

ADAHL, KARIN, and SAHLSTROM, BERIT, *Islamic Art and Culture in Sub-Sahara Africa*. Uppsala and Stockholm: Almqvist & Wikseli International, 1995

BASSANI, EZIO, *Arts of Africa: 7000 Years of African Art*. New York: Skira, 2005

BEN-AMOS, PAULA, *The Art of Benin*. Washington, D.C.: Smithsonian Institution Press, and London: British Museum Press, 1995

BERLO, JANET CATHERINE, and LEE ANNE WILSON, *Arts of Africa, Oceania, and the Americas: Selected Readings*. Englewood Cliffs: Prentice Hall, 1993

BLIER, SUZANNE PRESTON, *Royal Arts of Africa: The Majesty of Form*. New York: Harry N. Abrams, and London: Laurence King Publishing, 1998

BRAVMANN, RENE A., *African Islam*. Washington, D.C.: Smithsonian Institution Press, 1983

COLE, HERBERT M., *Mbari: Art and Life among the Owerri Igbo*. Bloomington: Indiana University Press, 1982

COOMBES, A.E., *Reinventing Africa: Museums, Material Culture, and Popular Imagination*. New Haven: Yale University Press, 1994

DREWAL, HENRY JOHN, JOHN PEMBERTON, III, and ROWLAND ABIODUN, *Yoruba: Nine Centuries of African Art and Thought*. New York: The Center for African Art and Harry N. Abrams, 1989

DREWAL, MARGARET THOMPSON, *Yoruba Ritual: Performers, Play, Agency*. Bloomington: Indiana University Press, 1992

ELISOFON, ELIOT, and WILLIAM FAGG, *The Sculpture of Africa*. New York: Hacker, 1978

ENWEZOR, OKWUI, et al., *Contemporary African Art Since 1980*. New York: Oxford University Press, 2002

ETTINGHAUSEN, RICHARD, and OLEG GRABAR, *The Art and Architecture of Islam, 650–1250*. New York: Viking Penguin, 1987

EYO, EKPO, and FRANK WILLETT, *Treasures of Ancient Nigeria*. New York: Knopf, 1980

EZRA, KATE, *Royal Art of Benin: The Perls Collection in the Metropolitan Museum of Art*. New York: The Metropolitan Museum of Art and Harry N. Abrams, 1992

FAGG, W.B., and John PEMBERTON, III, *Yoruba Sculpture of West Africa*. New York: Knopf, 1982

GARLAKE, PETER S., *Early Art and Architecture of Africa*. New York: Oxford University Press, 2002

GILLON, WERNER, *A Short History of African Art*. New York: Facts on File Publications, 1984

KASFIN, SIDNEY LITTLEFIELD, *Contemporary African Art*. London: Thames and Hudson, 2000

KERCHACHE, JACQUES, J.-L. PAUDRAT, and LUCIEN STÉPHAN, *Art of Africa*. New York: Harry N. Abrams, 1993

LEWIS-WILLIAMS, J. DAVID, *The Rock Art of Southern Africa*. Cambridge: Cambridge University Press, 1983

MACGAFFERY, WYATT, and MICHAEL D. HARRIS, *Astonishment and Power*. Washington, D.C.: Smithsonian Institution Press, 1993

McEVILLEY, THOMAS, *Fusion: West African Artists at the Venice Biennale*. New York: Museum for African Art, 1993

McLEOD, MALCOLM, and JOHN MACK, *Ethnic Sculpture*. Boston: Harvard University Press, and London: British Museum Press, 1985

NORTHERN, TAMARA, *The Art of Cameroon*. Washington, D.C.: Smithsonian Institution Press, 1984

OGUIBE, OLU, and OKWUI ENWEZOR, *Reading the Contemporary: African Art in the Marketplace*. Cambridge, MA: MIT Press, 1999

PERANI, JUDITH, and FRED T. SMITH, *The Visual Arts of Africa: Gender, Power, and Life Cycle Rituals*. Upper Saddle River, NJ: Prentice Hall, 1998

PHILLIPS, TOM, *Africa: The Art of a Continent*. London: Royal Academy of Arts, and Munich and New York: Prestel Verlag, 1995

PHILLIPSON, DAVID W., *African Archaeology*. 2nd edn. Cambridge: Cambridge University Press, 1993

PRUSSIN, LABELLE, *Hatumere: Islamic Design in West Africa*. Berkeley: University of California Press, 1986

SIEBER, ROY, and ROSLYN WALKER, *African Art in the Cycle of Life*. Washington, D.C.: Smithsonian Institution Press, 1987

SPRING, CHRIS, *Angaza Africa: African Art Now*. London: Laurence King Publishing, 2008

SULLIVAN, MICHAEL, *The Meeting of Eastern and Western Art from the Sixteenth Century to the Present Day*. Greenwich: New York Graphic Society, 1973

THOMPSON, ROBERT F., *African Art in Motion: Icon and Act*. Washington, D.C.: National Gallery of Art, and Los Angeles: Frederick S. Wright Art Gallery, University of California Press, 1974

—, *Black Gods and Kings: Yoruba Art at U.C.L.A.* Bloomington: Indiana University Press, 1976

—, *Flash of the Spirit: African and Afro-American Art and Philosophy*. New York: Random House, 1983

TRACHTENBERG, M., and I. HYMAN, *Architecture: From Prehistory to Post-Modernism*. New York: Harry N. Abrams, 1985

VANSINA, JAN, *Art History in Africa*. New York: Longman, 1984

VISONÀ, MONICA, et al., *History of Art in Africa*. 2nd edn. Upper Saddle River: Prentice Hall, 2007

VOGEL, SUSAN, *African Aesthetics*. New York: Center for African Art, 1986

VOGEL, SUSAN, ed., *For Spirits and Kings*. New York: The Metropolitan Museum of Art, 1981

VOGEL, SUSAN, et al., *Africa Explores*. New York: Center for African Art, 1991

WILCOX, A.R., *The Rock Art of Southern Africa*. New York: Holmes & Meier, 1984

WILLETT, FRANK, *African Art*. 3rd edn. London: Thames and Hudson, 2003

WILLIAMSON, SUE, *South African Art Now*. New York: Collins Design, 2009

CHAPTER 8

South America

BAUER, BRIAN S., *The Development of the Inca State*. Austin: University of Texas Press, 1992

BENSON, ELIZABETH P., ed., *Pre-Columbian Metallurgy of South America*. Washington, D.C.: Dumbarton Oaks, 1979

BONAVIA, DUCCIO, *Mural Painting in Ancient Peru*. Bloomington: Indiana University Press, 1985

—, *Chavín and the Origins of Andean Civilization*. London: Thames and Hudson, 1992

BOURGET, STEVEN AND KIMBERLY L. JONES, *The Art and Architecture of the Moche: An Ancient Andean Society of the Peruvian North Coast*. Austin: University of Texas Press, 2008

CONRAD, GEOFFREY W., and ARTHUR DEMAREST, *Religion and Empire: The Dynamics of Aztec and Inca Expansion*. Cambridge: Cambridge University Press, 1984

DONNAN, CHRISTOPHER B., *Moche Art of Peru: Pre-Columbian Symbolic Communication*. Los Angeles: University of California Press, 1978

—, ed., *Early Ceremonial Architecture in the Andes*. Washington, D.C.: Dumbarton Oaks, 1985

DONNAN, CHRISTOPHER B., and CAROL J. MACKEY, *Ancient Burial Patterns of the Moche Valley, Peru*. Austin: University of Texas Press, 1978

GASPARINI, GRAZIANO, and LUISE MARGOLIES, *Inca Architecture*. Bloomington: Indiana University Press, 1980

GILL, JERRY H., *Native American Worldviews*. Amherst: Humanity Books, 2002

GRIEDER, TERENCE, *Origins of Pre-Columbian Art*. Austin: University of Texas Press, 1982

HEMMING, JOHN AND EDWARD RANNEY, *Monuments of the Incas*. London: Thames and Hudson, 2010

JACKSON, MARGARET A., *Moche Art and Visual Culture in Ancient Peru*. Albuquerque: University of New Mexico Press, 2008

KIRKPATRICK, SIDNEY D., *Lords of Sipán: A Tale of Pre-Inca Tombs, Archaeology, and Crime*. New York: William Morrow and Company, Inc. 1992

KUBLER, GEORGE, *The Art and Architecture of Ancient America: The Mexican, Maya and Andean Peoples*. Pelican History of Art series. Harmondsworth and Baltimore: Penguin Books, 1984

LEVENTHAL, RICHARD M., and ALAN L. KOLATA, *Civilization in the Ancient Americas: Essays in Honor of Gordon R. Willey*. Albuquerque: University of New Mexico Press, and Cambridge, MA: Peabody Museum of Archaeology and Ethnology, Harvard University, 1983

MOSELEY, MICHAEL E., *The Incas and Their Ancestors: The Archaeology of Peru*. London: Thames and Hudson, 2001

MOSELEY, MICHAEL E., and KENT C. DAY, eds., *ChanChan: Andean Desert City*. Albuquerque: University of New Mexico Press, 1982

PANG, HILDEGARD DELGADO, *Pre-Columbian Art: Investigations and Insights*. Norman: University of Oklahoma Press, 1992

PASZTORY, ESTHER, *Pre-Columbian Art*. Cambridge: Cambridge University Press, 1998

PAUL, ANNE C., *Paracas Ritual Attire: Symbols of Authority in Ancient Peru*. Norman and London: University of Oklahoma Press, 1989

—, *Paracas Art and Architecture: Object and Context in South Coastal Peru*. Iowa City: University of Iowa Press, 1991

ROWE, JOHN H., *Chavín Art: An Inquiry into its Form and Meaning*. New York: Museum of Primitive Art, 1962

STIERLIN, HENRI, *Art of the Incas and its Origins*. New York: Rizzoli, 1984

STONE-MILLER, REBECCA, *To Weave for the Sun: Andean Textiles in the Museum of Fine Arts*. Boston: Museum of Fine Arts, 1992

—, ed., *Spun Gold: Virtuoso Textiles of the Ancient Andes*. Boston: Museum of Fine Arts, 1992

—, *Art of the Andes*. New York: Thames and Hudson, 1995

—, *Art of the Andes: From Chavin to Inca. 2nd edn.* London, Thames and Hudson, 2002

ZUIDEMA, R. THOMAS, *Inca Civilization in Cuzco*. Austin: University of Texas Press, 1990

Mesoamerica: Olmec and Maya

ALVA, WALTER, "Discovering the New World's Richest Unlooted Tomb," *National Geographic*, 174, no. 4 (October, 1998): 510–49

BRAUN, BARBARA, *Pre-Columbian Art and the Post-Columbian World: Ancient American Sources of Modern Art*. New York City: Harry N. Abrams, 2000

CLANCY, FLORA S., and PETER D. HARRISON, *Vision and Revision in Maya Studies*. Albuquerque: University of New Mexico Press, 1990

—, *The Land of the Olmec*, 2 vols. Austin: University of Texas Press, 1980

COE, MICHAEL D., *The Maya. 7th edn.* London: Thames and Hudson, 2005

COGGINS, CLEMENCY, and ORRIN SHANE III, *Cenote of Sacrifice: Maya Treasures from the Sacred Well at Chichén Itzá*. Austin: University of Texas Press, 1984

GRAHAM, JOHN A., ed., *Ancient Mesoamerica: Selected Readings*. Palo Alto: Peek Publications, 1981

GROVE, DAVID, *Chalcatzingo: Excavations on the Olmec Frontier*. New York and London: Thames and Hudson, 1984

HANKS, WILLIAM F., and DONALD RICE, eds., *Word and Image in Maya Culture: Explorations in Language, Writing, and Representation*. Salt Lake City: University of Utah Press, 1989

HENDERSON, JOHN S., *The World of the Ancient Maya*. Ithaca: Cornell University Press, 1981

JOYCE, ROSEMARY A., *Cerro Palenque: Power and Identity on the Maya Periphery*. Austin: University of Texas Press, 1991

KERR, JUSTIN, ed., *The Maya Vase Book. Vol. I, A Corpus of Rollout Photographs of Maya Vases*. New York: Kerr Associates, 1989

KOWALSKI, JEFF KARL, *The House of the Governor: A Maya Palace at Uxmal, Yucatán, Mexico*. Norman and London: University of Oklahoma Press, 1987

KUBLER, GEORGE, *The Art and Architecture of Ancient America: The Mexican, Maya and Andean Peoples*. Pelican History of Art series. Harmondsworth and Baltimore: Penguin Books, 1984

LOVE, BRUCE, *The Paris Codex: A Handbook for a Maya Priest*. Austin: University of Texas Press, 1994

MILLER, MARY ELLEN, *The Art of Mesoamerica from Olmec to Aztec*. World of Art series. London: Thames and Hudson, 1995

—, *The Murals of Bonampak*. Princeton: Princeton University Press, 1986

MILLER, VIRGINIA E., *The Role of Gender in Precolumbian Art and Architecture*. Lanham: University of Maryland Press, 1988

PASZTORY, ESTHER, *Pre-Columbian Art*. Cambridge: Cambridge University Press, 1998

PROSKOURIAKOFF, TATIANA, *An Album of Maya Architecture*. Norman: University of Oklahoma Press, 1963

REENTS-BUDET, DORIE, et al., *Painting the Maya Universe: Royal Ceramics of the Classic Period*. Durham, N.C.: Duke University Press, 1994

ROBERTSON, MERLE GREENE, and ELIZABETH P. BENSON, eds., *Fourth Palenque Round Table, 1980*. Vol. 6. San Francisco: Pre-Columbian Art Research Institute, 1985

ROBERTSON, MERLE GREENE, and VIRGINIA M. FIELDS, eds., *Fifth Palenque Round Table, 1983*. Vol. 7. San Francisco: Pre-Columbian Art Research Institute, 1985

SCHELE, LINDA, and DAVID FREIDEL, *A Forest of Kings: The Untold Story of the Ancient Maya*. New York: Morrow, 1990

SCHELE, LINDA, and MARY E. MILLER, *The Blood of Kings: Dynasty and Ritual in Maya Art*. Fort Worth: Kimbell Art Museum, 1986

TATE, CAROLYN, *Yaxchilán: The Design of a Maya Ceremonial City*. Austin: University of Texas Press, 1990

WHITTINGTON, MICHAEL, *The Sport of Life and Death: The Mesoamerican Ballgame*. Charlotte: Mint Museum Press, 2002

YOFFE, NORMAN, and GEORGE COWGILL, eds., *The Collapse of Ancient States and Civilizations*. Tucson: University of Arizona Press, 1988

Mesoamerica: Mexico

BAIRD, ELLEN TAYLOR, *The Drawings of Sahagun's Primeros Memoriales: Structure and Style*. Norman: University of Oklahoma Press, 1993

BERLO, JANET CATHERINE, ed., *Art, Ideology, and the City of Teotihuacán*. Washington, D.C.: Dumbarton Oaks, 1992

BENSON, ELIZABETH P. AND BEATRIZ DE LA FUENTE, *Olmec Art of Ancient Mexico*. Washington, D.C.: National Gallery of Art and Harry N. Abrams, 1996

BERRIN, KATHLEEN, ed., *Feathered Serpents and Flowering Trees: Reconstructing the Murals of Teotihuacán*. San Francisco: The Fine Arts Museums of San Francisco, 1988

BOONE, ELIZABETH HILL, ed., *The Aztec Templo Mayor (1983 Conference)*. Washington, D.C.: Dumbarton Oaks, 1987

BRAUN, BARBARA, *Pre-Columbian Art and the Post-Columbian World: Ancient American Sources of Modern Art*. New York: Harry N. Abrams, 1993

BRODA, J., D. CARRASCO, and E. MOCTEZUMA MATOS, eds., *The Great Temple of Tenochtitlán*. Berkeley: University of California Press, 1987

BRODA, J., *The Great Temple of Tenochtitlán: Center and Periphery in the Aztec World*. Berkeley: University of California Press, 1993

CARRASCO, DAVID, *Quetzalcóatl and the Irony of Empire: Myths and Prophecies in the Aztec Tradition*. Chicago: University of Chicago Press, 1983

CLENDINNEN, INGA, *Aztecs: An Interpretation*. New York: Cambridge University Press, 1991

COE, MICHAEL D., and REX KOONTZ, *Mexico: From the Olmecs to the Aztecs. 6th edn.* London: Thames and Hudson, 2008

DAVIES, NIGEL, *The Aztecs: A History*. Norman: University of Oklahoma Press, 1980

DIEHL, RICHARD, *Tula*. London: Thames and Hudson, 1983.

DIEHL, RICHARD, and JANET BERLO, eds.,

Mesoamerica after the Decline of Teotihuacán, AD 700–900. Washington, D.C.: Dumbarton Oaks, 1989

FLANNERY, KENT V., and JOYCE MARCUS, *The Cloud People: Divergent Evolution of the Zapotec and Mixtec Civilizations*. New York: Academic Press, 1983

FURST, JILL LESLIE MCKEEVER, *The Natural History of the Soul in Ancient Mexico*. New Haven: Yale University Press, 1995

GILLESPIE, SUSAN D., *The Aztec Kings: The Construction of Rulership in Mexican History*. Tucson: University of Arizona Press, 1989

GROVE, DAVID, ed., *Ancient Chalcatzingo*. Austin: University of Texas Press, 1987

HEALAN, DAN, ed., *Tula of the Toltecs*. Iowa City: University of Iowa Press, 1989

KAMPEN, MICHAEL E., *The Sculptures of El Tajín, Veracruz, Mexico*. Gainesville: University of Florida Press, 1972

KELLY, JOYCE, *The Complete Visitor's Guide to Mesoamerican Ruins*. Norman: University of Oklahoma Press, 1982

KOONTZ, REX, *Lightening Gods and Feathered Serpents: The Public Sculpture of El Tajín*. Austin: University of Texas Press, 2009

KRISTAN-GRAHAM, CYNTHIA, *Mesoamerican Architecture as a Cultural Symbol*. Cambridge: Cambridge University Press, 1995

KUBLER, GEORGE, *Esthetic Recognition of Ancient Amerindian Art*. New Haven: Yale University Press, 1991

LEON-PORTILLA, MIGUEL, *Pre-Columbian Literatures of Mexico*. Norman: University of Oklahoma Press, 1969

MATOS MOCTEZUMA, EDUARDO, *The Great Temple of the Aztecs: Treasures of Tenochtitlán*. London: Thames and Hudson, 1988

—, *Teotihuacán: The City of the Gods*. New York: Rizzoli, 1990

MILLER, ARTHUR G., *The Mural Painting of Teotihuacán*. Washington, D.C.: Dumbarton Oaks, 1973

MILLER, MARY ELLEN, *The Art of Mesoamerica: From Olmec to Aztec*.

MILLER, VIRGINIA, ed., *The Role of Gender in Precolumbian Art and Architecture*. Lanham: University Press of America, 1988

PASZTORY, ESTHER, *Aztec Art*. New York: Harry N. Abrams, 1983

PINA CHAN, ROMAN, ed., *The Olmec: Mother Culture of Mesoamerica*. New York: Rizzoli, 1989

SCHEVILL, M.B., J.C. BERLO, and E. DWYER, eds., *Textile Tradition in Mesoamerica and the Andes*. New York: Garland Press, 1991

SHARER, ROBERT J., and DAVID GROVE, eds., *Regional Perspectives on the Olmec*. Cambridge and New York: Cambridge University Press, 1989

TOWNSEND, RICHARD, *The Aztecs*. London: Thames and Hudson, 1992

North America

BERLO, JANET C., "Portraits of Dispossession in Plains Indian and Inuit Graphic Arts," *The Art Journal*, vol. 49, no. 2 (Summer, 1990):133–41

BLOMBERG, NANCY J., *Navajo Textiles: The William Randolph Hearst Collection*. Tucson: University of Arizona Press, 1988

BRASSER, TED, *Native American Clothing: An Illustrated History*. Tonawanda: Firefly Books, 2009

BRODY, J.J., *The Anasazi: Ancient People of the American Southwest*. New York: Rizzoli, 1990

—, *Anasazi and Pueblo Painting*. Albuquerque: University of New Mexico Press, 1991

BROSE, DAVID S., JAMES A. BROWN, and DAVID W. PENNEY, *Ancient Art of the American Woodland Indians*. New York: Harry N. Abrams, 1985

BROWN, DEE, *Bury my Heart at Wounded Knee*. New York: Bantam Books, 1970

BYRES, MARTIN, *The Ohio Hopewell Episode*. Akron: University of Akron Press, 2004

CHAPPELL, SALLY A.K, *Cahokia: Mirror of the Cosmos*. Chicago: University of Chicago Press, 2002

COE, RALPH T., *Lost and Found Tradition: Native American Art, 1965–1985*. Seattle: University of Washington Press, 1986

DEVON, MARJORIE, *Migrations: New Directions in Native American Art*. Albuquerque: University of New Mexico Press, 2006

DOCKSTADER, FREDERICK J., *The Song of the Loom: New Traditions in Navajo Weaving*. New York: Hudson Hills Press and the Montclair Art Museum, 1987

DUFFEK, KAREN, *Bill Reid: Beyond the Essential Form*. Vancouver: University of British Columbia Press, 1986

FANE, DIANA, IRA JACKNIS, and L.M. BREEN, *Objects of Myth and Memory: American Indian Art at the Brooklyn Museum*. New York: The Brooklyn Museum, and Seattle: The University of Washington Press, 1991

FARELLA, JOHN R, *The Main Stalk: A Synthesis of Navajo Philosophy*. Tucson: The University of Arizona Press, 1990

FEEST, CHRISTIAN F., *Native Arts of North America*. London: Thames and Hudson, 1992

FENTON, WILLIAM N., *Parker on the Iroquois*. Syracuse: Syracuse University Press, 1968

FURST, PETER T., and JILL L. FURST, *North American Indian Art*. New York: Rizzoli, 1982

GALLOWAY, PATRICIA, ed., *The Southeastern Ceremonial Complex: Artifacts and Analysis*. Lincoln: University of Nebraska Press, 1989

HARRISON, JULIA, *The Spirit Sings: Artistic Tradition of Canada's First Peoples*. Alberta: The Glenbow Museum, and McClelland and Stewart, 1987

HOLM, BILL, *Indian Art at the Burke Museum*. Seattle and London: University of Washington Press, 1974

—, *The Box of Daylight: Northwest Coast Indian Art*. With contributions by Peter L. Corey, Nancy Harris, Aldona Jonaitis, Alan R. Sawyer, and Robin K. Wright. Seattle: University of Washington Press, 1983

HUDSON, CHARLES, *The Southeastern Indians*. Knoxville: University of Tennessee Press, 1976

JENSEN, DOREEN, and POLLY SARGENT, *Robes of Power: Totem Poles on Cloth*. Vancouver: University of British Columbia Press, 1986

JOHNSON, HARMER, *Guide to the Arts of the Americas*. New York: Rizzoli, 1992

KENT, KATE PECK, *Navajo Weaving: Three Centuries of Change*. Santa Fe: School of American Research Press, 1985

LEKSON, STEPHEN H., *Great Pueblo Architecture of Chaco Canyon*. With contributions by William B. Gillespie and Thomas C. Windes. Albuquerque: University of New Mexico Press, 1986

MAURER, EVAN, ed., *Visions of the People: A Pictorial History of Plains Indian Life*. Seattle: University of Washington Press, 1992

MILNER, GEORGE R, *The Moundbuilders: Ancient People of Eastern North America*. Ancient People and Places series. London: Thames and Hudson, 2005

MORGAN, WILLIAM N., *Prehistoric Architecture in the Eastern United States*. Cambridge, MA: MIT Press, 1980

O'CONNOR, MALLORY McCANE, *Children of the Sun: Ceremonial Art and Architecture of the Ancient Southeast*. Gainesville: University Presses of Florida, 1994

—, *Lost Cities of the Ancient Southeast*. Gainesville: University of Florida Press, 1995

PAREZO, NANCY J., *Navajo Sandpainting: From Religious Act to Commercial Art*. Tucson: University of Arizona Press, 1983

PAUKETAT, TIMOTHY, *Ancient Cahokia and the Mississippians*. Cambridge: Cambridge University Press, 2004

PENNEY, DAVID, ed., *Art of the American Indian Frontier: The Chandler-Pohrt Collection*. Detroit: Detroit Institute of Arts, and Seattle: University of Washington Press, 1992

PENNY, DAVID W., and GEORGE HORSE CAPTURE, *North American Indian Art*. London: Thames and Hudson, 2004

PHILLIPS, RUTH, *Trading Identities: Native American Tourist Arts from the Northeast, 1700–1900*. Seattle: University of Washington Press, 1994

POWER, SUSAN, *Early Art of the Southeastern Indians: Feathered Serpent and Winged Beings*. Athens: University of Georgia Press, 2004

REILLY, F. KENT, and JAMES GARBER, eds., *Ancient Objects and Sacred Realms*. Austin: University of Texas Press, 2004

ROMAIN, WILLIAM F., *Mysteries of the Hopewell: Ohio History and Culture*. Akron: University of Akron Press, 2000

RUSHING, W. JACKSON III, *Native American Art in the Twentieth Century: Makers, Meanings, Histories*. New York: Routledge, 1999

RUSHING, W. JACKSON III, *Native American Art and the New York Avant-garde: A History of Cultural Primitivisim*. Austin: University of Texas Press, 1995

RUSHING, W. JACKSON, and KAY WALKING STICK, eds., "Recent Native American Art," *The Art Journal*, vol. 5, no. 3 (Fall, 1992): 6–27

SAMUEL, CHERYL, *The Raven's Tail*. Vancouver: University of British Columbia Press, 1987

SHADBOLT, DORIS, *Bill Reid*. Seattle: University of Washington Press, 1986

SZABO, JOYCE M., *Howling Wolf and the History of Ledger Art*. Albuquerque: University of New Mexico Press, 1994

THOM, IAN M., *Robert Davidson: Eagle of the Dawn*. Seattle: University of Washington Press, 1993

THOMAS, DAVID HURST, *Exploring Ancient Native America*. New York: Macmillan, 1994

TOWNSEND, RICHARD, *The Ancient Americas: Art from Sacred Landscapes*. Chicago: The Art Institute, 1992

TOWNSEND, RICHARD, *Hero, Hawk, and Open Hand: American Indian Art of the Ancient Midwest and South*. New Haven: Yale University Press, 2004

WADE, EDWIN, ed., *The Arts of the North American Indian: Native Traditions in Evolution*. New York: Hudson Hills Press, 1986

WITHERSPOON, GARY, *Language and Art in the Navajo Universe*. Ann Arbor: The University of Michigan Press, 1994

WYATT, GARY, *Mythic Being: Spirit Art of the Northwest Coast*. Seattle: University of Washington Press, 1999

CHAPTER 9

BERLO, JANET C., *Native North American Art*. Oxford: Oxford University Press, 1998

COLE, HERBERT M., *Icons: Ideals and Power in the Art of Africa*. Washington, D.C., and London: National Museum of African Art and the Smithsonian Institution Press, 1989

D'ALLEVA, ANNE, *Art of the Pacific*. London: Weidenfeld and Nicolson, and New York: Harry N. Abrams, 1998

FERGUSON, RUSSELL, ed., *At the End of the Century: One Hundred Years of Architecture*. Los Angeles: The Museum of Contemporary Art, and New York: Harry N. Abrams, 1998

FISHER, JEAN, "Yinka Shonibare: Camden Arts Centre, London," *Artforum International*, 39, no.1 (2000): 186

GAO MINGLU, ed., *Inside Out: New Chinese Art*. Berkeley, Los Angeles, and London: University of California Press, 1998

KAMIN, BLAIR, *Terror and Wonder: Architecture in a Tumultuous Age*. Chicago: University of Chicago Press, 2010

LEE, JAMES, "Yi Bul: The Aesthetics of Cultural Complicity and Subversion," *Asian Women Artists*, ed. Dinah Dysart and Hannah Fink. Roseville East: Craftsman House, 1996: 34–41

MUNROE, ALEXANDRA, *Japan After 1945: Scream Against the Sky*. New York: Harry N. Abrams, Inc., 1994

MUNROE, ALEXANDRA et al., *Yes Yoko Ono*. Harry N. New York: Abrams, 2000

OBRIST, HANS ULRICH, and LEE BUL, "Cyborgs and Silicon: Korean Artist Lee Bul about her Work," *Art Orbit*, no. 1 (March, 1998)

PERANI, JUDITH, and FRED T. SMITH, *The Visual Art of Africa: Gender, Power, and Life Cycle Rituals*. Upper Saddle River: Prentice Hall, 1998

RUSHING, W. JACKSON, and KAY WALKING STICK, eds., "Recent Native American Art," *Art Journal*, vol. 5, no. 3 (Fall, 1992): 6–27

SILVERMAN, RAYMOND A., ed., *Ethiopia: Traditions of Creativity*. Seattle: University of Washington Press, 1999

SULLIVAN, MICHAEL, *Art and Artists of Twentieth-Century China*. Berkeley, Los Angeles, and London: University of California Press, 1996

VERCOE, C., and R. LEONARD, "Pacific Sisters: Doing it for Themselves," *Art Asia Pacific*, 14 (1997): 42–5

VINE, RICHARD, *New China, New Art*. New York: Prestel, 2008

PICTURE CREDITS

Laurence King Publishing, the author, and the picture researcher wish to thank the institutions and individuals who have kindly provided photographic material. Collections are given in the captions alongside the illustrations. Sources for illustrations not supplied by museums or collections, additional information, and copyright credits are given below. Numbers are figure numbers unless otherwise indicated.

While every effort has been made to trace the present copyright holders we apologize in advance for any unintentional omission or error and will be pleased to insert the appropriate acknowledgment in any subsequent edition if informed.

Abbreviations
AA: Art Archive, London; AKG: AKG-images, London; BAL: The Bridgeman Art Library, London; RHPL: Robert Harding Picture Library, London; WFA: Werner Forman Archive, London

1.1 © Dirk Bakker/BAL; **1.2** Courtesy of the Missouri Historical Society, St. Louis; **1.3** © National Geographic Image Collection/Alamy; **1.4** © 2012 Banco de México Diego Rivera & Frida Kahlo Museums Trust, México D.F./DACS; **1.5** DEA/G. DAGLI ORTI/Getty Images; **2.1** Corbis/Reuters/Zainal Abd Halim; **2.2, 2.3** B.O'Kane/Alamy; **2.5** AA/Dagli Orti; **2.6** Bildarchiv Preussischer Kulturbesitz, Berlin/SCALA, Florence; **2.7** © Witold Skrypczak/Alamy; **2.8** © Alain Machet (4)/Alamy; **2.9** © imagebroker/Alamy; **2.10** Simmons Aerofilms Ltd; **2.11** © The Trustees of the Chester Beatty Library, Dublin. Is. 1422; **2.12** BAL; **2.13** AA/Dagli Orti; **2.14** Arthur M. Sackler Gallery, Smithsonian Institution, Purchase – Smithsonian Unrestricted Trust Funds, Smithsonian Collections Acquisition Program, and Dr. Arthur M. Sackler, S1986.103; **2.15** RHPL/Gavin Hellier; **2.16** AKG/Erich Lessing; **2.19, 2.20** RHPL/Robert Harding; **2.21** RMN-Hervé Lewandowski; **2.22** Victoria and Albert Museum, London; **2.23** AKG/Erich Lessing; **2.24** © Images & Stories/Alamy; **2.25** Photograph © 1986 The Metropolitan Museum of Art/Scala, Florence; **2.26** Corbis/Paul H. Kuiper; **2.28** © Tibor Bognar/Corbis; **3.2** (left) AA/Dagli Orti; **3.3** National Museum of India, New Delhi, India/BAL; **3.4** © Asia Alan King/Alamy; **3.5** Scala, Florence; **3.6** RHPL/Adam Woolfitt; **3.7** RHPL/Richard Ashworth; **3.8** Dinodia/Alamy; **3.9** © Atlantide Phototravel/Corbis; **3.11** © The Trustees of the British Museum; **3.12** Ancient Art & Architecture Collection Ltd/Alamy; **3.13** © RHPL/Alamy; **3.14** Dinodia/Alamy; **3.15** RHPL/I. Griffiths; **3.16** courtesy Rossi & Rossi, London; **3.17** RHPL/Gavin Hellier/Alamy; **3.18** RHPL/David Holdsworth; **3.19** RHPL/Rolf Richardson/Alamy; **3.20** RHPL/Alamy; **3.21** RHPL/Adam Woolfitt; **3.22** © Muthuraman Vaithinathan/Alamy; **3.24** © Angelo Hornak/Alamy; **3.25** RHPL; **3.26** Museum Rietberg, Zürich. Eduard von der Heydt Collection. Photo: Wettstein & Kauf; **3.27** RHPL/Alamy; **3.29** RHPL/Richard Ashworth/Alamy; **3.30** RHPL/Gavin Hellier; **3.31** RHPL/Sassoon; **3.32** Julia Ruxton, London; **3.33** RHPL/J.H.C. Wilson/Alamy; **3.34** Chester Beatty Library/BAL; **3.35** Freer Gallery of Art, Smithsonian Institution, Washington, D.C., purchase #F1942.15.a; **3.36** Getty/Image Bank/Andrea Pistolesi; **3.37** RHPL/Victor Kennet; **3.38** Victoria and Albert Museum, London, UK/The Stapleton Collection/BAL; **3.39, 3.40** Dinodia/Alamy; **3.41** Photo: Phillip de Bay; **3.42** © Danny Lehman/Corbis; **3.43** © Exotica.im 16/Alamy; **4.2** Cultural Relics Publishing House, Beijing; **4.3** Seattle Art Museum. Gift of Mrs. Donald E. Frederick. Photo Paul Macapia; **4.4** Corbis/WFA; **4.6** Freer Gallery of Art, Smithsonian Institution, Washington D.C., (purchase # F1940-11ab); **4.7** © Cleveland Museum of Art. Anonymous gift # 1952.584; **4.8** © tbkmedia.de/Alamy; **4.9** John Fleming & Hugh Honour; **4.10** Cultural Relics Publishing House, Beijing; **4.11** RHPL/V. Kennet; **4.12** AKG/Erich Lessing; **4.13** Cultural Relics Publishing House, Beijing; **4.14** © British Library Board. All Rights Reserved/BAL; **4.15** Cultural Relics Publishing House, Beijing; **4.16** © The Trustees of the British Museum; **4.17** Photo © 2006 Museum of Fine Arts, Boston. Denman Waldo Ross Collection #31.643; **4.20** Photo: Unei Kyoryokukai; **4.21** DNP Archives.com/Daitokuji, Tokyo; **4.23** Freer Gallery of Art, Smithsonian Institution, Washington, D.C., purchase # 1930.8; **4.25** Purchase: Nelson Trust # 40-45/1,2. The Nelson-Atkins Museum of Art, Kansas City. Photo E.G. Schempf; **4.26** Victoria and Albert Museum, London; **4.27** Purchase: acquired through the generosity of the Hall Family Foundations and exchange of other Trust Properties #86-3/6. Photo: Robert Newcombe; **4.29, 4.30** Cultural Relics Publishing House, Beijing; **4.31** Collection C.C. Wang family; **4.32** Photo: Ole Woldbye; **4.34** Keystone/Hulton Getty Picture Collection Ltd, London; **4.35** Michael Sullivan, Oxford; **5.1** AA; **5.2** Getty Images/Yoichi Tsukioka; **5.3** AA ; **5.4** Courtesy Jingu Administration Office; **5.7** © Aflo/Aflo/Corbis; **5.8** BAL/Asuka-en, Nara; **5.9** Paul Quayle; **5.10** Sakamoto Photo Research Laboratory; **5.11** Panoramic Images/Getty Images; **5.12** Scala, Florence/Art Resource; **5.13** Freer Gallery of Art, Smithsonian Institution, Washington, D.C., purchase # F1969.4; **5.14** Tokugawa Art Museum, Nagoya; **5.15** Photo © 2006 Museum of Fine Arts, Boston, Fenollosa-Weld Collection # 11.4000; **5.16** Photo Institute for Art Research, Tokyo; **5.17** © ILYA GENKIN/Alamy; **5.18** Brooklyn Museum, Gift of Mrs Darwin R. James III (#56.138.1 a&b); **5.19** Photo: Unei Kyoryokukai; **5.20** Paul Quayle; **5.21** WFA; **5.22** Courtesy Agency for Cultural Affairs, Tokyo; **5.23** BAL; **5.24** WFA; **5.25** Sakamoto Photo Research Laboratory; **5.26** Freer Gallery of Art, Smithsonian Institution, Washington, D.C., gift of Charles Lang Freer # (F1899.34); **5.27** Photo:

Shimizu Kogeisha; **5.28** © Sakamoto Photo Research Laboratory/CORBIS; **5.30** National Museum, Seoul, Korea/BAL; **5.31** © Cleveland Museum of Art. Bequest of James Parmelee #1940.1031; **5.32** Private collection; **5.33** Victoria and Albert Museum, London; **5.34** Ishibashi Museum of Art, Ishibashi Foundation, Kurume, Fukuoka prefecture. Photo: Tomokazu Yamaguchi; **5.35** BAL/Fitzwilliam Museum, University of Cambridge; **5.36** Van Gogh Museum, Amsterdam. Vincent van Gogh Foundation #S114V/1962; **5.37** © Photo Japan/Robert Harding World Imagery/Corbis; **5.38** © Kazuo Shiraga Former members of the Gutai group Courtesy Ashiya City Museum of Art & History, Japan; **5.39** Ronald Grant Archive, London/Teshigahara; **5.41** Museum of Art, Kochi. Photo courtesy Council for the International Biennale in Nagoya. © Yanagi Yukinori; **6.1** © Museum Victoria, Melbourne; **6.2** © DACS, 2012; **6.4** WFA; **6.5** Photo: Peter Horner; **6.6** Metropolitan Museum of Art, New York. Michael C. Rockefeller Memorial Collection of Primitive Art, Gift of Nelson A. Rockefeller and Mrs Mary Rockefeller, 1965 # 1978.412.1248, 1249 & 1250/Scala, Florence; **6.7** Photo: Peter Horner; **6.8, 6.9** from *Prehistoric Architecture in Micronesia* by William N. Morgan. Copyright © 1988. By permission of the author and the University of Texas Press, Austin; **6.10** Adrienne L. Kaeppler, Washington, D.C. 1992; **6.11** Courtesy of Donald Rubinstein. Peabody Essex Museum, Salem. On loan from Donald Rubinstein, Guam; **6.12** Private collection; **6.13** AA/Dagli Orti; **6.14** Courtesy David Bateman Ltd, Auckland/Photo: Krzysztof Pfeiffer; **6.15** Pesi Fonua at Vava'u Press; **6.16, 6.17** © The Trustees of the British Museum; **6.18** Robert Estall, Sudbury, Suffolk; **6.19** AA; **6.22** Lonely Planet Images/Alamy; **7.1** Robert Estall Photo Library, Sudbury, Suffolk/Beckwith Fisher; **7.2** Robert Estall Photo Library, Sudbury, Suffolk/David Coulson; **7.3** © RHPL/Alamy; **7.4** Photo: Bernd-Peter Keiser, Braunschweig; **7.5, 7.7** BAL/Heini Schneebeli; **7.8** WFA/Christie's Images; **7.10, 7.11** © Dirk Bakker/BAL; **7.12** John Pemberton III, Amherst, MA; **7.14** Private collection; **7.15** Eliot Elisofon, 1970. Eliot Elisofon Photographic Archives, National Museum of African Art, Smithsonian Institution, Washington, D.C., # 1 BNN 2.4.3 (7590); **7.16, 7.17** © The Trustees of the British Museum; **7.18** Phyllis Galembo (from *Divine Inspiration from Benin to Babia*, University of New Mexico Press 1993); **7.19** © The Trustees of the British Museum; **7.20** Henry J Drewal. Henry J. & Margaret Thompson Drewal Collection. Eliot Elisofon Photographic Archives, National Museum of African Art, Smithsonian Institution, Washington D.C. # 1992-028-00639; **7.21** Herbert Cole, Santa Barbara; **7.22** Marie Pauline Thorbecke. Historisches Fotoarchiv, Rautenstrauch-Joest Museum für Völkerkunde, Cologne #19336; **7.23** BPK, Berlin/Scala Florence; **7.25** © Gavin Hellier/Alamy; **7.26** WFA; **7.27** © Seattle Art Museum/Corbis; **7.28** Sabena Jane Blackbird/Alamy; **7.29** October Gallery, London; **7.30** © Robert Estall photo agency/Alamy; **7.31** Courtesy and © George Hallett; **7.32** Photo: Gordon Blaker; **7.33** Photo © 2006 Museum of Fine Arts, Boston. Bequest of Maxim Karolik #64.619; **7.34** Scala/Art Resource, New York/National Museum of American Art, Washington, D.C. # 1970.353.1; **7.35** Photo Courtesy DC Moore Gallery, New York. © Romare Bearden Foundation/DACS, London/VAGA, New York 2012; **8.1** Photo © 2006 Museum of Fine Arts, Boston (William A. Paine Fund #31.501); **8.4** © Nathan Benn/Corbis; **8.5** Courtesy Donna McClelland & Christopher Donnan 1979; **8.7** NGS Image Collection/Ned Seidler; **8.8** © Tina Manley/Alamy; **8.9** Photo © 2006 Museum of Fine Arts, Boston (Charles Potter Kling Fund #1978.46); **8.10, 8.11** Michael Kampen O'Riley; **8.12** © Thomas Cockrem/Alamy; **8.13** AA/Dagli Orti; **8.14** RHPL/Robert Frerck; **8.17** WFA; **8.18** Scala, Florence; **8.20** © 2005, Kimbell Art Museum, Fort Worth, Texas/Photo Robert I Newcombe; **8.21** © Andrea Di Martino/Alamy; **8.22** Justin Kerr/Kerr Associates, New York/The Art Museum, Princeton University, New Jersey. #65-4-511; **8.23** © John Elk III/Alamy; **8.24** Angelo Hornak/Alamy; **8.25** © Merle Greene Robertson 1976; **8.26** Jean-Pierre Courau/BAL; **8.27** Courtesy Peabody Museum, Harvard University; **8.28** AA/Dagli Orti; **8.29** RHPL/Robert Frerck; **8.30** AA; **8.31** © Esther Pasztory 1972; **8.32** © Cleveland Museum of Art, Purchase from the J.H. Wade Fund. #1973.3; **8.33** Bill Ross/© Corbis RF/Alamy; **8.35** Angelo Hornak/Alamy; **8.36** RHPL/Bildagentur Schuster; **8.37** AA/Dagli Orti; **8.38** BAL; **8.39** © The Trustees of the British Museum; **8.40** Bodleian Library, Oxford. # MS Arch. Seldon.A.1, f.2r; **8.41** AA/Dagli Orti; **8.42, 8.43** © 2012 Banco de México Diego Rivera & Frida Kahlo Museums Trust, México D.F./DACS; **8.44** © Ohio Historical Society, Columbus; **8.45** Corbis/Richard A. Cooke; **8.46** Private collection; **8.50** Library of Congress; **8.51** Courtesy Alaska Historical Library, Juneau; **8.52** National Museum of the American Indian, New York. Bequest of Clarence H. Young. Photo: Walter Larrimore; **8.53** Reinhard Derreth, Vancouver; **8.54** AA; **8.55** Scala/Art Resource/Smithsonian American Art Museum, Washington, D.C. Gift of Mrs Joseph Harrison, Jr. 1985.66.507; **8.56** Peter T. Furst, Santa Fe; **8.57** National Museum of the American Indian, Smithsonian Institution, Washington, D.C. Photo David Heald 11/7680; **8.58** Peter T. Furst, Santa Fe; **8.59** AA/Buffalo Bill Historical Center, Cody, Wyoming; **8.60** Courtesy of Santa Barbara Studios and Pathways Productions, Santa Barbara, CA; **8.61** Corbis/Tom Bean; **8.62** Courtesy Museum of New Mexico, Santa Fe; **8.63** Corbis/Underwood and Underwood; **8.64** RHPL/P. Koch; **8.65** Corbis/Henry Peabody; **8.66** Photo Herbert Lotz, Santa Fe, NM; **8.67** Natural History Museum of Los Angeles County. The William Randolph Hearst Collection. # A.5141.42-151; **8.69** Courtesy and © HKG Architects; **9.1** Courtesy and © the Artist; **9.2** © Michael Kemp/Alamy; **9.3** © Emmanuel Lattes/Alamy; **9.4** Axiom Photographic Agency, London/M. Winch; **9.5** © City Image/Alamy; **9.6** © Gavin Hellier/Alamy; **9.7** Corbis/Reuters/John Schults

INDEX

Abbasid Caliphate 25, 36-8, 39
Abe, Kobo 194
Abe, Shuya 195
abedun adekai (carved fantasy coffins) 260-2, 268, **7.30**
Abelam people 208; ceremonial houses 208, **6.5**
Aboriginals, Australian 204-7; *The Aboriginal Memorial* (Dhatangu and others) 224-5, **6.23**; the Dreaming 205, 206, 225, 226, **6.23**; installation art 224-5, **6.23**; paintings 205-7, **6.1**, **6.2**
Abstract Expressionism 99, 193, 195
Abu, Mount, India: Jain temples 89, **3.33**
Abu Dhabi 354
Abu'l-Fazl Presenting the First Book of the "Akbarnama" to Akbar (Govardhan) 90, **3.34**
Achaemenid Persians 41
Adena culture 314, 315, 317; grave goods 315; human effigy pipe 315, **8.44**
Admonitions of the Instructress to the Ladies of the Palace (Gu Kaizhi) (silk handscroll) 122-3, **4.14**
adobe bricks 256, 268, 333
Aesthetic Gommata, The, Indragiri Hill, Karnataka, India 88-9, **3.32**
Afghanistan: Buddhist sculpture 74, **3.15**
Africa/African art 14-1, 230-3, 266, 267; Central 240-2; East 238-40; map 230; masks 231-2, 235, 238, 249, 251, 268, **7.1**, **7.17**, **7.20**; postcolonial 258; religion 239-40, 249-50, 257, 263, 264, **7.6**, **7.18**, **7.33**; "Scramble for Africa" 258; slave trade 15, 233, 234, 258, 263-4; Southern 235-7; time chart 231; and trade 233-4, 237; West 242-58 *see also* basketmaking; ivories; painting; sculpture; individual countries
African Foundation of Fashion Design, Mali 259
African-Americans 263, 266-7; ceramics 263-4, **7.32**; quilts 264-5, **7.33**
Agbonbvbare, Madame 249, 250, **7.18**
Agra, India 90; Taj Mahal 92-4, **3.36**
Ah Maxam 291
abu 219, 220, 226
Ai Weiwei 348-50; "Bird's Nest" Olympic Stadium, Beijing 349; *Remembering* 349; *Sunflower Seeds* 349, **9.2**
Airowayoye I of Orangun-ila (Yoruba ruler) 246, **7.12**
'airport art' 232, 268
Ajanta, India 73, **3.14**; *The Beautiful Bodhisattva Padmapani* 73, **3.14**
Akbar (Mughal Emperor) 90
Akbarnama 90, **3.34**
Akshardam Swaminarayan Temple Complex, New Delhi, India 99-101, 347, **3.42**, **3.43**
Al-Aqsa Mosque, Jerusalem 29
Alhambra, Granada 34-6: Court of the Lions 34-6, **2.9**
al-Hariri: *Maqamat* 38, **2.12**
al-Jahiz 28
altars: Benin 247, 249, **7.15**, **7.18**
altepetl 299, 300, 307, 308
Ambum Stone, Papua New Guinea 207-8, **6.4**
Americas, the 15, 272-3; maps 274, 287, 313, 330; time charts 274, 286, 312 *see also* Native American art; Pre-

Columbian art; South America
Amitabha (Amida) Buddha 66, 124-5, 146, 162-4, **4.15**, **5.12**
Ananda Attending the Parinirvana of the Buddha (Sri Lanka) 77, **3.18**
Ananda Temple, Pagan, Myanmar 77, **3.19**
Anang, Eric Adjetey 261
Anasazi, the 330
Anatolia 50-4
ancestor worship: Africa 230-1, 237, 238, 240, 250, 266; Australian Aborigines 203-4, 205; China 108, 111, 112, 125; Japanese 169; Maori 222, 223; New Guinea 208, 209, **6.6**; Pacific Islanders 203-4; Polynesia 214-15
Andean culture 274
Angel Carrying Arquebus ("dressed statue," Cuzco) 285, **8.13**
Angkor Thom, Cambodia: Bayon temple 87, **3.31**
Angkor Wat, Cambodia: 86-7, **3.30**
aniconic art 28, 56, 64
Anthemis of Tralles (with Isidorus of Miletus): Hagia Sophia, Istanbul 50-1, **2.23**
Aquinas, St Thomas: *Summa Theologica* 35
arabesques 28, 36, 40, 47, 56
Arabian Nights *see* One Thousand and One Nights
Arabic language 26, 27, 37-8
Arapaho, the 324, **8.59**
Arapoosh (Sore Belly): war shield 327, **8.57**
Archaic period (North America) 314-15
architectonic painting 300, 342
architecture: Africa: 236-7, 252-4, 255, **7.3**, **7.24**; Cambodia 86-7, **3.30**, **3.31**; China: (Period of Disunity) 121; (Qing) 138-40, **4.28-4.30**; (Shang) 111; (temples) 109-10, **4.1**; India: (British colonial) 96; (Buddhist) 61-2, 65-70, 73, **3.5**, **3.6**, **3.8-3.10**; (Hindu) 61, 80-4, 85-6, 99-101, **3.22-3.25**, **3.27-3.29**, **3.42**, **3.43**; (Indus Valley) 62; (Jain) 89; (Mughal) 92-4, **3.36**; Indonesia (Buddhist) 78, 214, **3.20**; Japan (Buddhist) 158-60, 163-4, 179, **5.7**, **5.11**; (Heian) 166, 167, **5.11**; (Kamakura) 168, **5.15**; (modern/post-1912) 192, **5.37**; (Momoyama) 175-8, **5.21**, **5.22**, **5.25**; (Nara) 161-2, **5.9**; (Shinto) 154-5, 173, **5.4**; (Tokugawa) 182-4, **5.28**, **5.29**; Malaysia 351-2, **9.4**; Maori 204, 221-4, 226, **6.19**, **6.20**; Melanesia 207, 208, 210-11, **6.5**, **6.7**; Micronesia 211-13, 226, **6.8-6.10**; Myanmar 77, **3.19**; Native American 321, 324-5, 330-3, 341, 342, **8.51**, **8.60**, **8.61**, **8.64**, **8.69**; Pre-Columbian 273, 283-4, 286, 293-6, 298-306, **8.10-8.12**, **8.15**, **8.21**, **8.23**, **8.24**, **8.28-8.30**, **8.35-8.37**; Tibet 76-7, **3.17**; Timurid 42-3, **2.15**; Umayyad 32-6, 36, **2.6**, **2.7**, **2.8**, **2.9**; United Arab Emirates (UAE) 352-4, **9.5**, **9.6**; *see also* mosques
Ardabil carpets 49, **2.22**
Ardashir Captures Ardavan (from the *Shahnama*) 41, **2.14**
Ardashir I, King of Persia 41, **2.14**
Arifi: *The Siege of Belgrade* (from the *Sulaymannama*) 54, **2.27**
Armani, Giorgio 354
Aryans 64
Ashikaga period (Japan) *see* Muromachi (Ashikaga) period (Japan)
Ashoka, Maurya emperor 64-5, 65-6;

lion capital 65, **3.4**
Asmat people: ancestral poles 209-10, **6.6**
Asuka period (Japan) 158-60
Atahualpa 284
atman 64, 102
Australia 204-5, 224, 225 *see also* Aboriginals, Australian
Averroes 35
Avicenna: *Canon of Medicine* 35
Avalokitesvara 66
Aztecs, the 18-20, 272, 273, 286, 299, 305, 307-9; ball games 294; Calendar Stone 308, **8.41**; Codex Mendoza 307-8, **8.40**; gods and goddesses 18-19, 20, 299, 307, 308-9, **1.5**; sculpture 18-19, 20-21, **1.5**

Babur (Mughal Emperor) 89-90
backstrap looms 275, 342
Baghdad, Iraq 36, 38, 42
Bahram Gur in the Green Pavilion (Shaykhi) 45, **2.17**
bai 212-13, 226, **6.10**
Bai Juyi 126
Bai-ra-Irrai, Belau 212-13, **6.10**
ball game (Mesoamerica) 292, 293, 294, 301-2, 342, **8.21**, **8.32**, **8.33**
Bamana, the 232: *Chi Wara* antelope headdress 257-8, 267, **7.26**
Bamiyan, Afghanistan 121; Colossal Buddhas 74, **3.15**
Bamum people, Cameroon 254: palace at Foumban 255, **7.24**
Barabudur *see* Borobudur
bark cloths: Micronesian 213; Polynesian 216, **6.14**
bark painting, Aboriginal 205-6, **6.1**
Basho, Matsuo 174
basketmaking: Africa 239, **7.5**; Native American 313-14, 326, **8.56**
Bayon temple, Angkor Thom, Cambodia 87, **3.31**
Beaded Dress (Sky Arrow) 327, **8.58**
beadwork: African 244-6, **7.12**; Native American 326, 327, 328, **8.56**, **8.58**
Bearden, Romare 266-7: *Mecklenburg County, Daybreak Express* 267, **7.35**
Beautiful Bodhisattva Padmapani, the (Ajanta, India) 73, **3.14**
Beauvoir, Simone de: *The Second Sex* 355
Beijing National Stadium *see* "Bird's Nest" Olympic Stadium, Beijing
Beijing Spring (China) 145, 348
Beijing, China 116; "Bird's Nest" Olympic Stadium 349; Imperial Palace 134, 138-40, **4.28**, **4.29**; 789 Arts Zone 347
Bengal Renaissance 97-8
Benin/Benin City, Africa 233, 234, 246-50, 268, **7.13**, **7.14**; altars 247, 249, **7.15**, **7.18**; bronzes 247, 248, **7.16**; ivories 248, 249, **7.17**; terracottas 247, 248
Bhagavad Gita, the 79, 81, 102
Bhaja, India: chaitya hall 68, **3.8**
bhakti 13, 80, 81, 85, 94, 102
Bharat Mata (Tagore) 98, **3.40**
Bichitr, *Jahangir Preferring a Sufi to Kings* 90-2, 3.34
Bihzad 43, 45, 90; *The Seduction of Yusuf* 43-4, **2.16**
"Bird's Nest" Olympic Stadium, Beijing (Ai Weiwei/Herzog & de Meuron) 349
bisj mbu ceremony 209-10, 226, **6.6**
blankets: Chilkat 322, **8.52**; Navajo 337, **8.67**; Tlingit 322, **8.52**
bodhisattvas 14, 66, 70, 73, 75, 87, 124-5, 157-8, **3.14**, **3.16**, **4.15**, **5.6**
body art *see* tattooing
bogolanfini 258-9, 268, **7.27**
Bolivia 282

Bollywood (Indian film industry) 99
Bonampak, Mexico: murals 297-8, **8.27**
books: Islamic 37 *see also* calligraphy; codices; manuscripts; Qur'an
Borobudur, Java: 78-9, 214, **3.20**
boshan lu (Han bronze) 119, 120, **4.11**
Boucher, François, *Le Chinois gallant* 142, **4.32**
Boxer Rebellion (China) 143-4
Brahma (Hindu deity) 81
brahman/Brahmanism 13, 60-1, 64, 66, 79-80, 81, 84, 102
brahmins 62, 81, 102, 129
Brash Brands, London 354
Bridge in the Rain, The (van Gogh) 191, **5.36**
Brihadesvara temple, *see* Rajarajeshvara temple
British East India Company 95
bronzes: Benin 244, 248, **7.16**; Chinese (Han) 119, 120, **4.11**, **4.12**; (Shang) 112-14, **4.3**; (Xia) 111; (Zhou), 114-15, **4.6**; Japanese 153, 157-8, **5.6**; Korean 157-8, **5.6**; lost-wax metal casting 243, 244, 268; piece-mold casting 114, **4.5**
Buddha (Siddhartha Gautama) 61, 65, 66, 79, 102, 129; images and statues 13-14, 65, 66, 67-8; (Afghanistan) 74, **3.15**; (China) 121, **4.13**; (India) 70-1, 72-3, **3.11**, **3.13**; (Indonesia) 78; (Japan) 162-4, 196, **5.10**, **5.12**, **5.40**; (Sri Lanka) 77, **3.18**; (video art) 196, 347, **5.40**
Buddhism 13-14, 60, 61, 66, 102; Chan/Zen 14, 109, 126, 128, 129, 130, 131, 132, 146, 151-2, 155, 170-2, 174, 179, 186, 193, 195, 199, 354; Esoteric 151, 162, 198; Hinayana 70, 77, 102; Mahayana 66, 70, 74, 78-9, 86, 87, 102, 158; Pure Land Buddhism 124, 129, 147, 151
Buddhist art and culture: 14, 61-2, 65-6, 174-5; architecture 14, 61-2, 65-70; (India) 61-2, 65-70, 73, **3.5**, **3.6**, **3.8-3.10**; (Indonesia) 78, 314, **3.20**; (Japan) 154-5, 158-60, 163-4, **5.4**, **5.7**, **5.11**; (Myanmar) 77, **3.19**; (Tibet) 76-7, **3.17**; gardens: 172-3, **5.20**; painting: (China) 124-7, 130-1, 135, **4.15**, **4.16**, **4.21**, **4.24**; (India) 65-6, 68, 73, **3.4**, **3.7**, **3.14**; (Japan) 162-4, 196, **5.10**, **5.19**; (Tibet) 74-6, **3.16**; sculpture (see also Buddha: images and statues); (India) 64-5, 70-3, **3.4**, **3.7**, **3.12**; (Korea) 157-8, **5.6**; (Sri Lanka) 72-3, **3.13**
burial mounds *see* tombs
Burj Al Arab Hotel (WS Atkins PLC), Dubai 352-3, **9.5**
Burj Khalifa (Skidmore, Owings and Merrill), Dubai 352, 353-4, **9.6**
Burma *see* Myanmar
Bustan (Sa'di): 43, 44, **2.16**
byobu (Japanese folding screens) 177-8, 198, **5.23**, **5.24**
Byodo-in complex, Uji, Japan: Ho-o-do (Phoenix Hall) 163, 180, 192, **5.11**
Byzantine Empire 25, 27, 29, 50-1; mosaics 30, 31

Cage, John 195, 355
Cahokia, Illinois 317-18; Monk's Mound, Cahokia 318, **8.47**
calendar systems: Aztec Calendar Stone 308, **8.41**; Mesoamerican 287, 308; Mayan 289, 308; Muslim 26
calligraphy: Chinese 14, 109, 110, 113, 122, 123-4, 130, 143, 146, **4.14**, **4.33**; Islamic 28, 37, 41, 46, 52, 56, 166, **2.25**; Japanese 164, 166, 180, 181, 186, 187, **5.13**; Maya 18, 289,

290-1, 292, **8.17** see also writing systems
Cambodia: Angkor Wat 86-7, **3.30**; Bayon Temple, Angkor Thom 87, **3.31**
Cameroon 254-5; thrones and palaces 254, **7.22-7.24**
Canon of Medicine (Avicenna) 35
Cape Town: South African National Gallery 262, **7.31**
caravanserais 46, 56
Caroline islands: Bai-ra-Irrai, Belau 212-13, **6.10**; textiles 213, **6.11**
carpets, Islamic 48-9, **2.22**
Catlin, George: The Last Race, Part of Okipa Ceremony (Mandan) **8.55**; Mato-Tope (Four Bears) 324, 327, **8.54**
celadon ware (Korea) 170, 198, **5.18**
ceques 283, 342
ceramics: African-American 263-4, **7.32**; Chinese 52, 109; (Ming) 134-6, 146, **4.25**; (Neolithic) 110, 113; (Song) 128, 132, **4.22**; (Tang) 132; Chinoiserie 142; Japanese 152-3, 180-1, 198, **5.1**, **5.26**; Korean 170, 180, **5.18**; Lapita 207, **6.3**; Maya 290, 291, 293, **8.20**, **8.22**; Moche 279, **8.4**, **8.5**; Native North American 313-14, 334, **8.65**, **8.66** see also porcelain
Chac (Mayan deity) 298-9, **8.29**
chacmool 305, 306, 342
Chaco Canyon, New Mexico: Pueblo Bonito 330-1, 332, **8.60**
chaitya halls 68-70, 73, 83, 102, **3.8**, **3.9**, **3.10**
Chan Buddhism 14, 109, 126, 128, 129, 130, 131, 132, 146, 171, 172-3
ChanChan, Chimu Empire 280, 283, **8.6**
Chand, Sansar 95
Chang'an, China 124, 125, 138, 161, 170
chanoyu 178, 198
Chavín de Huántar/Chavín art 276-7, 282
Cheyenne, the 324
Chi Wara: antelope headdress 257-8, 268, **7.26**
Chibunda Ilunga (Chokwe) 241, **7.8**
Chichén-Itzá, Mexico 306; The Nunnery 298, 305, **8.29**; Temple of the Warriors 305, **8.36**
Chilkat blankets 322, **8.52**
Chimu Empire 280
China 106-10: Buddhism 109, 121, 126; Confucius/Confucianism 108, 109, 115, 116, 118, 119, 121, 122, 125, 133, 146; contemporary art market 347; Daoism 108, 109, 118, 119-20, 121, 124, 129, 139, 146, 173; Five Dynasties period 128; Dao de jing (Lao Zi) 108, 146; Han dynasty 109, 113, 116, 118-20, 135, 140, 150, 156, 158, **4.10**; Liangzu culture 110, **4.2**; map 106; Ming dynasty 52, 134-7, 146, **4.24-4.27**; modern (post-1911) 144-5, 346-51, **9.1**, **9.2**; Neolithic period 110-11, 112; Period of Disunity ("Six Dynasties") 121-24, 156; Qin dynasty 106, 113, 116-18; Qing dynasty 138-43; Shang period 108, 111-14, 123, **4.3**, **4.4**; Song dynasty 109, 128, 171; Sui dynasty 124; Tang dynasty 120, 124-6, 136, 161, 162, 185; time chart 107; tombs 108, 111-12, 113; and trade 14, 108, 142, 143, 145; Warring States period 115-16; Wei dynasty 121-4; writing and calligraphy 109, 110, 111, 113, 118, 122, 123-4, 130, 143, 146, 161, **4.14**, **4.33**; Xia dynasty 106, 111; Yuan dynasty

52, 132-34, 136, 140, **4.30**; Zhou dynasty 114-15, 116, **4.6**
Chinois gallant, Le (Boucher) 142, **4.32**
chinoiserie 14, 142, 146
Chokwe, the: Chibunda Ilunga 241, **7.8**
chumon 158, 198
Chunkey player shell engraving 319, 320, **8.48**
Clerical script (Chinese) 123
Coatlicue (Aztec sculpture) 18-19, 20-21, 309, **1.5**
Codex Mendoza 307-8
Codex Nuttall 306-7, **8.39**
codices 342: Aztec 307-8, **8.40**; Mayan 290, **8.18**; Mixtec 306-7, **8.39**
coffin workshops, Ga, Ghana 260-2, 268, **7.30**
collages 267, **7.35**
conceptual Art 195, 348, 354 see also performance art
Confucius/Confucianism 14, 108, 109, 110, 115, 116, 118, 120, 121, 122, 125, 133, 146, 150, 175, 184; Liji ("Book of Rites") 115, 146
cong jades 110-11, **4.2**
Constantinople see Istanbul
Cook, Captain James 215, 216, 219
Copán, Honduras: Maya stela 297, **8.26**
Córdoba, Spain 35: Great Mosque 33-4, **2.7**, **2.8**
Court of Gayumars, The (Sultan-Muhammad) 46, **2.18**
Crane Scroll, The (Koetsu and Sotatsu) 181, **5.27**
Crow, the 324; war shield (Arapoosh) 327, **8.57**
Ctesiphon, Iraq 25, 36
Cultural Revolution (China) 144-5
cun brushstroke 128, 129, 146
Cursive script (Chinese) 123
Cut Piece (Ono) 354, 355, **9.7**
Cuzco 274, 279, 280, 283, 285, **8.10**
Cypress Trees (Eitoku) (attrib.) 177, **5.23**

Dada 192, 195, 196, 348, 355
Dai, Lady of: tomb of 118-19, 120, **4.10**
Daibutsuden, Todai-ji complex, Nara, Japan 161, **5.9**
daimyo 151, 168, 169, 170, 182, 198
Daisen-in garden, Kyoto 172-3, **5.20**
Dalai Lamas 75, 76-7
Dalokay, Vedat 54, **2.28**
Damascus 28, 29: Great Mosque 31-2, **2.5**
Dan, the 232, 245
dance: African 231, 232, 251-2, 257-8, 268, **7.1**, **7.20**; Native American: 323, 327, 329, 332, 340-1, 342, **8.59**, **8.63**
darsana 13, 61, 80, 101, 102
Davidson, Robert 324
Delhi, India 89
Democratic Republic of Congo 241
Deng Xiaoping 347, 348
Descent of the Ganges, The (Mamallapuram, India) 80, **3.21**
Design of the World (Naqsh-i Jahan), Isfahan 46-7, 48
Devi (Hindu deity) 81
dharma 64, 102
dharmachakra 65, 72
Dharmaraja Ratha, the (Mamallapuram, India) 80-1, **3.22**
Dhatangu, Paddy (and others): The Aboriginal Memorial 224-5, **6.23**
didon 245, 268
diffusionists 112
ding (Shang bronze vessel) 112, 146, **4.3**

Djenné, the Great Mosque 256-7, 267, **7.25**
Dogon, the, Mali 231, 257; Kanaga masks 231-2, 268, **7.1**
Dome of the Rock, Jerusalem 29-30, 31, **2.2**, **2.3**
Dong Qichang: Landscape in the Manner of Old Masters 137, **4.27**
Drafting script (Chinese) 123-4
Dreaming, the (Australian Aboriginal) 205, 342, **6.22**
Dresden Codex (Mayan) 290, **8.18**
"dressed statue" images, Cuzco 285, **8.13**
Dubai, United Arab Emirates (UAE): Burj Al Arab Hotel (WS Atkins PLC) 352-3, **9.5**; Burj Khalifa (Skidmore, Owings and Merrill) 352, 353-4, **9.6**
Dunhuang, China: wall-paintings 124-5, **4.15**

Eagle Dancer (Howe) 338-9, **8.68**
Easter Island 204, 220; moai (stone heads) 14, 219-20, 226, **6.18**
Ecuador 272, 275
Edenshaw, Charles 323
Edirne, Turkey: Selimiye Cami (Mosque of Selim II) 51-2, **2.24**
Edo period (Japan) see Tokugawa (Edo) period (Japan)
Edo, Japan see Tokyo (Edo), Japan
Eight Deer (Mixtec ruler) 306-7, **8.39**
Eitoku, Kano: Cypress Trees (attrib.) 177, **5.23**
El Anatsui 259-60: In the World, But Don't Know the World 260, **7.29**
El Tajín, Veracruz 301-4; Pyramid of the Niches 303-4, **8.35**; sculptures 301, 304, **8.32**; South Ball Court 301-2, **8.33**
Ellora, India 82-3: Kailasanatha temple 82-3, **3.23**, **3.24**
emakimono 166-7, 198, **5.14**
Esoteric Buddhism 151; in Japan 162, 198
Ethiopia 239: Gospel of St Matthew 239-40, **7.6**
ewà 245, 268
Execution (Yue Minjun) 347-8, **9.1**
Existentialism 354-5
"eyedazzler" blankets (Navajo) 337, **8.67**

Faisal mosque, Islamabad 54, 347, **2.28**
Fake Design Cultural Development Ltd. (Ai Weiwei) 349
Fan Kuan: Travelers amid Mountains and Streams 128-9, **4.18**
Father (Luo Zhongli) 145, 347, **4.35**
featherwork, Hawaiian 218-19, **6.17**
feng shui 139, 146
film: Indian 99; Japanese 192, 194-5, **5.39** see also video art
Firdawsi: Shahnama 41, 45-6, 52-4, **2.14**, **2.18**
Fluxus 195, 198, 354, 355
Flying Horse... (Han bronze) 120, **4.12**
Foguangsi temple, Shanxi, China 109-10, **4.1**
Foreigners in Yokohama (Sadahide) 188-9, **5.33**
Foumban, palace at (Bamum) 255, **7.24**
Fu Hao, Lady: tomb 111-12
Fujiwara court/rulers (Japan) 162, 164, 167, 168

Ga, the: fantasy coffins 260-2, 268, 347, **7.30**
Gandhara, Pakistan 64-5, 70, 121, 158, **3.11**
garbhagriha 81, 83, 84, 85, 102, **3.28**
gardens: Chinese 140, 142, **4.30**;

Japanese 183: (Zen) 172-3, **5.20**
gaso 171, 198
Gateway of the Sun, Tiahuanaco 282, **8.8**
Gauguin, Paul 203, 214
Ge'ez 239-40
GEISAI art festival 350
Gelede ritual, Yoruba, Nigeria 250-2, 268, **7.20**
Genghis Khan 25, 38, 90, 132
Genji, The Tale of (Lady Murasaki) 166-7, 199, **5.14**
geoglyphs: Nazca 278-9, 342, **8.3**
Ghana 256, 259: carved fantasy coffins 260-2, 268, 347, **7.30**
Ghost Dance 329, 342: clothing 327, **8.59**
Giryama rituals, Kenya 238, **7.4**
glazes (ceramics) 40, 56, 109, 128, 132, 136; celadon 170, 198, **5.18**; crackle 109, 132, 146, **4.22**
Gogh, Vincent van 190-1, 191: The Bridge in the Rain 191, **5.36**
gold leaf 175, 177, 181, 285, **5.23**, **5.27**
goldworking: Africa 256; Inca 284; Korea 156, **5.5**
Gommata statues 88-9, **3.32**
Govardhan, Abu'l-Fazl Presenting the First Book of the 'Akbarnama' to Akbar 90, **3.34**
Granada, Spain 34-6: Alhambra 34-6, **2.9**
Great City of Tenochtitlan, The (Rivera) 18, 311, **1.4**, **8.42**
Great Congregational Mosque (Masjid-i-Jumah), Isfahan 39, 40, 46, **2.13**
Great Goddess, the, Teotihuacán (mural) 300, **8.31**
Great Mosque, Samarra 36-7, **2.10**
Great Plains culture 16-17, 324-9
Great Wave of Kanagawa, The (Hokusai) 186, **5.32**
Great Zimbabwe 236-7, 269; Great Enclosure, the 236-7, **7.3**
green technology 356
Gu Kaizhi: Admonitions of the Instructress to the Ladies of the Palace 122-3, **4.14**
Guan ware 132, **4.22**
Guan Yu 135, **4.24**; Guan Yu Captures an Enemy General (Shang Xi) 135, **4.24**
Guanyin 66, 125, **4.16**; Guanyin as the Guide of Souls (silk painting) 125, **4.16**
Gupta period (India) 72-3, 74, 86, **3.13**, **3.14**
Gutai Bijutsu Kyokai (Gutai group) 192-4, 355, **5.38**
Gwangju Biennale 197

Gwangju Biennale 197

haboku style 171, 193, 198, **5.19**
Haboku Landscape for Soen (Sesshu Toyo) 171, **5.19**
hadiths 27
Hagia Sophia, Istanbul 50-1, **2.23**
Haida, the 320-1, 323-4, **8.53**; "totem poles" 321-2, **8.50**
haiku 152, 156, 174, 179, 198, 354
Hakuho period (Japan) 158-60
Hampton, James: Throne of the Third Heaven... 265-7, **7.34**
Han dynasty (China) 109, 113, 116, 118-20, 135, 140, 150, 156, 158, **4.10**
Han Yu 126
Hangzhou, China 128, 133, 184
haniwa 153-4, 196, 198, **5.3**
'Happenings' see performances
hara-kiri 168
Harappa 62, 62; Dancing Figure 63-4, **3.3**
Harlem Renaissance 266-7
Harun al-Rashid, Caliph 36, 38
Hasaw Chan K'awil 291, 295, **8.19**
Hawaii 204, 218-19; featherwork 218-

19, **6.17**; sculpture 218, **6.16**
headhunting 208-10
Heian period (Japan) 151, 162-7
Heiji Monogatari 167-8, **5.15**
heiva Tiurai festival (Tahiti) 216
Herat, Khurusan 39, 43, 45
Herzog & de Meuron: "Bird's Nest" Olympic Stadium, Beijing 349
Hideyoshi, Toyotomi 173, 175, 176, 179, 180
hieroglyphs/hieroglyphics 342; Aztec 307-8; Mayan 18, 289, 290-1, 292, **8.17**; Mixtec 306-7, **8.39**
Himeji Castle, Hyogo, Japan 176, 180, **5.21**
Hinayana Buddhism 70, 77, 102
Hinduism/Hindu art 13, 60, 61, 67, 79-87, 102; architecture: (Cambodia) 86-7, **3.30**, **3.31**; (India) 61, 80-4, 85-6, 99-101, **3.22-3.25**, **3.27-3.29**, **3.42**, **3.43**; painting 94-5, 98 **3.38**; sculpture 79, 80-1, 94, **3.21**, **3.22**
Hinomaru Illumination (Amaterasu and Haniwa) (Yukinori) 196, 347, **5.41**
Hiroshige, Ando 190-1; *Ohashi Bridge in the Rain* 190-1, **5.35**
Ho-o-do (Phoenix Hall), Byodo-in 163-4, 180, 192, **5.11**, **5.12**
hochxo 335, 336, 342
hogans (Navajo) 335, 342
Hohokam culture (Southwestern USA) 330
Hokusai, Katsushika: *The Great Wave of Kanagawa* 186, **5.32**
Hong-do, Kim: *Schoolroom* 184, **5.30**
Hopewell culture 314, 315-17; Serpent Mound 316-17, **8.45**
Hopi culture 332-3; ceramics 334, **8.65**, **8.66**; *kachinas* 333, 342, **8.63**
Horyu-ji complex, Nara, Japan 158-9, **5.7**
hosho 185
House of the Governor, Uxmal (Maya) 298, **8.28**
House of the Prophet, Medina 30, **2.4**
Howe, Oscar 338-9, 346: *Eagle Dancer* 338-9, **8.68**
hozho 312, 335, 336, 342
huacas 283, 342
Huari, Peru 282: tapestries 282, **8.9**
Hughes, Langston: *Negro Mother* 266
Hui Neng...Chopping Bamboo at the Moment of Enlightenment (Liang Kai) 130-1, **4.20**
Huitzilopochtli (Aztec god) 19, 307, 309
human sacrifice 19, 215, 294, 301-2, 305, 309, **8.33**
Hunter and Kangaroo (bark painting) 205-6, **6.1**
Husain, Maqbool Fida: *Vedic* (from the Theorama series) 99, **3.41**
hypostyle mosques 30, 39, 56

Ibn al-Haytham 28
iconoclasm 28, 56
Ieyasu, Tokugawa 181, 182
ifarabale 245, 268
Ife-Ife, Nigeria 243-4, 246, **1.1**
Igbo people, Owerri, Nigeria 252-3, **7.21**
Ilkhans, the 25, 39, 41, 42
illuminations 56: African 239-40, **7.6**; Islamic 37-8, 49, **2.12**, **2.25**; Ottoman 54, **2.27**; Persian 41, 42, 43, 44, 90, **2.14**, **2.16**
Imperial Palace, Beijing 134, 138-40, **4.28**, **4.29**
In the World, But Don't Know the World (El Anatsui) **7.29**
Inca, the 15, 272, 273, 274-5, 278-9, 280, 282-5

India: British colonial 14, 95, 96-8, **3.39**, **3.40**; film industry in 99; Gupta period 72-3, 74, 86, **3.13**, **3.14**; Kushan period 70-1, **3.11**, **3.12**; map 60; Maurya period 64-5, 80; modern 99-101; Mughal 89-94; religions 60-2 (*see also* brahman/ Brahmanism, Buddhism, Hinduism, Jainism); Shunga/early Andhra periods 65-8; time chart 61 *see also* Indus Valley
Indian independence movement 97-8
Individualists, the (China) 141, 146
Indonesia: Java 78, **3.20**
Indus Valley 62-4, 81, **3.1**; script 63, **3.2**
installations/installation art: African 260, **7.29**; Australian/Aboriginal 224-5, **6.23**; Chinese 349, **9.2**; Japanese 195-6, **5.40**, **5.41**; Native North American 314 *see also* altars; multimedia art; *raigo*; video art
interlaces 28, 56
internationalism 347-8, 354, 356; architecture 351-4; multimedia/ performance 354-5; painting and sculpture 347-51
Internet, the 350
Intihuatana Stone, Machu Picchu 284
Iran 25, 38, 39
Irian Jaya (New Guinea, Melanesia) 208-9; Asmat people 209-10, **6.6**
irimoya 160, 198
Ise: Grand Shrine 154-5, 173, **5.4**; Yoruba palace 250
Isfahan, Iran 25, 39, 46; Great Congregational Mosque (Masjid-i-Jumah) 39, 40, 46, **2.13**; Masjid-i Shah (Masjid-i Iman) 47, **2.19**, **2.20**
Ishiyama-gire album **5.13**
Isidorus of Miletus (with Anthemis of Tralles): Hagia Sophia, Istanbul 50-1, **2.23**
Islam/Islamic art 12, 24-8, 55; calligraphy 28, 37, 52, **2.11**, **2.25**; carpets 48-9, **2.22**; manuscripts 35, 37-8, 43, **2.12**, **2.16**; mosaics 30, 31-2, 40, **2.2**, **2.3**, **2.5**; textiles 48, **2.21** *see also* illuminations; mosques; Qur'an
Islamabad, Pakistan: Faisal mosque 54, 347, **2.28**
Ismail, Shah 45
Istanbul 25, 50-1: Hagia Sophia 50-1, **2.23**; Topkapi Palace 52, **2.26**
ivories 248, 249, **7.17**
iwans 39-40, 43, 47, 56, **2.13**, **2.20**
Iznik tiles 52, **2.26**

jade: Chinese 110-11, 112, 115, 119, **4.2**, **4.7**; Olmec 288, **8.16**
Jahan, Shah 92, 94
Jahangir Preferring a Sufi to Kings (Bichitr) 90-2, **3.35**
Jain art/Jainism 60, 61, 67, 79, 87-9, 102, **3.32**, **3.33**
Jami (Abd al-Rahman) 43
Japan: 150-2; Asuka period 158-60; Buddhism 151-2, 156, 158; Heian period 151, 162-7; Jomon period 152-3, **5.1**; Kamakura period 166-9; Kofun period 153-6; map 150; Meiji Restoration period 187-92; modern (post-1912) 192-6, 350-1, **9.3**; Momoyama period 173-81, **5.21**, **5.22**; Muromachi (Ashikaga) period 170-3, 179, **5.19**; Nara period 161-2; Neolithic period 152-3, **5.1**; Shintoism 14, 151, 152, 153, 154-6, 158, 172, 193, 197, 199; time chart 151; Tokugawa (Edo) period 182-6; Yayoi period 153

japonisme 14, 174, 177-8, 190-1, 198, **5.36**
jatakas 73, 78
Java, Indonesia: Borobudur 78-9, 214, **3.20**
Jemaa, Head from (Nok) 243, **7.10**
Jerusalem: Al-Aqsa Mosque 29; Dome of the Rock 29-30, 31, **2.2**, **2.3**
jinas 87-8, 89, 102, **3.32**
Jing Hao: *Notes on the Art of the Brush* 128
Jingdezhen, China: ceramics 134-6, 147, 349
Jocho: Amida sculpture, Byodo-in 163-4, **5.12**
jodo Buddhism *see* Pure Land Buddhism
Jodo *see* Pure Land Buddhism
Jomon period (Japan) 152-3, **5.1**
Jordan: Mshatta, palace façade 32, **2.6**
Juzaburo, Tsutaya 185

Ka'ba, Mecca 26, **2.1**
kabuki plays/theaters 182, 185, 190
kachinas 332-3, 342, **8.63**
Kahlo, Frida: *The Two Fridas* 311, **8.43**
Kaikai (Murakami) 350, **9.3**
Kaikai Kiki Co. (Murakami) 350, 351
Kailasanatha temple, Ellora, India 82-3, **3.23**, **3.24**
kakemono 171, 198
Kama Sutra 86
Kamakura period (Japan) 166-9
Kamehameha I (Hawaii ruler) 218
kami 154, 156, 198
Kanaga masks 231-2, 268, **7.1**
Kandarya Mahadeva temple, Khajuraho, India 85-6, 101, **3.27**, **3.28**
Kanishka I (Kushan emperor) 70; sandstone figure 70-1, **3.12**
Kano School (Japanese screenpainters) 177, 187, 198
Karli, India: *chaitya* hall 69, **3.9**, **3.10**
karma 64, 78-9, 102
Karnataka, India: Aesthetic Gommata, the 88-9, **3.32**
Katsura Detached Palace, Kyoto, Japan 182-4, **5.28**, **5.29**
'Kearny Cloak' (Hawaiian) 218, **6.17**
Kenko, Yoshida 168
kente cloth 259, 268, **7.28**
Kenya: Giryama rituals 238, **7.4**
Khajuraho, India: Kandarya Mahadeva temple 85-6, 101, **3.27**, **3.28**; Parsvanatha temple 86, **3.29**
Khamsa (Nizami) 45
kie bingoas 216-17, 226, **6.15**
Killer Whale (Reid) 323, **8.53**
kimono 198
Kingdom Tower, Riyadh, Saudi Arabia 354
kivas 332, 342, **8.62**
koans 131, 146, 172-3, 195, 196, 348
Koetsu, Hon'ami 181: *The Crane Scroll* 181, **5.27**; Mount Fuji tea bowl 180, **5.26**
Kofun period (Japan) 153-6; mound tombs 153-4, 198, **5.2**; shrines 154-6, **5.4**
Kojiki 161
kondo 158, 159-60, 161, 198, **5.9**
Kongo Rikishi 158; Unkei's sculpture 169, **5.17**
Kongo: *nkisi nkondi* (hunter figures) 241-2, 268-9, **7.9**
Koran *see* Qur'an
Korea 150-1, 157-8, 197: ceramics 170, 180, **5.18**; Koryo dynasty 170; map 150; sculpture (Buddhist) 157, **5.6**; Silla kingdom 156, 170; and tea ceremonies 181; Three Kingdoms period 156-8; time chart 151; post-1945 197
Korean Wave (Hallyu) 197

koto 166, 198
Krishna 94-5, 100, **3.38**
Kuala Lumpur, Malaysia: Petronas Towers (Cesar Pelli & Associates) 351-2, **9.4**
Kuaua, New Mexico 332, **8.62**
Kubilai Khan 132-3, 170
Kukailimoku (Hawaiian sculpture) 218, **6.16**
Kufic script 37, 56
Kun-Can (Shiqi) 141
Kunz Axe (Olmec) 288, **8.16**
Kushan period (India) 70-1, **3.11**, **3.12**
Kwei, Seth Kane 261
kyo-ka (Japanese poetry) 182
Kyoto (Heiankyo), Japan 162, 167, 170, 175, 182; Daisen-in garden 172-3, **5.20**; Katsura Detached Palace 182-4, **5.28**, **5.29**; Nishi Hongan-ji 177, **5.22**

La Venta, Mexico 287-8, **8.15**
lacquerwork: Chinese 136-7, 142, 146, **4.26**; Japanese 160, **5.8**
Lahawri, Ahmad: Taj Mahal 92-4, **3.36**
Lakshmi (Hindu deity) 81, 86
lamas/lamaism 74, 75, 133
Landscape (Yuan-Ji) 141-3, **4.31**
Landscape in the Manner of Old Masters (Dong Qichang) 137, **4.27**
Lankesvara temple, Ellora, India 83
Lao Zi 14, 115: *Dao de jing* 108, 146
Lapita art/culture 204, 207, **6.3**
Last Race, The (Catlin) 325, **8.55**
latte sets 212, 226, **6.9**
Legalism (China) 116
Leonardo da Vinci 35
Lhasa, Tibet 75; Potala monastery-palace 76-7, **3.17**
li 108, 110, 129, 140, 146
Li Zhaodao 124
Liang Kai: *Hui Neng...Chopping Bamboo at the Moment of Enlightenment* 130-1, **4.20**
Liangzu culture, China: Jade cong 110, **4.2**
Liberia 232, 245
Liji ("Book of Rites") (Confucius) 115, 146
linga 83, 85, 101, 102
Li'o, Lese 216
Lion capital (Pataliputra, India) 65, **3.4**
Lion Grove Garden, Jiangsu, China 140, **4.30**
literati, Chinese (*wenren*) 14, 109, 129-30, 133, 141, 143, 146
literature and poetry: Chinese 109, 115, 122, 124, 135, 153; Hindu 79, 80, 81, 84, 86, 94-5, 98; Islamic: 37-8, **2.12**; (Persian) 42, 43, 44, 45-6, **2.16**, **2.17**; Japanese 152, 156, 161, 164, 166-7, 174, 182, **5.14**; Mughal 90, **3.34**
Liu Sheng (king of Zhongshan): burial 119
Liu Zongyuan 126
lost-wax casting 243, 244, 268
lotus flowers 65, 68, 69
Luo Guanzhong: *Romance of the Three Kingdoms* 135
Luo Zhongli: *Father* 145, 347, **4.35**
Luoyang, China 124

Ma-Xia style 130
Ma Yuan 130, 131, 171: *Scholar Contemplating the Moon* 129
machiy (Waisemal) 213, 226, **6.11**
Machu Picchu, Peru 284, **8.12**
Macianus, George 195
madrasa 42-43, 46, 56, **2.15**
Madurai, India: Minakshi-Sundareshvara temple 94, **3.37**
Mahabharata 80, **3.21**

Mahavira 88
Mahayana Buddhism 66, 70, 74, 78-9, 86, 87, 102, 158
Maimonides, Moses: Mishneh Torah 35
Maitreya Budda 66, 78; Korean bronze 157-8, **5.6**
Makonde, Mozambique: masks 238
malanggan ceremonies/sculptures (New Ireland) 210-11, 226, **6.7**
Malangi, David: (and others) *The Aboriginal Memorial* 224-5, **6.23**; *Sacred Places at Milmindjarr* 206-7, **6.2**
Mali, West Africa 256; Bamana, the 232; (Chi Wara headdress) 257-8, 267, **7.26**; Great Mosque at Djenné 256-7, 267, **7.25**;
Mamallapuram, India: monuments 80-1, **3.21, 3.22**
mana 14, 203-4, 214, 218-9, 223, 226
Manchu dynasty *see* Qing Dynasty
mandalas 67, 77, 78, 84, 87, 102, 151, 162, 163
Mandan, the 324, 325-7, **8.54, 8.55**
mandapas 83, 84, 85, 102, **3.23, 3.28**
Mandela, Nelson 262, **7.31**
Manjushri (Tibetan *thangka*) 75, **3.16**
Mansudae Artist Studio, Pyongyang 197
mantras 84
manuscripts: African 239-40, **7.6**; Islamic 35, 37-8, 43, **2.12, 2.16** *see also* codices; illuminations
Mao Zedong 144-5, 347, 349: *Statue of the Seated Mao Zedong* (Ye Yushan) 144, **4.34**
Maori, the 112, 220-1, 223, 224; meeting-houses 204, 221-4, 226, **6.20**; storage houses 221, **6.19**; tattooing 215, 222, **6.21**
Maqamat (al-Hariri) 38, **2.12**
marae 204, 214-15, 221, 226, **6.12**
Mariana Islands: House of Taga, Tinian Island 212, **6.9**
Marquesas Islands 204; tattooing 215-16, **6.13**
Marske, Dean: Vocational Education Building, Sisseton-Wahpeton College, South Dakota 341, **8.69**
Martinez, Maria: ceramics 334, **8.66**
Masanobu, Kano 177
Masjid-i Shah (Masjid-i Iman), Isfahan 47, **2.19, 2.20**
masks: African 231-2, 235, 238, 249, 251, 268, **7.1, 7.17, 7.20**; Native North American (*kachina*) 332
Master of the Circled Cross 234
Master of the Leopard Hunt 234
Mathura, India 70, 72, **3.12**
Mato-Tope (Four Bears) (Catlin) 324, **8.54**
Mauritania 256
Maurya period (India) 64-5, 80
Maya, the 17-18, 273, 286, 289-99; architecture 286, 289, 293-6, **8.23, 8.24**; ceramics 290, 291, 293, **8.20, 8.22**; codices 290, **8.18**; hieroglyphs 18, 289, 290-1, 292, **8.17**; Popul Vuh 292; sculptures 289, 297, 8.26; wall paintings 297-8, **8.27**
mbari houses, Nigeria 252-4, 268, **7.21**
Mecca 26, 27, **2.1**
Mecklenburg County, Daybreak Express (Bearden) 267, **7.35**
Medina 26: House of the Prophet 30, **2.4**
meditation 61, 79, 80, 88, 101, 172, 174
Mehmed II (Ottoman ruler) 25, 50
Meiji Restoration period (Japan) 187-92
meisho-e 186, 190
Melanesia 202, 204, 207-11
Mesa Verde, Colorado: Cliff Palace 331-2, **8.61**
Mesoamerica 17-18, 286-309, 342; ball

game 282, 293, 294, 301-2, 342, **8.21, 8.32, 8.33**; map 287; time chart 286
metalworking/metal casting 112, 114, 153, 156, 233, 242-3, 248 *see also* bronzes
Mexico 18, 112, 272, 286, 297-304 *see also* Aztecs; Chichén-Itzá; Maya; Olmecs; Palenque; Tenochtitlán; Teotihuacán; Veracruz style, Classic
Micronesia 202, 211-13
mihrab 30, 33, 56
Milpurruru, George (and others): *The Aboriginal Memorial* 224-5, **6.23**
Mimbres, the 330
mimi 205-6, 226, **6.1**
Minakshi-Sundareshvara temple, Madurai, India 94, **3.37**
minarets 30, 56
minbar 27, 30, 56, **2.4**
Ming dynasty (China) 52, 134-7, 146, **4.24-4.27**
Mishneh Torah (Maimonides) 35
Mississippi culture (North America) 314, 317-20, **8.48, 8.49**
Mixtecs, the: codices 306-7, **8.39**
moai, Easter Island 14, 219, 226, **6.18**
Moche, Peru: burial cult 279, **8.5**; ceramics 279, **8.4, 8.5**
Mohenjo-Daro, Pakistan 62, **3.1**; seals 62-3, **3.2**
moko tattoos 222, **6.21**
moksa 61, 81, 102
Momoyama period (Japan) 173-81
Mongols 25, 38, 75, 87, 132-3, 134, 136, 170
Monk's Mound, Cahokia 318, **8.47**
mosaics 56: Byzantine 30, 31; Islamic 30, 31-2, 40, 43, **2.2, 2.3, 2.5**
mosques 26-7, 54, 55, 56: Córdoba, Spain 33-4, **2.7, 2.8**; Damascus, Syria 31-2, **2.5**; Djenné, Mali 256-7, 267, **7.25**; Edirne, Turkey 51-2, **2.24**; hypostyle 30, 39, 56; Isfahan, Iran 39-40, 47, **2.13, 2.19, 2.20**; Islamabad, Pakistan 54, 347, **2.28**; Istanbul, Turkey 50-1, **2.23**; Jerusalem, Israel 29-30, **2.2, 2.3**; Samarra, Iraq 36-7, **2.10**
mounds, ancient North American 315, 316; Adena 315; Hopewell 316-17, **8.45**; Monk's Mound, Cahokia 318, **8.47**; Newark and Heath, Ohio 317, **8.46**; Serpent Mound, Ohio (Hopewell) 316-17, **8.45**
Mount Abu, India: Vital Vasahi temple 89, **3.33**
Mount Fuji (*raku* ware, Japan) (Koetsu) 180, **5.26**
Mozambique 238; Makonde masks 238
Mshatta, Jordan: palace façade 32, **2.6**
Mu Qi (Fa Chang): *Six Persimmons* 131, **4.21**
mudra 70, 102
Mughal India 89-94
Muhammad, the Prophet 12, 25, 26-7, 29, 42
multimedia art: African 231, 250, 258, 260, **7.29**; Japanese 354-5, **9.7**
Mumbai, India: film industry 99
Mumtaz Mahal 92
muqarnas 40, 52, 56
Murakami Takashi 350-1, 356: 2010 exhibition at Versailles, Palace of, Paris 350-1, **9.3**; *Kaikai* 350, **9.3**; Tokyo Pop Manifesto 351
Murasaki, Lady: *The Tale of Genji* 166-7, 199, **5.14**
Muromachi (Ashikaga) period (Japan) 170-3, 179, **5.19**
murti 101
music: African 231; (Yoruba, *gelede* ritual) 251-2, 268, **7.20**; Native North

America: Navajo 335; Northwest Pacific Coast 323; Great Plains (Pow Wows) 340-1, 342
Mvuala (staff handle) 240, **7.7**
Myanmar 77: Ananda temple, Pagan 77, **3.19**

nagas 80
namban byobu 178, 187, 188, **5.24**
Nampeyo, Leah 334, **8.65**
Nan Madol complex, Pohnpei, Micronesia 211, **6.8**
Nandi shrine, Kailasanatha temple, Ellora, India 83, **3.23**
Naqashkhane, the 52, **2.25**
Nara/Nara period (Japan) 161-2; Horyu-ji 159-60, **5.8**; Todai-ji complex 161-2, 169, **5.9, 5.17**
Natchez, the 318
National Mosque of Pakistan *see* Faisal mosque, Islamabad
Native American art 12, 15-17, 312-14: Adena 314, 315, 317, **8.44**; Great Plains 16-17, 324-9, 341, **1.2**; Hopewell 315-17, **8.45**; Mississippi period 314, 317-20, **8.48, 8.49**; Northwest Pacific coast (*see also* Haida; Pomo, Tlingits) 112, 320-24; Southern Cult 317, 343; Southwestern USA (*see also* Hopi; Navajo; pueblos) 330-7; 20th century 323-4, 329, 334, 338-41, **8.53, 8.66, 8.68, 8.69**
Navajo, the 15-16, 312, 330, 335-7; blankets/weaving 335-7, **8.67**; sand paintings 17, 312, 335, **1.3**
Nayak dynasty (India) 94
Nazca geoglyphs 278-9, 342, **8.3**
Neo-Confucianism 134, 146, 182
Neo-Dadaism 195
Neolithic period: China 110-11, 112; Japan 152-3, **5.1**
Nepal 74
nephrite *see* jade
New Delhi, India: Akshardam Swaminarayan Temple Complex 99-10, 347, **3.42, 3.43**
New Guinea 207-8
New Ireland: 204, 210-11; *malanggan* ceremonies/sculptures 210-11, 226, **6.7**
New Mexico: Kuaua 332, **8.62**; Pueblo Bonito, Chaco Canyon 330-1, 332, **8.60**; Taos Pueblo 333, **8.64**
New Wave film movement 194
New Zealand 204, 220, 224 *see also* Maori, the
Newark and Heath, Ohio 317, 319-20, **8.46**
Ngongo ya Chintu 234
Nigeria 233, 242-3, 244: sculpture 15, **1.1, 7.10, 7.11** *see also* Benin; Ife-Ife; Nok style; Yoruba
Night Attack on the Sanjo Palace (Japanese hand scroll) 167-8, **5.15**
Nihon Shoki 161
nimbus 72, 73, 92, 102
Nintoku (Japanese emperor): mound-tomb 153-4, **5.2**
nirvana 61, 66, 77, 78, 102-3, **3.18**
Nishi Hongan-ji, Kyoto 177, **5.22**
Nizami: Khamsa 45
Njoya, King of the Cameroons 254-5, **7.22**
nkisi nkondi (hunter figures) (Kongo) 241-2, 268-9, **7.9**
Nobunaga, Oda 174, 175
Noh drama/theater 152, 156, 174, 179, 198, 354
Nok style 242-3, 269: terracotta 243, **7.10**
Notes on the Art of the Brush (Jing Hao) 128

Nsa'ngu, King of Bamum people: throne 254, **7.23**
Nunnery, the, Chichén-Itzá (Maya) 298, **8.29**

Obsessional Art 194
obsidian 299
Occidentalism 175
Oceania *see* Pacific Islands
Ohashi Bridge in the Rain (Hiroshige) 190-1, **5.35**
Okipa ceremony (Mandan, Great Plains) 325, **8.55**
Olmecs, the 272, 286-8: La Venta 287-8, **8.15**; sculpture 266-7, **8.14, 8.16**
Olórun (Yoruba deity) 245
Olowe of Ise: doors, Ikere Palace 250, **7.19**
One Thousand and One Nights (Arabian Nights) 36, 38, 56
onna-e style 166-7, **5.14**
Opium Wars, the 143
oracle bones, Chinese 113, 123, **4.4**
Orozco, José Clemente 310
otaku 350, 351
otoko-e style 166
Ottoman Empire 50-4

Pachakuti (Inca ruler) 283, 284
Pacific Arts Festival, the 224-5, 347, **6.22**
Pacific Islands 14, 203-4; map 202; time chart 203
Pagan, Myanmar: Ananda Temple 77, **3.19**
Pago Pago, American Samoa: Pacific Arts Festival, the 224, 347, **6.22**
pagodas 158-9, 198
Paik, Nam June 195-6: *TV Buddha* 196, 347, **5.40**
painting: Aboriginal 205-7, 227, **6.1, 6.2**; Africa 235, **7.2**; China: (Ming) 135-7, **4.24-4.27**; (modern/post-1911) 144, 145, 347-8, 349, **9.1**; (Period of Disunity) 122-3, **4.14**; (Qing) 141-3, **4.31, 4.33**; (Song) 128-31, 133, 171, **4.18-4.21**; (Tang) 124-6, **4.15-4.17**; (Xie He's canons) 109, 123, 129, 133, 135; (Yuan) 133-4, **4.23**; India 73, **3.14**; (colonial era) 96-8, **3.39, 3.40**; (Hindu) 94-5, 98, **3.38**; (Mughal) 90-2, **3.34, 3.35**; Japan 152, 166-7, 185, 199; (Heian) 162-3, 166-7, **5.10, 5.13, 5.14**; (Kamakura) 167-8, **5.15**; (Meiji Restoration) 189-92, **5.34**; (Momoyama) 177-8, 181, **5.24, 5.27**; (post-1912) 192-3, **5.38**; Native American 313; Nepal and Tibet (*thangkas*) 74-5, **3.16** *see also* bark paintings; illuminations; silk/silk paintings
Pakal, Hanab (Mayan King): sarcophagus lid 296, **8.25**
Pakistan: Faisal mosque, Islamabad 54, 347, **2.28** *see also* Gandhara; Harappa; Mohenjo-Daro
Palenque (Maya) 296: Temple of Inscriptions 296, **8.24**
Pallava dynasty (India) 80, **3.21, 3.22**
palma (El Tajín) 301, **8.32**
paper 37, 123, 133, 185
Papua New Guinea (New Guinea, Melanesia) 207-8; Abelam houses 208, **6.5**; Ambum Stone 207-8, **6.4**
Paracas textiles, Peru 277-8, **8.1**
Paradise under the Sea (Shigeru) 189-92, **5.34**
Parsvanatha temple, Khajuraho, India 86, **3.29**
Pataliputra, India: Lion capital 65, **3.4**
Pax Mongolia 38

Pelli & Associates: Petronas Towers, Kuala Lumpur 351-2, **9.4**
Penance of Arjuna, the (Mamallapuram, India) 80, **3.21**
performances: Japanese 192-4, 354-5, **5.38**, **9.7**; Native North American 314, 335
see also dance; multimedia art; music; tea ceremony (Japan); theater
"Period of Disunity" (China) 121-24, 156
Persia/Persian culture: illuminations 41, 42, 43, 44, 46, 90, **2.14**, **2.16**, **2.17**, **2.18**; painting 41, 42, **2.14**; poetry 42, 43, 44, 45, 2.16, **2.17**; textiles/fiber art 48-9, **2.21**, **2.22**
Peru 15, 272, 273, 275; Paracas textiles 277-8, **8.1**; Sipán, Lord of (burial) 281, **8.7** see also Chavín de Huántar/ Chavín art; Huari; Moche
Petronas Towers, Kuala Lumpur (Cesar Pelli & Associates) 351-2, **9.4**
Picasso, Pablo 235, 266
pictographs 342; Chinese 113; Mayan 289, **8.17**
piece-mold casting 114, **4.5**
pipes 315; Adena culture 315, **8.44**
Pizarro, Francisco 284
poetry see literature and poetry
Pohnpei, Micronesia: Nan Madol complex 211, **6.8**
Polo, Marco 133
Polonnaruwa, Sri Lanka: Buddhist sculptures 77, **3.18**
Polynesia 202, 204, 214, 273 see also under individual countries
Pomo, the: baskets 326, **8.56**
Popul Vuh 292, 342
porcelain 132, 142, 147, 349; Ming 134-6, **4.25**
Portuguese Merchants and Trading Vessels (Japanese screen) 178, **5.24**
post-and-lintel structure (architecture) 109, 110, **4.1**
Postmodernism 189, 346
Potala monastery-palace, Lhasa, Tibet 76-7, **3.17**
potlatches 313, 322-3, 342
pottery see ceramics
poupou 222, 226, **6.21**
Poverty Point, Louisiana 315-16
Pow Wows 314, 327, 338, 340-1, 342, 347
Powers, Harriet: pictorial quilt 264-5, **7.33**
Pre-Columbian art 15, 272-3, 286, 342 see also Aztecs; Inca, Maya; Olmecs; Toltecs
primitivism 234, 236, 266, 269
Princeton Vase, the (Maya) 293, **8.22**
printing see woodblock prints/printing
Pueblo Bonito, Chaco Canyon 330-1, 332, **8.60**
pueblos 15-17, 272, 273, 330-2, 333-5, 342, **8.60**, **8.61**, **8.64**
Puranas, the 81
Pure Land Buddhism 124, 129, 147, 151, 162-4, 198
Purea of Tahiti: marae 214-15, **6.12**
pyramids: El Tajín, Veracruz: Pyramid of the Niches 303-4, **8.35**; Teotihuacán: Pyramid of the Sun 299-300, 302, 303, 309, **8.30**

qi 14, 109, 110, 123, 124, 139, 140, 147
qibla 30, 56
Qin dynasty (China) 106, 113, 116-18
Qin Shihhuangdi (Emperor) 116; tomb 116-18, **4.8**, **4.9**
Qing dynasty (China) 138-43
Queen Mother (Benin bronze head) 248, **7.16**
quilts 264-5, **7.33**
quipus 283, 342

Qur'an, the 12, 26, 27-8, 37, 43, 47, 56, 94, **2.11**

Radha 94-5, **3.38**
Radha and Krishna in the Grove (Hindu miniature) 95, **3.38**
raigo 163-4, 198, **5.12**
Raimondi Stela (Chavín bas relief) 276-7, **8.2**
Rajarajeshvara temple, Thanjavur, India 83-4, **3.25**
raku ware (Japan) 180-1, 198, **5.26**
Ramayana 175
Raminginging artists: The Aboriginal Memorial 224-5, **6.23**
ranga/rangaku 175
Rapa Nui see Easter Island
rasa 13, 62, 79-80, 103
Rashtrakuta dynasty (India) 82-3
rathas 80-1, **3.22**
Reconquista 34
Red Fudo (Heian silk painting) 162, **5.10**
Registan, the, Samarqand, Uzbekistan 42-3, **2.15**
Reid, Bill: Killer Whale 323, **8.53**
reliquaries 158, 159, 198
Remembering (Ai Weiwei) 349
Ren Xiong, Self-Portrait 143, **4.33**
retablos 311
rib vaulting 33-4, 57, **2.8**
Rivera, Diego: 310-1; The Great City of Tenochtitlán 18, 311, **1.4**, **8.42**
Riyadh, Saudi Arabia: Kingdom Tower 354
Rodrigues, Father João 179, 180
Romance of the Three Kingdoms (Luo Guanzhong) 135
Romans 25, 70
rongorongo script (Easter Island) 220
Ru ware 132
Rukupo, Raharuhi 221, 222; Self-Portrait in the House Te Hau-ki-Turanga 222, **6.21**
Rumi, Jalal ad-Din Muhammad 45
Runnels, Victor: Vocational Education Building, Sisseton-Wahpeton College, South Dakota 341, **8.69**
Rwanda: Tutsi baskets 239, **7.5**
Ryobu Shinto 156

Sa'di of Shiraz: Bustan 43, 44, **2.16**
sabi 14, 154, 156, 179, 180, 198
Sacred Places at Milmindjarr (Malangi) 206-7, **6.2**
Sacsahuaman, Peru: stonework 284, **8.11**
Sadahide, Hasimoto: Foreigners in Yokohama 188-9, **5.33**
Safavid dynasty (Iran) 25, 39, 45-9, 52
Sahara, the 233-4
Sahul 204, 207
Sajama Lines 283
Saljuq dynasty (Iran) 25, 38, 39-40, **2.13**
Samarqand, Uzbekistan 39, 41-2; The Registan 42-3, **2.15**
Samarra, Iraq 38: Great Mosque 36-7, **2.10**
Samoa: bark cloths 216
samsara 64, 79, 85, 88, 103
samurai 152, 168, 169, 170, 182, 186, 198
San, the 235; paintings 235, **7.2**
San Lorenzo, Mexico: colossal stone heads (Olmec) 266-7, **8.14**
Sanchi, India: Great Stupa 66-8, **3.5-3.7**
sand paintings (Navajo) 17, 312, 335, **1.3**
sanghati 66, 72, 74, 77
Sanskrit 60, 61, 64, 79, 80, 94, 103
santa 80
Sante Fe Indian School (Studio School) 338

Sarnath, India 65; Seated Buddha Preaching the First Sermon 72, 73, **3.13**
Sartre, Jean-Paul 355
Sasanian Persians 25, 27, 45
satori 172, 198
Saz style 52, 57, **2.26**
Scholar Contemplating the Moon (Ma Yuan) 129
Schoolroom (Hong-do) 184, **5.30**
screens/screen painting: Japanese 177-8, 184, 198, **5.23**, **5.24**
Scroll of the Emperors (Yan Liben) 125-6, **4.17**
scrolls: Chinese (hand) 122-3, 125-6, 133-4, **4.14**, **4.17**, **4.23**, **4.27**; (hanging) 127, **4.18-4.20**, **4.24**, **4.33**; Japanese (hand) 166-8, 181, **5.14**, **5.15**, **5.27**; (hanging) 171-2, 180, 198, **5.19** see also thangkas
sculpture and carving: Africa 15, 238, 240-4, 247-9, 250, 260-2, 268, 347, **1.1**, **7.4**, **7.7-7.11**, **7.16**, **7.17**, **7.19**, **7.30**; Aztec 18-19, 20, 308-9, **1.5**, **8.41** Buddhist (see also Buddha: images and statues); (India) 64-5, 68, 70, **3.4**, **3.7**; (Korea) 157-8, **5.6**; (Sri Lanka) 77, **3.18**; China 121, **4.13**; Hawaii 218, **6.16**; Hindu 79, 80-1, 84, 85, 86, **3.21**, **3.22**, **3.26**, **3.29**; India 70-1, **3.12**; Indus Valley 62-4, **3.3**; Islamic 32, **2.6**; Jain 87-9, **3.32**; Japan 169, 350-1, **5.3**, **5.16**, **5.17**, **9.3**; Korea 157-8, **5.6**; Maori 220-4, **6.20**, **6.21**; Maya 289, **297**, **8.26**; Melanesia 208-11, 226, **6.6**, **6.7**; Micronesia 212-13; Native American 313, 318, 319, 320-2, 323, 332, 342, **8.49**, **8.50**, **8.53**; Olmec 266-7, 268, **8.14**, **8.16**; Papua New Guinea 207-8, **6.4**; Toltec 20, 305-6, **8.38**; Veracruz 301-2, **8.32**, **8.33**
Seal script 123
seals: Indus Valley 62-3, 79, **3.2**
Second Gutai Art Exhibition 193, **5.38**
Second Sex, The (Beauvoir) 355
Seduction of Yusuf, The (Bihzad) 43-4, **2.16**
Self-Portrait (Ren Xiong) 143, **4.33**
Self-Portrait in the House Te Hau-ki-Turanga (Rukupo) 222, **6.21**
Selim II 51
Selimiye Cami (Mosque of Selim II), Edirne, Turkey 51-2, **2.24**
Sen no Rikyu 179: Tai-an tea house, Myoki-an, Japan (attrib.) 179-80, **5.25**
Serpent Mound, Ohio (Hopewell culture) 316-17, **8.45**
Sesshu Toyo 193: Haboku Landscape for Soen 171, **5.19**
789 Arts Zone, Beijing 347
Seydou, Chris 258-9
Shah Abbas 25, 46-7
Shah Jahan (Mughal Emperor) 92, 94
Shahnama (Firdawsi) 41, 45-6, 52-4, **2.14**, **2.18**
shamanism: Chinese 108, 111, 112, 113, 114, 147; Native American 273, 312, 315, 317; Pre-Columbian 277
Shang dynasty (China) 108, 111-14, 123, **4.3**, **4.4**
Shang Xi: Guan Yu Captures an Enemy General 135, **4.24**
Shanghai Expo 2010 356
Shanxi, China: Foguangsi temple 109-10, **4.1**
sharia 27
Shaykh, Bahram Gur in the Green Pavilion 45, **2.17**
Sheep and Goat, A (Zhao Mengfu) 133-4, **4.23**
shi mo (ink painting) 129, 147

Shi'ites, the 27, 42, 57
shibui 179, 198
Shigefusa, Uesugi: portrait of (sculpture) 169, **5.16**
Shigeru, Aoki: Paradise under the Sea 189-92, **5.34**
Shiji ("Record of the Historian") (Sima Qian) 116
shin 171-2
shinden 166, 167, 199
Shingon sect 162
Shintoism 14, 151, 152, 154-6, 158, 172, 180, 193, 197, 199; shrines 154-6, 173, **5.4**
Shiraga Kazuo: performance at the Second Gutai Art Exhibition 193, **5.38**
Shitao see Yuan-Ji
Shiva (Hindu deity) 80, 81, 82, 83, 84, 86; Shiva as Nataraja, Lord of the Dance (sculpture) 84-5, **3.26**
shoguns 151, 152, 168, 175, 182, 199
shoins 182, 199
Shona Kingdom, Great Zimbabwe 236-7, 269
shrines: Japan (Shinto) 154-6, 173, **5.4** see also altars; mbari houses
Shroud of St Josse (Islamic silk) 48, **2.21**
Shunga dynasty (India) 65-8
Siege of Belgrade, The (Arifi) 54, **2.27**
silk: Chinese 112, 118-19, 122, 125, 142, **4.10**, **4.14**, **4.16**; Islamic 48, **2.21**; Japanese 162, **5.10**
silk painting: Chinese 118-19, 122, 125, 128-31, **4.10**, **4.14**, **4.16**, **4.18**, **4.19**; Japanese 162, **5.10**
Silk Road 25, 36, 38, 41-2, 55, 70, 118, 121, 124, 133, 145
Silla kingdom (Korea) 156, 170, **5.5**
Sima Qian: Shiji ("Record of the Historian") 116
Sinan, Koça ("The Great") 25, 51-2, **2.24**
sinology 106, 121, 147
Sioux, the 324
Sipán, Lord of: tomb of 281, **8.7**
Siqueiros, David Alfaro 310
Sisseton-Wahpeton College, South Dakota: "Song to the Great Spirit" 341, **8.69**
Six Dynasties period ("Period of Disunity") 121-24, 156
Six Persimmons (Mu Qi) 131, **4.21**
Skidmore, Owings and Merrill: Burj Khalifa, Dubai 353-4, **9.6**
Sky Arrow, Mrs Minnie: beaded dress 327, **8.58**
skyscrapers 351-4, 356, **9.4-9.6**
slavery/slaves 233, 234, 258, 263-4
Smith, Adrian B. 354
Soami: Daisen-in (Zen garden), Kyoto 172-3, **5.20**
Song dynasty (China) 109, 128, 171
Sotatsu, Tawaraya: The Crane Scroll 181, **5.27**
South African National Gallery, Cape Town: exhibitions 262, **7.31**
South America 15, 285; map 274; time chart 274
Southern cult (Mississippi culture) 317, 343
Sri Lanka 77, **3.18**; Buddhist rock-cut sculptures 77, **3.18**
Staff God 276-7
stelae (Maya) 293, 297, 343, **8.26**
Stone of Five Suns see Aztec Calendar Stone
Strengths and Convictions exhibition, South African National Gallery, Cape Town 262, **7.31**
Studio School (Sante Fe Indian School) 338
stupas 14, 61-2, 65-8, 103; Borobudur,

Java (Indonesia) 78, 214, **3.20**; Great Stupa, Sanchi (India) 66-8, **3.5-3.7**
Su Shi 137
"Sudden Lords" (Japan) 170, 179
Sufism 42, 44-5, 57
Sui dynasty (China) 124
Suiko period (Japan) *see* Asuka period (Japan)
Sulaymannama 52-4, **2.27**
Süleyman II Kanuni ("The Magnificent") 51, 52, **2.25**
Sultan-Muhammad, *The Court of Gayumars from the Shahnama* 46, **2.18**
Summa Theologica (Aquinas) 35
Suna no Onna ("Woman of the Dunes," Teshigahara) 194-5, **5.39**
Sunda 204
Sunflower Seeds (Ai Weiwei) 349, **9.2**
Sunnis, the 27, 42, 57
Suzhou, Jiangsu, China 184: Lion Grove Garden 140, **4.30**
Surrealism 194
sutras 66, 77, 103
swadeshi movement 97, 98

tableros 303, 343
Tabriz, Iran 39, 45, 90
Tada, Nigeria: seated figure 244, **7.11**
Taga, house of, Mariana islands 212, **6.9**
Tahiti 214; *heiva Tiurai* festival (Tahiti) 216; *marae* 214-15, **6.12**
Tahmasp, Shah 45-6, 90, **2.18**
Tai-an tea house, Myoki-an, Japan (Sen no Rikyu) (attrib.) 179-80, **5.25**
Taizong, Emperor 120
Taj Mahal, Agra, India 92-4, **3.36**
Tajore, Abanindranath: *Bharat Mata* 98, **3.40**
Tale of Genji, The (Lady Murasaki) 166-7, 199, **5.14**
taluds 303, 343
Tamamushi Shrine, Horyu-ji Treasure House, Nara, Japan 159-60, **5.8**
Tamerlane (Tamburlane) *see* Timur the Lame
Tang dynasty (China) 120, 124-6, 136, 161, 162, 185
Tange Kenzo: Olympic Stadium, Tokyo 192, **5.37**
Tanjore, India *see* Thanjavur, India
tanka poetry/poets 152, 166, 174, 179
Tantras 81
Tantric Buddhism 74, 86, 102, 129
Tanzania 238
taonga 223, 227
Taos Pueblo, New Mexico 333, **8.64**
taotie 112, 115, 147
tapestries 275; Huari, Peru 282, **8.9**
tapu 14, 203, 221, 227
tatami (reed mats) 177, 178, 182, 199
tattooing 204, 207, 224, 227; Maori 215, 222, **6.21**; Polynesian 215-16, **6.13**
Te Hau-ki-Turanga Meeting House, Poverty Bay, New Zealand 221-4, **6.20**
tea ceremonies, Japan 155, 156, 175, 178-81, 184, 185, 198, 354
teaching vase (Maya) 291, **8.20**
Ten Aspects of Physiognomy of Women (print series) (Utamaro) 186, **5.31**
Tendai sect 162
tenno-sei 196
Tenochtitlán, Mexico 18-19, 21, 307, **1.4**, **1.5**, **8.40**; Templo Mayor 307, 308
Tenzin Gyatso 75
Teotihuacán 299-300, 302-3, 308-9, **8.34**; Citadel compound 302, 303; Great Goddess, the (mural) 300,

8.31; Pyramid of the Moon 302, 309; Pyramid of the Sun 299-300, 302, **8.30**
"terracotta army" (tomb of Qin Shihhuangdi) 116-18, **4.8**, **4.9**
terracottas: Benin 247, 248; Japanese *haniwa* 153-4, 196, 198, **5.3**; Nok 243, **7.10**
Teshigahara, Hiroshi: *Suna no Onna* ("Woman of the Dunes") 194-5, **5.39**
textiles/fiber art: African 258-9, 268, **7.27**, **7.28**; Andes 275-6; (Paracas) 277-8, **8.1**; (Huari) Peru 282, **8.9**; Islamic 46, 48-9, **2.21**, **2.22**; Micronesia 213, **6.11**; Native North American 313-14, 322, 327, 335-7, **8.52**, **8.58**, **8.59**, **8.67**; Polynesian bark cloths 216, **6.14**; (Tahitian) 214 *see also* quilting; silk
thangkas 74-5, 103, **3.16**
Thanjavur, India: Rajarajeshvara temple 83-4, **3.25**
theater: Japan 152, 156, 182, 185, 192
Theorama series (Husain) 99, **3.41**
Theravada Buddhism 66, 70
Throne of the Third Heaven… (Hampton) 265-7, **7.34**
Tiahuanaco, Bolivia 282: Gateway of the Sun 282, **8.8**
Tibet 74-7, **3.16**, **3.17**; Potala monastery-palace 76-7, **3.17**; 74-5, 103, **3.16**
Tikal (Maya) 289, 295; Inscription (Temple IV) 289, **8.17**; Temple I (Temple of the Great Jaguar) 195, **8.23**
tiki 222, 227
tiles 40, 47, 52, **2.19**, **2.20**, **2.26**
Timur the Lame (Tamerlane, Tamburlane) 25, 41, 42, 90, 92
Timurids, the 25, 39, 41-5
tirthankaras 88-9, 103
tlamatinime 18, 19-20, 308, 343
Tlingits, the 321, 322-4; blanket 322, **8.52**; whale house interior **8.51**
Todai-ji (Great Eastern Temple) complex, Nara, Japan 161-2, 169, **5.9**, **5.17**
tohunga 223, 227
tokonoma 180, 199, **5.25**
Tokugawa (Edo) period (Japan) 182-6
Tokyo (Edo), Japan 167, 182, 184-5, 188; Imperial Hotel 192; Olympic Stadium 192, **5.37**
Tokyo Pop Manifesto (Murakami) 351
Toledo, Spain 35
Toltecs, the 20, 305, 308, **8.36**
tombs: China 108, 111-12, 113, 116-19, 120, **4.8-4.10**; India 92-4, **3.36**; Japan 153-4, 196, 198, **5.2**; Korea 156, **5.5**; Mayan 290, 296, **8.25**; Native American 312-13, 315; South American 281, **8.7**
Tonga 203, 216-7; bark cloths 216, **6.14**
Topkapi Palace, Istanbul: tiles from the kiosk of Süleyman 52, **2.26**
toranas 67-8, 155, **3.6**, **3.7**
torii 155, 199
Toshodai-ji temple, Nara, Japan 161
totem poles 312, 320-1, 343, **8.50**
"tourist art" 232, 268
trade: Africa 233-4, 237, 256; China 14, 108, 142, 143, 145; Japan 175, 187, 188, 190, 191; Native Americans 312, 315-16, 328 *see also* Silk Road, the
Travelers amid Mountains and Streams (Fan Kuan) 128-9, **4.18**
tribhanga pose 64, 68, 84, 103, **3.7**, **3.26**
Triumph of Indrajit, The (Varma) 96, **3.39**
tughra of Süleyman II (illumination)

52, **2.25**
tuhuka/tuhuna 215
tukutuku 222-3, 227
Tula, Mexico 305-6; sculptures 306, **8.38**; Pyramid B 305, 306, **8.37**, **8.38**
Tupuhia, Teve 217
Turkoman dynasties (Iran) 25, 39, 45
Tutsi, the: baskets 239, **7.5**
TV Buddha (Paik) 196, 347, **5.40**
Two Fridas (Kahlo) 311, **8.43**

ukiyo-e prints 184-8, 190, 196, 199, **5.31**, **5.32**
Umayyad Caliphate 25, 29-36
Underground Railroad 264
Unkei: Kongo Rikishi (sculpture), Todai-ji temple compound, Nara, Japan 169, **5.17**
Upanisads 64, 103
Ushak animal carpets 49
Utamaro, Kitagawa 185-6: *Woman Holding a Fan* 186, **5.31**
Uxmal, Yucatán: House of the Governor 298, **8.28**

Vajrayana Buddhism 74, 86, 102
Valdivian culture 275
van Gogh *see* Gogh, Vincent van
Varma, Ravi 96-7: *The Triumph of Indrajit* 96, **3.39**
Vastu Shastra 100
Vedas 64, 81, 100, 103
Vedic (Husain) 99, **3.41**
Veracruz style, Classic 301-2, **8.32**, **8.33**
Versailles, Palace of, Paris: Murakami exhibition (2010) 350-1, **9.3**
video art: African 258, 262; Japanese 195-6, **5.40**
viharas 68, 103; Ajanta 73
vimana 81, 83, 84, 85, 103
Vinci, Leonardo da 35
Viracocha (Inca deity) 283
Vishnu (Hindu deity) 79, 81, 94
Vishnu and Lakshmi (sculpture) Parsvanatha temple, Khajuraho, India 86, **3.29**
"Vision 2020" programs: India 99, 101; Malaysia 351, 352
Vital Vasahi temple, Mount Abu, Rajasthan, India 89, **3.33**
Vocational Education Building, Sisseton-Wahpeton College, South Dakota 341, **8.69**
"Voodoo" 242

wabi 14, 154, 156, 179, 180, 198, 199
wall paintings/murals: China 124-5, **4.15**; India 73, 74, **3.14**; Maya 297-8, **8.27**; Mexican (20th century) 18, 311, **1.4**, **8.42**; Native American 332, **8.62**; Persian 32; Teotihuacán 300, 310, **8.31**
Wang Wei 124
warp and weft 275
Warring States period (China) 115-16
Waxaklahun Ubah K'awil (Copán ruler): portrait statue (Stela A) 297, **8.26**
weavers/weaving *see* textiles/fiber art
Wei dynasty (China) 121-4
Wei zhi (Chinese chronicle) 153
Wei, Lady 124
Wen Zhengming 137
wenren (Chinese literati) 14, 109, 129-30, 133, 141, 143, 146
"were-jaguars" 288
Western Paradise (wall painting) 124-5, **4.15**
White Heron Castle *see* Himeji Castle, Hyogo, Japan
Wo-Haw between Two Worlds (Wo-Haw)

16-17, 338, **1.2**
Woman Holding a Fan (Utamaro) 186, **5.31**
woodblock prints/printing: China 128; Japan 98, 166, 184-6, 188-9, 190-1, **5.31-5.33**, **5.35**
Wounded Knee, South Dakota 329
Wright, Frank Lloyd: Imperial Hotel, Tokyo 192
writing systems: Chinese 110, 113, 118, 123-4, 161; Japanese 164-6; Maya 288, 289, 290-1, **8.17**; Pacific Islands (*rongorongo* script) 220 *see also* calligraphy
WS Atkins PLC, Burj Al Arab Hotel (Dubai) 352-3, **9.5**
Wululu, Jimmy (and others): *The Aboriginal Memorial* 224-5, **6.23**

"X-ray" style 205-6, 227, **6.1**
Xia dynasty (China) 106, 111
Xia Gui 130
Xibalba 290, 292, 293, 294, 295, 296
Xie He 14, 110; *Gu hua pin lu* 109, 123, 129, 133, 135, 141

yakshis 68, 70, 103, **3.7**
Yamato-e painting style 166-7, 185, 199, **5.14**
Yan Liben (attrib.): *Scroll of the Emperors* 125-6, **4.17**
Yayoi period (Japan) 153
Ye Yushan, *Statue of the Seated Mao Zedong* 144, **4.34**
Yijing ("Book of Changes") 115, 147
yin and *yang* 14, 108, 147
yoga 61, 62, 78, 79, 101, 103, 129, 172
yogi 79, 81, 100
Yokohama, Japan 188-9
Yoko Ono 195, 354-5, 356; *Cut Piece* 354, 355, **9.7**
Yoruba, the 15, 232, 243-6, 250, **7.19**: *gelede* ritual 251-2, 268, **7.20** *see also* Ife-Ife
Yoshihara Jiro 192, 193, 194, 355
yu (bronze vessels) 113-14, 115, 147, **4.6**
Yuan dynasty (China) 52, 132-34, 136, 140, **4.30**
Yuan-Ji (Shitao): *Landscape* 141-3, **4.31**
Yue Minjun: *Execution* 347-8, 356, **9.1**
Yukinori, Yanagi: *Hinomaru Illumination* (*Amaterasu and Haniwa*) 196, 347, **5.41**
Yungang, Shanxi, China: Buddhist monuments at 121, **4.13**; cave temples 121
yunqi 120, 147

zarifs 12, 28, 57
Zeitgeist philosophy 13
Zen Buddhism 109, 129, 151-2, 155, 170-3, 186, 193, 199; gardens 172-3, **5.20**; meditation 174; and painting 171, 193, 198, **5.19**; and performance art 195, 354; and poetry 174; and tea ceremonies 179
zenga 172, 199
Zhang Hua 122, **4.14**
Zhang Qian 118
Zhao Mengfu: *A Sheep and Goat* 133-4, **4.23**
Zhou dynasty (China) 114-15, 116, **4.6**
zimbabwe (walled enclosures) 236-7, 267, 269, **7.3**
Zimbabwe 235, 237: Great Enclosure, the 236-7, **7.3**
Zoroastrianism 100